JOHN RUSKIN

No Wealth but Life

Dearest Mum, Jennifer
and Grandma,

Happy Birthday

with lots of love
from

Richard, Magdalena,
Tara and Sashie

March 2000

JOHN RUSKIN

No Wealth but Life

John Batchelor

Chatto & Windus
LONDON

Published by Chatto & Windus 2000

2 4 6 8 10 9 7 5 3 1

Copyright © John Batchelor 2000

John Batchelor has asserted his right under the Copyright, Designs and
Patents Act 1988 to be identified as the author of this work

First published in Great Britain in 2000 by
Chatto & Windus
Random House, 20 Vauxhall Bridge Road,
London SW1V 2SA

Random House Australia (Pty) Limited
20 Alfred Street, Milsons Point, Sydney,
New South Wales 2061, Australia

Random House New Zealand Limited
18 Poland Road, Glenfield,
Auckland 10, New Zealand

Random House (Pty) Limited
Endulini, 5A Jubilee Road, Parktown, 2193, South Africa

The Random House Group Limited Reg. No. 954009
www.randomhouse.co.uk

A CIP catalogue record for this book
is available from the British Library

ISBN 1 856 19580 5

Papers used by Random House are natural,
recyclable products made from wood grown in sustainable forests.
The manufacturing processes conform to the environmental
regulations of the country of origin

Typeset by SX Composing DTP, Rayleigh, Essex
Printed and bound in Great Britain by
Biddles Ltd, Guildford

Contents

For Henrietta
with love

List of Illustrations

Colour illustrations

1. *John Ruskin, aged three-and-a-half.* Painting by James Northcote, 1822. (*National Portrait Gallery, London*)

2. *Christ Church Cathedral from Tom Quad.* Painting by John Ruskin, 1839. (*The Governing Body, Christ Church, Oxford*)

3. *The Ca d'Oro, Venice.* Pencil, watercolour and body colour by John Ruskin, 1845. (*Ruskin Foundation, Ruskin Library, University of Lancaster*)

4. *St Mark's, Venice: after the rain.* Painting by John Ruskin, 1846. (*Ashmolean Museum, Oxford*)

5. *Exterior of the Ducal Palace, Venice.* Painting by John Ruskin, 1845 or 1852. (*Ashmolean Museum, Oxford*)

6. *Tomb of Ilaria di Caretto at Lucca.* Painting by John Ruskin, 1874. (*Ashmolean Museum, Oxford*)

7. *Portrait of Effie.* Drawing by John Ruskin, 1850. (*Ashmolean Museum, Oxford*)

8. *Gneiss rock, Glenfinlas.* Study by John Ruskin, 1853. (*Ashmolean Museum, Oxford*)

9. *John Ruskin.* Painting by John Everett Millais, 1853. (*National Portrait Gallery, London*)

10. *Slavers throwing overboard the dead and dying – Typhoon coming on.* Painting by Joseph Mallord William Turner, 1840. (*Henry Lillie Pierce Fund/Museum of Fine Arts, Boston*)

11. *Nocturne in Black and Gold: the Falling Rocket.* Painting by James Abbott McNeill Whistler, 1875. (*Gift of Dexter M. Ferry, Jr./The Detroit Institute of Arts*)

12. *Mystic Nativity* by Sandro Botticelli. (*National Portrait Gallery, London*)

13. *The Dead Christ* by Andrea Mantegna 1431–1506. (*Brera Gallery, Milan. Bridgeman Art Library*)

14. *Rose la Touche.* Pencil, watercolour and body colour by John Ruskin, c. 1862. (*Ruskin Foundation, Ruskin Library, University of Lancaster*)

15. *Self portrait.* Painting by John Ruskin, 1874. (*Wellesley College Library, Special Collections. Gift of Charles Eliot Goodspeed*)

Black and white illustrations

Author's Foreword

The right question to ask, respecting all ornament, is simply this: Was it done with enjoyment – was the carver happy while he was about it?

That country is the richest which nourishes the greatest number of noble and happy human beings.

All good architecture is the expression of national life and character.

How long most people would look at the best book before they would give the price of a large turbot for it?*

In 1906 the radical journalist W.T. Stead conducted a survey to learn from the first Labour intake into the House of Commons which books or authors had most influenced their beliefs. The result showed that Ruskin was the clear favourite, followed in order by the Bible, Dickens, Henry George, Carlyle, J.S. Mill, Scott, Shakespeare and Bunyan (among these, Henry George had been hugely influenced by Ruskin, while J.S. Mill was one of Ruskin's most ferociously assailed targets). Tolstoy, an admirer, saw Ruskin as a prophet and a huge social and political force, but he also thought that the bulk of the work was simply overwhelming and that to read all of Ruskin was to weaken the effect. Proust and Gandhi were also disciples of Ruskin but again they were selective; for Proust the great text was *The Bible of Amiens*, for Gandhi it was *Unto this Last*.

For William Morris, one of the most complete and devoted of Ruskinians, the chapter on 'The Nature of Gothic' from the second volume of *The Stones of Venice* (1853) was 'one of the very few necessary and inevitable utterances of the century'. Like J.A. Hobson and Henry George, Morris saw Ruskin as one of the fathers of radical socialism. Morris's fantasy *News from Nowhere*, 1890–91, displays a Utopian society which represents Morris's interpretation of Ruskin's vision of England, expressed in *Fors Clavigera* and in Ruskin's plans for the Guild of St George. This future society in *News from Nowhere*

*These four quotations are taken from: Chapter V, 'The Lamp of Life', of *The Seven Lamps of Architecture*, 1849; Essay IV, 'Ad Valorem', in *Unto this Last*, 1862; 'Traffic', a lecture delivered in Bradford in 1864 and published in *The Crown of Wild Olive*, 1866; and 'Of King's Treasuries', a lecture delivered in Manchester in 1864 and published in *Sesame and Lilies* in 1865.

is a kind of medieval community of happy craftsmen living in great houses, free of social structures, of money and (obviously) of the tyranny of industrial capitalism, and placing the highest value on craftsmanship and manual labour (one of the best characters is a splendidly dressed dustman who writes novels in his spare time). Ruskin's friend Carlyle, by contrast, saw Ruskin as an assailant of mid-Victorian life from a viewpoint which was philanthropic but broadly conservative, like Carlyle's own. And Ruskin himself in his auto-biography, *Praeterita*, wrote in the 1880s that he was, like his father before him, a 'Tory of the old school'.

In a sense all these perspectives on Ruskin are correct. Ruskin was nurtured by the Romantic movement, especially the work of Byron, Scott and Wordsworth, and his radicalism is best understood as that of a Romantic visionary. He embraces and expounds artists and civilisations which can be enlisted as exhilarating alternatives to the prevailing order, and in his later work he ferociously attacks high-Victorian capitalism and then proposes his own quasi-feudal society as an alternative to it. *Modern Painters* celebrates the art of the moment and of the future, *The Stones of Venice* is an impassioned championing of a civilisation of the past; both challenge, with equal energy, the inert present. In the 1850s and after, Ruskin often sounds like Carlyle, who was by this time a close friend and would later (after the death of Ruskin's father in 1864) become Ruskin's adopted 'Papa'. Ruskin often seems to be using the same strategies as Carlyle. Carlyle (born in 1795, the same year as Keats, and reared on German Romantic literature) was himself part of the Romantic movement and he offers a radical if autocratic future in *Heroes and Hero-Worship* and enlists a medieval society to correct the Victorian world in *Past and Present*. Both writers were intended by their devout parents for the ministry, both retained the rhetoric of the preacher throughout their careers, both were enraged by industrial capitalism's alienation of the worker, both believed passionately in the value and dignity of work.

Read selectively, Ruskin's work will yield almost any political position. This presents us with a problem: it would be easy to agree with Tolstoy that the work *has* to be read selectively because there is simply too much of it, but the fact is that to arrive at a grasp of Ruskin we have to take him whole. And the devotion of his disciples has ensured that the whole has become huge. After Ruskin's death his friend Charles Eliot Norton, who was one of his executors, took the view that enough had been published and that his literary executors

should exercise restraint and selectiveness, but in the event E.T. Cook and Alexander Wedderburn, in their thirty-nine volume edition of Ruskin's *Works*, went for inclusiveness. Everything that Ruskin had published and a great deal of his unpublished work, including many of his letters, was included, and the edition was ordered to show Ruskin's output falling into a pattern. Wonderful though it is, the Cook and Wedderburn edition is Edwardian in tone and intention, a proud monument to an illustrious Victorian career. His editors make Ruskin seem grand, majestic and *tidy*.

In reality, he was never tidy, though to be untidy is not to be incoherent. The central faiths that emerge from the complete Ruskin are in the autonomy of the workman, the centrality of nature in human experience, the dignity of man, the wickedness of industrial capitalism, and the notion that a better society can be enlisted to replace the one in which we live. In the 1840s and '50s, that better society is fourteenth- and fifteenth-century Venice; in the 1870s with the setting up of his Guild of St George, it is a kind of feudal agrarian community which he believed could be created, with enough private investment and enough goodwill, in the present in late Victorian Britain.

As soon as we open one of the thirty-nine volumes, Ruskin's exuberant untidiness is forced upon us as a fact. Apart from his fairy-tale, *The King of the Golden River*, and his autobiography, *Praeterita*, all Ruskin's works defy generic neatness. His early works, *Modern Painters* and *The Stones of Venice*, were 'books' in a reasonably traditional sense of the word, but even there the reader constantly feels that the activities of the art critic and the critic and historian of architecture are spilling over into other activities. The passages on Turner's painting of water in *Modern Painters* I become acts of creation, startling realisations in prose of how the sea actually moves. The account of Venice becomes an exhilarating intellectual adventure, asking us to concede the daring proposition that we can *read* architecture as we read Shakespeare or Dante, and that in such reading we can find central political and social truths about the civilisation which created the buildings.

After 1860 the discrete book gives way in Ruskin's output to what is in effect occasional writing: the literary essay, the letter and the lecture determine the shape of the later books, and each is for a particular audience. His first audiences were familial: *Modern Painters* is written for his parents (Volume II in particular reflects his mother's desires for him) while *The Stones of Venice* is for his parents and his wife, Effie,

who accompanied him on his Venetian research visits between 1849 and 1852.

'The Nature of Gothic', the pivotal chapter of *The Stones of Venice*, led him to his radical assaults on the social and economic structures of his fellow-Victorians in the 1860s in such books as *Unto this Last*. *Unto This Last* was published by Ruskin's faithful friends and publishers, Smith and Elder, in their new venture, the *Cornhill Magazine*, set up in 1862 with Thackeray as editor. The audience for the four essays in the *Cornhill*, some 80,000 subscribers, was a broad cross-section of the intelligent high Victorian middle-class. Ruskin was addressing a similar audience in his later series of essays, *Munera Pulveris*, in *Fraser's Magazine*, edited by the great historian (and Carlyle's biographer) J.A. Froude. The audiences for *Time and Tide*, addressed to Thomas Dixon the Sunderland 'cork cutter' and first published in *The Leeds Mercury*, would have been very different. Often Ruskin defines his audiences: *Ethics of the Dust* is addressed to 'little housewives' and *Fors Clavigera* to 'the workmen and labourers of Great Britain'.

Whatever the form of publication, though, his greatest impact was on people like his father, the intelligent, prosperous, anxious middle classes; these were his central audience. The wealth of the new rich marked a social revolution: wealth was no longer rooted in the land, but was an all-powerful, partly intangible force determining the shape and style of industrialised Britain. By 1850 Britain had become predominantly an urban society; this was the first time in history that this had been true of any nation. The growth of the cities brought with it urgent questions: what was to be the future shape of Britain? What were to be the guiding principles underlying it? The new rich were aware that their power brought with it responsibility, and they were hungry for moral guidance. Ruskin met this need, both as an arbiter of taste, telling them that it was morally right to spend their money on Pre-Raphaelite paintings and Gothic architecture, and globally, urging them to look at and rectify the urban wastelands they had created. His attacks on utilitarianism and laissez faire, like those of Dickens (in such works as *Hard Times*) and Carlyle, found a ready audience in the class that he was attacking. His teaching contributed to the widespread recognition, in the high Victorian period, of the need for corrective action: to create schools and parks, libraries and museums, and to restore to the labourer a sense of ownership of his labour. Enlightened industrialists and businessmen were to prove among the most loyal

members of Ruskin's Guild of St George.

By the time we reach *Fors Clavigera*, Ruskin had personally revolutionised the publishing industry. He believed that the business-man, the middle-man, should be removed from all trade, and that competition and profit should be excluded from all transactions. He therefore determined to part company with Smith, Elder (the final breach with this loyal and long-suffering firm came in 1873). Ruskin arranged to have his works published and distributed by one of his employees, George Allen, who was to send the numbers of *Fors Clavigera* at a fixed price direct to purchasers. Reviewers and shop-keepers alike were thus circumvented. With this initiative Ruskin created what became the 'net book agreement', the rule (abandoned in the UK only recently) whereby a book is to be sold at the publisher's price and cannot be sold at a discount. The publishing company Allen and Unwin is also a direct fruit of this enterprise.

The books published after 1860 were occasional works written usually in serial form and addressed to specific audiences. They replaced the volume form with a flexible and in a sense provisional literary form. And Ruskin himself saw his early work also as pro-visional and was constantly intending to revise the books on which his reputation was founded, *Modern Painters* and *The Stones of Venice*, but these plans tended to be abandoned in mid-flight. Instead of revising *Modern Painters* he allowed his friend and neighbour Susan Beever to make a selection from it, *Frondes Agrestes* (1874), which – since it was authorised, rearranged and annotated by Ruskin – indicates how he might have revised his famous first book by removing its Protestant evangelical rhetoric and displaying the natural world – sky, water, mountains, plants and flowers – in a sequence of ordered set-pieces which could then be compared with Turner's paintings in order to demonstrate the painter's huge mastery.

The sub-title of the present book is taken from 'Ad Valorem', the fourth of Ruskin's 'Four Essays on the first principles of Political Economy', collected as *Unto this Last*. Ruskin writes 'THERE IS NO WEALTH BUT LIFE' and follows this, two sentences later, with the sentence that I have used as the second epigraph to this Preface, 'that country is the richest which nourishes the greatest number of noble and happy human beings'. 'Unto this last' is itself a Biblical quotation, taken from Christ's parable of the vineyard. The labourers are hired at different times of the day, so that by evening some have worked throughout the day, others

only for the last hour or so. Nevertheless, the lord of the vineyard pays them all the same amount. One of the labourers complains, saying: 'These last have wrought but one hour, and thou hast made them equal unto us, which have borne the burden and the heat of the day.' And the lord replies: 'Friend, I do thee no wrong: didst not thou agree with me for a penny? Take that thine is, and go thy way: I will give unto this last, even as unto thee.' Payment is geared not to desert but to *need*. There is to be no competition, no market forces, no laws of supply and demand and no industrial capitalism. The function of work is not to create profit but to generate wealth, and wealth is not money, wealth is life.

John Batchelor
Matfen, Northumberland
November 1999

CHAPTER I

1819–35

> I had generally my own little affairs to see after; and, on the whole, by the time I was seven years old, was already getting too independent, mentally, even of my father and mother; and, having nobody else to be dependent upon, began to lead a very small, perky, contented, conceited, Cock-Robinson-Crusoe sort of life, in the central point which it appeared to me, (as it must naturally appear to geometrical animals,) that I occupied in the universe.[1]

Praeterita, the autobiography published in twenty-eight parts between July 1885 and July 1889, was John Ruskin's attempt to make sense of his own life – or rather, to use one of the preferred phrases of Ruskin's maturity, it was his attempt at gathering and governing the elements in his life which he felt, with justification, to have been scattered prodigally over too broad a field. But in writing this beautiful autobiography Ruskin solves the problems created by his own prodigality not by synthesising but by radically selecting. When the facts don't suit him he leaves them out.

The result – as with much autobiography – is a work that has a paradoxical status. It is both an indispensable historical document and a work of fiction. It evokes wonderfully the child's slowly evolving perception that the life that he takes for granted and regards as normal is in fact highly abnormal. John Ruskin had no siblings and few companions, and the occupations his parents selected for him tended to be sedentary and restricted. Parental pressures drove him from early childhood to behave like a precocious genius and to think of himself as a moral teacher. Parental pressures also contributed substantially to the emotional maladjustment, which caused disaster to his marriage and other close relationships with women, and to the insanity that dogged him for the last thirty years of his life. His huge talents were cherished and fostered, while at the same time his loving parents horribly mauled his inner life. It seems likely that the two halves of this double process were inseparable from each other. As is so often the case where an over-loved child has been emotionally mutilated by its parents, nobody is to blame.

John Ruskin's parents were first cousins, his mother being older than his father, and their son was the child of their middle age.

Beyond the fact of being related to each other, John James Ruskin (1785–1864) and Margaret Cock (1781–1871) would appear at first sight to have had little in common. Their letters[2] reveal John James as a strong, widely read, ambitious, spirited and creative man, and Margaret as a woman of (comparatively) limited reading and narrow outlook, her moral horizons determined by evangelical Christian principles. The qualities they shared, though, were intelligence, honesty and thrift, an urgent desire to better themselves and a belief that life has to be grounded in a firm moral code (John James's devotion to solvency was as binding as his wife's devotion to the Bible). It became clear to them both that they could trust each other better than they could trust anybody else.

The relationship between John James and Margaret developed in the Edinburgh home of John Thomas Ruskin (1761–1817), John James's father and John Ruskin's paternal grandfather.[3]

John Thomas's father, John Ruskin (1734–1830), came from Cheshunt in Hertfordshire. His grandfather, also John Ruskin, is referred to in the county records as a 'yeoman' of Cheshunt; he died in 1753. He may have been the son of a Robert Ruskin of Berkhamsted who married in 1713, and grandson of a Thomas Ruskin of Berkhamsted who married in 1660. The Cheshunt John Ruskin spent most of his life in the City of London parish of St Bartholomew the Great. He was father of both John Thomas Ruskin, paternal grandfather of the subject of this book, and Margaret Ruskin (later Cock, 1756?–1817), his maternal grandmother.

John Thomas Ruskin was apprenticed to a wine-trading company, London Vintner, in 1776, when he was fifteen, and probably completed his apprenticeship. By December 1783 he had married Catherine Tweddale (1763–1817), had set himself up as a grocer in Edinburgh (he seems never to have been in the wine trade, despite his apprenticeship) and fathered his first child, Janet Ruskin (later Richardson), John Ruskin's 'Aunt Jessie' (1783–1828).[4]

By 10 May 1785 – the date of the birth of John James – John Thomas Ruskin referred to himself as a 'Merchant'. By 1802 he was working as the Scottish agent for a London grocer, T.I. Moore. This led to disaster: by 1808 John Thomas Ruskin was in a web of debt from which he

could not extricate himself. To save money he and his wife left Edinburgh and moved to Dysart in Fife, where they lived near a Mr John Jameson (grandfather of Euphemia Chalmers Gray, John Ruskin's future wife). By 1815 John Thomas Ruskin had moved to Perth, where he rented a house called Bowerswell. He was still in debt, and he was unhappy about his son's proposed marriage to a cousin. In 1817 he committed suicide (shortly after his wife's death).

John Thomas's wife, Catherine Tweddale Ruskin, John Ruskin's grandmother, was socially several rungs of the ladder above her husband's family. She was descended from four prominent Scottish Galloway families. Her father, the Reverend James Tweddale of Glenluce, was a Presbyterian minister in what was in effect a family living, previously held by his uncle. Her mother, Janet Adair, came from an ancient landowning family of Little Genoch, near the head of Luce Bay in Galloway. Janet Adair's mother, Jean Ross, came from the Ross family of Balsarroch and Balkail, and Janet Adair's grandmother was an Agnew; the Agnews were the hereditary barons of Lochnaw. Catherine Tweddale was very proud of her family and its grand connections.[5] In 1808 John James asked her for an account of his connection with General Hew Whiteford Dalrymple. Her letter shows intricate knowledge of the family network (and a fine nose for social advantage). It appears from her letter that her great-uncle Alexander Ross (brother of Jean Ross) had married into the Dalrymple family, thus establishing a relationship with the Earls of Dumfries and Stair. In the midst of the distress caused by her husband's profligacy and hopeless debts, Catherine Tweddale probably derived comfort from this opportunity to set out in detail her mother's family's hereditary grandeur.[6]

It is tempting to see John James Ruskin's abilities as inherited from the aristocrats and Presbyterians in his mother's background, but the imaginative and creative side of his temperament seems to owe a lot to his father. And it could well be argued that history disadvantaged John Thomas and favoured John James. John Thomas had failed, financially, while the country was at war with France. John James established his wine business, Ruskin, Telford & Domecq, in 1815, the year that the war ended. His early success came during the boom years of post-war trade when English middle-class purchasing power and upward social mobility meant that any reasonably able merchant, selling such accessories of gentility as fine wines, was likely to do well.

John James was born in Edinburgh while his father was still a grocer

living in a tenement in Kennedy's Close. He was a pupil at the Edinburgh Royal High School from the age of ten to sixteen. When John James was eleven his father moved the family to a better address – 15 St James's Square, in the New Town. As the son of a prospering (at that time) tradesman who was determined to better himself, John James might reasonably have been expected to move on from the Royal High School to Edinburgh University, but John Thomas seems to have felt that his son's interests would be best served by starting out in business at an early age.[7]

By the age of sixteen John James had met his future wife, his cousin, Margaret Cock. She moved to Edinburgh to live with John James's parents some time between 1801 and 1804. Janet Ruskin, 'Aunt Jessie', married on 1 November 1804 Mr Patrick Richardson (1774–1824) of Perth. Patrick Richardson was a tanner, thus a surprisingly humble choice of son-in-law for the socially ambitious John Thomas. As John Ruskin says in *Praeterita*, it was not to be a particularly prosperous or happy match.[8] It may have been to fill the vacant place left by Janet's marriage that Margaret Cock moved to Edinburgh.[9] But it is possible that she had already moved there in 1801.

Certainly in June of 1801 John James wrote a poem addressed to his cousin Margaret. For a sixteen-year-old grocer's son who was now leaving school and expected to go to London and find employment for himself, it is a confident lyric. Its opening is as follows:

> Suppose a youth entitled to comment,
> On praising earthly Beauty fully bent,
> Say could he find a mortal face like thine,
> Where Natures graces ever lovely shine?

It anticipates the fulsome rhetorical style of the many love letters that John James would write to Margaret. He also continued to write poems (of this occasional and classically inspired kind) and was an enthusiastic reader of poetry throughout his life. The poem ends with a true statement of the circumstances of its writing:

> The first thou art that e'er his fancy caught,
> To lavish words on Beauty never taught,
> Inspired by thee, tis nature dictates all
> Those lines that from his pen unpolish'd fall.[10]

As he says here, Margaret was his first and only love, and poetry was not his trade.

John Thomas, who seems to have been dazzled by the splendour of

his wife's family connections, believed that the best start in life for John James could be found by obtaining from Catherine's relations advantageous introductions for the young man to the London commercial world. James Tweddale (1768–1844), Catherine's brother, had married a Margaret McTaggart, whose brother, John McTaggart (d. 1810), was a successful London 'Colonial Broker'. Equipped with a letter of introduction to John McTaggart from his uncle James Tweddale, John James was sent off to London early in 1802. Confidently expecting that McTaggart would produce something advantageous for his son quickly, John Thomas made what he saw as a temporary arrangement for John James to work (for no compensation) with a firm called 'Fyfe Druggist', and to board with the Mr Moore to whom John Thomas was an agent in Scotland. Virtually penniless and often hungry, John James had breakfast and tea with the Moore family 'except Sundays', when he seems to have had nothing. He endured this bleak regimen for fifteen months before admitting defeat and going home to Edinburgh (in the late summer of 1803).[11]

At length, in response to renewed pressure from the Ruskins, McTaggart did come up with a job in London, and John James worked for Amyand Cornwall Co., 'a German and Russian House', importers and exporters, from some time late in 1804. Unfortunately he had joined this once great company at a time when it was in decline. He gained valuable experience with them, and, in deference to McTaggart, Amyand paid the young man £100 a year. But he had to find £60 a year to stay 'in a miserable Lodging House'. The life was hard: he worked a gruelling timetable for four (or possibly five) years without a break. He records that he worked until 8.00 p.m. three nights a week, until 11.00 p.m. two nights a week and until 4.00 p.m. on Saturdays. In February 1808 he heard from his mother that his father had got himself into financial difficulties, and John James promptly added to his own burdens by undertaking to pay off the parental debts.[12] He also moved into cheaper lodgings[13] and delayed his plans to marry.

From 1808 – again as a result of action on the part of John McTaggart – John James worked for a larger and more prosperous London trading company, Gordon Murphy Co., which dealt with South America and Spain. It was partly owned by Sir William Duff Gordon – another of the grand family connections found by Catherine Tweddale through her grandmother Ross's family. Luck and good timing gave John James important responsibilities:

happily for me, an Irish Clerk . . . embezzled the petty Cash & I was asked
if I would undertake the whole Custom House Business, including the
clearing out the Ships for they employed no Brokers[.] I agreed at once
but found some difficulty for every Vessel that came to us from South
America, brought packages or articles contrary to Law & there was
perpetual detention and memorializing the Treasury but I kept my
troubles quiet & fought on[.] I thought I could hardly get into a worse
Scrape than my Predecessor who had, by a Blunder, got a Cargo worth
£270,000 – seized and the House had £500 to pay to get her released – I
was to have £150 salary but they were satisfied & gave me £200 – I was
now 23 [1808–9] & my Father was by good living getting behind – I saw
my only dependence was here & I seized every opportunity to make
myself useful –

He was sharp and alert, more reliable than the gentlemanly
youngsters to whom Gordon Murphy Co. were accustomed to entrust
too much of their business, and he had soon made himself indispens-
able to the firm's three owners, Sir William Duff Gordon, Colonel
Murphy and James Farrell.

The Cash Keeper was a young man of some Property & he came to
business on Horseback at 11 & 12 oClock – I was out getting Bills
discounted by Gurneys long before this – I thought I could manage Cash
& Custom house too – I displaced [Sir] Williams Cash Keeper – our
payments were £1/2 million a year on an average – Every morning at 9
for a long time I met the wily Duncan Hunter to exchange
accommodation Bills – I recollect a warm Saturday in July 1810 on which
I had £28000 to pay & at 10 oClock I had only £10,000 at the Bankers
– I raised the rest among the Jews & Quakers – Sir Wm D. Gordon
managed the English Correspondence with Jamaica & Cadiz but he was
member [MP] from Worcester & much engaged – I heard him one night
say he would write on an important Subject next day to Cadiz – I knew
his Sentiments – I wrote a Letter at night & placed it before him next day
– He read & signed & from that day I had Cadiz & Jamaica
Correspondence to myself except when Farrell wrote a Letter – They
raised my salary to £300 & gave me Rooms in the House with the Junior
Partner where I also dined every day he was at home – Having Cash,
Correspondence & Custom House I was safe enough if the House had
been so –[14]

But the 'House' was not safe. Sensitised by his father's behaviour to
the evils of an over-lavish life-style, John James could see that the
partners, especially Sir William Gordon, were spending too much of the
firm's money on their own fine living. When offered another
opportunity, John James took it.

A fellow clerk at Gordon Murphy's was Juan Pedro Domecq,[15] son of a long established Spanish wine-exporter, whose firm had been established in 1730 in Jerez (which gave its name to the white wines known as *sherries*). Domecq's home, Macharnudo Castle, was the site of an excellent white wine vineyard. Domecq's proposal to John James concerned not his father's wines but those of his uncle, another major exporter, Juan Carlos Haurie. Gordon had imported and sold Haurie's wine, but the two men had quarrelled, so that Haurie needed a new London agent. In 1813 Pedro Domecq approached John James '& asked if I would join him & be agent to his Uncle if he could get the appointment for us'; thus early in 1814 'I joined Domecq as agent for the Sale of Haurie-Wine'.[16] Domecq kept his own vineyard as a separate business and in due course became a major wine trader independently of his London partnership with John James (who was perfectly happy with this arrangement). To raise capital, having only £1,500 between them, John James and Pedro Domecq had turned again to the McTaggart connection. John McTaggart had died in 1810, but his nephew, Henry Telford, was persuaded. In 1815 the new partnership was agreed, and the three young men opened the offices of Ruskin, Telford & Domecq, at 11 Billiter Street, in London (a property owned by Henry Telford).

Telford had the habits and outlook of a Yorkshire country gentleman. A man of considerable substance and (from John James's viewpoint) an admirably cautious attitude to his wealth, he was a bachelor who lived with his sisters. He had absolute confidence in John James, who in turn became devoted to Telford. After Telford's death in 1859 John James was to write:

> we had been Partners for 44 years without a word of dispute or even a difference of Opinion. He was the Kindest hearted & most gentlemanly man I almost ever knew & is greatly regretted by many friends – As a Yorkshireman he was very fond of Horses & a first rate Judge – He enjoyed the Turf but this never gave me one moments thought or uneasiness for his Character was such that I felt it like an Impossibility for Mr. Telford ever to Commit the Slightest Imprudence.[17]

The miserable business of John Thomas's debts is recorded in the letters that John James exchanged with his parents. For example, John James wrote in loving, though reproachful, terms to his father, on 29 February 1808:

> Long have I seen the Storm from a distance – & it was to prepare an

asylum if possible for you and my Dr. [Dear] Mother that I fled from my Home – before the Storm burst upon your head . . . Most sincerely I thank you for making at last a Confident of me. I have long lamented in secret that I was treated but as a Stranger & left to imagine the Worst. It has preyed upon my Mind – weigh'd down the Spirit of my Youth. So now could I rest assured that I was no longer from motives of affection deceived as to the amount of your Embarrassments – instead of being rendered more unhappy as my Dr. Mother so much fears – I should be relieved in part from a load of Sorrow which I have long borne. I am now more desirous of approaching you my Dr. Father as a Son & a Friend – The distance you have kept me at & the Concealment of your affairs has given me much grief. I cannot now hesitate in expressing my Willingness to afford you in person that Comfort which perhaps a Change of life may for a little deprive you of – tho in the end I am sure it will lead to your real Happiness. There is but one wish of my Heart – which is to do what is right in the Sight of God & of my Parents.

By 1825 John James had paid off £3,203 18s 2d of debts of some £5,000.[18] There was a price, however, for his industry, energy and filial dutifulness. He was ill with typhus fever in August 1813, when he was taking the coach from London to Edinburgh on a journey to visit his parents in Perth: this would have been his first holiday for nine years, and he had been seriously over-worked by Sir William Duff Gordon (Gordon kept his young agents at work until midnight or 1.00 a.m., because it was his habit to look in at the office after an evening session of the House of Commons). In order to help his parents, he also postponed his marriage plans.

On 15 March 1808 his mother Catherine Ruskin had written to him resisting his selfless plan not to marry in order to be free to help her and his father, and dropping a very broad hint that Margaret would be acceptable to her as John James's wife:

I will not have My Son an old Batchelor[19] – believe me my beloved Child I feel the full force and value of that affection that could prompt to such a plan – Dear as your society is to me it would then become the misery of my existence . . . Indeed my Dr. [Dear] John the greatest happiness I look forward to in life is to see you with an Amiable Wife and a sweet young [child][20] I know that your Mother will always have a proper share of your [Love] Then instead of being tempted to wish my self out of the World for destroying your happiness – my days would pass, in peace and tranquility in witnessing your domestick enjoyments –

You will make me very proud among you who can say what I can say – here is my Son, a hansome accomplished young man of three and twenty – he wil not Marry that he may take care of his Mother – here is my Dr.

Margaret [Cock] hansome Amiable and good, and she would not leave her, *Ant* (I meant Aunt) for any Man on Earth – Ah My dear and valuable Children dear is your affection to my heart, but I will never make so base a use of it – I entreat my Dr. John that you may never give your self one moments uneasiness about me – I will at all events have £86 a year for life that your Father cannot deprive [me] of . . .

You forget my Dr. how much a woman can do in Domestick affairs to save Money – a Woman that has any management at all can live with more comfort on £50 a year then a Man could do on two Hundred – There was one year of my life that I maintained my self and my two children on twenty pound[21]

Eventually John James obeyed his mother's instructions, marrying the handsome, amiable and good Margaret and fathering the one – only one – sweet young child. But he and Margaret Cock had to wait for nearly ten more years before he had cleared enough of his father's debts to feel able to marry,[22] and meanwhile Catherine's feelings changed.

John James continued to show resolution and courage. On 21 August 1813 Catherine wrote urging Margaret to prevent him from travelling to see his parents until he was fully fit: 'No my dear I would not have you to move on here sooner then what is proper only as soon as my Dear John is able . . . God grant you was all safe here we will not mind a yellow Complexion.'[23]

In obedience to John Thomas's wishes, Catherine now tried to delay the marriage between the two young people. She and John Thomas continued to bring pressure to bear, and John James was driven beyond endurance. He came to believe that Margaret was receiving actual ill-treatment from his parents, and on 13 April 1815 he wrote passionately to her: 'My own Margt you shall not suffer this way I shall marry you in Feby next be the consequences what they may.' And on the same day he wrote indignantly to his parents.[24] Their behaviour looks like callous self-interest – it suited them to have Margaret's companionship and help in the house, and it suited them to have their son's financial support. John James was now over thirty, he had been making his own way since he was sixteen, he was supporting these old people and he had made a success of his business life, which contrasted sharply with his father's financial failure. His parents were abusing his love and loyalty. He told them:

Oh my own Mother as you have always loved me will you & my dear Father assure Margt that you have both become reconciled to our union & be happy – or will you see her & me both fall sacrifices to this anxiety.

9

I have already said that if it leads to eternal Ruin I will fulfill my engage-
ment with Margt. I hope my Dr. Father will therefore no longer cause us
any uneasiness. I have much to do – & unless Margt be well I can do
nothing I shall not soon recover the shock I received on Monday [when
he had learnt that his father had made Margaret ill by opposing the
marriage].

Oh if you expect me to make some efforts to keep the family united –
do not let her on whom my Life depends sink under my Father & your
displeasure. The State of our [wor]ldly matters requires that [w]e should
not oppose each other in other things [to] add to the distress. . . .

My Dr. Father If you open this will you do me the Kindness to say to
Margt that you will never say any more against our union. you surely
cannot wish to see her sink into her grave & if she sees you oppose our
wishes she will[.][25]

This letter makes it clear that John James planned to marry Margaret
in 1816. But he did not realise this hope. His father fell ill and John
James wrote to his mother (1 April 1817) in terms which combine
continuing affection, heroic generosity and understandable contempt:
'Poor man we must forget his bad qualities, & pity him & comfort him
as far as God gives us the means & I am very happy that you are so able
to manage him . . . I will bear any expence to the extent of my whole
Income sooner than let him be moved so long as he can safely be at
home.'[26]

John James did not have to wait long for his freedom. His mother
died on 13 October 1817, and two weeks later John Thomas Ruskin
died. In *Praeterita* John Ruskin wrote that his grandfather had killed
himself, and linked the suicide to the financial mismanagement which
had wrecked the past ten years. Family tradition had it that grief over
his wife's death caused John Thomas to cut his throat.[27] John James
had to devote several months to the financial muddle that his father left
behind him, but he could at last fulfil his promise to Margaret.

Although she was his first cousin, Margaret Cock belonged to a social
layer that was clearly lower than John James Ruskin's. John Thomas
Ruskin had moved up the social scale by marrying into the Scottish
gentry, while his sister Margaret, by her marriage in 1780 to William
Cock (1754–87), had moved downwards. Ruskin family tradition
would subsequently seek to gentrify William Cock by changing his
name and calling so that he was known as 'Captain Cox of Yarmouth'.
('Cock' was both a lower-class name and – in the eighteenth century as
today – a sexual colloquialism.) William Cock was a 'Victualler' and

tenant-landlord of the King's Head, a tavern in the market-place in Croydon. After his death in 1787 Margaret Ruskin Cock carried on as the King's Head's landlady. She prospered, and was able to pay for her daughter Margaret to have a good education at the Croydon Academy for Ladies. Another daughter, Bridget Cock (1783–1830), married a Croydon baker called George Richardson (no relation of the Patrick Richardson of Perth who had married Jessie).

When Margaret Cock, the intelligent and promising niece of the Ruskins, was sent to live with John Thomas Ruskin in Edinburgh it must have seemed an advantageous move. Her mother probably felt that this arrangement would restore her daughter to the social level that she had herself lost by her marriage to William Cock.

For years before their marriage Margaret Cock was John James Ruskin's principal confidante. In the summer of 1815 John Thomas Ruskin suffered a mental illness from which John James believed he would never recover. John James's letters to Margaret are full of affectionate concern. On 30 June 1815 he wrote: 'He must be provided with every comfort & kept in a place where no Surrounding Horrors may intrude upon the lucid moments which God in his goodness may give him.' And on 3 July he added: 'I want to know my mothers plans for I conclude we must make up our minds to a long continuance of this disorder in my Father. At all events should Heaven give him his reason again my Mother must take the management of the funds. . . . Is he allowed to drink. He ought not.'[28] A custodial tone is breaking through John James's filial concern. He had had enough of his father.

John Thomas's insanity reinforced the bond between the lovers. John James's letters to Margaret are in a sense letters to a colleague, co-operating with him in the financial business and management of the old people. The stress of the situation damaged John James's health – never robust after his typhus in 1813. By the summer of 1817 John James himself was ill with nervous distress, 'with a feeling like choaking & a Burning Heat over my whole Body except my feet which are cold . . . I dread the mind destroying the Body.'[29]

Within a few months of this letter his vexatious parents were dead, he had married his Margaret and had settled in 54 Hunter Street, Brunswick Square, London, a four-storey house in a Georgian terrace (demolished in 1969).

John Ruskin was born here on 8 February 1819 and christened at home on 20 February.

*

Margaret Ruskin is regularly blamed for bringing up her only child, John Ruskin, in too strict and narrow a way. But her long experience of John Thomas Ruskin's self-indulgence, self-will and financial mismanagement seems to have given her a lifelong faith in thrift, virtue and self-control. It is not at all surprising that she sought to pass these qualities on to her son. The birth was difficult and she suffered years of pain and fragile health afterwards. She was thirty-nine. There are hints that she would have liked more children (in her letters she speaks of her pregnancy as her 'first confinement') but given her age and health it seems likely that soon after the birth she and John James decided to use some form of birth control. Her letters to John James from the first few months of little John Ruskin's life expressed her joy in her security with her husband and the pride and pleasure that she took in looking after the baby. John Ruskin aged about six weeks was already a prodigy: 'there is something about John so sweet and he gets so fat and healthy that you will see few children like him'. And at five months he is already a 'companion' to his mother. But when he is still only just over a year old Margaret displays a somewhat chilling confidence in corporal punishment for her son:

> I fear . . . he will be very self willed and passionate – he has twice alarmed me a good deal by getting into such a passion that I feared he would have thrown himself into a fit this will I trust be cured by a good whipping when he can understand what it is for properly at present I am compelled to give way more than I like for fear of baiting it[.][30]

The contrast between the respective epistolary styles of Ruskin's parents was striking. Margaret's letters were workaday documents, expressing pleasure in her husband and child and well-merited satisfaction in her own new position. John James's letters were powerful literary performances on the theme of sexual love. No doubt John James was a passionate man for whom sexual pleasure, so long deferred, meant a great deal. But it could also be that he was not going to admit – even to himself – that his matrimonial bargain had not been particularly brilliant. To some extent his letters constructed a woman who wasn't there – a fresh young princess, rather than this familiar, older person whose status in his parents' house had been somewhere between that of poor relation and unpaid servant. Writing on 23 January 1822 he asserted that the four years since their marriage had been 'one almost uninterrupted course of Enjoyment & increasing Happiness':

I have drank of the Cup of pleasure without perceiving one drop of Bitters in the Draught – & hope it is yet very far from being drained, but will again once to my Lips overflowing as before. To me your face your voice your figure are all enchantment. . . . Oh this redeeming Love how does it mingle with the destinies of man to dispel with its brightness all the gathering Clouds around them – how it cheers & warms & supports & elevates. Whatever is unpleasant in my mind or in my pursuits – if the day be dull or the night dreary – if I call you to be present to my fancy – my troubled thoughts will pass away as if they obeyed the wand of a magician – & visions of happiness possessed or to be possessed will come & I feel that you are my whole my only Bliss my paradise of Joys unspeakable, that seem to increase with possession & to bloom fresh & unfading as Flowers, in Realms of Bliss that never die.[31]

The flowing literariness of John James's letters reminds us that he was well read in Shakespeare and in the contemporary Romantics (especially Scott and Byron). There is no point in asking whether John James believed what he was saying – these letters, written on his hard travels round the country winning orders for the firm of Ruskin, Telford & Domecq, are a businessman's reminders to himself that he has a sweet domestic haven where he will be consoled and soothed and allowed to rest after the battle.

In *Praeterita* Ruskin recalls that 'I was . . . never allowed, on my visits to Croydon, to go out with my cousins, lest they should lead me into mischief'.[32] Among his earliest recollections is the social distance set by his parents between their precious John and the children of Bridget and George Richardson:

my aunt had remained in Croydon, and married a baker. By the time I was four years old, and beginning to recollect things, – my father rapidly taking higher commercial position in London, – there was traceable – though to me, as a child, wholly incomprehensible, – just the least possible shade of shyness on the part of Hunter Street, Brunswick Square, toward Market Street, Croydon.[33]

The family correspondence tells a slightly different story. Margaret was fond of her sister Bridget and spent a good deal of time in Croydon, which was still in the country. In her letters Margaret praises the effects of the air and the diet on John's health. But she was very protective of him. Ruskin's account indicates that his mother was simultaneously stifling and harsh, forcing early reading of the Bible on him, punishing him for the slightest infringement of her rules and isolating him from other children. She writes proudly to her husband – about a child who

had not yet reached his third birthday – to report that he knows the Ten Commandments and the Lord's Prayer: 'his memory astonishes me and his understanding too'.[34] This letter, of 30 January 1822, is written from the Richardsons' home in Croydon. She makes it clear that John has a separate diet from her sister's children and takes his exercise and pursues his amusements in her company rather than theirs:

> We go down stairs merely say good morning and away we go for our walk[,] we are seldom in before one[.] John gets his mutton Chop[.] if the day continues fine another short walk and then up to his own room and he is no more seen till the next morning[,] I mean by the family in general sometimes Charles & Mary [Richardson cousins, of whom little John Ruskin was very fond] go up for a short time but they soon tire of one place.[35]

Margaret was critical of her sister. Bridget was fat, she was careless, she was too relaxed in her housekeeping. But Bridget was loving towards John and made a fuss of him for his third birthday, which was spent at her house (8 February 1822).[36]

Young John had two sets of cousins called Richardson. The second set were the children of John James's sister Janet ('Aunt Jessie'), who had married Patrick Richardson (the tanner) of Perth. Of her ten children, three died as babies, three as young children and one, James, when he was eighteen; only three survived to normal adult life. All this mortality among children made Margaret understandably anxious about her one and only child. Margaret's letters speak of James Richardson and some of the younger children dying of 'consumption', i.e. tuberculosis. By this date it was not clearly established that tuberculosis was infectious, but Margaret's wish to keep her John away from the Perth Richardson children is understandable.[37]

Margaret's many references to the better air enjoyed by little John's country cousins in Croydon indicate that Brunswick Square, though quite a good address, was never for her the right place to bring up a child. A house convenient for John James's business but enjoying some of the amenities of country life was obviously desirable. And as John James prospered so the feasibility, and the social appropriateness, of a larger house in a more favoured position became clear. In 1823 John James took a 63-year lease of 28 Camberwell Road, Herne Hill, then in Dulwich, a substantial and handsome semi-detached house with a large garden. The Ruskins moved in early in 1825.

*

In *Praeterita* the earliest memories that John Ruskin recorded were of sources of visual excitement. The windows of 54 Hunter Street, Brunswick Square, 'commanded a view of a marvellous iron post, out of which the water-carts were filled through beautiful little trap-doors, by pipes like boa-constrictors; and I was never weary of contemplating that mystery, and the delicious dripping consequent'.[38] The dramatic scheme of his narrative requires the Hunter Street house to be a kind of prison, from which the infant Ruskin would enjoy 'occasional glimpses of the rivers of Paradise'. 'Paradise' here refers to the Richardsons' house in Market Street, Croydon, and the countryside round about. The Ruskins on their visits to the Croydon Richardsons would go for walks in the fresh air 'on Duppas Hill, and on the heather of Addington'. And Ruskin remembers the Richardsons' shop as a place where his father would make 'drawings in Indian ink' and where the small child enjoyed a friendly dog and the lower regions of the building, 'the shop, the bakehouse, and the stones round the spring of crystal water at the back door'. The humble warmth of the Richardsons' home is contrasted sharply, in his narrative, with his confinement in the Hunter Street house, where, he says, he had no toys and no company.

> The pity of my Croydon aunt for my monastic poverty in this respect was boundless. On one of my birthdays, thinking to overcome my mother's resolution by splendour of temptation, she bought the most radiant Punch and Judy she could find in all the Soho bazaar. . . . My mother was obliged to accept them; but afterwards quietly told me it was not right that I should have them; and I never saw them again.

Otherwise he says that his toys were a bunch of keys, a cart, a ball, and when he was five or six years old a box of bricks. Despite the boredom he was quiet and well behaved because, as he recalled, he was 'summarily whipped if I cried, did not do as I was bid, or tumbled on the stairs'.[39]

The picture that Ruskin painted here is simplified and distorted. For example, he certainly had toys. The family correspondence shows that in the spring of 1823 he was ill and his mother had read him a great many children's stories. She asked John James to bring home 'The Children in the Wood' (from Percy's *Reliques*) or 'Sinbad the Sailor' (from *The Arabian Nights*), those being stories she had not read to John. John himself then sent a letter, written (in his mother's handwriting) on 15 March 1823, when he was four. In this letter he refers to a model of Waterloo Bridge which he has been building, to toy

boats and a ship which he plans to sail on the pond near the home of his Croydon aunt, and to a little whip he has spoilt because it stuck to his fingers – he asks his father for a new whip instead of the books that his mother has specified. He could not yet read, but his mother proudly added a covering letter:

> Your boy has been very busy scrawling with a pencil on a piece of paper which he said was a letter to send to you[.] I told him I was afraid you would not be able to make it out and he said he would read it to me if I would write it to you[,] the above is exactly word for word what he pretended to read from his paper[,] the signature you will see is his own[.] [S]ometimes he makes the letters much better[,] he is beginning to copy from his books and will soon learn himself to write I think–[40]

But although he was wrong about the toys many of Ruskin's memories in *Praeterita* are in fact reliable. Everything we know about Margaret Ruskin bears out this testimony: 'My mother had, as she afterwards told me, solemnly "devoted me to God" before I was born; in imitation of Hannah.' What this meant in practice – in addition to the discipline – was that his education was to fit him to be a clergyman and a gentleman instead of going into the wine trade like his father. His father – this also rings true – 'had the exceedingly bad habit of yielding to my mother in large things and taking his own way in little ones', and 'allowed me, without saying a word, to be thus withdrawn from the sherry trade as an unclean thing'.[41]

A recurrent refrain of the early chapters of *Praeterita* is that in the parental home 'I had nothing to love'.[42] After the family's move from Hunter Street to Herne Hill, Dulwich, when Ruskin was six, he draws a picture of a little boy whose emotional life, in the absence of human affection, attached itself to ants on the paths in the garden (which the gardener would tidy away) or birds which came to be fed (but if he tried to befriend one the cats would get it). Of his mother he recalled daily teaching, every morning between 9.30 and noon (or later, if he was slow to learn). From the age of three he was made to read and memorise parts of the Bible with her, and from the age of seven Latin was added. In the evenings he would sit quietly in a corner of the drawing-room while his father read aloud to his mother. John James was an excellent reader, and his chosen texts – 'Shakespeare, Pope, Spenser, Byron, and Scott' and 'Goldsmith, Addison, and Johnson'[43] – were thus among John Ruskin's earliest literary memories. He also wrote his own poems and stories (part of a story called *Harry and Lucy*, written when he was seven, is quoted in *Praeterita*). The author

of *Harry and Lucy* wished to control all aspects of book production: plates, print styles, title-page and so on are all given detailed attention, and one of his drawings ('Harry's new road') displays great pleasure in drawing mountain scenery.[44] By choosing a house on a hill his parents fed one of the little boy's strongest appetites:

> The view from the ridge on both sides was, before railroads came, entirely lovely: westward at evening, almost sublime, over softly wreathing distances of domestic wood; – Thames herself not visible, nor any fields except immediately beneath; but the tops of twenty square miles of politely inhabited groves. On the other side, east and south, the Norwood hills, partly rough with furze, partly wooded with birch and oak, partly in pure green bramble copse, and rather steep pasture, rose with the promise of all the rustic loveliness of Surrey and Kent in them, and with so much of space and height in their sweep, as gave them some fellowship with hills of true hill-districts.[45]

The paragraph continued with an angry account of the subsequent destruction of these views – but in Ruskin's narrative, after fifty years, the memory of them was still fresh.

When John Ruskin was about six, one of his cousins, James Richardson of Perth – eleven years older than little John, and therefore not much use to him as a play-mate – was taken on by John James to work for Ruskin, Telford & Domecq. James Richardson stayed in the Ruskins' house in Herne Hill, and John Ruskin recalled him 'in his little room, the smaller of the two looking west at the top of Herne Hill house, a pleasant, gentle, tall figure of a youth'.[46] He was a warm and attractive addition to the household – but when he joined John James he was already weak with tuberculosis, and he soon had to go home to Perth where he died on 26 May 1826, aged eighteen.

James Richardson's sister Mary (1815–49) became a permanent addition to the Ruskin household when Ruskin was in his tenth year. Her mother Janet ('Jessie') Richardson of Perth was widowed in 1824 and characteristically John James helped his sister financially. In 1827 he sent her some £224 (this included a sum for the education of her son William, who was at the University of Aberdeen).[47] The arrangement for Mary was initially part of the attempt to help Jessie, Margaret and John James planning to have her to live with them in 1827. The following year (18 May 1828) Jessie died and Mary Richardson, now orphaned, became in effect the adopted daughter of John James and Margaret. So from that year onwards John Ruskin had a constant companion.[48] In *Praeterita* Ruskin recalls her with affection but not a

great deal of warmth; he refers to her as 'a serene, additional neutral tint in the household harmony'.[49]

Margaret Ruskin's sister, Bridget Richardson of Croydon, was indignant about the arrangement made for Mary Richardson of Perth as she had hoped that her daughter – also called Mary Richardson – might have joined the prosperous Ruskin household on Herne Hill. John James was generous, and he tried to put things right by spreading his liberality evenly: he paid the school fees for Mary Richardson of Croydon.[50]

The most constant object of John's affections when he was a child was his father – perceived as a glamorous, warm, adventurous figure, often away but full of stories, encouragement and welcome presents when he came home.[51] John Ruskin loved to write poems for his 'Papa', on major occasions such as his father's birthday (10 May). This poem for New Year 1827 was written when John Ruskin was seven years and eleven months:

> Papa whats time a figure or a sense
> Tis one but not the other. Is not time
> a figure[?] Yes it is for on the tops of shops
> we often see a figure with two wings
> a scythe upon one shoulder and a lock
> of hair upon his forehead . . .[52]

John James thought his son's promise as a poet was remarkable, and surely he was right. John Ruskin was writing poetry regularly by the age of seven and his first poem to be published was written when he was nine. 'On Skiddaw and Derwent Water' was printed in *The Spiritual Times: A Monthly Magazine* in February 1830. The poet had written these verses in 1828 and they were based on his memories of his visit to the Lakes in 1826, when he was seven. For publication they were heavily revised and polished by John James, who had clearly thrown himself into enthusiastic partnership with his brilliant son. The lines are remarkable, both for their confident handling of Wordsworthian diction for a Wordsworthian subject, and for their honest acknowledgement that the manner can become tedious after a while. As a piece of unconscious early Wordsworthian 'tyranny of the eye', Ruskin's account of Derwent Water – which John James altered less than the rest of the poem – is a very good pastiche. I quote from its original state, not as it was published in 1830:

> Now Derwent Water come! – a looking-glass
> Wherein reflected are the mountain's heights,
> As in a mirror, framed in rocks and woods;
> So upon thee there is a seeming mount,
> A seeming tree, a seeming rivulet.
> All upon thee are painted by a hand
> Which not a critic can well criticise.[53]

Ruskin's next Lake District poem was a Wordsworthian miniature epic, the *Iteriad; or, Three Weeks Among the Lakes*, a poem in four books written between 28 November 1830 and 11 January 1831. Over 2,000 lines, it is an extraordinary work for a boy writing between the ages of eleven and a half and twelve. Its subject is a holiday in the summer of 1830. Ruskin and his parents and Mary Richardson reached Lowwood, Windermere, from Kendal on Tuesday 22 June; on 23 June they drove to Keswick, where they stayed at the Royal Oak; on 24 June they visited Friar's Crag and Castlehead, and on Sunday they saw Southey at Crosthwaite Church. Next day they went to Buttermere, on the Wednesday they ascended Skiddaw, on Sunday 4 July they saw Wordsworth worshipping at Rydal Chapel and on the Tuesday they visited Coniston. They left Lowwood for Kendal and the journey home on 12 July.

All these episodes are recorded in the poem. John Ruskin wrote his description of Skiddaw first, soon after the end of the holiday in 1830. He was, of course, revisiting the subject of his 1828 poem. He says jauntily that it is his ambition to be a 'proper lake-poet' but he knows that he will fail because he cannot write convincingly about solitude. Because the chosen form is rhyming couplets the effect is more eighteenth-century and less 'sublime' than that of 'On Skiddaw and Derwent Water'.

> The hills were obscured in a curtain of cloud;
> Every stern, savage fell had its vapoury shroud.
> Not yet the dark veil of the East was withdrawn,
> And cheerless and drear the approach of the morn.
> As we looked on the clouds with great feelings of sorrow,
> How sadly we thought, 'We must wait till to-morrow!'
> Sometimes we did mope, as the clouds passed us by;
> And again we did hope, as appeared the blue sky.

Ruskin was right – and it was a good insight for an 11-year-old – to say that lack of solitude is one of the things that stops this from being a 'Lake-poet' treatment of the Lakes. 'We' did this, that and the other

thing: the 9-year-old quasi-Wordsworthian solitary of the earlier poem has here become a social poet, chatty, observant and working – rather hard – for comic effect:

> Oh, what an affair of importance then made is,
> While settling and helping and mounting the ladies!
> 'I am sure I shall fall! I am sure I am tumbling!' –
> 'Oh, no, ma'am, you're safe.' – 'But my steed is a-stumbling!'[54]

On this holiday John James and Margaret Ruskin seem to have chosen their churches for worship on the successive Sundays with the specific object of seeing first Southey and then Wordsworth in the flesh. Mary Richardson and John Ruskin kept a prose journal of the holiday which John Ruskin later used as a source for his poem. The journal describes the Crosthwaite Church as disgracefully dirty, but the family had a fine view of the principal exhibit: 'In the seat directly opposite Mr. Southey we sat. We saw him very nicely. He seemed extremely attentive; and by what we saw of him, we should think him very pious. He has a very keen eye, and looks extremely like – a poet.' The following Sunday the family went to Rydal in search of their second trophy, Wordsworth, who disappointed them. The cousins wrote in their journal that 'he appeared asleep' and that he 'possesses a long face and a large nose'. The poem accordingly enthuses for several lines over Southey's heroic black flashing eyes, while the sighting of 'old Mr. Wordsworth' is recorded without comment.[55]

By the age of ten Ruskin had developed his own untutored style of draughtsmanship. He made a number of sketches in the course of a trip to Dover in 1829 – Dover Castle, Tunbridge Castle, Canterbury Cathedral and Battle Abbey – and believed that his first sketch 'from nature' was a scene in Sevenoaks. He loved looking at the sea, and 'spent four or five hours every day in simply staring and wondering' at its 'tumbling and creaming strength'.[56] By early 1832 Ruskin was having instruction in drawing and painting from Charles Runciman (1798–1864), who also taught his cousin Mary. Ruskin was later inclined to disparage Runciman, but his teaching was obviously felt to be satisfactory at the time, since the arrangement was to last for several years. And Ruskin was always grateful to Runciman for teaching him perspective.[57] (Runciman's principles of perspective were later to be recorded by his daughter in *Rules of Perspective*, 1886, with a brief introductory commendation from Ruskin.)[58]

A powerful stimulus to his drawing came from Henry Telford, his father's partner, who gave him a copy of Samuel Rogers's *Italy* on his thirteenth birthday, 8 February 1832. The book is inscribed, by John James Ruskin, 'J. Ruskin, Junr., from his esteemed friend Henry Telford, Esq.'.

Samuel Rogers (1763–1855) was a lifelong bachelor, a wealthy, genial connoisseur, a famously generous London host, and a man of letters with a wide and influential circle of literary friends.* Most of his poetry was published at his own expense and not much of it had wide circulation, until *Italy*, initially published in two volumes which attracted little attention (1822 and 1828), found a substantial market in 1830 when he republished it in a handsome new edition illustrated with steel engravings by J.M.W. Turner and Thomas Stothard. The section called 'Venice' is headed by a very pleasing Turner vignette of the Doge's Palace and the Piazzetta, and begins, sturdily if unremarkably:

> There is a glorious City in the Sea.
> The Sea is in the broad, the narrow streets,
> Ebbing and flowing; and the salt sea-weed
> Clings to the marble of her palaces.[59]

Rogers's verse narrative oscillates somewhat uneasily between late eighteenth-century picturesque set-pieces and macabre anecdotes about dungeons and torture-chambers which sound like episodes from Lewis's *The Monk* rendered into verse (with nods in the direction of Byron's hugely popular *Childe Harold's Pilgrimage*, first published in 1813). As Dickens was later to do, Rogers makes much of the popular tradition that prisoners used to be held captive in 'narrow cells' under the roof of the Doge's Palace. The young Ruskin responded passionately to the illustrations in Rogers's *Italy* which, he said, 'determined the main tenor of my life'.

> At the time I had never heard of Turner, except in the well-remembered saying of Mr. Runciman's, that 'the world had lately been much dazzled and led away by some splendid ideas thrown out by Turner.' But I had no sooner cast eyes on the Rogers vignettes than I took them for my only masters, and set myself to imitate them as far as I possibly could by fine pen shading.[60]

*It is a mark of Rogers's standing that in 1850, on the death of Wordsworth, he was offered the post of Poet Laureate, which he declined on the grounds of old age – he was by then eighty-seven. The laureateship subsequently went to Tennyson.

Ruskin's childhood remained short of companions, but from 1832 he made a lasting friendship with a younger boy, Richard Fall (1822–78), the son of some Herne Hill neighbours. John James arranged for the two boys to study together. A letter from Ruskin of 14 January 1832 shows that he enjoyed Richard Fall's company; it was clearly good for him to share his lessons with another boy. Ruskin boasts about the amount of Latin and Greek that he is learning and gives an account of his and Richard's boisterous games with the Ruskins' spaniel, Dash.[61] The friendship continued after Richard went away to boarding school (Shrewsbury) in 1834; John claimed him for outings when he was home for the holidays – the correspondence shows him out walking with Fall in December 1836, just before he went up to Oxford. (Their friendship continued in an undemanding way, and though a planned holiday together in 1841 was abandoned because Ruskin was taken ill, they went walking in the Alps in 1849.)

The young Ruskin's strongest feelings of these years were for his Croydon cousin Charles Richardson, who 'was like the last-born in a fairy tale, ruddy as the boy David, bright of heart . . . a fearless master of horse and wave'. This was a powerful emotional bond:

> the new and beaming presence of cousin Charles became a vivid excitement, and admirable revelation of the activities of youth to me, and I began to get really attached to him. I was not myself the sort of creature that a boy could care much for. . . . But Charles was always kind to me, and naturally answered with some cousinly or even brotherly tenderness my admiration for him, and delight in him.[62]

Charles Richardson was apprenticed as a teenager to Smith, Elder & Co., the publishers, and dined at Herne Hill every Sunday. He introduced the Ruskins to Thomas Pringle, editor of *Friendship's Offering*, an annual anthology of poetry published by Smith, Elder.

Pringle took an interest in the precocious Ruskin and his poetry, and occasionally published some of it in *Friendship's Offering*, although at the same time Ruskin recalls that Pringle told his parents to be realistic in their judgement of the quality of their son's work: 'He was the first person who intimated to my father and mother, with some decision, that there were as yet no wholly trustworthy indications of my one day occupying a higher place in English literature than either Milton or Byron.' When John Ruskin was about thirteen Pringle took him to meet Samuel Rogers (whose *Italy* had introduced Ruskin to Turner). To be received by Rogers was an honour, but for a boy of such restricted

social experience it was also a challenge. Nervous and gauche, Ruskin was unwittingly rude to Rogers:

> I was unfortunate in the line of observations by which, in return for his [Rogers's] notice, I endeavoured to show myself worthy of it. I congratulated him with enthusiasm on the beauty of the engravings by which his poems were illustrated, – but betrayed, I fear me, at the same time some lack of an equally vivid interest in the composition of the poems themselves.[63]

Rogers was offended, but the relationship survived and later became cordial.

Travel was a business necessity for John James, but it was also – from an early date – seen as an important part of the education of his son. Every summer John James would make a tour taking with him Margaret and little John (and, usually, Mary Richardson and a nurse as well as other servants). In 1825, when John Ruskin was six, the family visited Paris, Brussels, Ghent and Bruges, and it was on this tour that Ruskin was first taken to see the field of Waterloo. Thereafter the summer tours were usually in the British Isles, taken in a private carriage (sometimes hired, sometimes borrowed from Telford). John James took care to visit picturesque places and to take in cathedrals and castles – this was all part of the stimulus and nurturing that he felt due to the genius of his growing son. The summer tours were of Scotland (in 1824, 1826 and 1827), Wales (1831), the west of England (1828), Derbyshire (1829), and the Lake District (1824, 1826 and 1830).

The gift of Rogers's *Italy* in 1832 was followed in 1833 by a gift from his father of *Sketches in Flanders and Germany* by Samuel Prout (1783–1852). Ruskin's excitement over these books prompted John James to take him to see the originals of the scenes that the artists had depicted. Accordingly in 1833 the family (plus Mary and an old servant) made a serious tour of the continent, for four months, by carriage. Their route took them to Calais, Cassel, Lille, Tournay, Brussels, Heidelberg, Constance, the Splügen Pass, Milan, Genoa, Turin, the St Bernard Pass, Vevey, Interlaken, Chamonix and Paris. The result was an ambitious, and amazingly precocious, literary project. In the winter of 1833–4, beginning before his fourteenth birthday, Ruskin worked on *A Tour on the Continent*, comprising verse and prose accounts of the places that they visited and carefully drawn vignettes of some of the more picturesque sights. The sketches

23

are detailed and painstaking, and the verses are (often) written out in imitation of copperplate script so that the whole will give the appearance of a printed book. The castle of Ehrenbreitstein, on the Rhine,* stimulated a page which is a particularly effective imitation of the appearance of the pages in Rogers's *Italy*.[64]

On the tour Ruskin responded to the beauty and dignity of medieval buildings, and even more passionately to the rugged violence of mountain scenery. In his account of Lille the word 'Gothic' – later to take on central aesthetic and political significance in his writing – leaps from the page:

> The bending Gothic gable-roof
> Of past magnificence gave proof;
> The modern window's formal square
> With Saxon† arch was mingled there.[66]

One of his most interesting observations is his account of his first sight of the Alps, where what initially seemed to be clouds turned out to be mountains. In his journal – and later in *Praeterita*, which is based on the journal there – he makes much of this piece of visual delayed decoding, and he also translates it into enthralled (Shelleyan) verse:

> The Alps! the Alps! – it is no cloud
> Wreathes the plain with its paly shroud!
> The Alps! the Alps! – Full far away
> The long successive ranges lay.
> Their fixed solidity of size
> Told that they were not of the skies . . .[67]

In *Praeterita* Ruskin makes of this moment a pivotal, liminal event in his narrative of his personal growth. He and his family had arrived at Schaffhausen and had taken a fairly uneventful walk out of the little town to a vantage-point in a public garden, 'so as to command the open country across [the Rhine]. . . . At which open country of low undulation, far into blue, – gazing as at one of our own distances from

*Kenelm Digby, the ardently medievalising author of *The Broad Stone of Honour* – published in 1822 and later greatly revised and expanded – chose Ehrenbreitstein (which, translated, gave him the title of his book) as the outstanding example of a chivalric castle. As an adult Ruskin would greatly admire Digby's work and, as we shall see, Digby's teachings were to contribute powerfully to Ruskin's perception of the way in which society should organise itself. In *Modern Painters*, V (1860) Ruskin wrote that 'the reader will find . . . every phase of nobleness illustrated in Sir Kenelm Digby's "Broad Stone of Honour"'.[65]

†The 'Saxon arch' is a mistake, of course. Cook and Wedderburn note in their Library Edition of Ruskin's *Works* that he had hitherto seen only English medieval architecture.

Malvern of Worcestershire, or Dorking of Kent, – suddenly – behold – beyond!' He effectively enacts here the astonished delight with which he found his field of vision extending itself:

> There was no thought in any of us for a moment of their being clouds. They were clear as crystal, sharp on the pure horizon sky, and already tinged with rose by the sinking sun. Infinitely beyond all that we had ever thought or dreamed, – the seen walls of lost Eden could not have been more beautiful to us; not more awful, round heaven, the walls of sacred Death. It is not possible to imagine, in any time of the world, a more blessed entrance into life, for a child of such a temperament as mine. . . . I went down that evening from the garden-terrace of Schaffhausen with my destiny fixed in all of it that was to be sacred and useful. To that terrace, and the shore of the Lake of Geneva, my heart and faith return to this day, in every impulse that is yet nobly alive in them, and every thought that has in it help or peace.[68]

'Written up' for *Praeterita* in the 1880s as it is, this performance has none of the innocent ardour that Ruskin displayed when he was fourteen. It is a consciously literary performance, modelling itself on Wordsworth, Scott and Rousseau. The mind expects one visual effect and gets another which is far more powerful; the child's experience is recognised as pivotal and becomes a central memory to which the adult will always return; the massive imprinting of landscape on the child's mind is both a source of moral education and a psychological resource in times of adult stress: in all of these respects Ruskin's procedure here resembles that of Wordsworth in *The Prelude*. Ruskin in his sixties is constructing a post-Romantic reading of his own temperament. This is certainly an important strand of his intellectual life and emotional development. But this strand coexisted with others, which are of equal weight and importance.

Late in 1833 Charles Richardson decided to leave Smith, Elder and join his elder brother, who was prospering in Australia. Charles went to join his ship, which was at anchor off Cowes and could not sail because of the west wind. He volunteered to go ashore in the ship's cutter to fetch water. Ruskin wrote:

> 'May I go, too?' said Charles to the captain, as he stood seeing them down the side. 'Are you not afraid?' said the captain. 'I never was afraid of anything in my life', said Charles, and went down the side and leapt in. The boat had not got fifty yards from the ship before she went over, but there were other boats sailing all about them, like gnats in midsummer.

Two or three scudded to the spot in a minute, and every soul was saved, except Charles, who went down like a stone. . . . My uncle told all the story, in the quiet, steady sort of way that the common English do, till just at the end he broke down into sobbing, saying (I can hear the words now), 'They caught the cap off of his head, and yet they couldn't save him'.[69]

Charles was drowned on 22 January 1834 – a date which Ruskin engraves, as though on a tombstone, across the page of *Praeterita* on which this tragic death is narrated. John Ruskin, the child who had nothing to love, had warmed to Charles. The death of this idolised and idealised young hero was his first terrible loss.

Young as he was, Ruskin felt that he had become emotionally frozen by the death of his cousin: 'The death of Charles closed the doors of my heart.'[70]

*

Despite the tragedy of Charles's death, the travelling, writing and sketching Ruskin blossomed in 1834 and 1835. By March 1835 he was having tuition in water-colour with Copley Fielding (1787–1855), president of the 'Old Water-colour Society' (the Society of Painters in Watercolours), and the new confidence with which he uses water-colour in his sketches on his travels reflects this new teaching.[71] Fielding was an artist whom John James greatly admired (and collected; he had bought several Fielding water-colours by the time John went to Fielding for tuition). In *Praeterita* Ruskin gives a rather distorted account of the effect on him of Fielding's teaching, saying that Fielding's water-colour technique was over-conventional and was no help to him when he attempted to sketch the Alps;[72] but at fifteen he was eagerly appreciative of Fielding's work and was to remain so for several years (in a letter of March 1836 he urges his father to buy more Fieldings and Prouts to adorn the walls of the drawing-room at Herne Hill).[73]

A long continental tour with his parents, through France, Switzerland and Italy, in 1835 produced another travel journal and another substantial body of poetry. (About a quarter of the volume called *Poems* in the Library Edition of Ruskin's complete *Works* was written in 1835.) The young poet had become technically proficient and confident. His 'Journal of a Tour Through France to Chamouni, 1835' contains thirty stanzas in the difficult *ottava rima* form chosen by Byron for *Don Juan*, a form which permits Ruskin to be colloquial, ironic and sentimental by turns. He then abandons the Byronic form

and writes a series of lyrics on individual places, including a solemnly elegiac piece, with a whiff of Rogers about it, on the ghost of a doge revisiting his palace in Venice, and 'Saltzburg' which appeared in Thomas Pringle's *Friendship's Offering* for 1835.[74]

During Ruskin's teenage years John James had prospered. By 1835 Ruskin, Telford & Domecq had for several years been the leading importers of wines from Jerez. John James had always been socially ambitious, and by 1834 was seeking that reliable mark of a 'gentleman', a coat of arms, which he was granted by the Heralds' Office on 10 January 1835; it features a boar's head and the motto '*Age Quod Agis*'.[75] (In later life Ruskin was to change the motto to 'Today'; the boar's head prompted him to refer to himself as 'pigwiggy' or 'little pig'.[76]) It is surprising that John James's social ambition didn't lead him to consider sending his son away to one of the great public schools, such as Eton or Westminster. It seems that he and Margaret would not entrust their son to anyone whom they could not directly supervise and accordingly had him taught by tutors. By 1832 they had engaged John Rowbotham (1798?–1846), a teacher who ran his own private school and had published numerous educational books (textbooks in mathematics, German and Latin, and French grammars). He came twice a week to Herne Hill, for about five years, to teach Ruskin mathematics.[77] For other subjects, such as the Classics and religious instruction, John went initially to a Reverend Dr Edward Andrews – a wayward and fashionable preacher, of real ability (though in *Praeterita* Ruskin accuses him of ignorance). In the autumn of 1833 Andrews was replaced by the Reverend Dr Thomas Dale (1797–1870), who ran a day school which Ruskin attended in the mornings. He was thus fourteen when he went to school for the first time.

Dr Dale was a distinguished scholar and churchman; he was shortly to be appointed incumbent of St Bride's, Fleet Street, seen by his fellow churchmen as a key appointment. He had served as the first Professor of English Literature at London University, giving lectures at University College from 1828 to 1830.* In *Praeterita* Ruskin expresses some reservations about Dale, but it is nevertheless clear that he learnt a great deal from him and his letters to Dale in the early 1840s demonstrate the respect and affection that he felt for him as a young man.[78]

At Dale's school he was exposed for the first time to other boys of his own age in large numbers. He recalls his strangeness:

*This appointment was renewed at King's College, London, 1836–9.

Finding me in all respects what boys could only look upon as an innocent, they treated me as I suppose they would have treated a girl; they neither thrashed nor chaffed me, – finding, indeed, from the first that chaff had no effect on me. Generally I did not understand it, nor in the least mind it if I did, the fountain of pure conceit in my own heart sustaining me serenely against all deprecation, whether by master or companion. I was fairly intelligent of books, had a good quick and holding memory, learned whatever I was bid as fast as I could, and as well; and since all the other boys learned always as little as they could, though I was far in retard of them in real knowledge, I almost always knew the day's lesson best.[79]

He made some friends: notably Dale's own son Thomas and Edward Matson, one of three sons of Colonel Matson of Woolwich. John James and Margaret invited the Matsons to dine at Herne Hill (probably in order to promote their son's friendship with the Matson boys).[80]

For a time it was something like conventional schooling: mornings at Dr Dale's, homework with Mary, holiday pursuits with Richard Fall – there was a routine in place. But early in 1835 Ruskin was removed from Dr Dale's school because of an attack of what was thought to be pleurisy, and spent much of the rest of the year travelling round Europe with his parents. John James and Margaret displayed extreme anxiety over his health; with so many deaths among the Richardson cousins this was not unreasonable, but their consequent actions were. They would never let John out of their sight if they could help it, hugging him to themselves and keeping him away from companions of his own age as much as possible. This regimen, understandable and probably beneficial when he was little, was becoming increasingly inappropriate for a developing adolescent.

After the 1835 tour Ruskin was again sent for tuition with Dale, this time attending his lectures in English literature at King's College, London. The object was to prepare Ruskin for future study at Oxford when he reached his eighteenth year. Recently established (1829), King's College was housed on the Strand in a fine new building by Richard Smirke. Ruskin wrote an appreciative letter to his father (10 March 1836) describing the contrast between the commercial bustle of the Strand and the hushed and elegant scholarly interior of the College.[81] His letters show that his course of study at King's was comprehensive by the standards of the day. He went to lectures given by other professors on 'logic' (mathematics) and translation from Latin and Greek as well, and he was required to write essays for tutorials with Dale in a group of three (the other two were his friends Thomas

Dale junior and Edward Matson; Matson was later a fellow-undergraduate at Oxford).[82] In *Praeterita* Ruskin recalls that before he went to Dale's lectures he knew no literature earlier than Pope,[83] but Dale's subjects included early English literature: Ruskin refers to Mandeville, Gower, Chaucer and Wycliffe as the subjects of the lectures that he was attending in March 1836.[84]

At the end of this course of study, Dale held a formal examination so that he could report on his pupils' readiness for undergraduate studies. Part of the examination was an essay to be written on a question set by Dale: 'Does the perusal of works of fiction act favourably or unfavourably on the moral character?' In a letter to his father (24 December 1836) Ruskin gleefully reported that he had seized the opportunity given by the 'longitudinal essay' to challenge Dale's preference for earlier literature.[85] In his essay Ruskin champions recent literature, especially Scott and Byron. In particular, he vigorously defends Byron's genius, not by seeking to deny its 'occasional immorality' but by claiming for Byron a Shakespearean universality. Ruskin is deliberately teasing Dale when he refers to 'minds, and great ones, too' who are unable to read Byron: 'unable to bask themselves in the light of his glory, without fearing to be scorched by his sin'.[86] He shows sturdy intellectual independence from his teacher – but, strikingly, no independence from his father, whose views on Scott and Byron the essay exactly reflects.

Despite Ruskin's impertinent essay, Dr Dale obviously thought well of him and wrote to John James (26 December 1836) saying that in his view Ruskin had read widely enough in the Classics to be ready for Oxford, and that he hoped to keep in touch with him: 'I trust the foundation has been laid of a friendship which will end only with life.'[87]

One of the things that John James and Margaret wanted Oxford to do for their son was to cure him of a hopeless infatuation. On the visit to Paris that was part of their European tour in 1834, the Ruskins had stayed with the Domecq family. The Domecqs had five daughters. Ruskin, aged fifteen, felt himself at a loss with the sophisticated Domecq sisters. But early in 1836, when Ruskin was nearly seventeen, Pedro Domecq visited London with his younger daughters, Adèle-Clotilde, Cécile, Elise and Caroline. John James invited the daughters to stay at Herne Hill, and it was while the four girls were in the house that John Ruskin developed a passion for Adèle Domecq. Younger than him but more worldly, she was accustomed to Paris society, fluent in

French (as well as her native Spanish), and spoke charming broken English. In *Praeterita* Ruskin tends to make light of this youthful love, treating it as a doomed and silly infatuation and blaming it on his parents' lack of vigilance. He asks how they could have allowed 'their young novice to be cast into the fiery furnace of the outer world in this helpless manner'.*

The *Praeterita* account suggests that once his parents became aware of his feelings for Adèle they reacted in different ways. John James and Adèle's father were mildly in favour of the relationship 'in the interests of the business', while Margaret Ruskin 'looked upon the idea of my marrying a Roman Catholic as too monstrous to be possible' and hoped 'when the Domecqs went back to Paris, we might see no more of them, and that Adèle's influence and memory would pass away – with next winter's snow'.

His mother's anti-Catholicism provides Ruskin – writing fifty years after the event – with the imagery of religious martyrdom with which to express the effect of the Domecq girls on his feelings:

> Virtually convent-bred more closely than the maids themselves, without a single sisterly or cousinly affection for refuge or lightning rod, and having no athletic skill or pleasure to check my dreaming,[88] I was thrown, bound hand and foot, in my unaccomplished simplicity, into the fiery furnace, or fiery cross, of these four girls – who of course reduced me to a mere heap of white ashes in four days. Four days, at the most, it took to reduce me to ashes, but the *Mercredi des cendres* lasted four years.

Ruskin is wry and engaging about his adolescent clumsiness as a suitor, comparing himself to some of Dickens's ungainly young men: 'I had the real fidelity and single-mindedness of Mr. Traddles, with the conversational abilities of Mr. Toots, and the heroic ambition of Mr. Winkle.' To commend himself to Adèle he opted for fatally priggish and self-congratulatory antics: 'I endeavoured to entertain my Spanish-born, Paris-bred, and Catholic-hearted mistress with my own views upon the subjects of the Spanish Armada, the Battle of Waterloo, and the doctrine of Transubstantiation.'

In order to impress Adèle he wrote an elaborate Italian tale called 'Leoni'. This story was published in *Friendship's Offering* for 1837, 'and Adèle laughed over it in rippling ecstasies of derision, of which I

*It is some indication of the degree of the adolescent Ruskin's emotional and social isolation that these four female children, all under sixteen and staying as guests in his parents' house, were experienced by him as 'the fiery furnace of the outer world'.

bore the pain bravely, for the sake of seeing her thoroughly amused'. He also wrote a number of poems to Adèle, a love letter in French seven pages long, and an incomplete Byronic 'tragedy on a Venetian subject', *Marcolini*.[89]

Praeterita's version of this relationship is misleading in two respects: it is unfair to John James and Margaret, who did what they could to shield him from pain and who had real anxieties about his health; and it treats lightly something which, at the time, was intensely serious. Ruskin's passion for Adèle lasted for four years and it made him ill. But *Praeterita* is accurate about Adèle. She felt nothing for Ruskin and she found his attentions embarrassing. At the same time it was inevitable that John Ruskin and Adèle would continue to meet. Undoubtedly the situation was made worse for Ruskin by the closeness between their two fathers. John James was the one person in the world in whom Pedro Domecq had complete confidence: when his health failed in 1838 Domecq, who had difficulties with his wife, asked John James to act as guardian to his children.

It is not surprising that Adèle laughed at 'Leoni: A Legend of Italy', which draws on *Romeo and Juliet* and *Robin Hood* and is how Ruskin imagined he himself would have been, 'had I been brought up as a bandit'.[90] It is a mark of John James's weight with his literary friends that W.H. Harrison, who had succeeded Pringle as editor of *Friendship's Offering*, agreed to publish it, though he insisted on cutting a good deal and in its published state 'Leoni' is mercifully brief. In a letter to Harrison accepting the cuts, Ruskin more or less conceded that his tale was rubbish.[91] Passion for Adèle may have spurred him to write the story, but his primary motive for publishing it was to please John James, whose gratification at seeing his brilliant child's work in print was as yet undisturbed by judgement.

The love lyrics Ruskin wrote early in 1836 were, by contrast with 'Leoni', often rather good. Some address Adèle by name but she is also disguised as 'Jacqueline' and placed in a Swiss setting.[92] Shelley's lyrics and Scott's ballads determine their methods, but real pain and emotional loneliness make themselves felt under the borrowed poeticisms.[93]

Marcolini was an act of homage to Byron's Venetian dramas, *Marino Faliero* and *The Two Foscari*, which were in turn based on Shakespeare. Its high emotional scenes are written in iambic pentameters and its knavery and skulduggery in Jacobean prose. In writing such a work the young poet was typical of his period; not only Byron, but also Southey,

Keats, Shelley and such minor figures as Joanna Southcote all attempted Shakespearean tragedies in the first thirty years of the century.[94]

The author of this Shakespearean work felt himself ready to pronounce upon other people's attempts to interpret Shakespeare. In the Royal Academy exhibition of 1836 J.M.W. Turner exhibited *Juliet and her Nurse*, *Rome from Mount Aventine* and *Mercury and Argus*. These paintings were attacked in *Blackwood's Magazine* for October 1836. The reviewer complained of 'confusion', 'glare' and 'daub' in the paintings, and protested that Turner had unaccountably moved the setting of *Romeo and Juliet* from Verona to Venice (as indeed he had):

> Amidst so many absurdities, we scarcely stop to ask why Juliet and her nurse should be at Venice. For the scene is a composition as from models of different parts of Venice, thrown higgledy-piggledy together, streaked blue and pink, and thrown into a flour tub.[95]

John Ruskin was moved to reply, and he did so with a passionate and carefully considered defence of Turner. Just as, with Dale, he had developed the confidence to defend his literary preferences, so here he defends his (and his father's) favourite painter from another authority, the patriarchal 'much loved Maga' (as *Blackwood's Magazine* was known). He (unfairly) attributes to the reviewer a preference for pedestrian and literal mimetic art, and then is able to say that Turner 'is not so mad as to profess to paint nature. He paints *from* nature, and pretty far from it too.' What he means by this is that Turner is as free to reinvent his material as Shakespeare had been: 'His imagination is Shakespearean in its mightiness.' Ruskin then writes a passage in which the prose itself becomes yet another order of creation, reinventing and re-creating the painting which is both the subject of, and the point of departure for, a *bravura* literary performance:

> Many-coloured mists are floating above the distant city [Turner's Venice], but such mists as you might imagine to be aetherial spirits, souls of the mighty dead breathed out of the tombs of Italy into the blue of her bright heaven, and wandering in vague and infinite glory around the earth that they have loved. Instinct with the beauty of uncertain light, they move and mingle among the pale stars, and rise up into the brightness of the illimitable heaven, whose soft, sad blue eye gazes down into the deep waters of the sea for ever.[96]

And so on. It is tempting here to point to the two subjects, Turner and Venice, and to the impassioned creative prose, and to say that at this juncture Ruskin finds both his characteristic voice and the central

preoccupations of the next twenty years of his life. But to read the adolescent Ruskin with the benefit of hindsight is to confer on his life a directedness which, in 1836, it certainly did not have. This gifted, cheeky 17-year-old seems to be picking quarrels with figures of authority as a kind of displacement activity, because he is unable to go through the normal young man's rite of passage by fighting with his parents.

John James took the precaution of sending Ruskin's piece to Turner before seeking to publish it. Turner may well have been embarrassed by Ruskin's fulsomeness.

> I beg to thank you for your zeal, kindness, and the trouble you have taken in my behalf, in regard to the criticism of *Blackwood's Magazine* for October, respecting my works; but I never move in these matters, they are of no import save mischief and the meal tub, which Maga fears for by my having invaded the flour tub.[97]

John James had determined that his son should go to the best of Oxford's colleges, Christ Church, on the best terms that money could buy, and his approaches to the dean had shown that the best route was as a 'gentleman-commoner'. Ruskin would be somewhat out of place, since the 'gentleman-commoner' category of undergraduate was normally reserved for very wealthy and aristocratic young men who were not reading for an Honours degree. But to enter as a 'commoner' required an examination which, with his limited schooling, Ruskin was unlikely to pass. Also – of course – John James was enticed by the thought of his son joining the aristocracy in this way: he was to be among the most privileged young men of his generation, and was to gain the inestimable social advantage of participation in the carefree splendour of their lives.

In the autumn of 1836 John Ruskin was still helplessly in love with Adèle and still, as he later felt, making a nuisance of himself with his moping: 'I had neither the resolution to win Adèle, the courage to do without her, the sense to consider what was at last to come of it all, or the grace to think how disagreeable I was making myself at the time to everybody about me.'[98] But matriculation took place in October 1836, and he was to go into residence in January 1837. John James's ambition for his son

> was that I should enter at college into the best society, take all the prizes every year, and a double first to finish with; marry Lady Clara Vere de

Vere; write poetry as good as Byron's, only pious; preach sermons as good as Bossuet's, only Protestant; be made, at forty, Bishop of Winchester, and at fifty, Primate of England.[99]

Once he arrived at Oxford, Ruskin says, 'I . . . entered into command of my own life.'[100] But this was an illusion. Even undergraduate life was to be lived under parental supervision. There was to be no escape.

CHAPTER 2

1836–42

The only thing that occurred during the lecture which will *please you particularly* was that Ld. March & Ld. Desart came and placed themselves beside John, and L March having forgot to bring a pencil asked John if he could lend him one, John said certainly if his Ldship would accept a short one so he cut his own in two and both were accomodated – he had but the one with him. (Margaret Ruskin to John James Ruskin, Wednesday 15 February 1837)[1]

The breathless snobbishness of this letter from Margaret Ruskin written a month or so after John Ruskin came into residence at Christ Church, Oxford, is an indicator of what the Ruskins thought their son was going to Oxford for.

Although term began on 14 January 1837, Ruskin and his mother drove to Oxford on the 17th, staying the night at the Angel Hotel. He had been fitted out with a full new wardrobe, appropriate to the status of a gentleman-commoner, and these preparations were crowned by the fitting of his gentleman-commoner's cap and gown (for which John James paid £8).

His mother went to Oxford with him. Presumably Ruskin agreed to this arrangement, but it is unlikely that he was given much chance to resist. Margaret Ruskin moved into lodgings at 90 High Street, and Ruskin into his rooms on Staircase 4 of the Peckwater Quad.

As a gentleman-commoner he would have occupied first-floor rooms, which were considered grander than those occupied by commoners on the ground floor. The life-style of a gentleman-commoner was that of a young eighteenth-century country squire, transplanted to a university but not expected to change his habits. A memoir of undergraduate life at Christ Church in the 1830s tells us that

> the chief amusements of rich non-reading undergraduates were hunting and shooting; in the afternoons, grinds, tandem-driving, hack-riding, long walks, rat-killing, cock-fighting, prize-fighting, otter-hunting, badger-baiting, boating; after college dinner at five, or later at the Bullingdon or the Mitre, expensive 'wines', heavy suppers, billiards, or

doing the 'High' in sets, lounging, betting, and smoking in popular shops; occasional gown and town rows, knocker-stealing.[2]

In a letter of 8 February 1837, Margaret Ruskin was both impressed and worried by the social grandeur of John's new associates:

> I hope with you he will have little to do with uproarious meetings. I have no fear of his drinking but in these scuffles he might meet with injury tho' not at all taking part in them – he heard last night that Ld. Marchs horse had come down in yesterdays hunt and thrown him . . . what a risk to run for worse than nothing for all necessary for health could be gained at much less hazard besides the extreme cruelty of the sport.[3]

This is the same Lord March (Charles Henry Lennox, 1818–1903, Earl of March) who gave Margaret particular pleasure by borrowing half a pencil from her son at a lecture. Margaret records with pride the fact that Ruskin has had invitations to Wines from Lord Ward and Lord Desart, and at the same time displays satisfaction over the fact that he has declined the invitations and chooses to go to bed at ten o'clock.[4] But Ruskin's habits changed slightly. On 24 February she reports that John 'went to Ld. Desarts at ten, found about twenty Lds. March & Emlyn Mr. Strangways Dawson Grimston and some he did not know'. There were cards, dice and wine, and the young noblemen were playing for quite large sums. She is anxious both to assure her husband that their son did not join in the drinking and the gambling and that he continues to be a social success with the peerage. 'I think the intimacy between Ld March & John is on the increase, they were much together last night.'

In the same letter she expresses triumph over his weekly essay: 'John is to read his Essay in Hall tomorrow, the Sub Dean met him, told him he had looked over his Essay, thought it very good & if he had no objection would like him to read it in the Hall . . . the having to read in public does not seem to give him John an uneasy thought, this is a thing to be thankful for.'[5]

Ruskin describes this in *Praeterita*:

> It was an institution of the college that every week the undergraduates should write an essay on a philosophical subject, explicatory of some brief Latin text of Horace, Juvenal, or other accredited and pithy writer; and, I suppose, as a sort of guarantee to the men that what they wrote was really looked at, the essay pronounced the best was read aloud in Hall on Saturday afternoon, with enforced attendance of the other under-graduates. Here, at least, was something in which I felt that my little faculties had some scope, and both conscientiously, and with real interest

in the task, I wrote my weekly essay with all the sagacity and eloquence I possessed. And therefore, though much flattered, I was not surprised, when, a few weeks after coming up, my tutor announced to me, with a look of approval, that I was to read my essay in the hall next Saturday.

Serenely, and on good grounds, confident in my powers of reading rightly . . . I read my essay . . . and descended from the rostrum to receive – as I doubted not – the thanks of the gentlemen-commoners for this creditable presentment of the wisdom of that body. But poor Clara, after her first ball, receiving her cousin's compliments in the cloak-room, was less surprised than I by my welcome from my cousins of the long-table. Not in envy, truly, but in fiery disdain, varied in expression through every form and manner of English language . . . they explained to me that I had committed grossest *lèse-majesté* against the order of gentlemen commoners.[6]

Gentlemen-commoners were not supposed to *work* at the weekly essay. Most of the young grandees of the period paid a shopkeeper or a scout (a college servant) to write the essay for them, or at best 'aimed at filling their regulation three pages with few words, long and well spread out'.[7] The triumph over his weekly essay was nonetheless something in which Ruskin displayed legitimate pride (he knew that his father would take unmixed pleasure in this).

Ruskin's first surviving letter to his father from Oxford is a facetious affair. 'Calmly, brightly, beautifully dawns the day over the mouldering columns of Peckwater, when, every morning at 5 minutes to 7, precisely, I assume my seat of learning – my dignified armchair.'[8] The style of heavy comedy enables him to distance himself from his exciting companionship with the noblemen.

The letters continue to give instances of upper-class high spirits among the young men of Christ Church: Wines, the breaking of windows, the bonfires in Peckwater Quad, dangerous feats of climbing (in order to get into the college after hours; Margaret remarks that 'they say midshipmen and Oxonians have each more lives than a cat and they have need of them they run such risks'[9]). But not all Ruskin's friends were of this kind. The unusual gentleman-commoner was taken up by one of the young tutors in the college, H.G. Liddell (1811–98, later dean of the college and father of Alice in Wonderland). Liddell made a point of bringing the then dean, Thomas Gaisford (1779–1855; dean of Christ Church from 1831 to 1855), to call on the unusual gentleman-commoner in order to look at the sketches for which he was becoming known.[10] Liddell was struck by Ruskin's individuality, describing him as a 'very wonderful

gentleman-commoner' and 'a very strange fellow, always dressing in a great-coat with a brown velvet collar, and a large neckcloth tied over his mouth'.[11] There was further contact with Dean Gaisford at 'Collections' at the end of term. Ruskin reports in his letter to his parents of 15 March 1837:

> The Dean was highly pleased . . . [said] that he had heard a great deal of my drawings – said he would be much obliged to me if I would send them in – said I had been very regular – that he was highly pleased with me, and that he hoped I should continue so, and that I had got excellently through my collections, and he was glad to observe I had taken great pains with my themes.
>
> I called at his house – to ask permission – veniam abeundi [to go down, it being the end of term] – he was excessively gracious – made me walk into his study before him – told me the day of return [at the beginning of the next term] – shook two fingers – and I had concluded my negotia. This is what I call getting gloriam – famam or, as the cant word is – kudoz [renown].[12]

At the start of Ruskin's second term at Oxford the brilliant excitement of the first term gave way to a sense of routine. 'Things at College go on so much in the same way, that I have nothing particular to inform you of,' wrote Margaret on 22 April 1837. Ruskin added to the same letter an engaging account of a dinner party at the house of a senior member, Dr Buckland. He wrote vividly about the preposterous Aladdin's-cave quality of the Buckland house: 'not a chair fit to sit down upon – all covered with dust – broken alabaster candlesticks – withered flower leaves – frogs cut out of serpentine – broken models of fallen temples, torn papers – old manuscripts – stuffed reptiles . . . stuffed hyena's, crocodiles and cats'.[13]

The letters indicate a kind of game of collusion going on between the brilliant, odd undergraduate and his parents. As a child he had been unlike all other children – educated at home, looked after by adoring parents and teachers who were treated as though they were additional servants in the household. And at Oxford the strangeness continued. Unlike all other gentlemen-commoners, he was a resolute intellectual. Unlike all other undergraduates, of whatever degree, he had his mother move into Oxford to look after him. But *Praeterita*, written at a safe distance from the events, is bland in its treatment of the situation:

> I count it is just a little to my credit that I was not ashamed, but pleased, that my mother came to Oxford with me to take such care of me as she could.[14]

His father was left at Herne Hill during the week and would join Ruskin and his mother in Oxford at weekends. It was Ruskin's habit to join his mother every evening for tea after dinner in Hall. He would leave her lodgings in time to be back in the college by 9.00 p.m. At weekends he accompanied his parents to church at St Peter in the East. Beyond that, his parents did not go out with him in public, 'lest my companions should laugh at me, or any one else ask malicious questions concerning vintner papa and his old-fashioned wife'. He goes on:

> None of the men, through my whole college career, ever said one word in depreciation of either of them, or in sarcasm at my habitually spending my evenings with my mother.[15]

Perhaps the reason for their silence was not acceptance but dumb astonishment.

Ruskin's own account of his early days at Oxford invites indulgence of his younger self. Temperamentally unlikely to turn into a hunting-shooting-fishing man, he was a gentle creature, of fixed habits that contrasted sharply with the eighteenth-century behaviour of the young lords of Christ Church.

> I expected some ridicule, indeed, for these my simple ways, but was safe against ridicule in my conceit: the only thing I doubted myself in, and very rightly, was the power of applying for three years to work in which I took not the lightest interest. I resolved, however, to do my parents and myself as much credit as I could, said my prayers very seriously, and went to bed in good hope.[16]

And in due course this obstinate adherence to his own patterns of behaviour, his refusal to compromise, would be a source of strength. Ruskin seems to have been a kind of plaything for the other young men, who admired his water-colours and his poetry. For example, Margaret Ruskin writes to John James on 18 May 1837, full of the news that Ruskin had been elected to 'the Christ Church society', a club for members of the college, which saw itself as very exclusive.

Ruskin had been proposed by Henry Wentworth Acland (1815–1900), then in his third year at the college, who was to be Ruskin's lifelong friend.[17] Ruskin records in *Praeterita* his own feelings about Acland:

> Fortunately for me – beyond all words, fortunately – Henry Acland, by about a year and a half my senior, chose *me*; saw what helpless possibilities were in me, and took me affectionately in hand. His rooms,

next the gate on the north side of Canterbury [Quad], were within fifty yards of mine, and became to me the only place where I was happy. He quietly showed me the manner of life of English youth of good sense, good family, and enlarged education; we both of us already lived in elements far external to the college quadrangle.[18]

'The only place where I was happy': this entry seems to express the truth: Ruskin felt out of place in Christ Church and had only one real friend. Margaret seems not to have noticed this.

He has breakfasted, lunched, and drank tea with me every day – the latter rather by me than with me, as he has not been in, either evening till between seven and eight. Monday he was at his club, they want two or three more members but cannot fix on any sufficiently superior and steady to make the offer of admission to, you see it is no small distinction, the belonging to this Club, last night John took wine with Dart* and heard part of a poem written in Cantos very good John says Dart is in lodgings in High Street he has been his twelve terms in college I did not hear if he intends trying again for the prize.

To night John takes wine with Lord Carew, who called on him yesterday and is highly delighted with his drawings, as is also Liddle who with Beauclerc[,] Goring [took] wine with him till past eleven monday night.[19]

It was impossible for Ruskin to be a normal Christ Church gentleman-commoner. He was already a published writer, with his poems in *Friendship's Offering*, his piece on 'The Colours of the Water of the Rhine' in *Loudon's Magazine of Natural History* (1834) and his essay 'The Poetry of Architecture' in the *Architectural Magazine*. The pen-name for 'The Poetry of Architecture', 'Kataphusin', means 'according to nature': a phrase which could be the heading for much of Ruskin's writing on art and architecture.

Ruskin was not really a poet, but his fierce ambition carried him through to win the coveted Newdigate Prize with his poem *Salsette and Elephanta* which he read at Commemoration on 12 June 1839.†

The editor of both the *Magazine of Natural History* and the *Architectural Magazine* was J.C. Loudon, who had written an

*'Dart' was Joseph Henry Dart (1817–87). He and John Ruskin had been boys together at Dr Dale's school, and Dart was now (since 1834) an undergraduate at Exeter College. He had tried for the Newdigate Prize for poetry, and would compete again (and win) the following year.

†*Salsette and Elephanta* is a tribute to the British empire, and a tedious exercise in exotic orientalism with a dutiful conclusion in which the gods of India surrender to Christianity. It is one of the least readable of Ruskin's poems. One wonders what else was entered in competition for the Newdigate Prize that year.

extraordinarily enthusiastic letter to John James about young Ruskin, saying that he was

> Certainly the greatest natural genius that ever it has been my fortune to become acquainted with; and I cannot but feel proud to think that, at some future period when both you and I are under the turf, it will be stated in the literary history of your son's life that the first article of his which was published was in *Loudon's Magazine of Natural History*.[20]

He was also constantly praised by W.H. Harrison, editor of *Friendship's Offering*, who loyally continued to publish any verse that Ruskin offered to him. Precocity and fame continued for him as an undergraduate. His water-colours and sketches rapidly became known among the senior members of the college. Henry Liddell wrote about him

> living quite in his own way among the odd set of hunting and sporting men that gentlemen-commoners usually are. . . . [He] tells them that they like their own way of living and he likes his; and so they go on, and I am glad to say they do not bully him, as I should have been afraid they would.[21]

The most advanced of Ruskin's intellectual interests at this age was in geology, the science which was rapidly extending the known age of the world. Like other clever young men of the 1830s he was captivated by Charles Lyell's *Principles of Geology* (Tennyson read it in 1837 and its impact is felt in the more sceptical lyrics in *In Memoriam*). The Christ Church don who meant most to Ruskin was Dr William Buckland, Professor of Geology, who by virtue of his Chair was a canon of the cathedral and a student of the college. In his house in the college* Buckland kept a great many strange animals, and he boasted that he had served most of the animal kingdom, cooked, at his table.

Ruskin was introduced to Charles Darwin in Buckland's house. The range of Ruskin's interests as an undergraduate is reflected in his memberships of learned societies: in 1839 he became a member of the Oxford Society Promoting the Study of Gothic Architecture. In 1840 he received recognition from the adult world when he was elected a Fellow of the Geological Society.

He made friends with two other senior members of the college, the Reverend Osborne Gordon, censor of the college, and the Reverend

*The Aladdin's cave of Ruskin's letter (see p. 38).

Walter Lucas Brown. Both taught Ruskin Greek. Osborne Gordon was taken up by John James and Margaret and would visit Herne Hill in the vacations and give Ruskin additional tuition in Greek (because Ruskin had had no formal schooling it was felt that he needed extra help to get through the Oxford examinations).

As one might expect in so strange a young man Ruskin made few friends of his own age, but there were two important relationships: with Henry Acland, the medical student who was later to be Professor of Medicine at Oxford, and who became Ruskin's lifelong friend and champion; and with a very different young man, Edward Clayton, to whom Ruskin sent the series of letters – intelligent and thoughtful inquiries into religious matters – later published as *Letters to a College Friend*.

In 1839 Adèle Domecq became engaged to a wealthy Frenchman, the Baron Du-Quesne. The Domecq girls visited the Ruskins for Christmas that year, but John James and Margaret managed to keep knowledge of Adèle's engagement from John until after the holiday. On 28 December 1839 he wrote in his diary: 'I have lost her.'[22]

Ruskin's undergraduate life was constantly watched over and protected, of course, by his mother living in her lodgings in the High Street. In April 1840 her vigilance was, in a sense, rewarded: Ruskin found himself coughing up blood. His parents immediately removed him from the university.

With this illness Ruskin was effectively moved out of the society of lively young men – the closest approach to normal upbringing that his parents had allowed him – and was reabsorbed into the parental cocoon.

In the summer of 1840 there was a very important meeting, at the home of the dealer Thomas Griffith.

> Introduced today to the man who beyond all doubt is the greatest of the age; greatest in every faculty of the imagination, in every branch of scenic knowledge; at once *the* painter and poet of the day, J.M.W. Turner. Everybody had described him to me as coarse, boorish, unintellectual, vulgar. This I knew to be impossible. I found in him a somewhat eccentric, keen-mannered, matter-of-fact, English-minded – gentleman: good-natured evidently, bad-tempered evidently, hating humbug of all sorts, shrewd, perhaps a little selfish, highly intellectual, the powers of the mind not brought out with any delight in their

manifestation, or intention of display, but flashing out occasionally in a word or a look.[23]

Thus did Ruskin record his first meeting with his hero J.M.W. Turner.

Others were less kind about Turner, who had a reputation for surliness and awkwardness: one contemporary described him as 'short, stumpy, and vulgar, without one redeeming personal qualification, slovenly in dress, not over cleanly, and devoid of all signs of the habits of a gentleman, or a man moving in good society'.[24] The meeting did not lead to the kind of profound conversation and deep friendship that one might have imagined developing between the old genius and his most famous disciple. Turner was unappreciative of what he felt to be naïve and puppyish admiration. Ruskin for his part was in poor health, and his parents were about to take him away from England, so the relationship had no chance to develop.

Another significant meeting was with Effie (Euphemia Chalmers) Gray. Her father was an old friend of John James, and she and her family visited the Ruskins at Herne Hill in the late summer. Ruskin was enchanted by the little girl (she was twelve) and wrote his only completed work of fiction, *The King of the Golden River*, for her.

In the early autumn the Ruskin family travelled to Genoa, then Lucca, Pisa, Florence and Rome. Henry Acland had given Ruskin letters of introduction to the painter George Richmond and his brother, then both working in Rome, and to Joseph Severn who had been the last companion of the dying Keats, twenty years earlier. Ruskin describes in *Praeterita* his first attempt to visit Joseph Severn:

> I forget exactly where Mr. Severn lived at that time, but his door was at the right of the landing at the top of a long flight of squarely reverting stair . . . up this I was advancing slowly, – it being forbidden to me ever to strain breath, – and was within eighteen or twenty steps of Mr. Severn's door, when it opened, and two gentlemen came out, closed it behind them with an expression of excluding the world for evermore from that side of the house, and began to descend the steps to meet me. . . . One was a rather short, rubicund, serenely beaming person; the other, not much taller, but paler, with a beautifully modelled forehead, and extremely vivid, though kind, dark eyes. They looked hard at me as they passed, but in my usual shyness . . . I made no sign, and leaving them to descend the reverting stair in peace, climbed, at still slackening pace, the remaining steps to Mr. Severn's door, and left my card and letter of introduction with the servant, who told me he had just gone out. His dark-eyed companion was George Richmond.[25]

Severn and Richmond rapidly became friends with Ruskin's parents. As he got to know Severn, Ruskin thought him 'cleverish, and droll, but rather what I should call a cockney, though he has lived twenty years in Rome: but Cockneyism is in spirit, not habitation'.[26]*

Letters to his friend Edward Clayton were important for Ruskin in that they kept him in touch with an intelligent fellow-undergraduate during his enforced absence from the university. In the letters to Clayton we hear the voice of a brilliant young man showing off, affectionately, to an intimate friend; they are somewhat mannered but full of wit and invention, and they touch on everything that attracted Ruskin's busy attention. He enjoys comic hyperbole: the coins that Clayton has been spending too freely are products of majestic labour at the furnace and the mint (one of the few passages in Ruskin where he praises machinery): 'For you, night and day, have heaved the dark limbs of the colossal engine – its deep, fierce breath has risen in hot pants to heaven – the crimson furnace has illumined midnight, shaken its fiery hair like meteors among the stars – for you – for you, to abuse and waste the result of their ceaseless labour!'[27] And when he shares his love of the Lake District† with Clayton he directs his friend's walks with the fussy detailed bossiness which recurs in all his educational writings: 'Do not miss Helvellyn on any account, and go up on the *Thirlmere* side, descending to Patterdale if you like, but on no account ascending from Patterdale.'[28] He thinks aloud about art, developing what will in due course become parts of the argument of *Modern Painters*:

> The object of high art is to address the feelings *through* the intellect. It will not do to address the feelings, unless it be through this medium – still less, to address the intellect alone. Consequently the mere conveying of a certain quantity of technical knowledge respecting any given scene can never be the object of art. Its aim is not to tell me how many bricks there are in a wall, nor how many posts in a fence, but to convey as much as possible the general emotions arising out of the real scene into the spectator's mind.[29]

He communicates what was already his established belief in the superiority of Turner to all other artists, and urges his friend to buy Turner's work whenever opportunity presents itself. And as he travels

*Joseph Severn's son, Arthur, was in due course to marry Joan Agnew, Ruskin's cousin; Joan, the 'Joanna' of *Praeterita*, was to become the most important person in Ruskin's life during the many illnesses of his last thirty years.
†Ruskin knew and loved the Lakes all his life, and was to make his home on Coniston Water after 1871.

south into Italy he sketches, constantly, giving an artist's reaction to what he sees.

He is impressed by the scale and splendour of St Peter's and by the sculptures in the Vatican, but 'As for ancient Rome, it is a nasty, rubbishy, dirty hole – I hate it. If it were all new, and set up again at Birmingham, not a soul would care twopence for it.'[30] In a letter to W.H. Harrison on 30 January 1841, he gives a comically bilious reaction. The water in the Roman aqueduct is

the only thing in Rome that does not look diseased or cursed – dying or dead – plague or terror-struck – falling, fallen, or to fall – desolate – desecrate – dismal – dull – or damnable – every possible word beginning with *d* – your d is a foul letter – the only thing wanting to any evil to make it the very devil – and St. Peter's! Pshaw! I never saw so much good marble and ground wasted. They don't know what architecture means, in Italy; it is all bigness and blaze with them. The Duomo at Florence has an effective exterior – nothing but marble and jasper – and as big as St. Paul's – but it is a regular begin-to-build-and-not-able-to-finish affair – a mere shell – with no inside – a fine craniological development with no brains – a Pharisaical piece of ecclesiastical hypocrisy.[31]

It should be remembered, when reading this callow provincial stuff, that Ruskin felt ill much of the time on this Italian journey. His diary entries give a more measured account. Rome was indeed beautiful, but its beauty was to be found in picturesque effects:

the old clothes hanging out of a marble architrave, that architrave smashed at one side and built into a piece of Roman frieze, which moulders away the next instant into a patch of broken brickwork – projecting over a mouldering wooden window, supported in its turn on a bit of grey entablature, with a vestige of inscription; but all to be studied closely before it can be felt or even seen.[32]

Ruskin is feeling his way towards the contrast between Renaissance and Gothic architecture which was to be fully developed in due course in *The Stones of Venice*. On 29 November 1840 he wrote of St Peter's: 'the style of the Italian churches in general . . . and of this in particular, is *not* adapted for sacred architecture. One interior like that of Chartres . . . would be worth all the churches of Italy put together.'[33]

The moment he was sketching he felt less bad-tempered with what he was looking at; the Forum and the Colosseum, initially 'disgusting', became the subjects of some absorbing sketches and pleased him, on 10 December, in the evening light: 'the Forum glowing with sunset, and all the Apennines clear, and the groups of ruin toward the Colosseum red

and rich with light'.[34] As the visit lengthened he came to see Rome as intensely beautiful, but felt at the same time that he was being cheated of its beauty by his illness. On 30 December he wrote of having all Rome before him, 'towers, cupolas, cypresses and palaces, mingled in every possible grouping', and 'trying to find out why every imaginable delight palls so very rapidly on even the keenest feelings'. The problem was one common to Romantic young men, a problem that Coleridge had recognised in the 'Dejection' Ode: 'With all this around me, I could not *feel* it . . . all was exquisitely beautiful . . . I saw this, though I could not feel it, and got into a rage with myself, to no purpose.'[35] Naples in January found him with an equally discouraging deadening of the senses: 'How little could I have imagined, sitting in my home corner, yearning for a glance of the hill-snow, or the orange leaf, that I should at entering Naples, be as thoroughly out of humour as ever after a monotonous day in London – more so. Vanity of vanities! And I shall read and remember this hereafter and be mad with myself.'[36]

He believed, of course, that he had tuberculosis and that he would die young. The diary continues, throughout this tour, to make references to feeling 'blue' and to coughing up blood. What was he to do with his short life? One answer, adumbrated in a letter to Edward Clayton from Naples, is to write his big study of Turner:

> I have begun a work of some labour which would take me several years to complete; but I cannot read for it, and do not know how many years I may have for it. I don't know if I shall even be able to get my degree; and so I remain in a jog-trot, sufficient-for-the-day style of occupation – lounging, planless, undecided, and uncomfortable, except when I can get out to sketch – my chief enjoyment. I am beginning to consider the present as the only available time, and in that humour it is impossible to work at anything dry or laborious or useful. I spend my days in a search after present amusement, because I have not spirit enough to labour in the attainment of what I may not have future strength to attain; and yet am restless under the sensation of days perpetually lost and employment perpetually vain.[37]

Three months later he writes to Clayton with fresh dilettante plans for his life (he is thinking of setting up in a cottage in Wales with a pony and his own cabbages, and working at geology – 'my minerals'). 'Senses of duty and responsibility too are confounded bores. What a nice thing it was at six years old to be told everything you were to do, and whipped if you did not do it!' Still, he was happy drawing – 'I find nothing equal to quiet drawing for occupying the whole mind' – and,

above all, happy with the family's visit to Venice. After his angry dismissal of the 'bigness and blaze' of all Italian architecture, it is good to see that his spirits were raised by Venice: 'I have found nothing in all Italy comparable to Venice. It is insulted by a comparison with any other city of earth or water.'[38] The diary says simply: 'Thank God I am here! It is the Paradise of cities and there is a moon enough to make half the sanities of earth lunatic, striking its pure flashes of light against the grey water before the window; and I am happier than I have been these five years'; happier, that is, than he had managed to feel since Adèle had rejected him. 'I feel fresh and young when my foot is on these pavements, and the outlines of St Mark's thrill me as if they had been traced by A[dèle']s hand.'

The sensation was not to last: Venice, too, was to disappoint, but Ruskin knew that it was his inner disorder that was responsible for this loss of sensation: 'I think a single passage of the grand canal or the Piazzetta worth all Rome and Naples together,' he wrote on 9 May, 'but the whole is not up to my recollection of it, and a little of my romance is going. The canals are I think shallower, and I am sure dirtier, than they were of old; and I have lost the childish delight at the mere floating and dashing – the joy of watching the oars and waves – which mingled with and assisted other and higher impressions. I have got all wrong with my drawing too, and that upsets me in humour.'[39] The general peevish discontent continues as he leaves Venice 'without *much* regret and now I want to be home – odd – odd – very odd – when six months ago I was only mourning because I could not stay abroad all my life'. He is still frightened by a tendency to cough up blood.[40]

Back in England, he set out for a walking tour with his friend Richard Fall, but anxiety about his health persuaded him to turn back. He spent several weeks in lodgings at Leamington Spa under the famous Dr Jephson, whose water cure was the fashionable remedy for almost any ailment. It seems to have done Ruskin no harm; the diary and letters indicate that he was very bored during this period, but it saw the completion of *The King of the Golden River*.

This children's story is derived from the Grimm brothers' fairy-tales: it is set in a Germanic mountainous country called variously 'Styria' or 'Stiria', and the three brothers in the story have German names, two of which are precise aptronyms, expressing the moral natures of the characters: 'Schwarz' the black-hearted one contrasted with 'Gluck' the happy one (it is not clear why the second wicked brother is named

'Hans', unless Ruskin was acknowledging Hans Andersen as another godfather in the genre). The story, written for Effie Gray, is an allegory of all Ruskin's economic and social thinking. It could have been subtitled 'There is no wealth but life'. Gluck is a kind of male Cinderella while his brothers are monsters of capitalism, hoarding, profiteering, manipulating the market and starving their employees. The wicked brothers are turned into black stones by the King of the Golden River, while Gluck's Christian charity brings a simple reward: the golden river diverts itself into Gluck's valley and makes him rich. At this point the story loses its logic and buys into the Protestant ethic, just as Dickens's ostensibly anti-capitalist narratives (particularly *Great Expectations*) would do later in the century. Presumably Gluck will be wholly philanthropic with his wealth, but there is no suggestion that he is not entitled to it. Ruskin's writing about wealth in such later works as *Time and Tide* and *Fors Clavigera* was to display a similar ambivalence.

Late in 1841 Ruskin resumed reading for the Oxford degree, and also took painting lessons from J.D. Harding. By April 1842 he was back in Oxford where he took his degree, a 'Double Fourth'.* The question he had to confront – what was he to do with his life? – was still unanswered. His interest in becoming a clergyman was clearly waning. From Leamington Spa on 22 September 1841 he had written to his old tutor Dr Thomas Dale a letter which explored the whole question (from an evangelical viewpoint) in startlingly immodest terms: would he, Ruskin, better serve God by using his talents, as the great artists of the past had used theirs, or by becoming a clergyman? 'Was not the energy of Galileo, Newton, Davy, Michael Angelo, Raphael, Handel, employed more effectively to the glory of God in the results and lessons it has left, than if it had been occupied all their lifetime in direct priestly exertion . . . ?'[41] The question contains its own implicit answer.

Clayton was clear about his own vocation and was by this time ordained. Ruskin by contrast is already showing signs of the humanism which was to demand his loyalty after 1860. He wrote to his friend:

what do you think that a man – candidly and earnestly looking into his own heart, will find there. He will find I think – first – selfishness – an

*He would not normally have taken an honours degree because his illness had meant a year out from his studies. The 'Double Fourth' was honorary, a concession recognising the intelligence of the candidate while at the same time maintaining the received distinction between the 'Honours' degree and the 'Pass' degree.

instinct of choosing his own good rather than anyone elses. & secondly –
such a degree of sympathy and love & of other animated creatures that
he has pleasure in seeing them happy & would willingly part with some
portion of his own good – to secure theirs – not with *all* his own happiness
– but with a portion of it, provided he could secure a larger portion to
them. By yielding to all his sensual passions, he may in time blunt these
feelings of benevolence – eradicate them – but the animal man, as born
into the world, is, I believe, much as I describe, a creature preferring its
own good to that of others where uncomfortable with it – but yet having
delight in the good of others & ready to make certain sacrifices to advance
it.

Man says to himself: 'Here am I, the highest in the scale of animals but
yet evidently made *like* other animals.' Ruskin reflected on the feeling
of love that God had given him, 'separating me from the Brute'.[42]

Unlike most other young men of his period, this 'graduate of Oxford'
came down from university still extraordinarily alone. He almost
seemed to find friendships easier to conduct on paper than in the flesh.
Generations of brilliant young men who impacted on Ruskin's life were
to pass through Oxford; Burne-Jones and William Morris at Exeter
College in the next decade were to gather round them an extraordinary
circle of friends, including Dante Gabriel Rossetti. But Ruskin himself
was to be apart from all this, never involved in the fellowship and high
spirits of the young men, looking on fastidiously from a distance. His
Oxford was a curiously empty place.

CHAPTER 3

1843–50

> One day on the road to Norwood, I noticed a bit of ivy round a
> thorn stem, which seemed, even to my critical judgment, not ill
> 'composed'; and proceeded to make a light and shade pencil study
> of it in my grey paper pocket-book, carefully, as if it had been a bit
> of sculpture, liking it more and more as I drew. When it was done,
> I saw that I had virtually lost all my time since I was twelve years
> old, because no one had ever told me to draw what was really
> there![1]

The young man who wrote *Modern Painters* had had little experience
of the arts or of life – but from the pedestal on which his parents had
placed him he handed down judgements of extraordinary assurance.

The question of what is really high in art is to be decided only by
those of real judgement, not by the preferences of the majority:

> If I stand by a picture in the Academy, and hear twenty persons in
> succession admiring some paltry piece of mechanism or imitation in the
> lining of a cloak, or the satin of a slipper, it is absurd to tell me . . . that
> the feeling and knowledge of such judges . . . could come to any right
> conclusion with respect to what is really high in art. The question is not
> decided by them, but for them.[2]

Rome has nothing to offer the artist:

> In no city of Europe where art is a subject of attention, are its prospects
> so hopeless, or its pursuits so resultless, as in Rome; because there, among
> all students, the authority of their predecessors in art is supreme and
> without appeal, and the mindless copyist studies Raffaelle, but not what
> Raffaelle studied.[3]

The 'older masters' about whom the young man has chosen to be
rude are

> Claude, Gaspar Poussin, Salvator Rosa, Cuyp, Berghem, Both, Ruysdael,
> Hobbima, Teniers (in his landscapes), P. Potter, Canaletto, and the
> various Van somethings and Back somethings, more especially and
> malignantly those who have libelled the sea.[4]

The central proposition of Ruskin's book was dazzlingly simple.
Wordsworth among writers and Turner among painters were the two

figures who most faithfully presented the natural world. Wordsworth's poetry and Turner's painting displayed God's handiwork.

Ruskin's worship of Turner is fulsome, beautiful and extravagant. For example, he compares paintings of Venice by Canaletti (Ruskin's preferred form for Canaletto), Prout, Stansfield and Turner: 'The effect of a fine Canaletti is, in its first impression, dioramic. We fancy we are in our beloved Venice again, with one foot, by mistake, in the clear, invisible film of water lapping over the marble steps.' Ruskin goes on to condemn Canaletto roundly for reducing the arabesque ornament on a palace to 'five black dots', and the next palace's rich combination of weed growth and decay to 'One red square mass, composed of . . . five-and-fifty bricks'. Prout gives the brilliancy and cheerfulness of Venice but his drawing lacks the required detail, Stansfield's detail is accurate but too hard and sharp. Turner's achievement, by contrast, is described as follows:

> Let us take, with Turner, the last and greatest step of all. . . . Dreamlike and dim, but glorious, the unnumbered palaces lift their shafts out of the hollow sea, – pale ranks of motionless flame, – their mighty towers sent up to heaven like tongues of more eager fire, – their grey domes looming vast and dark, like eclipsed worlds, – their sculptured arabesques and purple marble fading farther and fainter, league beyond league, lost in the light of distance. Detail after detail, thought beyond thought, you find and feel them through the radiant mystery, inexhaustible as indistinct, beautiful, but never all revealed; secret in fulness, confused in symmetry, as nature herself is to the bewildered and foiled glance, giving out of that indistinctness, and through that confusion, the perpetual newness of the infinite, and the beautiful.
>
> Yes, Mr. Turner, we are in Venice now.[5]

*

The revelation on the road to Norwood, set down as an epigraph to this chapter, did not actually happen. It is quoted from *Praeterita*. As so often in that marvellous book, Ruskin has compressed a number of events into one. Indeed it is likely that the experience that he thinks he remembers here (he was writing in 1886) actually happened not to him but to his teacher J.D. Harding.[6] What is clear is that his relationship with the work of J.M.W. Turner had been evolving since the year 1836, when he had been moved to defend the painter.

Ruskin and his father became eager buyers of Turner's work, and in 1842 Griffith, Turner's agent, approached them hoping that they

would buy some sketches made in Switzerland and on the Rhine. Ruskin saw in these sketches that 'even in the artifice of Turner there might be more truth than I had understood. I was by this time very learned in *his* principles of composition; but it seemed to me that in these later subjects Nature was composing with him':[7] the Romantic artist opens his temperament to the truth of reality, which creates the composition for him. This is what is described in the apocryphal event on the road to Norwood and in another episode near Fontainebleau in 1842 where he draws an aspen tree:

> Languidly, but not idly, I began to draw it; and as I drew, the languor passed away: the beautiful lines insisted on being traced, – without weariness. More and more beautiful they became, as each rose out of the rest, and took its place in the air. With wonder increasing every instant, I saw that they 'composed' themselves, by finer laws than any known of men. At last the tree was there, and everything that I had thought before about trees, nowhere.[8]

This 'memory' also is not borne out by other sources.[9] But there is no doubt that, as a result of this new Romantic theory (that nature collaborates with the artist) Ruskin decided that he would write the huge book now known as *Modern Painters*.

He was also motivated by the critical attacks on paintings exhibited by Turner in the Royal Academy in 1842. A reviewer had written of Turner's *Snowstorm – Steamboat off a Harbour's Mouth* that it was 'of most unintelligible character – the snow-storm of a confused dream'; a writer in *The Athenaeum* that Turner's technique was outlandish. He has 'on former occasions chosen to paint with cream, or chocolate, yolk of egg, or currant jelly, – here he uses his whole array of kitchen stuff'.[10] Ruskin saw that Turner's experiments were hopelessly misunderstood.

He wrote steadily and passionately, working from his knowledge of Turner and of the paintings in the Dulwich picture gallery, which was within easy distance of his parents' new house, 163 Denmark Hill. Volume I of *Modern Painters* was finished towards the end of April in 1843. John James Ruskin, who for the rest of his life was to act, in effect, as his son's literary agent, offered the book to John Murray. Murray declined it on the grounds that Turner was not a promising subject for the market – he felt that a study of the medievalising German school known as the 'Nazarenes' would do better – and John James then offered it to Smith, Elder. The book came out (with amazing speed) in May 1843.[11]

Modern Painters was originally to have been called *Turner and the Ancients*. George Smith of Smith, Elder & Co. successfully resisted this but the spirit of it survives in Ruskin's full title: '*Modern Painters:/ Their Superiority in the Art of Landscape Painting/ To all/ The Ancient Masters/* proved by examples of/ The True, the Beautiful and the Intellectual,/ From the/ Works of Modern Artists,/ especially/ From those of J.M.W. Turner, Esq., R.A./ By a Graduate of Oxford'. Although he always denied that he was influenced by the great Catholic Gothic architect Pugin (one of the designers of the new Houses of Parliament), this big, cumbersome and confrontational title, with its stress on an absolute contrast between one moral position and another, reminds one irresistibly of the title-page of Pugin's *Contrasts*, published in 1836. Pugin's full title had been: '*Contrasts:/* or, A Parallel/ between the/ Noble Edifices of the Middle Ages,/ and/ Corresponding Buildings of the Present Day;/ shewing/ The Present Decay of Taste'. And Pugin's preferred method of exhortation, like Ruskin's, was to urge the reader to look on this picture and then on this: to compare, for instance, his 'contrasted residences of the poor', the modern brutal workhouse and the almshouses of a medieval abbey, or a Catholic town of 1440, with its abbeys, monasteries and hospices, and the same town in 1840, where the dominant features now are a new jail, a gas works, a lunatic asylum and an iron works.[12]

The first volume of *Modern Painters* itself had some unsympathetic reviews. One of the reviewers who had attacked Turner in *Blackwood's Magazine**now attacked what he saw as Ruskin's breathless naivety: 'We do not think that the pictorial world, either in taste or practice, will be Turnerized by this palpably fulsome, nonsensical praise. In this our graduate is *semper idem*, and to keep up his idolatry to the sticking-point, terminates the volume with a prayer, and begs all the people of England to join in it – a prayer to Mr Turner!'[13] Another enemy of Turner, *The Athenaeum*, was annoyed by Ruskin's youthful presumption: 'Whether the author be an Oxford Graduate or no, he appears beyond doubt an under-graduate in Criticism, – a very "freshman;" sanguine and self-confident, he would cut the Gordian knot with a bulrush', and so on: 'we suspect his opinions to be

Blackwood's Magazine, known as 'Maga', the Scottish conservative organ, was beloved of the masculine professions, especially the armed services and the Church of England. The reviewer, the Reverend John Eagles, had in a sense triggered Ruskin's career as a champion of Turner, because it was Eagles's piece on Turner in 'Maga' in 1836 that provoked Ruskin to write the spirited reply which remained unpublished until after his death.

inveterate, however immature'.[14] But there were also many favourable notices.[15] An early review, which gave pleasure to John James and his son, appeared in the *Britannia*. John James guessed correctly that the author was a friend, one Dr Croly. Croly's piece is intelligent and prescient:

> [*Modern Painters: Their Superiority in the Art of Landscape Painting To all The Ancient Masters*] is the bold title of a bold work, a general challenge to the whole body of cognoscenti, dilettanti, and all haranguers, essayists, and critics on the art of Italy, Flanders, and England, for the last hundred years. Of course, it will raise the whole *posse comitatus* of the pencil in arms. The phalanx of the pen will be moved against the Oxford graduate; the 'potent, grave, and reverend signors' who fill the reviews with profound theorems which defy all readers, and the haunters of exhibitions for the purpose of seeing their own portraits, and laughing at those of everyone else, will anathematize the new heresy; and yet we should not be surprised if the time should arrive when the controversialists will be turned into converts, and the heresy be dignified with the honours of the true belief. Our space allows of scarcely more than a sketch of this volume, which we pronounce to be one of the most interesting and important which we have ever seen on the subject, exhibiting a singular insight into the true principle of beauty, order, and taste – a work calculated more than *any other* performance in the language to make men enquire into the nature of their sensations of the sublime, the touching and the delightful, and to lead them from doubt into knowledge, without feeling the length of a way so scattered over with the flowers of an eloquent, forcible, and imaginative style.[16]

So what was the nature of this project? Why did it infuriate some of its first readers and what was its lasting importance? To take up some of the points made by Croly: it caused a stir because it attacked established beliefs. To clear the ground for his praise of Turner, Ruskin ferociously attacked Claude Lorraine, together with Salvator Rosa, Poussin and the Dutch painters, men who were regarded as the unimpeachable masters of landscape painting; he attacked, too, the principles of composition set out in Sir Joshua Reynolds's *Discourses*, the received wisdom of the Royal Academy. To support the case for Turner *and his contemporaries* in the first volume (in its first state) he offered fulsome and surprising praise of Prout, Harding, Fielding and Landseer. His pen-name 'A Graduate of Oxford' was itself a form of cheek. He was claiming the authority of the university in order to pull down authorities. He was also compensating himself for his 'Double Fourth' honours degree.

The manner of the book was radical, intellectually democratic and morally passionate. Anyone, any intelligent Victorian, could see, once Ruskin had pointed it out, how Turner's work displayed 'truth' to nature. One did not need to be an expert to take on board the argument. As W.G. Collingwood, Ruskin's secretary, put it in the biography that he wrote in Ruskin's lifetime: 'by beginning with the observed facts of nature – truths, he called them – and the practice (not the precept) of great artists', he 'created a perfectly new school of criticism'. He 'brought the whole subject to the bar of common-sense and common understanding. He took it out of the hands of adepts and initiated jargoners, and made it public property, the right and the responsibility of all.'[17] The tone of unwavering certainty and moral conviction in Ruskin's writing struck a very sympathetic chord with the new rich, people like John James; their tastes and judgements were validated and given moral authority. The reader of the first volume of *Modern Painters* emerged happy in the conviction that to admire Turner's work was consistent with devout Anglican Christianity. Ruskin spoke to the insecurities of a whole generation – the intelligent ambitious men who were making Victorian England the wealthiest and most powerful civilisation that the world had ever seen.

Conceived initially as a spirited pamphlet, *Modern Painters* expanded to a huge work of five volumes. The sequence was as follows: Volume I appeared in 1843, Volume II in 1846, Volumes III and IV (together) in 1856 and Volume V in 1860. In the 10-year interval between Volumes II and III, 1846–56, Ruskin wrote his major studies of architecture: *The Seven Lamps of Architecture* (1849), *The Stones of Venice*, Volume I (1851) and *The Stones of Venice*, Volumes II and III (1853). The five volumes of *Modern Painters* are written, then, over a period of seventeen years during which Ruskin underwent major changes in his personal and intellectual life. When he finished the great book, Ruskin wanted to say that it had a unity of purpose, but if this is true then the purpose has to be seen as evolving rather than static. In the Preface to Volume V (1860) Ruskin says that while there have been 'oscillations of temper' and 'progressions of discovery' in the work, 'in the main aim and principle of the book there is no variation, from its first syllable to its last. It declares the perfect and eternal beauty of the work of God; and tests all work of man by concurrence with, or subjection to that.'[18]

Volume I at first sold slowly. The publication in May comprised 500

copies, and by the end of the year only 150 had been sold. But early in 1844 Ruskin was able to issue a second edition, with a Preface in which he defended himself from the hostile reviews of the first edition. In 1846, as he wrote in the Preface to the third edition, he had decided the objective – justice to Turner – had been achieved and that there was so much immaturity and haste about this first volume that the right thing would be to replace it with a new one. The third edition, accordingly, was substantially revised. There was another edition in 1848 and a fifth, again substantially revised, in 1851. There were further editions of the first volume in 1857 and 1867, and it reappeared in complete reissues of the whole work in 1873 (the 'New Edition') and the Complete Edition of 1888. For all editions except the last the publisher was Smith, Elder. In 1888 the publisher was George Allen, who had been gradually taking over all of Ruskin's books since 1871.

Modern Painters begins as a philosophical work.* The objective is to establish a methodology that can then be used to demonstrate the claims made in the title and introduction. The titles of the chapters in Section I give us a sense of the scale of Ruskin's ambition: 'Of the Nature of the Ideas Conveyable by Art', 'Definition of Greatness in Art', 'Of Ideas of Power', 'Of Ideas of Imitation', 'Of Ideas of Truth', 'Of Ideas of Beauty', 'Of Ideas of Relation'. In Section II we might expect some practical application, but instead we get more ideas: 'General Principles respecting Ideas of Power', 'Of Ideas of Power, as they are Dependent upon Execution', 'Of the Sublime'. And then in Part II of his volume he extracts a single idea, 'Truth', and applies it to the relation between Turner's painting, the natural world, and the critic. 'That the Truth of Nature is not to be discerned by the uneducated Senses' is the title of Chapter II of Part II, and may be taken as summing up Ruskin's notion of that network of relationships. But Chapter VII, called 'General Application of the Foregoing Principles', takes us to the heart of the matter. Here Ruskin vigorously traces a history of painting that will culminate in Turner and in the paean to Turner's Venice that I have quoted above.

As a critical study that establishes a big theoretical base for itself, the first volume of *Modern Painters* resembles Coleridge's *Biographia Literaria*. In the first volume of that extraordinary book Coleridge

*With Volume III in 1856, Ruskin declares that he is abandoning system, but that is some years ahead.

surveyed the philosophy that he had been reading and in the second used the position arrived at to write his brilliant founding essay on Wordsworth. Similarly, Ruskin positions himself philosophically and then writes his celebration of Turner. As he does so he often sounds like an intellectual godchild of the English Romantics. For example, at the end of Part I, Chapter V of *Modern Painters*, I, he seems to quote from the final lines of Keats's 'Ode on a Grecian Urn':

> Ideas of truth are the foundation, and ideas of imitation, the destruction, of all art. We shall be better able to appreciate their relative dignity after the investigation which we propose of the functions of the former; but we may as well now express the conclusion to which we shall then be led – that no picture can be good which deceives by its imitation, for the very reason that nothing can be beautiful which is not true.[19]

In later editions of the book Ruskin italicised the last two lines, reinforcing the fact that the phrase has the resonance of a quotation.

The topics dealt with in the successive chapters become building blocks in the definition of art. Thus, in the first chapter of Section II of this first volume, we learn that ideas of power are 'associated with, or dependent upon, some of the higher ideas of truth, beauty, or relation' ('Truth', 'Beauty' and Relation' being the topics discussed in preceding chapters).[20] The sensation of power has to do with seeing the artist in action: 'the first five chalk touches bring a head into existence out of nothing'.[21] The qualities that especially please Ruskin in the way an artist works are decision and speed, and he is not sure that he values 'finish' as much as the quality of a good sketch.

Repeatedly in this volume Ruskin relates his work to eighteenth-century and Romantic theories of art. In his chapter 'Of the Sublime' he takes issue with Burke's *Philosophical Inquiry into the Origin of our Ideas of the Sublime and Beautiful* (1756). For Burke, the sublime is associated with terror, the beautiful with order. While conceding much to the 'ingenuity' of Burke's argument Ruskin presses for a view of the sublime which (although he doesn't put it in so many words) aligns it with tragic heroism. It is 'not the instinctive shudder and struggle of self-preservation, but the deliberate measurement of the doom, which is really great or sublime in feeling. It is not while we shrink, but while we defy, that we receive or convey the highest conceptions of the fate. There is no sublimity in the agony of terror.' Sublimity expresses the effect of greatness, including great beauty, on the temperament,[22] and at the end of Part I Ruskin arrives at a broad rule-of-thumb sense of the

word 'sublimity': 'I take the widest possible ground of investigation, that sublimity is found wherever anything elevates the mind; that is, wherever it contemplates anything above itself, and perceives it to be so.'[23]

There remains a contradiction: art is simultaneously universal and restricted in its appeal. The highest art 'can only be met and understood by persons having some sort of sympathy with the high and solitary minds which produced it – sympathy only to be felt by minds in some degree high and solitary themselves. He alone can appreciate the art, who could comprehend the conversation of the painter, and share in his emotion, in moments of his most fiery passion and most original thought.'[24] In general Ruskin wants to say, as the Romantics said, that art is for everybody, but he also wants to say that it speaks best to the initiated and the educated. This raises a difficulty that was already present in the thinking of the Romantics themselves, especially in Wordsworth's 'Preface' to the *Lyrical Ballads*: art both is and is not democratic and accessible. Ruskin is addressing this contradiction in Chapter II of 'Ideas of Truth' where he writes that 'it is possible for *all* men [my emphasis], by care and attention, to form a just judgment of the fidelity of artists to nature'. But his 'care and attention' mean rigorous training, and 'all men', therefore, has to mean all educated men. The possession of such judgement will be restricted in practice to persons (Ruskin continues to say 'men') whose powers of observation and intelligence can 'by cultivation . . . be brought to a high degree of perfection and acuteness'. The untutored average man will not be able to see nature by trusting his instincts. The 'thoughtless and unreflective' must be disabused of the notion that they 'know either what nature is, or what is like her'.[25]

The attempt to establish a theoretical base for his defence of Turner is serious and ambitious. But what we remember most vividly from a reading of *Modern Painters*, I, is Ruskin's passionate pleasure in looking both at Turner's paintings and at the natural world which stimulated them. His feelings threaten to swamp him: 'the truth of what I believe and feel respecting Turner would appear in this place, unsupported by any proof, mere rhapsody'.[26] At times Ruskin trusted his rhapsodies, and so can we.*

> Turner – glorious in conception – unfathomable in knowledge – solitary
> in power – with the elements waiting upon his will, and the night and the

*This passage was cut from later editions.

morning obedient to his call, sent as a prophet of God to reveal to men the mysteries of His universe, standing, like the great angel of the Apocalypse, clothed with a cloud, and with a rainbow upon his head, and with the sun and stars given into his hand.[27]

'Truth' – moral and aesthetic truth – is the test throughout *Modern Painters*, I. Straightforward and unalloyed joy is communicated by Ruskin's comparisons of the embarrassing activity of painters such as Poussin, with his sky-blue hills and his green clouds, and Turner's careful registration of what he believes to be there in front of his eyes. Not even Turner can display the full beauty and wonder of God's world, but he gets closer to it than anybody else. 'Truth' as a defence takes on special urgency for Ruskin because exaggeration, failure to get the 'truth' of what is seen, was a major charge brought against Turner's paintings by some of his hostile critics. Thus, of a great Turner painting which was later to become his own property (it was a munificent New Year's gift to Ruskin from his father in January 1844), *Slavers throwing overboard the Dead and Dying – Typhoon coming on*, Ruskin wrote:

> I think, the noblest sea that Turner has ever painted, and, if so, the noblest certainly ever painted by man, is that of the Slave Ship, the chief Academy picture of the Exhibition of 1840. It is a sunset on the Atlantic, after prolonged storm; but the storm is partially lulled, and the torn and streaming rain-clouds are moving in scarlet lines to lose themselves in the hollow of the night. The whole surface of sea included in the picture is divided into two ridges of enormous swell, not high, nor local, but a low broad heaving of the whole ocean, like the lifting of its bosom by deep-drawn breath after the torture of the storm. Between these two ridges the fire of the sunset falls along the trough of the sea, dyeing it with an awful but glorious light, the intense and lurid splendour which burns like gold, and bathes like blood. Along this fiery path and valley, the tossing waves by which the swell of the sea is restlessly divided, lift themselves in dark, indefinite, fantastic forms, each casting a faint and ghastly shadow behind it along the illumined foam.

It is striking that Ruskin's response to this painting is aesthetic to the exclusion of almost all else. He does comment, briefly, on the painting's narrative content by referring to the ship as 'guilty', but the reason for the guilt is relegated to a footnote: 'She is a slaver, throwing her slaves overboard. The near sea is encumbered with corpses.'[28]

The method is comparative. Works by other painters which have received disproportionate praise are contrasted with paintings by Turner:

I am fond of standing by a bright Turner in the Academy, to listen to the unintentional compliments of the crowd – 'What a glaring thing!' 'I declare I can't look at it!' 'Don't it hurt your eyes?' . . . It is curious after hearing people malign some of Turner's noble passages of light, to pass to some really ungrammatical and false picture of the old masters, in which we have colour given *without* light.[29]

'Truth' tolls through the titles of Ruskin's sections – 'Of Truth of Sky', 'Of Truth of Clouds' – as a reiterated rebuke to the hostile accusation that Turner's work somehow lacks it. Praising Turner's treatment of clouds, Ruskin writes:

Now this is nature! It is the exhaustless living energy with which the universe is filled; and what will you set beside it of the works of other men? Show me a single picture, in the whole compass of ancient art, in which I can pass from cloud to cloud, from region to region, from first to second and third heaven, as I can here, and you may talk of Turner's want of truth.[30]

The ironic refrain – the invitation to 'talk of Turner's want of truth' – returns as a massive rhetorical gesture at the end of the chapter called 'Of Truth of Clouds'. Ruskin invites the reader to spend a day standing on a mountain watching rain-clouds and to consider, at the end of each division of the day, 'Has Claude given this?':

You shall see those scattered mists rallying in the ravines, and floating up towards you, along the winding valleys, till they crouch in quiet masses, iridescent with the morning light, upon the broad breasts of the higher hills, whose leagues of massy undulation will melt back and back into that robe of material light, until they fade away, lost in its lustre, to appear again above, in the serene heaven, like a wild, bright, impossible dream, foundationless and inaccessible, their very bases vanishing in the unsubstantial and mocking blue of the deep lake below. Has Claude given this?[31]

Beauty is truth, but it appears also from Chapter 6 of *Modern Painters*, I, that the capacity to perceive beauty is a God-given mystery: 'Why we receive pleasure from some forms and colours, and not from others, is no more to be asked or answered than why we like sugar and dislike wormwood.' It is determined by 'the simple will of the Deity that we should be so created'.[32] Ideas of beauty are the subjects of 'moral, but not of intellectual perception'.[33] And theology and Romanticism come together when Ruskin praises 'mystery' as a power peculiar to great art. 'Nature is always mysterious and secret in her

use of means; and art is always likest her when it is most inexplicable.'[34]

The bits of *Modern Painters*, I, that work best are those in which Ruskin in effect scraps his theories and systems and relies on the authority of his feelings and the vivid contrasts brought out by his 'demonstrations'. The painter must bring out the 'talkative facts' in his subject. If he is painting a tree he must give 'the appearance of energy and elasticity in the limbs which is indicative of growth and life' rather than the precise details of leaves and branches. By contrast, the old masters' desire to deceive the 'ordinary eye' into thinking that a landscape painting is a window *kills* the subject.[35] No one who experiences and enjoys the sea 'with its bright breakers, and free winds, and sounding rocks' can be other than angered by Claude's seascapes. No one 'accustomed to the strength and glory of God's mountains, with their soaring and radiant pinnacles' will tolerate Salvator's 'contemptible fragment of splintery crag'. No one who loves 'the grace and infinity of nature's foliage, with every vista a cathedral, and every bough a revelation', will put up with Poussin. The problem with these three painters is their lack of love for nature and of humility in its presence: they never 'lose sight of themselves'.[36] Turner, by contrast, is devoid of self, ravished, like Ruskin, by the subject before him. When Turner paints the play of light on objects there is 'not a stone, not a leaf, not a cloud, over which light is not felt to be actually passing and palpitating before our eyes'. Turner records 'breathing, animated, exulting light, which feels, and receives, and rejoices, and acts . . . leaping from rock to rock, from leaf to leaf, from wave to wave'.[37] Ruskin is at his most confident when writing in this Keatsian, celebratory, 'negative capability' mode.

The success of *Modern Painters*, I, was both exciting and burdensome; exciting because the identity of the 'Graduate of Oxford' was soon an open secret, and burdensome because the task of continuing it now became a public duty rather than a private pleasure. Although the book's reputation spread fairly slowly, it introduced Ruskin's name to the grandest literary figures of the day. Wordsworth, who plays such a large role in it, admired it and so did Charlotte Brontë, George Eliot, who saw Ruskin as a 'prophet', Tennyson and Elizabeth Barrett Browning, who liked it with careful reservations: 'Very vivid, very graphic, full of sensibility, but inconsequent in some of the reasoning, it seemed to me, and rather flashy than full in the metaphysics. . . . Still,

he is no ordinary man, and for a critic to be so much of a poet is a great thing.'[38]

At the same time Ruskin's social world was being expanded by his growing fame. He found himself in demand in fashionable London, but now and throughout his life he disliked the conventional social world, especially that of politicians and courtiers – the world that Samuel Rogers with his famous breakfasts inhabited so easily. Ruskin was comfortable only within his own tight-knit family circle, and the social occasions that suited him best were those organised for him by his father. John James carefully invited to Denmark Hill the people that he knew his son would most like: Turner, for instance, who dined at Denmark Hill on New Year's Day 1846 and again on 8 February,* Ruskin's birthday, and on 19 March, when the other guests included George Richmond and Joseph Severn.

As for the continuing work on *Modern Painters*, Ruskin often found himself bogged down and vexed by the project. Some of his diary entries make sad reading from such a young man: 'Feb 25. [1844] – Sunday – a good day because wet. I wish Sunday were always wet, otherwise I lose the day.'[40]

In May, June, July and August of 1844 he travelled on the continent with his parents with the object of making further observations from nature of Turner's subjects. But other sights now distracted him. The most exciting experience of this tour was his encounter with the stained glass of Rouen on 18 May 1844. In Chamonix, where the Ruskins arrived in June, the rocks and geological compositions pleased him. On 7 June he made the acquaintance of Joseph Marie Couttet, the Swiss guide who was to be his mentor and friend on his European travels for the next thirty years. But the return home in August found Ruskin with a sense that very little had been achieved.[41]

In April 1845, when he was twenty-six, Ruskin set out on his first journey abroad without his parents. His servant, John Hobbs, who was twenty, accompanied him (Hobbs was known in the family as 'George' to distinguish him from his master).

The new railways were being established in Europe; but the Ruskins abominated them, and Ruskin travelled by rented carriage. In Geneva,

*After the publication of *Modern Painters*, I, John James seems to have made a point of inviting Turner to dinner on his son's birthday each year, as a kind of princely encounter between the great painter and his most articulate advocate, but the relationship was always marked by a certain reserve.[39]

Couttet, the Chamonix guide, joined him. Couttet bribed custodians to gain access to works of art, cooked for him and looked after his health (still regarded by his parents as delicate). The wine-merchant's son travelled in the same 'milord' style that his father had bought for him as a gentleman-commoner at Oxford.

On this tour Ruskin had two objectives. He wanted to collect further examples of landscape for the next volume of *Modern Painters*, but he also needed to study Italian painting. He knew that *Modern Painters*, I, had been written with very narrow knowledge of the 'ancients' with whom he contrasted his modern painters, and that he needed to learn more. In Lucca, the architecture of the old churches stimulated his imagination more than did the paintings. In Pisa, he studied the frescoes in the Campo Santo. But he was again drawn by the architecture, especially that of the Baptistery and Santa Maria della Spina. In Florence, the paintings in the Uffizi and the Pitti Palace were important to him, but he was especially drawn to the pictures in the churches and cloisters: particularly Santa Maria Novella, San Marco, Santa Croce and the Carmine.

His intention was to stay only for two weeks in Venice, but the changes since he had previously seen it in 1841 provoked in him a sense of rage and urgency. 'Restoration' was under way in the city, damaging St Mark's and the cloisters and many of the other churches. Modernisation was also doing harm. He stayed for five weeks, measuring and taking architectural notes, and also encountering the work of Tintoretto, which overwhelmed him.[42]

The directions of much of Ruskin's subsequent work in architecture and painting were laid down by this tour. The paintings that he saw determined much of the content of *Modern Painters*, II. To his celebration of Turner in the first volume, he added his excited proclaiming of Fra Angelico and Tintoretto in the second; and to his celebration of nature, he added his delight in the portraiture of man. The many references to Tintoretto and Michelangelo in *Modern Painters*, II, testified to the thrill that Ruskin felt in the presence of representations of the human body engaged in violent activity. As in Volume I, the method was comparative, but in Volume II he chose to compare works that he admired equally in their different ways. He invited the reader to join him in contemplation of the 1450 *Annunciation* by Fra Angelico in the upper corridor of San Marco in Florence, and then to accompany him on a magical journey from this monastery to the Scuola di San Rocco in Venice, to look at Tintoretto's *Annunciation* (*c.* 1580):

Severe would be the shock and painful the contrast, if we could pass in an instant from that pure vision to the wild thought of Tintoret. For not in the meek reception of the adoring messenger, but startled by the rush of his horizontal and rattling wings, the Virgin sits, not in the quiet loggia, not by the green pasture of the restored soul, but houseless, under the shelter of a palace vestibule ruined and abandoned, with the noise of the axe and the hammer in her ears, and the tumult of a city round about her desolation.[43]

This momentous discovery – the power of Tintoretto – came when Ruskin had already stayed abroad longer than he had intended. Discoveries and impressions had crowded in on the young man, extending his experience and helping him towards some independence of his parents. From Annecy, on 13 April, he wrote indignantly to his mother who had put a copy of Bunyan's *Grace Abounding* into his luggage: 'Much of Bunyan's feeling amounts to pure insanity.' He was rereading his favourite Christian poet, George Herbert, and developed a spirited contrast between the two writers. Herbert had learnt his Christianity 'through his brains, Bunyan through his liver'.[44]

Once he reached Italy he strayed increasingly from the parental plan. To study the paintings remained important, but to study the architecture was critical, indeed urgent. 'What in the wide world I am to do in – or out of – this blessed Italy I cannot tell. I have discovered enough in an hour's ramble after mass, to keep me at work for a twelvemonth.' The anguish he felt at the damage being done by 'restoration' to the ancient buildings was palpable: 'One sees nothing but subjects for lamentation, wrecks of lovely things destroyed, remains of them unrespected, *all* going to decay, nothing rising but ugliness & meanness, nothing done or conceived by man but evil.'[45] On 6 May he wrote from Lucca that he was drawing the façade of San Michele, which was crumbling before his eyes:

Nimrods with short legs and long lances – blowing tremendous trumpets – and with dogs which appear running up and down the round arches like flies, heads uppermost – and game of all descriptions – boars chiefly, but stags, tapirs, griffins & dragons – and indescribably innumerable, all cut out in hard green porphyry, & inlaid in the marble. The frost where the details are fine, has got underneath the inlaid pieces, and has in many places rent them off, tearing up the intermediate marble together with them, so as to *uncoat* the building an inch deep. Fragments of the carved porphyry are lying about everywhere. I have brought away three or four, and restored *all* I could to their places.

The same visit to this cathedral brought him face to face with a work of art that was to haunt him all his life, the Jacopo della Quercia tomb of Ilaria di Caretto:

> She is lying on a simple pillow, with a hound at her feet. Her dress is of the simplest middle age character, folding closely over the bosom, and tight to the arms, clasped about the neck. Round her head is a circular fillet, with three star shaped flowers. From under this the hair falls like that of the Magdalene, its undulation *just* felt as it touches the cheek, & no more. The arms are not folded, nor the hands clasped nor raised. Her arms are laid softly at length upon her body, and the hands cross as they fall. The drapery flows over the feet and half hides the hound. It is impossible to tell you the perfect sweetness of the lips & the closed eyes, nor the solemnity of the seal of death which is set upon the whole figure. The sculpture, as art, is in every way perfect – *truth* itself, but truth selected with inconceivable refinement of feeling. The cast of the drapery, for *severe natural* simplicity & perfect grace, I never saw equalled, nor the fall of the hands – you expect every instant, or rather you seem to see every instant, the last sinking into death.[46]

Amid all this solemnity there was room for comedy. A beggar enters a church with his dog: the beggar goes to the holy water stoup and crosses himself while 'at the *same instant*' the dog cocks its leg against the stoup's pedestal.[47]

Of Pisa, he wrote: 'my mind is marvellously altered since I was here – everything comes on me like music'. But on the following day:

> I do believe that I shall live to see the ruin of everything good and great in the world, and have nothing to hope for but the fires of the judgment to shrivel up the cursed idiocy of mankind. . . . I have not the slightest doubt but these conservators, who let the workmen repairing the roof drop their buckets of plaster over whole figures [of the frescoes in the Campo Santo] at a time, destroying them for ever, will hinder *me* with my silky touch & fearful hand, from making [by tracing the frescoes] even so much effort at the preservation of . . . any one of them.[48]

He cried out at the frustration of seeing so much damage and being powerless to halt it. 'Why wasn't I born 50 years ago. I should have saved much, & seen more, & left the world something like faithful reports of the things that have been – but it is too late now.'[49]

His parents fretted if there was an interruption of Ruskin's letters, if he spent more money than they had allowed and if he departed from John James's plan. Ruskin's attention to *buildings* could seem only a distraction from *Modern Painters*. In a letter from Pisa (Sunday 25 May

1845), Ruskin conceded that he spent too much on guidebooks: 'I buy all I can lay my hands on – no matter how bad, they serve me for scratching notes on and references which would otherwise be a mere mass of confusion.' John James had been scolding him:

> To go back to your letter. I keep my book [*Modern Painters*], I assure you, most strictly in view, but it is a most bitter feeling to me to see every day all that is beautiful vanishing away – just as I am coming to an age capable of in some measure recording it.[50]

As well as sticking to *Modern Painters* John James wanted him to write *poetry*. On 31 May Ruskin wrote that he had not forgotten his promise to write an 'Alpine Vignette' in verse but 'somehow I can't write a bit here in Italy. I usually write at night when I go to bed, and here I am always as sleepy as a cat by the fire. I will try to do it however now I am settled.'[51] Clearly poetry-writing was now felt by him to be a chore.

His distress over poor restoration work continued. Even the decay of San Michele at Lucca was better than what was happening in Florence. 'All that remains at Lucca is genuine – it is ruined, but you can trace through all what it has been. . . . Here, in Giotto's campanile, they are perpetually at work chipping & cleaning, & putting in new bits, which though they are indeed of the pattern of the old ones, are entirely wanting in the peculiar touch & character of the early chisel. So that it is no longer Giotto's.'[52]

On 26 June Ruskin again justified the way he was working. He defended it, rightly, as courageous: 'Architecture – sculpture – anatomy – botany – music – all must be thought of & in some degree touched upon, & one is always obliged to stop in the middle of one thing to take note of another.'[53]

From Parma, on 10 July, the Graduate of Oxford decided to rank the painters that he had now seen, as in an Oxford class list. The distinction between the first class and the (undivided) second class reveals a lot about the stranglehold that the parental religious attitudes still had on the young man. In the first class comes 'Pure Religious art. The School of Love', which includes Fra Angelico, 'Raffaelle' and 'John' Bellini. The second class comprises artists valued for 'General Perception of Nature human & divine, accompanied by more or less religious feeling. The School of the *Great* Men.' This includes Michelangelo, Giotto, Leonardo, Ghirlandaio and Masaccio, all *second* class because the Christian content coexists with their profound observations of the human.[54]

He arrived in Venice on 9 September, accompanied by his friend and former teacher the painter J.D. Harding (who had joined him at Baveno). The railway, new since his last visit of 1841, now crossed the lagoon to link Mestre to Venice: 'The Afternoon was cloudless, the sun intensely bright, the gliding down the canal of the Brenta exquisite. We turned the corner of the bastion, where Venice *once* appeared, & behold – the Greenwich railway, only with less arches and more dead wall, entirely cutting off the whole open sea & half the city, which now looks as nearly as possible like Liverpool at the end of the dockyard wall.' Another source of dismay was the gas-lamps 'in grand new iron posts of the last Birmingham fashion',[55] the new bridges, and worst of all the attempts at 'restoration'. He wrote on 23 September:

> You cannot imagine what an unhappy day I spent yesterday before the Casa d'Oro, vainly attempting to draw it while the workmen were hammering it down before my face . . . and all the while with the sense that *now* one's art is not enough to be of the slightest service, but that in ten years more one might have done such glorious things. Venice has never yet been painted as she should, never, & to see the thing *just* in one's grasp, & snatched away . . . is too bad, far too bad. The beauty of the fragments left is beyond all I conceived, & just as I am becoming able to appreciate it, & able to do something that would have kept record of it, to have it destroyed before my face.[56]

But he was more than compensated for the loss of the Ca' d'Oro by the discovery of Tintoretto. On 23 and 24 September Ruskin wrote: 'I had always thought him a good & clever & forcible painter, but I had not the smallest notion of his enormous powers.' He had visited the Accademia and seen Tintoretto's *Assumption*. 'I had altogether forgotten the Academy here – it is full of treasure – but it is marvellously lucky I came here, or I might have disgraced myself for ever by speaking slightly of Tintoret. I look upon him now, though as a less *perfect* painter, yet as a far greater man than Titian ipse.' And on the following day Ruskin and Harding saw the great cycle of paintings in the Scuola di San Rocco. This was the date that the two men were scheduled to return home, and Harding did indeed go, but Ruskin stayed on to absorb the experience of Tintoretto's paintings. He wrote to his father on 24 September:

> I have had a draught of pictures today enough to drown me. I never was so utterly crushed to the earth before any human intellect as I was today, before Tintoret. Just be so good as to take my list of painters [his class list of 10 July], & put him in the school of Art at the top, top, top of

everything, with a great big black line underneath him to stop him off from everybody – and put him in the school of Intellect, next after Michael Angelo. He took it so entirely out of me today that I could do nothing at last but lie on a bench & laugh. Harding said that if he had been a figure painter, he never could have touched a brush again, and that he felt more like a flogged schoolboy than a man – and no wonder. Tintoret don't seem to be able to stretch himself till you give him a canvas forty feet square – & then, he lashes out like a leviathan, and heaven and earth come together. M Angelo himself cannot hurl figures into space as he does, nor did M Angelo ever paint space itself which would not look like a nutshell beside Tintoret's.[57]

On 1 October, when his return home was already seriously overdue, he wrote from Venice describing both his own sense of helplessness and the continuing vandalism that he was having to witness:

I am ashamed of staying so long here & doing so little. I work very unsatisfactorily at present. I suppose it is a warning not to stay longer from you and indeed I shall start [for home] soon now, though indeed it hurts me sadly to look on St. Mark's – *old* St. Mark's – for the [last] time, for the sort of thing they are scrapin[g] out of I[t is qu]ite good for nothing. What would I not give to have back again ten years, & to be set, with my present powers & feelings, in St. Mark's place . . . [in] 1835.[58]

He finally left Venice on 14 October. By the 23rd, when he had reached Martigny, he had received indignant letters from his father, who said (among other things) that he was planning a tour in the following year, 1846, which would take Ruskin to Venice again, so that the protracted stay was unnecessary. Ruskin protested that he had not known about this plan, and he added: 'if I had, I should still have staid, for one of the windows of the Ca d'Oro was destroyed before my eyes, the scaffolding is now all over it, and the Foscari palace is threatened in a *month*'. He continued to defend himself about 'the book' – *Modern Painters* 'shall go steadily & will be out at the same time, whatever that time be, whether I stay at home or go abroad'. He refused, with some spirit, to be hurried or tied to a deadline.[59]

Looking on, the reader longs for the young Ruskin to seize the moment to put up even more of a fight to free himself from his parents' possessiveness. There is a diary entry written on 4 January 1846 but recalling an event in late 1845, when he was tempted to have a quarrel with his father, but put the temptation aside. We can only guess at the good that he would have done himself if he had had the will to fight his father this early in his life. In Lausanne, he had received 'a short letter

from my Father, full of most unkind expressions of impatience at my stay in Venice. I had been much vexed by his apparent want of sympathy throughout the journey, and on receiving this letter my first impulse was to write a complaining and perhaps a bitter one in return.' One can only applaud this impulse, but it didn't last:

> I considered that I should give my father dreadful pain if I did so, and that all this impatience was not unkindly meant, but only ungoverned expression of extreme though selfish affection. At last I resolved, though with a little effort, to throw the letter into the fire, and say nothing of having received it, so that it might be thought to have been lost at Brieg, whence it had been forwarded.

So this opportunity to throw off the parental yoke was lost. And the diary entry showed Ruskin getting himself into a dangerous state of false consciousness. Having blocked his healthy impulse to have a row with his father he experienced a 'religious' revelation. We see the sad spectacle of this brilliant young man casting himself in the role of a martyr enjoying the reward of his martyrdom, whereas in reality what had happened was that he had chosen the path of least resistance, made the weak decision, and surrendered a chance of freedom:

> I had no sooner made this resolution than I felt an extraordinary degree of happiness and elation totally different from all my ordinary states of mind, and . . . I could not but feel there was some strange spiritual government of the conscience; and I began to wonder how God should give me so much reward for so little self-denial.

A magnificent view of Mont Blanc, 'a revelation of nature intended for me only', confirmed this deluded belief that virtue had been rewarded. The feeling that Ruskin is 'in denial' here is heightened by the fact that he did not complete this diary entry for a whole year. He added the rest of it on 19 January 1847, in a footnote, saying that the beauty of Mont Blanc made him think of Bunyan's celestial city, and braced him for various disagreeable duties: writing to relations about recent bereavements and devoting himself to 'various Scripture readings and resolutions of amendment'. Not surprisingly, this devotion of the self to duty produced distressing physical symptoms, reviving Ruskin's earlier anxiety about his health:

> I was alarmed by the distinctness of a strange numbness in my throat, not soreness, but continual stiffness and uneasiness, like nothing I had ever felt before. This increased upon me, and much despondency also, until we stopped at Champagnole, cold and weary; and I very anxious and unwell,

stood over the fire leaning on the chimneypiece, sadly comparing my then feelings with those I had had in passing seen months before.

I prayed, though despondently, that night; and we travelled the next two days to Montbard – the despondency, if anything, increasing upon me, and the numbness in the throat remaining without any other symptoms that might account for it. I arrived at Montbard totally discouraged, and went up to my room in the fear of not being able to get farther towards home, fancying I had cancer in the throat, or palsy, or some other strange disease.[60]

As one would expect, after the revelatory tour of 1845, *Modern Painters*, II, shows a marked difference in subject-matter from *Modern Painters*, I. The second volume is a much more consciously philosophical, 'academic' production than the first and moves the focus from what is seen to the nature of the person doing the seeing: a moral being. Beauty is spiritual, and the right apprehension of beauty requires the 'Theoretic faculty' which is concerned with 'the moral perception and appreciation of ideas of beauty'. This is to be clearly distinguished from the 'Aesthetic', which is an 'operation of sense' (as against the whole intellect and moral being). Ruskin adds on this page a note written in 1883 (*Modern Painters*, I, having been first published in 1846), prompted by anger about the Aesthetic movement: 'It is one of the principal reasons for my reprinting this book, that it contains so early and so decisive warning against the then incipient folly, which in recent days has made art at once the corruption, and the jest, of the vulgar world.'[61]*

Modern Painters, II, is certainly intellectually ambitious. It is a continuation of *Modern Painters*, I, in that it takes further the serious attempt to provide art criticism with a methodology and a theoretical base, though it departs from it in closing with massive praise for Renaissance painters, Tintoretto and Fra Angelico. The central thrust of Volume I, therefore – the superiority of Turner to the 'ancients' – is replaced by a quite different set of discoveries and enthusiasms. The

*Ruskin had been urged by his Oxford tutor, Osborne Gordon, to read Hooker's *Ecclesiastical Polity* as a model of style and argument. He took the instruction all too seriously, and many years later he was to lament the pedantry and consciously highbrow weightiness of this early book. He withdrew Volume II from some later editions of *Modern Painters*, restoring it only in 1883 with annotations chastising his younger self for evangelical narrowness and for affectations of style. In his 'Preface to the Re-Arranged Edition' of 1883 he speaks of the shame and indignation that he feels, on rereading *Modern Painters*, II, 'at finding the most solemn of all objects of human thought handled at once with the presumption of a youth, and the affectations of an anonymous writer'.[62]

whole volume records the rapid growth, in experience and intellectual ambition, that the young man had undergone during his tour of 1845.

In 1841, as he writes in the 'Epilogue' to *Modern Painters*, II, he had had no thought of writing about art at all; indeed he had thought he was dying 'and should never write about anything'. The impact of Turner's work and of the old man's friendship had spurred the work of advocacy that is Volume I, a work full of 'enthusiasm and the rush of sap in the too literally sapling and stripling mind of me'.[63] In *Modern Painters*, II, he was consciously positioning himself in an august philosophical tradition. 'The use of the word "Theoria" for "contemplation",' he writes in 1883, together with a quotation from Aristotle, 'were not so much affectations, as an appeal to pre-established authority.' In a word, the young man was nervous. He translates the passage from Aristotle's *Ethics* (on its first appearance he had left it in Greek): 'Perfect happiness is some sort of energy of Contemplation, for all the life of the gods is (therein) glad; and that of men, glad in the degree in which some likeness to the gods in this energy belongs to them. For none other of living creatures (but men only) can be happy, since in no way can they have any part in Contemplation.'[64] He was claiming the standing of an authority, an authority who knew Hooker and Aristotle, and who had rapidly taken on board some great Italian painting during his tour of 1845.

For all its conscious solemnity *Modern Painters*, II, has the beguiling freshness and urgency of a young man's book. It describes the excitement of rapidly absorbed experience: 'False taste may be known by its fastidiousness. . . . True taste is for ever growing, learning, reading, worshipping, laying its hand upon its mouth because it is astonished, lamenting over itself, and testing itself by the way that it fits things. And it finds whereof to feed, and whereby to grow, in all things.'[65]

Like the great theoretical works of the major Romantics this book concerns itself with the activity of the mind in the act of contemplation. The mind must discipline itself in its acts of attention:

> That which is required in order to the attainment of accurate conclusions respecting the essence of the Beautiful is nothing more than earnest, loving, and unselfish attention to our impressions of it, by which those which are shallow, false, or peculiar to times and temperaments, may be distinguished from those that are eternal. And this dwelling upon and fond contemplation of them (the Anschauung of the Germans), is perhaps as much as was meant by the Greek Theoria: and it is indeed a very noble

exercise of the souls of men, and one by which they are peculiarly distinguished from the anima of lower creatures, which cannot, I think, be proved to have any capacity of contemplation at all, but only a restless vividness of perception and conception, the 'fancy' of Hooker.[66]

Despite 'Theoria' the model of mind that he is using is Romantic, and specifically draws on the Wordsworth of the *Ode on Intimations of Immortality*: 'There was never yet the child of any promise (so far as the Theoretic faculties are concerned) but awaked to the sense of beauty with the first gleam of reason; and I suppose there are few among those who love Nature otherwise than by profession and at second-hand, who look not back to their youngest and least-learned days as those of the most intense, superstitious, insatiable, and beatific perception of her splendours.' He quotes the Wordsworth Ode as the work of 'one whose authority is almost without appeal in all questions relating to the influence of external things upon the pure human soul'.[67] And he gives his own Wordsworthian recollections, primal memories which become building blocks of the consciousness:

> Let the eye but rest on a rough piece of branch of curious form during a conversation with a friend, rest however unconsciously, and though the conversation be forgotten, though every circumstance connected with it be as utterly lost to the memory as though it had not been, yet the eye will, through the whole life after, take a certain pleasure in such boughs which it had not before, a pleasure so slight, a trace of feeling so delicate, as to leave us utterly unconscious of its peculiar power; but undestroyable by any reasoning, a part, thenceforward, of our constitution.[68]

And again:

> One . . . of these child instincts, I believe that few forget, the emotion, namely, caused by all open ground, or lines of any spacious kind against the sky, behind which there might be conceived the Sea. It is an emotion more pure than that caused by the sea itself, for I recollect distinctly running down behind the banks of a high beach to get their land line cutting against the sky, and receiving a more strange delight from this than from the sight of the ocean. I am not sure that this feeling is common to all children . . . but I have ascertained it to be frequent among those who possess the most vivid sensibilities for nature; and I am certain that the modification of it which belongs to our after years is common to all, the love, namely, of a light distance appearing over a comparatively dark horizon.[69]

This book has the ardour of a young man working as though he is a Romantic poet, and it also has the huge ambition of such a man. He

identifies the characteristics of 'mere matter' which make for the beautiful and continues:

> It will be our task in the succeeding volume to examine, and illustrate by example, the mode in which these characteristics appear in every division of creation, in stones, mountains, waves, clouds, and all organic bodies, beginning with vegetables, and then taking instances in the range of animals, from the mollusc to man.

He adds a note in 1883: 'This was indeed the original plan of the book, – formed, the reader will be pleased to observe, in 1845. I reflected on it for fifteen years, – and then gave it up.' He continues with a side-swipe at Darwin, whose great work *The Origin of Species* was published in 1859: 'In another fifteen years the scientific world professed itself to have discovered that the mollusc was the Father of Man; and the comparison of their modes of beauty became invidious; nevertheless, it is possible I may have a word or two to say, on the plan of the old book, yet.'[70] And he was of course, in *Deucalion, Loves Meinie* and *Proserpina*, exploring among other things the way in which the artist responds to rocks, birds, plants and other orders of creation.

The volume celebrates the qualities that he had found in Tintoretto, the animal energy and exuberance of the paintings in the Scuola di San Rocco. Because these are Christian paintings their physical splendour does not disturb the provincial piety which marks the whole of *Modern Painters*, II, and impedes the reader in engaging with Ruskin's wonderfully fresh young intelligence, when he seems to be writing in a code forced on him by an alien authority. The piety of the book belongs to his mother's evangelical, Bible-bound Protestantism, a creed of which Ruskin was already tiring.

In 1846 Ruskin took a tour with his parents. This involved some bafflement and mutual exasperation among the three members of the party. John James was mystified by Ruskin's behaviour and he wrote to W.H. Harrison from Venice:

> He is cultivating art at present, searching for real knowledge, but to you and me this is at present a sealed book. It will neither take the shape of picture nor poetry. It is gathered in scraps hardly wrought, for he is drawing perpetually, but no drawing such as in former days you or I might compliment in the usual way by saying it deserved a frame; but fragments of everything from a Cupola to a Cart-wheel, but in such bits that it is to the common eye a mass of Hieroglyphics – all true – truth itself, but Truth in mosaic.[71]

The personality that was making this historic shift from painting to architecture in this year was delicate, highly strung, and 'feminine'. His friend F.J. Furnivall wrote of him:

> Ruskin was a tall, slight fellow, whose piercing frank blue eye lookt through you and drew you to him. A fair man, with rough light hair and reddish whiskers, in a dark blue frock coat with velvet collar, bright Oxford blue stock, black trousers and patent slippers – how vivid he is to me still! The only blemish in his face was the lower lip, which protruded somewhat: he had been bitten there by a dog in his early youth. But you ceast to notice this as soon as he began to talk. I never met any man whose charm of manner at all approacht Ruskin's. Partly feminine it was, no doubt; but the delicacy, the sympathy, the gentleness and affectionateness of his way, the fresh and penetrating things he said, the boyish fun, the earnestness, the interest he showd in all deep matters, combined to make a whole which I have never seen equalld.[72]

Ruskin worked so hard that he strained his eyes and created what are known as 'floaters': common among short-sighted people, but frightening to him. From Oxford, in June 1847, where he was attending a meeting of the British Association, he wrote to his parents in the following unwise terms:

> I can neither bear the excitement of being in the society where the play of the mind is constant, and rolls *over* me like heavy wheels, nor the pain of being alone. I get away in the evenings into the hayfields about Cumnor, and rest; but then my failing sight plagues me. I cannot look at anything as I used to do, and the evening sky is covered with swimming strings and eels.[73]

The parent Ruskins were understandably panicked by this and packed him off to another 'cure' with Dr Jephson of Leamington Spa.

The Seven Lamps of Architecture (1849) is the first of five illustrated books about architecture (the others being the three volumes of *The Stones of Venice* and the one volume of *Examples of the Architecture of Venice*). The continental tour of 1846, especially, had drawn Ruskin's attention to the medieval Italian buildings that were being damaged by insensitive restoration. On this tour he took with him an influential book by Robert Willis, Professor of Architecture at Cambridge, on the *Architecture of the Middle Ages*. He saw Professor Willis as 'the first modern who observed and ascertained the lost structural principles of Gothic architecture' and said that the book 'taught me all my grammar of central Gothic'.[74]

The Seven Lamps of Architecture was published in 1849, with fourteen plates etched by Ruskin himself. It had a second edition in 1855, with additional plates, and a third edition in 1880 published by George Allen. This became the basis for all later editions in Ruskin's lifetime. The reason for the long gap between the second and third editions is that Ruskin became disenchanted with the book's religious posture – its aggressive evangelical Protestantism – and kept meaning to revise the book completely but when it came to the point he simply lacked the will and energy to do so.[75] Temperamentally he would always rather create anew than revisit.

The book had been conceived and written during a period of violent political unrest throughout Europe. By then Ruskin was married and with his customary generosity John James had taken a house for the young couple (an extremely eligible address: 31 Park Street, Grosvenor Square). But Ruskin wanted to travel again; in the summer of 1848, before they moved into the new house, he decided to take his young wife on a tour of northern France. The disturbances in France were such that they hesitated about going, but by 11 August they judged that the situation was looking reasonably safe for travellers, and they left for the continent. It was his wife's first journey abroad (she suffered severely from sea-sickness on the crossing). Ruskin devoted the tour to a study of the cathedrals of northern France, using detailed note-taking, sketching, measurements and daguerreotypes (the latter taken by George Hobbs). Most of this work would find its way into *The Seven Lamps of Architecture*.

Ruskin was horrified by the violence in Paris and by the desperation in the other northern French cities.* In October 1848 he wrote to W.H. Harrison describing what he had seen: in Paris 'evidence of distress, degradation and danger, the most utter and immediate' and 'increasing – universal – and hopeless suffering'. He had no sympathy with the republicans: 'The only hope at present is from the common sense views which have at least been forced on the bourgeoisie – who are, as well as the soldiery, thoroughly sick of the republic.'[76]

On his return from France Ruskin settled into the Park Street house

*King Louis-Philippe, who had been brought to the throne by an earlier revolution (the 'July Monarchy' of 1830) had fled France in February 1848, and the Second Republic had established an unprecedented degree of political freedom. But this broke down in June of that year, with savage street-fighting in Paris between the interim government and the workers, and was followed by a constitution which provided for an elected President (Louis-Napoleon Bonaparte, nephew of the Emperor, who from 1852 successfully re-established a hereditary empire and was crowned Napoleon III).

and got to work on *The Seven Lamps of Architecture*. Given the background of international unrest, John James thought that a treatise on architecture would have no audience but he was gratifyingly wrong. On its appearance early in 1849 *The Seven Lamps* established architecture as a moral presence in the life of the average Victorian and, like *Modern Painters*, insisted on 'truth' as the test: a building should clearly look what it was, and should display the purpose for which it was built. The book caused a stir. Ruskin was already a name to conjure with. Charlotte Brontë wrote to Smith, Elder, 'I congratulate you on the approaching publication of Mr. Ruskin's new work. If *The Seven Lamps of Architecture* resemble their predecessor, *Modern Painters*, they will be no lamps at all, but a new constellation, – seven bright stars, for whose rising the reading world ought to be anxiously agape.'[77] The book was widely reviewed – tribute to Ruskin's growing fame – and the *John Bull* compared its method with that of *Modern Painters*: 'the Oxford Graduate . . . treats of architecture in a like spirit, and in a broader, freer, and, if anything, a nobler and more impressive manner . . . its exalted tone is sustained throughout, sounding like a hymn to architectural loveliness'.[78] Though *Blackwood's* and *The Athenaeum* had a go at him again, and there were objections from practising architects in *The Builder*, in general the impact was as pleasing as he and John James could have wished.

As its more sympathetic reviewers saw, the point of *The Seven Lamps of Architecture** was that it firmly related architecture to the moral life of the nation; it argued that 'certain right states of temper and moral feeling were the magic powers by which all good architecture had been produced'.[79]

The Seven Lamps introduces the new political note in Ruskin's writings in that it is about work and the workplace.

> While precious materials may, with a certain profusion and negligence, be employed for the magnificence of what is seldom seen, the work of man

*Ruskin's 'lamps' need not have been restricted to seven. The number is magical and the title, as with most of Ruskin's books, has symbolic force. The lamps are Christian virtues – sacrifice, truth, power, beauty, life, memory and obedience. To find these moral properties in architecture – and the way in which Ruskin finds them – may seem to modern readers too thoroughly bound by the early Victorian evangelical discourse within which Ruskin was working to speak to us very directly about architecture, though the notion that creative endeavour in any art should be expressive of *power* is fully acceptable at the beginning of the twenty-first century.

cannot be carelessly and idly bestowed, without an immediate sense of wrong; as if the strength of the living creature were never intended by its Maker to be sacrificed in vain, though it is well for us sometimes to part with what we esteem precious of substance, as showing that in such service it becomes but dross and dust.[80]

The ways in which work is described can sometimes seem mystical. Under 'The Lamp of Power' we are told that

All building . . . shows man either as gathering or governing; and the secrets of his success are his knowing what to gather, and how to rule. These are the two great intellectual Lamps of Architecture; the one consisting in a just and humble veneration for the works of God upon the earth, and the other in an understanding of the dominion over those works which has been vested in man.[81]

Many of Ruskin's best books were digressions or acts of truancy, and this book on architecture was a holiday from *Modern Painters*. And the period of preparation for it also indicates a shift, intellectually, towards the liberal end of the political spectrum. He wrote to W.H. Harrison from Dunbar:

I am much better since I left London, getting regular exercise and rest. I hope I shall not again fall into the state I was in all this winter, grievous to myself and stupid to everybody. Still there is a certain amount of spleen, or what else it may more justly be called, mingled with my present feeling . . . It is woeful to see these poor fishermen toiling all night and bringing in a few casks of herrings each. . . . How much more enviable the sea-gulls that, all this stormy day, have been tossing themselves off and on the crags and winds like flakes of snow, and screaming with very joy.[82]

Architectural writing was a digression from his writing on painting, but *The Seven Lamps of Architecture* was conceived as a single volume (at that stage he believed that *Modern Painters* would take only one more volume), as *The Stones of Venice* was to be. An important part of his motivation was conservationist. The beautiful northern French cathedral towns were being wrecked by restoration. Of Abbeville, on 9 August 1848, he wrote:

there is not a street without fatal marks of restoration, and in twenty years it is plain that not a vestige of Abbeville, or indeed of any old French town, will be left. How I pity the poor people who must live then; and myself, for I was too young to understand or feel enough of it till now, when it is all going. I got into a café and have been doing my best to draw the Cathedral porch; but alas, it is not so easily done. I

seem born to conceive what I cannot execute, recommend what I cannot obtain, and mourn over what I cannot save.'[83]

His 'lamps' of 'sacrifice', 'truth', etc., were initially to be called 'spirits'. Perhaps he was thinking of architecture constantly surrounded by the activity of angels. In the lamp of 'sacrifice' he argued that wealthy materials must be used in building regardless of whether they were or were not visible – this for the glory of God. In 'The Lamp of Truth' he complained about the use of iron in Gothic buildings and arrived at a principle: 'metals may be used as a *cement*, but not as a *support*'.[84]

In his introduction to *The Seven Lamps of Architecture* Ruskin was conscious that he was writing a political book at a time of political crisis: the Chartist movement in England and revolutions in most of the European capitals in 1848. Architecture was political: to live by contingency rather than by principle in public life was disastrous, and 'What is true of human polity seems to me not less so of the distinctively political art of Architecture. I have long felt convinced of the necessity, in order to its progress, of some determined effort to extricate from the confused mass of partial traditions and dogmata with which it has become encumbered during imperfect or restricted practice, those large principles of right which are applicable to every stage and style of it.'[85] The buildings that he loved had to be recorded because the violence of the late 1840s put the civilisation that sustained them in doubt: 'The aspect of the years that approach us is as solemn as it is full of mystery; and the weight of evil against which we have to contend, is increasing like the letting out of water. It is no time for the idleness of metaphysics, or the entertaining of the arts. The blasphemies of the earth are sounding louder, and its miseries heaped heavier every day.'[86]

Ruskin's sense that this was urgent and important had surely been fed by Carlyle's *Chartism* (1840). There Carlyle said that the disturbances created by the English working class indicated a diseased 'condition of England', and that it was a scandal that the 'reformed' (in 1832) House of Commons had been unable to address this disease. The House in Hansard considered a huge number of questions: 'Surely Honourable Members ought to speak of the Condition-of-England question too.' Carlyle combined huge sympathy with the working class, these 'wild inarticulate souls, struggling there, with inarticulate uproar', with a fundamentally conservative view of institutions and

political processes. The violence of the Chartists frightened and repelled him.[87]*

Beautiful architecture, Ruskin believed, should be present only where the mind was at rest: 'Wherever you can rest, there decorate; where rest is forbidden, so is beauty. You must not mix ornament with business, any more than you may mix play. Work first, and then rest.'[90] It followed that the decoration of railroad stations was a 'strange and evil tendency': 'The whole system of railroad travelling is addressed to people who, being in a hurry, are therefore, for the time being, miserable.' No one with any sense of beauty would ever travel by train: 'It transmutes a man from a traveller into a living parcel.' Stations should be functional: 'Better to bury gold in the embankments, than put it in ornaments on the stations.'[91] Travel in Venice was totally different: 'It was a wise feeling which made the streets of Venice so rich in external ornament, for there is no couch of rest like the gondola.'[92] He went on to be rude about King's College Chapel, Cambridge, because its four pinnacles looked like four legs of a table upside-down and did not conform to any natural form.[93]

A key political phrase occurred in *The Seven Lamps of Architecture*: 'I believe the right question to ask, respecting all ornament, is simply this: Was it done with enjoyment – was the carver happy while he was about it?'[94] Memory is a true lamp of architecture because 'it is in becoming memorial or monumental that a true perfection is attained by civil and domestic buildings'.[95] 'Honourable, proud, peaceful self-possession' accounts for the 'great architecture of old Italy and France. To this day, the interest of their fairest cities depends, not on the isolated richness of palaces, but on the cherished and exquisite decoration of even the smallest tenements of their proud periods.'[96] He went on to praise the 'most elaborate' piece of architecture in Venice, the Palazzo Contarini-Fasan, a small and unimportant dwelling house.

At one level *The Seven Lamps of Architecture* is a repellent work. Its narrowness, anti-Catholicism and dogmatic conviction of its own

*Quite how Ruskin and Carlyle first met is not recorded, but Ruskin probably came to know Carlyle in 1849, the year of the publication of *The Seven Lamps of Architecture*. The older man was to become one of the most loved of all Ruskin's friends, but Ruskin's initial reaction to Carlyle's work had not been auspicious. Of *Heroes and Hero-Worship* Ruskin had asked in 1841: 'What are these Carlyle lectures? People are making a fuss about them, and from what I see in the reviews, they seem absolute bombast.'[88] But George Richmond encouraged him to read *Past and Present* (1843) and this time Ruskin was favourably impressed; in later years he would press the book on his readers.[89] By 1851 the friendship was blossoming; Carlyle was a warm admirer of the first volume of *The Stones of Venice*.

rightness can leave the reader feeling that this young writer was an insufferable prig. At the same time, in its conclusion it looked forward to the centre of Ruskin's political philosophy. The teaching of architecture to students or apprentices should be the imposition of a rigid and exclusive list of permissible styles. Ruskin drew a false analogy with the teaching of Latin in the course of this argument:

> when a boy is first taught to write Latin, an authority is required of him for every expression he uses; as he becomes master of the language he may take a license, and feel his right to do so without any authority, and yet write better Latin than when he borrowed every separate expression. In the same way our architects would have to be taught to write the accepted style. We must first determine what buildings are to be considered Augustan in their authority.

Despite the dogmatism of tone, the proposal becomes weirdly interesting as one thinks about it. Once the grounding in the 'right' principles is in place, the art – Latin or architecture – is free to evolve. 'We might perhaps come to speak Italian instead of Latin, or to speak modern instead of old English.'[97]

The style to be chosen will be restricted (by the free exercise of Ruskin's own prejudices). The choice between Gothic and Classical cannot be conceived 'questionable' when one thinks in terms of the evolution of style from first principles: 'I cannot conceive any architect insane enough to project the vulgarization of Greek architecture' and the kind of Gothic selected must be early rather than late. There are four possible choices: '1. The Pisan Romanesque; 2. The early Gothic of the Western Italian Republics . . . 3. The Venetian Gothic in its purest development; 4. The English earliest decorated. The most natural, perhaps the safest choice, would be of the last, well fenced from chance of again stiffening into the perpendicular.' This kind of Gothic is flexible. And once adopted its constraint would confer, paradoxically, freedom: 'It is impossible for us to conceive, in our present state of doubt and ignorance, the sudden dawn of intelligence and fancy, the rapidly increasing sense of power and facility, and, in its *proper sense*, of Freedom, which such wholesome restraint would instantly cause throughout the whole circle of the arts.'[98] It is always better for builders to erect a cathedral than for engineers to make a tunnel or diamond polishers to create a tiara.[99] All three are work, but only one is the right kind of work. By the right kind of work: 'I do not mean work in the sense of bread, – I mean work in the sense of mental interest.'[100] 'It is not enough to find men absolute subsistence; we

should think of the manner of life which our demands necessitate; and endeavour, as far as may be, to make all our needs such as may, in the supply of them, raise, as well as feed, the poor. It is far better to give work which is above the men, than to educate the men to be above the work.'[101]

*

In 1827 George Gray, a rising young lawyer, had bought Bowerswell House, Perth, the house that had belonged to Ruskin's ill-fated grandfather, John Thomas. George Gray's oldest child, Euphemia Chalmers Gray (Effie), had been born (in the same room in which John Thomas Ruskin had cut his throat) on 27 May 1828. Effie's parents were old friends of John Ruskin's parents, partly because John James Ruskin's sister, Jessie, was married to a Perth man and therefore lived close to Bowerswell (until her early death in 1828). John James Ruskin and Margaret Ruskin both had a certain horror of Bowerswell House itself, because of John Thomas's suicide there in 1817, and Margaret, in particular, refused ever to set foot in it. But the Grays regularly visited the Ruskins in London. And it was in this way, as a family friend, that Effie had become known to John Ruskin.

She was a bright, talented child with a particular aptitude for music and languages, the oldest of a large and, in its early years, happy family. At the age of twelve she was sent to school in Stratford upon Avon and in August stayed for a few days at 28 Herne Hill with the Ruskins. She came for a longer stay in 1841 (the year of *The King of the Golden River*) but this visit was tragically cut short when her three little sisters died of scarlet fever within a week of each other in June and she went back to Perth early to be a comfort to her parents.* These family tragedies interrupted Effie's schooling, but during her brief periods at Stratford she won prizes for French and history, was an excellent singer and an accomplished young pianist. Part of the reason for sending her to school in England was social; the intention was that Effie was to lose her Scottish accent, but in fact she retained it to the end of her life. (Despite being born and brought up in London John Ruskin, also, had from his parents a slight Scottish accent.)

In October 1846 Effie again came to stay with the Ruskins, this time

*Two younger brothers survived. One of those was to die in 1844 but the Grays thereafter had six more children.

in the large house at Denmark Hill, and it was during this period that Ruskin fell in love with her. The older Ruskins did not think her a suitable match, and John James Ruskin pressed his son instead to pursue Charlotte Lockhart, Sir Walter Scott's granddaughter (her father was Scott's biographer).

Effie fully understood that Ruskin was being propelled by his father into an ostensible courtship of Miss Lockhart on the basis of very slight acquaintance and no mutual feeling. She wrote to her mother on 14 May 1847:

> if he [John] marry the young Lady it is from prudence and a false notion of duty; he had only seen the young Lady six times at parties in his whole life and does not love her a bit, but believes they have each qualities to make the other happy were they married. Did you ever hear such philosophy? I think Mr and Mrs R are doing very wrong, at least they are wishing for their son's happiness and going the wrong way to work. He adores them and will sacrifice himself for them, as I see, too easily. Private![102]

Ruskin himself wrote of this odd episode in *Praeterita*. With the success of *Modern Painters*, I and II, he was becoming known in literary circles, and Lockhart, Charlotte's father, then editor of *The Quarterly Review*, invited him to review Lord Lindsay's *Sketches of the History of Christian Art* for the periodical. Ruskin says that his feelings for Charlotte Lockhart prompted him to accept this invitation. He recalls Charlotte as 'a Scottish fairy, White Lady, and witch of the fatallest sort, looking as if she had just risen out of the stream in Rhymer's Glen'. But Charlotte was unattainable: 'I never could contrive to come to any serious speech with her; and at last, with my usual wisdom in such matters, went away into Cumberland to recommend myself to her by writing a *Quarterly* review.'[103]

When he discovered that he was mistaken about Charlotte Lockhart and that his son appeared to love Effie, John James wrote to him an astonishingly crude letter:[104]

> I have only time to thank you briefly for your very long kind letter to your Mother which I read to her & for your line to me. In regard to E.G. you have taken more objection out of my manner than I had in my mind. be sure of this that all *hesitation or pause* on my part is for fear of you. Vanity does mingle a little – but mortification I should have had double in the L[ockhart] union I always knew this – but we had kept you to ourselves till Marriage & I expected you might marry rather high from opportunities given & that then we must give you – up – never with E.G.

I gain much – I escape also from painful communication even for a short time with people out of my sphere. As for the opinion of J. Richmond & Acland I think E.G. superior to Mrs R[ichmond], Mrs A[cland], & for all I know to the two Mrs Liddells – but for you I fear a little worldly trouble of affairs & I dread any future discourse of what you seem to fear – motives of ambition more than Love – or of tutored affection or semblance of it though I only do so from the knowledge of the desirableness of the union to the Father not as you do from supposing you not lovable I reckon there are not Mr Dales number 74 but 174 in love with you at this date 2 Sept 1847 – I cannot deliberate in an hour but in a moment I say – go on with E.G. but not precipitately – If her *health* is good & she suffers little watch her but do not *show* her for 6 or 12 months – I do not ask you to do this if you prefer marrying at once but as I want you to stand well with Lockhart & the Intellectuals I should be sorry to let him fancy that your affections were not at all concerned in your proposals to his Child – as to your fears & opinions of wedded life – the unhappiness is generally in the Individual – the Ladies only draw out a temper which exists – make their husbands show their paces. A man cannot be very unhappy that in the greatest difference with a wife never for a moment wished himself unmarried.[105]

And on 5 September John James Ruskin wrote again: 'I beg you will make yourself easy & do anything you feel would most conduce to your own felicity – sooner or later regard[ing] yourself more than Mama or me who can never be satisfied but by seeing you happy.'[106]

Ruskin became engaged to Effie at the end of October 1847. John James and George Gray, Effie's lawyer father, arrived at a financial agreement over the marriage: a draft of settlement was exchanged between them. Effie's father was a professional man, while John James was in trade, and in a sense the social balance was in George Gray's favour, but he had lost a great deal of money through railway speculations: John James could thus feel, temporarily, that he securely held the upper hand in any power struggle that might develop with the family into which his son was marrying.

Ruskin's letters to Effie herself at the time of their engagement make painful reading. The tone is that of a lover but the content is that of a controlling parent. On 11 November 1847 he wrote planning a European tour which was to comprise himself and Effie *and* his parents, and he passed on bossy messages from his mother about clothes:

It may be as well to remind you – that any dresses you may be buying for next year, had better be of the plainest kind – for travelling – of stuffs that

will not crush – nor spoil, nor be bulky in a carriage – for you know we shall be *four* – and very simply made – you will only want one of any more visible or exhibitable kind – in case we might go to opera at Paris – or be seen a day or two here [Denmark Hill] before leaving. You may guess there is no *dressing* at Chamouni – the higher the rank commonly the plainer the dress – and it would be no use to leave handsome dresses behind you here, merely to find them out of fashion when you come back.

And so on.

The marriage was planned to take place outside Lent in deference to Ruskinian family observance – and on 23 February Ruskin sent Effie a letter in which he again treated her with extraordinary bossiness, as though she were a small child. To keep herself in a 'tranquil and healthful state of mind' before the wedding her 'best conduct would have been a return – as far as might be – to a schoolgirl's life – of early hours – regular exercise – childish recreation – and mental labour of a *dull* and *unexciting* character'. He reminded her that he had told her to study 'French, Italian and Botany' and she had failed to do this.[107]

They married at Effie's parental home, Bowerswell,* near Perth, on 10 April 1848.

In the winter of 1848 Ruskin finished *The Seven Lamps of Architecture*, and in 1849 he took another European tour *again with his parents*. Effie was left behind with her parents in Scotland. She was unwell and 'not this year able for Swiss excursions' as John James put it in a letter to Effie's father.

Ruskin set out with his parents and George Hobbs. He was joined by his old schoolfriend Richard Fall; and Ruskin, Fall and George Hobbs went walking and observing the rocks in Chamonix in May while the older Ruskins stayed at Vevey.

It is hard to fathom what was going on in Ruskin's mind. Was he, literally, walking away from his marriage? It seems that he was already demonising Effie by deciding that she was insane. On 5 July 1849 he wrote to George Gray, his father-in-law:

> Having heard the late correspondence between you and my father I think it well that you should know from myself my feelings respecting Effie's illness as this knowledge may more straitly direct your influence over her.

*The old Bowerswell, John Thomas Ruskin's house, had been replaced in the 1840s by a more modern building with gaslight and amenities. Even so, because of the horrible family associations that the place had for them John James and Margaret would not come to the wedding.

I have no fault to find with her; if I had it would not be to her father that I should complain: I am simply sorry for the suffering that she has undergone and desirous that you should understand in what way your advice may prevent its recurrence. If she had not been seriously ill I *should* have had fault to find with her: but the state of her feelings I ascribe, now, simply to bodily weakness; that is to say – and this is a serious and distressing admission – to a nervous disease affecting the brain.

Among the symptoms of this nervous disease cited by Ruskin was 'causeless petulance towards my mother', followed by 'depression', fits of weeping, and so on.[108]

To the onlooker it seems obvious that Effie was waking up to the fact that she was married to a man who took no emotional interest in her, who was determined to dominate her and who in turn was dominated by his parents.

It would be easy to see the Ruskin parents as wholly at fault, but they were baffled and angered by the fact that his marriage brought him distress rather than well-being. John James, always ruthlessly honest, wrote to George Gray about his disappointment in Effie:

Was it likely that we should feel otherwise than hurt at seeing a creature who came to us so readily and, as often as we asked her, professing considerable attachment to us and appearing happy with us, at once change on becoming our daughter-in-law.

He pleaded with George Gray to prevent Effie's separating Ruskin from his mother:

I knew John's attachment was unshaken, but he had firmness of character enough not to become the altered man towards his parents which it was sought to make him – towards that mother especially to whom, under God, he was all that he now or ever will be. I know Effie's power and acknowledge her talents. My son may with her become a more social being, better man of the world, and with all I trust a very happy man, but with all deference to Effie and to all she can ever bring about my son, I feel that he may lose as much as he may gain by his total withdrawal, if it shall prove so, from maternal influence and authority.

John James went on to say that Ruskin owed his genius and the quality of his teaching to his mother. We may be sure that John James meant all this, that he was expressing deep feelings in his possessive love for his son, and that he was simply unable to see the situation from a 'normal' perspective.[109]

*

In October 1849, Ruskin, Effie and a friend called Charlotte Ker (taken along as a chaperone for Effie) left for Venice. John James had – as always – come up with the money; he financed the trip as well as maintaining the house that he had provided for Effie and Ruskin in London. The party arrived at Venice in mid-November and stayed in the Danieli hotel until early March 1850. Ruskin worked on his study of Venice for *The Stones of Venice*, Effie socialised and partied.

Ruskin's diaries of 1849–50 show, as one would expect, two sharply contrasting sets of interests. On his bachelor walking tour with George Hobbs and Richard Fall he had recorded the natural world, in Venice he recorded buildings. Both read like displacement activities: obsessive engagements with anything that is not an emotionally demanding human being.

In Venice he had the troubling companionship of a beautiful young wife for whom he was unable to feel any sexual desire. The city itself became the object of his displaced sexual drive. At the same time, the trip was an enjoyable experience for Ruskin and gave huge stimulus to his work on architecture.

Effie also enjoyed the stay in Venice. She was free from the Ruskin parents; infected by her husband's love of the place, she went visiting all the sights with Charlotte Ker. Effie was intelligent and resourceful, and no doubt she was doing her best to strengthen the marriage by learning as much about her husband's interests as she could. As a great beauty married to a famous man she was much fêted. Ruskin was at work all day, either in the hotel or out measuring and drawing the buildings, and Effie made many friends. In December she wrote to her parents in terms which make it clear that she had real hope that the Venice trip would improve the marriage.

> I daresay now his [Ruskin's] health is better he will also feel more amiable and as I, too, am stronger I hope we shall be better friends. For all I care his parents may have John as much with them as they please for I could hardly see less of him than I do at present with his work, and I think it is much better if we follow our different occupations and never interfere with one another and are always happy, but I shall take care to let them be as little as possible together [after the couple's return home to England] for they had far too much time for grumbling about nothing before.[110]

If Ruskin had been able to be kind to Effie the marriage might have been saved.

The season in Venice was at the initiative of Effie,* who had suggested that full work on *The Stones of Venice* required Ruskin to make further visits to the city.

November 1849 was a strange time for English visitors to stay in Venice because the city had been bombarded by the Austrians in the previous year and was in a low state. Many of the Venetians were desperate, indeed starving. The best Italian families had left during the bombardment, and there were very few English. On the other hand, it was cheap. Effie was a beautiful, wealthy, intelligent young woman with a passionate interest in society. The society available was mostly Austrian officers billeted in the city. Effie was only twenty-one and her letters to her mother show that she was aware that her conduct with these young men might cause talk, but she was always careful. Her family was anxious but given that Venice was a city of pleasure and sexual licence Effie's flirtations seem relatively innocent. The subtext of her behaviour, of course, was that Ruskin had not consummated the marriage. On the surface he gave it out that he was hugely busy and that if she was occupied with agreeable young male friends he had no objection.

The friend who meant most to her was a young Austrian officer called Charles Paulizza, first lieutenant of the cavalry with the Austrian army of occupation. The circumstances in which Effie met him are unclear, but they soon became very close. Effie was clever at languages, she spoke German (Ruskin did not) and had made rapid strides in Italian. Her conversations with Paulizza were in German. Her letters home describe his physical beauty, his long moustaches with his very white teeth glinting between them as he talked, his beautiful eyes, his great intelligence and accomplishments, his courage and daring as a soldier. It was Paulizza who had devised the balloon-borne bombs that had done considerable damage to the fabric of Venice. (These bombs were not without hazard to their creator: an adverse wind caused a number of them to blow on to an island held by Paulizza himself and his men.) Effie wrote to her father:

> John took to him directly from his exquisite drawings, many of them engineering ones, plans of attack and plans of the Lagoons so finely finished that John, who you know is a first rate judge, was perfectly surprized with their delicacy and style, and he is very useful to John in getting him into Barracks & Guardrooms &c of Palaces which before

*She also supported the second season in Venice, from 1851 to 1852.

were closed to him. He is a very brave man & was decorated by the Emperor with two crosses. He is besides a Poet, plays on the Piano, speaks five or six Languages, etches on steel . . . he is very fair, a very fine clear complexion & eyes without being effeminate and although 38, he looks not much above thirty. Charlotte [Ker] and I agree that he is the handsomest man in Venice & his grey military cloak lined with scarlet which bye the bye the Officers here do not wear but hang it upon them in a very becoming manner over the rest of their uniform, sets off his fine figure to great advantage.[111]

Effie could be so innocently open about her feelings because she was very young, completely without sexual experience and as yet devoted to her husband. Whether Paulizza saw her as sexually available is anybody's guess. Certainly, he missed no opportunity to be with Effie. Her illness enabled him to touch her and to offer amateur medical treatment which she had the good sense to resist. Effie wrote to her brother in January 1850 describing Paulizza as her 'second doctor' (the first being a Dominican friar). Paulizza 'takes a spoon in a scientific way, examines my throat and feels my pulse at the hand which he says is steady enough but he pointed out to John that the pulse just under the ear told a different story'. He wanted to put leeches on Effie. 'I thought surely my ears had deceived me but now I am astonished at nothing foreigners do, for their life & education is so different from ours . . . John & I could hardly help smiling when we looked at our handsome friend with his long curling moustaches and striking dress, and I thought of the horror such a request would be listened to in our country.'[112] Effie's brother George was indignant about this and she had to send another letter, to her mother, assuring her family that everything she did was with her husband's knowledge and approval, and that the young foreign men were not being allowed too much familiarity: 'I assure you that John and I had more than one good laugh at his [her brother George's] anger at the Austrian, and John declared he would not be George's wife when he got one for something if he was so jealous as to be terrified to trust her in other people's society.'[113]

Paulizza professed that he loved and admired Ruskin as much as he loved Effie: he wanted to be like Ruskin and felt that he could have had a similar career had he not been one of the ten sons of a poor man. His story ends sadly. A wound to the head caused him long-term difficulty. During his friendship with Effie he kept complaining of headache and poor eyesight, and, while John and Effie were back in England in

1850–1, he died; he was totally blind some weeks before his death. The Ruskins did not hear of his death until they arrived in Venice for their second joint visit in September 1851.

Another of Effie's admirers was Prince Alexander Troubetzkoi, a retired colonel of the Russian Guards and now in the Austrian army. He had bought the Ca' d'Oro for his mistress, a dancer called Taglioni. Effie remarked that this liaison seemed accepted in Venice: 'The people here when they call on Taglioni always leave a card for Prince Troubetzkoi . . . that is the way people here often live and their constancy to one another is truly surprizing.'[114] On 9 February she wrote to her mother about a ball on the 6th where Paulizza was 'very angry . . . with Prince Troubetzkoi who promised to let him twice have a turn with me in the waltz, and danced the whole time although Paulizza was waiting and never told me'.[115] Back in London in July 1850 Effie had formed a different view of Troubetzkoi, because of gossip that she had heard about him. He called on her in July and invited her to a ball, but she resisted. She spoke of him as 'a bad man as ever I knew' and 'he is to Paulizza what a coal is to a diamond'. On her second visit to Venice, she wrote to her mother: 'nobody . . . do I hear of bad character but Prince Troubetzkoi'.[116]

The friend to whom she wrote about Troubetzkoi in July 1850, Rawdon Lubbock Brown,* was one of the most devoted of the Ruskins' English friends in Venice. (It is a tribute to him that he remained friends with both Effie and Ruskin after their marriage had been dissolved.) Brown was a bachelor, a single-minded private scholar who devoted his life to Venetian history. He edited the despatches of Sebastian Guistinian who had been Venetian ambassador to the court of Henry VIII from 1515 to 1519. This work was published by Ruskin's publisher, Smith, Elder, in 1854. Effie helped Brown to correct it and see it through the press.

The Cheneys, wealthy English brothers who had taken a palace in Venice, were also friends, though Edward Cheney wrote to his friend Lord Holland, in August 1851, remarking on the strangeness of the Ruskin marriage and expressing a surprising degree of contempt for Ruskin:

Mrs Ruskin is a very pretty woman and is a good deal neglected by her husband, not for other women but for what he calls literature. I am

*Brown never held an official position and was often hard up, but he was later (1862) commissioned by Lord Palmerston to calendar the Venetian state papers that had a bearing on English affairs and this provided him with a salary.[117]

willing to suppose he has more talent than I give him credit for – indeed he could not well have less – but I cannot see that he has either talent or knowledge and I am surprised that he should have succeeded in forming the sort of reputation that he has acquired.[118]

Effie, however, wrote on 24 February 1850:

I never could love anybody else in the world but John and the way these Italian women go on is so perfectly disgusting to me that it even removes from me any desire to coquetry which John declares I possess very highly, but he thinks it charming, so do not I. I tell him every word Paulizza says to me and tell the latter so too, so that they perfectly understand each other and after me I think Paulizza likes John better than any one else here.[119]

And when they had to take leave of Paulizza she again stressed his affection for her husband. It was a startlingly emotional scene, as she described it from Verona, on 9 March 1850: 'He seized John in his arms and kissed him over both sides of his face and Lamented our departure bitterly in Italian. John went away and his distress with me was so great that I was almost thankful when he was gone. I could not help crying when I saw this strong man so overwhelmed with grief.'[120]

Effie kept up a brave front about her marriage, but she did make it clear that John was simply not available to her in Venice because he spent all his time working and hated the social life that Effie enjoyed: 'John is very busy at his drawings and books, writing beautiful descriptions and very poetical – he goes out after Breakfast and I never see him till dinner time.'[121] John's complete dependence on his parents grated, but Effie made allowances for him.

In December 1851 John had written about his wife to his parents, who for their part were angry with Effie and welcomed any sign their son showed of subduing his wife's spirits. This letter demonstrated how completely his loyalty to his parents superseded any that he may have felt towards his wife. The Ruskin parents canvassed the notion that John and Effie might move closer to Denmark Hill on their return to England. They also – clearly – still imagined that Ruskin might become a clergyman, as though the writing of some of the most important books on art and architecture to be published in the nineteenth century were not in any sense a career. Ruskin replied: 'I cannot settle my mind, because I always feel that though I am not fit to be a clergyman, it is my own fault that I am not: i.e. though I don't love people, and am made

ill by being disturbed, and am over excited in discussion and so on – I ought to love people more.'

He had no sense of fixed personal relations and no sense of a fixed abode: 'every house I live in can only be looked upon as *lodgings* – and this is bad for Effie', 'for a man who has no attachments to living things . . . leaves him very anchorless indeed'. Presumably Effie is included among the 'living things' to which he has no attachment. Having thus made clear – to his parents' satisfaction – that Effie is no threat, he then gives his own chilling view of their future living arrangements:

I believe the *proper* thing would be for me and Effie to live at Denmark Hill as long as you stay there – while I am working on my two books – only I am afraid Effie would succeed in making my mother and you both so uncomfortable – if she chose – that you could not bear it.

He then suggests ways in which they could control and discipline his wife: 'If you and my mother could treat Effie with perfect coolness – if she was late for dinner, let her have it cold – without comment or care – and if she chose to be out late at night – let her own maid sit up for her.' The bullying goes on:

Her duty is not determinable by an established law – and probably the world is nearly equally divided in its opinion respecting us – one half of it blaming *me* for neglecting *her* – the other half blaming *her* for neglecting *you*. Then in the second place, we are always too little disposed to allow for different nature and education. It may literally be as impossible for Effie to *live solitary* without injury, as for me to *go into company* without injury . . . I am always either kind or indifferent to Effie – I never scold – simply take *my own way* and let her have hers – love her, as it is easy to do – and never vex myself – If she did anything definitely wrong – gambled – or spent money – or lost her character – it would be another affair – but as she is very good and prudent in her general conduct – the only way is to let her do as she likes – so long as she does not interfere with *me*: and that, she has long ago learned – won't do.[122]

Effie got wind of the plans being made for her and wrote indignantly to her own parents:

These Ruskins are what the French would denominate 'des gens impossible' . . . both he & Mrs R send the most affectionate messages to me and all the time write *at* or *against* me and speak of the hollowness of worldly society and the extravagance of living in large houses and seeing great people, all of which is perfectly true if it applied in the least to us, which it does not. . . . They always put themselves in the position of the injured party who give up everything to please us, or rather *me*,

and then they have got so much power over John by touching his feelings. . . . John said he *never intended as long as they lived to consult me* on any subject of importance as he owed it to them to follow their commands implicitly.

After this absolutely damning observation about her husband Effie felt the need to defend him: 'He is, like all men of genius, very peculiar but he is very good and considerate in little things and I think for my own peace of mind the best thing is to let them all take their own way and I try to be as happy as I can.' And at least Venice had its consolations: 'Everybody is fond of me and pets me; I am the Belle at all the Balls and the people respect me for being virtuous and occupied.'[123]

The Protestant practice of self-examination and his parents' habit of fussing over his health contributed to the self-involvement that characterised some of Ruskin's letters to his father. On 23 November 1851 he wrote that the 'bad taste' in his mouth was probably unimportant and that the 'nervousness and quickness of pulse' were both better. He contrived indirectly to blame these symptoms on Effie's social life ('merely the consequence of being so often up till past midnight last season') and to come up with an idiosyncratic medical theory: 'It seems to be a fixed law that the time taken in recovering from mischief, shall be, *at the least* equal to the time taken in doing it. . . . So as I had been sitting up late – &c. – for six months – I do not expect to be quite right again until six months from the time I came here,' but now said that he had 'perfect quiet', with the suggestion that Effie had mended her ways and was no longer subjecting him to the tyranny of a social life: 'Effie did not even ask me to [go] to the great fete of the Salute with her, when they made a bridge over the grand canal. I staid at home writing – she went with Lady Sorel and was very uncomfortable all the time in the crowd.' The old Ruskins would have liked that contrast – studious son safely in his room writing while his feckless wife exposed herself to discomfort – and they would have enjoyed even more Ruskin's full account of his health written in his birthday letter of 8 February 1852: 'I have two things to watch – my stomach and my circulation – neither of which are so well as they were in 1844.' Finishing *Modern Painters*, II, was 'the greatest exertion of thought I ever made – The last sheet of it was written at Calais, and I had then a general feeling of weight all over the head – and the veins swelled in the left temple – and my eyesight dim.' Anxiety about his eyesight is a recurrent theme. His 'floaters' became a 'black serpent' in the left eye.

Completion of work on the proofs of *Modern Painters*, II, exacerbated the 'despondency and prostration'.

Acland said of him that he had been 'Dreadfully overworked' and prescribed prussic acid (dilute prussic acid had been used since the 1830s as a sedative and a treatment for chest congestion).

Ruskin continued the narrative of his recent life, saying that in Venice 'I could not help working against time for the five months'. He was taking care of himself because of his terror of 'paralysis' and 'disease of the heart'. The letter went on, in the voice of a mature man who has no privacy, no boundaries and no dignity when confronted by his parents' demands for information: 'The bowels are exceedingly regular, the headaches being generally the sign of looseness with burning rather than of confinement. . . . I am certainly better than when I came to Venice – but of course – still obliged to be watchful – avoiding all over labour and excitement, and I have no doubt all will come right with time and peace, and no more society.'[124]

Did his father see that his relationship with his son was over-possessive and inappropriate? It is possible. Ruskin writes on 11 February: 'I assure you there is no fear of my accusing either you or my mother of taking too much care of me – I always take very good care of myself, and know it to be necessary.'[125]

It is good to recall that this self-regarding semi-invalid was also a hugely productive man of genius. Many of his letters to his father reveal a great deal about Ruskin's mind and his methods of work during this period. Early in the visit of 1851 he sees a kind of inevitability in the notion that Venice is the centre of the world, in consequence of profound natural forces:

> I am almost disposed to admit a sort of special providence for Venice. The tide at this end of the Adriatic is a mystery no philosopher has explained. The structure of the mouths of the Brenta and Adige is unexampled in the history of Geology. It seems that – just in the centre of Europe, and at the point where the influences of East and West – of the old and new world – were to meet, preparation was made for the existence of the city which was to unite the energy of the one with the splendour of the other: and the Sea, which in other countries is an Enemy as well as a Servant – and must be fought with to be enslaved – or else – as to us in England is a severe Tutor as well as protector – was ordered to minister to Venice like a gentle nurse – and to nourish her power without fretting her peace – to bear her ships – with the strength of our English seas – but to surround her palaces with the quietness of the Arabian sands.[126]

The lagoon was shallower than it is now, at low tide sometimes exposing the beds of the canals on which the palaces stand, yet the city was already subject to the high tides which have threatened it in the late twentieth century. The 'acqua alta' was a source of delight to Ruskin: 'in all over our courtyard – and over the great part of St. Mark's place – and nothing could be more exquisite than the appearance of the church from the other end, with the reflection of its innumerable pillars white and dark green and purple, thrown down far over the square in bright bars, fading away in confused arrows of colour – with here and there a touch of blue and gold from the mosaics'.[127]

There was some tension between Ruskin and his father because John James saw *Modern Painters* as the great work, and *The Stones of Venice* as an interruption of it. In an attempt to get John back to the central topic of *Modern Painters* John James suggested that he should write a biography of Turner (a reasonable suggestion, given that Turner had died in 1851 and Ruskin was now one of his executors). Ruskin responded on 5 January 1852: 'I have been thinking about writing Turner's life, but have nearly made up my mind to let it alone, merely working in such bits of it as please me in *Modern Painters*. Biography is not in my way. Besides I should be too long about it.'[128] His thoughts were much on Turner:

> I have been reading *Paradise Regained* lately. It seems to me an exact parallel to Turner's latest pictures – the mind failing altogether – but with irregular intervals and returns of power – exquisite momentary passages and lines,
>
> > 'To warm him wet returned from field at eve . . .
> > He added not – and Satan – *bowing low*
> > *His gray dissimulation*, disappeared.'

Milton's 'gray dissimulation' describes a Turner seascape, and his account of a temple describes St Mark's:

> And higher yet the glorious temple reared
> Her pile, far off appearing, like a mount
> Of Alabaster, topt with golden spires.[129]

The work in Venice was not an interruption of the great book, *Modern Painters*, but a continuation of it and a contribution to it. Ruskin defended all his visits to Venice on the grounds that he had learnt a great deal, not only about architecture, for his architectural books, but *about painting*:

The sketches I made when here with you, in May, 1846, are now so worthless in my eyes that I would give them all for a single walk with you in the piazzetta. . . . It is therefore the knowledge that I have gained to which I ought to look as the true result of these years' labour: and I am only apt to be discontented because I forget – in the feeling how little I know now, how much less I knew in 1842. When I wrote the first volume of *Modern Painters* I only understood about *one third* of my subject: and one third, especially of the merits of Turner . . . I knew *nothing* of the great Venetian colourists – nothing of the old religious painters – admired only, in my heart, Rubens, Rembrandt, and Turner's gaudiest effects: my admiration being rendered however right as far as it went – by my intense love of nature.

It was Venice, he reminded his father, that made *Modern Painters*, II, the success that it was: the overwork that involved 'studying Tintoret and architecture at once' (in 1845) was essential because it gave 'an entirely new perception of the meaning of the word *colour*. . . . This change, or advance, rather than change, in all my views was like being thrown into a great sea to me. I wrote 2nd volume of *Modern Painters* in the first astonishment of it. I then perceived a thousand things that I wanted to know before I could write any more.' The European tour of the summer of 1848 stimulated the interest in architecture 'and the *Seven Lamps* and *Stones of Venice* were the result. The materials collected in 1849, in Switzerland, are of immense value to me – the fruit of 1846–7 – and – 9 is all, I hope, to come in second [he means third] volume of *Modern Painters*. The architectural works have been merely bye play – this *The Stones of Venice* being a much more serious one than I anticipated.'

He was defending himself from two charges – of neglecting *Modern Painters* and of wasting his time. He added in many other letters, though not here, that the architectural work of retrieval was urgent – taking sketches, daguerreotypes and measurements of the buildings that he had learnt to love, before they were ruined by restoration. The process had been one of radical education, enabling him to see clearly the quality of great contemporary painters such as Millais. One further consequence of *that*, a consequence which Ruskin clearly saw as inevitable – and his father saw as regrettable – was that his work was losing its popular appeal: 'It has cost me 7 years' labour to be able to enjoy Millais thoroughly. I am just those seven years' labour farther in advance of the mob than I was, and my voice cannot be heard back to them. . . . I see a hand they cannot see; and they cannot be expected to believe or follow me: And the more justly I judge, the less I shall be

attended to.'[130] This is irresistible: Ruskin speaks here with justifiable pride and authority.

John James Ruskin was seriously worried by the likely lack of popularity of *The Stones of Venice*, and Ruskin came to the defence of his present book vigorously again in a letter of 18 February 1852:

> I am sorry you are not at all interested in my antiquarianism – but I believe you will like the book better when you see it finished – at all events, it would be foolish to abandon the labour of two whole years, now that it is just approaching completion. I cannot write anything but what is *in* me and interests me. I never could write for the public – I never *have* written except under the conviction of a thing's being important, wholly irrespective of the public's thinking so too – and all my power, such as it is, would be lost the moment I tried to catch people by fine writing. You know I promised them no Romance – I promised them Stones.[131]

His father's challenge was good for him because it forced him to think about the relationship between his projects. In a celebrated letter of 22 February 1852 he directly linked the decline of Gothic into Renaissance architecture with the centrality of nature in Romantic literature and in Turner's paintings, so that far from being a departure from *Modern Painters*, *The Stones of Venice* became an introduction to the conclusion of the larger work:

> The reason that I have added [his account of Renaissance architecture in *The Stones of Venice*] . . . is chiefly because I see a very interesting connection between it and *Modern Painters*: The first part of this book will give an account of the effect of Christianity in colouring and spiritualizing Roman or Heathen architecture. The second and third parts will give an account of the Transition to Gothic, with a definition of the nature and essence of the Gothic style. The fourth part of the decline of all this back into Heathenism: and of the reactionary symptoms attending the course of the relapse of which the strongest has been the development of landscape painting: For as long as the Gothic and other fine architectures existed, the love of Nature, which was an essential and peculiar feature of Christianity, found expression and food enough in them . . . but when Heathen architecture came back, this love of nature, still happily existing in some minds, could find no more food there – it turned to landscape painting and has worked gradually up into Turner. The last part of this book therefore will be an introduction to the last of *Modern Painters*.[132]

Any account of these years must, in justice to John James Ruskin,

acknowledge his huge generosity to the young people. He set them up in a London home (Park Street in 1848 and Herne Hill in 1852), met all their financial needs, paid for the trips to Venice and all the other pleasures that they enjoyed. He continued to act as Ruskin's literary agent. But in return he assumed the right to complain, at length and in detail, about his son's way of life. He wrote on 29 August 1851:

Going from London to Venice is passing from one dissipation to another & I fear your taking up House will merely make it a Venice Season as a London one – a perpetual Crowd – You are quite fashionable too in going abroad in Debt – I will not trouble you till you ask – with particulars but I see £800 against you beside all the £1680 – recd for Literary Labour gone in 3½ years beside £300 from me & £300 paid by me for House & wine & many things furnished. This shows you the Expence of *Night* work over day work – I grudge you nothing – but it is a moderate sum only that Day pleasures & wholesome Happy pursuits require – & I allude to the subject matter to put you on your guard as to Launching out at Venice with no rational end or good to yourself. You spoke of turning over a New Leaf which brought me to the subject – Your Expenditure is £1670 in place of £1170 & annum. Mamma & I were at Park St. & glad we are you are out of it. What a height of Stair & what holes on the 4th Story. If you are ever committed to Newgate you will have a better Dressing Room & in such a place the money to go so fast!!! . . . I write against the Dissipations of both London & Venice as the Destroyers of your Repose & weakeners of those powers which are given for no ordinary purpose & which require protection & studying how best to invigorate, not dissipate.

The idea that the young Ruskins' social life was damaging his son's work continued to haunt John James. He wrote on 12 September 1851:

I trust the crowd of tourists, Officers & artists that you will be in all the Winter, will not scatter your Ideas – nor interrupt your Work & that you will really be enabled to deliver your Message fully & to give the world the story which Venice & Verona tell to your privileged Ear & Eye – it would be lamentable indeed to have the thoughts lost, the mind distracted & the hand hindered – by the mere frivolity of a place – the only mind & hand perhaps existing, capable of giving utterance & expression to the spirit past & present of Venice or of Italy. Pardon my anxieties – I will not call them fears for I have more and more trust in your firmness. We are just beginning your 2nd Volume which reads finer than ever.[133]

In relation to his son's marriage, and despite his material generosity, John James Ruskin was doomed always to appear inept and tactless, as when he initially opposed the relationship with Effie because he hoped

Ruskin would make a socially advantageous marriage to Charlotte Lockhart. Whereas such a marriage would have taken Ruskin beyond his own social range, the marriage to Effie was a social disappointment. In 1849 John James wrote about the Gray family as though they were grasping inferiors (8 August, from Geneva):

> I am sorry they don't think about your employment – I told Mrs Gray you would be out of your Place quite sauntering about George Street – but she looks at one duty – I at another – Your Mama and I were ready so far to put you from us as to get you into the Society fitted to you & my difference with these Perth people is that they are not satisfied to do so &, totally blind to their own wants, they expect to make you one of them, to exhibit you among their set & seem beside to set no value on the Intellectual or Wellborn people, unless in the Scotch way they can use you & Effie as a ladder by which to mount up into it themselves – They are right only in wishing you to be more with their Daughter – you must remember that we are as much in Effie's way as her Father & Mother are in yours. . . . I admitted to Mrs Gray that perhaps it was wrong – in each of you going where the other could not come – I wish Effie would scamper over Hills as some Ladies do.[134]

At every stage of John's courtship of Effie and throughout their marriage John James displayed rough tactlessness and desperate love for his son in equal measure. He continued to worry frantically about John's health: 'carrying on these notes with the new & exciting work of gathering material for the Stones of Venice may hurt your Brain & health. You better know you strength now & I must trust to your not letting the Fascinations of Venice (which will not die this year or for many to young people) draw you into a double task & an accumulation of Labour dangerously heavy.' He was also not above transparent emotional blackmail: 'Think of it, both of you, & Take your own way. Mamma & I can bear any privation that your Happiness or you fame impose upon us. So set that consideration aside.' But there is something touching about the way he tried to bury his doubts and express confidence in his son's gifts: 'So I beg of you to go where you Health & your work or pursuits lead you – If you are well & able to do for Venice what I think you will I may say Go where Glory waits thee.'[135]

The one thing that was consistent about John James's letters to Ruskin was his desire to promote Ruskin's *work*, even when the work was moving in directions that John James found it hard to understand. And Ruskin was responding to his doubts, as well as his trust, when he writes triumphantly:

I am getting my chapters and drawings all packed up, so as to have my last days here quite free. And the turning of my mind to another subject is very useful for a day or two – for in working on the details of my book, I was beginning to lose sight of its general plan and pursuing stray game too far, here and there – the leaving it off a little is like going back to see the effect of a picture: and I see what I ought to leave out, or slur over: The fact is the whole book will be a kind of great 'moral of the Ducal palace of Venice'.[136]

CHAPTER 4

1851–5

Beyond those troops of ordered arches there rises a vision out of the earth, and all the great square seems to have opened from it in a kind of awe, that we may see it far away; – a multitude of pillars and white domes, clustered into a long low pyramid of coloured light; a treasure-heap, it seems, partly of gold, and partly of opal and mother-of-pearl, hollowed beneath into five great vaulted porches, ceiled with fair mosaic, and beset with sculpture of alabaster, clear as amber and delicate as ivory, – sculpture fantastic and involved, of palm leaves and lilies, and grapes and pomegranates, and birds clinging and fluttering among the branches, all twined together into an endless network of buds and plumes; and in the midst of it, the solemn forms of angels, sceptred, and robed to the feet, and leaning to each other across the gates, their figures indistinct among the gleaming of the golden ground through the leaves beside them, interrupted and dim, like the morning light as it faded back among the branches of Eden, when first its gates were angel-guarded long ago. (Ruskin's account of the visitor's first view of St Mark's, Venice, from *The Stones of Venice*, II)[1]

I went through so much hard, dry, mechanical toil there [in Venice], that I quite lost, before I left it, the charm of the place: Analysis is an abominable business: I am quite sure that people who work out subjects thoroughly are disagreeable wretches – One only feels as one should when one does'nt know much about the matter: If I could give you, for a few minutes – just as you are floating up the canal just now, the kind of feeling I had when I had just done my work – when Venice presented itself to me merely as so many 'mouldings,' – and I had few associations with any building but those of more or less pain and puzzle & provocation – Pain of frost bitten finger and chilled throat as I examined or drew the windowsills in the wintry air; puzzlement from said windowsills which did'nt agree with the doorsteps – or back of house which would'nt agree with front – and Provocation, from every sort of soul or thing in Venice at once. (Ruskin to Charles Eliot Norton, May 1857)[2]

The two passages quoted as epigraphs to this chapter illustrate two salient points about *The Stones of Venice*. It was a book that treated

the buildings themselves as the most important historical documents that Venice had to offer, so that the physical appearances of the Byzantine church, St Mark's, and the Gothic masterpiece, the Doge's Palace, were displayed in this volume with loving and minute elaboration.[3] And it was a book that was copiously and exhaustively researched. Ruskin devoted himself to months of drawing, measurement, note-taking (assisted by the recently developed daguerreotype) and the 'abominable business' of analysis. He spent much of every day in Venice out of doors with George Hobbs or another assistant, recording his data in easily carried pocket notebooks. He had larger notebooks for writing up his records of the buildings in the evenings. The two research trips to Venice in Effie's company, 1849-50 and 1851-2, largely comprised a self-imposed routine of relentless and physically demanding grind. Between the two trips he spent part of the year 1850-1 writing The Stones of Venice, I. The younger Ruskins were now living in the house John James had taken for them, 31 Park Street, but to write his book Ruskin continued to use his old study in the parental home at Denmark Hill.

The Stones of Venice, I, was published in March 1851. On 1 May all London was agog over the opening of the Great Exhibition, Prince Albert's triumph, in Paxton's massive Crystal Palace (a building Ruskin despised). Ruskin himself ignored the excitement, sitting in his study at Denmark Hill, listening to the birds, and struggling with his book.

The Stones of Venice, II and III, were published close together, in July and October of 1853. The Stones of Venice, I, seen as dry and excessively technical on its own, had sold very slowly. With the completion of the three volumes, though, the shape and purpose of the whole project became apparent. Readers saw that Ruskin's work revalued Byzantine and Gothic Venice. A review in The Daily News, 1 August, marked the nature of the innovation, saying that Ruskin had shed a new light on Venetian architecture 'which, until the appearance of the Seven Lamps and the Stones of Venice, was popularly regarded as the result of the "barbarous" taste to which in Wren's and Evelyn's time even the pointed Gothic was attributed': Ruskin had shown the medieval architects to be 'artists of profound and tender feelings'. The old attitude to St Mark's was that it was a mess, with 'its ill-shaped domes; its walls of brick incrusted with marble; its chaotic disregard of symmetry in the details; its confused hodge-podge of classic, Moresque, and Gothic'. Ruskin had disposed of that view for ever.[4] And the three volumes created a vogue for Venetian Gothic as an architectural style:

Students who, but a year or so previously, had been content to regard
Pugin as their leader, or who had modelled their works of art on the
principles of the *Ecclesiologist*, found a new field open to them and
hastened to occupy it. They prepared designs in which the elements of
Italian Gothic were largely introduced; churches in which the 'lily capital'
of St. Mark's was found side by side with Byzantine bas-reliefs and mural
inlay from Murano; town halls wherein the arcation and baseless
columns of the Ducal Palace were reproduced; mansions which borrowed
their parapets from the Calle del Bagatin, and windows from the Ca'
d'Oro. They astonished their masters by talking of the savageness of
Northern Gothic, or the Intemperance of Curves, and the Laws of
Foliation; and broke out into open heresy in their abuse of Renaissance
detail.[5]

The reference to Pugin is crucial here. Pugin of course was a Roman
Catholic, and Ruskin made the Gothic acceptable to the mid-Victorians
by the energy – and substantial success – with which he separated
Venetian Gothic from Catholic theology and *claimed it for
Protestantism*. Ancient Venice had been a strong republic which had
excluded the claims of the papacy. The decline of its political prosperity
coincided with the republic's giving way to an oligarchy that was
willing to submit to the will of the papacy in Rome. Britain in the
1850s, Ruskin is saying, is making the same mistake. The Catholic
Emancipation Act of 1829 had in due course enabled the Vatican to
create a Roman Catholic hierarchy in Britain headed by Cardinal
Wiseman, Archbishop of Westminster from 1850. Ruskin has a spirited
comment on this in Appendix V to *The Stones of Venice*, I: 'To have
sacrificed religion to mistaken policy, or purchased security with
ignominy, would have been no new thing in the world's history; but to
be at once impious and impolitic, and seek for danger through
dishonour, was reserved for the English Parliament of 1829.'[6]*

*Pugin died in 1851 but Ruskin's animosity continued. The reason for this was that he was
thought by some to have plagiarised from Pugin. Frank Howard, for example, accused him
in front of the Liverpool Architectural Society in 1852 of adopting Pugin's principles and of
having 'dressed himself in Pugin's feathers'. Ruskin defended himself in an appendix to
Modern Painters, III: 'It is . . . often said that I borrow from Pugin. I glanced at Pugin's
Contrasts once, in the Oxford architectural reading-room, during an idle forenoon. His
"Remarks on Articles in the *Rambler*" were brought under my notice by some of the reviews.
I never read a word of any other of his works, not feeling, from the style of his architecture,
the smallest interest in his opinions.'[7] It has been pointed out that there is surviving evidence
to show that Ruskin had studied more of Pugin than he ever acknowledged: 'There are
significant differences between Ruskin's view of Gothic and Pugin's, but Ruskin's denial of
any debt can only be explained by the sectarian fervour that gripped much of England at
midcentury.'[8]

Because sales of *The Stones of Venice*, I, were slow, there was no new edition until 1858 when all three volumes went into a second edition, though Ruskin did not envisage or attempt revisions comparable with those that he made to the first two volumes of *Modern Painters*. The New Edition of 1874 (the third) was the first to publish the whole work together. The fourth edition, published by George Allen in 1886, was the basis of the small complete edition of 1898. A 'traveller's edition', a selection from the complete work intended as a practical guide for visitors, was issued in two volumes, in 1879 and 1881; this was a popular publication and had a number of subsequent editions and reprintings in Ruskin's lifetime.

Ruskin's account of his work on Venice shows him driven as though by animal appetite. His research was not a series of ordered questions:

> I don't think myself a great genius – but I believe I have genius; something different from mere cleverness, for I am *not* clever – in the sense that millions of people are – lawyers – physicians – and others: But there is the strong instinct in me . . . like that for eating or drinking. I should like to draw all St. Mark's – and all this Verona – stone by stone, to eat it all up into my mind – touch by touch.[9]

He loved Venice and experienced sheer sensual pleasure in being within the city. But his driven sensibility did not allow 'sheer' pleasure. So pleasure became work, and the work built through the first volume of *Stones of Venice*, frustratingly slowly in its account of the elements of a building, to the astonishing achievement in the second volume when 'The Nature of Gothic' provided a retrospect from which the preceding writing could be seen to make sense. Ruskin was hugely pleased by the links he saw between the arts that delighted him – Gothic architecture and Turner's painting – and the ideal society, one in which the workman is happy in his work. This last theme, central to *The Stones of Venice*, was already becoming important in *The Seven Lamps of Architecture*. In 'The Lamp of Life' he seems to restrict his question about the happiness of the worker to 'ornament', but the context makes it clear that he is actually thinking of all work. 'Was the carver happy?' If the work is not 'happy' it will not be 'living'.[10] 'We are not sent into this world to do any thing into which we cannot put our hearts. We have certain work to do for our bread, and that is to be done strenuously; other work to do for our delight, and that is to be done heartily: neither is to be done by halves and shifts, but with a will; and what is not worth this effort is not to be done at all.'[11]

However, when discussing the 'Grotesque Renaissance' in *The*

Stones of Venice, III, Ruskin seems in no doubt that pleasure in work is in some sense a class-bound matter. He thus withdraws or modifies the generous and passionate recommendations made in the earlier volume:

> I have dwelt much, in a former portion of this work, on the justice and desirableness of employing the minds of inferior workmen, and of the lower orders in general, in the production of objects of art of one kind or another. So far as men of this class are compelled to hard manual labour for their daily bread, so far forth their artistical efforts must be rough and ignorant, and their artistical perceptions comparatively dull. . . . The working man who turns his attention partially to art will probably, and wisely, choose to do that which he can do best, and indulge the pride of an effective satire rather than subject himself to assured mortification in the pursuit of beauty [so the grotesque is an appropriate form for working-class men to work in].[12]

Art is necessary play for the workman: 'All the forms of art which result from the comparatively recreative exertion of minds more or less blunted or encumbered by other cares and toils, the art which we may call generally art of the wayside, as opposed to that which is the business of men's lives, is, in the best sense of the word, Grotesque.'[13] Raphael's paintings in the Vatican are the highest perfection of Grotesque, 'an elaborate and luscious form of nonsense'.[14] The grotesque can be noble:

> the central man of all the world, as representing in perfect balance the imaginative, moral, and intellectual faculties, all at their highest, is Dante; and in him the grotesque reaches at once the most distinct and the most noble development to which it was ever brought in the human mind. The two other greatest men whom Italy has produced, Michael Angelo and Tintoret, show the same element in no less original strength, but oppressed in the one by his science, and in both by the spirit of the age in which they lived.

Ruskin adds in a note here: 'I had not at this time extricated myself from the false reverence for Michael Angelo in which I had been brought up. It held me longer than any other youthful formalism. The real relations between Michael Angelo and Tintoret are given in my Oxford lecture' (1881).[15] Shakespeare, Aeschylus and Homer also display the grotesque.

Education is directly related to the way in which the workman is adapted to his art: many have been 'forced by the inevitable laws of modern education into toil utterly repugnant to their natures'.[16] A

related topic is his notion that great geniuses break the rules: 'in spite of the rules of the drama we had Shakespeare, and in spite of the rules of art we had Tintoret'.[17]

The pamphlet on 'Pre-Raphaelitism' has a strikingly clear statement about the nature of work which relates to the ideas that he is working out in *The Stones of Venice*: 'It may be proved . . . that God intends no man to live in this world without working: but it seems to me no less evident that He intends every man to be happy in his work.'[18] He distinguishes here between contentment in work and *ambition*. What we would recognise as a proper and central Victorian drive – to move upwards socially – is replaced by a quite different vision based on a vision of the medieval world:

> When a man born of an artisan was looked upon as an entirely different species of animal from a man born of a noble, it made him no more uncomfortable or ashamed to remain that different species of animal, than it makes a horse ashamed to remain a horse, and not to become a giraffe. But now that a man may make money, and rise in the world, and associate himself, unreproached, with people once far above him, not only is the natural discontentedness of humanity developed to an unheard-of extent, whatever a man's position, but it becomes a veritable shame to him to remain in the state he was born in, and everybody thinks it his *duty* to try to be a 'gentleman.'

The antidote to this misplaced ambition is to deny the existence of such social divisions as the word 'gentleman' indicates, and to commend that gentlemen alter society's attitudes by their example: 'Showing that it was possible for a man to retain his dignity, and remain, in the best sense, a gentleman, though part of his time was every day occupied in manual labour, or even in serving customers over a counter'.[19]

A Romantic view of work is here opposed to the mid-Victorian Protestant ethic. Effort does not make for achievement: '*No great intellectual thing was ever done by great effort*; a great thing can only be done by a great man, and he does it *without* effort.' The concept of the Great Man can undo the social structure supporting the 'gentleman' and invoke instead the genius:

> Is not the evidence of Ease on the very front of all the greatest works in existence? Do they not say plainly to us, not, 'there has been a great *effort* here,' but, 'there has been a great *power* here'? It is not the weariness of mortality, but the strength of divinity, which we have to recognize in all mighty things.[20]

The function of great genius in art is to identify truth: 'It is most

difficult, and worthy of the greatest effort, to render, as it should be rendered, the simplest of the natural features of the earth.'[21]

Wordsworth, to whom Ruskin in this phase of his life turned constantly as a supremely confident genius, is admired for his aggressiveness:

> Strong instincts are apt to make men strange and rude; self-confidence, however well founded, to give much of what they do or say the appearance of impertinence. Look at the self-confidence of Wordsworth, stiffening every other sentence of his prefaces into defiance.[22]

In November 1853 Ruskin delivered four 'Lectures on Architecture and Painting' to the Philosophical Society of Edinburgh. He told his Edinburgh audience: 'You are all proud of your city; surely you must feel it a duty in some sort to justify your pride; that is to say, to give yourselves a *right* to be proud of it. That you were born under the shadow of its two fantastic mountains, – that you live where from your room windows you can trace the shores of its glittering Firth, are no rightful subjects of pride.'[23] It is domestic architecture, not civic or church architecture, that makes a great city. The bold square-cut jambs of 'the New Town of Edinburgh' are dull. The pointed arch is inherently stronger and more beautiful than the square-cut window because it appeals to nature:

> It is also the most beautiful form in which a window or door-head can be built. Not the most beautiful because it is the strongest; but most beautiful, because its form is one of those which, as we know by its frequent occurrence in the work of Nature around us, has been appointed by the Deity to be an everlasting source of pleasure to the human mind.

'Nature abhors equality'; the leaves of the ash tree 'spring from the stalk *precisely as a Gothic vaulted roof springs*'; and to build in iron and glass is illegitimate because there are no references to successful building in these materials in the Bible.[24]

Ruskin was absolutely serious in his recommendation to the citizens of Edinburgh that they should rebuild their city:

> Introduce your Gothic line by line and stone by stone; never mind mixing it with your present architecture; your existing houses will be none the worse for having little bits of better work fitted to them; build a porch, or point a window, if you can do nothing else; and remember that it is the glory of Gothic architecture that it can do *anything*.[25]

The third lecture was called 'Turner and his Works', and the fourth, delivered on 18 November 1853, 'Pre-Raphaelitism' (it is quite distinct

from the pamphlet of the same title). This fourth lecture revisited the praise for Turner in *Modern Painters*, I and II, and pointed to him as the natural precursor of the Pre-Raphaelites, who also displayed this admirable quality of profound fidelity to nature. There has been a central constellation of great minds, Shakespeare, Bacon (Baron Verulam) and Turner:

> By Shakespeare, humanity was unsealed to you; by Verulam the *principles* of nature; and by Turner, her *aspect*. All these were sent to unlock one of the gates of light, and to unlock it for the first time. But of all the three, though not the greatest, Turner was the most unprecedented in his work. Bacon did what Aristotle had attempted; Shakespeare did perfectly what Aeschylus did partially; but none before Turner had lifted the veil from the face of nature; the majesty of the hills and forests had received no interpretation, and the clouds passed unrecorded from the face of the heaven which they adorned, and of the earth to which they ministered.[26]

Ruskin's account of Turner's death in this lecture sounds like part of the biography that he didn't write:

> Turner had no one to teach him in his youth, and no one to love him in his old age. Respect and affection, if they came at all, came unbelieved, or came too late. . . . He received no consolation in his last years, nor in his death. . . . The window of his death-chamber was turned towards the west, and the *sun* shone upon his face in its setting, and rested there, as he expired.[27]*

The 'Pre-Raphaelite Brethren', although their chosen title was ludicrous, were right to choose 'Raphael as the man whose works mark the separation between Mediaevalism and Modernism'; right because the Middle Age ended with the fifteenth century, and the 25-year-old Raphael, in the Vatican, painted a fresco of Theology 'presided over by *Christ*' and beside it a fresco of poetry 'presided over by *Apollo*'. 'And from that spot, and from that hour, the intellect and the art of Italy date their degradation.'[29] There is a kind of dotty mesmeric power about this simplification of history. The Pre-Raphaelites are like medieval painters *and also* like Turner in that 'Pre-Raphaelitism has but one principle, that of absolute, uncompromising truth in all that it does, obtained by working everything, down to the most minute detail, from nature, and from nature only.'[30]

*'The Sun is God' is a memorable phrase attributed to Turner (a few weeks before he died).[28] Ruskin is alluding to it here.

The lecture and, even more emphatically, the 'Addenda' which followed it, were extravagantly enthusiastic in their praise of the young painters Millais and Hunt, to whom he now added the name of Rossetti. Ruskin was flushed with the pleasure of patronage; ironically, while he was throwing his authority behind the Pre-Raphaelites, his wife was falling in love with the most talented of them.

The Stones of Venice is characterised by vast pragmatic study, the eating up of the architecture into his mind, stone by stone, coexisting with an overriding scheme. It remains broadly true that the book is an illustration of the principles laid down in the introductory work, *The Seven Lamps of Architecture*. In the Preface to the first edition, 1851, Ruskin described an experience common to many researchers of large projects. He had known Venice for seventeen years and had taken a great many notes, but in 1849 he went back to the city, for a long winter research trip with Effie, in order, as he said, to check his notes 'not doubting but that the dates of the principal edifices of the ancient city were either ascertained, or ascertainable without extraordinary research'. But he found no reliable authorities on the dates of anything. He then resorted to his own hugely time-consuming research methods, measuring, recording and studying in detail in order to work out the chronology of the buildings that he was examining. He in effect took the subject back to first principles and invented his own methodology for conducting his research.[31] His knowledge of his subject's 'stones' was won by physical, hands-on, grimy and exhausting research, climbing ladders, bribing sacristans, begging and beseeching co-operation from priests, custodians and archivists.

The Stones of Venice came to be seen by its creator as a failure. In the Preface to the third edition, 1874, he complains that only the recommendation that Italian Gothic should be adopted as a building style has made any impact on his audience, while his major teaching has been ignored. He describes the three volumes as presenting, first, an analysis of the best structure of stone- and brick-building and then, in the second and third volumes, showing how the rise and fall of the Venetian builder's art depended on the moral or immoral temper of the state. In addition to this, the main purpose of Volumes II and III, he examines the relation of the life of the workman to his work in medieval times and the necessity of that relation at all times, and the formation of Venetian Gothic from the earliest Romanesque types until it perished in the revival of Classical principles in the sixteenth century.[32]

The Preface to the first edition emphasises a different point. Ruskin was writing now of developing his work on architecture, and this prompted him to the simple but important reflection that while painting can be seen as elitist, architecture affects all mankind:

> Every man has, at some time of his life, personal interest in architecture. He has influence on the design of some public building; or he has to buy, to build, or alter his own house. It signifies less whether the knowledge of other arts be general or not; men may live without buying pictures or statues; but, in architecture, all must in some way commit themselves: they *must* do mischief and waste their money, if they do not know how to turn it to account. Churches, and shops, and warehouses, and cottages, and small row, and place, and terrace houses, must be built, and lived in, however joyless or inconvenient.[33]

Architecture is a universal, and architecture observes moral laws. Once he gets into the body of the book Ruskin does two distinct things: he beguiles the reader into agreement with the solemn, magisterial music of the writing and he presents moral convictions with such clarity and force that we feel confident in them even when they are clearly not the product of thought-out argument. The music is the vehicle that carries the conviction:

> Since first the dominion of men was asserted over the ocean, three thrones, of mark beyond all others, have been set upon its sands: the thrones of Tyre, Venice, and England. Of the First of these great powers only the memory remains; of the Second, the ruin; the Third, which inherits their greatness, if it forget their example, may be led through prouder eminence to less pitied destruction.[34]

Venice stands at the juncture of the Arabic, Byzantine and 'Lombardic' or Romanesque architectural traditions, and its ducal palace 'contains the three elements in exactly equal proportions' and is thus 'the central building of the world'.[35]

Architecture is as subject to moral judgement as is painting, but the basis of such judgement is unclear: 'No man can speak with rational decision of the merits or demerits of buildings' but Ruskin is convinced that 'good architecture might be indisputably discerned and divided from the bad', and the objective of his book is to show such judgement in action by 'making the Stones of Venice touch-stones'.[36] The stones are a metaphor for his 'canons of judgment, which the general reader should thoroughly understand'. These canons are his 'foundations', and they comprise much of the first volume of the book.[37]

Ruskin's history of Venice is compelling in its simplification. We learn that the Arabic influence settled and was transformed into pure Gothic which prevailed from the middle of the thirteenth century to the beginning of the fifteenth, and that after 1418 the architecture of Venice declined into the Renaissance art which was 'Rational': 'The Rationalist kept the arts and cast aside the religion. . . . Instant degradation followed in every direction, – a flood of folly and hypocrisy.' Ruskin's account of the history of art since the Renaissance is expressed with a kind of comic violence:

> Mythologies ill understood at first, then perverted into feeble sensualities, take the place of the representations of Christian subjects, which had become blasphemous under the treatment of men like the Caracci. Gods without power, satyrs without rusticity, nymphs without innocence, men without humanity, gather into idiot groups upon the polluted canvas, and scenic affections encumber the streets with preposterous marble. Lower and lower declines the level of abused intellect; the base school of landscape gradually usurps the place of the historical painting, which had sunk into prurient pedantry, – the Alsatian sublimities of Salvator, the confectionery idealities of Claude, the dull manufacture of Gaspar and Canaletto, south of the Alps, and on the north the patient devotion of besotted lives to delineation of bricks and fogs, fat cattle and ditchwater. And thus, Christianity and morality, courage, and intellect, and art all crumbling together in one wreck, we are hurried on to the fall of Italy, the revolution in France, and the condition of art in England (saved by her Protestantism from severer penalty) in the time of George II.[38]

One of the purposes of the book was to strike an effective blow against the 'pestilent art of the Renaissance'.[39] English Renaissance architecture was a matter of failure to follow preferences clearly. 'Half the evil in this world comes from people not knowing what they do like; – not deliberately setting themselves to find out what they really enjoy.' The things they enjoy include giving away money and doing good: good actions are also pleasurable actions, but few of us discover that from experience.[40] The book is to be practical instruction to the reader in how to build. The reader is to experience for himself (always him) the pleasures of good workmanship.

Ruskin's visit to Venice with Effie in 1851–2 was less gruelling than the visit of 1849–50. That previous trip had prioritised research, and the relentless collection of detail on that visit had perhaps exhausted him. For this second joint visit he allowed himself more pleasure. He put

down all the *factual* material that goes into Volumes II and III of *The Stones of Venice*, reserving the writing up for his return to England. His father complained about the lack of fine moral teaching and fine writing in the batches of manuscript that reached him. Ruskin was working according to a self-imposed empirical discipline, building up his material and moving towards general statements which he made back in London, 1852–3, away from Venice. The empirical led to the moral, the loving observation of Venice's history written in its buildings led to his famous attack on the conditions of work in nineteenth-century England as compared with the conditions of work in the medieval world:

> Now, reader, look round this English room of yours, about which you have been proud so often, because the work of it was so good and strong, and the ornaments of it so finished. Examine again all those accurate mouldings, and perfect polishings, and unerring adjustments of the seasoned wood and the tempered steel. Many a time you have exulted over them, and thought how great England was, because her slightest work was done so thoroughly. Alas! If read rightly, these perfectnesses are signs of a slavery in our England a thousand times more bitter and more degrading than that of the scourged African, or helot Greek.[41]

This chapter of *The Stones of Venice*, 'The Nature of Gothic', was to take on a life of its own as a pamphlet introducing the work of F.D. Maurice's Working Men's College, an institution with which Ruskin was much involved in its early years, and as a central plank, later, in William Morris's beliefs. Morris reprinted it at the Kelmscott Press in 1892 with an introduction which brings out the central political thrust of the chapter:

> To my mind . . . it is one of the most important things written by the author, and in future days will be considered as one of the very few necessary and inevitable utterances of the century. . . . For the lesson which Ruskin here teaches us, is that art is the expression of man's pleasure in labour; that it is possible for man to rejoice in his work, for, strange as it may seem to us to-day, there have been times when he did rejoice in it; and lastly, that unless man's work once again becomes a pleasure to him, the token of which change will be that beauty is once again a natural and necessary accompaniment of productive labour, all but the worthless must toil in pain, and therefore live in pain. So that the result of the thousands of years of man's effort on the earth must be general unhappiness and universal degradation.[42]

Although Ruskin contrasts the Gothic with the contemporary

Victorian room he finds something inherently Gothic about the temperament of all Englishmen. 'There will be found something more than usually interesting in tracing out this grey, shadowy, many-pinnacled image of the Gothic spirit within us; and discerning what fellowship there is between it and our Northern hearts.' The 'elements' of Gothic architecture are 'certain mental tendencies of the builders, legibly expressed in it; as fancifulness, love of variety, love of richness, and such others', while the 'external forms' are its pointed arches, vaulted roofs and similar features. The 'mental tendencies' or characteristics of the Gothic builder are Savageness or Rudeness, Love of Change, Love of Nature, Disturbed Imagination, Obstinacy and Generosity.[43] The Gothic has features of English Romantic individualism, in other words. Ruskin reinforces this idea by suggesting that 'Gothic' was an opprobrious term, recently rehabilitated:

> At the close of the so-called Dark ages, the word Gothic became a term of unmitigated contempt, not unmixed with aversion. From that contempt, by the exertion of the antiquaries and architects of this century Gothic architecture has been sufficiently vindicated; and perhaps some among us, in our admiration of the magnificent science of its structure, and sacredness of its expression, might desire that the term of ancient reproach should be withdrawn, and some other, of more apparent honourableness, adopted in its place.

But there is no need for this, because the epithet with its connotations expressed a truth: 'It is true, greatly and deeply true, that the architecture of the North is rude and wild; but it is not true, that, for this reason, we are to condemn it, or despise. Far otherwise: I believe it is in this very character that it deserves our profoundest reverence.' Gothic is a rough, northern, mountainous style. There is 'a look of mountain brotherhood between the cathedral and the Alp . . . magnificence of sturdy power, put forth only the more energetically because the fine finger-touch was chilled away by the frosty wind'.

There is an obvious problem here, which is that Ruskin's book has been devoted to a *southern* European city, Venice, but Ruskin rides over this difficulty and makes a virtue of it. Venetian Gothic is not the best, but the city is a perfect example of confluence: here the architectural forces that generated Gothic converged. Ruskin wants us to see the savageness of northern Gothic as both noble and spiritual, an index not of climate but of 'religious principles'. One of these religious principles is servility. In sharp contrast with the ambitions of the Greek architects Gothic acknowledges its own imperfections, its 'lost power

and fallen nature'. The Gothic has accepted an essentially Christian teaching: 'Do what you can, and confess frankly what you are unable to do; neither let your effort be shortened for fear of failure, nor your confession silenced for fear of shame.'[44] The modern English are to be compared with the ancient Greeks in that they seek a kind of perfection, and the effect of this is to debase the worker: 'You must either make a tool of the creature, or a man of him. You cannot make both. Men were not intended to work with the accuracy of tools, to be precise and perfect in all their actions.' And it is by requiring workmen to be tools that the Englishman makes his room into an instrument of oppression and reduces the English workman lower than the scourged African and helot Greek.[45]

Ruskin had been stirred by the revolutions of 1848 to see the debasing of the worker as a central evil: the 'degradation of the operative into a machine' is 'leading the mass of the nations everywhere into vain, incoherent, destructive struggling for a freedom of which they cannot explain the nature to themselves. . . . It is not that men are ill fed, but that they have no pleasure in the work by which they make their bread, and therefore look to wealth as the only means of pleasure.'

There is a huge humanity about this. He knows that pleasure is important, and that there is no reason why it should not be available to everyone, at every level of society. And it is worth reflecting that this philosophy comes from a man for whom sexual pleasure, and pleasure in relationships, were impossible. His drives are redirected into religious fervour, a passionate, indeed an erotic, attachment to the city of Venice, and into his philanthropy, his belief that it is important to be kind to his fellow-man. And in the middle of the brutality and arrogant wealth of the Victorians it is hard not to relate warmly to what he says here. What is lacking is dignity, not material wealth or ease. 'No pleasure in the work by which they make their bread' is a phrase with a deadening, leaden ring to it. He recognises that the rich upper-class world is broadly philanthropic, but argues that the philanthropy is misdirected and the huge wealth of the modern world has made for a differential that has led to a catastrophic loss of dignity for the working man. In a very sensitive analysis Ruskin points out that the working man is not pained by 'the scorn of the upper classes' but cannot bear his contempt of himself: 'they feel that the kind of labour to which they are condemned is verily a degrading one, and makes them less than men.' Society has become so wealthy that the differentials are now insulting, there is 'a precipice between upper and lower grounds in the

field of humanity, and there is pestilential air at the bottom of it. I know not if a day is ever to come when the nature of right freedom will be understood, and when men will see that to obey another man, to labour for him, yield reverence to him or to his place, is not slavery.'[46]

It should be possible for the relationship between rich and poor to be ennobling: 'To yield reference to another, to hold ourselves and our likes at his disposal, is not slavery; often it is the noblest state in which a man can live in this world.' But the factory worker is a slave:

> To feel their souls withering within them, unthanked, to find their whole being sunk into an unrecognized abyss, to be counted off into a heap of mechanism numbered with its wheels, and weighed with its hammer strokes – this, nature bade not, – this, God blesses not, – this, humanity for no long time is able to endure.[47]

Ruskin was justifiably delighted by his discovery of many close connections between the Gothic and the natural world. Like the natural world, the Gothic is changeful and 'imperfect': 'It seems a fantastic paradox, but it is nevertheless a most important truth, that no architecture can be truly noble which is *not* imperfect.' Imperfection is 'in some sort essential to all that we know of life' in that 'nothing that lives is, or can be, rigidly perfect. . . . The foxglove blossom, – a third part bud, a third part past, a third part in full bloom, – is a type of the life of this world.' The asymmetry of the human face and of all objects in the natural world is a necessary virtue. A building needs irregularity so that we can read it 'as we would read Milton and Dante', where there is a combination of pattern, or rhythm, and *variety*. 'Change or variety is as much a necessity to the human heart and brain in buildings as in books.' We find all men of true feeling 'delighting to escape out of modern cities into natural scenery: hence, as I shall hereafter show, that peculiar love of landscape, which is characteristic of the age'. This point is important. The kind of pleasure that man takes in representations of the natural world was furnished by Gothic architecture but is absent from modern architecture, which accounts for the rise in prestige and popularity of landscape painting in the eighteenth and nineteenth centuries. This gave Ruskin a satisfactory link between the two major projects of 1843–60, his studies of painting and architecture.[48]

There are two great truths of human nature which Gothic architecture expresses: 'the confession of Imperfection, and the confession of Desire of Change'.[49] 'To the Gothic workman the living foliage became a subject of intense affection' and he sought to represent

John Ruskin,
aged three-and-a-half.

The hills in the
background, 'as blue
as my shoes', were
included at the request
of the infant Ruskin
because 'the idea
of distant hills was
connected in my mind
with approach to
the extreme felicities
of life'.

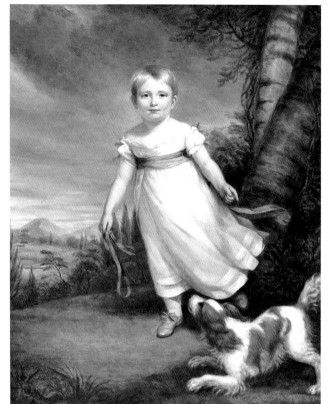

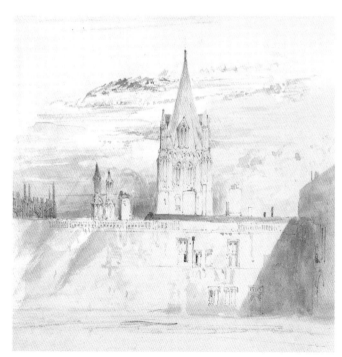

Christ Church
Cathedral from
Tom Quad.

'An epitome of
English history.
Every stone, every
pane of glass, every
panel of woodwork,
was true, and of
its time.'

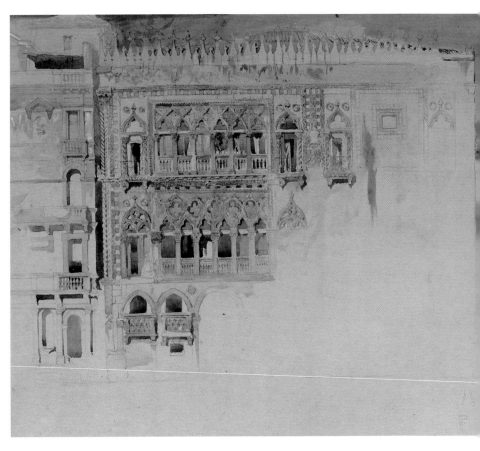

The Ca d'Oro, Venice.

'You cannot imagine what an unhappy day I spent yesterday before the Casa d'Oro, vainly attempting to draw it while the workmen were hammering it down before my face.'

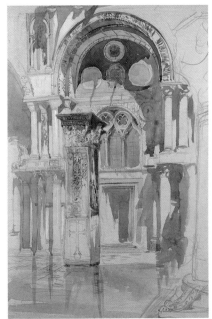

St Mark's, Venice, after rain.

'Arches charged with goodly sculpture, and fluted shafts of delicate stone.'

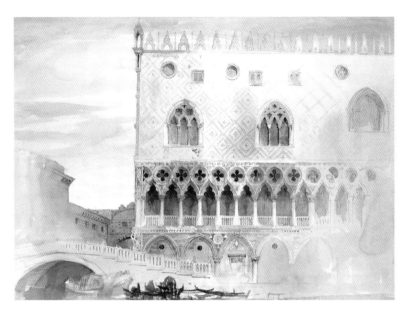

The Ducal Palace, Venice.

'The central building of the world.'

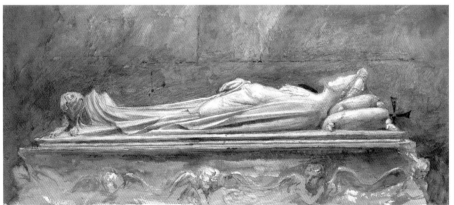

Ilaria di Caretto, Lucca.

This tomb figure by Jacopo della Quercia was a touchstone for Ruskin throughout his life. As early as 1845, he had written to his father: 'It is impossible to tell you the perfect sweetness of the lips & closed eyes, nor the solemnity of the seal of death which is set upon the whole figure. The sculpture, as art, is in every way perfect – <u>truth</u> itself.'

Effie, in 1850, the year before publication of *The King of the Golden River*, which had been written for her in 1841. Ruskin's marriage to Effie was a major stimulus to the writing of *The Stones of Venice*.

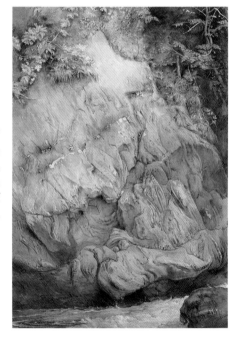

Gneiss rock, Glenfinlas.

Ruskin's loving delineation of the natural form of stone, made as an example of what he wanted in the great portrait of him by Millais (opposite).

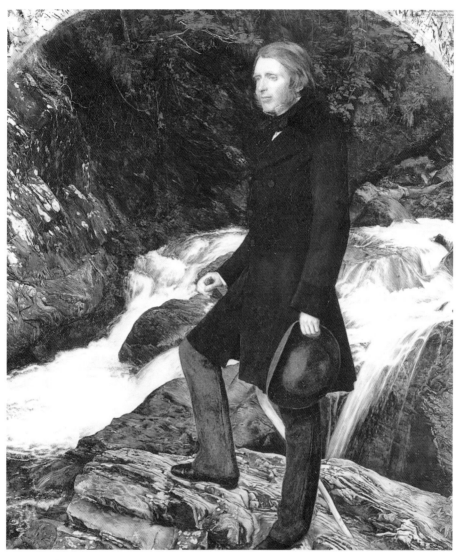

John Ruskin by John Everett Millais: the realisation of everything that
Ruskin most admired in Pre-Raphaelite theory and practice.

Ruskin's marriage to Effie was by then in difficulties; and while Millais made
this painting at Glenfinlas in 1853 he and Effie were falling in love.

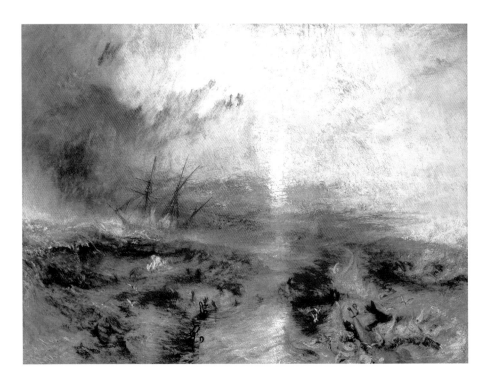

Slavers throwing overboard the dead and dying – Typhoon coming on by J. M. W. Turner, 1840.

This painting was a New Year's gift to Ruskin from his father in 1844: 'The noblest sea that Turner has ever painted, and, if so, the noblest certainly ever painted by man.'

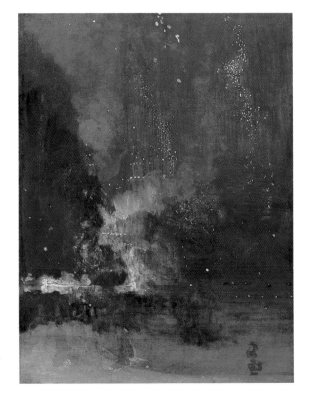

Nocturne in Black and Gold: the Falling Rocket by James Abbott McNeill Whistler, 1875.

'I have seen, and heard, much of Cockney impudence before now; but never expected to hear a coxcomb ask two hundred guineas for flinging a pot of paint in the public's face.'

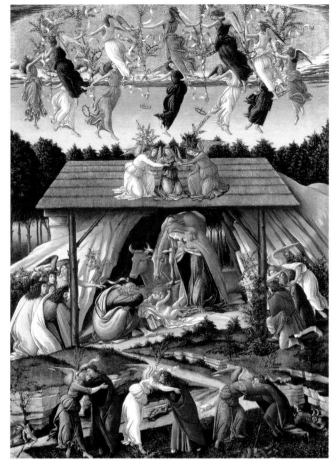

Mystic Nativity by Sandro Botticelli.

'Suppose that over Ludgate Hill the sky had indeed suddenly become blue instead of black; and that a flight of twelve angels ... had alighted on the cornice of the railway bridge.'

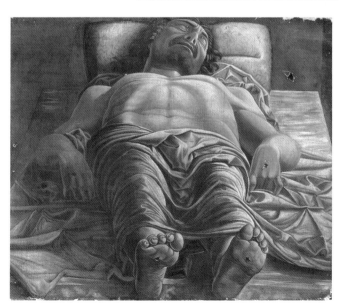

The Dead Christ by Andrea Mantegna.

'Demoniacal power ... minute, contemptible and loathsome ... only an anatomical study of a vulgar and ghastly dead body.'

Rose la Touche, c1862.

In 1861 Ruskin had written
this plaintive little lyric:

Rosie, Posie – Rosie rare,
Rocks, & woods, & clouds, and air
Are all the colour of my pet:
And yet, & yet, & yet, & yet
She is not here – but, where?

Self portrait.

Ruskin at 55. The Slade Professor is
weary; but the blue stock he habitually
wore shows that the public role is still
a proud part of his private self-image.

it in his art, the simple arch evolving into a Gothic arch that pleased because of its resemblance to a tree branch. This evolution reflects an evolution in the temperament of the northern Europeans who created it. 'Gothic architecture arose in massy and mountainous strength, axe-hewn, and iron-bound, block heaved upon block by the monk's enthusiasm and the soldier's force.' Gradually, as the 'enthusiasm' became 'more thoughtful' the resemblance to trees develops: 'the stony pillar grew slender and the vaulted roof grew light, till they had wreathed themselves into the semblance of the summer woods at their fairest.'[50]

The Stones of Venice, II, shows Ruskin at his most warm, sympathetic and philanthropic and is a kind of intellectual furnace in which ideas that will determine his later political life appear in their first hot and molten form. In the book love of mankind competes for primacy with a terrible sense of loss. The world in which man could live a dignified existence – the world of the medieval craftsman who was both artist and artisan, and was happy with his position – has been replaced by a colder and less sympathetic world. *The Stones of Venice*, III, is subtitled 'The Fall'. The first and clearest meaning of this 'fall' is that the progression from Gothic to Renaissance architecture is as much of a moral disaster as the Fall of Man.

In a passage from the first chapter of Volume III, 'Early Renaissance', Ruskin writes: 'There is one magnificent attribute of the colouring of the late twelfth, the whole thirteenth, and the early fourteenth century ... the union of one colour with another by reciprocal interference.' He then finds in this slightly weird concept, reciprocal interference, a 'magnificent principle' for both art and human life:

> It is the great principle of Brotherhood, not by equality, nor by likeness, but by giving and receiving; the souls that are unlike, and the nations that are unlike, and the natures that are unlike, being bound into one noble whole by each receiving something from and of the others' gifts and the others' glory. I have not space to follow out this thought, – it is of infinite extent and application, – but I note it for the reader's pursuit, because I have long believed, and the whole second volume of *Modern Painters* was written to prove, that in whatever has been made by the Deity externally delightful to the human sense of beauty, there is some type of God's nature or of God's laws.[51]

This is a matter of feeling and vision rather than argument. Ruskin excitedly felt – welling up, as it were – moral conclusions to his otherwise arduous and often arid work on buildings. Here his

enthusiasm for mankind, his new-found sense of Brotherly Love as virtue, balance his disappointment with Venice in its decline. The debasement of Venetian architecture distresses him so much that he does not 'intend to delay the reader long by the Gothic sick-bed' but will devote himself to showing how the human spirit found different ways to survive the Renaissance 'assault' on 'degraded Gothic'.[52]

The idea that the Gothic was self-evidently good and that the Renaissance was an inevitable decline from it is, obviously, far too crude to fit real history. Ruskin knows this and from early in the work his taste and intelligence force him to qualify this basic pattern. For example, in the chapter on 'Early Renaissance' we have the following: 'The first appearance of the Renaissance feeling had the appearance of a healthy movement.' The awkward repetition of 'appearance' here shows that Ruskin knew he was in a muddle. The muddle is created by the awkward existence of undeniably great Renaissance artists:

> A new energy replaced whatever weariness or dulness had affected the Gothic mind; and exquisite taste and refinement, aided by extended knowledge, furnished the first models of the new school; and over the whole of Italy a style arose, generally now known as cinquecento, which in sculpture and painting . . . produced the noblest masters whom the world ever saw, headed by Michael Angelo, Raphael, and Leonardo.

His law about 'imperfection' as a feature of great Gothic architecture is now invoked. The Renaissance could not produce a great style in architecture because 'perfection is therein not possible', and it failed 'more totally than it would otherwise have done, because the classical enthusiasm had destroyed the best types of architectural form'. Ruskin then, frankly, backs away from the intractable historical problem he has created for himself. He starts with a slightly flimsy distinction:

> The Renaissance principle, as it consisted in a demand for universal perfection, is quite distinct from the Renaissance principle as it consists in a demand for classical and Roman *forms* of perfection. And if I had space to follow out the subject as I should desire, I would first endeavour to ascertain what might have been the course of the art of Europe if no manuscripts of classical authors had been recovered, and no remains of classical architecture left, in the fifteenth century.

An interesting question, certainly, but the phrase about lack of space indicates that we have to take Ruskin's historical generalisations on trust; we are not going to get systematic research and systematic argument from Ruskin: he is a romantic, a visionary and a preacher.

And we are not permitted to look for the details of the argument behind his central assertion about the 'evil principles' of the Renaissance, which is that 'its main mistake' was the 'unwholesome demand for *perfection*, at any cost'. And he is able, with some triumph, to make the connection back to his observations about finish and the slavery of the workman in 'The Nature of Gothic'. 'I hope enough has been advanced, in the chapter on the Nature of Gothic, to show the reader that perfection is *not* to be had from the general workman, but at the cost of everything – of his whole life, thought, and energy.'[53]

In its broad teaching *The Stones of Venice*, III, is resolutely Christian, like its predecessors. Ruskin expresses dismay over modern English education. Public schoolboys and undergraduates get no moral training, he argues, they are trained only in facility in the Classics. In education 'The Pagan system is completely triumphant' and 'his own religion is the one in which a youth's ignorance is most easily forgiven' provided that 'he write Latin verses accurately, and with speed'. England, because it has 'hidden roots of active and earnest Christianity', will recover from this error. But in Venice the roots themselves are withered. Ruskin has despaired of Venice as a civilisation: 'From pride to infidelity, from infidelity to the unscrupulous and insatiable pursuit of pleasure, and from this to irremediable degradation, the transitions were swift, like the falling of a star.'[54]

Yet the ideal of the artist set out in these early chapters of *The Stones of Venice*, III, looks Romantic rather than 'Christian'. Like the figure of the poet advocated in Keats's letters or in Wordsworth's 'Expostulation and Reply', the artist does not need learning. Specifically and explicitly he does not need the sciences. 'Science studies the relations of things to each other: but art studies only their relations to man' and the artist does not need the kinds of information provided by science.

> The whole function of the artist in the world is to be a seeing and feeling creature; to be an instrument of such tenderness and sensitiveness, that no shadow, no hue, no line, no instantaneous and evanescent expression of the visible things around him, nor any of the emotions which they are capable of conveying to the spirit which has been given him, shall either be left unrecorded, or fade from the book of record. It is not his business either to think, to judge, to argue, or to know. His place is neither in the closet, nor on the bench, nor at the bar, nor in the library. They are for other men, and other work. He may think, in a by-way; reason, now and then, when he has nothing better to do; know, such fragments of knowledge as he can gather without stooping, or reach without pains;

but none of these things are to be his care. The work of his life is to be two-fold only; to see, to feel.[55]

This artist is a product of the Romantic movement, he looks remarkably like the aesthete as developed by Pater and Wilde later in the century, and he is a heroic individualist. This version of the artist is the one that Ruskin believes in, clearly, while his first, Christian version is the one that he feels obliged to keep asserting.

Ruskin wrote to his father almost every day while he was in Venice working on *The Stones of Venice*.[56] These letters show how warm and close the relationship was between the two men and how much Ruskin depended on his father for day-to-day scholarly support. Ruskin's servant George Hobbs steadily made fair copies of the growing book from Ruskin's manuscripts to be sent home to John James, and one can feel that for Ruskin the fact that John James was always there, a ready, eager and sympathetic audience for his work, provided a great stimulus to the writing. Also John James was willing to undertake detailed research: getting one of his clerks to copy pages of Lyell's *Principles of Geology*, for example, and following up a whole list of specific queries about the kinds of stone used in St Mark's. In a letter of 16 December 1851 Ruskin asked for the following:

> Would you . . . be so very kind as any time when you are passing Tennant's in the Strand to obtain from him what information he professes on the following points?
> 1. Is *Greek* alabaster now used in the fine arts?
> 2. What is the appearance, and where are the quarries, of the most valued alabasters now used, and what is their price at the quarry, and in London – per cubic foot?
> 3. What is the locality especially of *veined* and zoned alabasters – yellow and white – white and grey – and white and deep purple: like flux spar, and what is their price per cubic foot?
> 4. What is 'Verd antique' understood generally to mean by mineralogists and where is it found, and what is its price per foot?
> 6th [sic] Finest deep red porphyry – Its locality and price per foot.[57]

At the same time Ruskin had to overcome his mother's fears that he might be becoming a Catholic sympathiser. An absurd misunderstanding arose: Ruskin wrote that Effie had been to the German Protestant services in Venice and that he had not. His father wrote back to say that his mother was in tears over the fact that her son was going to Mass in preference to a Protestant service and Ruskin had to write

an elaborate explanation: the *only* Protestant services available in Venice were in German, a language that Effie understood but he did not. Religion is a topic that is never far away from these letters. Ruskin's parents had longed for him to become a clergyman – indeed a bishop – and Ruskin is clearly having to handle the matter with tact. He now feels himself unsuited to such a vocation: 'I can do nothing right but when I am quiet and alone' and 'I don't love people'. So: 'I have been putting off all thoughts about my future life until the works I have undertaken are done.' But he does not close off the possibility of ordination completely: 'I can never tell but some change might come over my religious feelings.'

He is depressingly cold towards Effie's needs. Effie is to have no choice in the question of where they will live. In England they will live economically in a quiet suburb, Norwood perhaps, and he will work on Turner. The evils of Venice, where 'I am obliged to spend . . . twice what I intended, merely by being in too large a house, and being on visiting terms with the upper classes', will be replaced by a life-style which Effie, he observes coldly, will hate:

> I do not speak of Effie in this arrangement. . . . She will be unhappy – that is her fault – not mine – the only real regret I have, however is on her account – as I have pride in seeing her shining as she does in society – and pain in seeing her deprived, in her youth and beauty, of that which 10 years hence she cannot have – The Alps will not wrinkle – so *my* pleasure is always in store – but her cheeks will: and the loss of life from 24 to 27 in a cottage at Norwood is not a pleasant thing for a woman of her temper – But this cannot be helped.[58]

John James was troubled by expressions of political opinion which seemed to be deviating from loyalty to Church, State, monarchy and so on, and correspondence about this helped Ruskin to sharpen his own political thinking. In a letter of 29 March 1852 he wrote: 'do not vex yourself because you think I am turning republican'. He had 'changed no opinion since I wrote that passage in the *The Seven Lamps* about loyalty. I meant the word to signify what it really *does* in the long run signify *loy* – alty – respect for loy or law: for the King as long as he observes and represents law.'[59]

J.M.W. Turner, Ruskin's 'earthly Master', died on 19 December 1851. Ruskin learned the news in a letter from his father. For Ruskin it was a personal bereavement. On receipt of his father's letter he wrote on 28 December 1851: 'For *one* thing I was not altogether prepared – the

difference of feeling with which one now looks at the paper touched by his hand – the sort of affection which it obtains as that on which something of his Life remains.' Turner had named Ruskin as an executor in his will; delighted by the degree of control that this might give him, Ruskin wrote: 'I am very thankful to God for giving me some power over that which above all things in the world, I should desire to have power over.' But he was at the same time miffed to be left no paintings, though he expressed himself in Christian terms: 'though Turner would do me no favour, he had some trust in my feeling towards him'.[60]

Turner left his work to the nation, requesting in his will that an extension to the National Gallery be built to show his paintings. The plan came to nothing because of disputes over the will, but at this early date it seemed likely that the gallery would go ahead. Ruskin hoped to design the gallery himself, and his plan, described in a letter of 1 January 1852, would have been about a century ahead of its time:

> I would build such a gallery as should set an example for all future picture galleries. I have had it in my mind for years. I would build it in the form of a labyrinth – all on ground story – but with ventilation between floor and ground – in form of labyrinth, that in a small space I might have the gallery as long as I chose – lighted from above – opening into larger rooms like beads upon a chain – in which larger pictures should be seen at their right distance – but all *on the line*, never one picture above another. . . . There would never be a crowd any where: no people jostling each other to see two pictures hung close together. Room for everybody to see everything. The roof of double plate glass of the finest kind – sloping as in crystal palace [a structure Ruskin despised] – but very differently put together – No *drip*.
>
> 50,000, would do it all – splendidly – and leave 30 – for interest for repairs, and servants' salaries.

One of John James Ruskin's ambitions was that Ruskin should write a biography of Turner. But Ruskin hesitated because a biography might require him to deal with distasteful material: 'There might be much that would be painful to tell and dishonest to conceal.' Also, he regarded *Modern Painters* as in itself his book on Turner:

> If I were not going to write *Modern Painters* I should undertake it at once, but I will make *that* so complete a monument of him, D.V. that there will be nothing for the life but when he was born – and where he lived – and whom he dined with on this or that occasion. All which may be stated by anybody.[61]

Ruskin, who had done more for Turner's reputation than anyone else in England, confronted with fortitude a will that was little short of curmudgeonly to him. But he did allow himself a spurt of injured pride over one item: Turner's only legacy to him was nineteen guineas for a mourning ring. John James pithily remarked: 'Nobody can say you were paid to praise.' Ruskin himself wrote on Monday 12 January 1852: 'As for his £19-19-6: I will be indebted to him for no such matter: I will wear some sign of mourning for him, though.'

John James accepted, unquestioningly, that it was his job to look after every detail of the life of his beloved young genius who was thus to be freed utterly for the writing of the great works. For example, John James put himself to considerable trouble and expense to find a London home for the young Ruskins to replace the Park Street house (which had been taken in 1848 on a three-year lease). The house he found was 30 Herne Hill, next to the former family home at Number 28. (When they eventually saw the house John and Effie in fact disliked it and were dismayed by the style in which John James had furnished it.) John Ruskin responded to his father's plans very much *en prince*. He wrote from Venice (14 January 1852) to say that he liked the sound of the house, but that his father was not to spend too much money furnishing it. 'The situation would be excellent – but the [£]1000 for furnishing [an astronomical sum in today's terms] is a very serious consideration.' The reason why it was 'serious' was that Ruskin reserved the right not to live in London, or indeed in England: 'If I settled in Yorkshire or Switzerland I should have no need of expensive London furniture.' This letter amounted to emotional blackmail of his father: not only will he live wherever his whim dictates, but his health is so fragile that he may not survive for very long anywhere: therefore, on reflection, he will permit his father to make a huge financial outlay on furniture for him. 'There might be some good in getting at once a few of the things that I am likely to need during my life – if I live – I might always be accustomed to my furniture if not to my house.' Ruskin then appeared to delegate the decision to his father – 'I must leave you to do as you think best' – but immediately contradicted that by making very precise requirements: 'You will of course see that there is a comfortable room for me to escape into if people come whom I don't want – and Effie does – it would not do always to have to cross over to my study on the other side of the road. And see that the chimnies [sic] don't smoke – I would

make no bargain for a house without trying its chimnies in all the four winds.'

Many aspects of this invite adverse comment: the spoilt child's demands, the cold hostility to his wife ('people . . . whom I don't want – and Effie does'). There is of course a power struggle going on under the surface. By pouring out his money on his son John James was controlling him. By threatening to live in Switzerland or Yorkshire, or indeed to die(!), Ruskin was resisting the control. By shutting out Effie – and Margaret – the two men were creating a kind of male solidarity which they both needed. And they did love each other. The love was intensified by Turner's death and his will's treatment of Ruskin. However disappointing other male heroes might be, and however tiresome his wife (and his mother) might be, Ruskin could always rely on John James's blind loyalty. In the middle of all this controlling, blackmailing, manipulative and collusive behaviour father and son had a common purpose, which was to enable Ruskin to write his books and spread his fame. And without the books and the fame we would not, of course, be interested in him at all. So the balance is in John James Ruskin's favour. However wrong-headed a parent he was, our culture owes him an enormous debt of gratitude.

Every aspect of Ruskin's work, every problem in his writing, was confided to his father: 'When I get into a thorough writing humour I can do a good deal nearly in correct hand, but when I write only for two hours each morning – and that partly with the desire only to *secure* facts rather than to set them in the best light – the result needs a great deal of squeezing and lopping before it comes right.' And he was free to communicate his moments of despair. He wrote: 'When I have done these two books [*The Stones of Venice*, II and III], D.V. I shall give up being an author altogether. . . . It is a vexatious life: the pleasures of it not worth the labour – and the pains all into the bargain. I shall live in study of nature – go back to my old geology and mineralogy, and leave the world to darkness.'[62] This must have been discomfiting for John James, whose dearest wish was that Ruskin would finish *Modern Painters*. Maybe Ruskin was in a sense issuing a threat, because in the same letter he had to apologise for having spent far more in Venice than John James had expected. There is no indication that John James had threatened to cut off the funds. Nevertheless Ruskin can be read here as saying, in effect: 'If you start getting tight with the money there will be no more *Modern Painters*.' Also, he was living with a constant sense of real loss. As he wrote on 18 January 1852: 'The feeling of Time

running away from me operates very unfortunately on writing – for I am firmly persuaded that neither writing nor drawing can be done against time.' But *The Stones of Venice* was coming: 'I trust when you see the whole book together, with such retouching as I may be able to give it at home, that you will not think my twelve months in Venice have been misspent.' He worried that his text was too loose and needed condensing, but also – 23 January 1852 – he was robust with critics who said they cannot follow his arguments: 'People in general call me a bad reasoner – begging their pardon, because my reasoning is a little too consistent for them to follow without some pains – and because if they lose a link – they cannot recover it.'

This letter was remarkably peevish. Its main purpose was to persuade his father to buy as many drawings as possible as and when Turner's works came on the market in London. He complained that his father had not bought him enough Turners in the past (what would have been 'enough'?) and that he himself had not been sufficiently devoted to Turner over the past ten years; complained, too, of feebleness of circulation, a sensation of being nervous and unfit for work, and black despair over Italy. Looking at Italy now is 'really too painful – everything is being destroyed'. In a way this is a constant refrain: loss, destruction, loss of life, loss of time. His sense of his own old age was truly absurd: 'When a man is 33, and likely to lie by for several years – it is very possible he may not care to scramble [i.e. take mountain walks] much more.' He follows this with another threat to live abroad: 'Wherever *my home* is, I shall stay much more quietly than you might think. . . . My delight was always to *stay* in places that I loved.'63

John James tried hard to support the younger man in his emotional despondency and depression. On 28 January 1852, after returning to Venice from Verona, where he and Effie had been to a ball at Marshal Radetzky's (Effie was the '*reine du bal*'), Ruskin wrote: 'You do quite right to scold me about being sad.' He is distressed by the disappointments over the Turner acquisitions and also by the retouching of Tintoretto's *Paradise*. 'Men are more evanescent than pictures yet one sorrows for lost friends – and pictures *are* my friends. I have none others. . . . If the great Tintoret here were to be destroyed, it would be precisely to me what the death of Hallam was to Tennyson . . . with an addition of bitterness and indignation – for *my* friend would perish murdered – *his* by a natural death.'64

To stand back from Ruskin's letters from Venice is to be struck very

forcibly by Ruskin's extraordinary unhappiness. Here is this wealthy young man living in one of the most beautiful cities in the world with only himself to please and work for, and the very fact of his freedom appears to be a source of anguish. On Sunday 2 May 1852 he wrote that he was subject to a peculiar trial 'owing to my pleasure in my work being entirely dependent on my satisfying *myself*'. A man working for money has external pressure, while Ruskin works only for love. Perhaps the word 'love' is the key. Maybe the anguish is linked to the constant, aching sexual inadequacy which inevitably accompanied every day and night of this young man's life:

> For me, who am always doing things for love of them, if I can't do them, I feel like a lover who has lost his mistress – and a quantity of labour besides, and it is difficult to retain one's equanimity under such circumstances. I fancy also, I have more intense pleasure than others, in succeeding, and in obtaining something of what I want – and great light always implies great shadow – somewhere.[65]

*

The group of young painters who called themselves 'The Pre-Raphaelite Brotherhood' were Ruskinians who were unknown to Ruskin himself. William Holman Hunt, in particular, had read *Modern Painters*, I and II, in the 1840s and talked about them to his fellow-students at the Royal Academy, especially the brilliant young John Everett Millais.* Hunt said that 'Ruskin feels the power and responsibility of art more than any author I have read.'[66]

In 1848 Hunt and Millais became friendly with Dante Gabriel Rossetti, and the three men, under the influence of Keats's poems and of a book of reproductions of the frescoes in the Campo Santo at Pisa (works also of significance to Ruskin), formed themselves into a secret society devoted to the virtues of Italian painting that pre-dated Raphael. The three painters recruited four other friends, perhaps because seven was a mystical number: the PRB thus comprised three major painters, Hunt, Millais and Rossetti, a civil servant (William Michael Rossetti, Dante Gabriel's brother), two more painters, F.G. Stephens and James Collinson, and a sculptor, Thomas Woolner. It was

*John Everett Millais (1829–96) had entered the Royal Academy Schools as a child prodigy in 1840; was a gold medallist in 1846 and first exhibited at the Royal Academy in the same year. In due course he would be the most successful painter of the Victorian era, amassing a substantial fortune and becoming President of the Royal Academy.

Rossetti who deemed the Pre-Raphaelites a 'brotherhood'. This group of excited young men gave their Brotherhood an informal structure with an unofficial president, Hunt, and a chronicler, William Michael Rossetti, who wrote the *PRB Journal*. Forming this society and then seeking serious attention for their paintings at the Royal Academy was a strategic mistake; paintings exhibited by the young artists came in for scathing attacks in the press in the summer of 1850. Faithful in their attention to the natural world, the paintings took the Bible and Shakespeare as their texts: Millais exhibited *Christ in the House of his Parents* and *Ferdinand lured by Ariel,* and Holman Hunt exhibited *Claudio and Isabella.* Ruskin saw the paintings but did not pay much attention to them. It was the 1851 paintings from the PRB that Ruskin took seriously: Millais's *Mariana* (based on Tennyson's poem), *The Return of the Dove to the Ark* and *The Woodman's Daughter.* The other PRB paintings of the season were Hunt's *Valentine Rescuing Sylvia from Proteus* (from *Two Gentlemen of Verona*) and Collins's *Convent Thoughts.*

The Times published a ferocious attack on 7 May:

> We cannot censure as amply or as strongly as we desire that strange disorder of the mind or eyes which continues to rage with unabated absurdity among a class of juvenile artists who style themselves *Pre-Raphaelite-brethren*. Their faith seems to consist in absolute contempt for perspective and the known laws of light and shade, an aversion to beauty in every shape, seeking out every excess of sharpness and deformity. Mr Millais, Mr Hunt, and Mr Collins have undertaken to reform art on these principles. The Council of the Academy have allowed these extravagances to disgrace their walls for three years, and though we cannot prevent men from wasting their talents on ugliness and conceit, the public may fairly require that such offensive jests should not continue to be exposed as specimens of their profession.[67]

The Catholic poet Coventry Patmore was a friend of Ruskin's, and Millais conceived the bold idea of approaching him to get Ruskin to intervene (the subject for *The Woodman's Daughter* was taken from a Patmore poem). The plan worked and Ruskin wrote two letters to *The Times* in 1851 defending the young painters. The defence was magisterial, cautious and distant but effective. In his first letter, of 13 May, he regretted that the review of 7 May was 'scornful as well as severe' and then signalled that the Brotherhood might be the future of painting in England: 'I believe these young artists to be at a most critical period of their career – at a turning-point, from which they may either

sink into nothingness or rise to very real greatness.' He established the objectivity of his judgement; acknowledged that he had not much liked Millais's painting of *Christ in the House of his Parents*,which had been exhibited in the previous year; made it clear that he had no personal acquaintance with the artists; and distanced himself from what he saw at that time as their 'Romanist and Tractarian tendencies'. The nub of his first letter was this:

> These Pre-Raphaelites (I cannot compliment them on common sense in choice of a *nom de guerre*) do *not* desire nor pretend in any way to imitate antique painting as such. They know very little of ancient paintings who suppose the works of these young artists to resemble them. As far as I can judge of their aim – for, as I said, I do not know the men themselves – the Pre-Raphaelites intend to surrender no advantage which the knowledge or inventions of the present time can afford to their art. They intend to return to early days in this one point only – that, as far as in them lies, they will draw either what they see, or what they suppose might have been the actual facts of the scene they desire to represent, irrespective of any rules of picture-making; and they have chosen their unfortunate though not inaccurate name because all artists did this before Raphael's time, and after Raphael's time did *not* this, but sought to paint fair pictures, rather than represent stern facts.[68]

The second of the two letters from 'The Author of "Modern Painters"', published on 30 May, went into more detail about the paintings. As though to establish his claim to objectivity beyond reproach, Ruskin had some fairly harsh things to say about one of the figures in Millais's *The Return of the Dove to the Ark*: 'a type far inferior to that of average humanity, and unredeemed by any expression save that of a dull self-complacency'. But at the same time he praised other particularities of the painting, especially 'the ruffling of the plumage of the wearied dove' and the hay on the floor of the ark, 'painted not only elaborately, but with the most perfect ease of touch and mastery of effect'. He closed by saying of the painters:

> if they temper the courage and energy which they have shown in the adoption of their systems with patience and discretion in framing it, and if they do not suffer themselves to be driven by harsh or careless criticism into rejection of the ordinary means of obtaining influence over the minds of others, they may, as they gain experience, lay in our England the foundation of a school of art nobler than the world has seen for three hundred years.[69]

These sentiments were, of course, hugely gratifying to the Brotherhood. Hunt said that the first letter was like 'thunder out of a clear sky'. Hunt and Millais wrote to Ruskin, as Hunt recorded: 'After letting a sufficient interval to follow Ruskin's last letter in *The Times* to make sure we should not be influencing in any degree or manner the judgement of the writer, Millais and I posted a joint letter to thank him for his championship. The address in Gower Street [Millais's address] was given in the letter, and the next day John Ruskin and his wife drove to the house, they saw my friend.' The interview was 'mutually appreciated' and Millais became firm friends with Ruskin from that moment.[71] It was not in fact Millais's first meeting with Effie; they had met at a ball when they were adolescent.[72]

It was good for Ruskin to find a group of young artists who showed signs of creating a Ruskinian 'school of art' for Britain at a time when the world of the visual arts in general seemed to be turning against him. He was appalled by the vulgarity of the Great Exhibition, 1851, and of what was in effect a related project, the setting up of national Schools of Art to promote British industry by providing a training in design of mass-produced products. One of the directors of the Great Exhibition, Henry Cole, was authorised to set up government art schools which would teach new methods of 'ornamental' instruction. The effect of this was to segregate fine art, as taught at the Royal Academy, from applied art. Applied art was taught at the new museum and art school at South Kensington, and at related schools in Dublin, Manchester, Edinburgh, Birmingham and elsewhere. Ruskin was to attack this division between fine and applied arts in his lectures collected as *The Two Paths* (1859), and when he became Slade Professor of Fine Art at Oxford saw it as a major purpose to resist the 'Kensington Schools'.[72]

Millais was attracted by Effie's beauty, and soon asked her to model for him; a surprising request, surely, but one in which Ruskin acquiesced. Effie modelled the Highland wife in Millais's celebrated painting, *The Order of Release*, now in the Tate Gallery, in which the strong resolute woman has secured freedom for her husband, imprisoned after the 1745 Jacobite rising. It is tempting to see the painting as an encoded message – Effie needed to be released from her marriage – but it seems unlikely that at that stage Millais's feelings for Effie had progressed that far.

It was Ruskin's decision to take Millais, who had never seen

Scotland, together with Effie and Millais's brother, for a holiday at Glenfinlas, in the beautiful hilly region known as the Trossachs. Ruskin had been invited to give a group of lectures in Edinburgh. It seemed a good idea to visit *en route* his close friends Calverley and Pauline Trevelyan in Northumberland.

Lady Trevelyan was a formidably intelligent, childless woman, married since 1834 to Sir Walter (always known by his second name, Calverley) Trevelyan, descendant of a very grand West Country family (baronets since the seventeenth century and prominent in public service since the reign of Henry VI). Heir to great estates, he was a teetotaller, a geologist and botanist, and a man of austere piety. He was much older than his wife and older, of course, than Ruskin, but at Oxford he had been taught by the same William Buckland who had so impressed Ruskin at Christ Church, and this had given decided direction to his intellectual pursuits. He owned two splendid houses, one in Somerset and one at Cambo in Northumberland, some twenty miles north-west of Newcastle. Pauline Trevelyan much preferred Wallington Hall, the Northumberland house, because of the wild beauty and spaciousness of the landscape. Also, the cold austerity of life in Northumberland suited the temperament of both the Trevelyans. They greatly improved Wallington Hall, creating within it a magnificent Italianate saloon which was decorated in due course with frescoes by, among others, Ruskin. Ruskin himself did not admire Wallington but he loved Northumberland.

On the publication of *Modern Painters* Pauline Trevelyan had been an early convert; she regarded the book as a work of genius and agreed completely with its conviction that faithful registration of nature was the supreme tutor for young artists. In the West Country the Trevelyans were friends and neighbours of the Aclands, and thus of Ruskin's friend Henry Acland who promised as early as 1844 to introduce them to the new young genius, but their first meeting seems not to have taken place until 1847 when the Trevelyans called on the Ruskin family at Denmark Hill. Effie Gray was staying with them. By 1853 the Trevelyans, then, were established and very sympathetic friends of both Effie and John.

It is a tribute to Lady Trevelyan that she was able to retain the friendship of people who were antipathetic to one another. She was loyal to an artist who worked in Newcastle, William Bell Scott, director of the Newcastle Government School of Design. Later in the 1850s she helped Scott's career as a painter by commissioning from

him large murals showing work in Northumberland from two widely divided historical periods, the building of Hadrian's Wall and shipbuilding on the Tyne. Scott's work for the government schools meant that he and Ruskin were in opposite camps over the training of artists. Pauline Trevelyan brought the two men together but they disliked each other; Scott was a fairly rough and prickly personality, envious of Ruskin's fame and appalled, when he saw it, by what he held to be the finicky realism that Ruskin forced on his students at the Working Men's College. Ruskin in turn found little merit in Scott's painting.

On 22 June 1853 the Ruskin party arrived at Wallington. Lady Trevelyan had reviewed the 'Pre-Raphaelitism' pamphlet, and was pleased by the evidence in it that Ruskin was returning from the architectural studies of *The Stones of Venice* to his earliest interest, painting. They travelled on to Edinburgh and thence to Brig o' Turk at Glenfinlas in early July. A little later Henry Acland joined them for a few days. At Glenfinlas Ruskin made a lovingly detailed drawing of a gneiss rock, and on his father's instructions commissioned Millais to paint a portrait of him which would incorporate the rock. The painting was to have all the virtues of naturalism admired in *Modern Painters* and in Ruskin's writings on the Pre-Raphaelites: it would display a loving fidelity to water, plants and stones, the central figure to be at one with the minutely observed scene in which he was placed.

Throughout this holiday, Millais and Effie were, of course, falling in love. Millais was ten years younger than Ruskin and one year younger than Effie. To him the situation seemed hopeless, and as the summer wore on into autumn and he addressed himself to the highly uncongenial task of painting the great portrait of Ruskin, Millais became ill. Uncomprehending, Ruskin wrote in October 1853 to his mother to say that Millais seemed in a very low state of mind:

> I wish that the country agreed with Millais as well as it does with me, but I don't know how to manage him and he does not know how to manage himself. He paints till his limbs are numb, and his back has as many aches as joints in it. He won't take exercise in the regular way, but sometimes starts and takes races of seven or eight miles if he is in the humour: sometimes won't, or can't, eat any breakfast or dinner, sometimes eats enormously without seeming to enjoy anything. Sometimes he is all excitement, sometimes depressed, sick and faint as a woman, always restless and unhappy. I think I never saw such a miserable person on the whole.[73]

Millais's inseparable friend William Holman Hunt was planning to visit the East in order to paint biblical subjects in their settings (one of the products of this expedition was *The Scapegoat*). Ruskin wrote to him on 20 October to try to persuade him not to go, so desperate did Millais's condition seem to be:

> I can't help writing to you to night; for here is Everett lying crying upon his bed like a child – or rather with that bitterness which is only in a mans grief – and I don't know what will become of him when you are gone – I always intended to write to you to try and dissuade you from this Syrian expedition – I suppose it is much too late now – but I think it quite wrong of you to go. I had no idea how much Everett depended on you, till lately – for your own sake I wanted you not to go, but had no hope of making you abandon the thought – if I had known sooner how much Everett wanted you I should have tried.[74]

There is no reason to doubt that Ruskin was acting here out of real affection and concern for Millais. He was also, of course, acting in the interests of art; Millais's painting of him at Glenfinlas was not finished, and the artist's distress was such that it was impossible for him to work. Presumably the real source of his depression was the impossible triangle in which he found himself, developing passionate feelings for Effie while Ruskin, genial but cold and uncomprehending, appeared to push the two young people together. It was not difficult for Millais to see that Ruskin had no sexual interest in his wife and that the marriage was effectively over.

The Glenfinlas visit ended with the painting still incomplete and Ruskin delivered his Edinburgh lectures – the 'Lectures on Architecture and Painting' (on 1, 4, 8 and 11 November 1853, the last lecture being on Pre-Raphaelitism). The lectures, for which Ruskin was paid twenty guineas, were in the hall of the Philosophical Institution in Queen Street. Effie's parents came down from Perth, and Sir Walter and Lady Trevelyan travelled up from Wallington. The course was a success and afterwards relations between the Ruskin family and the Gray family seemed warm and cordial, reinforced by these events. Effie, by contrast, was ill with a sore throat and other symptoms, back at her parents' house at Perth.

Millais had developed a conviction that Ruskin was seeking to discredit his wife in order to put an end to the marriage. In December 1853 he wrote an extraordinary letter to Effie's mother – whom he had met for the first time at the Edinburgh lectures in November – describing Ruskin as a 'plotting and scheming fellow' and a 'quiet

scoundrel'. 'His absence in the Highlands seemed purposely to give me an opportunity of being in his wife's society – His wickedness must be without parallel if he kept himself away to the end that has come about, as I am sometimes inclined to think. Altogether his conduct is incomprehensible – he is either crazed, or anything but a desirable acquaintance.' And he railed against the Ruskin family: 'Why he ever had the audacity of marrying her with no better intentions is a mystery to me. I must confess that it appears to me that he cares for nothing beyond his Mother and Father, which makes the insolence of his finding fault with his wife . . . more apparent.'[75]

Millais knew that the marriage had not been consummated. And he may have been right to suggest that Ruskin and his parents were scheming to disgrace Effie so that a separation could be arranged.

Effie wrote to her parents, on 5 March 1854:

> I think you see John's plan clearly in regard to Millais – If I cannot go on with the Ruskins, I will do so at least till I see you in autumn or before it – but about Millais there is no doubt that he (John) is acting in a most decided manner to get me into a scrape. About this drawing of St Agnes, he most completely as far as I can learn from Sophie encouraged him to send it . . . last night I just thought, as I am now so accustomed to his ways, that notwithstanding all his approval that he might lead me into a mess and Millais too, and I said 'now you are going to Millais tomorrow what are you going to say to him from me. Do you really quite approve of my having this drawing and are you to tell him so.' 'No!' said he, 'I do *not* think you should take it – but you and Millais must settle that between yourselves.' I said that was quite impossible as I did not hold any intercourse with him – He looked incredulous and I said I will send the drawing back in the morning quite coolly.[76]

Effie, of course, was more intelligent and resourceful than the Ruskins realised. On 25 April 1854 she left her husband, ostensibly for a visit to her family but in fact for ever, and had a suit of nullity served on Ruskin at Denmark Hill, together with a packet containing her wedding ring, keys, account book and a letter for Mrs Ruskin with a copy for John James.[77]

Ruskin and his parents had got rid of Effie, but certainly not in the way they had hoped.

Ruskin was a self-sufficient man, notoriously reluctant to involve himself in the social world that had welcomed and fêted Effie, and giving the impression to everyone that his parents, his study, his books

and work were the society that he needed. Yet the unwelcome publicity that accompanied the end of his marriage made him aware that he needed his friends, and brought home the painful fact that the social world that he had shunned would itself be taking sides, and that some of its inhabitants would turn out to be harsh enemies. Fairly recent acquaintances included those prominent figures in the fine art world, Sir Charles and Lady Eastlake. Sir Charles Eastlake was president of the Royal Academy, 1850–65, and a leading figure in the Great Exhibition of 1851. Lady Eastlake professed friendship to both Ruskins but after the separation she became an energetic enemy of Ruskin, attacking his work in print with hearty animus.[78]* She wrote to Effie's mother:

> I continue to hear the same buzz of pity for her and indignation at him, and I continue to tell the tale [of Ruskin's impotence and his ill-treatment of Effie] whenever and wherever I think the *truth* can do good. Yesterday was the Private View at the Royal Academy [28 April 1854] . . . and the story was busy circulating through the rooms . . . I had not been long there when I saw Millais, so I went to him with a cordial heart, and asked a few commonplaces. We found ourselves suddenly in the *subject*, – my cheek white, his *crimson*. I asked him if he had heard anything from the other side, and he told me that he had had a note from J.R. on the *Wednesday*, merely saying in usual terms that he should delay a sitting [for the incomplete Glenfinlas portrait] till next week. Millais said that he did not know how he should bear to see him – truly I think it useless his finishing a picture which *nobody* will *look* at. He had known nothing of the *truth* and asked me with painful blushes if I had.[79]

Thomas Carlyle and his wife were becoming good friends of the Ruskins, yet their reaction to the affair of the marriage was mixed.† Jane Carlyle wrote to her brother-in-law on 9 May 1853:

> There is a great deal of talking about the Ruskin's here at present. . . .

*As a reviewer Lady Eastlake showed her form in a furious review of *Modern Painters*, I–III, for the *Quarterly Review*, March 1856. 'Mr Ruskin's writings have all the qualities of premature old age – its coldness, callousness, and contraction. There is no development apparent in all he has written. . . . His revilings of all that is most sacred in the past, and his insults to all who are most sensitive in the present, bear the stamp of proceeding rather from an unfeeling heart than a hasty judgement.' At her most excited she declares that his fertility in itself condemns him: 'One great proof, were there no other, of the falseness of Mr Ruskin's reasoning, is its quantity. Only on the wrong road could so much have been said at all. . . . Separate what is really to be thought and said about art from false assumption, futile speculation, contradictory argument, crotchety views, and romantic rubbish, and ninety-nine hundredths of what Mr Ruskin writes . . . will fall to the ground.'[80]
†The Carlyles had marital difficulties of their own; their marriage, like the Ruskins', was unconsummated.

There is even a rumour that *Mrs.* Ruskin is to sue for a divorce. I know nothing about it, except that I have always pitied Mrs. Ruskin, while people generally blame her, – for love of dress and company and flirtation. She was too young and too pretty to be left on her own devices as she was by her Husband, who seemed to wish nothing more of her but the credit of having a pretty, well-dressed Wife.

Carlyle wrote breezily to his brother on 27 November 1855, to say that Effie looked happy with her new husband (Millais) and that 'Ruskin is cheerful as if there had been no marriage invented among mankind'.[81] Against such a background – misunderstanding or laughter even from those he counted as friends – Ruskin greatly valued those whom he could really trust. Pauline Trevelyan proved one of the most loyal and supportive of his friends after the collapse of his marriage – Effie felt betrayed by her.

Among his male friends Henry Acland was a pillar of support. Ruskin's long and carefully considered letter to Acland is very revealing:

> 16 May 1854 [to Henry Acland Broad Street Oxford]
> My dear Acland, You have probably expected my promised letter with anxiety. I have been resting a little – after a period of much trouble – and keeping my mind as far as possible on other subjects – but I cannot delay longer telling you what you must wish to know.
>
> I married because I felt myself in need of a companion – during a period when I was overworked & getting despondent. I found Effie's society [could] refresh me and make me happy. I thought she loved me – and that I could make of her all that I wanted a wife to be. I was very foolish in thinking so – but I knew little of the world – and was unpracticed in judging of the expression of faces, except on canvas. I was especially deceived in the character of her parents, whom I thought straightforward & plain kind of people, but who were in reality mean, and designing. A fortnight before our marriage, – her father told me he was a ruined man – having lost all he possessed by railroads, and being some thousands of pounds in debt. I never expected any fortune with Effie – but I was surprised to hear this; and the fortnight spent in Edinburgh and at her fathers house before marriage was one of much suffering & anxiety – for *her* especially – who saw her father in the greatest misery about his future prospects, and was about to leave him, with a man for whom as it has since appeared, she in reality had no affection. I did what I could to support them all: but Effie appeared sadly broken by this distress, and I had no thought in taking her away but of nursing her – I never attempted to make her my wife the first night – and afterwards we talked together – and agreed that we would not, for some time consummate marriage; as

we both wanted to travel freely – and I particularly wanted my wife to be able to climb Alps with me, and had heard many fearful things of the consequences of bridal tours.

But, before three months had passed – I began to discover that I had been deceived in Effies character. I will not attempt to analyse it for you – it is not necessary for you to know it – nor is it easy for me to distinguish between what was definitely wrong in her – and what was disease – for I cannot but attribute much of her conduct to literal nervous affection of the brain – brought on chiefly I believe by mortification at finding that she could not entirely bend me to all her purposes. From the first moment when we were married, she never ceased to try to withdraw me from the influence of my father & mother – and to get me to live either in Scotland – or in Italy – or anywhere but near *them* – and being doubtless encouraged in this by her parents & finding herself totally incapable of accomplishing this purpose, mortification gradually induced hatred of my parents, and, at last, of me, to an extent which finally became altogether ungovernable, and which is now leading her into I know not what extremes.

The letter continues, telling the story of the marriage as one in which love was replaced by a power struggle:

My real sorrows were of another kind. Turner's death – and the destruction of such & such buildings of the 13th century, were worse to me, a hundredfold, than any domestic calamity. I am afraid there is something wrong in this – but so it is; I felt, and feel – that I have work to do which cannot be much helped by any other hand, and which no domestic vexation ought to interrupt – & I have always had the power of turning my mind to its main work & throwing off the grievance of the hour. But one thing tormented me much: The more I saw of my wife – the more I dreaded the idea of having children by her, and yet I felt it my duty to consummate the marriage whenever she wished. I straitly charged her to tell me if she thought her health suffered by the way in which we lived: – but it fortunately happened that at first she dreaded rather than desired consummation – and at last, seemed to have no feeling for me but that of hatred. For my own part I had no difficulty in living as we did, for her person – so far from being attractive, like her face, was in several respects displeasing to me.[82]

. . . One thing you ought to know – I need not caution you respecting the necessity of silence respecting it – but I think half confidences are no confidences. I have, myself, no doubt that Effies sudden increase of impatience and anger – and the whole of her present wild proceeding is in consequence of her having conceived a passion for a person whom, if she could obtain a divorce from me, she thinks she might marry. It is this which has led her to run all risks, and encounter all opprobrium.

After the collapse of his marriage Ruskin was curiously inert and fatalistic. He left his father and the lawyers to establish the terms of his separation and divorce from Effie, but he did write a statement (27 April 1854) giving his own account of the marriage,* in which he said that he and Effie had agreed not to consummate the marriage at first because they did not want children, and that later her aversion to him was such that there was no question of its consummation. He insisted that he was capable of consummating it, and we know from letters to his friend Mrs Cowper-Temple (over his tragic love for Rose La Touche) that he habitually masturbated; presumably he was referring to this in the document when he said: 'I can prove my virility at once.'[83]

Famously he said in this document that though Effie's face 'was beautiful, her person was not formed to excite passion. On the contrary, there were certain circumstances in her person which completely checked it.'[84] It has often been thought that this means that he did not know that women have pubic hair, because he had never seen a naked woman and the images of nude women that he had seen before his marriage had been Classical statues. It is likely, though, that the young aristocrats of Christ Church, with their pictures of 'naked bawds', did not leave him innocent about women's bodies, and that he was referring perhaps to menstrual flow or a smell he found unpleasant. Whatever the physical cause, his revulsion from Effie was clearly complete and has to do with deep problems in his sexuality. Presumably he was very attracted when he first met her (that is, when she was a child) but was unable to sustain his libido for her when she became an adult.

Ruskin's defence failed: on 15 July 1854 the marriage was annulled on the grounds of his 'incurable impotency'.[85]

Effie had had to undergo a medical examination, which showed that she was indeed a virgin. She married Millais in 1855 and was later to be a feared matriarch as Lady Millais, mother of eight children (as though she was seeking to make a point about Ruskin's 'impotency'). She was vindictive towards Ruskin to the end of her days. Millais was bound to complete the painting of Ruskin so there were further frosty and constrained sittings. Thereafter Ruskin made ill-advised attempts to stay friendly but Millais, not unnaturally, sharply rebuffed him.

*

*This statement was never used by his lawyers.

The disaster of the divorce freed Ruskin, and his parents, from a bond that had certainly, by 1853, become hateful and irksome. In 1854 he took a summer visit to Switzerland with his parents, happy to be free of his 'commonplace Scotch wife', determined to return now from *The Stones of Venice* – which had in a sense been Effie's book – to *Modern Painters* which was still above all his father's book.

John James Ruskin was wily and worldly enough to know that getting shot of Effie was to some extent a Pyrrhic victory. The word 'impotency' would do his son no good at all; it was damaging to his reputation and John James Ruskin may also have seen that it blocked any further marriage for his son, though given their possessiveness he and Margaret probably had few regrets about that aspect of the case. They had the satisfaction of feeling that John was theirs again. And, to the extent that he now devoted himself to the filial duty of finishing *Modern Painters*, this was true. But late in 1854, after the Swiss expedition, Ruskin embarked on a new interest of which his father was bound to disapprove.

In June 1855 John James Ruskin wrote an angry letter to Acland:

> 7 Billitter Street, City, London, 26 June 1855
> From a single passage read to me from a Letter of yours to my son, I find there is some impression on your mind of a meeting having had place yesterday at Denmark Hill on the subject of a working man's College at Oxford. – When at Tunbridge Wells my son had a note from Mr Furnivall saying Professor Trench and Mr. Monro (Sculptor) wished to see the Drawings and he would bring them out Monday 25th Jany. They came, with a Mr. Bayne of Edinb. and unless there was a Secret Conclave in the forenoon – I know after dinner not a word passed about a workman's college, and with due deference to Cambridge, I trust no such absurdity will obtain a footing at Oxford.
>
> Mr. Furnivall, a most amiable Radical and Philanthropist seems to have nothing to do but to start projects for others to work, and he may have an Eye to Oxford – but I sincerely hope neither you nor my son will take any trouble about it. I think both your Father and Mrs Acland must have been saddened to see the weight of work thrown upon you by the Museum. That must be at least quite enough for you and I know my Son has enough to do with his writings and his London College. I became reconciled to the latter because he seems to do good service to some good and true men, but neither kindness nor Charity require all places to be made the scene of these amiable Exploits – I should like the Experimentalists to feel their way – to go along gently and discreetly. It may be lack of enthusiasm in me makes me fear a lack of discretion in

them. I hope in trying to drag up the low they will not end in pulling down the high – very well for Mr Kingsley to dislocate society to make a Novel out but I hope they don't want Taylors yet at Stafford House – except for the legitimate purpose of taking measure for coat or trowsers.[86]

The background to this was Ruskin's involvement in the Working Men's College in London which had begun the previous year, November 1854. Ruskin had been recruited into the college by its founder, F.D. Maurice. He had met Maurice through correspondence over a paper on the nature of the priesthood which in turn arose from his preoccupation with religious questions in *The Stones of Venice: Notes on the Construction of Sheepfolds*, (1851). His friend F.J. Furnivall acted as intermediary between the two men. For Maurice to secure Ruskin as a practical drawing teacher at the Working Men's College was a considerable coup. Ruskin taught fortnightly classes at the college between 1854 and 1858, and taught there again in 1860.

Frederick James Furnivall (1825–1910) was one of those hugely energetic Victorians whose life-histories make them seem superhuman. A barrister who championed social reform and democratic principles, he wrote for the *Christian Socialist* and in 1850 published a pamphlet on 'Association a Necessary Part of Christianity'. He greatly admired all Ruskin's early books and in 1851 he invited F.D. Maurice's opinion of Ruskin's 'Notes on the Construction of Sheepfolds' and passed on the replies to Ruskin. He opened a Christian Socialist school in Bloomsbury, in 1849. In 1852 he and Maurice formed a Working Men's Association to give classes and hold lectures in Castle Street East, off Oxford Street. This led to the opening of the Working Men's College in Red Lion Square, 26 October 1854, with F.D. Maurice as principal.*

Furnivall, who has been described as 'devoid of tact or discretion in almost every relation of life', later quarrelled with Maurice, causing Maurice to resign as principal of the college. In the collapse of Ruskin's marriage to Effie, Furnivall took his side, and he remained loyal to Ruskin for the rest of his professional life. He also continued to involve Ruskin in his schemes; for example, in 1864 he founded the Early English Text Society and recruited, among seventy-five others, Ruskin and Tennyson as subscribers. (He was also, from 1876, a founder of the *New English Dictionary*.)

*The college later moved to Great Ormond Street.

F.D. Maurice (1805–72), another giant of energy and philanthropy, a messianic figure who published some forty books, was the founder of Christian Socialism – a movement with which Ruskin found it difficult to feel sympathy, although Furnivall aligned himself with it for a time. Maurice had been in holy orders since 1830 and he was also Professor of English Literature and History at King's College, London in 1840 and Professor of Divinity in 1846. The Chartist movement of the 1830s had moved him to publish a piece in the *Educational Magazine* (1839) in which he said that the Chartists should be treated as brothers, and that they should be supported in their demand for a society in which high and low, rich and poor, should be in fellowship as equals. The whole nation needed to see that these were also Christian principles.

The risings in 1848 in many of the major cities of Europe (including Ruskin's beloved Venice as well as Paris and London) and more demonstrations from the Chartists in that year triggered a further stage in Maurice's thinking. With a young barrister, John Malcolm Ludlow (with whom the concept of 'Christian Socialism' originated), and the novelist and historian Charles Kingsley, he published a periodical called *Politics for the People*; this attracted the support of other philanthropic and radical figures: Thomas Hughes, the poet Arthur Hugh Clough and, of course, Furnivall. The Working Men's Associations and subsequently the Working Men's College grew from these roots. Maurice was deprived of his appointment at King's College for the 'heterodoxy' of his *Theological Essays* in 1853, and as a direct result was invited by the Christian Socialists in 1854 to lead the new Working Men's College. Ruskin's teaching was seen as fundamental to the Working Men's College; 'The Nature of Gothic' from *The Stones of Venice*, II, was published as a pamphlet and distributed free of charge at public meetings to recruit students to the college.

Maurice believed in fellowship. For him the object of adult education was to develop the whole personality, and this could best be achieved within the corporate life of a college. He did not seek to erase the differences between the social classes, instead he looked for a productive relationship between men of learning and the working class. The teachers were to be 'tutors and not professors and should give lessons rather than lectures'. Each lesson was to be followed by free discussion: what in modern terms we would call a seminar.

Maurice's ideal was to adapt the principles of William of Wykeham's great foundations, Winchester College and New College, Oxford, for the working man. In *Learning and Working* in 1855 he wrote that

Instead of having the least of a monastical tendency, [William of Wykeham] was the best man of business of his time, the most thoroughly conversant with all civil affairs. . . . It is the union of Winchester College with New College, of the school for boys with the school for men, which is the great fact of his life. He evidently felt that the time was past when any good could come from the foundation of monasteries or abbeys; but that the principle which had been latent in them, and which was only producing idlers, might be turned to profit, provided the school and life could be connected, provided the stiff scholarship which belonged to the man could be bound up with the growth and expansion of the boy, through healthful exercises of the body as well as mind.[87]

This kind of education could transform the working class, not by elevating it but by enlightening it:

We have neither of us ever doubted that the whole country must look for its blessings through the elevation of its Working Class, that we must all sink if that is not raised. We have never dreamed that that class could be benefited, by losing its working character, by acquiring habits of ease or self-indulgence. We have rather thought that *all* must learn the dignity of labour and the blessing of self-restraint. We could not talk to suffering men of intellectual or moral improvement, without first taking an interest in their physical condition and their ordinary occupations. . . . We have never thought that we could help them to be individually wise or individually good, if we forgot that they were social beings, bound to each other by the ties of family, neighbourhood, country, and by a common humanity.[88]

The first 145 pupils were working-class or upper working-class men, who were extraordinarily lucky in their teachers; these included Kingsley, Hughes, Furnivall, Ruskin and Rossetti.[89] The college was 'the first serious attempt made in England to help workmen to attain to a full and satisfactory life, not by following the great social illusion of rising into a different class, but by simply fulfilling the most urgent needs of intellect and spirit. . . . It was an attempt to produce, through an affectional link between the master and labouring classes, a new type of social democracy based on mutual respect and understanding, order and goodwill.'[90] To this extent, with its emphasis on community and fellowship and its resistance to competition and personal advancement, it anticipated the good society – rural, free of technology, capitalism and competition, happy in its work and loyal to its 'masters' – that Ruskin was to advocate in *Time and Tide* and *Fors Clavigera* and was to establish in the Guild of St George.

It was Ruskin, of course, who brought Rossetti into the college as a

teacher. No institution, Oxford included, was to find Ruskin regular or reliable: his financial independence combined with a deep temperamental resistance to institutions of any kind and, more particularly, a resistance to having his time disposed of by persons other than himself or his parents, made him an impossible colleague. So Rossetti was recruited to cover for him when he was unable to take his classes at the college. The stormy friendship with Dante Gabriel Rossetti (1828–82) – whom Ruskin loved but treated as a brilliant, exasperating, wayward child – was a direct result of Ruskin's championing of the Pre-Raphaelites in his letters and pamphlets but had only taken root in 1854 after the friendship with Millais had ended. In a sense, Rossetti filled the emotional gap that Millais's spectacular defection had created.

The relationship was in some terms doomed from the start because Ruskin poured money into Rossetti in the belief that he could control him and dictate the way in which he would paint, whereas Rossetti contemptuously saw Ruskin as infatuated, a ready source of income constantly available to be milked, and an irritating master whose instructions were to be resisted.

Ruskin had known Rossetti's work since 1852, and had praised some of his paintings to mutual acquaintances, prompting a sneering remark from Rossetti to the sculptor Woolner: he wrote that Ruskin

> goes into raptures about the colour and grouping which he says are superior to anything in modern art; which I believe is almost as absurd as certain absurd objections which he makes to them. However, as he is only half informed about Art anything he says in favour of one's work is, of course, sure to prove invaluable in a professional way, and I only hope, for the sake of my rubbish, that he may have the honesty to say publicly in his new book [the later volumes of *Modern Painters*] what he has said privately, but I doubt this.[91]

In 1854 Ruskin wrote enthusiastically to Rossetti about *Dante Drawing an Angel in Memory of Beatrice*, saying: 'I think it a thoroughly glorious work – the most perfect piece of Italy, in the accessory parts, I have ever seen in my life.' When they met a few days later Rossetti did not take to Ruskin – found him ugly, regarded him as a man of essentially sterile mind, being a mere critic rather than an artist, but nevertheless recognised that, as he reported to Ford Madox Brown, Ruskin seemed 'in the mood to make my fortune'.[92]

He responded to the power of Ruskin's money, and in 1855 he acquiesced in Ruskin's wish that he should take a class at the Working

Men's College. Ruskin was exasperated by Rossetti's indolent habits of work, 'beginning work at nine o'clock and working impetuously till daybreak', but remained infatuated, throughout this year, with his talent and later with that of his mistress, the beautiful model Lizzie Siddal, who was also a painter and a designer. Lizzie, or 'Guggum' as she was known among the PRB, was in poor health and Rossetti saw Ruskin's interest in the two of them as a possible source of security; accordingly he allowed Ruskin to visit his studio while he was working (though this was something he hated) and he laboured to finish paintings which he hoped Ruskin would buy, *We are Seven* and *La Belle Dame Sans Merci*.[93] He put up with irritating criticism and advice from Ruskin. Because he was paying and was convinced that he was right Ruskin felt free at all times to use the imperative mood in his dealings with Rossetti, as, for example, in this letter of April 1855:

> I am not more sure of anything in this world (and I am very positive about a great many things) than that the *utmost* a man can do is that which he can do without effort. All beautiful work – singing, painting, dancing, speaking – is the *easy* result of long and painful practice. *Immediate* effort always leads to shrieking, blotching, posturing, mouthing.
>
> If you send me a picture in which you try to do your best, you may depend upon it it will be beneath your proper mark of power, and will disappoint me. If you make a careless couple of sketches, with bright and full colour in them, you are sure to do what will please me. If you try to do more, you may depend upon it I shall say 'Thank you for nothing' very gruffly and sulkily. . . . I tell you the plain truth – and I always said the same to Turner – 'If you will do me a drawing in three days, I shall be obliged to you; but if you take three months to it you may put it behind the fire when it is done.' And I should have said precisely the same thing to Tintoret, or any other *very* great man.[94]

Rossetti was being put in august company indeed! Ruskin was working hard to secure Rossetti's affection. He wrote as though Rossetti was an ideal confidant who could be trusted with Ruskin's disappointments and emotional vulnerability:

> You constantly hear a great many people saying I am very bad [in the aftermath of his failed marriage and the attendant gossip], and perhaps you have been yourself disposed lately to think me very good. I am neither the one nor the other. I am very self-indulgent, very proud, very obstinate, and *very* resentful; on the other side, I am very upright . . . I never betrayed a trust – never wilfully did an unkind thing – and never, in little or large matters, depreciated another that I might raise myself. I believe I once had affections as warm as most people; but partly from evil chance,

and partly from foolish misplacing of them, they have got tumbled down and broken to pieces. It is a very great, in the long-run the greatest, misfortune of my life that, on the whole, my relations, cousins and so forth [the working-class Richardsons], are persons with whom I can have no sympathy, and that circumstances have always somehow or another kept me out of the way of the people of whom I could have made friends. So that I have no friendships, and no loves.

This was embarrassingly personal stuff. And it was followed by extravagant praise for Rossetti which – if he had had any shame in his dealings with Ruskin – Rossetti should have found no less embarrassing:

> It seems to me that, amongst all the painters I know, you on the whole have the greatest genius, and you appear to me also to be – as far as I can make out – a very good sort of person. I see that you are unhappy, and that you can't bring out your genius as you should. It seems to me then the proper and *necessary* thing, if I can, to make you more happy, and that I should be more really useful in enabling you to paint properly and keep your room in order than in any other way.

This reads like an adolescent love letter, although it also has a governessy shaft embedded in it – 'keep your room in order' – but it was actually a rich man's business proposition. He intended to pay Rossetti a regular income in return for paintings, though he had to come to a financial agreement with John James – who, as ever, held the purse-strings – before he could name his figure. He added a sad postscript saying that he was not seeking by patronage to buy back the reputation that he had lost over his marriage, it was not 'in any wise an endeavour to *regain* position in public opinion. I *am* what I always was.'[95]

Ruskin was clearly in a very emotional state and displaying poor judgement. Rossetti was incapable of being the friend Ruskin wanted, but went along with the supposed intimacy for the moment in order to secure Ruskin's money. Elizabeth Siddal was thought to be suffering from consumption, and in May 1855 we find Ruskin arranging for her to be seen by Henry Acland and if necessary to be sent to the south of France or to Italy (at Ruskin's expense) for the good of her health.[96] Acland and his wife had her to stay with them in Oxford. She was a difficult guest. Henry Acland wondered whether she was not a malingering or at least a neurotic patient. He found nothing wrong with her lungs at all. He did think, however, that she had a nervous disorder. Ruskin felt some contrition over having landed Lizzie Siddal

on the Aclands. He wrote to Acland's wife to say: 'I don't exactly know how that wilful Ida [Ruskin's name for Lizzie, borrowed from Tennyson's *The Princess*] has behaved to you. As far as I can make out, she is not ungrateful but sick, and sickly headstrong – much better, however, for what Henry has done for her. But I find trying to be of any use to people is the most wearying thing possible.' Ruskin was learning the hard way that talent is apt to resent its patrons. 'The true secret of happiness would be to bolt one's gates, lie on the grass all day, take care not to eat too much dinner, and buy as many Turners as one could afford. These geniuses are all alike, little and big. I have known five of them – Turner, [G.F.] Watts, Millais, Rossetti, and this girl [Lizzie Siddal] – and I don't know which was, or which is, wrong-headedest. I am with them like the old woman who lived in the shoe, only that I don't want to send them to bed, and can't whip them – or else that is what they all want.'[97] Rossetti's ingratitude was the more galling since to cherish Rossetti was an act of rebellion.

Because of the end of the marriage, John James Ruskin had taken against Millais and all the PRB. In a later letter (probably January 1856) Ruskin had to warn Rossetti to make no reference to the fact that he was painting for Ruskin and receiving payment from him:

Don't say anything about pictures or money in answer to this, unless you send answer by bearer, because my father thinks me mad about Pre-Raphaelitism, and has been so provoked by Millais' behaviour that he is set against all of you, so that I am obliged to keep my pictures quiet, yet a while. I don't mean that my father does not like you personally; he likes you very much; but he don't like my getting thick again with any PRB.[98]

His relations with the Rossettis would run their complex course. In the meantime at the Working Men's College he made a number of contacts with the working men themselves which would be fruitful and important for him. Among them were William Ward and Arthur Burgess, later to work for Ruskin as copyists; J.W. Bunney, another copyist, and one of the most dedicated and hard-working; George Allen, who later became Ruskin's publisher; and Henry Swan, later curator of the Sheffield Museum which Ruskin founded in the 1870s. When he took these men on Ruskin barely differentiated between them and his household servants, and it is here that we have the model of what would become for Ruskin his utopia in his political writings: the perfectly managed fiefdom, with dedicated craftsmen working in

unquestioning obedience for a benevolent lord. For every uncontrollable Rossetti or Millais there was an Allen or a Bunney whose grumbles, if they grumbled at all (Bunney in fact grumbled a great deal), could never smoulder into open defiance. This aspect of his dealings with other people is one of the things that Ruskin is referring to when he says in *Praeterita* that he was a 'Tory of the old school'.

CHAPTER 5

1856–64

THERE IS NO WEALTH BUT LIFE. Life, including all its powers of love, of joy, of admiration. That country is the richest which nourishes the greatest number of noble and happy human beings; that man is richest who, having perfected the functions of his own life to the utmost, has also the widest helpful influence, both personal, and by means of his possessions, over the lives of others. (John Ruskin)[1]

Oh how strange a place is this world! Only those seem to possess power who don't know how to use it. What an accumulation of wealth and impotence! Is this what is gained by stability and old institutions? Is it for this that a people toils and wears out its myriad lives? For such heaping up of bad taste, for such gilding of hideousness, for such exposure of imbecility. (Ford Madox Brown)[2]

Ford Madox Brown and John Ruskin held each other in mutual suspicion and distaste, yet the two quotations used as epigraphs to this chapter – passages about 'wealth' from Ruskin and Madox Brown respectively – demonstrate a continuity between the attitudes held in common among the Pre-Raphaelite Brotherhood and the political views that Ruskin was developing in the 1850s. For Ruskin, defending the PRB was a blow for personal freedom and a translation into practice of his theories as art critic. Concurrently, his major practical architectural project of the 1850s, the Oxford Museum, was a translation into practice of his theories as a critic of architecture. The Oxford Museum is in a sense the only authentic Ruskinian Gothic building to be completed.

The museum was the brainchild of Henry Acland. This brilliant, persuasive and hugely energetic man had devoted himself to a crusade, which was to drag Oxford University into the nineteenth century by getting it to take the natural sciences seriously. When Acland and Ruskin were undergraduates in the late 1830s Oxford was still essentially an eighteenth-century institution, its magnificent resources devoted to maintaining the Classics and the Church of England and to furnishing a playground and finishing school for (male) members of the

ruling class. Acland's approach was two-pronged. Appointed Lee's Reader of Anatomy in 1845, he was acutely aware that there was an urgent need in the university for improved teaching facilities in the sciences, and to accompany this he wanted a museum for the physical sciences. In 1847 he initiated a campaign for the establishment of 'an edifice within the precincts of the University for the better display of materials illustrative of the facts and laws of the natural world', and in 1848 he and other beleaguered scientists urged the creation of an Honour School of Natural Science for undergraduates (it was established in 1850). In 1849 he set up a committee for the establishment of a museum 'with distinct departments under one roof, together with Lecture Rooms, and all such appliances as may be found necessary for teaching and studying the Natural History of the Earth and its inhabitants'.[3] His timing was good; the whole university was being overhauled by a state-appointed commission, and one of the commission's recommendations, when it reported in 1852, was the founding of a museum.

By 1854 a competition had been held to agree the design of the new building. The winning design came from two Irish architects based in Cork, Thomas Deane and Benjamin Woodward, disciples of Ruskin's writings on architecture. The detail and the methods of Trinity College, Dublin, their previous major commission, had been consciously Ruskinian, with care taken to ensure that the craftsmen were given independence of action as they carved the decorative features.

The successful design for the Oxford Museum combined the features of a late Gothic Venetian palace (its trefoil windows of the kind that Ruskin had illustrated so carefully in *The Stones of Venice*) with features of a north European secular Gothic building such as the cloth hall at Ypres. The main space was to be roofed with glass supported by iron, which was a violation of the Ruskin principles, but the details of decoration were to be entirely Ruskinian: corbels and capitals carved by craftsmen to illustrate the plant and animal kingdoms. A linked adjacent building was based on the Abbot's Kitchen at Glastonbury.

The building must have looked much better in 1859 than it does now, since before the erection of Keble College the museum stood proudly in its own space on the fringe of the University Parks and faced part of St John's College garden, whereas it now faces Keble, standing back from a fairly busy road, and has tourists and traffic hurrying past and some undistinguished later buildings crowding round it and behind it. This last drawback, though, is in a sense owed to Acland's plan: it

was always his intention that the building should be added to as the study of science developed, and this is what has happened.

Ruskin was delighted with the outcome of the competition. Through Rossetti he had come to know and like Benjamin Woodward, the younger and more talented member of the Irish partnership. The winning design was in fact Woodward's work. Since the choice of a Gothic and Venetian style was a direct result of his own advocacy in his books, Ruskin could scarcely have been other than pleased. On the day that he learnt of the success of Deane and Woodward's design he wrote to Acland:

> I have just received your telegraphic message from Woodward, and am going to thank God for it and lie down to sleep. It means much, I think, both to you and me. . . . The Museum in your hands, as it must eventually be, will be the root of as much good to others as I suppose it is rational for any single living soul to hope to do in its earth-time.[4]

He wrote later 'that the essence and power of Gothic, properly so called, lay in its adaptability to all need; in that perfect and unlimited flexibility which would enable the architect to provide all that was required, in the simplest and most convenient way; and to give you the best offices, the best lecture-rooms, laboratories, and museums, which could be provided'.[5]

The museum was to display a *fusion* of art and science, and part of Ruskin's ambition was that the PRB should contribute designs. He wrote excitedly to Acland:

> I hope to be able to get Millais and Rossetti to design flower and beast borders – crocodiles and various vermin – such as you are particularly fond of – Mrs Buckland [wife of the celebrated geologist]'s 'dabby things' – and we will carve them and inlay them with Cornish serpentine all about your windows. I will pay for a good deal myself, and I doubt not to find funds. *Such* capitals as we will have![6]

Millais had recently completed his vexed portrait of Ruskin at Glenfinals; Ruskin and his father were very proud of it, and Ruskin had written a warm letter of congratulation to Millais seeking to establish some kind of friendly footing. Millais sharply rebuffed him; Ruskin was hurt and John James angry.

As it happened, neither Rossetti nor Millais made designs, but other artists were persuaded, including the PRB member Thomas Woolner and his fellow-sculptor Alexander Munro. Ruskin and his father funded a set of windows and a statue. Ruskin himself made a number

of designs for capitals and window decorations, and one at least of his windows is still there (the first window to the left above the main entrance to the building).

The raising of funds was always going to be a problem. The university had voted a niggardly sum – £30,000. As well as putting in money himself, Ruskin persuaded Sir Walter and Lady Trevelyan and a Leeds friend, Miss Heaton (later a member of the Guild of St George), to contribute, and in 1859 Acland published a fund-raising book about the museum which included as part of its ammunition two long letters from Ruskin.

The university could not see the point of voting money for decoration. And yet the carving of the capitals and windows was the most purely 'Ruskinian' feature of the whole adventure. Woodward brought over from Ireland two stonemasons, brothers, genial red-bearded giants called James and John O'Shea. They and their nephew, Edward Whellan, carved forty-six capitals and a number of windows. They were craftsmen of genius, bringing in plants from the botanical gardens each day to carve the examples of flora in the capitals and corbels, while birds, insects and mammals were taken from the museum's own collection. The Irish masons were aware of their own skill and did not respond to directions – in short they behaved exactly as Ruskin's ideal creative craftsman was supposed to behave. And this caused trouble. In the entrance vestibule of the building they developed a freer hand than in the interior decorations and here they carved rabbits, owls and snakes. Congregation thought this decorative work was unnecessary and would not vote funds for carving the upper windows. James O'Shea received encouragement and vague promises of further funding from Ruskin and Acland, and he continued to work. He said of the windows: 'I never carved anything in my life that I will be so proud of if I do these . . . if I was to doo [sic] all the upper windows I would carve every jamb for nothing for the sake of art alone.' When it became known that unauthorised work on the museum was continuing, O'Shea was ordered to stop. Angrily he began work on images of parrots and owls on the portal arch of the museum (these incomplete carvings are still clearly visible) caricaturing the myopic obstinacy of the members of Congregation. The university could take no more and the O'Sheas were dismissed.[7]

In the 1870s, Ruskin came to regard the Oxford Museum as an underfunded failure and the taking-on of a lively Irishman as a mistake, but in adopting this view he was being disloyal to his younger self: the

Oxford Museum is *the* central Ruskinian building, and the O'Sheas were the epitome of the Ruskinian workman. He may not have liked to acknowledge it, but Ruskin was never to see his ideas translated into practice so fully as in the Oxford Museum in the 1850s.

Concurrent with the Oxford Museum was another Gothic project, the completion and decoration of the Oxford Union Library, another Deane and Woodward building, in which Morris, Burne-Jones, Rossetti and others spent a gleeful summer in 1857 painting frescoes on Arthurian themes. The building was newly completed and the walls on which they were painting were still damp, so that the frescoes – today much restored – are now barely visible, though Morris's lavishly decorated ceiling (restored by Morris himself) is a success.* But the young men had a great deal of fun. Ruskin took a warm interest in the project and paid for some of the work. He tried to exercise some control over the young artists but found them like naughty children. We find him complaining that the roof decoration '*is* and is *not* satisfactory – clever, but not right' and that the artists themselves are 'all the least bit crazy, and it's very difficult to manage them'.[8]

With the end of his marriage Ruskin had gone back to the old pattern of life, living with his parents at Denmark Hill and devoting himself to his work with his father's continuing love and encouragement. His work in the 1850s was demanding but largely congenial: the Oxford Museum, the completion of three more volumes of *Modern Painters*, and the huge task of sorting and conserving some 19,000 sketches and drawings left to the nation by Turner. The Turner material was in tin boxes in the basement of the National Gallery. With two assistants, William Ward and George Allen, Ruskin 'was at work all the autumn and winter of 1857 every day, all day long, and often far into the night', and he recalled: 'I have never felt so much exhausted as when I locked the last box and gave the keys to Mr. Wornum [keeper of the National Gallery] in May 1858.'[9] He also became surprisingly sociable. Effie, he believed, had tried to force him into a trivial social life ('I would not allow the main work of my life to be interfered with. I would not spend my days in leaving cards, nor my nights in leaning against the walls of drawing rooms'[10]). Now he could have the society of his choice.

*

*Had Ruskin been consulted, he would have counselled them that painting a fresco on newly laid bricks covered with fresh whitewash was not going to work.

Ruskin's social circle spread wide in the 1850s. With his letters to *The Times* he promoted the careers not only of Millais but also of Holman Hunt. His endorsement of Holman Hunt's *The Light of the World* (5 May 1854) cannot be improved on as a reading of that painting. In his account of the artist's *The Awakened Conscience* (25 May 1854) he might well have been making a point about Effie's lack of fidelity; he wrote about the sense of guilt shown by the woman in the painting as she becomes aware that she has 'fallen':* 'I suppose that no one possessing the slightest knowledge of expression could remain untouched by the countenance of the lost girl, rent from its beauty into sudden horror; the lips half open, indistinct in their purple quivering; the teeth set hard; the eyes filled with the fearful light of futurity, and with tears of ancient days.'[11]

His circle also now extended to some of the major poets of the day; he already knew Coventry Patmore, William Allingham and Samuel Rogers, but the great poets of the period were coming into flower in the 1850s and though Tennyson, who admired Ruskin's writing from a distance, was never more than an agreeable acquaintance, with Robert and Elizabeth Barrett Browning Ruskin became a close friend. The friendship with Browning was particularly lively. The two men had much in common: both lower-middle-class, both hugely interested in everything, both intensely responsive to Italy, both auto-didacts.

Ruskin wrote to Browning on 2 December 1855:

> I cannot at all make up my mind about these poems of yours [*Men and Women*]; and so far as my mind *is* made up, I am not sure whether it is in the least right. Of their power there can of course be no question – nor do you need to be told of it; for everyone who *has* power of this kind, knows it – *must* know it. But as to the Presentation of the Power, I am in great doubt. Being hard worked at present, & not being able to give the cream of the day to poetry – when I take up these poems in the evening I find them absolutely and literally a set of the most amazing Conundrums that ever were proposed to me. I try at them, for – say twenty minutes – in which time I make about twenty lines, always having to miss two, for every one that I make out.

He then reads 'Popularity',† line by line, giving examples of 'obscurity'. The case is well made, and he then takes the central image

*In *Brideshead Revisited* Evelyn Waugh chose this passage as epitomising Victorian attitudes to sexual guilt.
†The poem in which Browning explored the survival of the Romantic tradition (that of Keats) into the hacks' world of the mid-century.

of the poem – the idea that genius, like that of Keats, resembles the murex, the sea-shell which has to be fished up and pounded before it will yield its famous dye, the Tyrian purple – as a metaphor for all Browning's poems in this volume:

> There is a stuff and fancy in your work which assuredly is in no other living writer's, and how far this purple of it *must* be within this terrible shell; and only to be fished for among threshing of foam & slippery rocks, I don't know. There are truths & depths in it, far beyond anything I have read except Shakespeare – and – truly, if You had just written Hamlet, I believe I should have written to you, precisely this kind of letter – merely quoting your own Rosencrantz against you – 'I understand you not, my Lord.' . . . When a man has real power, God only knows how he *can* bring it out, or ought to bring it out. But, I would pray you, faith, heartily, to consider with yourself, how far you can amend matters, & make the real virtue of your work acceptable & profitable to more people.[12]

Browning defended himself energetically in a letter containing a famous phrase that may be taken as an epigraph to much of his work: 'all poetry being a putting the infinite within the finite':

> We [he and Ruskin] don't read poetry the same way, by the same law; it is too clear. I cannot begin writing poetry till my imaginary reader has conceded licences to me which you demur at altogether. I *know* that I don't make out my conception by my language; all poetry being a putting the infinite within the finite. You would have me paint it all plain out, which can't be; but by various artifices I try to make shift with touches and bits of outlines which *succeed* if they bear the conception from me to you. You ought, I think, to keep pace with the thought. . . . Do you think poetry was ever generally understood – or can be? Is the business of it to tell people what they know already, as they know it, & so precisely that they shall be able to cry out – 'Here you should supply *this* – *that*, you evidently pass over, & I'll help you from my own stock'? It is all teaching, on the contrary, and the people hate to be taught. They say otherwise, – make foolish fables about Orpheus enchanting stocks & stones, poets standing up and being worshipped, – all nonsense & impossible dreaming. A poet's affair is with God, to whom he is accountable, and of whom is his reward; look elsewhere, and you find misery enough. Do you believe people understand *Hamlet*?[13]

The similarities between the two men are brought out by this letter. Ruskin had of course already conceded the point about *Hamlet*, and in his own writing he took the view that people hated to be taught, and that it was good for them to attend to his work. The two men were playfully convinced of their own genius and of the absoluteness of their

own utterances. And it is good that Browning, who was disappointed by the reception of *Men and Women*, could be robust in response to Ruskin's comic bewilderment. Both men were role-playing, of course, and each acknowledging the other's genius.

Ruskin had liked Browning's 'The Bishop Orders his Tomb at St Praxed's Church', a poem which seemed to confirm all his own low opinions of the Renaissance and of the Catholic Church. Perhaps he was baffled by so many of the other poems in *Men and Women* because he was unable to enter into Browning's myriad-mindedness, his sheer interest in a wide variety of people. One may contrast with his mystification over *Men and Women* his delight in Tennyson's *Maud*, published in the same year. *Maud* was disliked by reviewers (one waggishly remarked that it should have been known as 'mad' or 'mud'). Ruskin wrote to Tennyson:

> I hear of so many stupid and feelingless misunderstandings of 'Maud' that I think it may perhaps give you some little pleasure to know my sincere admiration of it throughout. I do not like its versification so well as much of your other work . . . because I do not think that wild kind quite so good, and I am sorry to have another cloud put into the sky of one's thoughts by the sad story, but as to the general bearing and delicate finish of the thing in its way, I think no admiration can be extravagant.[14]

Ruskin endorsed in particular what he took to be the poem's political stance, its ostensible support for Britain's venture into war with Russia in the Crimea (in fact it is not at all clear that the mad narrator of *Maud* is articulating Tennyson's own view of this). Ruskin writes: 'It is a compliment to myself, not to you, if I say that I think with you in all things about the war.'*

Ruskin's reading of Tennyson's poetry was deep and constant. He saw *Maud* as a remarkable poem dealing with the contemporary world, and in an important and perceptive letter of September 1859 said that he wanted Tennyson to write about the present again rather than devoting himself to Arthurian legend (as in *Idylls of the King*):

> So great power ought not to be spent on visions of things past, but on the

*Support for the Crimean war was surprisingly common among the liberal intelligentsia – even Ruskin's enlightened and liberal friend Lady Trevelyan wrote to Ruskin: 'I hope you are insane about the War. You are perverse enough to say that you don't care about it, just out of malicious wickedness. Pray don't. It is such a wonderful thing and will do everybody such a quantity of good, and will shake up the lazy luxurious youth of England out of conventionalism and affectation into manhood and nobleness. What a comfort it is to find . . . no one has yet succeeded in laughing England's chivalry away!'[15]

living present. For one hearer capable of feeling the depth of this poem [the *Idylls*] I believe ten would feel a depth quite as great if the stream flowed through things nearer the hearer. And merely in the facts of modern life – not drawing-room, formal life, but the far-away and quite unknown growth of souls in and through any form of misery or servitude – there is an infinity of what men should be told, and what none but a poet can tell. I cannot but think that the intense, masterful, and unerring transcript of an actuality, and the relation of a story of any real human life as a poet would watch and analyze it, would make all men feel more or less what poetry was, as they felt what Life and Fate were in their instant workings.

This seems to me the true task of the modern poet. And I think I have seen faces, and heard voices, by road and street side, which claimed or conferred as much as ever the loveliest or saddest of Camelot. As I watch them, the feeling continually weighs upon me, day by day, more and more, that not the grief of the world but the loss of it is the wonder of it. I see creatures so full of all power and beauty, with none to understand or teach or save them. The making in them of miracles, and all cast away, for ever lost as far as we can trace. And no 'in memoriam.'[16]

It is heartening to see in this later letter – the date, 1859, is important – the shift away from the aesthetic and the conventional and towards social conscience which was subsequently to become so profound a feature of Ruskin's political writings.

Elizabeth Barrett Browning and Ruskin had been friends since at least 1852, something that offended Ruskin's old friend Samuel Rogers, who was now in his eighties, 'quoting himself with great enjoyment', and envious of other poets: 'He cannot bear to hear Tennyson so much as named' and he 'was not a little indignant at finding out' that Ruskin had Elizabeth Barrett Browning's most recent poem, *Casa Guidi Windows* (published in 1851), in the family carriage. Ruskin had met and liked her husband (at that time the less famous member of the partnership) when dining with Coventry Patmore: 'he is the only person whom I have ever heard talk rationally about the Italians, though on the liberal side. He sees all their worthlessness, and is without hope. His wife's poem takes the same view.'[17] Ruskin of course saw the 1848 revolutions in Europe as dangerous attacks on order. Mankind would be better consoling itself with religion: 'Happy those whose hope, without this severe and tearful rending away of all the props and stability of earthly enjoyments, has been fixed "where the wicked cease from troubling".'[18]

Casa Guidi Windows was an account of Florence in the grip of the

revolutionary fever of 1848: it celebrated a political demonstration in which citizens processed through the streets before attempting to seize independence ('Casa Guidi' was the house from which Elizabeth Barrett had watched the scene).

In her sympathy with the cause of Italian unification Elizabeth Barrett Browning was backing what would in due course be the winning side. But in their support of Italian liberalism the Brownings were untypical – Ruskin's suspicion was more characteristic of the official British view. Living in Venice with Effie had convinced Ruskin that the Italians were a feckless people who needed firm management (in the case of Venice, by the Austrians). Ruskin's letters tended, of course, to articulate a favourite theme, namely that the Catholic Church was at the root of all Italy's problems: 'The Italians are suffering, partly for sins of past generations, partly for follies of their own: the sins cannot be undone, nor the follies cured; and, I fear, their cup is not yet half full of their punishment. The government is as wise and gentle as a Romanist government well can be, and over a people of another language. . . . Their miseries are of their own causing, and their Church's, but they are pitiable enough still.'[19]*

Ruskin's attitude to Elizabeth Barrett Browning's work was one of prostrated devotion combined with schoolmasterish nagging. As he wrote to her, he found in her poetry 'hallowing and purifying influence', a '*baptism* of most tender thoughts'. He resolved to pass on to his students the moral force and 'unspeakable preciousness' of her poetry. He planned to do this by making her poems, literally, objects of veneration: 'I am going to bind your poems in a golden binding, and give them to my class of working men – as the purest and most exalting poetry in our language': 'one of the most glorious little burning books that ever had leaf turned by white finger', with 'one stanza in each vellum page, with deep blue and purple and golden embroidery'. But Ruskin would not be Ruskin if he did not qualify this honeyed devotion with some pithy advice: 'pray . . . alter that first verse of the "Drama of Exile".'[21]

If Elizabeth Barrett Browning was embarrassed by his fulsomeness, irked by his kitsch project or insulted by his frankness, she didn't show

*Ruskin's attitude to the Italians had been shared in an earlier generation by Shelley, who said: 'There are two Italies: one composed of the green earth & transparent sea and the mighty ruins of ancient times. . . . The other consists of the Italians of the present day, their work and their ways. The one is the most sublime and lovely contemplation that can be conceived by the imagination of man: the other the most degraded disgusting & odious.'[20]

it in her replies to his letters, though she did, quietly, firmly, defend her right to choose her own language for her own poems.[22] Undeterred, Ruskin went on telling her how to write, and in a letter of 19 June complained in his own comic verse about her 'designs upon the English language', which were:

> Tesseric, pentic, hectic, heptic,
> Phoenico-daemonic, and dyspeptic,
> Hipped-ic, Pipped-ic, East-wind-nipped-ic,
> Stiffened like styptic, doubled in diptych,
> Possi-kephaly-chersecliptic.[23]

As so often, this correspondence showed Ruskin's self-absorbed exhibitionism and tactlessness.

The Brownings were loyal and forbearing, and with *Aurora Leigh* in 1856 Ruskin found a Barrett Browning that drove him to ecstasies of praise. He wrote nevertheless to Robert Browning that it had 'one or two sharp blemishes, I think, in words, here and there, chiefly Greek'. But for all that it was 'the greatest *poem* in the English language, unsurpassed by anything but Shakespeare – *not* surpassed by Shakespeare's *sonnets*, and therefore the greatest poem in the language'.[24]

*

Ruskin trusted his devoted and long-suffering friend Henry Acland, who remained loyal to him to the end, and his letters to Acland comprise a long essay in self-analysis. On 27 April 1856, for example, he wrote about his political views:

> I don't care for POWER; unless it be to be useful with – the mere feeling of power and responsibility is a bore to me, and I would give any amount of authority for a few hours of Peace. . . .
>
> I have perfect leisure for enquiry into whatever I want to know. I am untroubled by any sort of care or anxiety, unconnected with any particular interest, or group of persons, unaffected by feelings of Party, of Race, of social partialities, or of early prejudice, having been bred a Tory – and gradually developed myself into an Indescribable thing – certainly *not* a Tory. . . .
>
> I am by nature and instinct, Conservative, loving old things because they are old, and hating new ones merely because they are new. If, therefore, I bring forward any doctrine of Innovation, assuredly it must be against the grain of me; and this in political matters is of infinite importance.

Lastly, I have respect for religion, and accept the practical precepts of the Bible to their full extent.

Consider now all these qualifications one by one. Consider how seldom it is that they all are likely to meet in one person, and whether there be, on the whole, chance of greater good or evil accruing to people in general from the political speculations of such a person.

I ought to have added one more qualification to the list. I know the Laws of *Work*, and this is a great advantage over *Idle* Speculations.

Against all these qualifications you will perhaps allege one – at first ugly looking – disqualification. 'You live out of the world – and cannot know *anything* about it.'

I believe that is almost the *only* thing you can say, but it does sound ugly at first, and sweeping. I answer, that just because I live out of it, I know more about it. Who do you suppose know most about the lake of Geneva – I, or the Fish in it?[25]

Their correspondence adds a dimension to Ruskin's pamphlet *Notes on the Construction of Sheepfolds*, which embodied his political and religious attitudes as they were in 1851. A large number of intelligent Englishmen agreed with him, alarmed as they were by the apparent helplessness of the established Church of England in the face of what Lord John Russell – hitherto an advocate of religious tolerance – had termed 'papal aggression'. Russell was referring to the re-establishment of a Catholic hierarchy in Britain in 1850.* In a kind of extended appendix to his attack on Catholicism in *The Stones of Venice*, Ruskin advocated a British parliament all of whose members would be practising Anglicans (he would, presumably, advocate the repeal of the Catholic Emancipation Act of 1829), and a Church of England in which the Evangelical wing and the 'High' church wing were reunited. This pamphlet sounds bigoted to modern ears, and we need to remember both that he was writing against a background of hysterical public fear and loathing of Roman Catholics and, more broadly, that literate Victorians were gripped by interdenominational debate and by the developing tension between religion and science. These were white-hot issues of the day.

Ruskin concluded:

The schism between the so-called Evangelical and High Church Parties in Britain, is enough to shake many men's faith in the truth or existence of Religion at all. It seem to me one of the most disgraceful scenes in

*Including the founding of the Catholic diocese of Westminster with Cardinal Wiseman as its archbishop – the subject of Browning's dramatic monologue 'Bishop Blougram's Apology'.

Ecclesiastical history, that Protestantism should be paralyzed at its very
heart by jealousies, based on little else than mere difference between high
and low breeding. . . . If the Church of England does not forthwith unite
with herself the entire Evangelical body, both of England and Scotland,
and take her stand with them against the Papacy, her hour has struck. . . .
Three centuries since Luther – three hundred years of Protestant
knowledge – and the Papacy not yet overthrown! Christ's truth still
restrained, in narrow dawn, to the white cliffs of England and white crests
of the Alps; – the morning star paused in its course in heaven; – the sun
and moon stayed, with Satan for their Joshua.[26]

Yet although in his pamphlet Ruskin fumed with bigotry and
violence, his letters to Acland show that his vehemence cloaked doubt.
The doubt had been provoked – as it was also for Tennyson – by
geology. Ruskin wrote:

You speak of the Flimsiness of your own faith. Mine, which was never
strong, is being beaten into mere gold leaf, and flutters in weak rags from
the letter of its old forms; but the only letters it can hold by at all are the
old Evangelical formulae. If only the Geologists would let me alone, I
could do very well, but those dreadful Hammers! I hear the clink of them
at the end of every cadence of the Bible verses.[27]

In a letter to his friend W.L. Brown, he referred to the source of his
evangelical outlook – his mother's training – and his youthful
intellectual laziness: 'My mother early made me familiar with the Bible,
and thereby rather aided than checked my feeling for what was
beautiful in language. I owe much to having early learned the 32nd of
Deuteronomy and the 15th Exodus *thoroughly* by heart.' There is a
good deal of *mea culpa* in this letter, as though to a father figure:

I was naturally vain and cowardly; it took all the best care of my father
and mother to keep me from lying; and the vanity, they, not perceiving
and partly sharing in, encouraged in the most fatal way. . . . I went on till
I was to go to College, *educating myself* in mineralogy, drawing, and the
power of stringing words together, which I called poetry. My intense
vanity prevented my receiving any education in literature . . . except what
I picked up myself.[28]

The title of *Notes on the Construction of Sheepfolds* is oblique and
misleading (the pamphlet was bought by unsuspecting farmers). Its
jokiness indicates defensiveness and uncertainty. It contrasts sharply
with Ruskin's other major pamphlet of 1851, *Pre-Raphaelitism*. Here
Ruskin was in complete command of his topic, writing with passionate
advocacy about the young painters (Millais and Holman Hunt) who

seemed to him to be fulfilling the hopes that he had expressed for contemporary painting in *Modern Painters*, I, where he had given what he described as advice to the young artists of England: 'they should go to nature in all singleness of heart, and walk with her laboriously and trustingly'.[29]

Ruskin's obsessions came together in the opening paragraphs of this pamphlet: his evangelical Christianity, his central discovery that the contented craftsman is the mark of a good society, and his intense delight in art which renders the visible world as God made it:

> It may be proved, with much certainty, that God intends no man to live in this world without working: but it seems to me no less evident that He intends every man to be happy in his work. It is written, 'in the sweat of thy brow,' but it was never written, 'in the breaking of thine heart,' thou shalt eat bread: and I find that, as on the one hand, infinite misery is caused by idle people, who both fail in doing what was appointed for them to do, and set in motion various springs of mischief in matters in which they should have no concern, so on the other hand, no small misery is caused by over-worked and unhappy people, in the dark views which they necessarily take up themselves, and force upon others, of work itself. . . . Now in order that people may be happy in their work, these three things are needed: They must be fit for it: They must not do too much of it: and they must have a sense of success in it.[30]

The pamphlet needs to be read in association with Ruskin's four famous letters to *The Times*,* displaying his huge excitement over the works of the young Millais and Holman Hunt, on exhibition at the Royal Academy. In the pamphlet, the virtues of the new painters were related directly to his vision of a society free of social gradations and free of ambition and jealousy. This vision anticipated a central feature of William Morris's *News from Nowhere* (a novel based throughout, of course, on Ruskin's teaching). Ruskin wrote: 'I do not believe that any greater good could be achieved for the country, than the change in public feeling on this head, which might be brought about by a few benevolent men, undeniably in the class of "gentlemen," who would, on principle, enter into some of our commonest trades, and make them honourable.'[31]

If the *Sheepfolds* essay is a kind of extended footnote to *The Stones of Venice*, and *Pre-Raphaelitism* a kind of extended footnote to *Modern*

*13 May 1851; 30 May 1851; 5 May 1854; 25 May 1854.

Painters, the extraordinary sequence of *Lectures on Architecture and Painting*, delivered in Edinburgh in 1853, shows Ruskin transforming the fruit of his years of quiet study into a noisy public performance.

In these two Edinburgh lectures he relished the role of *enfant terrible* and gadfly. He told his audience that the Greek style in which much of Edinburgh was built should be replaced by the Gothic. His position was both 'Protestant' and 'protestant'. He saw neo-Classical architecture as a debased product of the Renaissance, which as *The Stones of Venice* made clear was in his mind associated with Catholicism. And he enjoyed stirring people up, like a small child pulling rude faces:

> I cannot conscientiously tell you anything about architecture but what is at variance with all commonly received views upon the subject. I come before you, professedly to speak of things forgotten or things disputed; and I lay before you, not accepted principles, but questions at issue.

In this consciously radical posture, he claimed immunity from criticism – almost, it seems, from argument. To consult an established architect about Ruskin's views on architecture would be to miss the point completely: 'You might as well, had you lived in the sixteenth century, have asked a Roman Catholic archbishop his opinion of the first reformer. I deny his jurisdiction.'[32] He did, though, engage in further defence of his views in his Addenda to the lectures. His development of the point that ornamentation is an essential feature of architecture, and Gothic ornamentation nobler than Greek, was for him a moral and social matter, and it simplified and amplified the teaching of 'The Nature of Gothic'. 'On the acceptance of this [i.e. the superiority of Gothic ornamentation] depends the determination whether the workman shall be a living, progressive, and happy human being, or whether he shall be a mere machine, with its valves smoothed by heart's blood instead of oil.' Renaissance architecture had bullied and brutalised the workman, reducing him to the level of a machine. By contrast:

> In the Gothic times, writing, painting, carving, casting, – it mattered not what, – were all works done by thoughtful and happy men; and the illumination of the volume, and the carving and casting of wall and gate, employed, not thousands, but millions of true and noble *artists* over all Christian lands. Men in the same position are now left utterly without intellectual power or pursuit, and, being unhappy in their work, they rebel against it: hence one of the worst forms of Unchristian Socialism [a reference to the 'Christian Socialist' movement led by F.D. Maurice].[33]

*

In 1855 Ruskin met the person whom he called the 'second' friend of his life (after John Brown),* Charles Eliot Norton. In 1856, Norton recalled, Ruskin, then aged thirty-seven, struck him in these terms:

> He was a little above middle height, his figure was slight, his movements were quick and alert, and his whole air and manner had a definite and attractive individuality. There was nothing in him of the common English reserve and stiffness, and no self-consciousness or sign of consideration of himself as a man of distinction, but rather, on the contrary, a seeming self-forgetfulness and an almost feminine sensitiveness and readiness of sympathy. . . . He seemed to me . . . cheerful rather than happy. The deepest currents of his life ran out of sight.

Norton was right about the deepest currents. Ruskin's attitude to Christianity was undergoing a profound change during this period. His confidence in it was shaken, and he was becoming anxious about how much time remained to him. On Sunday 7 September 1856, he made a numerical 'calculation of the number of days which under perfect term of human life I might have to live'. He determined the number as 11,795, bringing him to the age of seventy, and noted the diminishing number of dates in his diary from that day for several years.[35]

In the summer of 1856 Ruskin took another European tour, again gathering material about mountains, landscape and the natural world. In August he wrote to Dante Gabriel Rossetti saying: 'I do nothing but walk and eat and sleep, and get stupider and lazier every hour' and that he found the Swiss stupefying: 'they make large quantities of cheese and cherry-brandy, and a great many of them are born idiots'.[36] To Lady Trevelyan he wrote that the tour had left him stale: 'We have been dividing our time between Interlachen, Thun, Friburg – Chamouni and Geneva: and I have done nothing but ramble in sun and eat breakfasts and dinners – and sleep: I am not so much the better for it as I ought to be – because I don't like it: I get sulky when I can't do anything – and

*Dr John Brown (1810–82) was an Edinburgh physician and man of letters. As a writer he was best known for his charming story about a dog, *Rab and his Friends*. He had published a flattering review of *Modern Painters*, II, in 1846 and at the same time he wrote a personal letter to Ruskin. Through their mutual friend Pauline Trevelyan they became close friends in the 1850s. Like Henry Acland, he was sufficiently trusted to have received a personal letter giving Ruskin's side of the story of his marriage following the annulment in 1854; this is probably why Ruskin was thinking of him as his 'first' friend at the time of his letter to Norton in 1855. Although personally loyal he was also intellectually objective. Shortly after the publication of *The Stones of Venice*, I, he wrote to Pauline Trevelyan complaining of the book's arrogant and savage tone and of its anti-Catholicism: 'his nonsense (and his father's) about Catholic Emancipation [is] most abundantly ridiculous and tiresome. I once thought him nearly a God; I find we must cross the river before we get to our Gods.'[34]

getting sulky puts one out of order – and I don't feel refreshed or up to my work again.'[37]

Ruskin had been wearing himself out with work. In the early part of 1857 he was working on the countless drawings of the Turner bequest. On 22 June 1857 he published *Elements of Drawing* (related to his teaching at the Working Men's College), on 3 July 1857 he was at Cowley writing *The Political Economy of Art* (later in 1880 to be called *A Joy for Ever*) and on 10 July in Manchester giving the first lecture of this title (the second was on 13 July). On 24 July he wrote to Tennyson an appreciative note about his *Poems* illustrated by Millais, Holman Hunt and others. On 14 September, in Edinburgh, he wrote about the despoliation of the castle foundations. In 1858 he took with Crawley another European tour.

This tour is very well documented – Ruskin's letters give a good sense of the writer in his thirty-ninth year resting from the intense labours of *Modern Painters*. He had to be careful how he put this to his father, who was impatient to see the great book finished, but Ruskin was firm about his needs. He wrote from Bellinzona: 'I am much stronger than when I left home and shall probably soon begin writing a little M.P. in the mornings, but I want to get a couple of months of nearly perfect rest before putting any push of shoulder to it.'[38]

After a period in his beloved Alps, sketching Turner views, he began to feel lassitude and discontent. Part of the trouble was that he would never be able to sketch as well as Turner did, part of it that the hotels were uncomfortable. And part of it was that the pleasures of mountains themselves began to pall: 'I sometimes do feel disposed to give it all up, take a house in the country and study natural history or people's history in peace; perhaps I may seriously consider the expediency of doing so when I have finished modern painters, and put a finishing *hand* to my elements of drawing.'[39]* He was coming round to his father's view that mountains are boring (9 July): 'I felt Hospenthal and the top of St Gothard, snow, gentians, and all – neither more nor less than melancholy & even "dull"!'[40] He arrived in Turin to find that he really liked cities:

I was obliged to come here by rail; there was no getting a voiturier from Arona. As all is railroad here-abouts they could not have got a fare back, but I do not now regret this as the train came with perfect steadiness, and

*Ruskin wanted to get the system of instruction set out in his *Elements of Drawing* (1857) adopted in the national schools of design.

luxurious comfort – the 'primi per *non* fumare' [first class non-smoking] being lined with cool chintz, and painted with fruit and garlands of flowers on the roof![41]

He wrote with a kind of comic shame:

It is just two months this evening since I arrived late at Bar le Duc from Paris, and was shown up the rough wooden stairs to the rougher room of a French country inn. With the exception of a single evening at the Trois Rois at Basle, my life since has been entirely rural, not to say savage – it having been my chance or need to lodge in an unbroken succession of either very primitive, or decidedly bad, inns. I am very sorry to say that after this rustication, I find much contentment in a large room looking into your favourite square [the Hôtel de l'Europe in the Piazza del Castello], a note or two of band – a Parisian dinner – and half a pint of Moet's champagne with Monte Viso ice in it.[42]

The glories of nature staled by comparison with the amenities of Turin. 'I find myself exceedingly well and strong here,' he wrote on 18 July. 'A fine sunset last night, but I don't care so much about these things as I used. I am gradually getting more interested in men and their misdoings.'[43]

Is this part of the transition from art to politics which is a feature of this period of his life? Being abroad gave Ruskin a life of 'sensation'. 'It is good for me to be on the continent as I get a sensation every now and then – and knowledge always: in England I can enjoy myself in a quiet way as I can in the garden at home but I get no strong feeling of any kind.'[44] As so often in his writings, this seems to indicate that aesthetic pleasure could simply *replace* sex and relationships for Ruskin.

He copied figures from Veronese's *Solomon and the Queen of Sheba* in Turin, and in his letters wrote out a commentary that became his 'Notes on the Turin Gallery'. In these notes Ruskin was responding to the 'good, stout, self-commanding, magnificent Animality' of the paintings. He was delighted by the 'Gorgeousness of life' while copying Veronese and listening to band music.[45] He remarked in the letters, perhaps with a degree of unconscious cruelty, that he got on better with his father by letter than in person: 'The fact is it is much easier and more natural to express one's feelings by letter than by word; and I have always noticed that we understand each other best and most deeply by writing.'[46]

In July 1858 in Turin Ruskin underwent what has become known as his 'unconversion'. He was overwhelmed by the secular splendour of

Veronese's *Solomon and the Queen of Sheba* and this contributed to the following landmark letter to his father:

I went to the Protestant church last Sunday [a large new church, completed in 1851] and very sorry I was that I did go. Protestantism persecuted or pastoral in a plain room, or a hill chapel whitewashed inside and ivied outside, is all very well; but Protestantism clumsily triumphant, allowed all its own way in a capital like this, & building itself vulgar churches with nobody to put into them, is a very disagreeable form of piety. Execrable sermon; – cold singing. A nice-looking old woman or two of the Mause Headrigg type [she is a figure in Scott's *Old Mortality*, 1817] – three or four decent french families – a dirty Turinois here and there spitting over large fields of empty pew – and three or four soldiers who came in to see what was going on and went out again, very wisely, after listening for ten minutes, made up the congregation. I really don't know what we are all coming to.[47]

One consequence of this summer's solitary and to some degree aimless pursuits was that Ruskin developed a theory of education. Like most of the systems worked out in his private correspondence this was provisional, but some of it spilt over into later published work. The role of John James Ruskin is very noticeable here – Ruskin's tough, intelligent father is a sounding board. Ruskin can fearlessly develop and pursue his ideas in his letters to John James, knowing that he will get argument and (often) disagreement, but never discouragement.

I believe the Essence of education, as given by old people to young people, to consist in giving them *command* of their minds and bodies; – When the command is obtained – the young man or woman – perfect in Bodily and Mental Form – must choose for themselves the kind of knowledge they wish to acquire in the world – & the direction in which they will apply their powers. We should teach to youth, Denial of appetites – Uprightness – laboriousness – Bodily exercises of all sorts, Fineness of sense, by music – drawing – & practice of delicate mechanical arts – Medicine – & the natural history of familiar objects & animals. The Creature produced – at one and twenty – coming of Age, ought to be exquisite in bodily beauty – true as steel – brave as lion (man or woman equally) – a good singer – a good rider – a good nurse or physician in case of need – a good chemist & ornithologist, respecting common . . . substances & birds. I would teach ornithology rather than botany because it involves more love & more exercise – & a finer class of beauty – and a perfect master or mistress of their own Language. Then they ought to be married; and so to begin life in their own way, pursuing, then, at their choice. Politics, or arts, or sciences, languages, or commerce. (It is wretched nonsense that people should learn languages young. I learned Latin at 12 and Italian at 30, and I know Italian incomparably the best).

Exercise, beauty, equal education for both sexes, early marriage, late languages, 'denial of appetites' – with its mixture of the radical and the prudish, this is Ruskin all over. The beauty of the Italians and the new respect he had learnt for Renaissance 'Animality' were contributing to this theory of education. But we must remember to whom the letter was addressed: his father would expect that this teaching be Christian. So it is, but it is a kind of Christianity that is moving away from his mother's text-based evangelical teaching:

> Now, this being the type of perfect education, united of course – for denial of Appetite, with which I began, cannot be taught otherwise – with the Love of God and our Neighbour – only those are not so much to be taught as to be the result of all the teaching – the Mistakes which bring about the evil of the world are mainly[:]
>
> 1. Teaching religious doctrines and creeds instead of simple love of God & practical love of our neighbour. This is a terrific mistake – I fancy the fundamental mistake of humanity.
>
> 2. Want of proper cultivation of the beauty of the body and the fineness of the senses* – a modern mistake chiefly.[48]

This lonely, privileged, strange, observant man wrote to the Comtesse de Montemerli, an aspiring novelist who had approached him to help her find a publisher:

> It is generally a law of this uncomfortable world of ours that wealth, in any form whatever, is not to be obtained by *genius* merely – it must always be won by Labour and very hard labour. If there is genius *added* to this labour the remuneration obtained is often enormous, but it never can be obtained *without* labour. – Do not start indignantly and say 'I *do* labour in writing my Books[.]' Yes, you do; but not in the way necessary to secure reward: you write much too easily & quickly. Consider now, what work has to be gone through by any professional person in the Arts, before they can make money. *You* know in the Art, for which you have so much genius, Music, how little that genius would avail without hours & years of laborious preparatory exercise. Now, believe me, the art of Authorship has also its preparatory torments; and no one will obtain the favour of the public, who has not gone through them.[49]

Ruskin could never resist the role of teacher, even when the pupil was (as this lady seems to be) relatively untalented and time-wasting. But he bullied her by requiring her to read Scott.

*

*Beauty of the body, 'fineness of the senses', athleticism – these heroic qualities were all found in Kenelm Digby's *The Broad Stone of Honour*. Ruskin had been praised in another recent book by Digby and is perhaps partly influenced by this fact in his account of ideal education.

Returning from Italy to England was marked by dullness and depression. On 24 October he wrote from Denmark Hill to Elizabeth Barrett Browning about his 'mid-life crisis':[50]

> I have had cloud upon me this year, and don't quite know the meaning of it; only I've had no heart to write to anybody. I suppose the real gist of it is that next year I shall be forty, and begin to see what life and the world mean, seen from the middle of them – and the middle inclining to the dustward end [Dante's 'Nel mezzo del cammin di nostra vita/mi ritrovai per una selva oscura']. I believe there is something owing to the violent reaction ... after the excitement of the arrangement of Turner's sketches; something to my ascertaining in the course of that work how the old man's soul* had been gradually crushed within him.

Ruskin's lassitude also owes something to loss of sensation, 'to my having enjoyed too much of lovely things, till they almost cease to be lovely to me, and because I have no monotonous or disagreeable work by way of foil to them'. His travels in Switzerland were no help but Turin, as we have seen, had been a discovery: 'Away I went to Turin! of all places – found drums and fifes, operas and Paul Veroneses, stayed another six weeks, and got a little better, and I begin to think nobody can be a great painter who isn't rather wicked – in a noble sort of way.'[52] He wrote on the same day in the same spirit to Charles Eliot Norton, presenting again his discovery that 'positively, to be a first-rate painter – you *mustn't* be pious; but rather a little wicked, and entirely a man of the world. I had been inclining to this opinion for some years; but I clinched it at Turin.'[53]

Ruskin had become acutely aware of the onrush of time. He wrote to Norton from Denmark Hill on 28 December 1858:

> I want to get all the Titians – Tintorets – Paul Veroneses, Turners and Sir Joshuas – in the world – into one great fireproof Gothic gallery ... I want to go and draw all the subjects of Turner's 19,000 sketches in Switzerland & Italy elaborated out myself. I want to get everybody a dinner who has'nt got one. I want to macademize some new roads to heaven with broken fools heads. I want to hang up some knaves out of the way. ... I want to play all day long and arrange my cabinet of minerals with new

*Ruskin had been shocked by the discovery of explicit and exuberant erotic drawings among Turner's works after the old man's death. He agreed that R.N. Wornum, Keeper of the National Gallery, should destroy these drawings in December 1858. He wrote to Wornum: 'I am satisfied that you had no other course than to burn them, both for the sake of Turner's reputation (they having been assuredly drawn under a certain condition of insanity) and for your own peace. ... I hereby declare that the parcel of them was undone by me, and all the obscene drawings it contained burnt in my presence.'[51]

white wool. I want somebody to nurse me when I'm tired. I want Turner's pictures not to fade. I want to be able to draw clouds, and to understand how they go. . . . I want to make the Italians industrious – the Americans quiet; the Swiss Romantic; – the Roman Catholics Rational – and the English Parliament honest – and I can't do anything and don't understand what I was born for.[54]

And he wrote from Schaffhausen a letter the tone and content of which were simply frantic: 'As I grow older, the evil about me takes more definite and overwhelming form in my eyes; and I have no one near me to help me or soothe me.' The immediate cause of his anger was the failure of Britain to support the Italian states that had risen against Austria in April 1859: 'I do not care to write any more or do anything more that does not bear directly on poor peoples bellies – to fill starved peoples bellies is the only thing a man can do in this generation – I begin to perceive.'[55]

> I much question whether any one who knows optics, however religious he may be, can feel in equal degree the pleasure or reverence which an unlettered peasant may feel at the sight of a rainbow.[56]

In 'The Moral of Landscape', the important chapter of *Modern Painters*, III, from which this quotation comes, Ruskin formulated his thoughts about art and individual freedom and dignity, or art and politics as one might say. He used the word 'romantic' in a modern and political sense:

> The charm of romantic association can be felt only by the modern European child. It rises eminently out of the contrast of the beautiful past with the frightful and monotonous present; and it depends for its force on the existence of ruins and traditions, on the remains of architecture, the traces of battlefields, and the precursorship of eventful history.[57]

In *Modern Painters*, III, Ruskin took the history of nature in literature as represented in the work of Homer, Dante and Scott. In Homer, the landscape is either functional – rich in product, oil or corn – or vital; the Greeks when they cut down a tree know that there is a god in it. They find man, not nature, supremely beautiful, and nature is simply man's setting. In Dante, the landscape is safe, enclosed and artificial, the grass enamelled – jewelled – instead of real: it is a place of recreation for man. A knight on horseback (Ruskin chose his example from Tennyson's *The Lady of Shalott*) is the most beautiful thing that the natural world has to offer to medieval man (he seemed happy with

Tennyson's figure as representative of the medieval world). In Scott, landscape is full of colour but still subordinate to heroic action. The primacy of nature found in Turner is a modern phenomenon, and probably temporary, a reaction from the wretchedness of the spiritual and moral state in which Victorian capitalist and industrialist life finds itself. The detail with which Ruskin explored his theme was inexhaustible: he climbed over the surface of the poetry with the same ant-like assiduity as he displayed when climbing over the buildings in *The Seven Lamps of Architecture* and *The Stones of Venice*.

Ruskin traced his own childhood as having been in a sense Wordsworthian. By rereading himself as Wordsworth, he almost, at one point, seemed to explain to himself his own bizarre sexuality:

> The first thing which I remember, as an event in life, was being taken by my nurse to the brow of Friar's Crag on Derwent Water; the intense joy, mingled with awe, that I had in looking through the hollows in the mossy roots, over the crag, into the dark lake, has associated itself more or less with all twining roots of trees ever since. . . . In such journeyings, whenever they brought me near hills, and in all mountain ground and scenery, I had a pleasure, as early as I can remember, and continuing till I was eighteen or twenty, infinitely greater than any which has been since possible to me in anything; comparable for intensity only to the joy of a lover in being near a noble and kind mistress, but no more explicable or definable than that feeling of love itself.[58]

His joy in nature seemed to him 'to come of a sort of heart-hunger, satisfied with the presence of a Great and Holy Spirit'. It 'faded gradually away, in the manner described by Wordsworth in his *Intimations of Immortality*'.[59]

Modern Painters, III, 'of many things', is a book that lacks direction, but it contains one of Ruskin's most striking and successful formulations. The painter and the art critic are engaged in intellectual inquiry as precise as that of the analytical scientist. Theirs is a 'science of aspects', a study of how things *look*: 'Turner, the first great landscape-painter, must take a place in the history of nations corresponding in art accurately to that of Bacon in philosophy; – Bacon having first opened the study of the laws of material nature . . . and Turner having first opened the study of the aspect of material nature.' Turner is master of this 'science of *Aspects*' as Bacon is master 'of the science of *Essence*'.[60]

Modern Painters, IV, began with the remark that the writing of the vast work was taking a surprising amount of time and that the writer had discovered that 'Life is shorter and less availably divisible than I

had supposed'.[61] But despite life's brevity the procedure becomes slower and grander as the book unfolds, as though the satisfaction that he finds in his method – the minute exploration of the natural world and then of Turner's attempts to render it – gives him so much pleasure that he does not want to let go of it.

The completion of *Modern Painters*, deferred for so long because of Ruskin's attention to his work on architecture, was now as it were perversely deferred because itself so satisfying, an exquisitely long-drawn-out act of worship of his supreme painter. He lingered, too, perhaps, because this was the topic with which he felt completely confident: the revisiting of this loved and intimately known artist was a constant source of renewal.

His chapters on Turnerian Light and Turnerian Mystery led him to what sounds like an anticipation of impressionist theory: 'There is continual mystery caused throughout *all* spaces, caused by the absolute infinity of things. WE NEVER SEE ANYTHING CLEARLY.'[62]

The man who wrote *Modern Painters*, V, was different again from the romantic returning to the too long neglected subject of his love – Turner – in *Modern Painters*, III and IV.

He had discovered that the animality of the great Renaissance painters was a valuable and important part of their work. He was adjusting his attitude to Renaissance art and the classical world, and we find him accommodating animality to his art system as he put man at the centre, thus:

> Man being thus the crowning and ruling work of God, it will follow that all his best art must have something to tell about himself, as the soul of things, and ruler of creatures. It must also make this reference to himself under a true conception of his own nature. Therefore all art which involves no reference to man is inferior or nugatory. And all art which involves misconception of man, or base thought of him, is in that degree false and base.

It is important that the nature of man is 'boldly animal, nobly spiritual' and that the two parts are interdependent. Much Christian art has done damage by 'its denial of the animal nature of man' and with 'monkish and fanatical forms of religion, by looking always to another world instead of this'.[63] It is right to celebrate man's sexual nature. Maybe after his anguished struggle with, and defeat over, the problem of his marriage Ruskin had arrived at a kind of resolution over the question of sex.

To move from veneration of nature to veneration of man as the

pinnacle of the natural order was characteristic of Wordsworth. And as though to reinforce this point Ruskin introduced, a few pages further on, figures who resemble Wordsworth's solitaries in their dignified rural poverty: a cress gatherer; and a former sailor, a McGregor from the Isle of Skye, possessed by grief and guilt because his wife has died in childbirth, and he blamed himself for forbidding medical intervention to 'rip her open, and take the child out of her side'. The Scot has adopted poverty as a kind of atonement: 'I lived for ten years after my wife's death by picking up rags and bones; I hadn't much occasion afore . . . I lives hard and honest, and haven't got to live long.'[64]

Modern Painters, V, doesn't finish, it stops. After the beautiful episode or interlude of 'The Two Boyhoods', where Ruskin displays the talent that could have given us a major biography of Turner had he been so disposed, he ended the book, reluctantly and lingeringly, by saying that he had to stop somewhere: 'Looking back over what I have written, I find that I have only now the power of ending this work, – it being time that it should end, but not of "concluding" it; for it has led me into fields of infinite inquiry, where it is only possible to break off with such imperfect result as may, at any given moment, have been attained.'[65]

*

Underneath the completion of *Modern Painters* and the writing of the essays on political economy that were to appear in *Unto this Last* seethed a conflict. For much of his life Ruskin and his father, side by side, had been engaged in a power struggle with the world, forcing it to listen to Ruskin's opinions and accept Ruskin's teachings.

But in the late 1850s and early 1860s the nature of the power struggle changed. Ruskin began painfully fighting his greatest ally, his hero and his constant companion in arms: his father. This was difficult.

Ruskin nevertheless began to permit himself a remarkably frank (indeed selfish) reproach of the older man. His father had been extraordinarily open-handed over the buying of Turner's works for his son; nevertheless Ruskin knew that time and again he and his father had missed the best paintings through John James's dislike of what he saw as the rapacity of picture dealers.* Ruskin wrote:

*In fact, largely through Ruskin's influence, the value of Turners had steadily risen, and if John James had acceded to Ruskin's every request he would have been making excellent investments.

Men ought to be severely disciplined and exercised in the sternest way in daily life – they should learn to live on stone beds and eat black soup, but they should never have their hearts broken – a noble heart, once broken, never mends, – the best you can do is rivet it with iron and plaster the cracks over – the blood never flows rightly again. The two terrific mistakes which Mama and you involuntarily fell into were the exact reverse in *both ways* – you fed me effeminately and luxuriously to that extent that I actually now could not travel in rough countries without taking a cook with me! – but you thwarted me in all the earnest fire and passion of life. About Turner you indeed never knew how much you thwarted me – for I thought it was my duty to be thwarted – it was the religion that led me all wrong there; if I had had courage and knowledge enough to insist on having my own way resolutely, you would now have had me in happy health, loving you twice as much (for, depend upon it, love taking much of its own way, a fair share, is in generous people all the brighter for it), and full of energy for the future – and of power of self-denial: now, my power of *duty* has been exhausted in vain, and I am forced for life's sake to indulge myself in all sorts of selfish ways, just when a man ought to be knit for the duties of middle life by the good success of his youthful life. No life ought to have *phantoms* to lay.[66]

The conflict between Ruskin and his father had been building up over several issues. The long-standing disagreement over the purchase of Turner's work was primary: John James annoyed if Ruskin entered into arrangements with Griffith, Turner's agent, without consulting him; Ruskin frustrated if he felt that he had missed a bargain.* Moreover, John James wanted Ruskin to write about *painting* (i.e. the many volumes of *Modern Painters*), while Ruskin instead became involved with *architecture* (*The Seven Lamps of Architecture* and *The Stones of Venice*).

Then there was the even more contentious issue of Ruskin's political

*When in 1852 John James complained that he would be spending some £10,000 on Turners if he allowed Ruskin to have his way, Ruskin replied that this would not be a bad investment: 'I have fifty pounds' worth of pleasure out of every picture in my possession *every week* that I have it. As long as you live, I shall not be so much abroad as in England – if I should outlive you, the pictures will be with me wherever I am. You count all I "would buy" – but I have named to you all I ever hope to get – supposing I live long – and outlive their present possessors – on which I have no business to calculate – I don't think that to have spent – by the time I am 50 or 60 – 10,000 – in Turners – sounds monstrous. People would not think it extravagant to buy a title or an estate at that price. I want neither. Some people would think it not too much at a contested election. But all depends on the view you take of me and of my work. I could not write as I do unless I felt myself a reformer, a man who knew what others did not know – and felt what they did not feel. Either I know this man Turner to be *the* man of this generation – or I know *nothing*.'[67]

and economic essays, work that attacked everything that John James believed in. Add to that Ruskin's religious apostasy* and the money he poured out on what John James saw as worthless causes (such as the careers of Rossetti and Lizzie Siddal). Quarrels rumbled beneath the surface, as in the summer of 1862. In July Ruskin wrote from Milan to Pauline Trevelyan describing his difficulties with his father:

> We disagree about all the Universe, and it vexes him – and much more than vexes me. If he loved me less – and believed in me more – we should get on – but his whole life is bound up in me – and yet he thinks me a fool – that is to say – he is mightily pleased if I write anything that has big words and no sense in it – and would give half his fortune to make me a member of parliament if he thought I would talk – provided only the talk hurt nobody & was in all the papers.
>
> This form of affection galls me like hot iron – and I am in a state of subdued fury whenever I am at home which dries all the marrow out of every bone in me. Then he hates all my friends – (except you) – and I have had to keep them all out of the house – and have lost all the best of Rossetti – and of his poor dead wife† who was a creature of ten thousand.[68]

Ruskin's anger erupted in August 1862. The immediate cause was that John James had unwisely let it be known that he thought Edward and Georgiana Burne-Jones unsuitable friends for his son. Ruskin was very sharp with the old people. Burne-Jones, from middle-class Birmingham, was not good enough in their eyes, he said, because their social snobbery 'has destroyed through life your power of judging noble character'. He pointed to the foolish parental pride in his aristocratic fellow-undergraduates in his Christ Church days. The bitter reproaches came flooding out:

> You and my mother used to be delighted when I associated with men like Lords March & Ward – men who had their drawers filled with pictures of naked bawds – who walked openly with their harlots in the sweet country lanes – men who swore, who diced, who drank, who knew *nothing* except the names of racehorses – who had no feelings but those of brutes – whose conversation at the very hall dinner table would have made prostitutes blush for them – and villains rebuke them – men who if they could, would have robbed me of my money at the gambling table –

*John James and Margaret were bound to take his remarks about 'Protestantism clumsily triumphant' in his letters from Turin in August 1858 as direct attacks on their faith.
†Rossetti had married Elizabeth Siddal in 1860. She died from an overdose of laudanum in February 1862.

and laughed at me if I had fallen into their vices – and died of them; And you are grieved, and you try all you can to withdraw me from the company of a man like [Burne-]Jones, whose life is as pure as an archangels, whose genius is as strange & high as that of Albert Durer or Hans Memling – who loves me with a love as of a brother – and far more – of a devoted friend – whose knowledge of history and of poetry is as rich and varied, nay – far more rich and varied, and incomparably more *scholarly*, than Walter Scotts was at his age.

Ruskin was punishing his father not just for his resistance to Burne-Jones but for the old man's fundamental belief (and Ruskin was right about this) that to be short of money was somehow immoral:

I have seen you pay the greatest respect to people at your own table, who are such utter knaves that they did not even know what honour meant: – but they are *Safe* knaves, men who were too proud – and who knew their own interest too well, to fail in a mercantile engagement – and who were rich, and decently conducted . . . I am forced to speak openly at last in this matter, because I cannot possibly bear the injustice you do my noble friends in thinking they do me harm – and it is also very bad for both my mother and you to have the gnawing feeling of continual disagreement with me in such matters. Try and correct yourself at least in this one mistake – ask [Burne-]Jones out to any quiet dinner – ask him about me – ask him anything you want to know about mediaeval history – and try to forget that he is poor.[69]

Ruskin had taken the Burne-Joneses with him on his visit to Italy in the summer of 1862. John James thought – correctly – that he was meeting their expenses and also that the Burne-Joneses were supporting Ruskin's desire to live abroad. In this letter Ruskin gave him brusque confirmation that he was indeed planning to make a permanent home in Switzerland, because 'beyond all doubt or mistake, my health compels me to leave London. . . . This autumn I shall take up the botany and geology of the Salève, and I feel as I said in much more comfort and peace than I have done for years.'[70] By 1863 the threat of Switzerland became a reality when Ruskin bought some land at Chamonix, but nothing came of his plan to build a home on the site, and he later sold it. By this date the Burne-Joneses were urging him not to live in Switzerland but to make an independent home for himself in England instead. Late in the year he was considering properties in the Lake District. (In 1871, he would acquire a home at Coniston.) Yet at the end of the year he was back at Denmark Hill, having given up his attempts to find an independent home, and he lived there quietly with

his parents for the first few months of 1864. In February his father became terminally ill with uremic poisoning.*

Ruskin's rebellions of 1862 and 1863 – which could appropriately have taken place when he was eighteen – caused terrible pain and had no satisfactory outcome. The will to strike had come too late; Ruskin was now in his forties and the enemy was very frail.

The Ruskins were provincial people, very conscious of being 'trade' rather than 'gentry', and one of the strategies whereby the provincial retains confidence is by refusing to mix with those who are demonstrably his superiors, professionally or intellectually. Thus Ruskin had refused to compete. And as long as he had his father's absolute devotion and support, he had not *needed* to compete. The world might agree or disagree with him, but his father adored him absolutely, and continued to bring out his books and support his genius.

There was always provincialism in Ruskin, and always a power struggle. His provincialism was instinctive and deep. It guided him towards positions in which he could show himself to advantage and away from situations in which he might not be able to exercise control. In his letter about eating up St Mark's and Verona 'stone by stone', written to his father from Verona on 2 June 1852, he had said:

> I begin to think that the real characteristic of men of genius – be they large or small – is that they are more instinctive and less reasonable than other people – that your true genius fights as Falstaff ran away, upon instinct. . . . 'Genius' . . . consists mainly in a man's doing things because he cannot help it, intellectual things, I mean: I don't think myself a great genius – but I believe I have genius.[71]

This letter can be seen as containing the strategies of the 'provincial': he is not clever, he does not propose to compete with competent professional people such as lawyers and doctors, but he does have 'genius'; i.e. he will not compete except on his own terms, he is in a class of his own. At the same time, the criteria by which he judges himself are exacting, and lead to disappointment: he is 'every year dissatisfied with what I did the last'. Earlier in the same group of letters, Ruskin had remarked:

What you say of Turner's death at Chelsea is very sad – and it is a striking

*After his father's death his mother needed a companion. His cousin, Joan Agnew, came to Denmark Hill to be with the old lady. Joan was to marry Arthur Severn in 1871, but her visit to Denmark Hill in 1864 was in effect the beginning of an association which would last for the remainder of Ruskin's life.

monument of the evil ways of this century that its greatest mind should have been left thus neglected. But the longer I live, the more the world and all that it inherits becomes a mystery to me. When I read the Bible – especially the New Testament – the standard it fixes appears so high that it is impossible for any creature to come near it; the great mass of the world therefore seems to give it up at once, and live as they list, in a sort of tacit despair: and we are worse in this respect than if we had no Bible. While the few who try to live by God's word find so much to dwell upon in themselves and to conquer that they are all intent upon their own battles – experiences – and dangers – and never seem able to look round with practical glance upon the outside world.[72]

For Matthew Arnold, who referred to one of Ruskin's many dubious etymological passages – in this case, on Shakespeare's names – as exhibiting 'the note of provinciality', to be provincial was a weakness. But Ruskin's provinciality, his isolated and self-taught genius, was strong. He was wayward, and confident in his waywardness; adverse criticism or a sense of losing the thread of his argument would not stop him writing. Everything he read was interesting to him, nothing need be taken in order, everything could be incorporated into whatever he happened to be working on at the moment:

I have been reading the *Odyssey* to-night with much delight, and more wonder. Everything now has become a mystery to me – the more I learn, the more the mystery deepens and gathers. This which I used to think a poet's fairy tale, I perceive to be a great enigma – the Apocalypse, in a sort, of the Greeks. . . . I see we are all astray about everything – the best wisdom of the world has been spoken in these strange enigmas – Dante's, Homer's, Hesiod's, Virgil's, Spenser's – and no one listens, and God appoints all His best creatures to speak in this way: 'that hearing they may hear, and not understand' [Matthew, xiii, 14]; but *why* God will always have it so, and never lets any wise or great man speak plainly . . . there's no guessing.[73]

The man of genius is licensed to write obscurely. Ruskin was in a way seeking to pre-empt the hostile reactions of readers to his work. Yet hostile readers could change his practice. The *Saturday Review* attacked his essays in the *Cornhill Magazine* as the hysterics, nonsense, twaddle, whines and snivels of a mad governess.[74] Ruskin was stung:

I am not going to cast more pearls before swine. I will do the work sternly and unanswerably, in shortest possible language. I think the insolence of these *Saturday Review* scamps in talking to Smith [Smith and Elder, publishers of the *Cornhill Magazine*] as if they would 'let' me do this or that passes all I ever met; and I'm not going to 'let' them have any more

fine 'language' to call me a 'mad governess' for. They shall have such language as is fit for them, and for the public.[75]

So, wayward, energised, self-indulgent, Ruskin finds in the word 'genius' a justification for his waywardness. The provincialism justifies itself. He was *right* not to compete.

As with *Modern Painters* and *The Stones of Venice* Ruskin's method when writing about economics was to take the research to first principles, to the basics. Just as the 'stone' is the basic subject of study in *The Stones of Venice*, so 'wealth' is the basic subject of study in *Unto this Last*,* and Ruskin shows the confidence of a man who is thinking the matter out for himself:

> Men nearly always speak and write as if riches were absolute, and it were possible, by following certain scientific precepts, for everybody to be rich. Whereas riches are a power like that of electricity, acting only through inequalities or negations of itself. The force of the guinea you have in your pocket depends wholly on the default of a guinea in your neighbour's pocket. If he did not want it, it would be of no use to you . . . the art of making yourself rich, in the ordinary mercantile economist's sense, is therefore equally and necessarily the art of keeping your neighbour poor.[76]

And he translated this, the power of the guinea in the pocket, into a clearly understood example: 'suppose any person to be put in possession of a large estate of fruitful land . . . but suppose . . . that he could get no servants? In order that he may be able to have servants, some one in his neighbourhood must be poor, and in want of his gold – or his corn.'[77] Were he unable to buy labour, his wealth would be no use to him. Ruskin then effectively turned this into a universal principle.

Unto this Last attacks 'laissez-faire' economic doctrine in general, and the economic writings of John Stuart Mill and David Ricardo in particular. John Stuart Mill (1806–73), the great liberal philosopher, worked for many years as a member of the East India Company and was thereafter an independent MP for Westminster. In *Principles of Political Economy* (1848) he aligned himself broadly with the 'laissez-faire' or free trade doctrine (also associated with the so-called Manchester school of economists). In this doctrine free international trade and free enterprise would ensure a steady expansion of national wealth. Mill's work in economics built in part on that of David Ricardo (1772–1823) whose book *On Principles of Political Economy and Taxation* (1817) was seen as a founding text underlying the doctrine of free trade. As J.T. Fain showed in *Ruskin and the Economists* (Nashville, TN: Vanderbilt University Press, 1956), Ruskin had studied the economists of his day more thoroughly than he acknowledged in his published work.

What is really desired, under the name of riches, is, essentially, power over men; in its simplest sense, the power of obtaining for our own advantage the labour of servant, tradesman, and artist; in wider sense, authority of directing large masses of the nation to various ends. . . . And this power of wealth of course is greater or less in direct proportion to the poverty of the men over whom it is exercised, and in inverse proportion to the number of persons who are as rich as ourselves. . . . [So that] the art of becoming 'rich,' in the common sense, is not absolutely nor finally the art of accumulating much money for ourselves, but also of contriving that our neighbours shall have less.[78]

This led, in Ruskin's argument, to 'mortal luxury, merciless tyranny, ruinous chicane'. The 'idea that directions can be given for the gaining of wealth, irrespectively of the consideration of its moral sources . . . [is] the most insolently futile of all that ever beguiled men through their vices'.[79]

It is hard to shake off the habits of a lifetime. Ruskin had loosened his attachment to the absolute authority of the Bible, but his mind was conditioned to see the authority of text as the source of visionary truth. The titles of the four essays of *Unto this Last*,* especially the last two, indicate clearly enough the strategy. Ruskin refused to allow economics to be a distinct discipline. It was inseparable from cultivated life. Its issues could be referred to the authority of the Bible, Shakespeare, Dante and Herbert, and the gnomic or oracular serendipities of wordplay. For rhetorical advantage he played to his strengths: imaginativeness, allusiveness, wide literary and artistic cultivation.† He closed the second essay with a question that put the issue in religious terms: 'whether, among national manufactures, that of Souls of a good quality may not at last turn out a quite leadingly lucrative one?'[80]

The third and fourth essays took as their titles quotations from within their own texts. The former comes from Dante quoting in his *Paradiso*[81] from the Wisdom of Solomon (the Latin phrase means 'Love righteousness, ye that be judges of the earth'), a book normally regarded by Protestants as part of the Apocrypha, but accepted by Catholics as biblical.‡

I hope I do not misrepresent [the popular economist] by assuming that he

*'The Roots of Honour', 'The Veins of Wealth', 'Qui Judicatis Terram' and 'Ad Valorem'.
†These artistic and literary qualities are exactly in the areas where the political economists were weakest.
‡Brilliantly and typically, Ruskin grounded his attack on political economy in a medieval Italian poet and a biblical text.

means *his* science to be the science of 'getting rich by legal or just means.' . . . It will follow that in order to grow rich scientifically, we must grow rich justly; and, therefore, know what is just; so that our economy will no longer depend merely on prudence, but on jurisprudence – and that of divine, not human law. Which prudence is indeed of no mean order, holding itself, as it were, high in the air of heaven, and gazing for ever on the light of the sun of justice; hence the souls which have excelled in it are represented by Dante as stars forming in heaven for ever the figure of the eye of an eagle [and tracing in light] 'DILIGITE JUSTITIAM QUI JUDICATIS TERRAM.'[82]

Moral force, moral and visionary authority, would make his argument work for him. The title of the last essay was similarly taken from within his text, with an ironic glance at the 'gentlemanly' education that Victorian merchants liked to buy for their sons:

Much store has been set for centuries upon the use of our English classical education. It were to be wished that our well-educated merchants recalled to mind always this much of their Latin schooling, – that the nominative of *valorem* . . . is *valor* . . . from *valere*, to be well or strong. . . . To be 'valuable,' therefore, is to 'avail towards life.' A truly valuable or availing thing is that which leads to life with its whole strength.[83]

The play, the irony and the cultivation led to what in a lesser person would look like name-calling, but in Ruskin was energetic moral discrimination:

In a community regulated only by laws of demand and supply, but protected from open violence, the persons who become rich are, generally speaking, industrious, resolute, proud, covetous, prompt, methodical, sensible, unimaginative, insensitive and ignorant. The persons who remain poor are the entirely foolish, the entirely wise, the idle, the reckless, the humble, the thoughtful, the dull, the imaginative, the sensitive, the well-informed, the improvident, the irregularly and impulsively wicked, the clumsy knave, the open thief, and the entirely merciful, just, and godly person.[84]

A marvellous list and a richly persuasive set of contrasts effectively segregated the capitalist from humankind. Shrewd, tough men like Ruskin's father were distinguished from people representing the whole range of the human condition and whose qualities included, of course, those that Ruskin reserved for himself: 'imaginative', 'sensitive', 'well-informed', 'merciful' and 'just'. And the question in the title of this fourth essay, 'What is value?', led him to rephrase, and then to answer, his own question at the end of his second essay (i.e. 'Is the nation

manufacturing Souls of good quality?'). He wrote: 'The question for the nation is not how much labour it employs, but how much life it produces . . . I desire, in closing the series of introductory papers, to leave this one great fact clearly stated. THERE IS NO WEALTH BUT LIFE.'[85]

In all this writing on political economy, so vividly text-based, he here revisited one of his most revered texts, Wordsworth's *The Excursion*:

> We live by Admiration, Hope and Love;
> And, even as these are well and wisely fixed,
> In dignity of being we ascend.[86]*

In 1872 Ruskin gave an account of the difficulties he encountered in publishing *Unto this Last*: 'Eleven years ago, in the summer of 1860, perceiving then fully, (as Carlyle had done long before), what distress was about to come on the . . . populace of Europe through these errors of their teachers, I began to do the best I might, to combat them.' His friend Thackeray, editor of the *Cornhill*, published the first three papers 'but the outcry against them became then too strong for any editor to endure, and he wrote to me, with great discomfort to himself, and many apologies to me, that the Magazine must only admit one Economical Essay more'.[87]†

In this last essay, Ruskin set out his vision of the good society. Wealth is to be found in life and art, not in competition. Society should be without ambition for advancement, profit or usury. The Ruskinian society will be a contented, self-sufficient, rural community, where the good and the beautiful are one, and the Bible remains the textual authority for man's actions:‡

> The presence of a wise population implies the search for felicity as well as for food. . . . The desire of the heart is also the light of the eyes. No scene is continually and untiringly loved, but one rich by joyful human labour; smooth in field; fair in garden; full in orchard; trim, sweet, and frequent in homestead; ringing with voices of vivid existence. No air is sweet that is silent; it is only sweet when full of low currents of under sound – triplets of birds, and murmur and chirp of insects, and deep-toned words of men,

*This passage was a touchstone in *Modern Painters* (see particularly Volume II; *Works*, IV, p. 29).

†'Ad Valorem' was the fourth and longest of the essays; by the time he wrote it Ruskin knew it would be the last.

‡Although he ostensibly attacked the theories of political economists, he was actually just using their works as a point of departure with which he could contrast his own vision of England.

and wayward trebles of childhood. As the art of life is learned, it will be found at last that all lovely things are also necessary; – the wild flower by the wayside, as well as the tended corn; and the wild birds and creatures of the forest, as well as the tended cattle; because man doth not live by bread only, but also by the desert manna; by every wondrous word and unknowable work of God. Happy, in that he knew them not, nor did his fathers know; and that round about him reaches yet into the infinite, the amazement of his existence.[88]

With the termination of his essays for the *Cornhill* he 'resolved to make it the central work of my life to write an exhaustive treatise on Political Economy'. J.A. Froude, editor of *Fraser's Magazine*, invited Ruskin to develop his ideas, and Ruskin wrote for him the essays that were published as *Munera Pulveris*, intended as the introduction to his 'exhaustive treatise'. These Froude 'ventured to print', in four chapters, but 'though the Editor had not wholly lost courage, the Publisher indignantly interfered; and the readers of *Fraser*, as those of the *Cornhill*, were protected, for that time, from farther disturbance'. Thereafter 'loss of health, family distress, and various untoward chances'* prevented him from writing the great work.[89]

There is something inherently romantic about this account of the project. Ruskin sees himself as having a great philosophical and political book, a key to all the ills of Victorian life, which remains the unwritten and unfinished centre of the rest of his intellectual life. What he actually managed to get published may be taken as satellites of this huge unrealised project.

But of course the necessary brevity gave his 'preface' – *Munera Pulveris* – an impact which the huge book might have lacked.

The Ruskin who wrote *Unto this Last* and *Munera Pulveris* had already to some degree freed himself from his father. The prose is often biting, full of satire, some of it recalling Swift's *Modest Proposal*. Ricardo in his *Principles of Political Economy* (Chapter 5, 'On Wages') had said 'the natural price of labour is that price which is necessary to enable the labourers . . . to subsist and to perpetuate their race' and to 'keep up' the number of labourers. That phrase 'keep up' seems to be the target of Ruskin's attack: he said Ricardo's objective was to 'maintain' the labourer (a misquote; Ricardo of course aimed at maintaining labourers in the sense of keeping their number constant). Ruskin played mercilessly with Ricardo's argument:

*He is referring to the death of his father in 1864 and to the agonising relationship with Rose La Touche, which was still going on at the time of writing, 1872.

Maintain him [the labourer]! yes; but how? . . . To what length of life? Out of a given number of fed persons, how many are to be old – how many young? that is to say, will you arrange their maintenance so as to kill them early – say at thirty or thirty-five on the average, including deaths of weakly or ill-fed children? – or so as to enable them to live out a natural life?[90]

By *reductio ad absurdum* he then considered how Ricardo's scheme for the appropriate use of a piece of land would translate into the actual management of a nation:

If the ground maintains, at first, forty labourers in a peaceable and pious state of mind, but they become in a few years so quarrelsome and impious that they have to set apart five, to meditate upon and settle their disputes; – ten, armed to the teeth with costly instruments, to enforce the decisions; and five to remind everybody in an eloquent manner of the existence of a God; – what will be the result upon the general power of production, and what is the 'natural rate of wages' of the meditative, muscular, and oracular labourers?[91]

The indignation and comedy coexist with a fundamental decency. By satirising the lawyers and the clergy as 'meditative' and 'oracular' labourers, Ruskin was challenging the fundamental assumption of Ricardo and Mill: that the proletariat have nothing in common with ourselves and require management rather than love and respect. Here and elsewhere, though, Ruskin dissociated himself from socialism. The alternative vision of England that he proposed does not include the idea of the equality of man. In a footnote he said:

I am not taking up . . . the common socialist idea of division of property: division of property is its destruction; and with it the destruction of all hope, all industry, and all justice. . . . The socialist, seeing a strong man oppress a weak one, cries out – 'Break the strong man's arms;' but I say, 'Teach him to use them to better purpose.'[92]

With the next group of essays in *Munera Pulveris* Ruskin meditated further on the meaning of wealth. 'Ad Valorem' has told us that 'there is no wealth but life'. The 1872 introduction* to the essays identifies a central finding of *Munera Pulveris*: art is also absolute wealth. Ruskin recalled seeing the damage done by the Austrian bombs to the Tintorettos in the Scuola di San Rocco in 1851: 'I knew already . . . that

*By the time Ruskin was writing this Preface in 1872, his father was dead, and Ruskin was able to write a piece about property which seems to go as far as Pierre-Joseph Proudhon's famous statement that 'property is theft'.[93]

the pictures of Tintoret in Venice were accurately the most precious articles of wealth in Europe, being the best existing productions of human industry.' But Europe neglected them, and preferred instead to squander its resources on the production of worthless lithographs of French dancers.[94]

Professor Henry Fawcett, a Cambridge economist who was always one of Ruskin's favourite targets, had written on rent in his book *Political Economy*, remarking that land-ownership was normally a historical result of conquest. Ruskin wrote in his Preface that he was amazed that Fawcett never challenged the principle underlying this: 'the maintenance, by force, of the possession of land obtained by force'. He said: 'the nearest task of our day [is] to discover how far [the] original theft may be justly encountered by reactionary theft, or whether reactionary theft be indeed theft at all'. If property is theft then revolution is just restitution.[95]

Ruskin directly attacked his father's attitude to capital. He recalled his father and his fellow merchants saying that 'if there were no National debt they would not know what to do with their money'. This led to an ironic flight on the subject of what capitalists in fact do with their money: they fund the peasants of poorer countries to kill each other: the peasants 'borrow guns, out of the manufacture of which the capitalists get a percentage, and men of science much amusement and credit':

> Then the peasants shoot a certain number of each other, until they get tired. . . . Then the capitalists tax both, annually, ever afterwards, to pay interest on the loan of the guns and gunpowder. And that is what capitalists call 'knowing what to do with their money'; and what commercial men in general call 'practical' as opposed to 'sentimental' Political Economy.[96]

Munera Pulveris developed Ruskin's comic perception of wealth and its abuses. One of the sharpest of his observations is both personal and Oedipal. The wealthy take pleasure in the idea that they have money which they might use for the good of another but which they can withhold. Pleasure taken '*in the imagination of power to part with that with which we have no intention of parting*, is one of the most curious, though commonest forms of the Eidolon, or Phantasm of Wealth'.[97] Paternal power, and Ruskin's resentment of it, are palpable here.

With regard to the nation as a whole, Ruskin continued to see wealth not as capital but as life. Mill had written: 'Industry is limited by

capital', and in a note Ruskin wrote: 'Industry dependent on Will, not on Capital. Single head and heart may do all. Napoleon – with his starving army.' He developed this in the text of his essay on 'Store-Keeping': the 'frequently uttered aphorism of mercantile economy – "Labour is limited by capital" . . . is untrue'. 'Out of a given quantity of funds for wages, more or less labour is to be had, according to the quantity of will with which we can inspire the workman; and the true limit of labour is only in the limit of this moral stimulus of the will, and of the bodily power.' Labour is limited only by 'the great original capital of head, heart, and hand'.[98] And he asked how to measure wealth in England:

> We will look first to the existing so-called 'science' of Political Economy; we will ask it to define for us the comparatively and superlatively rich, and the comparatively and superlatively poor; and on its own terms – if any terms it can pronounce – examine, in our prosperous England, how many rich and how many poor people there are; and whether the quantity and intensity of the poverty is indeed so overbalanced by the quantity and intensity of wealth, that we may permit ourselves a luxurious blindness to it, and call ourselves, complacently, a rich country.[99]

The fundamental logic of Ruskin's position – the separation of life from money – is constant, and underpins the whole argument: 'Everything is bought and sold for Labour, but Labour itself cannot be bought nor sold for anything, being priceless. The idea that it is a commodity to be bought or sold, is the alpha and omega of Politico-Economic fallacy.'[100]

In the essay on 'Coin-Keeping' he made some shrewd points about the nature of currency. All currency is in effect documentary evidence of debt. The choice of gold as the basis of currency is both arbitrary and absurd. We would do better to base currency on a substance of true intrinsic value, or to base it on more than one substance: 'If I can only claim gold, the discovery of a golden mountain starves me; but if I can claim bread, the discovery of a continent of cornfields need not trouble me.'[101]

Ruskin sounds extraordinarily wise about economics when he says that the hoarders of money are the people who do real harm. 'The circulation of wealth, which ought to be soft, steady, strong, far-sweeping, and full of warmth, like the Gulf stream, being narrowed into an eddy, and concentrated on a point, changes into the alternate suction and surrender of Charybdis.' This leads to another of his discourses on the nature of the value of products of the mind. Homer, Plato, Dante, Chaucer, Shakespeare and Goethe are supremely valuable

but 'useless to the multitude.'[102]

In the chapter on 'Government' Ruskin remarked that true education is the development of faculties of perceiving 'beauty, fitness, and rightness' and 'what is lovely, decent, and just'. With a characteristic side-swipe at science he added: 'It has been the great error of modern intelligence to mistake science for education. You do not educate a man by telling him what he knew not, but by making him what he was not.' A nation should receive high ethical training. The selfishness and irresponsibility of the upper class block this.[103]

In his great biography of Ruskin, published while Ruskin was still alive (in 1893), his friend and assistant W.G. Collingwood (1854–1932) explored Ruskin's political thinking. Collingwood's biography was the product of love, discipleship, intimate knowledge and admirable common sense: 'If we want to understand Mr. Ruskin, there is only one way of studying him; and that is to trace from point to point the growth of his mind.' *Modern Painters*, *The Seven Lamps of Architecture* and *The Stones of Venice* 'are works of a young man, not yet forty; that is to say, before the age at which most great authors, painters, and thinkers have done their best. They contain much that is valuable and much that is characteristic; but they are only the forecourt, not the presence chamber. They lead to his final conclusions, but they do not express them.' This leads him to Ruskin's notorious digressiveness and consequent obscurity: 'It is no use quarrelling with the author for not composing a consistent explanation of his views: though it would have been convenient for students; who might as well wish that Plato had left them a handbook of his philosophy, or that Shakespere had appended notes to *Hamlet*.'[104] Yet Collingwood took the view that, in a sense, a handbook of Ruskin's philosophy – or at least an interim expression of his views – was to be found in *Time and Tide*. Collingwood called *Time and Tide* 'the statement of his social scheme as he saw it in his central period'.

What Ruskin proposes as his ideal society comprises 'an organisation of labour akin to the ancient guilds, which he regarded as the combination, in each trade and in every kind of manufacture, agriculture and art, of all the masters with all the men. But while the old guilds were local, he would have them universal. . . . The workman, holding a well-defined position, and possessing some share of control, through the trade council, over his work and his wages, would have no ground for discontent.'

Collingwood was surely right to say that in its totality Ruskin's good society is an adapted 'feudalism of the Middle Ages in the sense that the whole body politic would be distinctly organic, and not anarchic: that its organisation would be based on a military scheme'.[105]

Unto this Last, Munera Pulveris and *Time and Tide* are Ruskin's most developed group of writings on economics.[106] *Unto this Last* attacks and destroys existing schemes of political economy, *Munera Pulveris* sets up an alternative scheme based on moral authority and substituting life for wealth at every point, and *Time and Tide* particularises the way in which the working man should conduct himself and construct a new society. The tones of the three works contrast interestingly. *Time and Tide* was in many ways the best. It was a series of letters to Thomas Dixon, a Sunderland cork manufacturer who was also a highly intelligent philanthropist and patron of the arts.*

Dixon was a bookish and cultivated person. An irony – about which he worried a great deal – was that although a teetotaller himself he made his fortune by providing corks, mostly for wine bottles. Anxious to prevent his employees from becoming victims of the demon drink, and vexed by the double standards shown by the brewing industry, he complained of Sir Benjamin Guinness (of the famous Irish brewing family) 'making his money by drink, and then giving the results of such traffic to repair the Cathedral of Dublin. It was thousands of pounds. I call such charity robbing Peter to pay Paul!' Dixon refers to the example of one of Ruskin's prominent northern friends: 'I honour men like *Sir W Trevelyan*, that are teetotalers, or total abstainers, as an example to poor men, and, to prevent his work-people being tempted, will not allow any public-house on his estate. If our land had a few such men it would help the cause.'[107] Ruskin, though, both as a wine-merchant's son and as a man who liked wine, found it convenient that the drinking of wine was endorsed both by the Bible (he cites the miracle of the marriage at Cana) and by Plato in the *Laws*.[108]

As Ruskin said, the letter form suited him. It suited his provincialism. He was always frightened of people potentially more intelligent, more successful, more established than he was. With Thomas Dixon he was undoubtedly addressing an inferior, but an intelligent inferior. Also, it should be remembered that until John James died, he was the person to

*The immediate context in public affairs was the agitation for extension of the franchise, which led to Disraeli's Reform Bill of 1867.

whom all Ruskin's writing had been addressed. After his father's death Ruskin cast around for another audience. In all his work after 1864 there is an auditor, an actual person who needs to be imagined listening to Ruskin. The identity of that auditor is always important.

The intimacy of the letter form allowed Ruskin to play with wildly radical ideas. On marriage he came up with a proposal which would completely transform society, involving as it did a heady mix of educational theory and eugenics. Young people should be permitted to marry only when they could show a 'nationally attested' level of educational attainment, and once married they should be allowed a fixed income from the state for the first seven years of married life. Young people with inherited wealth would not be permitted to exceed 'a given sum proportioned to their rank'.

Class distinction would be maintained, therefore, by some differential in income, but the whole of British society, without exception, would start married life with a high level of education and a guaranteed income. For the 1860s this was an extraordinarily utopian vision.[109] And it was a vision proposed by a man who saw himself as temperamentally conservative, and who refused to have anything to do with practical affairs. As he wrote in letter XIX:

> I am essentially a painter and a leaf dissector; and my powers of thought are all purely mathematical, seizing ultimate principles only – never accidents. . . . Though I can almost infallibly reason out the final law of anything, if within reach of my industry, I neither care for, nor can trace, the minor exigencies of its daily appliance. So, in every way, I like a quiet life.[110]

This is a good self-portrait. He insists on staying outside the mainstream of political and public life; he will arrive at his theories by working in isolation from first principles; he refuses to engage in action or debate. The isolation and the conscious provincialism have their roots of course in his family's social isolation and its inner directed evangelical strength. From one viewpoint this is a very strong position. He belongs to no organisation, he is answerable to no one but himself, he can analyse the society which so offends him from the position of a complete outsider.

Time and Tide started as a few simple letters to Dixon. These were in effect 'notes' to the big works, *Unto this Last* and *Munera Pulveris*. Referring to the immediate question of franchise reform, Ruskin encouraged the working man to have nothing to do with the House of

Commons but to set up an alternative parliament of his own. This parliament was to 'deliberate upon the possible modes of the regulation of industry, and advisablest schemes for helpful discipline of life; and so lay before you the best laws they can devise, which such of you as were wise might submit to, and teach their children to obey'.*

Ruskin certainly supported Dixon in his view that businessmen should lead by example. In the first two letters of *Time and Tide* he advocated co-operation rather than competition, and that the masters should exercise restraint in their demand for wealth, as an example to their men. The men were not to compete for money or advancement, and in turn the masters were to ensure that the men were paid enough for personal contentment, for provision for their old age, and for the establishment of their children in the same position in life. The good society required universal abandonment of competition.

Ruskin defended his use of the Bible as the text that indicates to us the nature of the good society. When his argument was made quickly, with rapid, flashing brushstrokes, it was at its most effective. In letter XI, for example, he promised in a future letter to discuss the significance of the parable of the Prodigal Son, and while making this promise gave a brilliant, quick, extempore account of its relevance to his argument. He explained the importance of music and pleasure in education ('the power of the Muses . . . and its proper influence over you workmen') as illustrated by the parable: 'I will take the three means of festivity, or wholesome human joy, therein stated, – fine dress, rich food, and music; – ("bring forth the fairest robe for him," – "bring forth the fatted calf, and kill it;" "as he drew nigh, he heard music and dancing"); and I will show you how all these three things, fine dress, rich food, and music (including ultimately all the other arts) are meant to be sources of life, and means of moral discipline, to all men.'[111]

Ruskin had gone into the political arena much as Shelley did, in a spirit of desperate moral outrage. In letter XIII, written on 21 March 1867, he referred to the mild early spring weather and remarked that 'by rights I ought to be out among the budding banks and hedges, outlining sprays of hawthorn and clusters of primrose'. But he and others like him (he was thinking particularly of George Cruikshank's temperance work) were 'tormented by agony of indignation of compassion, till we are forced to give up our peace, and pleasure, and

*Cook and Wedderburn observe that the Trades Union Congress, which is in a sense precisely such a parliament, met for the first time the following year, in Manchester.

power; and rush up and down into the streets and lanes of the city, to do the little that is in the strength of our single hands against their uncleanness and iniquity'.[112] In the same letter he hinted that all his political writing was to be regarded as a digression or departure from his real work. 'I mean these very letters to close my political work for many a day; and I write them, not in any hope of their being at present listened to, but to disburthen my heart of the witness I have to bear, that I may be free to go back to my garden lawns, and paint birds and flowers there.'[113] But the failure of moral authority in England compelled men of intelligence and goodwill to intervene. He had already written in *Sesame and Lilies* (1865) that moral authorities ('Bishops') should be appointed to high offices of state in order that they could monitor all areas of British life, and should oversee the day-to-day management of the hugely intrusive government envisaged by him. This omnipresent state machine* included universal education and nationalised utilities – roads, mines, harbours and the like – 'nothing of this kind should be permitted to be in the hands of private speculators'.[114] Ruskin was comically aware of how wild these words would sound to Dixon (and to his readers) but he pushed ahead with his vision of the good society because England was in peril.

The immediate causes of this peril were: 'the gradually accelerated fall of our aristocracy (wholly their own fault), and the substitution of money-power for their martial one', 'imminent prevalence of mob violence', 'continually increasing chances of insane war', and the 'monstrous forms of vice and selfishness which the appliances of recent wealth, and of vulgar mechanical art, make possible to the million'.[115]

In letter XV he had it that the decoration of railway stations was a form of theft (the money should be put to better uses) and that 'theft' of this kind as committed by capitalists was condemned by the Bible as worse than murder (Barabbas having been a murderer as well as a thief, but the word 'robber' is the one used to characterise him).[116] It is encouraging that this extravagance was followed by far-thinking good sense: 'Crime, small and great, can only be truly stayed by education.'[117] His account of the fundamental principles of education, given in letter XVI, was luminous in its vision and generosity.

In letter XIX of *Time and Tide* he expressed horror over the condition of the country in which he lived. It was a comic despair, coloured

*It anticipated a great many features of the welfare state introduced by the Labour Government of 1945.

as it was by the vexed exasperation of the wealthy philanthropist who was simply unable to meet all the demands on him. He described a begging letter that he had received for help for the family of an artist who has recently died 'of distress while he was catering for the public amusement'. This death was symptomatic of general distress: 'I feel constantly as if I were living in one great churchyard, with people all round me clinging feebly to the edges of the open graves, and calling for help, as they fall back into them, out of sight.'[118]

This situation bred in him a sense of hopelessness: 'for one we can relieve, we must leave three to perish'. Despite this, great inroads into his wealth were made by his charities, and

> It is not the mere crippling of my means that I regret. It is the crippling of my temper and waste of my time. . . . It is peremptorily not my business – it is not my gift, bodily or mentally, to look after other people's sorrow. I have enough of my own; and even if I had not, the sight of pain is not good for me. I don't want to be a bishop. In a most literal and sincere sense, 'nolo episcopari.' I don't want to be an almoner, nor a counsellor, nor a Member of Parliament, nor a voter for Members of Parliament. (. . . I have never voted for anybody in my life, and never mean to do so!)[119]

Ruskin knew that in these letters he was out on a limb, that he had abandoned caution, collegiality, even common sense, in order to express himself freely. He was charged with the passion of a man determined to draw attention to himself and determined to get his own way. It may sound as if the voice of a child in a tantrum is breaking through the famous adult, but the effect is powerful and oddly engaging. Ruskin would never have been a sober member of a committee, a 'reliable member of middle management', a 'safe pair of hands', a 'head of department'. He was far too great a man for that.

Having legislated for education he legislated in the remainder of *Time and Tide* for nations. He knew that what he was proposing was capricious and provocative and that it was theoretical only: it would never come into being. His ideal society was highly stratified, controlled and ordered by benevolent aristocrats and with a 'middle class' which was forced to practise a kind of eugenics. Young people had to earn the 'right' to marry – not before the age of seventeen for girls, twenty-one for men – and it would be a disgrace to have failed to earn this right by the age of twenty-one for girls, and twenty-four for men. He wanted to give them chivalric French names, the women to be 'rosieres' and the men 'bachelors'. Once married, for the first seven

years of married life the young people would be entitled to a guaranteed state income, calculated 'according to their position in life'. The upper classes were to administer their property and their land for the well-being of the whole community (there was no questioning their *right* to property and land). They were to live frugally, because to do otherwise was to create an enslaved class of workers who provided goods and services for the rich: 'You do not merely employ these people. You also *tread* on them.'[120] He displayed an unrepentant nostalgia for authority ('The office of the upper classes . . . is to keep order among their inferiors') and for empire: 'If I had to choose, I would tenfold rather see the tyranny of old Austria triumphant in the old and new worlds . . . than, with every privilege of thought and act, run the most distant risk of seeing the thoughts of the people of Germany and England become like the thoughts of the people of America.' He was clear about the disastrous effect of American republicanism: 'The Americans, as a nation, set their trust in liberty and in equality, of which I detest the one, and deny the possibility of the other.'[121] On property law in letter XXIII he had an excitingly mischievous time sticking his tongue out at Mill. Mill had supported the prosecution of Governor Eyre of Jamaica (who had tried and executed George Gordon, supposed leader of a rebellion on the island). Ruskin's response to this was gleefully outrageous:

> It is a curious thing to me to see Mr. J.S. Mill foaming at the mouth, and really afflicted conscientiously, because he supposes one man to have been unjustly hanged, while by his own failure, (I believe, *wilful* failure) in stating clearly to the public one of the first elementary truths of the science he professes, he is aiding and abetting the commission of the cruellest possible form of murder on many thousands of persons yearly, for the sake simply of putting money into the pockets of the landlords.[122]

What Ruskin meant by this he developed later in letter XXIII where he found Mill covertly supporting (while ostensibly attacking) the rights of landowners. It is a confused and incoherent argument, but its spleen and energy are infectious.

In March 1864 the father whom Ruskin so loved and depended upon, and with whom he had such deep misunderstandings and conflicts, died, leaving Ruskin a very wealthy man.

Ruskin insisted that the funeral rites should be kept to a minimum, and he wrote a loaded epitaph for John James Ruskin's tombstone. The latter part reads: 'He was an entirely honest merchant, and his memory

is, to all who keep it, dear and helpful. His son, whom he loved to the uttermost and taught to speak truth, says this of him.'[123] In this inscription the love is all one way.

In the aftermath of his father's death Ruskin's resentment was such that he was implicitly denying the obvious fact that for most of their long relationship the love had been fully reciprocated.

CHAPTER 6

1865–71

Have you ever thought what a world his eyes opened on – fair, searching eyes of youth? What a world of mighty life, from those mountain roots to the shore; – of loveliest life, when he went down, yet so young, to the marble city – and became himself as a fiery heart to it?

A city of marble, did I say? nay, rather a golden city, paved with emerald. For truly, every pinnacle and turret glanced or glowed, overlaid with gold, or bossed with jasper. Beneath, the unsullied sea drew in deep breathing, to and fro, its eddies of green wave. Deep-hearted, majestic, terrible as the sea, – the men of Venice moved in sway of power and war; pure as her pillars of alabaster, stood her mothers and maidens; from foot to brow, all noble, walked her knights; the low bronzed gleaming of sea-rusted armour shot angrily under the blood-red mantle-folds. Fearless, faithful, patient, impenetrable, implacable, – every word a fate – sate her senate. In hope and honour, lulled by flowing of wave around their isles of sacred sand, each with his name written and the cross graved at his side, lay her dead. A wonderful piece of world. Rather, itself a world. It lay along the face of the waters, no larger, as its captains saw it from their masts at evening, than a bar of sunset that could not pass away; but for its power, it must have seemed to them as if they were sailing in the expanse of heaven, and this a great planet, whose orient edge widened through ether.[1]

The completion of *Modern Painters* had been an act of filial love and duty. In the passage from Volume V quoted above Ruskin was pulling together some favourite topics. The chapter contrasted the childhood of Giorgione, reared in sumptuous Venice, and that of Turner, brought up among the mundane and ugly sights of eighteenth-century Covent Garden. Turner could turn anything into art: 'Dead brick walls, blank square windows, old clothes, market-womanly types of humanity – anything fishy and muddy, like Billingsgate or Hungerford Market, had great attraction for him; black barges, patched sails, and every possible condition of fog.'[2]

'The Two Boyhoods' was the first chapter of the biography of Turner that John James had long wanted Ruskin to write. It was no more than a gesture, but a very affectionate one. And it was also in a way a delicate

riposte. By using these two settings, Venice and London, Ruskin demonstrated what he had often asserted, that the work on Venice was a legitimate complement to the great book on Turner, not an interruption of it.

On 9 March 1864, Ruskin wrote to Henry Acland about John James's recent death, saying that the event had been 'the loss of a father who would have sacrificed his life for his son, and yet forced his son to sacrifice his life to him, and sacrifice it in vain. It is an exquisite piece of tragedy altogether – very much like Lear, in a ludicrous commercial way – Cordelia remaining unchanged and her friends writing to her afterwards – wasn't she sorry for the pain she had given her father by not speaking when she should?'[3]

Ruskin took the line that the death of his father was a release. The letters of 1864–71 show him playing, often, with illicit opinions. Thus to W.H. Harrison in 1865: 'All the worst evil on this earth is priests' work' and on 25 June 1865 to a Mr MacKay, a wine importer: 'What a divine thing is laziness! I owe whatever remains of health I have to it in myself. . . . What a busy place Hell must be! We get the look of it every now and then so closely in our activest places – what political economy there, and Devil take the hindmost in general!'[4]

It is ironic therefore that the years after his father's death, which should have been years of freedom, were so often characterised by frustration and anger. Ruskin was an intense egotist, of course, and the world simply would not bend to his will. Take, for example, the relationship with Dante Gabriel Rossetti. Ruskin had taken up Rossetti, encouraged him and Elizabeth Siddal, poured out money and resources on them and their work; but Rossetti remained obstinately his own person. Ruskin's desire to dominate and Rossetti's stubborn independence led to a breach which was marked by Ruskin's letter to Rossetti of July 1865:

> I am grateful for your love – but yet I do not want love. I have had boundless love from many people during my life. And in more than one case that love has been my greatest calamity – I have boundlessly *suffered* from it. But the thing, in any helpful degree, I have never been able to get, except from two women of whom I never see the only one I care for, and from Edward [Burne-]Jones, is 'understanding.'
>
> I am nearly sick of being loved – as of being hated – for my lovers understand me as little as my haters. I had rather, in fact, be disliked by a man who somewhat understood me than much loved by a man who understood nothing of me. . . .

Now in old times I did not care two straws whether you knew or acknowledged in what I was superior to you, or not. But now (being, as I say, irritable and ill) I do care, and I will associate with no man who does not more or less accept my own estimate of myself. . . . You know nothing of me, nor of my knowledge, nor of my thoughts, nor of the sort of grasp of things I have in directions in which you are utterly powerless; and . . . I do not choose any more to talk to you until you can recognize my superiorities as *I* can yours.[5]

Relationships with male friends such as Rossetti could go wrong, but many of his friendships with men during these years were strong and sustaining, especially those with Charles Eliot Norton and with Carlyle. It was just as well that Ruskin had such friendships, because from 1866 he was constantly tormented by his terrible relationship with Rose La Touche, and the suffering caused him by this young woman is a dark undertow to much of his work during this period. The marvellous thing is that he could achieve so much.

His father had *guided* Ruskin. His mother could not perform this role, and after his father's death Ruskin found himself wealthy. With his new independence he made mistakes. One such mistake was the recruitment of Charles Augustus Howell as his private secretary. Howell, aged twenty-six when Ruskin took him on in 1865, was part of Ruskin's expanding social world in that he was a friend of Dante Gabriel Rossetti (who introduced him to Ruskin) and of the Burne-Joneses. He was a personable and plausible young man, and while he was in Ruskin's employment – 1865–70 – Ruskin trusted him completely. Howell, however, was indiscreet, discussing Ruskin's affairs – such as the terms of his separation from Effie, his passion for Rose La Touche and the amount of money with which he was helping needy friends (for instance, Burne-Jones) – with third parties, among them Rossetti, who recorded the gossip in his diary.[6] Still, for most of their time together Ruskin was fond of Howell. He saw him as a good friend to Burne-Jones and is often found in his letters encouraging Howell to look after 'Ned' (who suffered periodically from depression). And Howell was entrusted with charitable disbursements; for example, to the fund for the relief of George Cruikshank (1792–1878), the engraver and illustrator, who had fallen on hard times in his old age.[7]

From 1866 Howell was in full charge of all Ruskin's affairs. On his marriage in 1867 he received generous presents from Ruskin, who even set him up, at a cost of some £200, in a house in Fulham so that he

could live near Burne-Jones and continue to offer support and encouragement to the painter.[8] But this all came to an abrupt end in 1870. Howell, Ruskin's trusted young friend, his beloved sweet 'Owl', was caught out in some piece of dishonesty, the details of which are obscure, and Ruskin immediately sacked him and thereafter refused to communicate with him except in writing: '[I] must beg you to conduct the business now between us by correspondence only' (letter of 4 September 1870).[9]

Ruskin was not the only person to be abused by Howell, who seems to have won the confidence of the poet Algernon Charles Swinburne. For some of the period that he was drawing a salary from Ruskin, Howell was acting as Swinburne's literary agent (making deals for the poet which turned out to be highly disadvantageous). The friendship was so close that we find Swinburne in 1865 writing to Howell asking him to provide pornographic dialogues 'between schoolmaster and boy – from the first summons. . . . To the last *cut* and painful buttoning up. . . . I want to see how real life you will make it. Describe also the effect of each stripe on the boy's flesh.'[10] Such letters were later used by Howell in an attempt to blackmail Swinburne.

Given Swinburne's reputation for outrage it seems surprising that he was also a friend of Ruskin himself, but the poet's grandfather was a friend and neighbour in Northumberland of the Trevelyans; and in the summer of 1853 (when Ruskin, Effie and Millais stayed with the Trevelyans on their way to Scotland) Ruskin had visited Capheaton, the Swinburnes' magnificent seventeenth-century house near Wallington, to see Sir John Swinburne's collection of Turners (at that time one of the best private collections in England). Swinburne, then only sixteen, was away at Eton. Later, as a Balliol undergraduate, Swinburne became friendly with Rossetti, Burne-Jones, William Morris and others of the PRB and he took a lively interest in the decoration of the Oxford Union building. After Oxford (he did no work and had to leave Balliol in 1859 without taking his degree) he became very close to Rossetti. He was with Rossetti on the night that his wife Elizabeth Siddal, whose supposed genius Ruskin had supported so enthusiastically, took a fatal overdose of laudanum, in February 1862; later that year he and Rossetti took a house, Tudor House, Cheyne Walk (the other tenants were William Michael Rossetti and George Meredith). Ruskin asked Rossetti if he, too, could rent a room in the house.[11] Given the life-styles of Swinburne and Rossetti, it is just as well that he did not. The menage lasted some two years; it has passed into legend as a Pre-Raphaelite

bohemia of free love and strange pets* – and Rossetti also installed in the house his model and mistress, the opulently splendid Fanny Cornforth. In fact, though, Swinburne's eccentricity, his habit of wandering around the house in the nude and his alcoholism – and probably, his loyalty to Lizzie Siddal's memory – meant that he and Rossetti were at odds from the first.[13]

Ruskin was asked to give his view of Swinburne's *Poems and Ballads* in advance of publication, and in December 1865 he visited the poet in London to hear them read. He wrote to Pauline Trevelyan: 'I went to see Swinburne yesterday and heard some of the wickedest and splendidest verses ever written by a human creature. He drank three bottles of porter while I was there – I don't know what to do with him or for him – but he must'nt publish these things.'[14] Swinburne did, of course, publish. Normally Ruskin would have condemned any kind of sexual explicitness, and it is to his credit that in the ensuing hullabaloo he was loyal to Swinburne's literary strength. He wrote in September 1866:

> He is infinitely above me in all knowledge and power, and I should no more think of advising or criticising him than of venturing to do it to Turner if he were alive again . . . he is simply one of the mightiest scholars of his age in Europe. . . . And in power of imagination and understanding simply sweeps me away before him as a torrent does a pebble. I'm *righter* than he is – so are the lambs and the swallows, but they're not his match.[15]

Ruskin's tone with Swinburne was one of fatherly indulgence; the PRB, of whom he saw Swinburne as a cadet member, continued in his mind to be his adopted children. 'I shall take sharp and energetic means', he wrote to Pauline Trevelyan, 'with both him and Rossetti. I have some right to speak to the whole set of them in a deeper tone than any one else can.'[16] But the 'Demoniac youth', as Ruskin called Swinburne, and his addicted friend (Rossetti became increasingly dependent on laudanum in the 1860s) were beyond Ruskin's control, and eventually he lost touch.

*

*E.T. Cook gives a list: 'owls, rabbits, dormice, hedgehogs, a woodchuck, a marmot, a kangaroo, wallabies, a deer, armadillos, a raccoon, a raven, a parrot, chameleons, lizards, salamanders, a laughing jackass, a zebu, a succession of wombats, and at one time, I believe, a bull.'[12]

In *Time and Tide* Ruskin had pulled together the teachings of *The Stones of Venice* and *Modern Painters* with those of *Unto this Last* and *Munera Pulveris*. The labourer must be happy, the work must be good: 'once forming the resolution that your work is to be well done, life is really won, here and for ever.' And there is a direct link between this and good education: 'To make your children capable of such resolution, is the beginning of all true education.'[17]

Some of Ruskin's best observations about education are found in *Time and Tide*. Moral education is to accompany training in physical grace and strength. Children are to learn 'truth'; in other words, history, mathematics and science. And Ruskin did not blink from the logic of his position: in a chapter called 'Difficulties' he remarked that it might seem odd in Victorian England to educate a workman as though he were a gentleman. Yet Ruskin did fully believe that each human being should be as developed as his capacity will permit, and that the good society would be one of which all the members were educated.[18]

But education for personal and social advancement was excluded. 'You must forget your money, and every other material interest, and educate for education's sake only!' Education 'should be clearly understood to be no means of getting on in the world, but a means of staying pleasantly in your place there'. State education is a necessity.* The 'first elements' of state education 'should be calculated equally for the advantage of every order of person composing the State. From the lowest to the highest class, every child born in this island should be required by law to receive these general elements of human discipline, and to be baptized – not with a drop of water on its forehead – but in the cloud and sea of heavenly wisdom and of earthly power.'[19] Education is good in itself, regardless of the career prospects of the pupil. And despite the contempt displayed for manual labour by all the writers whom Ruskin most respected, 'Shakespeare and Chaucer, – Dante and Virgil, – Horace and Pindar, – Homer, Aeschylus, and Plato', the workman should be educated. Philosophically, the society that chooses not to educate its workmen is a society that supports slavery: 'You imply that a certain portion of mankind must be employed in degrading work; and that, to fit them for this work, it is necessary to limit their knowledge.' Ruskin delicately and ironically

*State education was to be introduced by Forster's Education Act, 1870.

argued that those who wanted to restrict knowledge 'in a white's skull' also asserted that 'a black's skull will hold as much as a white's' (as an argument against slavery). 'It is a very profound state of slavery to be kept . . . low in the forehead, that I may not dislike low work.' The boy who will become a manual labourer is to be 'a youth properly educated – a good rider – musician – and well-grounded scholar in natural philosophy' whether he thereafter works as a tailor or a coalheaver.[20] To educate working-class people for working-class jobs is to build the thinking of slavery into society.*

For logically the opponents of elementary education for all should support slavery. Middle-class Britain's combination of philanthropy with continued defence of a class system underpinned by utilitarianism was an absurdity: 'You see, my friend, the dilemma is really an awkward one, whichever way you look at it.'[21] He returned to the theme of slavery in letter XXI of the series, where he said that a gentleman who employed the 'lower trades' was in effect perpetuating slavery in England. This of course perpetuated the attacks on utilitarian economists Ruskin had made in *Unto this Last* and in 'The Nature of Gothic' from *The Stones of Venice*, II. Supply and demand, despite the 'Manchester men', is an evil basis for economics. 'Employ no man in furnishing you with any useless luxury.' A man who consumes useless luxuries is in effect keeping slaves, and 'if you keep slaves to furnish forth your dress – to glut your stomach – sustain your indolence – or deck your pride, you are a barbarian.'[22]

The first element of this universal state education is to be physical training: 'the body must be made as beautiful and perfect in its youth as it can be, wholly irrespective of ulterior purpose.' By ulterior purpose Ruskin meant degrading and repetitive mill, factory or mine work. He added ironically: 'let the living creature, whom you mean to kill, get the full strength of its body first, and taste the joy, and bear the beauty of youth. After that, poison it, if you will. Economically, the arrangement is a wiser one, for it will take longer in the killing than if you began with it young; and you will get an excess of work out of it which will more than pay for its training.'[23] Having startlingly prioritised physical education in this way, Ruskin then enjoined the state to teach 'Reverence' and 'Compassion': 'To teach reverence rightly is to attach it to the right persons and things', while compassion

*It is noticeable that R.A. Butler's Education Act 1944, with its division of secondary education into grammar and secondary modern schools, perpetuated that 'slavery'.

is to be morally instilled so that 'in the code of unwritten school law, it shall be held as shameful to have done a cruel thing as a cowardly one'.[24] He is confident and full of moral authority.

As a famous, wealthy and influential man with a fascinatingly unhappy marital history Ruskin in the 1850s was a target for a certain kind of woman. One such admirer was Anna Blunden. Born in 1829, the daughter of a book-binder, she was a courageous young woman, determined to make her way in such male worlds as the Royal Academy (where she had her first painting accepted in 1854) and the Society of British Artists. She wrote to Ruskin in 1855 (in his first few letters to her, before they had met, he assumed that she was a young man). She expressed sympathy over the annulment of his marriage, and Ruskin was politely grateful: 'I see that you understand enough of me to know that *I* cannot have acted falsely or basely – touching the conduct of others – there never was a matter in which sorrowful "Judge not" was so entirely the sum substance of all that is to be uttered.' It was after this letter that she revealed herself to be a woman. Thereafter she pressed her work and her acquaintance on him, and Ruskin, who liked affection from young women and liked to be admired, not unnaturally opened himself up to her. The correspondence continued over some three years (1855–8) with Ruskin obviously understanding that her feelings for him were steadily developing, and trying to keep her at arm's length. Matters came to a head in October 1858. He tried to fend her off by playfully urging her to fall in love with someone else: 'you must try and get those warm feelings of yours nested somewhere properly'. At the same time he kept his guard up, saying that he was 'afraid of saying a word – afraid of *not* saying a word – afraid of hurting you – and still more afraid of giving you pleasure'. Miss Blunden was so infatuated that she read his playfulness as encouragement, made a full, passionate declaration of love, and then reproached him for trifling with her affections. A less responsive man would have closed the correspondence immediately, but Ruskin wrote back at great length in terms that cannot have brought Miss Blunden any comfort: 'You fancy yourself in love with me – and send me the least excusable insult I ever received from a human being – it was lucky for you I only glanced at the end and a bit or two of your long angry letter and then threw it into the fire – else if I had come upon the piece which you refer to to-day – about my being false – I might have burnt this one as well, without even opening it.' At

the end of October, while still firmly rejecting her passion for him, he went out of his way to be kind to her: 'What I want is simple, quiet, cheerful companionship. That you cannot give me. You are too fiery, too tender and too proud. . . . Besides, we can't see anything of each other, and I hate writing letters* as I do poison.'[25]

Miss Blunden was perhaps genuinely in love with Ruskin. There were other pushy women who may have thought themselves in love, or may simply have been gold-digging. As Ruskin wrote rather desperately to Miss Blunden: '*Every* young woman who loves a man who has not asked for her love . . . has lost proper control over her feelings.'[26] One such woman was an American, a Miss Blackwell, who in the summer of this same year, 1858, tried to force her way into Ruskin's company through his friends the John Simons. Ruskin wrote to his father: 'it appears this young person came from America expressly to see if I should suit her for a husband'.[27]

Miss Margaret Bell, headmistress of Winnington School, near Manchester, was an ambitious woman of a different kind. She may have been in love with Ruskin; what is certain is that she was an intelligent and gifted teacher who urgently needed Ruskin's backing (including his financial support) and sensed the right way to charm him successfully.

Margaret Alexis Bell was born in 1818, in Glasgow, the daughter of a remarkable figure within the Wesleyan Methodist ministry, Alexander Bell, one of the 'mightiest men of Methodism'. Bell was an itinerant preacher who as a young man had witnessed the degradation experienced by women and children working in the coal-mines of County Durham. He died in 1851 broken and humiliated by defeat in a venomous power struggle within the Wesleyan Methodist movement. Margaret Bell had been very proud of her father. She had used his standing within the Methodist ministry to promote her school, but by the time of her friendship with Ruskin had become wholly disillusioned. There is a pattern of similarity between her disillusionment with Methodism and Ruskin's disillusionment with Anglican Evangelism.

Margaret Bell set up a private girls' school in Manchester in 1841; over the next ten years the school moved to several different addresses in the city, and in 1847 her younger sister joined her as a partner in the project. In 1851 the sisters took Winnington Hall, Cheshire, a dilapidated but magnificent manor-house which had been remodelled by Wyatt in the 1770s. Miss Bell rightly felt that the splendour of the

*Certainly not true: letter-writing was an addiction for Ruskin.

place would attract the wealthy parents of Manchester, but she took every opportunity to go beyond what was at this date the standard curriculum for girls. Miss Bell's school taught the girls to play cricket (the first English girls' school to do this) and to participate in gymnastics and other sports, and attached importance to dancing as well as singing, painting and embroidery. Her educational methods, with their emphasis on music and physical education, were revolutionary in their day.

Ruskin may have met Miss Bell as early as 1857, in London, but his first visit to Winnington was in 1859. In February of that year he lectured on 'The Unity of Art' in Manchester. Miss Bell and some of her students were in the audience, and Ruskin visited Winnington two weeks later. At that time there were thirty-five girls in the school. Miss Bell had prepared for his visit carefully, making sure that the girls had read *The King of the Golden River* (which had been published in 1851) and that there were engravings from Ruskin's favourite painter, Turner, on the walls. She was a shrewd woman.[28]

Ruskin wrote to his father: 'I have'nt enjoyed myself so much anywhere – these many years – Miss Bell is both wise and cheerful – does not bore one with too much wisdom.' Miss Bell had made sure that the girls looked their best. Their sober costume buttoned up to the throat 'contrasted with the white tablecloth, gives the kind of light and shade one sees in the pictures of the Venetians. In the evening they of course put on a little better dresses, but still up to the throat & low on the arms – so that the groups are incomparably more graceful as well as more modest than any that one can see in general society by the lustre of candlelight.' In the evening the girls sang to him 'in full choir' a classical and religious programme 'for an hour and a half together'.[29] The whole visit was pure enchantment for Ruskin, who declared that he had fallen 'in love with thirty-five young ladies at once' and promised to 'serve – or please them'.[30] Thereafter the girls received a stream of letters from him, addressed to 'My dear Birds'. He also made them substantial material gifts.

Already in April 1859 John James Ruskin's account book (under 'Charities') shows that he paid out £300.[31] John James took the view that Winnington School would be a financial drain. Subsequent events proved him right. In 1861 Miss Bell was embroiled in a lawsuit and Ruskin felt obliged to come to the rescue, to the tune of £500. John James, of course, would ultimately be expected to produce the money. The commitment was made early in the year, but Ruskin felt unable to tell his father about

it until September, when he 'presented his accounts' for the year. John James was furious. Ruskin had to propitiate the old man: '*I quite agreed with you from the first, in your views about the school,* [this was manifestly untrue] *as I do in all that you say of lending money generally. I never lend except with intention of loss.*' It is hard to see how John James would be reassured by that, but he could take comfort from his son's promise: '*It is the last I mean to spend for Miss Bell.*' And paternal approval was assured for the next promise: '*I never mean again to have any poor friends.*' (Ruskin was thinking of Rossetti and Lizzie Siddal as well as Miss Bell.) '*It seems a hard saying, but is a right one. One's friends should be neither much richer nor much poorer, than one's self.*' He goes on immediately to cite an example of rich friends: '*I am unfortunate always in the choice of the people I take into my head to be interested in – and the wealth of the La Touche's is to my mind merely as much to be regretted as the poverty of other friends.*'[32]

Despite his promises to his father Ruskin's association with Winnington continued until the late 1860s. For some seven years he loved the place – it was a haven, a retreat from the adult life. Romps with the girls rejuvenated and refreshed him, and his parents (especially his mother) grudgingly recognised that his visits there were good for him. Miss Bell kept a room for him, and he in turn introduced her to his London friends. Georgiana Burne-Jones recalled her as 'extremely clever' with 'a powerful and masterful turn of mind', and as a woman who knew how to manage Ruskin; Miss Bell made it clear that she felt that 'Ruskin was the greatest man she had ever seen'. Georgiana's sketch brings out Miss Bell's energy and intellectual ambition: 'At dinner the first evening she talked as much as if it were her last opportunity of speech, and as one listened to her it seemed that no subject could be too high and no difficulty too great for her to deal with.'[33]

Many of Ruskin's 'Birds' became long-term friends and correspondents, and he continued to make financial loans and gifts to the school and to pay the fees of some of the pupils. John James found his son's support for the school a continuing source of vexation until his death in 1864.*

<center>*</center>

* After John James's death Ruskin was free to spend as he wished and by 1867 he had paid out £1,130 15s 4d to Miss Bell. In the end, though, he came round to something very like John James's view of her; he decided that he had been exploited. By 1873, when Miss Bell's difficulties were forcing her to auction off paintings that Ruskin had given her, he had lost his temper with her. He wrote to an intermediary: 'NEVER as long as you live be *security* for any human being. Nobody but rogues EVER ask it . . . and d—n Miss Bell.'[34]

Ruskin had become friends with the wealthy La Touche family at more or less the same time as he became associated with Miss Bell. John La Touche was a landowner and a Dublin banker. The whole family were evangelical Protestants, devout members of the Anglican Church of Ireland. Mrs La Touche had visited the Ruskins at Denmark Hill in 1858 in order to see their Turners. She had brought with her her daughter, Rose, then a child of nearly ten. Ruskin recalled this first encounter in *Praeterita*: 'Presently the drawing-room door opened, and Rosie came in, quietly taking stock of me with her blue eyes as she walked across the room; gave me her hand, as a good dog gives his paw, and then stood a little back.'

Ruskin found her irresistible: 'The eyes rather deep blue at that time, and fuller and softer than afterwards. Lips perfectly lovely in profile; – a little too wide, and hard in edge, seen in front; the rest of the features what a fair, well-bred Irish girl's usually are; the hair, perhaps, more graceful in short curl round the forehead, and softer than one sees often, in the close-bound tresses above the neck.'[35]

This was love at first sight. An intense attraction to little girls was a substantial component of Ruskin's sexuality. He had first been attracted to Effie when she was a child, and the pleasure that he took in his 'Birds' at Winnington can be seen as part of the same preference. But this is not the whole story. Adèle Domecq had been very young, but sexually mature, when he fell in love with her,* and we should remember that Ruskin was genuinely in love with Effie when she was aged nineteen (in the year before their marriage, 1847–8). He was to remain passionately attracted to Rose La Touche as she, too, became a young adult. Ruskin's case is thus different from that of his Oxford acquaintance C.L. Dodgson of Christ Church ('Lewis Carroll'). Dodgson was exclusively attracted to little girls.† With Ruskin, early fixation usually survived into the young adult life of the chosen girl. The word 'paedophile', sometimes used of him, does not in fact fit the pattern.

At the time of their first meeting Mrs La Touche was thirty-three. She was pretty and intelligent, a novelist and a passionate amateur of the arts who had been reading Ruskin's work for years. Ruskin was favourably impressed: 'What a wonderful creature,' he wrote to their

*The same is true of Kathleen Olander, the young woman with whom he fell in love much later, in the 1880s.

†Especially, of course, Alice Liddell, daughter of Ruskin's friend Henry Liddell, who had become Dean of Christ Church by the time Dodgson wrote *Alice in Wonderland* for the Liddell children.

mutual friend Lady Waterford; 'I found I could not venture a word carelessly before her – she saw so quickly when it *was* careless.'[36] Her husband, not an intellectual, lived the life of a country gentleman in Ireland. He was a philanthropist and humanitarian, active in relieving the distress experienced in the Irish famine of 1845, and he led an inner religious life. A Baptist convert, he tried to convert his wife, and when this failed he converted his daughter, Rose.*

Mrs La Touche was short of sympathetic society in Ireland, and she found London in general and Ruskin in particular hugely stimulating by contrast with the rather somnolent splendour of her husband's great house at Harristown, County Kildare.

After the first meeting Mrs La Touche wrote wistfully to Ruskin marking the difference between her world and his: 'You, who live with, and for Art, will not easily guess how much enjoyment you afford to me who am wholly unaccustomed to such an atmosphere – out of Dreamland.'[38] The friendship developed; the La Touches visited the Ruskins whenever they were in London. Rose became his occasional pupil for drawing lessons. She was his particular pet and he became her 'St Crumpet' (to distinguish him from her governess, Miss Bunnett, who was known as 'St Bun'). She also called him 'Archigosaurus' (this reflected her knowledge of contemporary geology with its interest in the discovery of dinosaurs). Ruskin in turn had a pet name for Rosie's mother, whom he called 'Lacerta'; 'the grace and wisdom of the serpent, without its poison'.[39]

The La Touche family took a European tour in the spring of 1861, and Rose, now aged thirteen, wrote Ruskin a letter which he included in *Praeterita*. It is a playful and loving document, full of affectionate teasing, and it shows how much of Ruskin's adult interests and pre-occupations had been communicated to Rosie's child mind: 'We went to the Louvre. Oh St. Crumpet how we thought of you there – How we looked and talked about the Titians you told us to look at.' She wrote: 'Don't be Kinfishery ['Kingfishery': that is, sitting sulkily on a branch] dear St. Crumpet; how good it was of you to give yr Turners that you love so much to the Oxford Museum.' They walked over the pass of the Esterelle; Rose despaired of describing the view: '*You* the author of M-P [*Modern Painters*] cd describe it Irish roses can't.'[40]

*In her teenage diaries Rose would recall that 'Papa said that the Bible was the great important study, and in my playtime . . . I sat and read it.'[37] The intense religious life adopted by Rose as she grew up was to be a major source of difficulty in her relationship with Ruskin.

In August 1861 Ruskin visited the La Touches in Ireland. He was normally an uncomfortable guest in great country houses, but Harristown was sweetened by the company of children, especially Rose. 'The two girls [Rose and her sister] are the most wonderful combination of deer and frog that ever naturalist was puzzled to define. They took every ditch (and nearly every fence) with flying leaps (Rosie doing seven feet clear without apparent effort. . . .).' But he would not be involved with the splendid dinner parties that the La Touches gave. Despite his fame and distinction he shared his parents' feeling that they, the Ruskins, were just not gentry: 'I never would go near them [the La Touches] on their great dinner days – knowing myself strange and inferior in all society-ways.' He preferred to spend the evening with the servants and the children.[41] The La Touches were not worried by Ruskin's odd social behaviour but they *were* worried about his religious views. Although Mrs La Touche resisted her husband's evangelical intensity she did not warm to the religious scepticism displayed by Ruskin since his 'unconversion' in Turin in 1858. Rose, too, was distressed by his religious doubts. He, in turn, was becoming intensely dependent on her.

In his letters to his friend Norton, Ruskin spoke of:

almost unendurable solitude in my own home – only made more painful to me by parental love which did not & never could help me, which was cruelly hurtful without knowing it; and terrible discoveries in the course of such investigation as I made into grounds of old faith [his 'unconversion'] . . . – I don't in the least know what might have been the end of it – if a little child – (only 13 last January) – had'nt put her finger on the helm at the right time; and chosen to make a pet of herself for me; and her mother to make a friend of herself.[42]

Ruskin cast himself as Bunyan's Pilgrim:

I've been nearly as hard put to it [by religious doubt] before, only I wasn't so old, and had not the great religious Dark Tower to assault – or get shut up in – by Giant Despair. Little Rosie is terribly frightened about me, and writes letters to get me to come out of Byepath Meadow.[43]

In the educational lectures of 1865, *Sesame and Lilies*, Ruskin was sustained by moral indignation and carried conviction through his wit and satirical energy. In his lifetime the most popular of all his books, it comprised two lectures on education. The first, 'Of Kings' Treasuries', was delivered at the Rusholme Town Hall, near Manchester, on 6

December 1864. This lecture was addressed to the education of boys, while its companion piece, 'Of Queens' Gardens', was addressed to girls. The treasury was a library, and 'Sesame' the word with which it was opened in *Ali Baba and the Forty Thieves* ('Open sesame'); the lilies were the girls in the Queen's garden. He opened with a scathing attack on those ambitious and pushy parents for whom education was an instrument of social advancement, the education 'befitting such and such a *station in life*', an education 'which shall keep a good coat on my son's back; – which shall enable him to ring with confidence the visitors' bell at double-belled doors; which shall result ultimately in establishment of a double-belled door to his own house; – in a word, which shall lead to advancement in life; – *this* we pray for on bent knees'.[44] This philistinism he countered by advancing the inherent value of literature for its own sake, and the virtue of a book as a repository, or custodian, of truth and moral teaching, and as a memorial to its author. The author of a book 'has something to say which he perceives to be true and useful, or helpfully beautiful. . . . He would fain set it down for ever; engrave it on rock, if he could; saying, "This is the best of me; for the rest, I ate, and drank, and slept, loved, and hated, like another; my life was as the vapour, and is not; but this I saw and knew: this, if anything of mine, is worth your memory."'[45] A book is a product of a man's whole being, his whole life. And yet philistine Britain values food and drink far more than it values books:

> How much do you think the contents of the book-shelves of the United Kingdom, public and private, would fetch, as compared with the contents of its wine-cellars? What position would its expenditure on literature take, as compared with its expenditure on luxurious eating? We talk of food for the mind, as of food for the body: now a good book contains such food inexhaustibly; it is a provision for life, and for the best part of us; yet how long most people would look at the best book before they would give the price of a large turbot for it?

Readers should *buy* books, and in a commercial world books are valued the more for costing high prices.

> The very cheapness of literature is making even wise people forget that if a book is worth reading, it is worth buying. No book is worth anything which is not worth *much*; nor is it serviceable, until it has been read, and re-read, and loved, and loved again; and marked, so that you can refer to the passages you want in it, as a soldier can seize the weapon he needs in an armoury, or a housewife bring the spice she needs from her store.[46]

The good reader will become a 'King', 'Mighty of heart, mighty of

mind'. True kings 'rule quietly, if at all, and hate ruling', and the function of a king is to dispense wisdom. A king, one might be forgiven for saying, is a kind of idealised librarian: 'Suppose kings should ever arise, who . . . gathered and brought forth treasures of – Wisdom – for their people?'[47]

Education for women is to be very similar to that for men, but appropriate to a woman's role in the relationship. In 'Of Queen's Gardens' Ruskin wrote:

> Believing that all literature and all education are only useful so far as they tend to confirm this calm, beneficent, and *therefore* kingly, power – first, over ourselves, and, through ourselves, over all around us, – I am now going to ask you to consider with me farther, what special portion or kind of this royal authority, arising out of noble education, may rightly be possessed by women; and how far they also are called to a true queenly power, – not in their households merely, but over all within their sphere.[48]

Contrary to the popular view of his attitude to women, Ruskin's work on the education of girls was in fact forward-looking and innovative. He believed that a young woman should learn science, history, mathematics and should engage in sports; this at a time when the average middle-class girl was taught at home by a governess. 'A girl's education should be nearly, in its course and material of study, the same as a boy's': though he did add the thoroughly mid-Victorian qualification that her education was to *complement* that of her husband: 'A man ought to know any language or science he learns, thoroughly – while a woman ought to know the same language, or science, only so far as may enable her to sympathise in her husband's pleasures, and in those of his best friends.' To equip her for her role, the female should be taught all the subjects of which the man has knowledge, except theology.* Women who study theology are often guilty of 'arrogance, petulance, or blind incomprehensiveness'.[49]

Girls, Ruskin had observed, mature earlier than boys: 'If there were to be any difference between a girl's education and a boy's, I should say that of the two the girl should be earlier led, as her intellect ripens faster, into deep and serious subjects: and that her range of literature should be, not more, but less frivolous.' Here he was obviously thinking specifically of *literary* education. Her reading was to be uncensored: 'The chance and scattered evil that may here and there haunt, or hide itself in, a powerful book, never does any harm to a noble girl.' She

*Rose La Touche's religious preoccupation was a major impediment to his relationship with her.

needed 'access to a good library of old and classical books' where she could be let loose like 'a fawn in a field'. And her teachers – this was a key point, clearly reflecting Ruskin's friendship with Miss Bell at Winnington Hall – should be chosen as carefully as her brother's. Ruskin made an incisive contrast between a gentleman's attitude to his son's tutors and to his daughter's governess:

> You do not treat the Dean of Christ Church or the Master or Trinity as your inferiors. But what teachers do you give your girls, and what reverence do you show to the teachers you have chosen? Is a girl likely to think her own conduct, or own intellect, of much importance, when you trust the entire formation of her character, moral and intellectual, to a person whom you let your servants treat with less respect than they do your housekeeper . . . and whom you yourself think you confer an honour upon by letting her sometimes sit in the drawing-room in the evening?[50]

In the next lecture, 'The Mystery of Life and Its Arts', given at the Royal College of Science, Dublin, in 1868, Ruskin linked his specific lectures on the education of boys and girls to a moral view of the responsibility of the middle class for education in society. Being in Dublin he referred to his late friend Benjamin Woodward's work in Gothic, to the Oxford Museum, and to his disappointment in the outcome of his attempt to introduce Gothic architecture to his society:

> The work we did together is now become vain. It may not be so in future; but the architecture we endeavoured to introduce is inconsistent alike with the reckless luxury, the deforming mechanism, and the squalid misery of modern cities; among the formative fashions of the day, aided, especially in England [it is important that he is speaking in Woodward's native Ireland], by ecclesiastical sentiment, it indeed obtained notoriety; and sometimes behind an engine furnace, or a railroad bank, you may detect the pathetic discord of its momentary grace, and, with toil, decipher its floral carvings choked with soot.[51]

In his writings on the education of women Ruskin continued to subscribe to a fixed Victorian notion: the sanctity of the home. The woman's role is to make the home a place of beauty and comfort for the warrior. The male–female relationship is complementary: 'Each [sex] has what the other has not: each completes the other, and is completed by the other.' The man is 'the doer, the creator, the discoverer, the defender'. The woman's role is 'sweet ordering, arrangement, and decision. . . . Her great function is Praise.' The man is locked into 'rough work in the open world' and for him home is 'the place of Peace; the shelter, not only from all injury, but from all terror, doubt, and division'.[52]

The relationship with Miss Bell and with the girls of Winnington Hall was contributing crucially during these years to his views of the education of women. Winnington fulfilled his notion of 'home'. When he asked Sir Charles Hallé to play Thalberg's arrangement of the popular 1823 ballad 'Home, Sweet Home' for the girls at Winnington, Hallé accused him of preferring this 'sickly and shallow' tune to Beethoven.[53]

At Winnington Ruskin could co-operate with a serious and forward-looking educational experiment while he could play and be a child surrounded by children. At this time, he was miserable in his love for Rose La Touche. Winnington provided a kind of antidote to this obsession. There were so many girls, they were *all* friendly, playful and robust, and he does not seem to have become embarrassingly fixated on any of them.

Winnington stimulated him to write *The Ethics of the Dust* (1866), dedicated to 'The Real Little Housewives, whose gentle listening and thoughtful questioning enabled the writer to write this book'. These dialogues worked out thoughts about education, art and moral example. In his preface to the first edition Ruskin spoke modestly of his ambitions: 'I have always found that the less we speak of our intentions, the more chance there is of our realising them; and this poor little book will sufficiently have done its work, for the present, if it engages any of its young readers in study which may enable them to despise it for its shortcomings.'[54]

One striking passage in *The Ethics of the Dust* shows that Winnington was not wholly successful as an antidote to the sufferings caused him by Rose La Touche, whose faith, as he thought, came between them. He had several bitter pages about the effects of religious enthusiasm on young minds. The tradition of punishment and reward in the afterlife belongs to the horrible errors of the medieval Catholic Church: 'There's no measuring the poisoned influence of that notion of future reward on the mind of Christian Europe, in the early ages. Half the monastic system rose out of that, acting on the occult pride and ambition of good people (as the other half of it came of their follies and misfortunes). There is always a considerable quantity of pride, to begin with, in what is called "giving one's self" to God.' He pursued the argument with the notion that the existence of the monasteries demonstrated the wickedness of Catholic Europe. The monks saved learning 'from the abyss of misery and ruin which that false Christianity allowed the whole active world to live in'. The 'few feeble or reasonable persons

left . . . who desired quiet, safety, and kind fellowship, got into cloisters'. Ruskin himself had much aesthetic sympathy with the monasteries:

> I have always had a strong leaning that way; and have pensively shivered with Augustines at St. Bernard; and happily made hay with Franciscans at Fésole, and sat silent with Carthusians in their little gardens, south of Florence; and mourned through many a day-dream, at Melrose and Bolton. But the wonder is always to me, not how much, but how little, the monks have, on the whole, done, with all that leisure, and all that good-will!

It is dangerous, and bad for young girls, to become possessed by the idea of 'merit, or exalting virtue, consisting in a habit of meditation on the "things above"'. We have no real authority for such reveries: 'what is said of pearl gates, golden floors, and the like . . . is as distinctly a work of fiction, or romantic invention, as any novel of Sir Walter Scott'.[55]

*

Ruskin's lectures of the 1860s on 'Work', 'Traffic', 'War' and 'The Future of England' build a vision of an alternative society: chivalrous, just, loving, harmonious. His blazing generosity of spirit, brilliance, wit, philanthropy and indignation burn through these pieces. As Matthew Arnold did in his schematic study *Culture and Anarchy* (1869), Ruskin saw contemporary society as horribly divided, and like Arnold he believed that education and enlightenment could close those divisions. But his real faith (like that of his mentor Carlyle) was in wise and loving strong men, tradition, goodwill and the inherent goodness of people. The good society would not be a product of trade unions and universal franchise, it would be a product of responsible leadership, universal moral (Christian) law and universal education. In the lecture on 'Work', given to the Camberwell Working Men's Institute, he replaced the conventional distinction between rich and poor with a distinction between 'idle poor and idle rich' and 'busy poor, and busy rich', and then inverted the conventional distinction between 'work' and 'play'. 'Play' included all commercial activity, everything that drove the capitalist machine. Ruskin's point here, and a shrewd one, was that competitiveness, vanity and recklessness rather than steady creative endeavour were the engines that drove the City of London:

The first of all English games is making money. That is an all-absorbing game; and we knock each other down oftener in playing at that, than at football, or any other roughest sport: and it is absolutely without purpose; no one who engages heartily in that game ever knows why. Ask a great money-maker what he wants to do with his money, – he never knows. He doesn't make it to do anything with it. He gets it only that he *may* get it. 'What will you make of what you have got?' you ask. 'Well, I'll get more,' he says. Just as, at cricket, you get more runs. There's no use in the runs, but to get more of them than other people is the game. And there's no more in the money, but to have more of it than other people is the game. So all that great foul city of London there – rattling, growling, smoking, stinking, – a ghastly heap of fermenting brickwork, pouring out poison at every pore, – is a great city of play; very nasty play, and very hard play, but still play.[56]

Other pernicious forms of 'play' were hunting and shooting, dressing (for women), literature, art and war. The honourable term 'work' was reserved for those who place the task above the competition or the reward: a good soldier 'wishes to do his fighting well', a good clergyman lives 'to baptize and preach', a good doctor desires 'to cure the sick'. The point in every case is that the vocation comes first, the fee or salary second. 'But in every nation . . . there are a vast class who are ill-educated, cowardly, and more or less stupid. And with these people, just as certainly the fee is first, and the work second, as with brave people the work is first, and the fee second. And this is no small distinction. It is between life and death *in* a man; between heaven and hell *for* him.' God is the 'lord of work' while the Devil is 'the lord of fee'. With this startling and extreme distinction Ruskin made his point: on the one hand good work, the contented and absorbed worker, and the good society; and on the other hand pernicious and wicked games. The capitalist, in another powerful and startling image, accumulates money in order to exercise power as a medieval baron fought for a castle on a promontory in order to exact a toll from all travellers on the pass beneath his crag. The effect is that the capitalist, or 'bagman', oppresses the poor just as thoroughly as the baron did: 'the poor vagrants by the roadside suffer now quite as much from the bag-baron, as ever they did from the crag-baron. Bags and crags have just the same result on rags.'[57] Capital is inherently unjust, and in a well-ordered society work will be 'honest', 'useful' and 'cheerful', like the employment of a well-conducted and well-brought-up child.

'Traffic', delivered in Bradford on 21 April 1864, brought back an earlier preoccupation – the Gothic – and linked it to his current

thinking about the good society. The style of the new Exchange to be built in the city was under discussion. In his lecture Ruskin advocated the Gothic style. (In revision of the lecture for publication he had to make it clear that he distanced himself from the design subsequently chosen – which was indeed Victorian Gothic, but to his mind a bad and feeble adaptation of the style.) He told his audience that the Gothic revival, substantially of his making, had led to a division between church and domestic architecture which was no part of his intention: 'When Gothic was invented, houses were Gothic as well as churches.'[58] And he pointed out that if they had invited him to seek his advice, then they should recall his teaching:

> The book I called *The Seven Lamps* was to show that certain right states of temper and moral feeling were the magic powers by which all good architecture, without exception, had been produced. *The Stones of Venice* had, from beginning to end, no other aim than to show that the Gothic architecture of Venice had arisen out of, and indicated in all its features, a state of pure national faith, and of domestic virtue. . . . Good architecture is the work of good and believing men . . . good architecture has always been the work of the commonalty, *not* of the clergy. . . . Gothic was formed in the baron's castle, and the burgher's street. It was formed by the thoughts, and hands, and powers of labouring citizens and warrior kings.

The Catholic Church – here he restated a leading prejudice from *The Seven Lamps of Architecture* and *The Stones of Venice* – corrupted the Gothic:

> By the monk it was used as an instrument for the aid of his superstition: when that superstition became a beautiful madness, and the best hearts of Europe vainly dreamed and pined in the cloister, and vainly raged and perished in the crusade, – through that fury of perverted faith and wasted war, the Gothic rose also to its loveliest, most fantastic, and, finally, most foolish dreams; and in those dreams was lost.[59]

He then confronted his audience by pointing to their characteristic structures – railroad stations, chimneys, warehouses and exchanges – as monuments to their contemporary perverted faith, their worship of 'the great Goddess of "Getting-on"': 'She has formed, and will continue to form, your architecture, as long as you worship her.'[60] The architectural form most characteristic of his philistine audience of manufacturers was the mill, 'not less than a quarter of a mile long, with one steam engine at each end, and two in the middle, and a chimney three hundred feet high'. And the system that allowed them to put up

such horrible buildings, and to control the lives of the thousands of people who work in such places, was inherently evil. Ruskin threatened obscurely that their mills would be swept away by revolution:

> Even good things have no abiding power – and shall these evil things persist in Victorious evil? All history shows, on the contrary, that to be the exact thing they never can do. Change *must* come; but it is ours to determine whether change of growth, or change of death. Shall the Parthenon be in ruins on its rock, and Bolton priory in its meadow, but these mills of yours be the consummation of the buildings of the earth, and their wheels be as the wheels of eternity?[61]

In 'War' Ruskin developed a view of boys that had been under way in *Sesame and Lilies* – they should be 'true knights' – and in 'The Future of England' he urged military leaders to do away with the underclass that had developed in England. The upper classes, and the officer class, had betrayed their trust. As a consequence there had grown up

> a class among the lower orders which it is now peculiarly difficult to govern. . . . The lower orders lost their habit, and at last their faculty, of respect; – lost the very capability of reverence, which is the most precious part of the human soul. Exactly in the degree in which you can find creatures greater than yourself to look up to, in that degree, you are ennobled yourself, and, in that degree happy.[62]

The model, loosely, is chivalrous and medieval, and sounds a bit like John of Gaunt's speech in *Richard II*:

> To fill this little island with true friends – men brave, wise, and happy! . . . Must we remain . . . savage, – *here* at enmity with each other, – *here* foodless, houseless, in rags, in dust, and without hope, as thousands and tens of thousands of us are lying? . . . Where are men ever to be happy, if not in England? By whom shall they ever be taught to do right, if not by you? Are we not of a race first among the strong ones of the earth; the blood in us incapable of weariness, unconquerable by grief? Have we not a history of which we can hardly think without becoming insolent in our just pride of it? Can we dare, without passing every limit of courtesy to other nations, to say how much more we have to be proud of in our ancestors than they?[63]

It is noble rhetoric. It is the voice, obviously, of Ruskin the Tory social-ist, defying utilitarianism, defying *laissez-faire* and the Manchester school, and inviting his audiences to recover a heroic, chivalrous, Gothic vision of their country.

*

The major event of early 1866 was Ruskin's proposal of marriage to Rose La Touche. He had not seen her for three years, since April 1862. Relations with her parents had been first friendly and then mysteriously difficult; the La Touches had offered Ruskin a cottage on their estate at Harristown but had then withdrawn the offer, without explanation. Ruskin told Miss Bell that he thought the reason was 'that their Irish neighbours would never understand it', but one can conjecture that there was a marital disagreement in the background, and that John La Touche had had enough of his wife's friendship with Ruskin.

Rose's religious attitudes had deepened, as Ruskin knew, to the point of mania, and she was subject to mysterious debilitating psychological illnesses. At the time of her first communion, October 1863, she had suffered a fit of hysteria, or what her mother, writing to George MacDonald, called one of her 'mysterious brain-attacks.... I am afraid she has *thought* herself into this illness, & I attribute it partly to the strong wish & excitement which resulted in her being admitted to her first Communion.' Rose suffered extreme pains in her head and a state of mind that her mother called 'clairvoyance', followed by a kind of amnesia: 'entire oblivion of all acquired knowledge, & of every person & thing not known to her eleven years ago'. Ruskin was in correspondence with Mrs La Touche throughout this illness and passed the news on to his parents; John James suggested to him that he should go out to Ireland to see if he could help, but Ruskin replied: 'It would do her no good to see me.' Perhaps he shrank from seeing Rose on her sick-bed, or perhaps – more probably – he knew that such a visit would not be welcome to her parents. For several months in 1864 she convalesced, at home in Ireland, and sent only brief notes to Ruskin, who wrote to George MacDonald: 'I can't love anybody except my Mouse-pet in Ireland, who nibbles me to the very sick-bed with weariness to see her.'[64]

Early in 1865 Mrs La Touche came on her own to London; relations with Ruskin had remained cordial, and she saw a lot of him and of their mutual friend George MacDonald. Rose came to London later in the year; Ruskin saw her on 10 December. The child he had known had now become a young woman, nearly eighteen.

Ruskin must have planned his proposal carefully; he gave a dinner party for her eighteenth birthday, 3 January 1866 (with his mother and his cousin Joan Agnew) and on this evening or soon after it he proposed to her. On 2 February, he told Acland, 'getting me to herself here in the garden, she turned to me and asked if I would stay yet three years, and

then ask her – for "She could not answer yet." ' He told Acland that Rose fully understood that by that time Ruskin would be fifty.[65]

It seems that at first the La Touches simply did not believe what had happened between their daughter and this famous middle-aged critic, whom she had asked to wait for her. Her parents now made it clear that they wanted her to be free to consider other suitors.[66]

Pauline Trevelyan, loyal friend and confidante who had supported Ruskin staunchly over his marriage to Effie, tried to come to the rescue over Rose. Ruskin's bitter disappointment made it imperative that he should get away. He resolved to take a continental tour and at the same time to give a treat to two young women, Joan Agnew, who was by this time his mother's companion, and a young friend, Constance Hilliard. Pauline Trevelyan had been in very poor health herself (she had had long-term 'liver' complaints and had suffered what appeared to be a stroke in 1864), but partly to support Ruskin and partly in the hope of benefiting from the change, she decided that she would join the party. Just before they left, Carlyle's wife died suddenly (21 April); a personally shocking event for Ruskin, because he had called at the Carlyle house in Chelsea, bringing flowers for her, only to be greeted at the door with news of her death.

For Pauline Trevelyan the expedition was agonising and brief; she became seriously ill on the third day in Paris and on 13 May, at Neuchâtel, she died. Ruskin was with her and her husband, as he described it in a letter to his mother: 'I said to Sir Walter [Calverley] that I was grateful to him for wanting me to stay: "I did not think he had cared for me so much." "Oh" he said, "we both always esteemed you above any one else." Lady Trevelyan made an effort, and said "He knows that." Those were the last conscious words that *I* heard her speak.'[67]

An autopsy on Lady Trevelyan showed that she had been suffering from long-term intestinal cancer, with a tumour the size of a child's head. Her suffering must have been appalling. It is astonishing that she undertook the continental journey. Maybe she was in such pain that she had deliberately taken risks in the hope of shortening her life.[68]

The loss of his 'two best women friends of older power',[69] Jane Carlyle and Pauline Trevelyan, was depressing to Ruskin. He wrote a letter of condolence to Carlyle, and Carlyle's reply was equally supportive of Ruskin:

You are yourself very unhappy, as I too well discern – heavy laden, obstructed and dispirited; but you have a great work still ahead, and will gradually have to gird yourself up against the *heat of the day*, which is coming on for you, – as the Night too is coming. Think valiantly of these things.[70]

Ruskin had now been involved with Rose since 1858. Rose's mother, vivacious, intelligent and attractive, who was five years younger than he, had assumed that she was herself the object of Ruskin's interest. She may well have been piqued and astonished to learn, in 1864, that Rose was the object of Ruskin's attachment. Ruskin wrote: 'the mother got jealous of the daughter and pulled us sharply asunder and then I quarrelled with *her*, for being foolish and wicked and things got darker – till it came to eighteen and forty-seven – and then the daughter spoke to me and asked me to wait for "three years"'.[71] In other words, Ruskin proposed and Rose had begged him to wait for her answer until she came of age at twenty-one.

The La Touches opposed the marriage. Mrs La Touche may well have been jealous but there were also good and disinterested reasons for seeing Ruskin – divorced and forty-seven – as an unsuitable husband for a girl of eighteen. On 19 February 1866, knowing that the La Touches wanted Rose to be free to consider other suitors, Ruskin sent a long, somewhat devious letter to Mrs Cowper-Temple:*

You might think it wrong of me to avail myself at all of the reluctant permission of the father & mother to continue in any shadow of our old ways. – But there is a quiet trust between Rosie and me which cannot be broken, except by her bidding. I know very certainly that she will not engage herself in any way without telling me about it first; – and also, that in my respect for her, (while her mother *will* always treat her as a mere child) and in my understanding of all her thoughts, and sympathy with them (which her father cannot always give) – my regard is precious to her; and she likes to be able to say anything she has in her mind to me – and

*Georgiana Tollemache (1822–1901) married the Hon. William Cowper in 1848. Ruskin saw her in Rome in 1840 and became acquainted with her in London in 1854, but the friendship did not blossom until the 1860s. Her husband, William Francis Cowper (1811–88), was a stepson of Lord Palmerston. He became Cowper-Temple in 1869 and was ennobled as Lord Mount-Temple in 1880. He was elected in 1835 and thereafter lived a very full public life; his public appointments included President of the Board of Health, Vice-President of the Board of Trade, Paymaster-General, Chief Commissioner of Works, Vice-President of the Education Department of the Privy Council and Chairman of a Committee on Enclosure Acts. In educational policy he was responsible for the 'Cowper-Temple Clause' which ensured the reading of the Bible in Board Schools. Ruskin persuaded him to become one of the first trustees of the Guild of St George in 1871.

would not be at all pleased if she were at present obliged to break off intercourse. And I am simply her servant. When she bids me leave her – I shall do so without a word of farther petition. But only *she* can bid me. I must not do it of my own purpose or thought. As far as a child who has never felt love, can imagine what it is, she knows so much of it as that I care only for her happiness.[72]

Under the ostensible sweet reasonableness of this is an obsession, of course: this is the voice of the addict rationalising his addiction and making it seem right to the world. The encouragement that Mrs Cowper-Temple showed him throughout their correspondence was wholly damaging to Ruskin.

Rose did bid him 'leave her', many times, over the following years. In 1868 he wrote a stream of anguished letters to Mrs Cowper-Temple. Rose's parents had been working on her to give Ruskin up because of the reports of his impotence (the reason given for the annulment of his marriage in 1854). On 13 May in Dublin he gave his lecture on 'The Mystery of Life and Its Arts' and on the same day he had a letter from Rose herself reading: 'I am forbidden by my father and mother to write to you, or receive a letter. Rose.'[73] She enclosed two rose-leaves. He took the rose-leaves, and other hints from her through intermediaries, as indications that despite her parents she actually wanted to stay in touch. 'How far do you mean her obedience to her parents to extend?' he asked desperately (19 May 1868). 'She *is* disobedient in not casting me off altogether, and being resolved in that, she ought not to allow herself to be made miserable.[74]

In June Effie Millais got in touch with the La Touches to say that the terms of the annulment of the marriage in 1854 meant that Ruskin was never free to remarry. If he had children by a second marriage the grounds for the dissolution of the first marriage – his impotence – were nullified so that the first marriage would in law be resurrected. The La Touches consulted a lawyer who confirmed Effie's opinion.[75] Ruskin protested desperately to Mrs Cowper-Temple that he was, after all, not actually impotent since he could still masturbate (an extraordinary confidence from a middle-aged man to an upper-class high Victorian woman): 'Have I not often told you that I was another Rousseau?'[76]

On 1 June 1871 he wrote William Cowper-Temple a letter in which self-control keeps slipping to show that he was in an agony of suspense over the question of whether he was legally free to marry, and whether, if so, Rose would accept him: 'It would indeed destroy both health and usefulness, if I allowed hopes to return such as I had once.' He wanted

Cowper-Temple to communicate with Rose only to 'undeceive Rose as to the points of unjust evilspeaking against me'. But this was contradicted by the very next statement: 'I am very weary of life; – and will not ask her to come to me. – If she wants to come, she must say so to me.'[77]

The obsession is as strong as ever, the mood-swings as violent and contradictory. Confident that he was now free to marry and that Rose would accept him, he wrote to Rose and was rebuffed. On 27 July he wrote to William Cowper-Temple the most heartening letter of his whole correspondence with the couple: one in which he seemed at last to have angrily broken with Rose:

> I sent her a very civil letter to which she sent an answer which for folly, insolence, and selfishness beat everything I yet have known produced by the accursed sect of religion she has been brought up in. I made Joanna [Joan Agnew] re-enclose her the letter, writing only, on a scrap of paper with it – (Joanna writing that is to say, not I) 'my cousin and I have read the enclosed – You shall have the rest of your letters as soon as he returns home – and your mother shall have her's' – so the letter went back, and the young lady shall never read written, nor hear spoken, word of mine more. I am entirely satisfied in being quit of her.[78]

But of course that was far from the truth.

It was partly the distress of the situation with Rose that prompted Ruskin's pessimistic analysis of his own emotional life. He surmised, justly, that his parents had crippled him emotionally. Some of the clearest self-analysis is in his letters to Charles Eliot Norton. The letter of 11 September 1868 is a good example. He wrote from Abbeville that he was thinking of writing his autobiography:

> I have often thought of setting down some notes of my life. But I know not how – I should have to accuse my own folly bitterly – but no less – as far as I can judge – that of the fondest – faithfullest – most devoted – most mistaken parents that ever child was blest with – or ruined by. For myself, I could speak of my follies and my sins – I could not speak of my good. If I did – people would know the one was true – few would believe the other. Many of my own struggles for better things I have forgotten – I cannot judge myself – I can only despise – and pity. In my good nature, I have no merit – but much weakness & folly. In my genius I am curiously imperfect & broken – the best and strongest part of it could not be explained. – And the greater part of my Life – as Life, (and not merely as an investigatory or observant energy –) has been one succession of love-sorrow, which I could only describe by giving myself up to do it hour by hour and pain by pain.[79]

Charles Eliot Norton was one of the few sane, male friends whom he took into his confidence, both about Rose and about his parents. One of his parents was of course now dead but the other, his mother, continued to seek to dominate him and required him to write to her regularly, which he did dutifully every day.

Collingwood* knew, of course, about the agonising relationship with Rose La Touche and referred in his biography of Ruskin to the pain that she had caused him, but did not name her: he simply wrote of the 'open secret – his attachment to a lady, who had been his pupil, and was now generally understood to be his *fiancée*', but who in 1872 finally rejected him on grounds, as Collingwood presented it, of religious incompatibility.[80] Maybe Collingwood's reticence made for a more balanced story than an account that pursued Ruskin's anguish into all its recesses would have done. But it needs to be remembered that his achievements of the latter part of this decade, the 1860s, were won against a background of constant debilitating and exhausting sexual obsession which filled him with grief, guilt and conflict.

Ruskin was *always* 'split': his sexual obsession nagged at him, wasted his time and energy and caused him to swing between helpless desire for Rose and massive resentment of her. And the pattern of his behaviour in the 1860s became increasingly 'split' – he was a dutiful son to his mother, yet he went on continental journeys away from her, and in 1871 he bought himself a home – Brantwood – which was separate from hers, as though marking his escape from her. And in his work there is a cultural division between the disciple of high art on the one hand and the utopian orator on the other.

Split behaviour is symptomatic of a bipolar disorder. Ruskin was what in modern terms one would call manic-depressive. His depression was obviously related to the unremitting state of sexual frustration in which he was trapped all his life. The manic side manifested itself in the explosions of energy and the apparent conviction of his own omnipotence that increasingly took hold of him in his later books. Both sides, the manic and the depressive, can be heard in his letters to Charles Eliot Norton. Ruskin spoke of 'the hollowness of me', though he would not write about it in full to his friend as yet: 'Some day, but not now – I will set down a few things for you – but the more you understand – the less you will care for me. I am dishonest enough to want you to take me for what I am, to you, by your own feeling.'[81] In

*Ruskin's friend and assistant, later his biographer.

the low mood-swings of 1868 and especially of 1869 – following his fiftieth birthday, 8 February 1869 – Ruskin believed that he had not long to live, asked Norton to draft his will and also required Norton to see his book on Athena, *The Queen of the Air*, through the press for him. This task Norton was to undertake as Ruskin's literary executor – as though Ruskin were already dead. Ruskin wrote from Denmark Hill to say that this task was 'a mere beginning of editing posthumous works – for all my work now is posthumous'.[82]

This was more than a joke. Ruskin intended that *The Queen of the Air* should initiate a new edition, or 'corrected series', of his complete works. It consciously established in Greek myth a theoretical and historical basis for the whole of his work: it was therefore a kind of 'prequel' to *Modern Painters*, *The Stones of Venice* and the other early books. This book displayed a passionate desire for integration and a single formula with which to confront life's complexity. Like Arnold's scholar gypsy, in flight from the sick hurry and divided aims of high Victorian life, Ruskin sought consolation in a magical view of art and the creative processes. Athena presides over life, art, and fresh air: 'Whenever you draw a pure, long, full breath of right heaven, you take Athena into your heart, through your blood; and with the blood, into the thoughts of the brain.'[83]

Athena is thus linked to life itself, and she is linked to all creative processes, artistic and natural, to music, and to the foundations of the culture which enable the artist to create. The myth of her was closely associated in Ruskin's mind with his central belief about the nature of 'work', a word and a concept widely explored in his writings of the 1860s. Athena is the 'directress of the imagination and the will':

Athena rules over moral passion, and practically useful art. She does not make men learned, but prudent and subtle: she does not teach them to make their work beautiful, but to make it right. In different places of my writings, and through many years of endeavour to define the laws of art, I have insisted on this rightness in work, and on its connection with virtue of character, in so many partial ways, that the impression left on the reader's mind . . . has been confused and uncertain. In beginning the series of my corrected works, I wish this principle (in my own mind the foundation of every other) to be made plain. . . .

The faults of a work of art are the faults of its workman, and its virtues his virtues.

> Great art is the expression of the mind of a great man, and mean art, that of the want of mind of a weak man. A foolish person builds foolishly, and a wise one, sensibly.[84]

This large and loud declarative statement was linked to his Rede Lecture given at Cambridge, 24 May 1867: 'On the Relation of National Ethics to National Arts'. In this lecture Ruskin portrayed good art as inseparable from the moral virtue of the artist and the moral life of the society that had produced the artist. 'We cannot teach art as an abstract skill or power. It is the result of a certain ethical state in the nation, and at full period of the national growth that efflorescence of its ethical state will infallibly be produced.'[85] These general observations need anchoring, and – to return to *The Queen of the Air* – they were triumphantly anchored by Ruskin in two touchstones of his personal experience: a Turner drawing and one of his own childhood poems.

The Turner drawing shows Geneva with Mont Blanc in the distance. The scene has surprisingly little colour or incident. Ruskin explored Turner's possible reasons for choosing this scene's quiet features:

> He took pleasure in them because he had been bred among English fields and hills; because the gentleness of a great race was in his heart, and its power of thought in his brain; because he knew the stories of the Alps, and of the cities at their feet; because he had read the Homeric legends of the clouds, and beheld the gods of dawn, and the givers of dew to the fields; because he knew the faces of the crags, and the imagery of the passionate mountains, as a man knows the face of his friend; because he had in him . . . the inheritance of the Gothic soul . . . and also the compassion and the joy that are woven into the innermost fabric of every great imaginative spirit, born now in countries that have lived by the Christian faith.

This snapshot of Turner turns out to be a snapshot of the ideal human being as envisaged in the whole of *The Queen of the Air*, that is, the perfectly integrated man and artist who is a product of Romantic engagement with landscape and of Greek, Gothic and Christian culture.[86]

Ruskin then moved seamlessly from Turner to himself and his own 'art-gift', conferred on him by Athena and by landscape. He quoted a short poem that he wrote in Scotland on 1 January 1828, when he was not yet nine years old. It linked the particulars of the landscape – its icicles, waterfall, stream and trees – with

> . . . mountains at a distance seen,
> And rivers winding through the plain.
> And quarries with their craggy stones,
> And the wind among them moans.

'So foretelling', Ruskin went on to remark, 'Stones of Venice, and this essay on Athena.'[87] There is a serious point at work in this seemingly trivial anecdote. Ruskin's childhood, like the childhoods of the great Romantic poets, contains seeds or visions of all that he will achieve as a man. Further, he is revisiting his childhood in order to reissue all his books and in effect rewrite his life: the connection between the Gothic (the stones of the poem) and the Greek (the myth of Athena, the element of the air) has always been there in his temperament, but its significance needed time and maturity to become apparent.

The Queen of the Air celebrated wholeness, purity, calm of mind, disinterestedness: qualities that Matthew Arnold was praising, in his critical essays and in *Culture and Anarchy*, during the same decade. And *The Queen of the Air* participated in another quest of the period, that for the 'key to all the mythologies'. The hapless Casaubon in George Eliot's *Middlemarch* (1869–71) is for modern readers the most famous victim of this obsession: his research too massive ever to be finished (and he has not read the German scholars who could have helped him). Ruskin in *The Queen of the Air* avoided any such difficulties by saying that scholarly inquiry was less important in this quest than vision. It was the intuition of the Romantic that would lead to clarity in this matter: 'You may obtain a more truthful idea of the nature of Greek religion and legend from the poems of Keats, and the nearly as beautiful, and, in general grasp of subject, far more powerful, recent work of Morris, than from frigid scholarship, however extensive.'[88] This comfortable faith in Romantic vision rather than frigid scholarship may be taken as the larger context for Ruskin's remarks about Turner's mind. The key to all the mythologies, the unity of knowledge, the wholeness of the culture which produces the great artist; these things are accessible to intuition and vision, not to empirical drudgery.

The Cestus of Aglaia, nine papers in the *Art Journal* published between February 1865 and April 1866, paralleled the preoccupations of – and in places contributed to the text of – *The Queen of the Air*. Arnold's faith in Greek civilisation as a corrective to the Victorian world and in literature as a moral touchstone for society seemed to be hovering in the background of these writings. And certainly Ruskin

wanted his contemporaries to turn their backs on the 'sick hurries and divided aims' of the contemporary world. In a passage on 'Haste' in *The Cestus of Aglaia* Ruskin gave a vivid account of what he saw as wrong with his civilisation. The date was 20 March 1865 and he was looking out of a window in the house that he was still sharing with his mother on Denmark Hill:

> As I look out of my fitfully lighted window into the garden, everything seems in a singular hurry. The dead leaves; and yonder two living ones, on the same stalk, tumbling over and over each other on the lawn, like a quaint mechanical toy; and the fallen sticks from the rooks' nest, and the twisted straws out of the stable-yard – all going one way, in the hastiest manner! The puffs of steam, moreover, which pass under the wooded hills where what used to be my sweetest field-walk ends now, prematurely ... signify ... that some human beings, thereabouts, are in a hurry as well as the sticks and straws, and, having fastened themselves to the tail of a manageable breeze, are being blown down to Folkestone.

The people on the train to Folkestone prompt questions about the destinies of human lives: 'Do many of them know what they are going to Folkestone for?' As he had said in 'Traffic', most of his contemporaries had short-term objectives, summed up as 'getting-on'. The destination is invisible to most people, 'so fixed on the mere swirl of the wheel of their fortunes, and their souls so vexed at the reversed cadences of it'.[89] Annoyed though he was by the cutting of the London-to-Folkestone railway-line across one of his favourite walks, Ruskin had been surprisingly excited and pleased, in an earlier paper, by the spectacle of a railway locomotive. Given his ecstatic rudeness about the railways in his writings of the 1840s and 1850s this was a remarkable passage:

> I cannot express the amazed awe, the crushed humility, with which I sometimes watch a locomotive take its breath at a railway station, and think what work there is in its bars and wheels, and what manner of men they must be who dig brown iron-stone out of the ground, and forge it into THAT!

There was, however, a sting in the tail of this: 'As I reach this point of reverence, the unreasonable thing is sure to give a shriek as of a thousand unanimous vultures, which leaves me shuddering in real physical pain.'[90]

In his letters to Norton of this period Ruskin praises Byron for his 'incontinence'. On 11 July 1869 from Verona he wrote to Norton:

'Why do you call Byron insincere? I should call his fault – "incontinence of emotion." I call him one of the sincerest – though one of the vainest of men – there is not a line he has written which does not seem to me as true as his shame for his clubfoot.' Byron is fitting himself into Ruskin's vision of the integrated man: 'If he were only at Venice now – I think we should have got on with each other.'[91] This may be linked to an earlier letter of 21 June (also from Verona) in which Ruskin said to his friend: 'I've suffered so fearfully from *Reticences* all my life that I think sheer blurting out of all in one's head is better than silence.'[92] The pain of the late 1860s provoked 'incontinence' and 'sheer blurting out' in his writing. The words poured out of him in molten streams. Every so often, pausing to look at what he had written, he produced one of those magnificent general observations that were designed to assure himself that the writing was part of a great design. And so indeed it was, but the design is itself organic and unstructured, like those of the great Romantic originals whose works his were coming increasingly in this period to resemble.

*

Ruskin's letters to Norton provide a spine for the narrative of his life in the years 1869 to 1871. In June and July 1869 he was enraged by Italian republicanism ('This Italy is such a lovely place to study liberty in! There are the vilest wretches of ape-faced children riding on my griffins [supporting the pillars of the porch of the Duomo in Verona] all day long') and architectural philistinism ('they are destroying so fast – and so vilely') and moral squalor ('There is nothing in Dante more loathsome – more obscene – more terrible – than the present state of Italy').[93] In his distraught emotional state he lashed out at his friend, as though the pain caused him by Rose could be alleviated only by causing pain to *someone*, preferably someone fond of him. From Faido on 15 August 1869, he chose to quarrel with Norton over Mill and political economy, castigating his long-suffering friend for ignorance and obtuseness over the 'evil' of Mill's doctrines and saying in effect that the friendship could not go on if Norton persisted in holding an opinion which did not coincide with Ruskin's own. 'I can't love you rightly as long as you tacitly hold me for so far fool as to spend my best strength in writing about what I don't understand [political economy].' From Giesbach on 18 August he wrote angrily that Norton was unable to

distinguish his morality from his economy: 'you do not yet clearly see that I do not (in my books) dispute Mills morality; but I flatly deny his *Economical science*'. And the letter took off into a tantrum: '*Don't tell me* any more about good & wise people "giving their lives" to the subject – and "differing from me" . . . they don't know the *alphabet* even of the science they profess . . . they hav'nt lives to give – They are not alive – They are a strange spawn begotten of misused money.'[94] And so on. It was spirited stuff and all Norton's tact was needed to prevent the disagreement from blowing up in a major quarrel. It could well be that Ruskin's characteristic dogmatism and self-assertion had been reinforced by the news, received by telegram on 14 August, that he had been elected Slade Professor of Fine Art at Oxford; thus from mid-August he was writing in the excited knowledge that a new role and a new platform were waiting for him back in England.

In late August Ruskin and Norton met, and Norton reproached Ruskin for his treatment. This wrung from Ruskin a kind of apology, and he said after the meeting (writing from Dijon): 'I saw more clearly [as a result of their meeting] the ways in which I have at different times hurt you . . . I have every cause to trust in your affection – and you hardly any to trust in mine.' He added a general comment on their friendship: that Norton was to him 'what many of my other friends and lovers have been – a seeker of my good in your own way – not in mine'. And he gave a telling example of what he meant from his late father's attitude to Turner's work: 'If I had asked my father to give me forty thousand pounds to spend in giving dinners in London – I could have had it at once – but he would not give me ten thousand – to buy all the existing watercolours of Turner with.'* He added that he would not want Norton to write a biography of him: 'I don't care about having my life written – and I know that no one *can* write a nice life of me – for my life has not been nice – and can never be satisfactory.'[95]

Back at Denmark Hill with his mother, he wrote on 17 November 1869 to Norton giving a truly awesome account of his work programme, including an account of seven lectures that he planned to give at Oxford in the spring. These lectures were to comprise a kind of universal account of the role of art in education.

The first scheme had to be abandoned because he had not understood that he was required to give *twelve* lectures. A letter of 1

*With hindsight this is indeed a vindication of Ruskin's judgement.

January 1870 gave his revised list of lectures. The list showed how seriously and how ambitiously he took his forthcoming post:

1. Introductory.
2. Relation of Art to Religion.
3. Relation of Art to Morality.
4. Relation of Art to (material) use. alter word perhaps. (Household – Furniture – Arms – Dress, – Lodging – Medium of exchange)
5. Line.
6. Light and shade.
7. Colour.
8. Schools of Sculpture. Clay, including glass, Wood, Metal, Stone.
9. Schools of Architecture. Clay, Wood, Stone, Glass in windows.
10. Schools of painting (Material indifferent) – considered with reference to immediate study & practice – A. of Natural History.
11. – B. of Landscape
12. – C. of the human figure.[96]

It was a big, ambitious scheme. The prospect of giving so many major public performances was daunting, and Ruskin was understandably nervous and eager to use his willing friend as a sounding board for his ideas. In the event he renegotiated the terms with the university and gave only seven lectures, but this task was itself difficult because an upsetting experience in January 1870 put him back for a whole month: he met Rose La Touche in the Royal Academy on 7 January and she rebuffed him. He described the experience to his friend Lady Mount-Temple:

I went into the rooms of the Royal Academy yesterday at about noon: and the first person I saw was R. She tried to go away as soon as she saw me, so that I had no time to think – I caught her, – but she broke away so that I could not say more than ten words – uselessly. She then changed her mind about going, and remained in the rooms apparently quite cheerful and undisturbed. Having looked at her well, I went up to her side again, and said 'I think you have dropped your pocketbook,' offering her her letter of engagement between the golden plates. She said 'No'.[97]

Ruskin habitually carried a letter from Rose – one that, in his view, contained her promise to marry him – in a gold pocket container (like an expensive cigarette box).

By 26 March his feelings for Rose were curdling from obsession into hatred ('she has set herself to thwart and torment me like a Fury'). Norton sympathised, and was angry with Rose. The ostensible reason for Rose's rejection of Ruskin was the religious differences between

them, and it is to this that Norton referred in his reply of 31 March 1870 (from Florence):

> There is nothing so cruel as the heart that thinks itself one with God. . . . It grieves me for all the shattered plans, – for the lectures written at disadvantage, – for the wearied soul & hurt heart. I had hoped that the past was past.

Like all Ruskin's wiser friends, Norton heartily wished by this time that Ruskin could get shot of Rose. But his comment provoked Ruskin to defend her: 'Do not be angry with poor Rose,' he wrote on 4 May (from Geneva), 'she has done all she could.' He was acknowledging that his sexual and emotional difficulties could not be laid at her door: 'My life was entirely at an end in a certain sense – before – it never could have been what you hoped' (in other words, he could never have had a normal married life like Norton's). 'And she made it now – far better than it was.'[98]

In the same year, 1870, German ambition (under Bismarck) led to the declaration of war by France and the consequent siege of Paris, which ended in humiliating defeat for the French in 1871. Norton's letters often expressed distress over the state of the world: in May he responded to a letter from Ruskin listing the causes of his despondency: 'Desire to be of service to one's world & inability to fulfil one's desire, the sense of the useless & needless misery among men, the living in a time in which one is out of sympathy with the ruling motives of the mass of men & women who surround them'. He wrote from Siena, ten days after the death of Dickens (which took place on 9 June 1870): 'Just at this time England can ill spare such a leader in the uncertain battle in which you & all other humane & thoughtful & patriotic men are engaged. The prospect of the field, dark enough before grows visibly darker, with the loss of one who so long had been among the foremost in the struggle. Dickens took the most serious view of the conditions of society in England.' He quoted Dickens as saying: 'If the storm once sets in it will be nothing short of a tornado, & will sweep down old fences.'[99] In other words, the selfishness of the upper class threatened England with a revolution. It was perfectly reasonable for Norton to suppose that Ruskin and Dickens would be on the same side politically, but in fact Ruskin rebuked him: 'Dickens was a pure modernist – a leader of the steam-whistle party par excellence.' Dickens's 'hero is essentially the iron-master' (Rouncewell from *Bleak House*). Politically, Ruskin thinks, Dickens supported 'the fury of business

competition'. This represented a sharp deterioration of the assessment of Dickens that he had given in *Unto this Last*, where he said that Dickens was 'entirely right in his main drift and purpose in every book he has written' despite the fact that he 'chooses to speak in a circle of stage fire'.[100] (Dickens's theatricality had become a major flaw, he 'was essentially a stage manager – and used everything for effect in the pit'.[101]) Ruskin developed further his strictures on Dickens, conceding that Dickens had genius and benevolence (Norton had obviously made these points) but complaining that he did not pursue 'truth'. 'It is Dickens delight in grotesque and rich exaggeration which made him I think nearly useless in the present.'[102]

In June and July 1870, when these letters were written, Ruskin and Norton had two pleasant meetings. At Siena they took a walk on a June evening among the fireflies (famously recorded in *Praeterita*), and for a few days at the end of June and in early July they were in Pisa, Pistoia and Prato together. Ruskin's project included both research and pleasure – he was accompanied by his friend Mrs J.C. Hilliard and her daughter Constance, as well as his cousin Joan Agnew.

Ruskin's preoccupations with Rose and with his own mental state had not abated. He wrote: 'I have been endeavouring this morning to define the limits of insanity – My experience is not yet wide enough – I having been entirely insane, as far as I know – only about Turner and Rose, and I'm tired; and have made out nothing satisfactory.'[103]

As the Franco-Prussian war developed, so Ruskin's sympathies shifted to the Prussians. In his attitude to all things German he was powerfully influenced by Carlyle's enthusiasm:

> You'll never make me miserable any more by thinking you might be right & Carlyle wrong, after all, – when I see how you misread this French war; – My darling Charles – this war is – on the one side – the French – the purest and intensest republicanism (choosing a fool for a leader, and able to kick him off when it likes –) joined to vanity – lust – and lying – against on the German side a Personal Hereditary Feudal government as stern as Barbarossas – with a certain human measure of modesty, decency, and veracity, in its people.
>
> And dear old Carlyle! – how thankful I am that he did his Friedrich [Carlyle's life of *Frederick the Great*] exactly at the right time.[104]*

This disagreement could have flared up into a quarrel, but Ruskin

*In terms of political events this letter was prescient: Napoleon III surrendered to the Prussians on 6 September and spent the rest of his life (until 1873) in exile in England.

now knew that Norton was invaluable to him and he took care to remain gentle and friendly in their correspondence. And Norton was eager, on his side, to accommodate Ruskin. He hoped that by settling at Oxford into his new appointment as Slade Professor, Ruskin would find fresh confidence and renewed peace. But the neuroses in Ruskin ran too deep. On 7 December 1870 he wrote from Oxford that he was 'tired' by people 'fastening on me and teazing me and my lectures, the fifth just given, causing me great labour'. In the same letter he told Norton of Joan Agnew's engagement to Arthur Severn, son of the Joseph Severn (1793–1879) who had been Keats's friend and the British consul at Rome. Maybe Joan's defection was contributing to Ruskin's depression, though he didn't say so. Norton replied from Florence: 'It troubles me that you are so worn, weary, & out of heart. England is fatal to you.' He was circumspect on the subject of Joan's engagement: 'I am glad if Joan's engagement satisfies you.'[105]

Norton was right to the extent that Ruskin's moods tended to lift when he was travelling abroad, especially in Italy. But it was not England that was fatal to him, it was his own nature. On 21 December he was 'giddy' with overwork, but he was determined not to be mastered by events: 'I won't live in a mere cobweb of fate any more.' On 3 April 1871 he wrote from Denmark Hill: 'I have been failing beyond all former failure.' This was partly because of the death of an old servant, whom he had buried close to his father's grave: 'It is very wonderful to me that those two, who loved me so much, should not be able to see me any more.' In the midst of his depression he was full of plans – displacement activity, to some degree, one may think. He had approached the Oxford University authorities in March with a scheme for the establishment of a practical art school in Oxford. Part of his purpose was to create a practising alternative to the government scheme for art education, founded in 1837 and at this date administered by the Department of Science and Art in South Kensington. Ruskin's long-standing quarrel with 'Kensington' was that its tuition was an adjunct to manufacture:

> At Oxford, having been Professor a year & a half, I thought it time to declare open hostilities with Kensington, and requested the Delegates to give me a room for a separate school on another system. – They went with me altogether, and I am going to furnish my new room with coins – books, catalogued drawings and engravings – and your Greek Vases [Norton had made a number of purchases for Ruskin during his travels in Italy in the previous year]; the mere fitting will cost me three or four

hundred pounds. Then I'm going to found a Teachership under the Professorship – on condition of the teaching being on such & such principles and this whole spring I must work hard to bring all my force well to bear, and show what I can do.

This was to become what is still the Ruskin School of Art, at Oxford. The first teacher 'under the Professor' was Alexander MacDonald. Ruskin was putting far more of his time and energy – and his own money – into the post than had ever been expected of him. He was embarking on this demanding project despite a more or less constant state of despair: 'Everything', he continued in the same letter, 'is infinitely sad to me – this black east wind for three months most of all.' (Elsewhere he spoke of this as a 'plague-wind', and his diaries and letters became increasingly loaded with miserable notices of the weather from this date on.) 'Of *all* the things that oppress me – this sense, of the evil-working of nature herself, – my disgust at her barbarity – clumsiness – darkness – bitter mockery of herself – is the most desolating.'[106]

In the summer of 1871 Ruskin had a serious illness. Three doctors attended him.

They gave me ice! and tried to nourish me with milk! Another twelve hours and I should have been past hope. I stopped in the *middle* of a draught of iced water, burning with insatiable thirst – thought over the illness myself steadily, – and ordered the doctors out of the house. Everybody was in agony, but I *swore* and raged till they had to give in; ordered hot toast and water in quantities, and mustard poultices to the bowels. One Doctor had ordered fomentation; *that* I persevered in, adding mustard to give outside pain. I used brandy and water as hot as I could drink it, for stimulant, kept myself up with it, washed myself out with floods of toast and water, and ate nothing and refused *all* medicine. In twenty-four hours I had brought the pain under, in twenty-four more I had healthy appetite for meat, and was safe – but the agony of poor Joanna [Joan Severn]! forced to give me meat, for I ordered roast chicken instantly, when the Doctors, unable to get at me, were imploring *her* to prevail on me not to kill myself as they said I should. The poor thing stood it nobly, of course – none of them could move *me* one whit. I forced them to give me cold roast beef and mustard at two o'clock in the morning!! And here I am, thank God, to all intent and purposes quite well again; but I was within an ace of the grave.[107]

The illness was physical, but it seems likely that its extreme severity – as he said, he nearly died – owed something to the continuing stress over the unresolved situation with Rose.

Following the illness came a kind of radical, unthought-out attempt to solve his personal problems by buying a house that he had never seen. On 13 September 1871 he bought Brantwood, on Coniston, 'with five acres of rock & moor – a streamlet and I think on the whole the finest view I know in Cumberland or Lancashire – with the sunset visible over the same. The House – small – old – damp – and smoky chimneyed.' Two days later he wrote with greater pleasure about this house: 'Here I have rocks, streams, fresh air, and for the first time in my life, the rest of the proposed *home*.' Norton's replies led Ruskin in a later letter to modify his rapture over Brantwood: it has not replaced Italy in his affections, nor will it become a lethargic and debilitating paradise: 'There is no fear of my sucking the orange at Coniston. There is none to suck. I have simply light and air, instead of darkness and smoke, – and ground in which flowers will grow. . . . What little pleasure I still look for will be in Italy, mixed with bitter pain – but still intense in its way.'[108]

The year closed with his mother's death on 6 December. She had been steadily declining. He had written in mid-November that she was 'merely asleep – speaking sometimes in the sleep – these last three weeks. It is not to be called paralysis, nor apoplexy – it is numbness and weakness of all faculty – declining to the grave. Very woeful: and the worst possible death for *me* to see.'[109]

On the day of her death he wrote to George Richmond, his parents' old friend: 'She looks very pretty and young. It is just possible you might like to come and see her – please do, if you would. In *any* case I know she had no more faithful friend, so mind you don't come merely for fear I should think you didn't care about her.'[110]

To Norton he could confess that he did not love his mother and that he was angered by the family and mourners at her funeral. Further, as Norton already knew, he had long ago abandoned his mother's religious beliefs. He wrote from Denmark Hill on 13 December 1871: 'All the real sorrow of my life about human creatures – is not connected with my manner of relationship.' Blood relatives mean little to him compared with Rose: 'People wanted to show respect and came in a crowd to the burial yesterday. Lunched afterwards – and stunned and horrified me all day long. If it had been Rosie or Joan I was burying – I should have pitched gravel in their faces – and sent them all to the worst place I could devote them to.' Norton responded comfortingly that 'Love will not follow relationship. It is not matter of blood but of spirit.'[111]

The two men had set out their religious convictions for each other with remarkable frankness in an exchange of letters in 1869. Norton did not believe in God or immortality, but asked Ruskin what he should say to his children (8 October 1869). Ruskin replied from London (16 October 1869) that he did not believe in immortality either, but that he retained a belief in 'a power' which had shaped the natural world, 'both the heath bell and me'. This, he said, 'all nature teaches me – and it is in my present notion of things, a vital truth'. So he urged Norton to pass on this much at least of theology to his children: 'teach them that they must live, and *Die – totally –* in obedience to a Spiritual Power, above *them*'. This is all the religious education they need: 'If you can teach them this – I think you show them the law of noblest heroism; and of happiest and highest Intellectual State.'[112]

CHAPTER 7

1872–8

> I was as fond of nature at five years old as I am now, and had as
> good an ear for the harmony of words. . . . My mother . . . could
> not have given me the *ear*, but the ear being there, she educated the
> taste in emphasis and never allowed a theatrical or false one.
> Here is one of the beginnings of wholesome education. There was
> no teaching of elocution, but merely of common sense and
> plainness. . . .
>
> My father never in any instance read a book to me which was
> bad in style, his taste being excellent; and having Johnson,
> Goldsmith, and Richardson read to me constantly, led me in the
> right way.[1]

Ruskin's mother remained narrowly evangelical to the end, but this
very characteristic produced an endearing anecdote. On her deathbed
she said that she was sure of seeing her husband. She did not hope to
speak to him because he had lived so much better a life than she had,
but it would be enough to be allowed to see him.

After the emotionally numb period of her death and funeral Ruskin
himself suddenly found that he missed her. On 4 January 1872 he
wrote to Norton saying that he felt very depressed, largely because
of 'the loss of that infinitude of love my mother had for me,
and the bitter pity for its extinction'. Even here, though, while
acknowledging her love for him, he made no reference to how he felt
towards her.[2]

His feelings for his mother had been and continued to be complex.
His relationship with her was both simpler and more difficult than his
relationship with his father; simpler because she was less sophisti-
cated than her husband, more difficult because on religious questions
her mind was closed. Since his unconversion of 1858 it had been hard
to discuss religious matters freely with her. His father had understood
what Tennyson called 'honest doubt'. As early as 1848 we find
Ruskin questioning 'God's government of this world': 'I believe that
you, as well as I, are in this same condition, are you not, father?
Neither of us *can* believe, read what we may of reasoning or of proof;
and I tell you also frankly that the more I investigate and reason over

the Bible . . . the more difficulties I find, and the less ground of belief.'[3]*

Ruskin felt free to use his father as a sounding board for radical ideas because, although flexible and intelligent, John James was ultimately secure in his own convictions. 'The whole system of modern society, politics, and religion seems to me so exquisitely absurd that I know not where to begin about it – or to end. My father keeps me in order, or I should be continually getting into scrapes,' Ruskin wrote in 1853. 'Look what has become of the most amiable men whom I knew at Oxford – half of them Roman Catholics, the others altogether unsettled in purpose and principle.'[4] This is part of a long letter of self-appraisal to one of his old Oxford tutors; the epigraph to this chapter comes from the same letter, in which he paid full and truthful tribute to both parents. Educationally Ruskin owed more to them than he did to Oxford. The letter gave his mother's teaching equal weight with his father's; John James made him a good reader, but it was Margaret who made him a *writer*. The infant Ruskin who learned the craft of words by memorising chapters of the Bible at his mother's knee became the young man who carved out a new kind of career for himself – a critic of *modern* art – from 1843 onwards. What was wholly distinctive about the adult Ruskin – the forging of an art criticism so eloquent that it forced itself on the public consciousness both as a major literary form and as a source of moral guidance – he owed to his mother. At the time of her death he had perhaps forgotten this, but when he came to revisit his infant self in *Praeterita* he remembered his early reading with her as 'the most precious, and, on the whole, the one *essential* part of all my education'.[5]

Over the ensuing years he often refers to the loss of both parents as a loss of sympathetic, like-minded companionship. The beauty of Brantwood, for instance, would have given him greater pleasure if they had been there to share it. To John Brown† he wrote: 'What all the lovely things round me here would have been to me had I had Father

*The revolution in France earlier in the summer was the immediate cause of these searching questions about the divine ordering of human affairs.

†Dr John Brown, whom Ruskin called his '*best* friend, because he was of my father's race and native town; *truest* because he knew always how to help us both, and never made any mistakes in doing so', disagreed with Ruskin about political economy, but nevertheless remained a loyal reader and supporter. His death in 1882 affected Ruskin as though it had been the death of a surrogate father.[6]

or Mother now, or what they would cease to be if I were to lose Joanie,* I cannot fancy.'[7]

Ruskin continued to suffer terrible anguish in his obsession with Rose, swinging violently between hope and despair, adoration of her and resentment. He noted in February 1872 that he had by then waited six years since his first proposal of marriage to have a reply from Rose. And we can be sure that her treatment of him underlay many miserable diary entries: 'Intensely languid, depressed and giddy' (3 January), 'Restless night, after one of the dismallest, weakest days I ever spent' (4 January), 'giddy: not fit for work' (5 January), 'I very ill during night with pain in back' (7 January), 'No use saying tired and ill: always, now' (11 January), 'All in confusion and arrear, and I weary and sad' (3 February). A summer tour of Italy which began on 11 April did nothing to lift his mood. 'I utterly miserable among the horrible changes, and my life flying like a dream' (Lucca, 1 May), 'Pouring rain, rooms horrible, and place more repulsive to me than ever' (Rome, 12 May), 'quarrelling with everything and everybody' (13 May), 'Days flying like the dust in the wind' (15 May).

Rose had written a number of letters to George MacDonald, expressing her unhappiness and her desire to be friends with Ruskin. As

*After his mother's death her place, as the home-maker for Ruskin, was taken by Joan Agnew (1846–1924) (Joan Severn since her marriage in 1871). She was related to Ruskin through the Rev. James Tweddale of Glenluce, grandfather both of John James Ruskin and of Joan's mother, Catherine Tweddale. Joan had effectively joined the Ruskin household in 1864; shortly after the death of John James Ruskin she had visited Denmark Hill 'for a week'. Margaret, who encouraged Joan to call her 'Auntie', made a pet of her and when the time came for the visit to end insisted that she should stay longer. She stayed – with intermissions to see her family – for seven years. Joan took a lot of domestic pressure off John Ruskin. Though unable to prevent his mother from ordering him about, she was skilled at keeping the old woman in a good temper and preventing her from bullying the servants. Through John Ruskin's friendship with Mrs La Touche and Rose, Joan became a friend and intimate of the La Touche family. This led to a complication: in 1866 Joan paid a visit to the La Touches at Harristown, and was courted by Percy La Touche, Rose's brother. In 1867 the young couple became engaged. The La Touche parents were dismayed: by this date they were doing what they could to separate Ruskin from Rose so a romantic link between their son and Ruskin's cousin was counter to everything they were trying to achieve. They prevailed, and Percy wrote to Joan late in 1867 breaking off the engagement.[8] Meanwhile Arthur Severn (1842–1931), son of Ruskin's old acquaintance Joseph Severn, knowing nothing of the engagement to Percy La Touche, began his courtship of Joan. For a time Ruskin, who by this time was Joan's guardian, made Arthur wait (Ruskin's own unhappiness over Rose made it difficult for him to grant happiness to others) but in due course he relented. After their marriage (20 April 1871), Ruskin gave the young couple a long lease on his parents' old home at Herne Hill (retaining for his own use his former nursery) where the Severns brought up their large family (they had five children). After Ruskin's illness in 1878 they increasingly made their home in Brantwood, which Ruskin made over to them by Deed of Gift in 1885.

a result, and in response to letters from MacDonald, Ruskin broke off his Italian tour to come back to England. He wrote to his friend Mrs Cowper-Temple, calling her Φιλγ ('friend' in Greek). The letter communicated his agitation and excitement over the prospect of seeing Rose and his pessimism over the possible outcome:

> My dearest Φιλγ,
> . . . I have not been able to write or think, or feel, most of my days, – except needful matters for my routine work. I am coming home, now, in haste – but not for my own sake – nor perhaps, much for any one else's. Whatever good can come now, is too late, except peace – which I hope to get or give, at last.[9]

Once he was back in England he became yet more agitated. He hoped that Mrs Cowper-Temple would invite him to Broadlands* to meet Rose. He wrote calling Mrs Cowper-Temple by another of his pet names for her, 'Isola', in terms that turn the Rose of his imagination into a kind of fetishised object. 'Now, wouldn't it be lovely if you had sent me a little note telling me to come to church tomorrow at Romsey, and that I might have a walk afterwards, beside the Liffey'; in other words, Romsey would become an Irish landscape if Rose were there. 'But what *is* to be done with me? What is she going to do? Is she going to wear that white hat again, and is everybody to see it except me. *Please* don't let her wear that white hat.' The letter goes on about the white hat – 'Please – please – please – don't let her wear that white hat – nor white shawl. Make her wear a black veil, – as they do at Verona – only quite over her face. Who should see her, if I may not?' He is locked into this obsession: 'Am I alive again – or are you only a beautiful Witch of Endor, – and I only raised for a moment to say – "Why hast thou disquieted me"?'[10]

But his mood was also often – irrationally, dangerously – high, the diary entries using triumphal and exaggerated prose:

> [13 August 1872] BROADLANDS. Entirely calm and clear morning. The mist from the river at rest among the trees, with rosy light on its folds of blue; and I, for the first time these ten years, happy.[11]

Rose La Touche and John Ruskin met at Broadlands on 13 August. The diary entry was deceptively calm: the emotional impact of the great day was massive, and its shock waves were recorded in two more letters to Mrs Cowper-Temple:

*Broadlands was the country seat in the New Forest inherited by William Cowper-Temple from his stepfather, Lord Palmerston.

[13 August] I do not believe that ever any creature out of heaven has been so much loved as I love that child. I am quite tired tonight – not with pain – but mere love – she was so good and so grave, and so gay, and so terribly lovely – and so merciless, and so kind – and so 'ineffable.' . . . Did you ever see anything half so lovely? As she was at last. How shall I ever thank you enough – I will try to be so good – but I am very weary – six years and a half – and scarcely any hope now. But the great good to me is finding how noble she is – she is worth all the worship.

The tone of abject surrender and religious frenzy continued in his letter of 15 August:

Dearest Isola

I have no words to day – I should come and lie at your feet all day long, if I could, trying to thank you with my eyes. Nothing can come now that I cannot bear – No death, nor life shall separate me from the love of God any more. However long she is kept from me, – whatever she does to me, – I will not fear, nor grieve – but wait – and be more like her when she is given at last – and more worthy of her. Oh how foolish we all were, – thinking it was *she* was unworthy – were not we?[12]

And ominously, on 17 August (in the nursery at Herne Hill once more) he wrote that he had got over another anxiety attack by reading Rose's latest letter: 'More and more anxious. . . . Disturbed night with strange dreams. . . . This morning better, and read R[ose]'s letter of 28th July, dated 28th June. Oh me, that ever such thoughts and rest should be granted me once more.'

On the following day he wrote a letter to Mrs Cowper-Temple in which the prostration and ecstasy that he experienced on 13 August had been replaced by an addict's helpless craving. It was prompted by a letter from Rose to George MacDonald, which gave him yet further hope that she might love him:

Oh me, dearest Isola – we are poor weak things. I thought my one day at Broadlands might have lasted me for a century, – and now – I am quite sick with pining for – one home – one minute more – Why did you let her go away – I was too timid & feeble, – but I did not know what hold I had. If only I had seen – what I saw yesterday: her letter to Mr Macdonald after she had first seen me – (28th July) – she never should have gone home – except to mine – now I'm all restless and wretched again. And though I know and am wholly sure, that unless some fearful tragic thing happens – she *must* come to me – still – this pleasant year is flying fast – another month of pain – and all the sweet summer days will be ended. *Can't* you get her back again for me. I was so foolish and wrong to let her go, – and yet I did it more in faith, and in reverence, than in foolishness – and I

ought not to have more grief for it. Ah, get her back for me, and give me yet some days with bright morning and calm sunset – in *this* year – I am very old, to wait, – think![13]

The reader longs for Ruskin to distance himself from friends such as MacDonald and Mrs Cowper-Temple, whose ill-advised meddling had included months of manoeuvring to bring Rose and Ruskin together. We are reminded, however, if reminder were needed, that Ruskin was in the grip of his own imperatives. The letters are like the screams of an outraged baby. They are also the work of a man possessed by the rightness of his own visions: 'Unless some fearful tragic thing happens – she *must* come to me.'

During August, Ruskin saw Rose in London. She was in poor physical and mental health, but he thought she still loved him. Then in early September his mood dipped: 'Didn't write. No letter. Miserable anxiety and poverty of heart' (1 September), 'Woke entirely depressed and ill' (3 September), 'Bad weather; worse fighting with fortune and myself' (5 September).

In his diary, Ruskin spoke of 7 September 1872 as 'The Ending Day'. Rose had declared that their relationship was over. In a later letter he said of this episode: 'She broke away from both Father and Mother, in the autumn of 1872 – and gave me a week of perfect life, – but wouldn't marry me – wants to be a saint.'

*

In the years 1872–8 Ruskin can be seen to be leading several parallel lives. His work in Oxford as 'professor', with all the importance and human interaction it involved, was balanced by the quiet retreat of Brantwood, with his humble neighbours and his many opportunities for healing physical exertion in a beautiful place. His Oxford lectures and his letters in *Fors Clavigera* balance each other also, in that the lectures are aimed at the governing class and *Fors Clavigera* at the working class. But under these contrasts is a constant and agonising split, between his productive working self and the self that was possessed emotionally by Rose La Touche. His obsession with her (largely secret) fed like a parasite on his time and energy and burrowed inward to destroy his mind. We look on with helpless pity at the suffering that she caused him, and with admiration at the amount that he was able to achieve despite the obvious fact that his anguish was like a fetter, impeding every step. For anyone with Ruskin's interests at

heart it is difficult to summon up much pity for Rose herself, though her plight was even worse than his.

Initially Ruskin's appointment to the Slade Chair was a challenge, a new role, a new platform. It was also a form of revenge. The gentleman-commoner whose undergraduate degree had been a fudged 'Double Fourth' was now invited back as an honoured authority, and in his inaugural course of lectures he reminded his audience that it was as the 'Graduate of Oxford' who wrote *Modern Painters* that he had been appointed to his new distinguished post.

It all started excitingly. Ruskin was greatly flattered to have been proposed to the Slade Chair by Acland and Dean Liddell. Acland's joy in Ruskin's appointment was unequivocal, but Liddell's was qualified, for he thought Ruskin somewhat unstable and unreliable. It was probably partly because he was aware that Dean Liddell regarded him with less than complete approval that Ruskin asked for, and got, an honorary fellowship at Corpus Christi College, next door to Liddell's Christ Church. To ask for a fellowship of another college when he was already an honorary Student of Christ Church was quite a snub.

Ruskin's 'Inaugural Course', his lectures on Art (Hilary Term 1870) and his lectures on the elements of Sculpture (published as 'Aratra Pentelici' and given in Michaelmas Term 1870) are among the most polished and carefully written of his productions. His 'morbid dislike of talking', which he told Norton was 'very inconvenient at Oxford',[14] meant that he wrote everything out word for word, with many revisions – though contemporary witnesses indicate that he departed widely from his written texts when he delivered the lectures.

W.G. Collingwood described Ruskin's first lecture as Slade Professor. The day was Ruskin's birthday, 8 February 1870. The room was far too small for the crowd of undergraduates, North Oxford families and university dignitaries: 'The place was densely packed long before the time; the ante-rooms were filled with personal friends of Mr. Ruskin, hoping for some corner to be found them at the eleventh hour; the doors were blocked open, and besieged outside by a disappointed multitude.' As Collingwood went on:

> Professorial lectures are not usually matters of great excitement: it does not often happen that the accommodation is found inadequate. After some hasty arrangements Sir Henry Acland pushed his way to the table, announced that it was impossible for the lecture to be held in that place, and begged the audience to adjourn to the Sheldonian Theatre. At last,

welcomed by all Oxford, the Slade Professor appeared, to deliver his inaugural address.

Collingwood described Ruskin's lecturing style:

> It was not strictly academic, the way he used to come in, with a little following of familiars and assistants, – exchange recognition with friends in the audience, arrange the objects he had brought to show, – fling off his long-sleeved Master's gown, and plunge into his discourse.

The lecture would start with reading from his prepared text, but he would soon break off from that 'and with quite another air extemporise the liveliest interpolations, describing his diagrams or specimens, restating his arguments, re-enforcing his appeal'.

He was a striking, indeed beautiful, figure, with long, thick brown hair and short, light whiskers; blue frock-coat, conspicuous cuffs and high collar and the famous bright blue stock which he always wore to match his eyes. Collingwood was particular about his facial features: big nose 'with great thoroughbred nostrils' and the mouth with its breadth of lower lip 'that reminded one of his Verona griffin, half eagle, half lion'. His appearance was 'Scotch in its original type', and the eyes, especially, enraptured Collingwood: 'The fieriest blue eyes, that changed with changing expression, from grave to gay, from lively to severe; that riveted you, magnetised you, seemed to look through you and read your soul; and indeed, when they lighted on you, you felt you had a soul of a sort.'[15]

These lectures of his first tenure of the Slade Professorship centred on art but related it to the whole moral basis of human experience. In the first lecture of the second course he revisited the teaching of *Modern Painters*: the test of art is its relationship with nature. 'Only *natural phenomena in their direct relation to humanity* – these are to be your subjects in landscape. Rocks and water and air may no more be painted for their own sakes, than the armour carved without the warrior.' And 'landscape is to be a *passionate representation* of these things. It must be done, that is to say, with strength and depth of soul.'[16]

But the writer of *Modern Painters* had learnt in the course of that huge work to revalue Renaissance painting. In his third lecture on landscape he discussed a wonderful Renaissance painting, Botticelli's *Mystic Nativity*, in the National Gallery, in which the painter had consciously abandoned the realist skills of the Renaissance and had displaced scale and perspective in favour of narrative, as would a medieval artist. The Virgin is larger than any other figure, the

foreground landscape is distorted and above the nativity scene a dozen angels dance in a ring. Although the date is probably 1500 and it is thus a late painting (the artist died in 1510), Ruskin called it an early work (presumably its post-medieval style led him to place in the 1460s). He delighted in it as a 'quite perfect example of what the masters of the pure Greek school did in Florence'. A characteristic of what he called the Greek school is that it is 'faceless':

> If you look first at the faces in this picture you will find them ugly – often without expression, always ill or carelessly drawn. The entire purpose of the picture is a mystic symbolism by motion and chiaroscuro. By motion, first. There is a dome of burning clouds in the upper heaven. Twelve angels half float, half dance, in a circle, round the lower vault of it. All their drapery is drifted so as to make you feel the whirlwind of their motion. They are seen by gleams of silvery or fiery light, relieved against an equally lighted blue of inimitable depth and loveliness. It is impossible for you ever to see a more noble work of passionate Greek chiaroscuro – rejoicing in light.[17]

In his sequence of lectures in 1872, on 'The Relation of Natural Science to Art' (later published as *The Eagle's Nest*), Ruskin returned to this painting. In Lecture III of this series he referred to the extraordinary natural 'Gothic' beauty of a bullfinch's nest (pointed out to him by John Gould, 1804–81, the great ornithologist) and asked of man's buildings: 'Why should not *our* nests be as interesting things to angels, as bullfinches' nests are to us?' It was probably the reference to angels here that triggered a return to the Botticelli painting later in the same lecture, to illustrate the horrible conditions in which people lived and worked in London in the 1870s. He wrote this lecture in the winter of 1871, probably at Christmas time, and it offers a vision of Botticelli's angels in London, a vision that is reminiscent of Dante's *Inferno* and precursor to that extraordinary modernist revision of Dante, Eliot's *The Waste Land*:

> suppose that over Ludgate Hill the sky had indeed suddenly become blue instead of black; and that a flight of twelve angels . . . had alighted on the cornice of the railroad bridge, as the doves alight on the cornices of St. Mark's at Venice; and had invited the eager men of business below, in the centre of the city confessedly the most prosperous in the world, to join them for five minutes in singing . . . cannot you fancy . . . the sensation of the crowd at so violent and strange an interruption of traffic.[18]

In a representative lecture from the same series, he recapitulated the course that he had been giving in that academic year: 'I stated, in the

first two [lectures], that the wisdom of art and the wisdom of science consisted in their being each devoted unselfishly to the service of men; in the third, that art was only the shadow of our knowledge of facts; and that the reality was always to be acknowledged as more beautiful than the shadow.' And so on – the lectures were all intimately related to moral teaching: 'sight was a distinctly spiritual power' and 'spiritual sight . . . was the source of all necessary knowledge in art'.[19] The preamble led him to the birds that were the subject of the lecture, an egret and kingfisher. The last egret known in England, he told his audience, was seen in 1840: 'it was killed by a labourer with a stick'. Ruskin was making a general point: all of us – artists, spectators, patrons of the art – should be reverent in the presence of nature. 'You all think with some horror of this man, beating the bird to death.' This was then turned into one of those feline Ruskinian jokes which made a point against his audience: 'Have English gentlemen, as a class, any other real object in their whole existence than killing birds? If they discern a duty, they will indeed do it to the death. . . . their idea of their caste is that its life should be, distinctively from inferior human lives, spent in shooting. And that is not an idea of caste with which England, at this epoch, can any longer be governed.' Here, addressing his audience of largely upper-class male Oxford undergraduates, Ruskin sounded like Arnold in 1869: 'The graver self of the Barbarian likes honours and consideration; his more relaxed self, field-sports and pleasure.'[20]

Ruskin's thesis was that most things offered at Oxford in the name of education were no more than fodder for the pernicious menace of competitive examinations. To him, competitiveness was an extreme evil, and the education offered at Oxford fundamentally misconceived: 'Reading and writing are in no sense education, unless they contribute to [the] end of making us feel kindly towards all creatures', while 'drawing, and especially physiologic drawing, is vital education of the most precious kind'. Rather than exercising power in the House of Lords the English nobleman should go back to his land, to 'keep his estate lovely in its native wildness; and let every animal live upon it in peace that chose to come there'. The university itself should 'so far recognize what education means as to surround this university with the loveliest park in England, twenty miles square' and exclude from it 'every unclean, mechanical, and vulgar trade and manufacture, as any man would forbid them in his own garden'.[21]

The themes and opinions expressed here are closely related to the

1876 'Appendix', 'Notes on the Present State of Engraving in England'. He took illustration (his immediate examples were woodcuts for *Barnaby Rudge* and the *Cornhill Magazine*) as evidence of steeply declining standards of taste and discrimination. His method of addressing these declining standards was direct, violent and provocative: the audience for such illustrations is a

> bestial English mob, – railroad born and bred, which drags itself about the black world it has withered under its breath, in one eternal grind and shriek, – gobbling, – staring, – chattering, – giggling, – trampling out every vestige of national honour and domestic peace, wherever it sets the staggering hoof of it; incapable of reading, of hearing, of thinking, of looking, – capable only of greed for money, lust for food, pride of dress, and the prurient itch of momentary curiosity for the politics last announced by the newsmonger.[22]

Ruskin turned savagely on his audience and on the university that had appointed him to address them:

> Under these conditions . . . no professorship, nor school, of art can be of the least use to the general public. No race can understand a visionary landscape, which blasts its real mountains into ruin, and blackens its river-beds with foam of poison. . . . For my own part, I have no purpose, in what remains to me of opportunity, either at Oxford or elsewhere, to address any farther course of instruction towards the development of existing schools.[23]

Notoriously, Michelangelo's work was the target of strikingly intemperate remarks in Ruskin's lectures. In the great frescoes of the Sistine Chapel, Ruskin said, Michelangelo was showing off his virtuosity, concerned not with his subjects but with 'his own powers of drawing limbs and trunks. . . . He flings the naked bodies about his ceiling with an upholsterer's ingenuity of appliance to the corners they could fit, but with total absence of any legible meaning.'[24]

To some extent this was a return to the violent and drastically simplified hostility to the Renaissance expressed in *The Stones of Venice*. In a furious temper and in a state of manic excitement, Ruskin wrote of Pollaiuolo (1876) that he was 'a man of immense power, but on whom the curse of the Italian mind in this age was set at its deepest', and he added: 'See the horrible picture of St. Sebastian by him in our own National Gallery.' This painting, *The Martyrdom of St Sebastian*, is attributed to Antonio del Pollaiuolo (*c.* 1432–98) and his brother Piero (*c.* 1441–96). Its scientific approach to reality, with precise

Margaret Ruskin.

'My mother had, as she afterwards told me, solemnly "devoted me to God" before I was born; in imitation of Hannah.'

John James Ruskin.

'A father who would have sacrificed his life for his son, and yet forced his son to sacrifice his life to him, and sacrifice it in vain.'

Ruskin's drawing of his rooms in Christ Church.

'I found myself the next day at evening, alone, by the fireside, entered into command of my own life, in my own college room in Peckwater.'

Ruskin's copy of the central part of Tintoretto's *Crucifixion*.

'I have had a draught of pictures today enough to drown me. I never was so utterly crushed to earth before any human intellect as I was today, before Tintoret.'

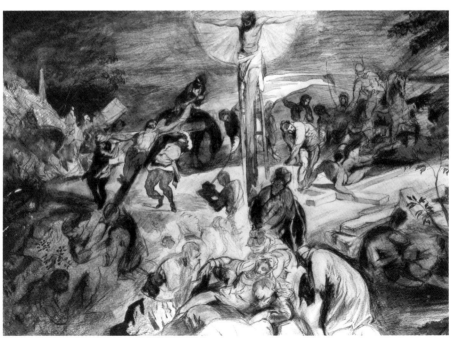

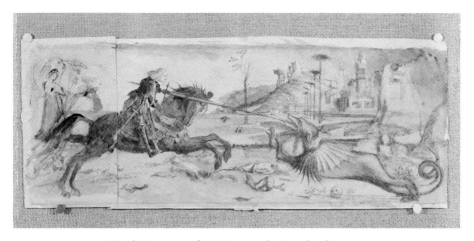

Ruskin's copy of *St George slaying the dragon.*

Carpaccio's painting gave Ruskin the symbolic figure under whose banner he created the Guild of St George.

Ruskin's copy of a detail of *The Dream of St Ursula.*

The figure of St Ursula from Carpaccio's wonderful painting merged in Ruskin's troubled mind with Rose la Touche, after the latter's death in 1875.

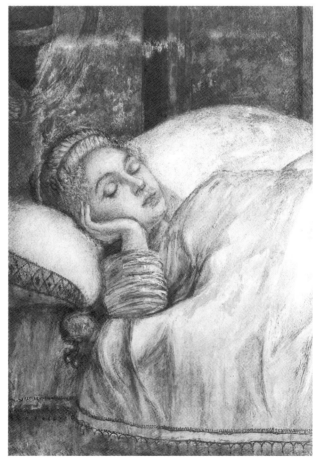

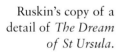

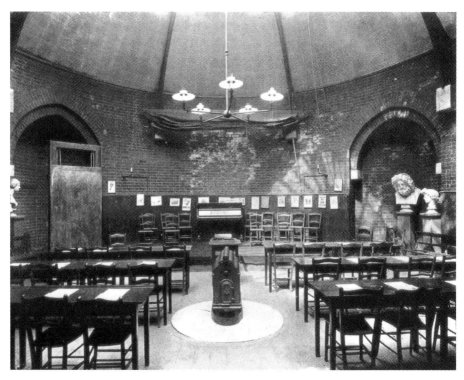

The Oval Room, Working Men's College, Great Ormond Street.

Ruskin started to teach drawing at the College in 1854, and also recruited his friend, Dante Gabriel Rossetti, as a teacher. *The Elements of Drawing* (1857) was based directly on Ruskin's practice as a teacher at the College.

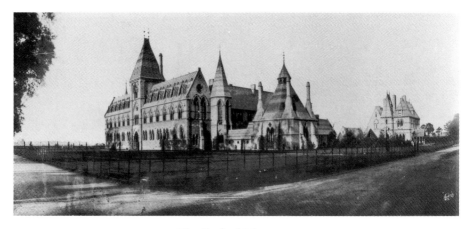

The Oxford Museum.

'An edifice within the precincts of the University for the better display of materials illustrative of the facts and laws of the natural world', the Museum was the example of 'Ruskinian Gothic' with which Ruskin himself was most closely associated.

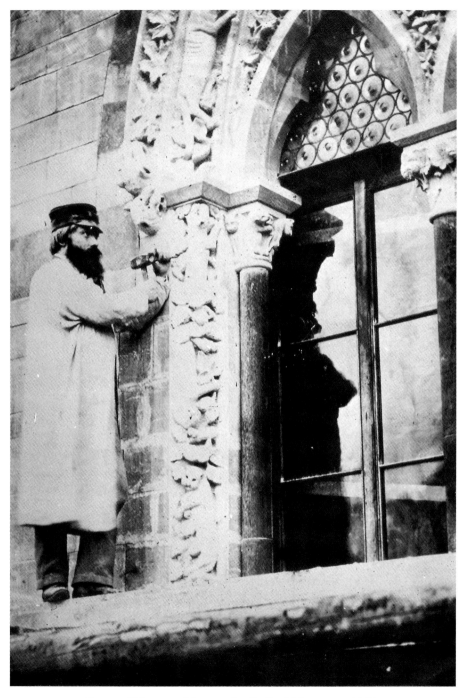

James O'Shea working on the Oxford Museum, c1857.

He said: 'I have never carved anything in my life that I will be so proud of ...
I would carve every jamb for nothing for the sake of art alone.'

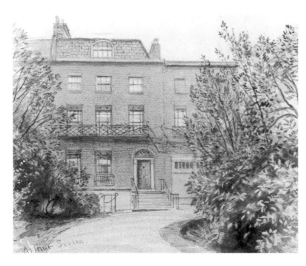

28 Herne Hill.

The Ruskins' family home from 1825 until 1842. Later, Ruskin kept the house on as a home for his cousin Joan Severn and her husband and family, retaining the old nursery for his own use as a London base.

163 Denmark Hill.

The very substantial house taken on a 36-year lease by Ruskin's father in 1842; this was to be Ruskin's permanent home until after his mother's death in 1871.

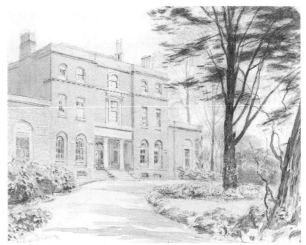

Brantwood, which Ruskin bought sight unseen in 1871.

'Here I have rocks, streams, fresh air, and for the first time in my life, the rest of the proposed <u>home</u>.' He died there in 1900.

Ruskin with Dante Gabriel Rossetti and William Bell Scott.

Ruskin disliked this photograph and called it a 'visible libel'. Rossetti, with his wife Elizabeth Siddal (who killed herself in 1862), had been Ruskin's beloved protégé in the 1850s, but the relationship had cooled. William Bell Scott had never got on with Ruskin; he resented Ruskin's power, while Ruskin was unable to admire Scott's work.

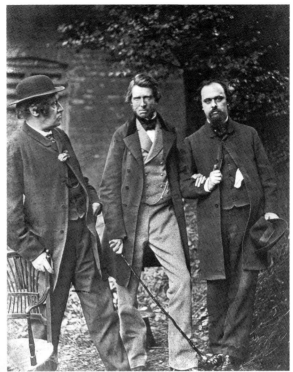

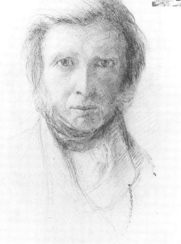

Probably one of the self-portraits made for Charles Eliot Norton. Ruskin was about 54. He wrote to Norton: 'All that is good in me depends on terrible subtleties, which I find will require my very best care and power of completion.'

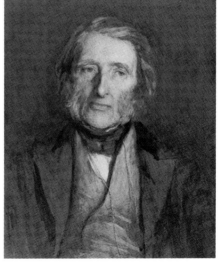

Ruskin at 60, the year after his first major breakdown.

W.B. Richmond, his successor as Slade Professor, wrote that his face had 'the beauty of mad sanity ... There is a sense of strife, inward and outward, revealed, and a dreamland yet unexplored.'

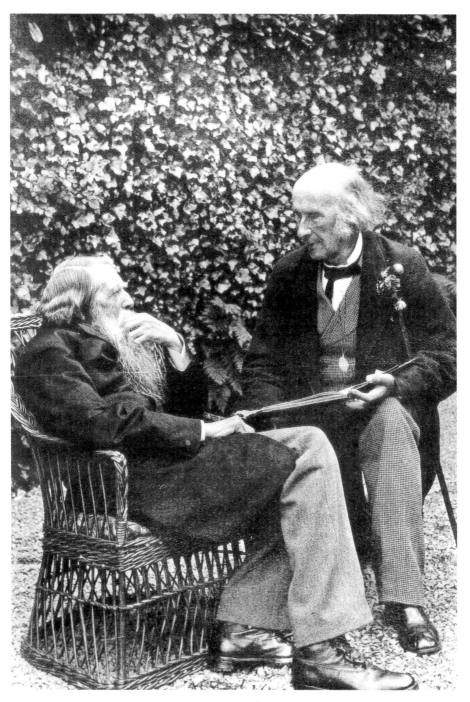

Ruskin and Henry Acland, in 1893.

Ruskin was still fond of games, and on this occasion he and Acland
played cards, but 'the two sages talked the whole time <u>de omni scibili</u>, and
showed one another their hands for purposes of comparison.'

definition of the straining muscles of the archers, and botanical treat-
ment of the landscape setting, anticipates that of Leonardo and
Michelangelo. Ruskin was enraged by this, as he was by the similar
technical virtuosity of Mantegna's painting of *The Dead Christ* (in the
Brera Gallery, Milan). In this painting Andrea Mantegna (d. 1506) dis-
plays a scientific interest in anatomy and perspective, with a consequent
extraordinary foreshortening of the figure. The painting provoked
Ruskin to write:

> The definite sign of such insanity is delight in witnessing pain, usually
> accompanied by an instinct that gloats over or plays with physical
> uncleanness or disease, and always by a morbid egotism. It is not to be
> recognized for demoniacal power so much by its *viciousness*, as its
> *paltriness*, – the taking pleasure in minute, contemptible, and loathsome
> things. [Mantegna's dead Christ is] only an anatomical study of a vulgar
> and ghastly dead body, with the soles of the feet set straight at the
> spectator, and the rest foreshortened . . . it is exactly characteristic of the
> madness in which all of them – Pollajuolo, Castagno, Mantegna,
> Leonardo da Vinci, and Michael Angelo, polluted their work with the
> science of the sepulchre, and degraded it with presumptuous and paltry
> technical skill. Foreshorten your Christ, and paint Him, if you can, half
> putrified, – that is the scientific art of the Renaissance.[25]

Why is Ruskin so angry? And what do 'insanity' and 'demoniacal
power' mean in this context? In 1845 he had been so excited by the
physical strength and energy of the figures in Tintoretto's paintings that
he decisively changed direction in *Modern Painters*. And Tintoretto
had taken as his examples the drawing of Michelangelo and the colour
of Titian. But here, in the 1870s, Ruskin seems to turn his back on all
that. It is as though the virtuosity that had formerly pleased him now
over-excited him, and he needed images of calm, tranquillity and piety
– bullfinches' nests and ordered dancing angels.

*

Ruskin's friendship with Thomas Carlyle had endured through his
transformation from critic of art and architecture into writer on
political issues and advocate of a new kind of society. When they had
first met, both men were married, and Carlyle was publishing the
extraordinary *Latter-Day Pamphlets* (1850), which articulated a form
of 'Toryism' with which Ruskin found it easy to sympathise. In a sense
they seem ill-matched friends: Carlyle, the brilliant son of working-

class Scottish parents, had walked ninety miles or so from Ecclefechan, his birthplace, to Edinburgh to seek a university education, and had made his way in literary London by sheer force of will, while Ruskin of course had never had to struggle for financial security. Yet they also had much in common. Ruskin, too, was a Scot, although a displaced one, who never felt wholly secure in the role of English gentleman purchased for him by his father. Both men believed themselves peculiarly destined to act as guides and teachers to their age. Ruskin hugely admired Carlyle's writings and learnt from them the rhetorical energy, not to say bombast, that characterised some of his own work. The influence was not always beneficial. But when Ruskin began to defy his father – by writing about politics rather than about art – Carlyle backed him up. Indeed sometimes Ruskin felt that Carlyle was the only sympathetic reader that he had in the world. And as the two men became closer he adopted Carlyle as a father-surrogate, an older male friend whose loyalty was unquestioning and unqualified, and to whom he could confide everything. As with Acland and Norton, being friends with Carlyle became a matter of important reassurance and support for Ruskin.

The friendship was often characterised by competitiveness, the two great writers seeking to outdo each other in the mountainous scale of their undertakings. Carlyle wrote from Chelsea about his struggle with his biography of Frederick the Great: 'My Prussian affairs are as bad almost as *Balaklava*,* and indeed resemble that notable Enterprise of the Turk War in several respects, – in this especially, that *I* had no business at all to concern myself in such an adventure, with such associates.'[26] In October 1855 Ruskin described the huge number of topics on which he had had to become expert in a short time in order to write *Modern Painters*, III and IV: 'On German Metaphysics, on Poetry, Political Economy, Cookery, Music, Geology, Dress, Agriculture, Horticulture, and Navigation, all of which subjects I have had to "read up".' Clearly excited by his own autodidactic energy and in a way naively pleased with the spectacle of it, he wrote that he was dissatisfied with the methods of botanical classification used by Linnaeus and others and so had developed his own, and that his studies of political economy had induced him to think also 'that nobody knows anything about that', so he was engaged in an independent study of 'money, rent and taxes',

*'The Charge of the Light Brigade' had taken place at Balaclava on 25 October 1854 (seven months before this letter was written).

and that he needed as well to study German metaphysics, navigation, and geology from first principles.[27] Carlyle expressed gratifying admiration: 'You are a happy swift man; I here, slower than the snail or the boring worm and less human, am very unhappy; buried in endless Giant-Mountains of Prussian Pedantry.'[28] And when he sensed Ruskin courting controversy, as in *Modern Painters, IV*, Carlyle gave him sturdy support: 'I can well understand how a comfortable R.A. reading these Books of yours, may be driven to exclaim, "I, stiff old stager, cannot *alter* according to this Ruskin's precepts: I must either blow my brains out, or convince myself that *he* is wrong!"'[29]

Carlyle's support became particularly valuable when Ruskin began publishing *Unto this Last*. 'You go down thro' those unfortunate Dismal-Science people' (Carlyle's phrase for political economists) 'like a Treble-x of Senna, Glauber and Aloes [purgatives]; like a fit of British Cholera, – threatening to be fatal!' In this important letter Carlyle recognised and acclaimed a complete change of direction in Ruskin's work:

> I have read your Paper with exhilaration, exultation, often with laughter, with 'Bravissimo!' – such a thing flung suddenly into half a million dull British heads on the same day, will do a great deal of good.
>
> I marvel, in parts, at the Lynx-eyed sharpness of yr logic, at the *pincer-grip* (red hot pincers) you take of certain bloated cheeks and blown-up bellies: – more power to yr elbow (tho' it is cruel in the extreme)! If you chose to stand to that kind of work for the next 7 years, and work out there a result like what you have done in painting: yes, there were a 'something to do,' – not easily measurable in importance to these sunk ages. Meantime my joy is great to find myself henceforth in a minority of *two* at any rate! –
>
> The Dismal-Science people will object that their Science expressly *abstracts* itself from moralities, from &c &c: but what you say, and show, is incontrovertibly true, that no 'Science' worthy of men (and not worthier of dogs or of devils) has a right to call itself 'Political Economy,' or can exist at all except mainly as a fetid nuisance and public poison, on *other* terms than those you now shadow out to it for the first time.

Carlyle closes by saying that he wants Ruskin's medicine for society to be less philanthropic; more authority, more judgement, more leadership of the kind advocated in Carlyle's own *Heroes and Hero-Worship* and in the *Latter-Day Pamphlets*.[30] 'A minority of two': it was immensely flattering and reassuring to Ruskin to know that he and Carlyle stood shoulder to shoulder against the world, and the great blazing heat and energy of this unqualified friendship can be felt urging

Ruskin on. In a sense the friendship was – among other things – a *folie à deux*. There was a direct practical consequence also. Carlyle wrote to his friend (and subsequently his biographer) J.A. Froude, editor of *Fraser's Magazine*: 'Ruskin, I have got to understand, is at last beginning upon his Political Economy. I think, if you were to send him a word or two of incitation, you might actually get a Paper out of him for yr next No, – which would be a beautiful thing to begin the Summer with!'[31] Hence the publication from June 1862 in *Fraser's* of the essays later collected as *Munera Pulveris*. Carlyle praised Ruskin's 'felicity of utterance' and called the work 'as true as gospel'.[32] (Ruskin reciprocated by expressing warm admiration for Carlyle's thunderous essay 'Jesuitism' in his *Latter-Day Pamphlets*.) Of one of the least admired and least read (in its day)* of Ruskin's books, *The Ethics of the Dust*, Carlyle wrote: 'Not for a long while have I read anything tenth-part so radiant with talent, ingenuity, lambent fire. . . . Never was such a lecture on *Crystallography* before.'[33]

The relationship was not always untroubled. There was an extremely awkward quarrel between the two friends in June 1867. In *Time and Tide*, to make a point about the deterioration of society in modern cities, Ruskin had reported that Carlyle had said in conversation with him, that because he was 'a grey, old man; and also because he is cleanly dressed', he was unable to walk in the streets of Chelsea without being insulted. Carlyle furiously denied having said any such thing. In any event a private conversation had been given a public airing.[34]

Still, by 1871 the relationship had become familial: Ruskin wrote immediately to Carlyle when Margaret Ruskin died on 6 December and in an idiom that would certainly have struck a chord with Ruskin Carlyle replied: 'The Wearied one has gone to her welcome Rest; and to you there is a strange regretful, mournful desolation in looking before and back; – to all of us the loss of our Mother is a new epoch in our Life-pilgrimage.'[35] This was literally true, and in 1873 Ruskin adopted Carlyle as his parent, referring to himself as 'ever your loving disciple – son – I have almost now a right to say'. From December 1873 he addressed the older man as 'Dear Papa' or 'Dearest Papa'.[36]

Carlyle's boisterous political opinions had always attracted Ruskin. They were 'conservative', homely, outrageous, funny and at times full, as it seemed to Ruskin, of profound good sense. This cry chimed precisely with Ruskin's views of society:

*This book has attracted a good deal of positive critical interest in recent Ruskin studies.

Education, kingship, command, – where is it, whither has it fled? Woe a thousand times, that this, which is the task of all kings, captains, priests, public speakers, land-owners, book-writers, mill-owners, and persons possessing or pretending to possess authority among mankind, – is left neglected among them all; and instead of it so little done but protocolling, black-or-white surplicing, partridge-shooting, parliamentary eloquence and popular twaddle-literature; with such results as we see![37]

In his lecture on 'The Future of England' (1869) Ruskin made much the same point about the relationship between the responsibilities of leaders (young officers were the immediate audience of this lecture) and education. Addressing them as 'Knights', he said:

The people are crying to you for command, and you stand there at pause, and silent. You think they don't want to be commanded; try them; determine what is needful for them – honourable for them; show it them, promise to bring them to it, and they will follow you through fire. 'Govern us,' they cry with one heart, though many minds. They *can* be governed still, these English; they are men still; not gnats, nor serpents. They love their old ways yet, and their old masters, and their old land. . . . You alone [the officer class, and by extension the whole of the governing class] can feed them, and clothe, and bring into their right minds, for you only can govern – that is to say, you only can educate them. Educate, or govern, they are one and the same word. Education does not mean teaching people to know what they do not know. It means teaching them to behave as they do not behave. . . . You are to spend on National Education, and to be spent for it, and to make by it, not more money, but better men; – to get into this British Island the greatest possible number of good and brave Englishmen.[38]

In addition to an England populated by well-educated kindly friends, the lecture envisioned a kind of medieval world free of machinery. Ruskin was being noisily Luddite: the steamship to be abolished and all sea-traffic to return to sail; agricultural steam engines to be replaced by yeomen working with animals or hand-tools. 'By hand-labour . . . and that alone, we are to till the ground. By hand-labour also to plough the sea; both for food, and in commerce, and in war: not with floating kettles [i.e. shipping to be driven by sail, not steam].'[39] It is ecologically and socially virtuous. Manufacture was to take place abroad – Ruskin seemed to imagine British overseas expansion as infinite. The possibilities of empire had been under-exploited: 'Are her dominions in the world so narrow that she can find no place to spin cotton in but Yorkshire?' England was to be beautiful, a land 'full of every kind of lovely natural organism, in tree, herb, and living creatures'. With the

right balance of working population between the mother country and the empire, 'You may make England itself the centre of the learning, of the arts, of the courtesies and felicities of the world. You may cover her mountains with pasture; her plains with corn, her valleys with the lily, and her gardens with the rose.'[40]

Not all of these attitudes can be blamed on Carlyle. But the faith in work owed much to Carlyle's *Past and Present* (1843) and to the common Protestant inheritance shared by the two friends. Carlyle there saw work as sacred, noble and blessed, a source of virtue and sanity: 'Blessed is he who has found his work; let him ask no other blessedness.' 'Labour is Life.'[41]

Carlyle's example egged Ruskin on; the older man's boldness and fearlessness gave him a sense of a warm, strong, forthright personality always aiding and abetting him: the older brother he had never had, as well as a replacement for his dead father. And he shared with Carlyle his periods of despair:

> I have not the least pleasure in my work any more, except because you and Froude and one or two other friends still care for it. One might as well talk to the March dust as to the English of today – young or old; nor can they help it, poor things – any more than the dust can . . . What pleasant things I have, seem to me only a kind of museum of which I have now merely to arrange the bequest. – while, so long as I *do* keep at work at all, the forms of it are too many and too heavy for my digestion (Literal) – & therefore only increase, instead of relieving despondency.[42]

Carlyle recognised that he and Ruskin lived in a shared ideological loneliness: 'I hear at the present time, no other Voice like him in this dreary Mother of dead dogs which is still commonly called a world', he wrote to Norton.[43] His letters to Ruskin constantly endorsed the work Ruskin was doing even when to all his other friends it seemed eccentric and aberrant.

In 1874 Ruskin resumed with Carlyle his practice of earlier years with his father, the writing of a daily letter which formed a kind of diary of his travels. But on 20 June Carlyle complained that Ruskin had not kept up his 'excellent scheme' of writing daily 'a detached bit of thought, observation, or experience'.[44] Ruskin's explanation, that he had not wanted Carlyle to come home to 'an unreadable mass of dead letters' after a journey away, was only half the truth. Ruskin was in a very troubled state of mind early in 1874 and his travels were partly to put space between himself and the source of his anguish.

In Italy Ruskin found himself increasingly drawn to the Roman Catholic Church, in spite of all his earlier opinions. On 21 May he wrote to Carlyle from Rome that he was 'greatly exercised in mind' by the monks. The consolation they gained from their religion felt like a rebuke to him: the rough monks led 'wretched lives. What do they gain by hypocrisy? My life is one of swollen luxury and selfishness compared with theirs; and yet it seems to me that I see what is right and *they* don't. How is it – how *can* it be?'[45] A service sung by the nuns of the Trinità de' Monte in Rome was intensely consoling and pleasing to him:

> Women's voices only, but very highly trained, yet remaining entirely modest and quiet, strong in effortless execution and perfectly right doing of the duty of sweet voices which charm may justly belong to the externals of such things – what allowable picturesqueness and romance of association, in the true remnant of a piece of old religion.[46]

As the summer advanced, so Ruskin became more and more monklike in his own life. June found him living in the sacristan's cell at Assisi. He asked Carlyle whether there wasn't a deep sympathy in Carlyle's mind for the religion of two men from his books, Abbot Samson of Bury St Edmunds (from *Past and Present*) and St Adalbert (from *Frederick the Great*). He added: 'To me, the question of their faith is a fearful mystery, but one which I am sure is to be solved; – I mean that we shall either live up to Christianity, or refuse it.' As June turned into July the heat intensified and Ruskin, in the sacristan's cell, felt he was in a 'cave', the one cool place in St Francis's church. There is much sympathy for Catholicism here, a sense of peace and retreat in this beautiful place; though the peace was only transitory, for on 8 July Ruskin wrote to Carlyle that he was leaving Assisi for Perugia, driven out by 'the noise at night' – the sound of cicadas, heard everywhere in Italy on summer nights – 'and beggars in the day'. The latter were Ruskin's own fault – when he showed charity to one or two beggars all the others in Assisi came at him 'like wasps at a rotten nectarine'.[47] He told Carlyle: 'The thirsty, lazy, hungry, miserable and totally uncared for population is coming upon me like a swarm of rats.'

> 'Kick them away,' says the practical Englishman – 'Haven't they wrecked themselves'? – 'Yes, of course they have. They had no pilot – no captain – no compass – and no port. They drifted here – and drank all the rum in the hold before they came ashore – you wise-acre – don't I know all that as well as you – but what's to be done now'?
> Meantime, the sense of the extreme and utterly hopeless misery of the

country almost unfits me for doing any work in it at all. While the cheerful English tourist goes dancing and coquetting about – and has been fifty years finding his pleasure and education in Italy – and never done it one pennyworth of good – How much *harm*, the devil only knows.[48]

From Perugia Ruskin wrote that he was glad to hear of Carlyle's pleasure in receiving the letters, 'putting you in the place of the poor Father, who used to be *so* thankful for his letter, and content with so little'. Carlyle was pleased by everything, even by Ruskin's wild display of bad temper over the gorgeous and luxurious room in which he found himself staying in Florence on 26 July. This room, full of gilt, mirrors, chandeliers, scarlet and gold furniture and fine carved marble, made Ruskin feel as though he were in Dante's Inferno.[49] Things got better in Lucca in August where he found picturesque 'Etruscan' piety among the peasants. He was kept in Lucca by 'unlooked-for difficulties in work, and *delights* in the neighbourhood. I underline that word, because I want you to be assured I don't write to you in mere *bilious* misery. I've plenty of that, and know it well. But I never allow it to alter my thoughts of things.'

> I was wretched in the Florence room, because I knew it to be English Nidification in Florence, and the Sum of English Influence there. And that it was pure Hell fire – in the midst of what I have here, every evening; – a country of Marble rocks – of purple hills, and skies of softest light – under which *still* dwell a people who labour, & pray. . . . I am at work here [in Lucca] on the statue carved in the olden times, 'Lady Gladness' (Ilaria) of Caretto – it lies on her tomb quite open – at the cathedral wall, as if she had been carried in, and laid there while they sang the burial service.[50]

Ruskin had loved this sculpture (executed by della Quercia in 1406) since he first saw it in 1845. As the relationship with Rose became sadder and deeper he tended to identify the figure of the young woman on the tomb with Rose.

There were always tensions between the two friends. Ruskin, for example, had taken the French side in the Franco-Prussian war of 1870 while Carlyle felt that German strength was always to be admired and applauded. Personal contact in London in November of 1874 renewed Carlyle's irritation. Carlyle wrote after a visit from Ruskin in Chelsea: 'I do not get much good of him . . . so high-flown is his strain of flattery, springing doubtless from the nervous nature of his being which is never to be got rid of in dialogue with him and spoils all practical communication'; and again: 'I have seen Ruskin, these three Saturdays in

punctual sequence at 2.00 p.m. . . . I get but little real insight out of him, though he is full of friendliness and is aiming as if at the very stars; but his sensitive, flighty nature disqualifies him for earnest conversation and frank communication of his secret thoughts.'[51] The problem, perhaps, was that Ruskin was *constructing* a surrogate father in Carlyle, not looking clearly at the increasingly frail and correspondingly opinionated man in front of him.

Fors Clavigera comprised ninety-six letters addressed to the 'Workmen and Labourers of Great Britain'; eighty-seven were published between January 1871 and February/March 1878, and a further nine followed between 1880 and 1884. Broadly, the objective was to challenge the capitalist economy to which the Victorians of the 1870s and 1880s owed their unprecedented and unrivalled prosperity. Ruskin thus struck at the foundations of the society within which he lived. The tone is consistently individual and idiosyncratic, often bitingly satirical, sometimes wildly angry. *Fors* has been characterised as Ruskin's *Hamlet*, jesting 'in pensive earnest with the skull of Yorick at the grave of Ophelia'.[52]

As well as throwing down a challenge to industrial and capitalist Britain, *Fors* offered an alternative. It proposed that the British workmen should organise themselves as a neo-medieval agrarian community, free of money or machines and united under a Master (Ruskin); this 'Company' became 'the Guild of St George'. Ruskin chose the title both because St George was patron saint of England and because of his great admiration for Carpaccio's paintings of St George at the Scuola di Schiavoni in Venice. Carpaccio's St George became for Ruskin the ideal man, a model of valour and chivalry. The intention was that the guild would acquire land and endowments from the gifts of philanthropic and wealthy 'Companions'. There were to be three classes of Companion, the Companion Servant and the Companion Militant (who worked at Guild duties or on Guild land as ordained by the Master) and the Companion Consular, who contributed a tithe to the Guild, but remained in his own profession or occupation. Had it grown as Ruskin hoped, the Guild of St George would have become a self-governing community, living on British soil but dissociated from British capitalism; an embodiment of the doctrine that 'there is no wealth but life'.

Carlyle called Letter 5 in *Fors Clavigera* 'a quasi-sacred consolation to me, which almost brings tears to my eyes! Every word of it is as if

spoken, not out of my poor heart only, but out of the eternal skies; words winged with Empyrean wisdom, piercing as lightning.'[53] It was here that Ruskin was writing in scathing dismissal of the sciences: of Darwin's discovery that 'there is no such thing as a Man, but only a transitional form of Ascidians and apes', of the recently developed ability to send telegraph messages from Bombay to London (the first message was sent on 7 April 1870), and of the 'Railroad Enterprise' which had put an iron network on the landscape of England:

> There was a rocky valley between Buxton and Bakewell, once upon a time, divine as the Vale of Tempe; you might have seen the Gods there morning and evening – Apollo and all the sweet Muses of the light – walking in fair procession on the lawns of it, and to and fro among the pinnacles of its crags. You cared neither for Gods nor grass, but for cash (which you did not know the way to get); you thought you could get it by what the *Times* calls 'Railroad Enterprise.' You Enterprised a Railroad through the valley – you blasted its rocks away, heaped thousands of tons of shale into its lovely stream. The valley is gone, and the Gods with it; and now, every fool in Buxton can be at Bakewell in half-an-hour, and every fool in Bakewell at Buxton; which you think a lucrative process of exchange – you Fools Everywhere.[54]

In this letter Ruskin linked his newly framed objections to science with his long-held favourite text from Wordsworth's *Excursion* (Book 4):

> There are three Material things, not only useful, but essential to Life. No one 'knows how to live' till he has got them. These are, Pure Air, Water, and Earth.
>
> There are three Immaterial things, not only useful, but essential to Life. No one knows how to live till he has got them.
>
> These are, Admiration, Hope, and Love.

These were what Political Economy should be delivering for man. He then gave a comic account of what it had in fact delivered. He started with the effects of industrialisation on the air:

> You can vitiate the air by your manner of life, and of death, to any extent. You might easily vitiate it so as to bring such a pestilence on the globe as would end all of you. You, or your fellows, German and French, are at present busy in vitiating it to the best of your power in every direction; chiefly at this moment with corpses [in the Franco-Prussian war], and animal and vegetable ruin in war: changing men, horses, and garden-stuff into noxious gas. But everywhere, and all day long, you are vitiating it with foul chemical exhalations; and the horrible nests, which you call

towns, are little more than laboratories for the distillation into heaven of venomous smokes and smells.[55]

The good society had been outlined in his books about the beautiful city, Venice. Here he took on, with fiery energy and contempt, the concept of the 'city' as created by and understood by high Victorian capitalism. The sharpest of the 'contrasts' in Ruskin's mind was that between the beautiful and the ugly cities.

Volume II of *Fors* developed further his ideas about the just and well-balanced society by way of the French writer Jean-François Marmontel (1723–99). Described by Ruskin as a 'peasant', Marmontel was a tailor's son who was befriended by Voltaire. He was the author of the hugely successful *Contes Moraux* (1755–65), which made '*la philosophie*' and the practice of virtue attractive. His early life, with its comfortable rural sufficiency, was taken by Ruskin as an example to the modern world of 'real' childhood recounted in clear and unadorned prose. He translated a passage from Marmontel's memoirs of childhood as follows:

> The harvest of our little farm assured our subsistence. . . . By the fireside, in the evening, while we heard the pot boiling with sweet chestnuts in it, our grandmother would roast a quince under the ashes and divide it among us children. The most sober of women made us all gourmands. Thus, in a household, where nothing was ever lost, very little expense supplied all our further wants; the dead wood of the neighbouring forests was in abundance, the fresh mountain butter and most delicate cheese cost little; even wine was not dear, and my father used it soberly.

Ruskin remarked that this is a model to autobiographers. 'Nothing is said pithily, to show the author's power, diffusely, to show his observation, nor quaintly, to show his fancy. He is not thinking of himself as an author at all; but of himself as a boy. He is not remembering his native valley as a subject for fine writing, but as a beloved real place, about which he may be garrulous, perhaps, but not rhetorical.' The reader may ask whether this is in truth a 'real' place. Ruskin's reply is: 'Yes, real in the severest sense; with realities that are to last for ever, when this London and Manchester life of yours shall have become a horrible, and, but on evidence, incredible, romance of the past.' The landscape of this childhood is preserved in memory: 'Real, but only partially seen; still more partially told. The rightnesses only perceived; the felicities only remembered; the landscape seen as if spring lasted always; the trees in blossom or fruitage evermore: no shedding of leaf: of winter, nothing remembered but its fireside.'[56]

Carlyle was right about the underlying unhappiness that drove *Fors*; he said that 'despair on the personal question' (the obsession with Rose La Touche) made Ruskin 'go ahead all the more with fire and sword upon the universal one'. The distinction between his elite audience in Oxford and the working-class people he longed to help via *Fors* led to increasing intensity and vividness of expression. Ruskin described entering the University galleries in Oxford to give a lecture, and encountering a little girl whipping a top – she was wearing an adult's cast-off shoes:

> There were some worthy people at my lecture, and I think the lecture was one of my best. It gave some really trustworthy information about art in Florence six hundred years ago. But all the time I was speaking, I knew that nothing spoken about art, either by myself or other people, could be of the least use to anybody there. For their primary business, and mine, was with art in Oxford, now; not with art in Florence, then; and art in Oxford now was absolutely dependent on our power of solving the question – which I knew that my audience would not even allow to be proposed for solution – 'Why have our little girls large shoes?'[57]

Often he despaired of his whole enterprise. He felt 'entirely unattended to, as he grew old, by his early friends' and he was unable to convert his audience: 'I did not quite know the sort of creature I had to deal with, when I began, fifteen years ago' (that is, when he turned to politics with *Unto this Last* in 1860). This reflection led to one of his many useful retrospects, in this case his attempt to sum up the purpose of the letters in *Fors*:

> I have not hitherto stated, except in general terms, the design to which these letters point, though it has been again and again defined, and it seems to me explicitly enough – the highest possible education, namely, of English men and women living by agriculture in their native land. Indeed, during these three past years I have not hoped to do more than make my readers feel what mischiefs they have to conquer. It is time now to say more clearly what I want them to do.

His objective was to acquire land for the Guild of St George and install tenants on it. Tenants who behaved well would be able eventually 'to purchase the piece of land they live on for themselves, if they can save the price of it'. They must be 'cheerful and honest ones, accustomed to obey orders, and live in the fear of God. Whether the fear be Catholic, or Church-of-England, or Presbyterian, I do not in the least care, so that the family be capable of any kind of sincere devotion; and conscious of the sacredness of order.'[58] He had thought in detail about

the evil aspects of the modern world which the guild was to challenge, and about the way in which the new society should be designed. All of it owed much to More's *Utopia*:

> In our present state of utter moral disorganization, it might indeed seem as if it would be impossible either to secure obedience, or explain the sensation of honour; but the instincts of both are native in man, and the roots of them cannot wither, even under the dust-heap of modern liberal opinions. My settlers, you observe, are to be young people, bred on old estates; my commandants will be veteran soldiers; and it will be soon perceived that pride based on servitude to the will of another is far loftier and happier than pride based on servitude to humour of one's own. . . . No machines moved by artificial power are to be used on the estates of the society; wind, water, and animal force are to be the only motive powers employed, and there is to be as little trade or importation as possible; the utmost simplicity of life, and restriction of possession, being combined with the highest attainable refinement of temper and thought. . . . The laws required to be obeyed by the families living on the land will be – with some relaxation and modification, so as to fit them for English people – those of Florence in the fourteenth century. In what additional rules may be adopted, I shall follow, for the most part, Bacon, or Sir Thomas More.[59]

Fors is autobiography as well as polemic. As his miserable obsession with Rose La Touche continued, the autobiography was often embarrassingly exposed. Ruskin sounded like a man who had thrown off all restraint. This damaged personality no longer knew where the private stopped and the public began: 'I was very much beaten and overtired yesterday, chiefly owing to a week of black fog, spent in looking over a work of days and people long since dead' (he had been rereading *The Stones of Venice* and reproaching himself for spending so long in Venice in 1849–51 against his parents' will). Letter 40 (4 March 1874), written in his fifty-fifth year, was full of self-pity and recrimination: 'I have been horribly plagued and misguided by evangelical people, all my life; and most of all lately.' The evangelicals who had influenced Rose La Touche are prime villains here, but his mother and his Aunt Richardson were not going to get off: 'my mother was one, and my Scotch aunt; and I have yet so much of the superstition left in me, that I can't help sometimes doing as evangelical people wish, – for all I know it comes to nothing. . . . It is all one to me, now, whether I read my Bible, or my Homer, at one leaf or another.'[60]

Science came in for periodic knocking throughout *Fors Clavigera*.

The theory of evolution, and its implicit assault on the Bible, was an abomination to Ruskin all through this phase of his intellectual life, but in May 1874 he picked the great pioneering natural scientist Michael Faraday (1791–1867) as his enemy.

> I am a simpleton, am I, to quote such an exploded book as Genesis? . . . I know as many flaws in the book of Genesis as the best of you, but I knew the book before I knew its flaws, while you know the flaws, and never have known the book. . . . Even your simple country Queen of May, whom once you worshipped for a goddess – has not little Mr. Faraday analysed her, and proved her to consist of charcoal and water?[61]

The decline of modern England was like the decline of Renaissance Venice: 'That England deserves little care from any man nowadays, is fatally true; that in a century more she will be – where Venice is – among the dead of nations, is far more than probable.' The 'dead of nations' clearly prompted a further renewal of his troubled feelings about his own dead, especially his mother. In the same letter he carefully listed all the books of the Bible that his mother made him memorise as a child, and in a remarkable passage of intellectual self-analysis said that this early training was the foundation of his mind.

> This maternal installation of my mind in that property of chapters, I count very confidently the most precious, and, on the whole, the one essential part of my education. For the chapters became, indeed, strictly conclusive and productive to me in all modes of thought.[62]

Fors Clavigera dealt in truisms, he wrote, because it sought to speak the truth: 'I should be ashamed if there were anything in *Fors* which had not been said before.' He claimed: 'there is nothing in it, nor ever will be in it, but common truths, as clear to honest mankind as their daily sunrise, as necessary as their daily bread; and which the fools who deny can only live, themselves, because other men know and obey.'[63]

He summarised the themes of the whole of *Fors* as 'rent, capital, and interest, all to be attacked at once! and a method of education shown to be possible in virtue, as cheaply as in vice!' His abstract of the first seven letters was an example of his attempts to find order in the chaos of his own writing and make some sense of the seemingly random path that his mind had taken. Letter 7, for instance, was about 'true, and spurious, Communism. Explanation of the design of true Communism, in Sir Thomas More's Utopia. This letter, though treating of matters necessary to the whole work, yet introduces them prematurely, being written, incidentally, upon the ruin of Paris.' It is always refreshing to

the reader of *Fors* when Ruskin stops raging against his enemies and finds an example of a well-ordered society – Thomas More's *Utopia*, or the republican world of the round, jolly Tyrolese peasant – that he can praise. Another such example appears at the end of this letter in his praise of France, a country he had always loved: 'the Franks . . . they are so inherently free and noble in their natures, that their name becomes the word for the virtue; and when you now want to talk of freedom of heart, you say Frankness, and for the last political privilege which you have it so much in your English minds to get, you haven't so much as an English word, but must call it by the French one, "Franchise."'[64]

After 'four years of medicancy', Ruskin cried out with pain over the lack of response to the Guild of St George. The disappointment, he wrote, was endangering his sanity: 'it has been the result of very steady effort on my own part to keep myself, if it might be, out of Hanwell, or that other hospital which makes the name of Christ's native village dreadful in the ear of London [Bethlehem/Bedlam]'. The beginning of madness is 'an exaggerated sense of self-importance'. And why do all his schemes come to nothing? 'I am defeated only because I have too many things on hand.' He quoted an imagined interlocutor: 'Does it never occur to me . . . that I may be mad myself?' His reply was: 'Well, I am so alone now in my thoughts and ways, that if I am not mad, I should soon become so, from mere solitude, but for my *work*. . . . We are in hard times, now, for all men's wits; for men who know the truth are like to go mad from isolation.' He felt horribly isolated: those of us of 'the old race' feel different from the modern 'yelping, carnivorous crowd, mad for money and lust, tearing each other to pieces, and starving each other to death, and leaving heaps of their dung and ponds of their spittle on every palace floor and altar stone'.[65]

Undeterred by the lack of volunteers to be Companions of St George, Ruskin declared that he would accept only the very best:

It is only the Rich, and the Strong, whom I receive for Companions – those who come not to be ministered unto, but to minister. Rich, yet some of them in other kind of riches than the world's; strong, yet some in other than the world's strength. But this much at least of literal wealth and strength they *must* have – the power, and formed habit, of self-support. I accept no Companion by whom I am not convinced that the Society will be aided rather than burdened; and although I value intelligence, resolution, and personal strength, more than any other riches, I hope to

find, in a little while, that there are people in the world who can hold money without being blinded, by their possession of it, to justice or duty.[66]

At the same time, lest his list of requirements seem exclusive, he was delighted that some young unmarried women had already become Companions, bound 'to comply in all sweet and subjected ways with the wishes and habits of their parents; remaining calmly certain that the Law of God, for them, is that while they remain at home they shall be spirits of Peace and Humility beneath its roof'.

Although he referred to his uncles the baker and the tanner, and said he would not have changed his childhood visits to them for lords and ladies' 'days of childhood in castle halls', he continued: 'I do not mean this for a republican sentiment; quite the opposite. I hate republicans, as I do all other manner of fools. I love Lords and Ladies.'[67]

The Companions were required to engage in, and enjoy, manual labour: 'since we are now coming to particulars, addressing myself first to gentlemen, – Do you think you can make a brick, or a tile?'[68] The duty to work with one's own hands coexists with a solemn duty to the environment. The world in which we live is a wondrous place, and we all neglect and abuse it:

> The men and women of these days [are] careless of such issue; and content, so that they can feed and breathe their fill, to eat like cattle, and breathe like plants, questionless of the Spirit that makes the grass to grow for them on the mountains, or the breeze they breathe on them . . .
>
> When everybody steals, cheats, and goes to church, complacently, and the light of their whole body is darkness, how great is that darkness! And . . . the physical result of that mental vileness is a total carelessness of the beauty of sky, or the cleanness of streams, or the life of animals and flowers.[69]

Ruskin continued to worry away at the constitution of the Guild of St George. When he was in rhetorical flight, violently attacking his contemporary world and reordering it, Ruskin was on top form, but the many alternative models for the guild, as a practical organisation, sound like more and more desperate expediencies and improvisations.

Fors Clavigera contains some of the most important of Ruskin's political statements, some of the wildest of his expressions of hatred of the contemporary world, and also some of the most maundering and embarrassing of his meditations on little girls. At its best his work expressed the positives. A recurrent feature, often dealt with playfully, is the idea of the 'gentleman'. He did not regard himself as a 'gentle-

man'; he wanted 'gentlemen' to man the guild; he believed that the constitutions of medieval Venice and ancient Rome were managed by gentlemen; and he held that a gentleman should work with his hands: these things came together in an engaging anecdote. Visiting the 'Calcina' (the *pensione* in which Ruskin was staying on the Zattere), Count Zorzi, one of the most important of Ruskin's Venetian friends and a major ally in his attempts to conserve Venice, found him in the courtyard with a hatchet in his hand and cried: 'Oh, oh! what are you doing? Are you preparing to execute summary justice on the assassins of artistic Venice?' Ruskin answered: 'No, no, my dear friend. As you see, I am cutting wood', and assured him that wood-cutting was 'a kind of gymnastics very beneficial to health'.[70]

Addressing his 'workmen' on the subject of the 'gentleman', Ruskin wrote: 'You want to be a gentleman yourself, I suppose? Well, you can't be, as I have told you before, nor I neither; and there's an end.' All of us, though, can have the gentleman's 'bodily and moral training' which starts with 'close companionship with the horse, the dog and the eagle. Of all birthrights and bookrights – this is his first.' The judgements come down from a great height, and can be exasperating, but Ruskin's noble ideal of the gentleman does have a kind of rhetorical authority. And interestingly the gentleman is now free from, separate from, the constraints of Christianity that served as a straitjacket for so much of Ruskin's earlier writing about morality:

> [The gentleman] needn't be a Christian, – there have been millions of Pagan gentlemen; he needn't be kind – there have been millions of cruel gentlemen; he needn't be honest, – there have been millions of crafty gentlemen. He needn't know how to read, or to write his own name. But he *must* have horse, dog, and eagle for friends. . . . To be friends with the falcon must mean that you love to see it soar; that is to say, you love fresh air and the fields. Farther, when the Law of God is understood, you will like better to see the eagle free than the jessed hawk. And to preserve your eagles' nests, is to be a great nation. It means keeping everything that is noble; mountains and floods, and forests, and the glory and honour of them, and all the birds that haunt them. If the eagle takes more than his share, you may shoot him, – (but with the knight's arrow, not the blackguard's gun) – and not till then.[71]

With this amoral, heroic view of the gentleman goes an amoral view of man. The question of whether man is wicked or not is unimportant. If he is *mad* he should be executed. 'Understand that a mad dog is to be slain; though with pity – infinitude of pity, – (and much more, a mad

man, of an injurious kind; for a mad dog only bites flesh; but a mad man, spirit: get your rogue, the supremely maddest of men, with supreme pity always, but inexorably, hanged).'[72]

Ruskin was very disturbed by the lack of response to the Guild of St George. Specifically, he felt betrayed by two of his most valued friends, Mr Cowper-Temple and Sir Thomas Acland* (who had resigned as guild trustees because they disagreed with Ruskin's decision to purchase a farm at Totley, near Sheffield, for the guild), and his anger with them propelled him into an attempt to sum up his life and his work:

> I see it must be my own task, with such strength as may be granted me, to the end. For in rough approximation of date nearest to the completion of the several pieces of my past work, as they are built one on the other, – at twenty, I wrote *Modern Painters*; at thirty, *The Stones of Venice*; at forty, *Unto this Last*; at fifty, the Inaugural Oxford lectures; and – if *Fors Clavigera* is ever finished as I mean – it will mark the mind I had at sixty; and leave me in my seventh day of life, perhaps – to rest. For the code of all I had to teach will then be, in form, as it is at this hour, in substance, complete.[73]

This, of course, is too schematic, as Ruskin was aware. His perception of himself as a writer remained Romantic. 'If poetry comes not as naturally as the leaves to a tree it had better not come at all', Keats had written,[74] and Ruskin, too, saw his work as a natural and inevitable growth: 'This, then, is the message, which, knowing no more as I unfolded the scroll of it, what next would be written there, than a blade of grass knows what the form of its fruit shall be, I have been led on year by year to speak, even to this its end.'[75] He was a poet allowing his words their own natural form, and loyal to the Romantic conception of art by which a great composition is produced 'with the same heavenly involuntariness' as a bird building her nest.[76] But there was also the figure of the Old Testament prophet unfolding his teaching.

Like the Romantics, he wanted to restore the past. But thinking about the past forced him to recognise that the historical guilds had

*Sir Thomas Dyke Acland (1809–98), brother of Ruskin's close friend Henry Acland, was for many years a West Country MP. He was a landowner and agricultural reformer but also an intellectual; a graduate of Christ Church, Oxford, and a Fellow of All Souls. In the 1850s he established the Oxford local examining boards. In 1871 he succeeded his father as the eleventh baronet. In the same year Ruskin persuaded him to act as one of the Trustees (with William Cowper-Temple) of the Guild of St George.

failed. He believed their decay was chiefly caused by 'the conditions of selfishness and isolation which were more or less involved in their vow of fraternity, and their laws of apprenticeship'. Ruskin saw his guild as 'a Christian ship of the high seas' and he wanted to launch it in Sheffield because Sheffield men were 'capable of co-operation'. A guild crafts- man must make useful things and sell them 'at absolutely fixed prices, for ready money only'. Casting out selfishness would bring 'peace of heart'.[77] Yet the guild was floundering for lack of support.

If people would only pay attention, Ruskin seems to say, he could save the world. The central assertion of the whole of *Fors* had been that 'All social evils and religious errors arise out of the pillage of the labourer by the idler'.[78] We need to restore the ideal of the hero, he thundered: 'it is precisely in accepting death as the end of all, and in laying down, on that sorrowful condition, his life for his friends, that the hero and patriot of all time has become the glory and safety of his country'. The power and passion of this are astonishing. Ruskin was on the verge of insanity at this date, but these are the words of an enraged prophet, not of a madman. Businessmen are 'wolf-shepherds' who have caused their employees to 'now lie starving at the mouths of the hell- pits you made them dig'. There will be no money in the Ruskinian utopia: '"Give us each day – our daily *bread*," – observe – not our daily money. For, that wages may be constant, they must be in kind, not in money. So much bread, so much woollen cloth, or so much fuel, as the workman chooses.' Ruskin would coin his own currency: his own 'angel' to be 'our golden standard' in this economy.[79]

The way Ruskin was perceived in 1877 can be felt in W.H. Mallock's lively satire published that year, *The New Republic*. Among the major Victorian figures affectionately parodied in that book is the great 'Mr Herbert', whose beautiful voice and irresistible presence command an audience, but whose utterances are disconcertingly pessimistic. According to Mr Herbert, the whole human race

> is now wandering in an accursed wilderness, which not only shows us no hill-top whence the promised land may be seen, but which, to most of the wanderers, seems a promised land itself. And they have a God of their own too, who engages now to lead them out of it if they will only follow him: who, for visible token of his Godhead, leads them with a pillar of cloud by day, and a pillar of fire by night – the cloud being the black smoke of their factory chimneys, and the fire the red glare of their blast- furnaces.[80]

When Mr Herbert is asked to consider the marvellous technical

developments of his age, especially electric telegraphs, railways and steam printing-presses, he replies: 'I have considered them for the last thirty years – and with inexpressible melancholy.' Mallock was particularly accurate about Ruskin's sense of himself as an isolated voice in the modern world:

> That in most of my opinions and feelings I am singular, is a fact fraught for me with the most ominous significance. Yet, how could I – who think that health is more than wealth, and who hold it a more important thing to separate right from wrong than to identify men with monkeys – how could I hope to be anything but singular in a generation that deliberately, and with its eyes open, prefers a cotton-mill to a Titian?[81]

Mallock, a nephew of Ruskin's friend Froude, respected his subject and treated him with considerable restraint, but he had obviously been reading *Fors Clavigera* and following Ruskin's tirades and schemes with commendable insight. Although he drew a caricature, he did it effectively:

> The only hope for the present age lies in the possibility of some individual wiser than the rest getting the necessary power, and in the most arbitrary way possible putting a stop to this progress – utterly stamping out and obliterating every general tendency peculiar to our own time. . . . I would collect an army of strong, serviceable, honest workmen, and send them to blow up Manchester, and Birmingham, and Liverpool, and Leeds, and Wolverhampton . . . and I am at the present moment collecting money, from such as will here and there confide in me, for the purpose of purchasing land, and of founding a community upon what seem to me to be true and healthful principles – a Utopia, in fact – in which I trust may be once again realised upon earth those two things to which we are now such strangers – order and justice.[82]

In 1872 Ruskin worked on and moved into Brantwood, the house that he had bought (prior to his mother's death) the previous year. Moving out of the Denmark Hill house where his parents had lived so long and so comfortably was a wrench, when the time came, and contributed to his low moods. He wrote of 'Increasing despondency on me, as time for leaving draws near' (11 January), and on 28 March made a significant entry in the diary recording the actual move out of the house: '*Thursday*. Morning. DENMARK HILL. Last day. I write my morning date for the last time in my old study.' The following day he was in Oxford, in Corpus Christi College: 'In my college rooms, having finally left my own home.' Looking back, he found old diary entries of his

father's and felt guilty about the first foreign tours he had taken without him. To a diary entry saying 'To Dover, by myself' he now added: 'Woe is me, for him. And now, he cannot see me, nor know.' In the following year, 1873, Ruskin revisited this diary entry and added a further note: 'Poor papa: – It is I who am by myself, now, papa.' He gave his parents' former house in Herne Hill to Joan and Arthur Severn, keeping his 'Nursery' for his own occupancy when he was in London.[83]

In November 1874 he wrote a very personal *Fors* letter about the houses that he had lived in. The subtext was that Ruskin had always regretted the move from Herne Hill to Denmark Hill. He felt that his father's desire for the grander house on Denmark Hill demonstrated, in a nutshell, all that was wrong with the Victorians. '"I mean to make money, and have a better and better house, every ten years." Yes, I know you do. If you intend to keep that notion, I have no word more to say to you.' Ruskin felt that his lower-middle-class family should have been content with a lower-middle-class house:

> [The house that is 'fit' for you is] one that you can entirely enjoy and manage; but which you will not be proud of, except as you make it charming in its modesty. If you are proud of it, it is *un*fit for you. . . . My aunt's house at Croydon was fit for her; and my father's at Herne Hill, – in which I correct the press of this *Fors* sitting in what was once my nursery, – was exactly fit for him, and me. He left it for the larger one – Denmark Hill; and never had a quite happy day afterwards. . . . I was his pride, and he wanted to leave *me* in a better house, – a good father's cruellest, subtlest temptation.[84]

Ruskin had owned Brantwood for a year by the time he moved into it, in September 1872, with Arthur and Joan Severn. On 13 September of that year he headed his diary entry BRANTWOOD for the first time. As he had marked 7 September – the break with Rose – 'The Ending Day', so he marked the first day of his residence at Brantwood 'The beginning day'. There was a great deal of satisfaction and pleasure in the tone of the brief diary entries, a valuable balance to the intensity of the violent emotional life that he had been living in the south.[85]

The view from the windows of Brantwood compensated for any ugliness within. All the principal rooms faced west; below them the ground sloped steeply from the house to the lake shore. Beyond lay the whole of Coniston Water. Ruskin had a little octagonal turret added to the bedroom at the south-west corner of the house, with latticed windows from which he could look down the full length of the lake.

Though he left most of the arrangement of the house to Joan, Ruskin took great trouble with his study. A round table at which he would write was put in the bow window. The specially made paper covered the walls, but not much of it was to be seen by the time that his book cases, mineral cabinets designed by himself, and a secretaire with sliding cases for pictures had been brought into the room – still less when a large early Turner of the Lake of Geneva was placed over the fireplace, and the rest of the walls were closely hung with smaller Turner water-colours.[86]

Brantwood gave him stability, peace, a centre. He could never be happy about Rose, but in late 1872 his mood over this lost love turned gradually to resignation. He wrote to Mrs Cowper-Temple on 2 October: 'I shall never more come to Broadlands, – but you and William may have really happy times here, when you want Cottage life – absolute peace – and any kind of *Watery* refreshment.'* On 4 October he wrote about 13 August at Broadlands (his day with Rose) as a memory to be treasured for ever even though there was no hope of renewing it: 'The good that you may be sure you have done me remember, is in my having known, actually, for one whole day, the *perfect* joy of love. . . . And this after ten years of various pain – and thirst.' He recalled Rose's appearance vividly, as though she were a figure in a painting, and turned the whole day into (as it were) an intense encounter with a work of art; he will never see it again but he has at least *seen* it. 'Was'nt it a day, to have got for me? – all your getting. And clear gain – I am no worse now than I was, – a day or two more of torment and disappointment are as nothing in the continued darkness of my life. But that day is worth being born and living seventy years of pain for.'[87]

Ruskin showed signs of rallying at the end of the year. Although he had a dream of Rose, it seemed to put her among Gothic figures and may be taken as preparing him for the likelihood that she would die young – 'Dreamed that I had charge of a little girl, who was eating at the same table with the spirit of Wisdom and of Death, and they were both cold, and I was terrified lest she should touch them' (29 December) – and after recording it he sounds stronger. On the last day of 1872 he wrote: 'I on the whole victorious and ready for new work; and my possessions pleasant to me in my chosen, or appointed, home; and my hand finding its deed.'[88]

*He did, of course, return to Broadlands in subsequent years.

Despite the breach of September 1872 Mrs La Touche kept in touch with Ruskin and his menage, especially with Joan Agnew. And early in 1874, when Rose was seriously ill and her parents brought her to England from Harristown for medical treatment, Joan went to see her. Rose was still forbidden by her parents to make contact with Ruskin, but Joan was willing to send him messages from her (he was in Italy), and in September 1874 Rose initiated a renewal of the relationship. She wrote to Joan on 4 September 1874:

> I wonder what Some People* are about just now. Joanie do you think I shall ever see him again? I sometimes wonder if you and your Arthur have thought at the bottom of your hearts that we weren't meant to be so far apart – or not? I wonder if you and Mama had any talks when she was at Herne Hill and if they'd ever give *real* permission to my having just a bit of a letter from him now and again? I cannot help coming out with this. Somehow a blight seems to have got at the very stalk of my life and I shall never grow out of it. Do you think he has forgiven me for my behaviour two years ago? I sometimes feel I would give so much to know Arthur's opinion about it all. I believe his opinion on all matters small and great would be just.

Joan forwarded this letter to Ruskin, who was then in Florence. She wrote from Herne Hill (5 September 1874): 'the enclosed is brought to me, and I feel I must send it and A[rthur] thinks I'd better. His opinion is, that if you both love each other enough to marry, *you ought to*, and *she* ought to leave father and mother, and cleave to *you*!' Another letter from Rose was forwarded by Mrs Hilliard. Ruskin wrote to tell Joan that he had heard from Rose. He resorted to baby-talk to pledge his loyalty to Joan:

> Dear wee mamie, pease be sure of one thing – that even if I get wee Rosie, I shall always be the same to my Doanie. Time was, when I would not have said so – when R. would have been all in all to me. But the seven years of our Denmark Hill life become more and more sacred to me as time goes on. If Rosie ever comes to me I do not think she will complain of being too little loved; but she cannot remember with me the bedside in the little room [his mother's room]. And, since the little room has been empty, Doanie has been to me a mother and sister in one – wee Doanie-amie.[89]

The La Touches, desperate about Rose's health, were substantially changing their attitude to Ruskin. They encouraged him to correspond

*Code for Ruskin; Rose and Ruskin referred to each other, to friends, as 'Some People'.

with her again because his letters were good for her state of mind and therefore for her health, and as she became more ill so they went further. Joan Severn wrote to Ruskin: 'Neither Lacerta* nor the Master will oppose your seeing R. I believe as much as you like.' Mrs La Touche was planning for Rose to settle in London for her health and Ruskin was encouraged to visit her, although the La Touches still opposed any idea of marriage. Mrs La Touche, wrote Joan, 'wishes very much Rosie would go and stay with a very nice Dr. at Kensington and "some people [Ruskin] could see her there as much as some people and other people pleased" . . . but she does *so* oppose every definite plan'.[90]

So, late in 1874, the whole painful business was resumed. Ruskin showed signs of trying to protect himself from the emotional damage that Rose had done him in the past. On 31 October he wrote to Joan from Oxford saying that his contact with Rose, now staying in London, was only for Rose's benefit, not a renewal of his role as suitor. It seems likely though that he was writing what he thought Joan and the La Touches would want to hear:

> The child is fearfully ill – and what hope there is of recovering her to any strength of mind or body depends on there being more peace between her parents and me. If they refuse it, her fate – whatever it may be – will be their causing, not mine. . . . And if they will believe it – much as I love her (and though now I never will marry any other woman if she won't come to me) – still, unless she changes much, I most assuredly will not marry her. I must be sure she is fit to join my life without destroying its usefulness. . . . You may send this letter itself to them, if you will.

As Slade Professor, Ruskin was living some of the time in Corpus Christi. He regularly took trains up to London to have lunch or tea with Rose, and it pleased him at other times to know that she was visiting Herne Hill: 'Fancy Rosie reading up there in the old room, I am so thankful she's near you.'[91]

At the end of the year, though, Rose was taken by her parents back to Ireland. Ruskin knew that she was dying. He wrote to Joan Severn: 'I fear there is no hope of any help now, for poor Sweet-briar; – I have had much talk with her, & perceive her entire being to be under-mined.'[92] And he wrote angrily to Charles Eliot Norton saying that he had just had a desperate letter 'in pencil from poor Rose – praying me to deliver her from her father – (who has driven her mad and is shutting

*Mrs La Touche.

her up with a Doctor in Dublin.) – I am of course helpless.'[93]

Presumably Rose was anorexic – descriptions speak of her pathetic thinness, her inability to eat more than a few grains of rice in a day. Ruskin wrote of her: 'very nearly dying – the best in great danger – half mad and half starved – & eating nothing but everything she liked (chiefly sugar and almonds, I believe)'.[94] In January she was back in London in a further bid from her parents to find medical treatment that would work.

Ruskin's state of mind during these months was desperate. His diary entries are full of anguished references to ailments (most of them obviously psychosomatic) and to the weather: 'intense biliousness and blindness, caused, I presume, by eating too much cold tongue at breakfast on Saturday. Just before dinner, zigzag frameworks of iridescent light fluttered in my eyes, and I could not see even to read large print.' And: 'the day black as the Inferno – impossible to do anything', and: 'Black as – a damp hell – candles wanted at ¼ to nine.' He recorded a 'fortnight of darkness'.[95]

Some time in February, possibly on his birthday, the 8th, he saw Rose in London for the last time. As he recorded in a letter to Joan Severn many years later, 'The last solemn promise she made me make to her, lying in my arms, after that fit of torment, was that I would never let her stand between me and God.'

On 25 May Rose died. Her parents were unable to be with her; they heard of her death by telegram on the same day. Ruskin was not told until 28 May. 'Of course,' he wrote to Joan Severn, 'I have long been prepared for this – but it makes one giddy in the head at first.'[96]

Later he ritualised her death, associating it with a pleasant walk he took on 25 May among the hawthorn blossoms: 'I had that lovely sunny walk in the buttercup fields under the hawthorn hedge . . . the day she died', he wrote to Joan on 4 June, and in a letter to Carlyle we can see that the linking of Rose's death with hawthorn has become a kind of literary trope:

> I have had so little to say of myself, pleasing to a Papa's ear, that I neither wrote nor came when I was last in London – for the rest, the Academy work [his *Notes on the Royal Academy*] involved much weariness. I had just got it done, with other worldliness, and was away into the meadows to see buttercup and clover and bean blossom, when the news came that the little story of my wild Rose was ended, and the hawthorn blossoms, this year – would fall – over her.[97]

Ruskin did not escape from Rose after her death. His diary entries have much to say about poor health, poor eyesight, sleeplessness and terrible weather. And towards the end of the year he was visiting the Cowper-Temples once more at Broadlands. They made a suite of rooms available to him (from October) and allowed him to avoid their other guests. He had been sensitised to the idea that immortality might after all be a truth by his visit to Assisi, where he had handled the relics of St Francis and felt himself entering into communion with the dead saint.

Mrs Cowper-Temple had been interested in spiritualism since the death of one of her brothers had led her to experiment early in the 1860s. In December 1875 she had among her guests a Mrs Acworth,* a medium. Ruskin told Joan Severn in a letter that Mrs Acworth said she had seen a spirit close to him 'as you were talking about men and women, last night'. Ruskin asked her what the spirit looked like. 'Fair, very tall & graceful, – she was stooping down close over you, as if she were trying to say something.' Mrs Acworth said that she had learnt from the spirit world that this spirit had not been married: 'I think she has not been long in the spirit world – not a year perhaps.'[98]

Ruskin was converted. He believed that the spirit of Rose was seeking to communicate with him. His diary shows him becoming persuaded by these spiritualist ladies: 'more and more wonderful or sad things told me'; 'long afternoon talk; and I gain knowledge of – I know not yet what, or how much'; 'first through Φιλγ and her friend, then, conclusively, in evening talk after reading, the truth is shown me, which, though blind, I have truly sought so long'.[99]

In 1876–7 Ruskin spent a year in Venice, during which he identified Rose with the figure of St Ursula in Carpaccio's cycle of paintings in the Accademia. He became fixated in particular on *The Dream of St Ursula*, a painting of which he slowly and obsessionally made a magnificent copy. Living examples of plants that appeared in the painting were sent to him by friends, and he took these as signs from the dead Rose, or 'messages from little bear' (a play on the name 'Ursula').

His state of mind during this period is exemplified in his letters to Joan Severn. He writes to Joan in a baby-language designed to show that he is simultaneously her parent and her child, and designed also, perhaps, to gain 'permission' for his experiments with the supernatural.

*Ruskin had in fact met Mrs Acworth at the Cowper-Temples' house years earlier, in 1864, when she had been a Miss Andrews; but at that earlier date he had been healthily sceptical about spiritualism.

Venice, 24th December 1876

My darling Joanie

I am thankful for that wee ettie [letter] from poor L[acerta, i.e. Mrs La Touche]. I have been asking for some sign from Rosie – it was a year on the shortest day since the last* – so I suppose she sent me this; and with it came a sprig of verbena from St Ursula (sent by good Mr Oliver†).

Oo must'nt *pek* [expect] anything di ma [dear mama] – but I do think, – St. Ursula's lips are coming pretty, – and her eyelids – but oh me, – her hair!

Toni, Mr. Brown's gondolier,‡ says she's all right – and he's a grave and close looking judge.

Ruskin wrote again to continue the story on Christmas Day 1876:

I am out of paper to write love on – if I had the world full, I could not tell you how thankful I am, this day, to have my Joanie, and that she is so happy. I have had a 'miraculously' (literally) happy morning, myself. – Lady Castletown sent me, last night the pink, living – 'from St Ursula out of her bedroom window, with her love'.** . . . Having got messages from Little Bear, entirely distinct about my public work, with separate yet involved message besides from the *little-bud*; which you know in her mortal life St Ursula is – (the *moss* rose) – I said to myself – Now if I had but a letter from Diddie,†† it would be perfect.[100]

These letters parallel two long bizarre narrative letters that Ruskin sent to Joan, dated 27–8 December and 29–31 December. He described himself in a very odd frame of mind wandering about Venice and being guided, at every turn, as he believed, by the spirit of dead Rose who was now identified with St Ursula, 'little bear'. Later he spoke of episodes of supernatural 'teaching'. He clearly felt the need to defend his belief in this spirit guidance; he dropped the baby-talk and wrote as though preaching an evangelical sermon:

You see . . . that the steady result in every point and moment of the teaching was to confirm in good purpose and holy thought, and make me think more highly, or more tenderly, of every person I knew; and more vigorously of my own work.

*He believed that he had had a sign of her continuing love from the dead Rose at the winter solstice in Broadlands the previous year, 1875.

†Daniel Oliver, keeper of the herbarium at Kew, had been prompted by Joan to send Ruskin an example of one of the plants in the Carpaccio painting, *The Dream of St Ursula*.

‡Antonio Valmarana was the servant and lifelong companion of one of Ruskin's oldest friends in Venice, the antiquary and confirmed bachelor Rawdon Brown.

**Lady Castletown was staying at Danieli's hotel, and had brought round to Ruskin's rooms a potted dianthus, Ruskin's 'pink' – the other plant that appears in the Carpaccio painting – with a card inscribed from Saint Ursula 'with her love'.

††Sara Anderson, known to the household as 'Dido', would later serve as Ruskin's secretary.

You see also that this teaching was accompanied with physical clearness of light; and that it was recognized throughout, from the very first, by me, as supernatural; and that the Virtue required by it, throughout was only happy, effortless obedience. My duty was to yield to every impulse, the moment I felt it – *Resistance* only was error.[101]

Joan not unnaturally became impatient. Ruskin wrote on 10 January: 'I was chilled a little, by your last letters, and it requires some effort to go on with what I was telling you. But it is of extreme importance that I should write it to some one; and if I turned now to Φιλγ instead of you, you would feel in disgrace.' After this somewhat bullying threat to adopt Mrs Cowper-Temple rather than Joan as his confidante, he instructed her to be more reverent with his testimony: 'So now, read these graver letters only in times when your mind is free – and yet inclined for grave thought; not when you are hurried by callers, or hurt by headaches.' He then went on to set out in sober prose the bizarre beliefs that had him in their grip. He had seen the Devil in the form of a boatman with red eyes, and had been protected from this figure by Rose's intervention; also Rose had been intervening in his copying of the *Dream of St Ursula*, granting success to every brush-touch 'that was done in true humility and desire to do right' and correspondingly bringing failure to 'every touch that was done in vanity – desire of display, or mere pleasure in her own beauty' (Ruskin had had difficulty* reproducing the eyes satisfactorily).

Joan continued to be unimpressed, and on 12 January Ruskin resorted again to baby-talk in order to coax some kind of reaction out of her:

> It's very pokin oos nevy taking [provoking your never taking] no mo notis [notice] of all my wee adventures, than if you never got a word of one of them. Pease [Please], when peepies [people] come in to michy punchy [before luncheon, presumably, in time to catch the afternoon post[103]] oo must say, *before* michy punchy begins, 'Me MUST ite [write] to my di pa.

Joan had been invited to Broadlands, and Ruskin told her that the spirit of Rose would look after her there: 'Di ma, if oos velly dood, like oos di pa: – I think she'll take care of *oo* too and show oo pitty wee things at Broadlands.'[104]

*Also, the Carpaccio painting had forced Ruskin to recognise the importance of understanding the anatomy of the skull under the face; something he had denied in his Oxford lectures of 1872 ('The skull in the human creature fails in three essential points. It is eyeless, noseless, and lipless': *Works*, XXII, p. 229).[102]

What is one to make of this sequence of letters? They demonstrate one profound effect of Rose's death; after some fifteen years of scepticism about the immortality of man Ruskin was returning to believe in such immortality once more. And they cannot be dismissed as a marginal aberration. 'My duty was to yield to every impulse'; that is also the principle on which *Fors Clavigera* was written, in the belief that *fors* (fate, chance or destiny) was guiding his choice of subjects and validating his visions. The belief that Rose was speaking to him is of a piece with his mystical view of his own calling in his work from 1870 onwards.

The preoccupation with Rose separated him from his most long-suffering friends as well as causing great anxiety to Joan. His correspondence with Norton reflects Norton's deepening alarm and dismay. Ruskin had written to him from Broadlands about Mrs Acworth, saying: 'I have seen a person who has herself had the Stigmata, and lives as completely in the other world as ever St. Francis did.' And following the spiritualist experiences at Broadlands, he wrote to Norton: 'At Broadlands, either the most horrible lies were told me, without conceivable motive – or the ghost of R was seen often beside Mrs Temple, or me.' Norton obviously wrote warning him against this nonsense and Ruskin wrote again, this time from Herne Hill, to say that he was grateful for the warning: 'and truly I need it for the forms of disturbance that present themselves to me, not at Broadlands only, are terrific in difficulty of dealing with'. He remarked that his newly recovered faith in the supernatural had made him now feel at one with the medieval world: 'You know the middle ages are to me the only ages, and what Angelico believed *did* produce the *best* work. That I hold to as demonstrated fact. All modern science and philosophy produces abortion. – That miracle believing faith produced good fruit – the best yet in the world.' To counter Norton's further remonstrations he wrote a long letter from Broadlands, setting out in a reasonably level tone his belief that the afterlife is indeed a reality, and that the spirit of Rose attended him. From Venice a year later he wrote sadly about the gap that now existed between their respective beliefs:

There is . . . now quite an enormous separation between you and me in a very serious part of our minds. Every day brings me more proof of the presence and power of real Gods, with good men; – and the Religion of Venice is virtually now my own – mine at least – (or rather at greatest) including hers, but fully accepting it, as that also of John Bunyan, and of my mother, which I was first taught.[105]

On his fifty-eighth birthday, 8 February 1877, Ruskin moved into cheaper lodgings in Venice – 'La Calcina', on the Zattere – and continued his obsessional water-colour copying of *The Dream of St Ursula*, while he went on writing: *Fors Clavigera*, the revised *The Stones of Venice*, *St Mark's Rest*, *Proserpina* and *Deucalion* were all worked on during this period. Also he was collaborating with the young Count Zorzi who was heroically resisting insensitive restoration of St Mark's and other monuments in the city. And he kept up his correspondence. On 10 March 1877 he wrote to Norton, again stressing the difference over religious matters that now existed between them, and said that in his 'new history of Venice' he alluded 'to the sorrows of a very dear friend, who can only account for the glory of Italian art by his conviction of the "beautiful mendacities of Heaven, and glorious Somnambulism of Man"'. And he further taxed Norton's friendship by going on as follows: 'Dead Rose making me wish always to live in dreams – suppose for both you & me – dreams *should* be perpetual – or then reality?'[106] Norton was seriously worried about Ruskin's state of mind, and a letter of 15 April can have done nothing to reassure him:

> Your grief at my letter makes *me* very sad, – but not in sympathy for it. Here is all Italy laid in final ruin by a horde of banditti – all Europe in the vilest harlotry and atheism – debating whether they shall begin universal murder – here is England once honest, a nation of rascals – here is your wife dead – my Rose – my Father – mother – nurse – my life gone all but a shred of it – here are the snows vanishing from the Alps – and God out of Heaven – and – forsooth – you are grieved! – because your friend sends you a cross letter! Are you not a very curious & wonderful Charles, when you think of it?[107]

Ruskin left Venice in late May and travelled slowly back to England, pausing in June in the Simplon to engage in botany, which he found refreshing and soothing, but he wrote to Norton that he was close to a breakdown because of 'the extreme need for doing all I could at Venice this winter – and I have reduced myself nearly to the state of a brittle log'.[108]

With some remissions, Ruskin's mental state was in fact steadily deteriorating in late 1877; he was confused, preoccupied with St Ursula, and behind with his work. Unable to prepare a new course of lectures for the Michaelmas term at Oxford, he delivered instead (to great acclaim) his 'Readings in Modern Painters'. In December 1877

and January 1878 his diary entries displayed increasing despair over the weather. In February 1878, as shown in the *Brantwood Diary*, he suffered complete psychological collapse and was seriously ill for several weeks.

*The Brantwood Diary of John Ruskin** is an extraordinary document. Ruskin was clearly very seriously ill, yet in the midst of his illness he was able to write down a record of his state of mind. It is hard to tell what these entries are about. Many of them are random and apparently free-wheeling references to Shakespeare. These do seem to have some kind of co-ordinating pattern, as though he is finding in Shakespeare reflections of his immediate predicament: loss of time, ill-treatment by women, haunting by dead parents. Ophelia, named in *Sesame and Lilies* as the least admirable of Shakespeare's heroines, seems to be identified with Rose in these jottings. As Ophelia did to Hamlet, Rose has betrayed Ruskin and then gone beyond his reach into the other world. Much of this material may have been seen by Ruskin as 'notes' for his next issue of *Fors Clavigera*, but to the reader it has the impact of an exposed testament, a kind of personal therapy with which the writer seeks to stave off the collapse which is coming.[109] Some samples indicate the nature of these diary entries:

> [17 February 1878] The devil put a verse into my head just now – 'let us not be desirous of *vain* glory.' I am NOT oh Devil. I want useful Glory. – 'provoking one another' – Oh Devil – cunning Devil – do you think I want to provoke Beata Vigri and little Ophelia then – ?
>
> I will – prov – voke – Somebody else, God willing 'to day' and to purpose.
>
> And Bishop Laertes, – you had as lief take your fingers from my throat – The Devil will not take my soul, yet a while – Also – look you – and also looking other [things may be at YOUR throat before long.] (Thou pray'st not well – even by your own account and the Devil will not answer you therefore[)] and least said is soonest mended – for – if up when the scuffle comes – the foils should be Sheffield whettles – it is dangerous work – Laertes – 'very' – as Mr Jingle said, even the public press & Mr Jingle will advise you of that. Public press Mr Jingle, in then! And St. George of England both Advise you of that.[110]

On 21 February he was becoming dangerously dislocated from reality. As the preoccupation with Rose fermented in his mind he

*Edited by Helen Viljoen, 1971.

became convinced that he had married her, and wrote to George MacDonald to say so:

Brantwood

Dear George*

We've got married – after all, after all – but such a surprise. Tell the Brown mother – and Lily –

Bruno's out of his wits with joy up at the Chartreuse Grande – and so am I, for that matter – I meant – but I'm in an awful hurry, such a lot of things to do –

Just get this done before Breakfast – the fourth letter. Ever your lovingest, John Ruskin. Oh Willie – Willie – he's pleased too, George dear![111]

On 22 February, Good Friday, the prose of the diary entries seems to be simply disintegrating. Preoccupation with Rose, sexuality and the Devil seems to be mixed in with a wide range of virtually random allusions to his habitual cultural interests:

Recollected all about message from Rosie to me as I was drawing on the scaffolding in St Georges Chapel – My saying I would serve her to the death –

Tonight – (last night) – lying awake – came – Ada with the Golden Hair.

1 – Can the Devil speak truth (confer letter to Francie about her little feet.)

and 2 If that thou beest a devil &c. connected with, (Made wanton – &c. the night with her)

To Burne-Jones. – Oh my Black Prince – and they take you for one of the firm of Brown – &c. – See Brown, &c., away on Lago Maggiore – Tintoret – Sempre si far il Mare Maggiore

To Connie – Oh Connie – did'nt we quarrel among the Alpine Roses, and make it up again by the moonlight.[112]

Ruskin's illness was such that it endangered his life. His diary broke off abruptly with a heading to a blank page: 'February, – to April – the Dream'. For ten days it seemed likely that he would die. Joan Severn, who came up hastily from London to Brantwood, wrote to Norton to say that on 28 February the household had given up hope for him, but he then rallied. A major problem was his refusal to eat.

Dr John Simon came to attend him from 26 February, and was able to write to Norton on 4 March to say that Ruskin's life was no longer in danger but that his mental state was still very poor: 'What may be

*This was the first occasion on which he addressed MacDonald as 'George'.

the degree of eventual recovery I cannot yet judge.' Henry Acland also spent several days at Brantwood; this caused tension because he was not particularly welcome to Joan, who greatly preferred John Simon as Ruskin's medical attendant. Acland wrote a gloomy letter to Gladstone:

> I write to you, I own, simply or in large part as a relief to pent-up feelings which either did not exist or had no expression while I was with him. For now his mind is utterly gone. He cannot be rightly said to know anyone. He *raves*, in the same clear voice and exquisite inflection of tone, the most unmeaning words – modulating them now with sweet tenderness, now with fierceness like a chained eagle – short disconnected sentences, no one meaning anything.

And in his madness Ruskin was violent: 'he would alternately strike at me and tenderly clasp my hands – once only giving almost certain sign of knowledge. To my question, "Did you expect to see me by your bed?" he answered in the most pathetic tone: "Yes, I expected you would come," and then no more light any more.'[113]

What actually happened when Ruskin went mad in February 1878 can be pieced together from what he wrote about it afterwards. On the night of 22 February he became 'powerfully impressed' by the idea that he was about to be seized by the Devil, feeling also 'convinced that the only way to meet him was to remain awake waiting for him all through the night, and combat him in a naked condition'. He took off his clothes and marched up and down, stark naked, 'wondering at the non-appearance of [the] expected visitor'. When dawn came he looked out anxiously from his window 'to make sure that the feeble blue light really was the heralding of the grey dawn' and at that moment 'a large black cat sprang from behind the mirror!' He took this to be the Devil, and threw himself

> [with] all my might and main against the floor . . . I had triumphed! Then, worn out with bodily fatigue, with walking and waiting and watching, my mind racked with ecstasy and anguish, my body benumbed with the bitter cold of a freezing February night, I threw myself upon the bed, all unconscious.[114]

Joan's care of him was heroic. In his diary entry for 18 June he noted: 'On the 7th April, this year, I got first down into my study, after illness such as I never thought to know. Joanie brought me through it.'[115]

CHAPTER 8

1879–88

As an unflinching Tory, my entire idea of Kingship is founded on the figures of Atrides and Achilles. . . . My conception of the glory of virginal womanhood is founded on Athena – and Briseis – on Chryseis and Nausicaa; my conception of household womanhood on the restored Helen, Arete and Penelope; of household order and economy on Ulysses' anger at the suitors and at his own maid-servants for wasting his goods, and that in disorderly life. The glory of all good workmanship is in the ideal of Vulcan; and surely all believing on true political economy is summed up in the lines (forgive me for numbering from Pope) 90–175 of the seventh *Odyssey*. Finally, the picture of Laertes among his vines begins and sums up all I have said and meant about rural labour.[1]

All my friends are throwing stones through my window, and dropping parcels down the chimney, and shrieking through the keyhole that they must and will see me instantly, and lying in wait for me if I want a breath of fresh air, to say their life depends on my instantly superintending the arrangements of their new Chapel, or Museum, or Model Lodging-house, or Gospel steam-engine. And I'm in such a fury at them all that I can scarcely eat.[2]

The epigraphs to this chapter illustrate two aspects of Ruskin in the late 1870s and 1880s: his sense of himself as politically and socially intransigent and his desperate desire not to be *bothered* by people. Politically, he was not to be aligned with any known party or figure. As his fame spread, he became acquainted with some of the most powerful men in the land, including Palmerston, Gladstone and Disraeli. Personally he got on with them but politically he kept his distance. Carlyle had taught him in the 1850s to despise Gladstone's liberal 'indecisiveness'. Ruskin stayed with Gladstone at his house, Hawarden, and began a sustained and friendly correspondence with his daughter, Mary; but as a 'Tory' he continued to denounce Gladstone's politics. In 1880 we find him writing a mischievous and to some extent self-parodying letter to Mary Gladstone about the 'adversary side' of himself:

I love and honour your father; just as I have always told him and you that I did. As a perfectly right-minded private English gentleman; as a man of purest religious temper, and as one tenderly compassionate, and as one earnestly (desiring to be) just. . . . Now for the other side . . . I have always fiercely opposed your Father's politics; I have always Despised . . . his way of declaring them to the people. I have always despised, also, Lord Beaconsfield's methods of appealing to Parliament, and to the Queen's ambition, just as I do all Liberal – so-called – appeals to the Mob's – not ambition (for Mobs have not sense enough, or knowledge enough, to be ambitious) but – conceit.[3]

By the time of his psychological collapse in 1878 Ruskin had suffered many years of turmoil and anguish. Signs of the disorder spilling over into his public life had been evident for some years – enough so to distress his friends – but the first conspicuous impact on his public role came with the disastrous affair of the Whistler libel action.

In the summer of 1877 Ruskin returned from Italy and visited the loan exhibition at the Grosvenor Galleries, recently opened by Sir Coutts Lindsay. The new gallery showed paintings by Burne-Jones, Millais, Alma Tadema, Leighton, Poynter, Richmond, and the American James Abbott McNeill Whistler. The Whistler paintings shown were *Nocturne in Black and Gold: The Falling Rocket*, *Harmony in Amber and Black*, *Arrangement in Brown*, *Arrangement in Black no. III*, two *Nocturnes in Blue and Silver*, *Old Battersea Bridge*, a *Nocturne in Blue and Gold* and the *Portrait of Carlyle*. In the *Fors Clavigera* letter of 18 June 1877 Ruskin praised Sir Coutts Lindsay's 'true desire to help the artists and better the art of his country' and he thought well of most of the artists invited to display there. He was delighted by Burne-Jones's work, but of Whistler he said:

For Mr Whistler's own sake, no less than for the protection of the purchaser, Sir Coutts Lindsay ought not to have admitted works into the gallery in which the ill-educated conceit of the artist so nearly approached the aspect of wilful imposture. I have seen, and heard, much of Cockney impudence before now; but never expected to hear a coxcomb ask two hundred guineas for flinging a pot of paint in the public's face.[4]

The tragedy is that the Ruskin who responded so magnificently to Turner's radical work in the 1830s and 1840s was unable to see the similar radical virtues of Whistler's work in the 1870s. The beautiful painting that infuriated Ruskin (it is now in the Detroit Institute of Arts) dates from 1875, and shows a firework display at the Cremorne Gardens with a rocket falling into the Thames.[5]

Whistler sued Ruskin for libel, and the consequence was the notorious trial, *Whistler* v. *Ruskin*, on 25–6 November 1878. The judge was Lord Huddleston, and Ruskin was defended by the Attorney-General, Sir John Holker, and Mr (later Lord) Bowen. The celebrated barrister 'Serjeant' Parry appeared for Whistler. It was argued that Ruskin had damaged Whistler's reputation maliciously, and in such a way as to damage his sales.

James Abbott McNeill Whistler (1834–1903) was an extraordinarily original artist. The 'nocturnes' of the 1870s bear comparison with the experiments of Monet and other contemporary French impressionists; they are attempts faithfully to record the effects of light as it falls on the retina. His titles seem to invite us to think of the works as though they are pieces of music, but Whistler said at the trial (as reported by *The Times*) that this was not his intention:

> Asked the meaning of the word 'Nocturne' Mr. Whistler said that a picture was to him throughout a problem, which he attempted to solve, and he made use of any incident or object in nature that would bring about a symmetrical result. 'An Arrangement' was an arrangement of light, form, and colour. Among his pictures were some night views, and he chose the word 'Nocturne' because it generalised and simplified them all.

Asked about the price asked for his picture Whistler said:

> The 'Nocturne in Black and Gold' he knocked off in a couple of days. He painted the picture one day and finished it the next. He did not give his pictures time to mellow, but he exposed them in the open air, as he went on with his work, to dry. He did not ask 200 guineas for two days' work; he asked it for the knowledge he had gained in the work of a lifetime.[6]

(This moment of the trial was improved in the telling in Whistler's own retrospective account:

Defence: 'Oh, two days! The labour of two days, then is that for which you ask two hundred guineas!'

Whistler: 'No; – I ask it for the knowledge of a lifetime.' Applause.)[7]

Ruskin's friends were embarrassed and many of them felt that their loyalties were divided. Burne-Jones, for example, who spoke in Ruskin's defence, was asked by the judge whether he was not a friend of Whistler's. Burne-Jones replied: 'I *was*,' and added: 'I don't suppose he will ever speak to me again after today.' Of the painting that Ruskin had attacked, Burne-Jones said that it was 'one of the thousand failures that artists have made in their efforts to paint right' and that it was not

worth the sum asked for it. William Michael Rossetti, brother of Dante Gabriel, who had always seen himself as a friend of Ruskin, was subpoenaed, without any warning, to give evidence for Whistler.

> I of necessity obeyed the subpoena, and expressed in the witness box my true opinion of more than one of the artist's paintings, including that which Ruskin had vilified, and which, indeed, I considered very inferior to some others. I was thus compelled to act, willy-nilly, in opposition to Ruskin's interests in the action. I regretted to have been coerced into so delicate, and in some sense so false, a position.[8]

Ruskin was enormously grateful for Burne-Jones's support, as is shown by his letters a few weeks before, and immediately after, the hearing:

> Brantwood, November 2 [1878] – I gave your name to those blessed lawyers as chief of men to whom they might refer for anything which in their wisdom they can't discern unaided concerning me. But I commended them in no wise and for no cause whatsoever to trouble or tease you; and neither in your case, nor in that of any other artist, to think themselves justified in asking more than may enable them to state the case in court with knowledge and distinctness.

> Brantwood, November 28th – I'm very grateful to you for speaking up, and Arthur [Severn] says you looked so serene and dignified that it was a sight to see. I don't think you will be sorry hereafter that you stood by me, and I shall be evermore happier in my serene sense of your truth to me, and to good causes – for there *was* more difficulty in your appearing than in any one else's [given that Burne-Jones was a friend of Whistler], and I'm so glad you looked nice and spoke so steadily.[9]

The defence position was that Ruskin had offered reasoned criticism of a work which had been put on public display and therefore invited critical comment, and that the price of two hundred guineas was outrageously high. Whistler's position was that Ruskin's attack had been reckless and unfair, and was made merely for the love of exercising his power.[10]

Following his illness earlier in the year Ruskin himself was unable to appear in court. The outcome of the trial is all too famous. The judge ruled that the terms of Ruskin's remarks constituted libel and that the jury must decide whether the libel merited substantial, or merely contemptuous, damages. The jury awarded Whistler only one farthing damages* and the judge required him to pay costs.[11]

*A farthing was worth one quarter of a penny and was the smallest coin then current.

Nevertheless Whistler felt morally vindicated and a month after the trial brought out a pamphlet, *Whistler versus Ruskin: Art and the Art Critics*, in which he declared that critics 'are not a "necessary evil," but an evil quite unnecessary, though an evil certainly'.[12] And Whistler assaulted Ruskin's position at Oxford:

> The war, of which the opening skirmish was fought the other day, in Westminster, is really one between the brush and the pen, and involves literally, as the Attorney-General has himself hinted, the absolute *raison d'être* of the critic. The cry, on their part, of *il faut vivre*, I must certainly meet, in this case, with the appropriate answer, *Je n'en vois pas la nécessité*.
>
> We are told that Mr. Ruskin has devoted his long life to art, and as a result – is Slade Professor at Oxford. In the same sentence, we have thus his position and its worth. . . . What greater sarcasm can Mr. Ruskin pass upon himself than that he preaches to young men what he cannot perform? Why, unsatisfied with his own conscious power, should he choose to become the type of incompetence by talking for forty years of what he has never done? Let him resign his professorship, to fill the chair of Ethics at the university. As a master of English literature, he has a right to his laurels, while as the populariser of pictures he remains the Peter Parley of painting.[13]

In fact Ruskin had already decided to resign the Slade Chair. He wrote to Dean Liddell on 28 November from Brantwood:

> Although my health has been lately much broken, I hesitated in giving in my resignation of my Art-Professorship in the hope that I might in some imperfect way have been useful at Oxford. But the result of the Whistler trial gives me no further option. I cannot hold a Chair from which I have no power of expressing judgment without being taxed for it by British Law. I do not know in what formal manner my resignation should be signified, but thought it best that the decisive intimation of it should be at once placed in your hands.

And he followed this with a letter saying that it was neglect of his opinions, not ill-health, that was forcing his resignation:

> It is much better that the resignation of the office should be distinctly referred to its real cause, which is virtually represented by the Whistler trial. It is not owing to ill-health that I resign, but because the Professorship is a farce, if it has no right to condemn as well as to praise. It has long been my feeling that nobody really cared for anything that I *knew*; but only for more or less lively talk from me – or else drawing-master's work – and neither of these were my proper business.[14]

It has been pointed out that the resignation from the Slade Chair was unfair to Oxford, since *Fors Clavigera* was not written and published as part of his Oxford duties. The resignation from Oxford became in Ruskin's mind a form of punishment – of the public in general – for the verdict against him.[15] He seemed unable to recognise that the outcome of the trial could be interpreted as a victory for him, since Whistler's damages of one farthing were obviously intended as a rebuke to the plaintiff and the court's refusal to award costs to Whistler pushed the painter's always precarious finances over the edge. Whistler's claim for damages had been for a thousand pounds: a very significant sum in those days. He had hoped, obviously, to redeem himself financially from the case and had failed ignominiously. The outcome was a victory for Ruskin to the extent that it had protected freedom of speech for the critic. No other artist (unless wildly obstinate or very rich) would be encouraged by the Whistler case to take action against a critic, meaning, clearly, that no critic need now fear to censure a work of art put on public display. A writer in the *Art Journal* remarked that the action was 'a foolish action to bring: no intelligent or upright jury could have hesitated to consider that Mr. Ruskin had a right to say what he did of Mr. Whistler's picture'.[16] But Ruskin himself was unable to see that. He thought it abominable that English law should rate his 'injurious opinion' as worth a farthing.[17] He seemed almost to say that if Whistler had been awarded a significant sum that would have at least testified to his, Ruskin's, capacity to inflict real injury.

By 1887 Ruskin was to write that he was disappointed by everything that he had done as Slade Professor. He referred to his mother, as though the fact that she had been still alive during the first year of his professorship gave it some additional authority:

> The following lectures were the most important piece of my literary work done with unabated power, best motive, and happiest coherence of circumstance. They were written and delivered while my mother yet lived, and had vividest sympathy in all I was attempting; – while also my friends put unbroken trust in me, and the course of study I had followed seemed to fit me for the acceptance of noble tasks and graver responsibilities than those only of curious traveller, or casual teacher.

Ruskin noted sadly that the ambitious schemes set out in the first four lectures were not fulfilled. The reasons he gave included two deaths: one his mother's and the other that of 'a dear friend' (Rose) in 1875 which 'took away the personal joy I had in anything I wrote or

designed'.[18] But the schemes set out in these lectures were doomed neither by bereavement nor by illness, but simply by their nature. There were too *many* schemes. Even if he had given all his energies to Oxford he would have been overwhelmed – as it was, he was at the same time giving his energies to writing what were in a sense the diametrical opposite of his Oxford lectures (the serial letters to workmen) and to the founding of a new civilisation (the Company or Guild of St George).

Although he had resigned from the Slade Chair, Ruskin was moved by a visit to a country house in Perthshire (belonging to a Mr William Graham) to write two essays, in which he declared that he was having a last word as an Oxford professor and, since he would no longer be able to lecture in Oxford, was writing out his views on a group of paintings that he had recently seen in Graham's house: Rossetti's *The Annunciation (Ecce Ancilla Domini!)*, Millais's *The Blind Girl* and a water-colour of Burne-Jones's, made in 1870, which Ruskin referred to from memory as a marriage dance; it shows King René of Anjou and his bride with a group of dancers. He was grateful to Burne-Jones for his support in the Whistler trial, obviously; of the young men whom Ruskin had chosen to champion in the 1850s, Millais and Rossetti had dramatically defected, but Burne-Jones had remained loyal. Accordingly these essays took further the huge praise that Ruskin had been lavishing on Burne-Jones in *Fors Clavigera* and hailed him as 'the greatest master whom that [Pre-Raphaelite] school has yet produced'.[19] It was characteristic of Ruskin at this stage of his writing about art that while his less enthusiastic descriptions of the two well-known oil paintings by Millais and Rossetti were more accurate, his account of the Burne-Jones water-colour was vague and general, despite his high praise for it. He was looking back to old certainties: the impact of Burne-Jones's work could be compared only with the most hallowed touchstone of Ruskin's earlier years, the della Quercia tomb of Ilaria di Caretto at Lucca. What the sculpture has in common with the Burne-Jones water-colour is its visionary quality:

> You are to note that with all the certain rightness of its material fact, this sculpture is still the Sculpture of a Dream. Ilaria is dressed as she was in life. But she never lay so on her pillow! nor so, in her grave. Those straight folds, straightly laid as in a snowdrift, are impossible; known by the Master to be so – chiselled with a hand as steady as an iron beam, and as true as a ray of light – in defiance of your law of Gravity to the Earth. *That* law prevailed on her shroud, and prevails on

her dust: but not on herself, nor on the Vision of her.[20]

He was trading on the authority of the author of *Modern Painters* when he wrote:

> Though I have neither strength nor time, nor at present the mind, to go into any review of the work done by the third and chief School of our younger painters, headed by Burne-Jones; and though I know its faults, palpable enough, like those of Turner, to the poorest sight; and though I am discouraged in all its discouragements, I still hold in fulness to the hope of it in which I wrote the close of the third lecture I ever gave in Oxford – of which I will ask the reader here in conclusion to weigh the words, set down in the days of my best strength.[21]

Ruskin's preoccupation with the Guild of St George coexisted with a revisiting in these years of his young, secure self on Denmark Hill. One effect of Ruskin's terrible illness in 1878 was that he now knew that excitement, of all kinds, was bad for him. His intemperate rage with the Whistler painting in June 1877 probably had to do with denial, with fierce resistance of a style of painting that would have appealed to his younger self. And so with everything: anything that appealed to the appetites and the senses was dangerous and to be denied.

Late in 1877 Ruskin had an absurd public quarrel with a long-term associate, Octavia Hill.* This quarrel was triggered by a bit of gossip

*The famous Victorian philanthropist Octavia Hill (1838–1912) read Ruskin's works when she was very young and made personal contact with him in the 1850s. He trained her, and then employed her, as a copyist of medieval illuminations (some of her copies appeared in the illustrations to *Modern Painters*, V). In 1856 F.D. Maurice appointed her as secretary to the women's classes at the Working Men's College, which formed a further link with Ruskin and his work. In the 1860s she involved Ruskin in her desire to improve the housing for the poor in London. After his father's death in 1864, when Ruskin had become very wealthy, he funded the purchase of the lease of Paradise Place, off Marylebone High Street, a semi-derelict slum property which Octavia restored and then managed on his behalf (the rents were fixed at 5 per cent of Ruskin's capital outlay). Another, much bigger property, Freshwater Place, followed in 1866: six houses which Ruskin bought for the very substantial sum of £2,880. Ruskin's extraordinary attack on her in *Fors* probably arose from her opposition to a financial arrangement proposed by him. He wanted the London properties that he had bought for her to become part of the 'Guild of St George' holdings. Octavia Hill resisted because she could see that the financial management of the guild was very precarious, whereas her own management of these properties was efficient. Also by this time the power-relationship between the two had changed decisively. In the 1870s she was becoming a major figure in housing reform and other philanthropic ventures. She was appointed manager of a Southwark property owned by the ecclesiastical commissioners in 1884. A supporter of Commons Preservation societies, in the 1880s she became one of the founders of the National Trust. It was she who persuaded her co-founders that a 'Trust' rather than a 'Company' was what was needed. 'An association for the Open Spaces Preservation and Land Development Society' was in being in 1885, but her phrase 'National Trust' was already circulating. The inaugural meeting of the National Trust as it now exists took place in 1894.

that reached him, to the effect that Octavia Hill thought him incapable of managing the Guild of St George. In the winter of 1877–8 he chose to publish her exchange of letters with him in *Fors Clavigera*. As Octavia Hill's replies amply show, she was determined both to defend herself and, if she could, to protect Ruskin from exposing his own disinhibited and manic state of mind publicly.

Ruskin launched his assault by writing: 'For the last three or four years it has been matter of continually increasing surprise to me that I never received the smallest contribution to St. George's fund from any friend or disciple of Miss Octavia Hill's.' But he had now been, as he felt it, stabbed in the back: a third party knew of a case 'in which a man of great kindness of disposition, who was well inclined to give aid to St. George, had been diverted from such intention by hearing doubts expressed by Miss Hill of my ability to conduct any practical enterprise successfully'. Octavia Hill wrote in October protesting, truthfully, that for twenty-four years she had been completely loyal to Ruskin. In reply to a further angry letter from him she wrote again (3 November 1877) giving the following honest and strong statement: 'I have spoken to you, I think, and certainly to others, of what appears to me an incapacity in you for management of great practical work, – due, in my opinion, partly to an ideal standard of perfection, which finds it hard to accept *any* limitations in perfection, even temporarily; partly to a strange power of gathering round you, and trusting, the wrong people.' Ruskin was nettled by this and reacted with what amounted to personal abuse: 'I have never yet, to my own knowledge, "trusted" any one who has failed me, *except* yourself, and one other person of whom I do not suppose you are thinking' (Rose, perhaps; or possibly C.A. Howell). Octavia returned a brief, dignified letter, which ended: 'My opinion of your power to judge character is, and must remain, a matter of opinion. Discussions about it would be useless and endless; besides, after your letters to me, you will hardly be astonished that I decline to continue this correspondence.' Ruskin responded with a furious and bullying letter demanding the return of his previous letter for publication. This Octavia sent back, adding, with commendable restraint, 'I disapprove of the publication of this correspondence. Such a publication obviously could not be complete, and if incomplete it must be misleading. Neither do I see what good object it could serve. I feel it due to our old friendship to add the expression of my conviction that the publication would injure you, and could not injure me.' She refused to be frightened by his tactics and she knew, now, if not before, that she

was dealing with someone who was already more or less insane.[22]

There were further furious tantrums in *Fiction, Fair and Foul*, the series of essays that he contributed to *The Nineteenth Century* in 1880. The first of these was the most temperate and made the most sense in relation to Ruskin's earlier work. In *Fors Clavigera* he had been advocating a pastoral peasantry and a return of chivalry. And as Carlyle had contrasted medieval Bury St Edmunds with Victorian England, so Ruskin now contrasted the golden Denmark Hill of his childhood with the horrible developed suburban place that it had become, and by extension contrasted the healthy rhythms of the pastoral life with the narrow, morbid and pleasure-addicted patterns of living in the city. The voice of the architect of the Guild of St George despairingly deplored the disappearance of old virtues and the privileging of sexual fulfilment in the modern world:

> An era like ours, which has with diligence and ostentation swept its heart clear of all the passions once known as loyalty, patriotism, and piety, necessarily magnifies the apparent force of the one remaining sentiment which sighs through the barren chambers, or clings inextricably round the chasms of ruin; nor can it but regard with awe the unconquerable spirit which still tempts or betrays the sagacities of selfishness into error or frenzy which is believed to be love.[23]

'Error', 'frenzy' and 'love': the association of these words followed naturally from the account of brain disease that had preceded them in the essay. Ruskin knew all too well that love is connected with brain disease. In an extraordinary footnote Ruskin associated 'brain disease' in the artist with grotesque and sensational subject-matter in the work of art (the novel or painting). This footnote contained in parenthesis a memory of his own illness in 1878: 'in my own inflammation of the brain, two years ago, I dreamed that I fell through the earth and came out on the other side' (this 'dream' was probably a memory of Dante, one of the heroes of this series of essays).[24] Excrement, sensation, sexual excitement, urban deprivation and filth, the destruction of traditional England and his own childhood innocence – these were the real subjects of these essays, and they were adumbrated in the arresting and powerful opening paragraphs in which Ruskin wrote his elegy for Croxted Lane.

Croxted Lane, Dulwich, was a sacred place of his childhood:

> In my young days, Croxted Lane was a green by-road traversable for some distance by carts; but rarely so traversed, and, for the most part,

little else than a narrow strip of untilled field, separated by blackberry hedges from the better-cared-for meadows on each side of it: growing more weeds, therefore, than they, and perhaps in spring a primrose or two – white archangel – daisies plenty, and purple thistles in autumn. A slender rivulet, boasting little of its brightness, for there are no springs in Dulwich, yet fed purely enough by the rain and morning dew, here trickled – there loitered – through the long grass beneath the hedges, and expanded itself, where it might, into moderately clear and deep pools, in which, under their veils of duck-weed, a fresh-water shell or two, sundry curious little skipping shrimps, any quantity of tadpoles in their time, and even sometimes a tittlebat, offered themselves to my boyhood's pleased, and not inaccurate, observation. There, my mother and I used to gather the first buds of the hawthorn; and there, in after years, I used to walk in the summer shadows, as in a place wilder and sweeter than our garden, to think over any passage I wanted to make better than usual in *Modern Painters*.

He contrasted this paradisal and prelapsarian condition of Croxted Lane with its present state. It now had

mixed dust of every unclean thing that can crumble in drought, and mildew of every unclean thing that can rot or rust in damp: ashes and rags, beer-bottles and old shoes, battered pans, smashed crockery, shreds of nameless clothes, door-sweepings, floor-sweepings, kitchen garbage, back-garden sewage, old iron, rotten timber jagged with out-torn nails, cigar-ends, pipe-bowls, cinders, bones, and ordure, indescribable; and, variously kneaded into, sticking to, or fluttering foully here and there over all these, remnants, broadcast, of every manner of newspaper, advertise-ment or big-lettered bill, festering and flaunting out their last publicity in the pits of stinking dust and mortal slime. . . .

For the children of today, accustomed, from the instant they are out of their cradles, to the sight of infinite nastiness, prevailing as a fixed condition of the universe, over the face of nature, and accompanying all the operations of industrious man, what is to be the scholastic issue? unless, indeed, the thrill of scientific vanity in the primary analysis of some unheard-of process of corruption – or the reward of microscopic research in the sight of worms with more legs, and acari of more curious generation than ever vivified the more simply smelling plasma of antiquity.

One result of such elementary education is, however, already certain; namely, that the pleasure which we may conceive taken by the children of the coming time, in the analysis of physical corruption, guides, into fields more dangerous and desolate, the expatiation of an imaginative literature: and that the reactions of moral disease upon itself, and the conditions of languidly monstrous character developed in an atmosphere

of low vitality, have become the most valued material of modern fiction, and the most eagerly discussed texts of modern philosophy.[25]

There is a direct link, then, between the urban child's exposure to urban pollution and the sensational and violent features of modern literature: his examples of such literary sensationalism, in passages of badly clouded judgement, were taken from Dickens, Balzac and George Eliot's *The Mill on the Floss*. But if we ignore the flawed literary judgements we can see that Ruskin was still writing about the virtues of the Guild of St George. He contrasted town and country life:

> The monotony of life in the central streets of any great modern city, but especially in those of London, where every emotion intended to be derived by men from the sight of nature, or the sense of art, is forbidden for ever, leaves the craving of the heart for a sincere, yet changeful, interest, to be fed from one source only. Under natural conditions the degree of mental excitement necessary to bodily health is provided by the course of the seasons, and the various skill and fortune of agriculture. In the country every morning of the year brings with it a new aspect of springing or fading nature; a new duty to be fulfilled upon earth, and a new promise or warning in heaven. No day is without its innocent hope, its special prudence, its kindly gift, and its sublime danger.
>
> The country dweller lives an innocent life governed by the seasons: the divine laws of seed-time which cannot be recalled, harvest which cannot be hastened, and winter in which no man can work, compel the impatiences and coveting of his heart into labour too submissive to be anxious, and rest too sweet to be wanton.

But in the streets of London where 'summer and winter are only alternations of heat and cold' the taste is coarsened: 'the thoroughly trained Londoner can enjoy no other excitement than that to which he has been accustomed, but asks for *that* in continually more ardent or more virulent concentration; and the ultimate power of fiction to entertain him is by varying to his fancy the modes, and defining for his dulness the horrors, of Death'.

This in itself unexceptionable observation about the urban temperament's craving for stimulus leads to a sublimely silly account of the deaths in *Bleak House* followed by a contrived comparison between Scott's heroic death scenes and Dickens's gratuitous and sensational deaths.[26]

Ruskin then turned against Wordsworth, his great literary hero of the 1840s, by comparing him unfavourably with Byron. In *Modern Painters* Wordsworth and Turner had been the two infallible observers

of nature. Now, in the third essay in *Fiction, Fair and Foul*, Ruskin gave a list of accurate observers of beauty: a 'sense of the material beauty, both of inanimate nature, the lower animals, and human beings . . . is found, to the full, only in five men that I know of in modern times; namely, Rousseau, Shelley, Byron, Turner, and myself'.[27] He had always admired Byron but now the admiration seemed intemperate, and the corresponding denigration of Wordsworth trifling and silly. In the fourth essay the tone became more absolutist and strident, the judgements more idiosyncratic, the egotism more jarring. Ruskin claimed that because he had 'used Wordsworth as a daily text-book from youth to age', and had lived moreover 'in all essential points according to the tenor of his teaching', he now had absolute authority to disparage Wordsworth, to point out that 'his excellent master often wrote verses that were not musical, and sometimes expressed opinions that were not profound'.[28]

In 1884 Ruskin gave two lectures on 'The Storm-Cloud of the Nineteenth Century', at the London Institution – these were wholly original, startling and timely accounts of changes that he had witnessed in the climate (really one lecture with addenda, the second being an expansion of the first). The burning of coal was indeed altering the climate of cities – the peculiar density and pungency of the London fogs recorded in Dickens's novels were products of fossil fuels – and the climatic changes that Ruskin saw over Lancashire were the product of fossil fuels burnt in the industrial centres of the West Midlands and at Barrow-in-Furness, quite close to his home at Brantwood. Ruskin quoted from his own diary, a particularly vivid entry being for 13 August 1879:

> The most terrific and horrible thunderstorm, this morning, I ever remember. It waked me at six, or a little before – then rolling incessantly, like railway luggage trains, quite ghastly in its mockery of them – the air one loathsome mass of sultry and foul fog, like smoke; scarcely raining at all, but increasing to heavier rollings, with flashes quivering vaguely through all the air, and at last terrific double streams of reddish-violet fire, not forked or zigzag, but rippled rivulets – two at the same instant some twenty to thirty degrees apart, and lasting on the eye at least half a second, with grand artillery peals following; not rattling crashes, or irregular cracklings, but delivered volleys. It lasted an hour, then passed off, clearing a little, without rain to speak of; not a glimpse of blue, and now, half past seven, seems settling down again into Manchester devil's darkness.

The 'plague-wind' and the 'plague-cloud', of which the above obser-
vation was an example, obscured the sun and 'blanched' it:

> In plague-wind, the sun is choked out of the whole heaven, all day long,
> by a cloud which may be a thousand miles square and five miles deep. . . .
> By the plague-wind every breath of air you draw is polluted, half round
> the world.[29]

The weather was clearly taking on the status of an obsession in
Ruskin's mind. He was convinced that what he saw had not existed in
this form before 1870. His diary entry of 6 August 1880, for example,
stated: 'I believe these swift and mocking clouds and colours are only
between storms. They are assuredly new in Heaven, so far as my life
reaches. I never saw a single example of them till after 1870.'[30]

*

During the period abruptly closed by his disastrous illness of 1878
Ruskin had, of course, been advocating his own peculiar vision of
England. To what extent had he succeeded in turning it into reality?
The short answer is hardly at all. Yet the bases of a Ruskinian social
order were in place for those who could see them. For one thing he had
established a new method of publishing. Since the first appearance of
Fors Clavigera he had used George Allen (1826–1907) as his publisher
and as distributor of his books.

Allen had started out as a carpenter. In 1851 he had married one of
the Denmark Hill servants (Hannah, Mrs Ruskin's maid) and indeed
throughout his life with Ruskin he was treated as though he was
himself a servant (at times he showed signs of resenting this). In 1855
he had enrolled in Ruskin's classes at the Working Men's College.
Ruskin rapidly found him serviceable and willing, and from about
1858 (when he helped Ruskin to catalogue the Turner bequest in the
basement of the National Gallery) he was more or less a full-time
Ruskin employee in one capacity or another. In 1871 he became
Ruskin's publisher, publishing and distributing Fors Clavigera to
subscribers from his own home, a cottage in Kent, thus circumventing
both commercial publishers and booksellers. Against all the odds this
unprecedented form of publication and distribution proved a
commercial success; Fors Clavigera steadily increased its sales and
Allen moved into a larger house – Sunneyside, Orpington, Kent – in
1874. He remained Ruskin's publisher until his death and his venture

was the basis of what was to become Allen and Unwin.[31]

Ruskin's educational ventures bore fruit in strange ways. The famous and comic episode in 1874 in which he persuaded a group of undergraduates into road-work had a serious educational point. The young men were to live out by practical experience the doctrine of the happy workman, and they were to show by example that there is no distinction between the gentleman and the artisan. As Slade Professor, Ruskin often found Oxford too noisy and crowded for him, and he took to staying at the Crown and Thistle Inn at Abingdon, some ten miles south of Oxford. From there he would give himself the pleasure of walking* into Oxford for his work. Distressed by the muddy and dirty condition of a lane in the village of Ferry Hinksey, through which he had to pass, he secured the owner's permission to organise work on it. In March 1874 he inaugurated the scheme with a breakfast party in his rooms at Corpus Christi College. The participants included Andrew Lang, Arnold Toynbee, the future Lord Milner, and one of Ruskin's future executors and editors, Alexander Wedderburn. Oscar Wilde made a brief appearance. The roadmending was supervised by Downs, Ruskin's gardener, who, of course, did much of the work himself. Journalists found the Slade Professor's determination to turn under-graduates into workmen irresistibly funny and there was widespread mockery: crowds gathered in Hinksey to jeer and there were lampoons in *Punch*. Henry Acland wrote to *The Times* in Ruskin's defence: 'Surely in an age of Liberty and Philanthropy well meaning men might be allowed to mend the muddy approaches of some humble dwellings of the poor without being held up to the public as persons meet only for the neighbouring asylum. Is it so, that the principles on which Mr. Ruskin and these youths are acting are insane?'[32] Far from being insane, they were part of the philosophy of the new order set out in Ruskin's political and educational writings.

By far the most important of practical educational achievements was the establishment of a museum in Sheffield. This, like the Oxford Museum, was primarily designed to educate. It fulfilled the other half of Ruskin's personal mission in these years: he was both Slade Professor and author of *Fors Clavigera*, addressed to the Workmen of Great Britain, and it was in the latter role – as a contrast and counterbalance to his work in Oxford – that the Sheffield museum is to

*He was always a heroic walker; staying at the Crown and Thistle meant that in practice he made a round trip on foot of twenty miles a day, which to him was no more than agreeable and refreshing exercise.

be seen. The central figure in the Sheffield project was the extraordinary Henry Swan (1825–89), another 'servant' who had been a pupil of Ruskin's. Swan was born at Devizes in Wiltshire; a member of Ruskin's classes at the Working Men's College (1854–8), he was thereafter a lifelong disciple. Swan was a Quaker and a vegetarian, a marked eccentric, and a man of a wide range of interests and great intelligence.[33] From his home in Walkley in Sheffield he corresponded with Ruskin, and at Swan's invitation Ruskin went down to Sheffield in 1873 to meet a group of working men. Their willingness, intelligence and rough strength delighted Ruskin, who was so pleased by this meeting that he chose Sheffield as the place for the St George's Museum. Ideally the museum as a focus for community education should have been established after the ideal community – agrarian, free of machinery and capital – had come into being. But Swan's enthusiasm caused him to change his mind. On 12 July 1875 we find him writing to Swan:

> It is very wonderful to me the coming of your letters just at this time. The chief point in my own mind in the material of education is the getting of a museum, however small, well explained and clearly and easily seen. Can you get with any Sheffield help a room with a good light, any where accessible to the men who would be likely to come to it? If so, I will send you books and begin with minerals, of considerable variety and interest, with short notes on each specimen, and others of less value, of the same kind which the men may handle and examine at their ease.[34]

Swan found a cottage with some land at Walkley, and on 18 July 1875 Ruskin wrote to him promising to arrange to 'enter into treaty for the purchase of the quiet detached piece of ground with the building thereon, if it can be bought at a price which I may justify to the Company' (St George's).[35] In Letter 56 of *Fors Clavigera* Ruskin wrote of becoming 'responsible for rent of a room at Sheffield in which I propose to place some books and minerals as the germ of a museum arranged first for workers in iron'.

In January 1876 Ruskin bought the cottage at Walkley, and installed Swan, rent-free, at a salary of £50 p.a. In March 1877 the salary was raised to £6 per month, and in August up to £100 for the year, 'and at that figure it remained'.[36]

The ten bound volumes of Ruskin's unpublished letters to Swan and his wife (now in the Rosenbach Museum and Library, Philadelphia) show that Swan worked extremely hard for Ruskin. Although after the illness of 1878 the relationship became difficult, from Swan's view-

point, because his revered master left everything to him and was simply too ill and too distracted to attend to the business of the museum in any detail, for the first few years the project went well, provided Swan recognised that there was no room for disagreement with Ruskin. For example, Swan sent Ruskin some poetry (it is not clear whether it was by him or another Sheffield man). Ruskin's letter in response made it clear that in practice he had no time for workman poets. 'The verses are fairly good, but it is always sad to me to see uneducated men setting their imperfect wits to work to do what others have done so much better long ago. . . . the business of the modern work man is to learn the difference between one man and another – not to pass his life in self laudation on the grounds of his having two legs with a stomach and a bladder between them.'[37]

The Walkley Museum was very small. As the building housed both the exhibition – largely copies of Ruskin's favourite paintings, done by Ruskin's employees, and books given by Ruskin – and Swan and his family, it was extremely cramped. Nevertheless it was a success. Swan wrote to J.W. Bunney, another former pupil at the Working Men's College and now one of Ruskin's most exhaustive copyists: 'there are many things which prove to be very charming in the eyes of the rough and hard-handed work men, and we've not had . . . a single instance of anything but most pleasant and reverent attention – nothing approaching even in the slightest degree to rude or flippant behaviour in them'.[38]

Among all the 'St George's' projects that he set in motion Ruskin found the most pleasure and fulfilment in the museum. In general, the objectives of the St George's fund and the Guild of St George were hard to meet, because far fewer people came forward with offers of land and money than Ruskin had expected. He was delighted with a gift from Mrs Fanny Talbot – later to become a Companion and one of his closest friends, the 'Dear Mama Talbot' of an intimate run of surviving letters – who gave land and cottages at Barmouth, on the Welsh coast. But in general too few potential 'Companions' with the right wealth came forward. Ruskin was too exacting. He wrote to the long-suffering Swans (the letter is addressed to Emily Swan) to say that they themselves could not become Companions because they lacked the personal wealth to make a sufficient tithe: 'But there are comparatively few to whom I will give power over the property of the company and the election of the Master, or deposition: and so much independence as to be able to afford a clear tenth of the salary is a

preliminary condition – and rather a severe one.'[39]

He continued to be generous, recklessly so, with his own money. In response to a request from the Sheffield 'mutual improvement class' – a group of communists among the working men – he agreed to visit Sheffield in April 1876 to talk to the group about communism. The talk produced a concrete proposal, namely that Ruskin should acquire land for the group on which they could live as a commune. Ruskin was flattered into agreeing with this. In a letter from Venice, he asked Swan for details about those proposing the commune: 'It is quite possible that if a certain number of Sheffield men were to join, of good character, I might advance them some of St. George's fund to buy land with, if land is to be had, in the neighbourhood.' And a follow-up letter to Emily Swan detailed the way in which this communist society should be managed, as already outlined in *Fors Clavigera*:

> the January Fors, as the first beginning of practical advice to the men of Sheffield, tells them to determine accurately a Sheffield district, within which they will endeavour to conduct things in a rational manner. Within that district, they are to number and register every person, with their families, in need of support from day to day, and they are to ascertain the total quantity of the wages earned by them, and the present manner of expenditure of those wages, and the quantity of good procurable with it, if rightly spent. Also, they are to elect some married couple, whom they can trust; and to give them the utmost powers the law permits – and entrust them to superintend all markets and sales of provisions. . . . As they can agree among themselves to establish greengrocers, butchers and bakers who will submit to their rules – and to see that no food is wasted or lost by competition or middlemen, or spoiled by overkeeping.[40]

Swan and the communists found a 13-acre farm at Totley, outside Sheffield, which Ruskin then bought. It was set up as a 'Commonwealth' under the direction of a socialist, William Hamilton Riley.

At the practical level Ruskin was more interested in museums than in farming. The Walkley museum made an excellent start under Swan and after Ruskin's illness of 1878 he told Swan that it was the only St George's project to which he would continue to commit himself: 'I got better gradually, and hope to be of some use in this present evil world, yet. I thought I was going to a much worse one, most of the time I was ill. The Museum, I hope to be able to attend to, as well as ever, in a little while. But the St. George's Company must shift for itself as if I were dead.'[41] As far as the farm was concerned, he warned Swan, he must not have demands made on him. He wrote: 'everything depends on my

not troubling myself, or thinking about it [St George's Company] a moment more than is pleasant to me, and you must all think of me as a mere King Cole with his pipe put out, and nothing much in his bowl, determined at least that he won't let anybody talk to him and interrupt his fiddlers.' The Commonwealth at Totley was, in effect, a set of badly managed allotments. The man in charge, Riley, would not work on the land himself. Quarrels broke out among the communists and in due course (as with the Hinksey roadmending) Ruskin arranged to send down David Downs, his gardener, and his wife, to manage the farm: 'in all matters respecting the management of the land, he is to have whatever authority I could have myself, if I were there . . . he is also an excellent accountant, and will look into whatever needs eyes, in the current money matters'.[42] The Ruskinian Republic was always managed like a medieval monarchy and here is a clear example of it with his commune manager* and his museum director both in effect members of his household. After his illness he would come back to the museum and to the activities of the guild with renewed force, but it was not until 1880 that *Fors* resumed its account of the way the Ruskinian Republic was to look.

The Walkley building was always too small for Ruskin's purpose. From his appointment by Ruskin in 1875 until his death in 1889 Swan did his best, but he often displayed vexation over the gap between the reality of the building and Ruskin's dreams for it. Ruskin would send parcels of books, minerals and other treasures – often very expensive – which would remain unopened because Swan had nowhere to display the things. In 1879 Prince Leopold, Duke of Albany, Queen Victoria's haemophiliac son, who had been a friend and patron of Ruskin since 1871, came to visit the museum. The royal visit was noticed in the press and shortly after it Swan wrote in comic despair to J.W. Bunney, using the Quaker forms of speech: 'The whole space we have at command for displaying either to royal princes or to nascent genius, is – one room 13 ft. square . . . I dare say thou hast seen the report in the "Times" which tells folk that the museum consists of a small mansion situated in its own grounds. Well that's reporter's English for a five-roomed cottage lying in a freehold land allotment.'[44]

There had been other vexations for Swan in 1879. After his illness of

*Downs ran the Totley farm as a fruit farm for a few years. The tenancy was then taken over by George Pearson, a former miner who managed the farm successfully for half a century.[43]

1878 Ruskin simply neglected the St George'sCompany. There was a major meeting of the company in Birmingham on 21 February 1879, but the Master did not go to it. Swan wrote in mild reproach:

> My dear Master, thanks and praise are in our hearts in that we could look into each others' eyes last Friday and say each to himself 'Yes, the good ship *is* launched.' Many eyes and hearts sought also to find their loved leader. Emily had persisted that thou would not be at the meeting but that all St. George's people should be present and *thereby strengthen each other*.

Even though he did not go to the meetings of his own company, Ruskin had written on 15 February saying that he wanted it to raise money for 'a museum building. They must try and get me some funds, and I'll soon design it, and set Creswick [an artisan turned sculptor] to carve. I mean to do it St. Mark's way, – brick with marble casing, so I can get my inner walls built and dry at once, and go on at leisure adding panel by panel of decoration.'[45]

Extension of the building would have to wait. Much of Ruskin's subsequent correspondence with Swan was to do with his attempts to raise money for this purpose. In 1885 the museum was extended by the building of a wooden gallery, and in 1890 with the help of Sheffield city it moved into a much larger building. After 1885, then, there was room for a better display of the paintings, including a big, painstaking painting of St Mark's, Venice, by Swan's correspondent John Wharlton Bunney (1827–82). Another of Ruskin's former pupils, Bunney was a laborious, careful copyist, always disappointed of an independent career as a painter. He and his family were supported by Ruskin for many years. Bunney found Ruskin a difficult and unsympathetic employer (he was especially upset when one of his children died and Ruskin appeared to ignore the bereavement) but Ruskin genuinely tried to establish Bunney as a painter and shared in his disappointment. The painting of St Mark's was Bunney's biggest work (left unfinished at his death); it took him two years of exhausting labour and indeed the effort appears to have killed him.

The display included copies of a number of the Italian paintings, especially Venetian ones, that had been most important to Ruskin, including Ruskin's own copy of Carpaccio's *St George and the Dragon*, from the Scuola di Schiavoni, and excellent copies by Angelo Alessandri (1850–1935) of a detail of Carpaccio's *Dream of St Ursula* (the figure whom Ruskin identified with Rose La Touche) from the

Accademia, and of Tintoretto's *The Annunciation* from the Scuola di San Rocco. These latter copies were displayed after 1890, by which date Ruskin had descended into his long final twilight.

In the 1880s Ruskin was constantly revisiting his own past. In a sense, this process went on all his life – he was constantly rereading and reworking old diaries, referring back to old memories, always acutely aware of loss and change and the relentless passage of time. The great literary achievement of the 1880s was his unfinished autobiography, *Praeterita*.

Rose La Touche had died in 1875 and Ruskin had become convinced during his year in Venice, 1876–7, that she was communicating with him through the figure of St Ursula (in Carpaccio's cycle of paintings). In the *Fors Clavigera* letters written in December 1876 and January 1877 (published in February and March) he remarked that he had had communications from mystified readers and he undertook an important exercise in autobiography, the better to explain himself to them. He wanted to satisfy his 'Sheffield men', the pioneers of the new utopian community of St George that he was setting up there. In the autobiographical letter he seemed full of hope – maybe he was simply pleased by the view from his window as he looked out from La Calcina over the Giudecca. He was glad to see shining under the Venice sun a ship which had 'St George's shield and cross on it; the first ship's bow I ever saw with a knight's shield for its bearing'.[46] He looked forward hopefully to the good work that his Sheffield men would do on the land that he had bought for them, the men 'to whom St George has now given thirteen acres of English ground for their own'. The basis of the enterprise was democratic, indeed communist, since St George's laws were not to be held to 'under any formal strictness'. Ruskin wanted his Sheffield men to see him as all permissiveness and goodwill in relation to this enterprise. The essential rule was good work and no steam engines, 'no moving of machinery by fire'. But a religious code underlay the Guild of St George, and this he proceeded to spell out. To do so involved giving an autobiographical account of his own religious development over the past twenty years.

> You cannot but have noticed – any of you who read attentively, – that *Fors* has become much more distinctly Christian in its tone, during the last two years; and those of you who know with any care my former works, must feel a yet more vivid contrast between the spirit in which the preface to the *Crown of Wild Olive* was written, and that in which I am

now collating for you the Mother Laws of the Trades of Venice.

His present attitudes were the product both of his private life (he made a veiled reference to the tragedy of Rose's death) and of an experience in Assisi in 1874 which had caused him to see that his teaching over the previous sixteen years – since his unconversion in Turin in 1858 – had been based on a fallacy.

> All my first books, to the end of the *Stones of Venice*, were written in the simple belief I had been taught as a child; and especially the second volume of *Modern Painters* was an outcry of enthusiastic praise of religious painting, in which you will find me placing Fra Angelico (see the closing paragraph of the book) above all other painters.
>
> But during my work at Venice, I discovered the gigantic power of Tintoret, and found that there was a quite different spirit in that from the spirit of Angelico; and, analysing Venetian work carefully, I found, – and told fearlessly, in spite of my love for the masters, – that there was 'no religion whatever in any work of Titian's; and that Tintoret only occasionally forgot himself into religion.' – I repeat now, and reaffirm, this statement; but must ask the reader to add to it, what I partly indeed said in other places at the time, that only when Tintoret forgets himself, does he truly find himself.[47]

In 1858 he had found 'a great *worldly* harmony' running through the work of the great Venetians, especially Titian and Tintoretto, whom he saw as 'worshippers of Worldly visible Truth'. He found it impossible to understand this from within the constraints of his evangelical faith, and he followed this observation with one account of his famous unconversion of 1858:

> In 1858, it was with me, Protestantism or nothing: the crisis of the whole turn of my thoughts being one Sunday morning, at Turin, when, from before Paul Veronese's Queen of Sheba, and under quite overwhelmed sense of his God-given power, I went away to a Waldensian chapel, where a little squeaking idiot was preaching to an audience of seventeen old women and three louts, that they were the only children of God in Turin; and that all the people in Turin outside the chapel, and all the people in the world out of sight of Monte Viso, would be damned. I came out of the chapel, in sum of twenty years of thought, a conclusively *un*-converted man – converted by this little Piedmontese gentleman, so powerful in his organ-grinding, inside-out, as it were. 'Here is an end to my "Mother-Law" of Protestantism anyhow! – and now – what is there left?' You will find what was left, as, in much darkness and sorrow of heart I gathered it, variously taught in my books written between 1858 and 1874. It is all sound and good, as far as it goes; whereas all that went

before was so mixed with Protestant egotism and insolence, that, as you have probably heard, I won't republish, in their first form, any of those former books.

Thus then it went with me till 1874, when I had lived sixteen full years with 'the religion of Humanity,' for rough and strong and sure foundation of everything; but on that, building Greek and Arabian superstructure, taught me at Venice, full of sacred colour and melancholy shade.

In Assisi he had made a copy of the fresco in the lower church, which was then attributed to Giotto: *The Marriage of Poverty and St Francis*:

And while making this drawing, I discovered the fallacy under which I had been tormented for sixteen years, – the fallacy that Religious artists were weaker than Irreligious. I found all Giotto's 'weaknesses' (so called) were merely absences of material science. . . . Don't be afraid that I am going to become a Roman Catholic, or that I am one, in disguise. I can no more become a *Roman*-Catholic, than again an Evangelical-Protestant. I am a 'Catholic' of those Catholics, to whom the Catholic Epistle of St. James is addressed – 'the Twelve Tribes which are scattered abroad'. . . . The St. George's creed includes Turks, Jews, infidels, and heretics; and I am myself much of a Turk, more of a Jew; alas, most of all, – an infidel; but not an atom of a heretic: Catholic, I, of the Catholics.[48]

Ruskin was attracted to the idea of being a Franciscan contemplative in the same way that he was drawn by the rocks and plants that he wrote about in *Proserpina* and *Deucalion*, and by the beauty and retirement of Brantwood; in his increasingly precarious state of mental health his instincts told him that peace was good for him. The public involvement in trade union affairs (in *Fors Clavigera* after 1880), in his attacks on sensational literature (in *Fiction, Fair and Foul*) and in his writing on the effect of industrialisation on the climate (in 'The Storm-Cloud of the Nineteenth Century'): these and his decision in 1883 to return to Oxford were all in their various ways dangerous for him. In the summer of 1880, for example, he wrote of 'paradisiacal' walks with Joan and her children at Brantwood, and perfect conditions for work:

July 2nd [1880]: Room in *perfect* order and I wonderfully well. Joanie home quite well, and children happy, D.G., and sun on fells, and a cranberry blossom in my saucer ready to be drawn. Found them yesterday, in breezy afternoon, on the hill, all sparkling like little rubies.

But the good state of mind was temporary. He was working on *Fiction, Fair and Foul*: 'Scott papers and Byron work very bad for me,

without a doubt. Some letters too have made me angry – worst of all.'[49] The diary entries over these years showed that he was aware of these dangers. The attraction to the religious life, which he had felt intensely at Assisi in 1874, was part of the self-regulating that went on in the diaries. In a spirit in which the typology and patterning of the Christian life offered redemption for the anxious self, he began a collection of writings which was to take Christian subjects as the source of universal moral teaching: *Our Fathers Have Told Us*, the work of Ruskin the Franciscan. The only part to be completed was *The Bible of Amiens*. Much of this was written when he took another French tour, in October 1880, and he gave a kind of summary of it as a lecture at Eton in November. Diary entries in October showed him dedicating himself to a version of the religious life of medieval monasticism. He organised the true 'St George' virtues into a pattern: 'Faith. Poverty. Charity. Chastity. Hope. Obedience.' And further work on the Eton lecture led him further into this ideal of life:

[31 October 1880] Slept better, after seeing my way to end of Eton lecture. Giotto – Poverty – Chastity and Obedience; as Faith – Hope – Charity. Purity is Hope; I keep under my body, striving for the Mastery, Temperance in all things. Obedience is Charity . . . Poverty, Principal as Faith.

He envisaged the virtues as 'all in a daisy cluster – radiant – round Christ'.[50]

Ruskin was to remain a hugely productive figure, but after 1878 the letters and diaries, friends' reports, manifold and often manic public activities, causes old and new, relationships with his family and his disciples, forays into love-making and so on, all tell one sad story – Ruskin was never fully to recover his mental health. After the disabling attack of 1878, he suffered further breakdowns in 1881 and 1882, each in the early spring. They left him enfeebled. Thereafter they recurred annually until 1889 when his mental illness effectively disabled him for the rest of his life. He was still in good physical condition – the record of his life in Brantwood shows him taking great walks over the hills, working with his own hands on the maintenance of the place and rowing his boat in all weathers over Coniston Water to visit friends – but his inner state was often agitated and panicky.

One characteristic effect of his illness was the difficulty that he had in sleeping. Whether at Brantwood or Herne Hill, Oxford or abroad,

he regularly woke before 5.00 in the morning and was unable to sleep again. He was therefore jaded and tired when he sat down to the day's work. The diary shows him trying to avoid stimulants at night and overeating: 'Still can't sleep – had to get up and write thoughts last night – after taking less tea and a long walk. – I hope it is currant pie and green pease, not tea, and will be resolute – next month [i.e. the next day, 1 August].'[51] It is unlikely that his insomnia had anything to do with diet, as problems with sleep are a characteristic symptom of depressive illness. He continued to feel under extreme pressure of work. Looked at objectively, Ruskin was under no obligation to do anything at all after 1878 – he could simply have rested at Brantwood and recovered himself. But he believed that destiny required him to continue with *Fors Clavigera*. Later, somewhat refreshed by a continental trip of 1882, he again felt a sense of obligation to resume the Slade Professorship at Oxford. At the same time, though, living from day to day, he was aware that he needed to protect himself from strain and exhaustion. He wrote to William Morris declining an invitation to speak (presumably in connection with the work of the Society for the Protection of Ancient Buildings):

> Please recollect – or hereafter know – by these presents – that I am old, ill, and liable any day to be struck crazy if I get into a passion. And, therefore, while I can still lecture – if I choose – on rattlesnakes' tails, I can't on anything I care about. Nor *do* I care to say on this matter more than I have done, especially since I know that the modern mob will trample to-morrow what it spares to-day. You younger men must found a new dynasty – the old things *are* passed away.[52]

He was working, of course, on *Fiction, Fair and Foul* as well as *Fors Clavigera* and an essay on snakes, which in due course became 'Living Waves'. The diary recorded the pressure of these commitments: 'Rain all day yesterday felt like a rest. This morning my head so full of crowded thoughts about Museums – Prosody, Clergy, Snakes, Scott & Byron – all in hand together – that I don't know what to do.' And the following day he pleaded for more time and energy than life seemed to make available to him: 'Heaven grant me wisdom and strength to spend these lengthening days well, and not to fear the shortening ones. But what Heaven means by letting me see my way to so much, and make my way to so little – Heaven must explain to – whom it chooses, in its own time. One thing I get more and more sure of – that the Devil is rampant everywhere.'[53]

Early in 1881 Ruskin suffered his second mental breakdown. It was

probably precipitated by the death of his beloved 'Papa' Carlyle on 5 February, an event marked in his diary with a cross and nothing else. He was insane between 20 February and 22 March of this year. One of the first friends to whom he wrote when he recovered was the steadfast Norton:

> I went wild again for three weeks or so, and have only just come to myself, if this *be* myself, and not the one that lives in dream.
>
> The two fits of – whatever you like to call them – are both part of the same course of trial and teaching – and I've been more gently whipped this time and have learned more: but I must be very cautious in using my brains yet, awhile.[54]

Clearly in his own mind Ruskin associated the illness partly with the death of Carlyle, partly with memories of Rose. Many of the diary entries and letters following the illness referred to Rose, and compared the extent to which she was responsible for this illness with her more obvious part in the illness of 1878. Another letter to Norton was particularly revealing:

> These illnesses of mine have not been from overwork at all, but from over-excitement in particular directions of work, just when the blood begins to flow with the spring sap. The first time [1878] it was a piece of long thought about St. Ursula; and this year it was brought on by my beginning family prayers again for the servants on New Year's Day.

Not that the 'family prayers' were dangerous in themselves, but the revival of religious observance tempted him to try (once more) to communicate with Rose in the spirit world. He had devoted his evenings 'into a steady try if I could n't get Rosie's ghost at least alive by me, if not the body of her'.[55]

He had another, less serious, episode of mental excitement in September of 1881 and he was, of course, throughout the year, continuing to work hard at his various projects:

> December 1st [1881, at Brantwood]. I begin the last twelfth of the year, in which I proceed, D.V., to finish IInd *Amiens* and 7th *Proserpina*; and in the year, I shall have done, in spite of illness, 3 *Amiens*, 1 *Pros[erpina]* and the Scott paper for *Nineteenth* [*Century*, the first paper of *Fiction, Fair and Foul*], besides a good deal of trouble with last edition of *Stones [of] Ven[ice]*. But alas, what a wretched year's work it is, and even that not finished yet! But there was some good drawing in spring.[56]

In March of 1882 he had another breakdown. This illness was preceded by agitated diary entries about the weather: 'a quite fearful

storm of our worst sort, disturbing me from work, with my head full of material, but yet weak from nightmare all night'; 'The morning *always* as black as Newcastle and the wind malignant all day long. My mind driven away from nature wholly into books (except for geology) with more harm to it than I can at all measure. The difference between a sweet sunrise over the Norwood hills, as I used to see it in youth, and this drifting blast of furnace smoke, tearing the leafage to and fro, and taking every hue of life out of grass, water, and hills!' The relationship between the apocalyptic January weather and the inner disorder becomes more bleakly obvious as the days pass: 'St. George's work getting into order and I sleep well, and enjoy minerals; but all the life taken out of nature by the diabolic weather. Y[esterday] a red, lurid, languid hundredth part of a sunset, all the sun we had in the day'; 'Y[esterday] a bad day of hesitations, shifts and despairings. Fog all day unbroken, and scum on lake. Today, pouring of rain in early morning, now stopped, but always dismal'; 'Fog like Manchester all yesterday; never got out. To-day the same, and I terribly languid'; 'The fifth day of entirely unbroken fog, filthy as Erebus'; 'the morning sky beginning to be fouled, as I write, by the plague-cloud!'; 'I don't know when – or if I ever – have felt so utterly listless and powerless as all y[esterday] aft[ernoo]n, in rowing through mist across lake, and walking sadly by the stream under the rocks which I saw to be lovely, without a ray of pleasure. The perpetual absence of sunshine has a quite deadly effect on me, but I never felt so empty of resolution or care – the last word I mean in the mixed sense of affection and attention. Too much luxury, in little things, sorrow in great, all through life.' In this last entry he summed up the child that he had been and the man that he had become, both spoilt and starved of affection.[57]

Mental illness struck again that March, at the Herne Hill house, now the home of the Severns. He was looked after by Sir William Gull.

In all his illnesses – 1878, 1881 and now 1882 – he had displayed a pathetic craving for affection. One of the people to whom he clung most desperately was Georgiana Mount-Temple,* who received frantic letters from him. After his 1878 illness he had written to her, addressing her as 'Grannie'. He regressed to a childlike relationship, he longed to be a little boy. He was rich enough, of course, to do no work at all and take holidays all the year round, and this is exactly what he promised to do in this letter 'as all good little boys should'. Georgiana Mount-

*Lady Mount-Temple after 1880.

Temple had nursed him through his illness at Matlock in 1871, and he said in this letter:

> I mustn't go on talking of myself. Else – I should have to tell you of sad things in that illness [of 1878] – a very wonderful and terrible one – much more so than the Doctors knew. But *you* know, I never had much favour for THEM. If I had had my senses, I should have called for my beautiful Nurse again – But as it was – I had nurses I didn't like – of my own imagining, and they wouldn't let me have even my own poor Joanie! who had a rather awful time of it! poor sweet – I really don't think I shall – be naughty more nor have naughty illnesses – as long as I live. I'm not going to eat any cake, Grannie – nor read any more nasty books, nor write them, except just a little Proserpina and so on – and you won't send me to school again – Please Grannie? and I'll be your obedient little boy all the year round.[58]

This letter spoke of Rose as though she were still there, and distressed by his illness: 'I was ashamed of myself and grieved R[ose] so, you *can't think!*'

After the 1881 illness he wrote to Lady Mount-Temple to say that he needed to keep completely quiet but his emotional life continued to flay him: 'I am all right again – in the head – very dark yet in the heart, and passing through an experience of which I imagine you and Φιλγ [her husband] know more than any one else can [this must be another reference to Rose's spirit returning to him]. The issue of the matter is that I must be much alone this summer.'[59]

He wrote to her again in the summer, a revealing letter that showed he was now reconciled with Rose's mother, Mrs La Touche ('Lacerta'). He had forgiven the La Touches their role in the Rose tragedy soon after Rose's death, and in the winter of 1876 had been pleased that Joan was in correspondence with Mrs La Touche. Now he told Lady Mount-Temple: 'I am fairly well again, except that I have lost much animal spirits; and am entirely forbidden some directions of thought – by all prudence' (Joan was actively discouraging all thoughts of Rose). 'The last illness was not so terrific as the first, – though quite as sad in the close – and *more* of a warning, since it showed the malady to be recurrent, if I put myself into certain lines of thought.' That these 'lines of thought' had to do with reunion with Rose was shown immediately by the next sentence: 'The visionary part of it was *half* fulfilled – as soon as I was well enough to make it safe for me, by Lacerta's coming to see me.'[60]

Mrs La Touche had visited him at Brantwood that spring,[61] and in

the summer Ruskin was writing to her about his second illness. The most painful of these letters identifies the trigger of his 1881 illness as the erotic obsession with Rose:

> It is nice to hear you call Joanie 'My Joanie.' It is a great shame she and Arfie don't go and see you. I told you of my dream, didn't I? How I set out barefoot to go to Ireland? and how you and R[ose] came here instead? I CAN'T understand how so extremely rational a person as I can lose their wits, and still more how they don't know they have lost them at the time.[62]

The desperate, naked craving for affection recurred in his illness of 1882. He wrote to Lady Mount-Temple: 'Darling Φιλγ Please come and look after me here tomorrow or any day, as soon as you can. I'm afraid I'm going off the rails again – and it looks to me more like a terminus than the other two times. Joan's not well, neither, and we all together want a good look and word in season.'[63] After his third illness he wrote to Mrs La Touche, saying that he saw his mental breakdowns as somehow predestined, not the products of overwork, and that Rose had again been a factor: 'These fits of illness are all *accidents* (what an Accident is – God knows – not I) not in the least consequences of my general work: and I rather fancy the three of them are all I'm meant to have. They were all part of a piece, and, Ireland and *her* "Rest" has had much more to do with them than my English work.'[64]

In his diary later Ruskin saw a moral significance in all three of his illnesses: 'in the first there was the great definite Vision of the contention with the Devil, and all the terror and horror of Hell – & physical death. In the second, there was quite narrowed demoniacal vision, in my room, with the terrible fire-dream in the streets of London; in the third, the vision was mostly very sad & personal, all connected with my Father.'[65]

Joan Severn saw Ruskin through each of his insane episodes, and it is clear that she was patient, loyal, affectionate and frantically worried. In 1878 he refused to eat and the anxiety was that he would starve himself to death. He was also violent. She naturally compared his second illness with the earlier episode. She wrote to Mrs Simon, wife of John Simon, who offered medical treatment in each of Ruskin's illnesses: 'I am sadly grieved to tell you that the poor Coz is ill again as he was before, with a breakdown of brain – it is in every way similar to the last attack – but as yet, without such violence & malice.' Joan had been with her young

family in London and reproached herself – needlessly – for neglecting Ruskin: 'I am miserable at ever having left him even for so short a time – for I guard him daily with the most jealous care – Heaven only knows whether this *could* have been prevented – I fear not under any circumstances.'[66]

Ruskin then again became violent and abusive; she wrote in distress a long letter to the Simons describing his aggressiveness. He had been breaking windows, 'giving absurd orders – & insisting on being Master'. He was 'full of delusions', 'smashed a pane of glass in his bedroom – & swore at everybody he saw – ordering them to leave the house – he was found kneeling in the hall "to receive Cardinal Manning"! – & insisted that the Duke of Argyle – & two ladies "one being Rose" were coming to dinner – & that everything was to be in readiness . . . he was furious at their never appearing – and accused *us*, of preventing it –' This particular manic episode blew itself out and he was exhausted: 'said he was tired – so Arthur with my persuasion got him to lie down on the sofa beside me (I being in bed [Joan had a sprained ankle] –) & wrapt him up – & he fell fast asleep – how I thanked God for that! – he woke much refreshed in about half an hour – wandering a *very* little – calling me "mama" – & himself "a little donkey boy"!'

But the situation remained unstable. Despite her sprained ankle Ruskin required Joan to serve a meal which he then threw at her, and later he locked the cook in his room thinking that she was the queen. Although Arthur Severn, as the senior able-bodied man in the place, was able to subdue him, Ruskin continued 'furious at everybody'. The Severns concluded their letter by asking the Simons to communicate with Dr Luke, who had attended Ruskin in his insanity before, to let him know that the Severns had legitimate authority in the house. Clearly their position was very difficult.[67]

Ruskin continued to give trouble, savaging his doctor (a Dr Parsons), abusing Arthur Severn and Laurence Hilliard, telling Joan that for her own safety he, Ruskin, intended to move out of Brantwood and live on the other side of the lake, the implication being that if he stayed under the same roof he would murder her. But by early April he had recovered.[68]

The distressing regressive episode in which he lay down by Joan and called her his 'mama' and himself her 'little donkey boy' is part of the pattern of his desperate desire for affection. Another recipient of this desire was his correspondent Norton: 'Dearest Charles', 'My darling

Charles', 'Darlingest Charles'. Norton's salutation, in reply, is warm but retains its reserve: 'My dearest Ruskin'.

After the illness of 1882 Ruskin travelled to Europe again, on medical advice, with his secretary W.G. Collingwood and his servant Baxter. His diary reads as though this trip was a conscious act of retrieval of his younger self, a conscious process of preparing to write his autobiography:

> It seemed to me, during a somewhat restless and sad interval of the night, as if my life, with its work and failing, were all looped and gathered in between St. Cergues farewell to Mont Blanc in 1845 and St. Cergues return in 1882. Thirty-seven years. If I am yet granted peace of heart and time enough to reprove – to sum – they have done *some* good. Thirty-seven: take ten to learn what I had only then begun to learn, and they are but 3 × 9 for Art, Geology and St. George.[69]

The diary was like a surrogate parent, a point of reference: the agitated Ruskin rereads his earlier self, and finds safety. It was also a monitor, marking the inexorable loss of time and the damage done by history to his favourite places and favourite works of art, and a repository for his continuing cries of despair over the climate:

> Perfectly black with rain-drizzle through every square inch of air; all y[esterday] the same! Went through it with Mephistopheles driver and the black dog* . . . I never was so tried by weather yet, in all my life; and yet somehow stand it better, pitying poor Collie [Collingwood] only.[70]

Outwardly he was cheerful and convalescent. He wrote to Joan Severn saying: 'I am deeply thankful to find my mind unchanged in any traceable way by my grave illnesses. I am not more irritable, nor more melancholy, except for the definite cause of being older, and what is left to enjoy is more deeply enjoyed and wondered at.'[71] But Lucca at the end of September prompted sad reminiscences and on 1 October he heard that John Bunney had recently died, which prompted further thoughts about his dead Rose:

> A heavy warning to me, were warning needed; but I fear death too constantly, and feel it too fatally, as it is. Y[esterday] up the marble hills again, where eight years ago I lay down so happy under the rocks beyond the monastery, to read R[ose]'s loving letters. Now, my strength half gone; my hope, how changed![72]

*Collingwood noted that he was later kind to this driver and his dog.

In October 1882, in Florence, Ruskin was introduced by a mutual friend, the artist Henry R. Newman, to Miss Francesca Alexander, an American in her mid-forties. Her stories and drawings of Tuscan peasants delighted Ruskin and caused him to lavish patronage on her. He wrote to Norton: 'I've actually been obliged to run away from Florence lest I should be converted into an American-citizen. There are two such precious American women there, Mrs & Miss Alexander.'[73] Ruskin bought the manuscript of Francesca Alexander's *The Roadside Songs of Tuscany*, illustrated with her own drawings, for 600 guineas for his Sheffield museum. He edited it and published it in twelve parts (1884–5) with his own Preface. He was also hugely pleased by a story told by Francesca about a young girl who died at the age of seventeen, 'The Maid of Fesole'. This, edited and published by Ruskin as *The Story of Ida* (1883), clearly echoed Rose La Touche in his mind.

It is hard to know what to make of Francesca Alexander. Her letters to Ruskin and her written recollections of him are sycophantic and sentimental, but probably genuine in feeling. She was astonished – rightly – that this great figure should take her seriously as an artist, and she clearly fell in love with him. But it seems to have been a kind of religious veneration rather than an attempt by a provincial gold-digger to make her fortune (she was often in poor health, and was in low water financially when she met him).

Ruskin seems to have been in earnest in his praise of her work. Her examples of peasant life in Italy came at the right time to embody, for him, the utopia that he had been seeking to create for the workman in Britain. Free of machinery, the peasant's lives displayed simplicity, purity, self-sufficiency, satisfaction in work and other Ruskinian virtues. Further, Ruskin was able to see Francesca as a kind of untutored genius with a natural gift for narrative, verse translation and perfect Pre-Raphaelite drawing. He used her simple virtues to castigate all that he thought was wrong with contemporary writing and fine art back in Britain. In his Preface to *The Story of Ida*, for example, he championed Francesca's little narrative as a perfect 'domestic history', contrasting sharply with the worthlessness of most 'modern biography'. *Fiction, Fair and Foul* had got Ruskin used to writing raucous and over-stated literary judgements, and that bad habit returned here. The highest moral ground, then, in terms of purity and simplicity, was secured for Francesca's narrative. And Francesca's 'faithfulness' made her the perfect Pre-Raphaelite: she 'represents any imagined event as far as possible in the way it must have happened, and

as it looked, when happening to people who did not then know its Divine import'. Unlike the English Pre-Raphaelites (including, presumably, for the moment, the figures whom Ruskin most admired, such as Burne-Jones and Holman Hunt), 'Miss Alexander represents everything as it would have happened in Tuscany to Tuscan peasants, while our English Pre-Raphaelites never had the boldness to conceive Christ or His mother as they would have looked, with English faces, camping on Hampstead Heath, or confused among a crowd in the Strand: and therefore, never brought the vision of them close home to the living English heart'. His anger with the English artists mounted as he warmed to his theme. To the point that the life of the Italian peasant was quite like that of Christ's followers in Palestine, while the life of the modern Londoner was not, Ruskin replied that artists 'have no business whatever to live in London, and that no noble art will ever be there possible'.[74]

'Noble' was apparently merging in Ruskin's mind at this period with non-British, non-technological, neo-medieval and *Catholic*. At some pains to show that he was not becoming a convert to the Roman Catholic Church, he followed Francesca Alexander's books with an explicitly Protestant story, the Swiss tale of *Ulric the Farm Servant* (by J. Gotthelf) translated by Julia Firth (a long-suffering member of the Guild of St George), and edited and published by Ruskin in 1886–8. Its publication countered the obvious charge that the virtues of Francesca's peasants were exclusively Roman Catholic.

Ruskin had imagined himself a Franciscan during his visit to Assisi in 1874. He had known Cardinal Manning since the 1850s and in the late 1870s became increasingly friendly with him; Manning saw in him a likely convert. Several years later, Ruskin was to say that only the doctrine of the Mass separated him from the Roman Catholics. He chose not to take that route, but by the 1870s and 1880s had obviously revised his earlier religious positions to the extent of recognising what he had always denied in his work on the Gothic in *The Stones of Venice* and *The Seven Lamps of Architecture*, namely that there was a direct connection between the glory of Gothic architecture and the power of the medieval Catholic Church.

Ruskin had befriended Jessie Leete, a governess who visited Brantwood in 1880. She told him that she was unable to find any suitable teaching materials about great Christian works of art. This led Ruskin to begin work on 'Sketches of the History of Christendom for

Boys and Girls who have been held at its fonts'. The plan for it* was splendid in its scale and enthusiasm. It was to have been in ten parts. The first exists as *The Bible of Amiens* (about Amiens Cathedral) and the two closing parts were to have been 'Pastoral Catholicism' and 'Pastoral Protestantism'. Ruskin wrote his plan with boundless optimism: 'I do not recognize, in the present state of my health, any reason to fear more loss of general power, whether in conception or industry, than is the proper and appointed check of an old man's enthusiasm: of which, however, enough remains in me to warrant my readers against the abandonment of a purpose entertained already for twenty years.'[75] In *The Bible of Amiens* itself he revisited the method and the ambitious viewpoint of *The Stones of Venice*. There Ruskin had created intersecting historical and geographical systems that established the Doge's Palace as the central building, both literally and symbolically, of the world. In Chapter 4 of *The Bible of Amiens* he made similar claims for the apse of Amiens: 'not only the best, but the very *first* thing done *perfectly* in its manner, by Northern Christendom . . . the first virgin perfect work – Parthenon . . . in that sense – of Gothic architecture. Who built it, shall we ask? God, and Man, – is the first and most true answer. The stars in their courses built it, and the Nations.'[76] This exemplary building is the flower of the civilisation of its day.

He never finished the series, but did manage to write two unpublished papers on English monasticism, called 'Candida Casa' and 'Mending the Sieve', which displayed a huge enthusiasm for the monastery as a benevolent, innocent community. Some pages read like prose equivalents of the plates in Pugin's *Contrasts*:† early in 'Mending the Sieve', for example, a discussion of two particular ruined abbeys in Walter Scott's border country, Melrose and Jedburgh, led into a kind of satirical diagram in which the ruins were located in modern England and juxtaposed with soulless modern industry and the self-serving vicar and squire of the modern Anglican parish:

> You cannot but feel that this British Isle of ours, after all its orthodox
> Reformations and cautious constitutions, presents you with materials for

**Our Fathers Have Told Us* was planned as a series of texts about Christian art: first, *The Bible of Amiens*; then studies of Verona, the foundation of the papacy and of monasticism, Pisa and Florence, English and Welsh monastic buildings (part of this section, to be called 'Valle Crucis', was written), Chartres, Rouen; and then the two conclusions.

†That important book of the 1830s by the central Catholic architect of the Gothic revival, a figure whose work Ruskin disparaged but had certainly learnt from.

this inquiry [into monastic life] in extreme sharpness and simplicity. At one crook of the glen are the remains of the Abbey, with its half-fallen tower and half-buried cloister; at the next are the new mills, with their cloud-piercing and cloud-compelling chimney, and their quarter of a mile of square windows in a dead wall. As you walk back to the village inn, you meet the clergyman inspecting the restoration of his parish church; in the parlour of it you find the squire, bent on the introduction of agricultural machinery, which will send the congregation to America. And among the various shades of benevolent avarice, pious egotism, and interest-bearing charity, in which the enterprises of a rational age must be undertaken, we shall surely be able to discover, if human nature be as constant as it is alleged, the likeness, in some sort, or even the remnant, of ancient enthusiasm, and discern, in the better movements and kindlier impulses of our own hearts, ground for believing that even monastic sentiment was not entirely dishonest, nor monastic adventure entirely selfish.[77]

The best part of the tour of 1882 was Ruskin's work in Pisa, where he was recovering his old role and his old confidence. Norton had raised a question about the principles of construction used by the architects of the Duomo and of the Leaning Tower. In reply Ruskin reverted to the methods of *The Stones of Venice*; that is to say, he examined the structures themselves, without preconceptions and without a great burden of received scholarship. He trusted his observation and his instincts. He wrote from Lucca to Norton, who was at Pisa: 'in all great medieval buildings you have foundation unequal to the weight – you have more or less bad materials – and you have a lot of stolen ones'. Addressing the question why the Pisa architect built his walls 'with the bottoms at the top and the sides squinting', he decided: 'He likes to show his thefts to begin with – if the ground gives way under him – he stands on the other leg. I've long believed myself that finding the duomo wouldn't stand upright – anyhow – they deliberately make a ship of it with the leaning tower for a sail!' Above all, the buildings conformed to the central principle of Ruskin's own teaching: the builders were contented with their work:

All this entanglement is of no importance as to the main question of – 'Liberty' of line, which even *I* have always taught to be the life of the workman, and which exists everywhere in good work to an extent till now unconceived, even by me – till I had seen the horror of the restoration which put it 'to rights.' Nearly all our early English Gothic is free hand in the curves – and there is no possibility of drawing even the apparent circles with compasses.[78]

This was followed by another big, happy letter, full of detailed observation, in which Ruskin was able to put flesh on the bones of his previous remarks. Now at Pisa with Commendatore Giacomo Boni (1859–1925), who had worked on the Roman forum, and was undertaking drawings of the main architectural sites at Pisa for Ruskin, he concluded that the uneven façade of the Duomo at Pisa was the consequence of inadequate foundations and piecemeal medieval building methods (as he had guessed in his previous letter). The medieval builders displayed 'an almost exalting delight in conquering difficulties or introducing anomalies, which is rather provoked to frolic than subdued by an interference of accident. It seems probable that the five western arches of the nave were added after the rest with less careful foundation, and that they sank away from the rest so.' He then included some drawings. The point of the letter was to say that the appearance of the building is a matter of accident rather than design.[79]

The tour of 1882 undoubtedly benefited his health and it seemed as if he might make a full recovery. His Oxford friends, led by Acland, felt enough confidence to propose reinstating him in the Slade Professorship. The sitting Slade Professor, on hearing that Ruskin would like to resume the post, obligingly resigned, and Ruskin was appointed by a telegram from Acland in January 1883.

Ruskin knew that part of his duty to himself was to secure a kind of equilibrium, and he wrote to Norton:

As far as I can judge, there is no threatening for I sleep quite soundly, and long enough, and people say I am looking well. But it is curious that I really look back to all those illnesses, except some parts of the first, with a kind of regret to have come back to the world. Life and Death were so wonderful – mingled together like that – the hope and fear – the scenic majesty of delusion so awful – sometimes so beautiful – In this little room – where the quite prosy sunshine is resting quietly on my prosy table – last year, at this very time, I saw the stars rushing at each other – and thought the lamps of London were gliding through the night into a World Collision – took my pretty Devonshire farm-girl Nurse [a young woman called Ruth Mercier] for a Black Vision of Judgment – when I found I was still alive – a tinkling Italian organ being to me the music of the Spheres.

Nothing was more notable to me throughout the illness, than the general exaltation of the nerves of Sight and hearing – and their power of making colour and sound harmonious as well as intense – with alternation of faintness and horror of course. But I learned so much about the nature of Phantasy and Phantasm, – it would have been totally

inconceivable to me without seeing, how the unreal & real could be mixed.

And Norton, in his sane, restrained way, responded with affectionate concern and excellent advice: 'I am thankful that you have passed so well through the dread season. It is vain to preach prudence to you, but still I hope that the need of caution will be steadily present with you, and I have a still deeper hope that advancing years will bring more tranquillity to your life and more peace to your heart than they have had in the past.'[80]

Norton continued to send good advice, sometimes directly to Ruskin and sometimes to Joan, who was increasingly (and rightly) seen by Ruskin's friends as 'in charge' of him. Ruskin nevertheless suffered another serious illness in July 1885. In September he was able to tell Norton about it:

Joanie tells me you sent me such a sweet scolding, – and then made her burn it. Alas, if I only had sharper scoldings from you long ago, and had been sensible enough to attend to them, – my life looking back on it now – is the woefullest wreck and dream to me.

The last illness [that of July 1885] is entirely irremediable – it has taken all hope out of me, and with hope, all pride. I feel nothing but the opportunities that I have lost and the follies I have done.

And I wonder every day & more & more that anybody cares for me. Happy at least in feeling – with the same increasing force – how much I owe to their care for me – and how good and precious they are. It is some little joy to me to think that you have missed my letters – and that I may perhaps still give you a little – not joy – but assurance of my love – by such broken words as I may yet sometimes write if my life be yet for a while left to linger. Poor Joanie, – she has no idea yet how sad things are – having seen me recover from other attacks – she keeps her daily cheerfulness, – and is more than ever all that the best of daughters and wisest of nurses could be. I was very cruel to her in the unconscious – as it seems to me *contrary* to consciousness – sayings of this last delirium. She forgets all, the instant the hope revives in her that I may be myself once more. . . .

To me the chief of the sorrow – and indeed – the manifoldly multiplied weight of it – is feeling how many love me in vain – and will be grieved when I am gone. – You will not think it pride to say this. I cannot believe in the sweet sayings of my friends. – The love you yourself have given me is – perhaps – of all the most wonderful, but, how could I but believe?[81]

On 1 October he dictated to Joan a letter to Norton saying that he had sadly neglected the work at Pisa initiated by Norton's questions

about the architects' principles (in October/November 1882). He was unable to remember whether the studies undertaken by Giacomo Boni had actually reached him (Joan put in a note to say that they had) and he closed sadly, saying that everything, even the Alps, was in decline. The mountains had contributed 'by the perishing of their snows' to the 'steady depression which has laid me open to these great illnesses'. His next letter to Norton said that he was writing his autobiography, but showed worrying evidence of agitation in a reference to Joan: 'The Dragon's out! – or I should never have got all this written!'[82]

It was peculiarly cruel and unjust of Ruskin to attack Joan, given that the real enemy was the memory of Rose. Mrs La Touche, Rose's mother, now forgiven, had become a regular visitor to Brantwood. For obvious reasons her visits tended to agitate Ruskin with unhappy memories. The true story behind the breakdown of July 1885 was that Ruskin invited Mrs La Touche to bring to Brantwood her granddaughter, a young girl who shared her dead aunt's name: Rose Ward. He wrote to 'Lacerta' – under the pet diminutive 'Lacy' – in pathetic excitement over the affectionate relationship he expected with this girl: 'With deep thankfulness will I call her Wisie and be her Di Pa. Come as soon as ever you can, – the heath is going to be wonderful this year – and I want some looking after, for I have been tired and sad lately – chiefly because I have not been at books but on the hills in sunshine, feeling that my days for them are gone.' Lacerta and 'Wisie' arrived on 14 July.

Ruskin's diary entries since 8 July had been recording dangerous agitation in the form of sleeplessness and bad dreams, which he routinely put down to indigestion. On 14 and 15 July he recorded that Rosie – the original, dead Rose – had led him to particular biblical texts. (Ruskin opened his Greek Bible at random and believed that her spirit guided him to alight on a text; on 15 July Rose gave him (in Greek) Luke, xviii, 13: 'God be merciful to me a sinner.') The sleepless nights got worse; 18 July was a '*nuit blanche*' and on or soon after 21 July he suffered his fourth delirious illness, from which he made no kind of recovery until 18 October.[83]

It ought to have been obvious to Mrs La Touche that the excitement of such a visit and of such associations, with the bringing back to life of Rose in her sister's child, was likely to be too much for Ruskin.

He was to be seriously ill every year, now, the threat of permanent insanity ever present. Yet during these years, 1885–9, when well, he

wrote *Praeterita*. It is a tribute to Joan Severn that this desperately ill man was able to function to the extent that he did. It is also a tribute to Brantwood itself. He knew how lucky he was to be able to respond to his beautiful hills at all: 'Y[esterday] desperately vexed by cuttings down of wood; though not a month ago I expected to die, and never to see Wood, or Hill, more.'[84] Here the hermit could meditate on his own past.

Praeterita is an inward, lucid triumph of the contemplative aspect of Ruskin's troubled soul, and the contrast between it and his Oxford lectures for 1883–5 is instructive and painful. As well as forwarding the work of Francesca Alexander, Ruskin now championed Kate Greenaway.* He had made contact with Kate late in 1883 and she was – obviously – delighted to be noticed by him and doubtless amazed to find that she was to be the subject of some of the Slade Professor's Oxford lectures. She visited Brantwood and stayed for what must have been an exhausting month in the spring of 1883.

Both the relationship with Francesca Alexander and that with Kate Greenaway were friendships of extremes: the old man of genius and the young women whose talents were more limited. The rewards for Ruskin were obvious – he was exercising power and enjoying the company of disciples unlikely to challenge or annoy him. Also he was able to tease his public with the singularity of his preferences. In the 1840s *Modern Painters* had challenged prevailing opinion and forced his will on the world, and by praising the works of Francesca Alexander and Kate Greenaway in the 1880s he was repeating the pattern. The sad difference was that in the 1880s his audience reacted not with fascinated attention but with embarrassment and laughter.

In his lectures on 'The Art of England' Ruskin displayed Francesca Alexander and Kate Greenaway as his new discoveries. It is sad to see that the man who had championed Turner and Tintoretto had come to this, sad to see him swinging between such horrible errors of judgement as his attack on Whistler, on the one hand, and his praise for the work of these agreeable women, on the other. Yet elsewhere in 'The Art of England' – for example, in his forceful advocacy of Burne-Jones and of G.F. Watts – Ruskin is both breaking new ground and making excellent sense. And between Francesca Alexander and Kate Greenaway Ruskin

*Kate Greenaway (1846–1901) studied art at South Kensington and at the Slade School, London, exhibited at the Royal Academy in 1877 and was, at the time that Ruskin befriended her, becoming famous as a creator and illustrator of original and charming children's books. Between 1883 and 1895 she published a highly successful annual *Almanack*.

could discriminate – in Francesca's work he found confirmation of his own teachings about the perfect society in *Fors Clavigera*, in Kate's work he found beguiling images of little girls. His praise for Kate's illustrations kept shading from serious advocacy into what amounted to a muted enthusiasm for soft porn. Reading his letters to her can be very painful.

The friendship produced a huge correspondence. Her letters were flirtatious and full of delicious drawings of little girls, his were appreciative but inevitably, as in all his relationships with artists, full of instructions. In one letter he urged her to take the clothes off her figures: 'As we've got as far as taking off hats, I trust we may in time get to taking off just a little more – say, mittens – and then – perhaps – even – shoes! – and (for fairies) even – stockings.' She had sent him a drawing of 'sylphs' and he wanted to see the one he liked best drawn in the 'Classical' style, i.e. nude: 'make her stand up, and then draw her for me without her hat – and, without her shoes . . . and without her mittens, and without her – frock and its frill? And let me see exactly how tall she is – and how – round.' Joan Severn added a note to the letter, saying: 'Do nothing of the kind.' Ruskin added a counter-note: 'That naughty Joan got hold of it – never mind her – you see, she doesn't like the word "round" – that's all.'[85]

Presumably it was the flavour of the whole transaction that Joan didn't like. But there was little she could do to stop it, given that this was, ostensibly, a relationship between a famous master and a gifted pupil. Undeterred by Joan, Ruskin pressed in the next letter for accurate observation of swimming children; their feet '– and – what else the Graces unveil in the train of the Sea Goddesses'. The serious point in these letters is that he was urging her to draw and paint from life, as the Pre-Raphaelites did: 'What you ABSOLUTELY need is a quantity of practice from things as they *are*', he wrote from Herne Hill, 'and hitherto you have ABSOLUTELY refused even to draw any of them so.' He teased her about her inability to understand perspective or chiaroscuro and urged her to 'give up drawing round hats'. But under it all was his desire that she depict her figures in the nude.[86]

Increasingly, the Oxford lectures became embarrassing. Ruskin's friends and family grew anxious in the course of 1884 as word spread among the merciless young that the point of going to these lectures was to see the old man making a spectacle of himself. The second series, 'The Pleasures of England', was to have ended with two highly contentious lectures about contemporary society and religious belief:

'Atheism: The Pleasures of Sense' and 'Mechanism: The Pleasures of Nonsense'. The temptations to make cheap jokes and flashy paradoxes was all too strong, and Ruskin's lectures were becoming a scandal. In his lecture on 'Protestantism: The Pleasures of Truth' (delivered on 15 and 17 November) he contrasted a pig ('a pig which is alert and knows its own limited business') by Bewick and a caricature of a 'Mr Stiggins', as examples of 'Protestant and Evangelical' art, to Carpaccio's St Ursula, which had appeared in a previous lecture as a 'type of Catholic witness'.[87] The presence of an excited audience caused Ruskin to lose his judgement and resort to sad antics and digressions (running across the stage flapping the sleeves of his gown to imitate a bird's flight, for instance). His diary entries for the autumn and winter of 1884 show that he gave these lectures in an agitated and often dangerously disturbed state of mind. He wrote of restless, sleepless, feverish nights: 'Terrible sickness came over me in walking by ruined Hincksey in grey sky yesterday. Have had more or less feverish night, dreaming of setting up some grand elephant or roc for lecturing on. [He was imagining that after his lectures on birds he would go on through the animal kingdom.] Chiefly stomach, but must take care.' He was in a dangerous state by the time the Oxford term was over and he was free to return home to Brantwood: 'Am off the rails altogether', he wrote, and again the next day: 'Badly off the rails, but keeping well' (that is, physically fit) 'and hope for an upspring again.' Back at Brantwood he suffered 'horrible depression after deadly cold'.[88]

Early in 1885 the diary shows him at Brantwood, often irritable and volatile, still enraged by the 'plague-cold' weather and by the people around him, but with disconcertingly sunny and happy days intervening. On 14 March, for example, he wrote: 'A most happy day y[esterday], painting peacock's feather and clearing path round Joanna's bay [on the lake-shore below his house]; with pleasant letters and entirely lovely quiet day, flecked with quiet cloud at evening.' And he was organising his books and papers and consulting all his old diaries with a view to writing his autobiography. On 1 February he had set up a timetable (had he not become ill *Praeterita* should have been finished very quickly): 'If I keep well, in every month of this spring I will bring it up to the end of another ten years of life, so that by the turn of the sun, I may have given some account of myself up to my 60th year – and so perhaps by Christmas, if all is well, have it ended and retouched supplementarily.' But the following day was the anniversary of his first

proposal to Rose and threw all the good resolutions into doubt: '19 years since!'

By the 1880s there were two new Chairs in medicine at Oxford: one was in anatomy, one in physiology. New physiology laboratories had been built. Ruskin campaigned against the awarding by Convocation (the university's governing body) of an annual research grant; he did so because the new professor, Burdon-Sanderson, was known for experimental work on animals. On 10 March 1885, after a debate on the use of animals for medical and biological research (Ruskin was particularly angered by the fact that his old friend Henry Acland had spoken in support), the university passed a decree authorising such experiment.[89] Ruskin resigned the Slade Chair on 22 March (for the second time), primarily because he opposed vivisection.

This issue is a sad end to the story of Ruskin's association with the study of the sciences at Oxford. He and Henry Acland together had pressed for, and pushed through, the building of the Oxford Museum, which became the basis for the study of natural sciences at Oxford. But, as Acland sadly noted, 'The Museum became, some twenty years afterwards, the cause of Mr. Ruskin's resignation, and of his withdrawal from Oxford.' His kind but clear account indicates that Ruskin was turning in a rage on a development that his younger self would have supported.[90] There is a parallel, perhaps, between this and the contradiction in his position over Whistler, whom he had attacked for his experimental qualities, qualities very like those of his great hero, Turner, whom he had endorsed in the 1840s.

His resignation was widely reported in the press. The *Pall Mall Gazette* ran a piece suggesting that in reality Ruskin had given up the Slade Chair because he was no longer able to cope with its responsibilities. Ruskin wrote to them saying their piece misrepresented him, but giving *two* reasons for his resignation:

> Whatever may be my failure in energy or ability, the best I could do was wholly at the service of Oxford; nor would any other designs, or supposed duties, have interfered for a moment with the perfectly manifest duty of teaching in Oxford as much art as she gave her students time to learn. I meant to die in my harness there, and my resignation was placed in the Vice-Chancellor's hands on the Monday following the vote endowing vivisection in the University, solely in consequence of that vote. . . . It is sufficient proof, however, how far it was contrary to my purpose to retire from the Slade Professorship that I applied in March of last year

for a grant to build a well-lighted room for the undergraduates, apart from the obscure and inconvenient Ruskin school; and to purchase for its furniture the two Yorkshire drawings by Turner of Crook of Lune and Kirkby Lonsdale – grants instantly refused on the pleas of the University's being in debt.

Ruskin later told E.T. Cook that 'double motives are very useful things'. In a sense, though, his resignation had a single motive, in that he was angry with the university for funding the medical school rather than his own project. The quarrel was the university's loss. His will, leaving his books, his best Turner drawings and his 'Titian' portrait of Doge Gritti to the university, was changed in May 1884, and in 1887 he withdrew a number of drawings and paintings from the Drawing School. He had parted from the university in high anger, and would never visit it again.[91]

To quarrel with Oxford and settle in Brantwood, with Joan and her family for company and trusted friends round about, was to retreat to a place that was reliable and safe. This and the writing of his autobiography gave a structure to his life in the years 1885–9. But even when 'normal' his behaviour was increasingly difficult. He became angry with the Severns, thinking that they were seeking to control him, usurp his place as master of his house and take his money. With Joan, in particular, he was often violent. When he needed physical restraint Arthur Severn – usually lazy and ineffectual – had to be called in to do it.

Anxieties about his health never left Ruskin: in April 1886, for example, he noted 'swimming head or eyes' and 'feeble swimming in eyes (as if I were going to faint, I fancy) – not getting proper hold of things'. This was soon after his resignation from Oxford, when he was 'irksome and angry' about 'Oxford business', but he continued to look for physical reasons – lack of exercise, stomach upset – for his symptoms. Later that month he was angry with Joan and Arthur for going away (to their home in London). He seems to have put much of his trust during this unhappy period in his Irish manservant, Baxter.

But Ruskin's instincts were still sound. Throughout this period he continued to work on his autobiography, and by way of controlling his moods he monitored them carefully in his diary: 'overworked in letters; generally mismanaged; choleraic illness at night – horrid – 2 to 7 of mere misery, with a look of danger. Yesterday, total collapse and despondency. Today down, nearly restored, but weak and warned once

more!'[92] 'Warned'; the diary and the autobiography work as confidants and guardians, performing an essential psychotherapeutic function. But he could not hold off the collapse. 'Things mixed, as they come into my head – coming extremely mixed this 1st July of 1886. And then, through the whole of July, the delirium again.' During this illness he was violent and fought his carers. He wrote on 13 August: 'Wrist always badly stiff and sore from past fightings. *I was fearfully ill managed in this last illness.*'[93]

In 1887 Ruskin got into yet another relationship with a much younger woman. Kathleen Olander was eighteen, an art student at Bedford Park Art School. In November she was copying Turner's *The Sun Rising in the Mist* in the National Gallery when she encountered Ruskin. Ruskin was making a brief and rare visit to London; he had spent much of the year at Sandgate, near Folkestone, with his servant Baxter (it was thought that quiet and the sea air would be good for his state of mind).

Ruskin was immediately attracted to Kathleen Olander and proposed to take her on as a student; he was soon in correspondence with her and with her parents, fairly humble folk who did not know about Ruskin's illnesses and were initially dazzled by what they saw as an extraordinary opportunity for their daughter to make her way in the world of fine art.

On 25 September 1888 Ruskin wrote to her from Milan, proposing marriage:

> You *will* be happy with me, while yet I live – for it was only love that I wanted to keep me sane – in all things – am as pure – except in thought – as you are – but it is *terrible* for any creature of my temper to have no wife – one cannot but go mad – And if I am spared to stay with you – suppose – it were but seven years like the seven wreaths of that chain – you would have many to love you and honour you – when I left you. – I'm not going on to speak of that – today, – but only to rejoice in you and over you –[94]

Kathleen Olander was inexperienced but not silly. The proposal astonished her:

> I thought he might have had some plans for me to live with him (on honourable terms of course: I considered his age would presuppose that), but that he should marry me and that I should bear children by him, I thought so scandalous that his reputation would be for ever ruined. So young a wife, I thought, could only impair the prestige he had built up over the years. The very idea seemed ludicrously inappropriate.

She did not at that time know about his earlier marriage to Effie and the annulment. When she learned about these things, she decided that his reputation was beyond damage and she resolved that she could marry him. In the meantime she had made the mistake of letting her parents know what was going on; not surprisingly, she met with absolute opposition from them. She continued to write to Ruskin, but Joan Severn was as determined as were her parents that the relationship should go no further, and Kathleen's letters were intercepted. She tells the end of the story (the date must have been about 1895):

> Some years later my mother, sister and I went to Keswick and Ambleside for a holiday. One day, to my surprise, my mother herself suggested that we should take a carriage and go to Coniston. On arrival she did not get out, but my sister and I walked round the lake. Halfway Mary stopped and waited for me, while I went on to Brantwood.
>
> I was exceedingly nervous of meeting Mrs Severn, and went round to the back door where I handed my card to a butler, asking him to give it to Mr. Ruskin, and requesting he should see me. I do not believe the card reached Ruskin, for the butler returned with the answer, 'Not today.'
>
> I then went round to the other side of the house and saw Ruskin at the first French window, sitting alone. But I was too alarmed to stay, for I was in full view of the next French window, where people were evidently dining.
>
> I kissed my hand to him, but he never saw me. Nor did we ever meet again.[95]

Ruskin's proposal of marriage to Kathleen Olander had come from Milan because in 1888 he had been taken abroad again in the hope that a 'change' would be good for his health. He travelled with Arthur Severn, who found him gripped in so deep a depression that the 'change' seemed pointless, but later in the tour they met two young architects, Sydney Cockerell and Detmar Blow, who were travelling in northern France armed with Ruskin's *The Bible of Amiens*, intent on studying the architecture and sculpture that Ruskin had described in that book. Because the young men's company seemed to lighten Ruskin's mood, Arthur Severn felt that he could leave Ruskin with them. Ruskin also had his manservant Baxter to look after him. So Severn went off, to accept a long-standing invitation to join a yachting trip in Norway and Ireland. Ruskin travelled on, first with Cockerell and Blow, later with Blow on his own, until he reached the Alexanders at Bassano. Fond though he was of Francesca Alexander and her mother, on this occasion he found the visit exhausting (because

Americans 'have the energy of American rivers – endless', as he wrote to Joan). He went on to Venice where Detmar Blow, who had never seen the city before, was virtually unable to benefit from the visit because of Ruskin's deep depression.

They turned homewards. When the party reached Berne, Baxter and Blow decided that Ruskin's state was such that they must take him straight back to England. In Paris at the Hôtel Meurice, Ruskin began to tremble and hallucinate; Joan was sent for by telegraph and she travelled immediately to Paris to collect him.[96] He was never to recover.

CHAPTER 9

EPILOGUE

Praeterita was the miracle of Ruskin's last years.

From 1889 onwards he was barely able to communicate. Although he received visitors, and occasionally wrote a letter to a friend, his life had effectively ended. But *Praeterita* was built on the past. A tendency to retrospection had marked much of his later work. In *St Mark's Rest*, for example, he wrote a personal guidebook to Venice which also revisited and retracted the prejudices of his younger self:

> As I re-read the description I gave, thirty years since, of St Mark's Church [in *The Stones of Venice*, II]; – much more as I remember, forty years since, and before, the first happy hour spent in trying to paint a piece of it, with my six-o'clock breakfast on the little café table beside me on the pavement in the morning shadow, I am struck, almost into silence, by wonder at my own pert little Protestant mind.[1]

Despite the turbulence of his periods of insanity, Ruskin was able to distance himself from dangerous sources of excitement by composing *Praeterita*, a personal memoir, which was written in a secluded place and itself centred on seclusion. Out of the world now, he recalled the childhood gardens of Herne Hill and Denmark Hill as themselves out of the world.

He closed his book with his careful tribute to Joan Severn, 'Joanna's Care', linking the gardens of his childhood with the garden at Brantwood in his old age. Joan was herself a physical link between these places. She had lived at Denmark Hill from 1864 to 1871, looking after his widowed mother until the old lady died. Then, after Joan's marriage to Arthur Severn, Ruskin had given her the lease of the Herne Hill house, retaining his nursery there as his London base. Increasingly, she spent time in Brantwood looking after him. She put up with the insanity and the terrifying tantrums, even physical violence. Herne Hill and Brantwood were to be her reward.

All his life Ruskin had created controllable alternatives to the world in which he actually lived. As Slade Professor at Oxford he set up an alternative reality, which he referred to as his university, in the Guild of

St George. In *Praeterita* he reinvented his childhood homes as lost paradises, which had never existed, and as safe alternatives to the dangerous social world of commercial London beyond the garden gate. And in Brantwood he made the most successful of these alternative worlds, his own private realisation of the ideals of St George, safely remote from the ungrateful cities, London and Oxford, in which he had suffered his defeats. The confidence and success of *Praeterita* had to do with the sure instinct that had led Ruskin to find calm in the midst of storms by rooting his book in his childhood gardens and then in his northern retreat. His mother had isolated herself socially; she would not visit neighbours more prosperous than herself on Denmark Hill, instead she invented her own little republic of husband, son and servants. Ruskin was repeating this pattern. It suited him.

Much of Ruskin's work from 1870 onwards can be seen as personal stock-taking and autobiography. He was consolidating and revisiting, and at the same time, in so doing, he was of course creating. What he created was a complete Ruskin-centred world, an alternative universe shaped by his educational convictions and furnished by examples of his choosing, his 'Ruskin Art Collection' at Oxford and his 'Ruskin Museum' in Sheffield, his rural communities at Barmouth, at Totley and at Bewdley* which with the museums were the concrete realisation of the Guild of St George, his studies of plants, birds and stones in parallel with his renewed studies of Venetian architecture and painting.

By setting up George Allen as his publisher he not only created his own publishing company but initiated a new method of publishing, and at Brantwood he invented the small personal kingdom with its extensive grounds and its beautiful setting by the lake, its many servants and the welcome children of Joan and Arthur Severn. It was his palace, his family, his fiefdom, and the home that decisively replaced the homes of his childhood in London. The massive authority of his parents had been reflected in the imagined figures of *Sesame and Lilies*, the future 'King and Queen' who were to benefit from the educational principles laid down in that book. From 1871 onwards they were replaced by more complex ideal figures: St George and St Ursula, the spiritual rulers of this Ruskinian kingdom.

The story of Ruskin's relationship with Carpaccio's great painting *The Dream of St Ursula* illustrates a general truth about this phase of

*One of the first gifts to the Guild was seven acres of woodland at Bewdley, in Worcestershire, given by a Birmingham merchant, George Baker, who ultimately succeeded Ruskin as Master of the Guild.

his work: he loved to work from primary materials, at first hand. He had the painting taken down from its position in the Accademia Gallery, in Venice, so that he could copy it in detail. This exercise enhanced the activity of seeing by making the painting his own first-hand possession. The copying was an act of love which made every last dramatic element of the painting come alive for him. Like Ruskin himself visualising a perfect society, St Ursula saw 'no dream, but a vision'. 'A real angel came, and was seen by Ursula's soul, when her mortal eyes were closed.' Ruskin was delighted by the fact that the angel was physical enough to go through doors, and that at his arrival *all* the doors in the house opened: 'He enters by one at the foot of her bed; but beyond it is another – open into the passage; out of that another into some luminous hall or street. All the window-shutters are wide open; they are made dark that you may notice them, – nay, all the press doors are open! No treasure bars shall hold, where *this* angel enters.'[2] This was explicitly an educational project, for his 'Sheffield men'.

The project spilt over into his other publications: the *Guide to the Academy, Venice, St Mark's Rest,* and the group planned as *Our Fathers Have Told Us* and *Bibliotheca Pastorum.* In these books Ruskin told the student precisely what he was to *do.* We may resent Ruskin's bossiness as he leans over us, urgently fussing and instructing, but his object is to share his first-hand experience, his direct apprehension of works of art. In his account of the St Ursula sequence in his *Guide to the Academy* he tells the student to go out immediately and compare some actual buildings with the Venetian scenes that Carpaccio has recorded in the paintings: 'So (always supposing the day fine) go down to your boat, and order yourself to be taken the church of the Frari. Landing just beyond it, your gondoliers will show you the way, up the calle beside it, to the desolate little courtyard of the School of St John the Evangelist.' It might have been 'one of the most beautiful scenes among the cities of Italy', had it not been horribly neglected by 'the good Catholics of Venice'. But even as it is, 'in the shafts and capitals you will see on the whole the most characteristic example in Venice of the architecture that Carpaccio, Cima, and John Bellini loved'. Then 'back, with straight speed, to the Academy', and there pause to study the square in front of the gallery, and imagine it grassed and with its little church restored to its fourteenth-century splendour; and in particular, see the scene *without* the Accademia Bridge, an iron structure that stirred Ruskin to fury: 'tear down the iron bridge which

some accursed Englishman, I suppose, greedy for filthy job, persuaded the poor Venetians to spoil their Grand Canal with, at its noblest bend'.[3]

St Mark's Rest displayed the same nervous anxiety to control the student, from its first line: 'Go first into the Piazzetta, and stand anywhere in the shade, where you can well see its two granite pillars', and then 'let your boatman take you across to San Giorgio Maggiore; there you can moor your gondola under the steps in the shade, and read in peace, looking up at the pillars when you like'.[4] To understand the work of carving the capitals in the Piazzetta the student has to practise carving a capital in a cube carved out of a piece of Gruyère cheese, 'tough and bad, with as few holes in it as may be'.[5] And so the guide continues, insisting on the exact spot on the Rialto where the student must stand to see an ancient fresco, and the exact position that he must take up to see the historic mosaics protected, largely because of Ruskin's intervention, in the basilica. The guide is peppered with angry references to the philistinism of the modern Venetians: the Rialto is 'very dirty, – it may be, indecently dirty, – that is modern progress' but from it you can see the neglected black and white marble of the Palace of the Camerlenghi: 'it may be, even before these pages get printed, it will be scraped and re-gilt – pulled down, to make a railroad station at the Rialto'.[6]

In parallel with these works he was writing his studies of birds, plants and stones, which were published in serial form during the 1870s and 1880s: *Love's Meinie*, *Proserpina* and *Deucalion*. Here too Ruskin insisted that his students were to *draw*, and thus observe intimately, moss, leaf, feather, stone. He engaged in *praxis* before he would conceptualise. In *Deucalion* he told his Oxford students to throw off the tyranny of theory:

> I have touched in this lecture briefly on the theories respecting the elevation of the Alps, because I want to show you how uncertain and unsatisfactory they still remain. For our own work, we must waste no time on them; we must begin where all theory ceases; and where observation becomes possible, – that is to say, with the forms which the Alps have actually retained. . . . I do not care, – and I want you not to care, – how crest or aiguille was lifted, or where its materials came from, or how much bigger it was once. I do care that you should know, and I will endeavour in these following pages securely to show you, in what strength and beauty of form it has actually stood since man was man, and what subtle modifications of aspect, or majesties of contour, it still suffers from the rains that beat upon it, or owes to the snows that rest.[7]

Whether writing for his Sheffield men or his Oxford undergraduates, his principle was the same: they were to experience, they were to know and to see at first hand, they were to have no science beyond the 'science of *Aspects*',[8] the knowledge of the way things actually look. Often he postpones the business of formulating and conceptualising so long, that a reader feels that the truth Ruskin is laboriously revealing, be it the inner value of birds, plants, rocks, the right management of a museum, the best practices to be observed in education, or the nature of a good society, will never be discovered.

Some of Ruskin's most beautiful drawings were of rocks, plants, or humble creatures – a crab, for instance. The side of Ruskin that protected himself from disturbance by a resort to botany and geology served him well throughout his last thirty years. In 1876 he gave a comic, Shandyan account of the way he saw himself, prone to anger and despair, yet comforted by quiet, lifelong interests such as the study of stones:

> The emotions of indignation, grief, controversial anxiety and vanity, or hopeless, and therefore uncontending, scorn, are all of them as deadly to the body as poisonous air or polluted water; and when I reflect how much of the active part of my past life has been spent in these states, – and that what may remain to me of life can never more be in any other, – I begin to ask myself, with somewhat pressing arithmetic, how much time is likely to be left to me, at the age of fifty-six, to complete the various designs for which, until past fifty, I was merely collecting materials.

A paragraph of comic hyperbole listed these designs: Florentine art in six volumes, Attic art in three volumes, northern thirteenth-century art in ten volumes, a biography of Turner in four volumes, a biography of Scott in seven volumes (the literary project most often mentioned), a life of Xenophon, a commentary on Hesiod, a study of political economy, and an account of the geology and botany of the Alps in twenty-four volumes. This paragraph was not wholly ironic; Ruskin did contemplate all of these projects at various times, some more seriously than others. He then spoke of all his projects as buildings, work with stones, and moved from that to his decision to work on what he took pleasure in: henceforth he would 'do as far as possible what I find pleasure, or at least tranquillity, in doing', which was to collect all his previous work in 'geology and botany'.[9]

But in these books, *Deucalion*, *Proserpina* and *Love's Meinie*, he did not, of course, collect and organise his previous work; instead he made more observations, more notes; the groundwork spread and expanded,

and the formulation never came. In the chapter on the leaf in *Proserpina* he gave minute directions:

> Now gather a branch of laurel, and look at it carefully. You may read the history of the beings of half the earth in one of those green oval leaves – the things that the sun and the rivers have made out of dry ground. . . . Look, then, to the branch you hold in your hand. That you *can* so hold it, or make a crown of it, if you choose, is the first thing I want you to note of it; – the proportion of size, namely, between the leaf and *you*. Great part of your life and character, as a human creature, has depended on that. Suppose all leaves had been spacious, like some palm leaves; solid, like cactus stem; or that trees had grown, as they might of course just as easily have grown, like mushrooms, all one great cluster of leaf round one stalk. I do not say that they are divided into small leaves only for your delight, or your service, as if you were the monarch of everything – even in this atom of a globe. You are made of your proper size; and the leaves of theirs: for reasons, and by laws, of which neither the leaves nor you know anything. Only note the harmony between both, and the joy we may have in this division and mystery of the frivolous and tremulous petals, which break the light and the breeze, – compared to what, with the frivolous and tremulous mind which is in us, we could have had out of domes, or penthouses, or walls of leaf.[10]

Providence, dispensation, order and pattern: all are in the leaf. And by extension providence and dispensation are in the cycle of the seasons, which generates the life and death of the leaf. In a spirit of Romantic wonder, Ruskin put a series of questions:

> Consider how fast this is done, in spring. You walk in February over a slippery field, where, through hoar-frost and mud, you perhaps hardly see the small green blades of trampled turf. In twelve weeks you wade through the same field up to your knees in fresh grass; and in a week or two more, you mow two or three solid haystacks off it. In winter you walk by your currant-bush, or your vine. They are shrivelled sticks – like bits of black tea in the canister. You pass again in May, and the currant-bush looks like a young sycamore tree; and the vine is a bower: and meanwhile the forests, all over this side of the round world, have grown their foot or two in height, with new leaves – so much deeper, so much denser than they were. Where has it all come from? Cut off the fresh shoots from a single branch of any tree in May. Weigh them; and then consider that so much weight has been added to every such living branch, everywhere, this side the equator, within the last two months. What is all that made of?[11]

He answered his own question by quoting the botanists. With these quotations he was able to show – as so often – that science that analyses

is reductive, and that the true science is the science of aspects, the science of the way that things actually look as you hold them in your hand, draw them, lovingly examine them, observe their shape and their pattern and their fitness for mankind's pleasure.

The patterning of the external world began very early in Ruskin's life. Some of his first drawings as a child were maps, organisations of space, and some of the best-known passages of his famous early books were maps in word-painting. The bird's-eye view of Europe, for example, in 'The Nature of Gothic', was designed to make good the deficiencies of existing maps:

> The charts of the world which have been drawn up by modern science have thrown into a narrow space the expression of a vast amount of knowledge, but I have never yet seen any one pictorial enough to enable the spectator to imagine the kind of contrast in physical character which exists between Northern and Southern countries. We know the differences in detail, but we have not that broad glance and grasp which would enable us to feel them in their fulness. We know that gentians grow on the Alps, and olives on the Apennines; but we do not enough conceive for ourselves that variegated mosaic of the world's surface which a bird sees in its migration, that difference between the district of the gentian and of the olive which the stork and the swallow see far off, as they lean upon the sirocco wind.

And his visual imagination permitted him to create precisely such a map:

> Let us, for a moment, try to raise ourselves even above the level of their flight, and imagine the Mediterranean lying beneath us like an irregular lake, and all its ancient promontories sleeping in the sun: here and there an angry spot of thunder, a grey stain of storm, moving upon the burning field; and here and there a fixed wreath of white volcano smoke, surrounded by its circle of ashes; but for the most part a great peaceful-ness of light, Syria and Greece, Italy and Spain, laid like pieces of a golden pavement into the sea-blue, chased, as we stoop nearer to them, with bossy beaten work of mountain chains, and glowing softly with terraced gardens, and flowers heavy with frankincense, mixed among masses of laurel, and orange, and plumy palm, that abate with their grey-green shadows the burning of the marble rocks, and of the ledges of porphyry sloping under lucent sand. Then let us pass farther towards the north, until we see the orient colours change gradually into a vast belt of rainy green, where the pastures of Switzerland, and poplar valleys of France, and dark forests of the Danube and Carpathians stretch from the mouths of the Loire to those of the Volga, seen through clefts in grey swirls of rain-cloud and flaky veils of the mist of the brooks, spreading low along

the pasture lands: and then, farther north still, to see the earth heave into mighty masses of leaded rock and heathy moor, bordering with a broad waste of gloomy purple that belt of field and wood, and splintering into irregular and grisly islands amidst the northern seas, beaten by storm, and chilled by ice-drift, and tormented by furious pulses of contending tide, until the roots of the last forests fail from among the hill ravines, and the hunger of the north wind bites their peaks into barrenness; and, at last, the wall of ice, durable like iron, sets, deathlike, its white teeth against us out of the polar twilight.[12]

It is a set-piece, of course, and a *tour de force* of visualisation. But more than that, it is a deeply satisfying act of spatial organisation. And in the last thirty years of his life Ruskin was working towards a total, spatial organisation, a kind of world-map called 'Ruskin', where his pupils – Oxford undergraduates, Sheffield steel-workers, workmen of Great Britain – would find a viable alternative to the real world, a place they could inhabit and in which they would be happy. The work on rocks, plants, birds and snakes, as well as on St Mark's and Carpaccio, was the elaboration of a vast design.

The design was incomplete, of course, interrupted by his illnesses. In its vast ambition and its incompleteness, this big system of interlocking projects conformed to the precedent of the Romantic visionaries, Wordsworth with his unfinished philosophic poem *The Recluse*, Keats with his *Hyperion* poems, Coleridge with his comprehensive visionary system: sweeping gestures towards a brilliantly visualised but unattainable goal. In this Palace of Art, this world called 'Ruskin', man would understand fully the Master's plan and find personal fulfilment free from money, machines and competition. There is no wealth but life; all Ruskin's teaching supported this doctrine. His teaching is the more potent in that it remains incomplete and unexplained, that there are so few neat formulations and conceptualisations for us to hang on to, that instead we are obliged to follow him through a labyrinth of examples and an exhausting sequence of practical demonstrations. To benefit from his teaching we must have participated in every stage of it, must be disciples and willing pupils, must create ourselves in the Master's image and will ourselves into participation in his world.

But we must never forget that this world-famous figure, the Slade Professor, philanthropist and visionary, was psychologically ill.

Ruskin wrote thousands of letters to Joan Severn, many of them in

baby-talk. From Corpus Christi College, Oxford, in the spring of 1876, he wrote that he would have liked to have

> 'pised [surprised] oo, last night and been 'at home' for oo – can't be. But oh dear, I tood'nt – everybody has something for me to do, and my masses of old drawings are in such a litter. I'm putting them in order and retouching & leaving – so that peepies [people] may know what they are, when I've gone away to Rosie. But me no want to leave oo, di ma [dear mama]. Only if it was'nt for oo, and I might go away to Rosie dectly [directly] – me should like it. only perhaps, – *she* would'nt.[13]

If it weren't for Joan he would kill himself in order to join Rose La Touche. We can imagine the emotional responsibility that this placed on Joan. The content of the letter is disturbing, the baby-language in which it is written points to a profound disorder in Ruskin. Since the deaths of his parents Ruskin had shown a tendency to adopt many of his friends as parent figures – Carlyle as 'Papa', Mrs Talbot as 'Mama', Mrs Mount-Temple as φιλη – and with Joan he constantly wanted to play this game of childhood regression.

The desire to be a child is combined with the desire to be privileged, unassailable and *safe*. In relation to other men Ruskin consistently refused to compete, to engage in real adult debate. The Romantic imagination is often, of course, a regressive imagination. The child in the garden in *Praeterita* who has the ants and the birds for company and is in complete command of his little kingdom grows into the adult who is creating this huge structure round himself in the late works, a structure, 'Ruskinland', in which he is undisputed king. Ruskin quarrelled with Oxford, he distanced himself from Rossetti and the Pre-Raphaelite circle, he replicated in Brantwood the gardens of his childhood, and there he was an absolute authority, still the three-year-old who stood triumphantly on a chair as though in a pulpit and instructed his captive congregation to be good. Ruskin was a genius and a visionary; he was also mad, and the madness is an inseparable part of his peculiar greatness.

In the 1890s Ruskin lived quietly at Brantwood, receiving friends, surrounded and sustained by Joan and her family. He was in his seventies but looked much older, indeed timeless, stooping very heavily and with a huge flowing white beard. Most of the time he was quiet, but an account of him in midwinter of 1897 speaks of how 'now and again a word flashing waywardly out, or a gesture impulsive as ever, betrays the fund of latent strength, and health in some measure

regained'. He remained active, walking every day; otherwise he spent much of his time sitting in his study, looking out at the lake and the sky: 'A spread of grey lake, overflowing the low fields by Coniston hall, and ridged into foam under a strong south wind. Above the gleaming wet roofs of the distant village ranges of crag, russet with fern, rose abruptly into the soft grey ceiling of cloud, and along their precipices there stood white waterfalls, forked and zigzagged like fixed lightnings.'[14]

As the man fell silent, so his fame spread. By the late 1880s Ruskin had spent a great deal of his inherited wealth on his many educational and social projects. The form of publication that he had insisted on since 1871 – very expensive, high-quality production of his works, bypassing the bookseller and available only by post from George Allen – had ensured that his readership, though passionately loyal, remained small. In the late 1880s he was persuaded to issue cheap editions of his work, which sold so well that by 1897 his income equalled that which he had enjoyed at the height of his wealth. Honours had poured in on him – despite his quarrel with Oxford he had been awarded the DCL by that university, conferred *in absentia* in 1893. His early disciples had set up Ruskin reading societies in the great industrial centres, Manchester, Glasgow and Liverpool. By 1897 there was a national Ruskin Reading Guild (with its own periodical, *Igdrasil*) as well as Ruskin societies in many provincial cities. He was becoming a civilisation.

Physically he remained fit until after his eightieth birthday in February 1899. Thereafter his household saw a steady deterioration; he no longer walked, but was taken out in a bath-chair round his garden and grounds, and spent much of his time in the little turret that he had built off his bedroom at Brantwood, being read to or looking out at the lake.

The end was sudden and surprisingly shocking: there was an influenza epidemic early in 1900, Ruskin became infected on 18 January and on the 20th he died.

There is an over-arching coherence in Ruskin's life and work. In the 1840s, his writing on Turner had brought on to the British national stage a new *critic* whose subject was new art. Such were the brilliance, rhetorical force and moral conviction of this young man's work that he was soon as much a household name as those great moralists and sages of the 1840s, Dickens and Carlyle.

The word 'stone' served as Ruskin's link between nature and art. In *The Stones of Venice* he spelt out the fundamental link between his admiration of Turner and his admiration of Venetian medieval buildings: 'The English school of landscape, culminating in Turner, is in reality nothing else than a healthy effort to fill the void which the destruction of Gothic architecture has left.'[15] The Gothic is a human equivalent of mountainous landscape. The imagination is exalted only among mountains: 'These great cathedrals of the earth, with their gates of rock, pavements of cloud, choirs of stream and stone, altars of snow, and vaults of purple traversed by the continual stars' are God's gifts, 'built for the human race, as at once their schools and cathedrals; full of treasures of illuminated manuscript for the scholar, kindly in simple lessons to the worker, quiet in pale cloisters for the thinker, glorious in holiness for the worshipper'.[16] Mountains instil sensitivity to 'loveliness of colour, perfectness of form, endlessness of change', conferring an advantage 'as measurable as the richness of a painted window matched with a white one, or the wealth of a museum compared with that of a simple furnished chamber'.[17] The right understanding of Venetian architecture joins the right understanding of Turner's paintings as a moral indicator, the mark of a good society. At the centre of that good society is the happy workman. Ruskin yields to no one in his conviction that it is possible for the workplace to be the preferred place, the place that we make for impatiently with each new day, full of creative energy, as though towards a lover. Life in the workplace can be dignified and fulfilling, it can involve and move the individual to the depths of his/her being.[18]

He was always a Romantic visionary. Like the political poets of the 1790s – Wordsworth, Coleridge, the young Southey – he was a man who espoused human dignity and ferociously attacked his age. As a 'Tory of the old school' he did something wholly characteristic of the Romantic poets: he took a civilisation of the past and projected it as a political model for the present. Implicit in his word 'Tory' was the recognition of his fellow 'Tories', Homer and Scott, as political writers, Homer creating an epic that underpinned the identity of the Greek republic, Scott reinventing Scotland as a wild place of the imagination inhabited by timeless clansmen confronting the inhospitable stringent orderliness of eighteenth-century England (Scott sided with the former in his poetry and with the latter in his novels). The pattern is one of unity of feeling and social sympathy underlying a seemingly chaotic succession of enthusiasms.

Ruskin is a Shelleyan lawgiver, inspired to tell the world new truths, he is a Byronic amoralist at the behest of no rules but his own. He writes so copiously and asserts so vehemently partly because he finds it difficult to understand himself: he writes in order to find out what he means. He will yield to his own impulses and assert himself as a supremely valuable individual. He will also claim the freedom to point in all directions at once. His moral code is grounded in (successively) Anglican, Humanist and semi-Catholic/aesthetic moral systems, while his intellectual energy is devoted to painting, architecture, economics, politics, ecology, botany and mineralogy, each of these enthusiasms in turn being ditched in mid-debate in favour of its successor.

Amid all this excitement there is a continuous philosophical conviction that the world of work should be driven by the human needs of the worker, not by economic laws. In that conviction he was in heroic and consistent opposition to the prevailing attitudes of his age. Work, industrial production and the conditions under which it was conducted, as understood by the mid-Victorians, damaged the worker. The tragedy of the situation as Ruskin saw it was that both sides, employer and worker, accepted this situation as inevitable. With his radical revision of the concept of 'wealth' in *Unto this Last* Ruskin sought to give back to the workman ownership of his productive life.

The radical critic who defended new painting in the 1840s became the writer on architecture who saw a seamless connection between structure, craftsmanship, art and a society's moral health in the 1850s; he in turn became the man who denounced the economic base of British society in the 1860s and proposed an alternative social order in the 1870s and 1880s. What unite all these roles are vision, conviction, huge talent, violent rhetorical power and fearless moral indignation. These, the qualities that fired him when he was a gifted child, sustained him when he was an astounding young prophet, and remained with him throughout his intellectual life. Despite the tragedies that befell him the central Ruskin remained undimmed.

BIBLIOGRAPHY

Archives

There are Ruskin archives at the following libraries: the Beinecke Library, Yale University; the Berg Collection, New York Public Library; the Bodleian Library, Oxford; Durham University Library; the J. Pierpont Morgan Library, New York; Newcastle University Library; Princeton University Library; the Rosenbach Museum and Library, Philadelphia; the Ruskin Library, University of Lancaster; the John Rylands Library, Manchester.

Primary works

Ruskin, John (1903–12). *The Works of John Ruskin* (library edition), 39 vols, ed. E.T. Cook and Alexander Wedderburn. London: George Allen.

Bradley, John Lewis (ed.) (1955). *Ruskin's Letters from Venice: 1851–1852*. New Haven, CT: Yale University Press. Reprinted Westport, CT: Greenwood Press, 1978.

Bradley, John Lewis (1964). *The Letters of John Ruskin to Lord and Lady Mount-Temple*. Columbus, OH: Ohio State University Press.

Bradley, John Lewis and Ousby, Ian (eds) (1987). *The Correspondence of John Ruskin and Charles Eliot Norton*. Cambridge: Cambridge University Press.

Burd, Van Akin (ed.) (1969). *The Winnington Letters: John Ruskin's Correspondence with Margaret Alexis Bell and the Children at Winnington Hall*. London: Allen and Unwin.

Burd, Van Akin (ed.) (1973). *The Ruskin Family Letters: The Correspondence of John James Ruskin, his Wife, and their Son, John, 1801–1843*, 2 vols. Ithaca, NY and London: Cornell University Press.

Burd, Van Akin (ed.) (1990). *Christmas Story: John Ruskin's Venetian Letters of 1876–1877*. Newark: University of Delaware Press.

Cate, George Allen (ed.) (1982). *The Correspondence of Thomas Carlyle and John Ruskin*. Stanford, CA: Stanford University Press.

Claiborne, Jay Wood (1969). 'Two Secretaries: The Letters of John Ruskin to Charles Augustus Howell and the Rev. Richard St John Tyrwhitt' (PhD thesis, University of Texas at Austin, TX). Ann Arbor, MI: University Microfilms International, 1977.

Dearden, James (ed.) (1990). *A Tour to the Lakes in Cumberland: John Ruskin's Diary for 1830*. Aldershot: Scolar Press.

DeLaura, David J. (1972). *Ruskin and the Brownings: Twenty-five Unpublished Letters*. Manchester: John Rylands Library.

Evans, Joan and Whitehouse, J.H. (eds) (1956–9). *The Diaries of John Ruskin*, 3 vols. Oxford: Clarendon Press.

Hayman, John (ed.) (1982). *John Ruskin: Letters from the Continent, 1858*. Toronto and London: University of Toronto Press.

Prynne, Kathleen and Unwin, Rayner (eds) (1953). *The Gulf of Years: Letters from John Ruskin to Kathleen Olander*. London: Allen and Unwin.

Ruskin, John (1915). *Frondes Agrestes: Readings in 'Modern Painters'* [1874]. London: George Allen.

Ruskin, John (1971). *The Elements of Drawing*, ed. Lawrence Campbell. New York: Dover.

Ruskin, John (1887). *Hortus Inclusus* (letters to the Misses Beever). Orpington: George Allen.

Shapiro, Harold I. (ed.) (1972). *Ruskin in Italy: Letters to his Parents, 1845*. Oxford: Clarendon Press.

Spence, Margaret (1959). *Ruskin's Correspondence with Miss Blanche Atkinson*. Manchester: John Rylands Library.

Spence, Margaret E. (1960). *Ruskin's Friendship with Mrs Fanny Talbot*. Manchester: John Rylands Library.

Spence, Margaret (1961). *Ruskin's Correspondence with his God-Daughter Constance Oldham*. Manchester: John Rylands Library.

Spence, Margaret (1966). *Dearest Mama Talbot: A Selection of Letters from John Ruskin to Mrs Fanny Talbot*. Manchester: Bulletin of the John Rylands Library.

Surtees, V. (ed.) (1972). *Sublime and Instructive: Letters from John Ruskin to Louisa, Marchioness of Waterford, Anna Blunden and Ellen Heaton*. London: Michael Joseph.

Surtees, V. (ed.) (1979). *Reflections of a Friendship: John Ruskin's Letters to Pauline Trevelyan, 1848–1866*. London: Allen and Unwin.

Swett, L.G. (ed.) (1931). *John Ruskin's Letters to Francesca: And Memoirs of the Alexanders*. Boston: Lothrop, Lee and Shepherd.

Viljoen, Helen (ed.) (1966). *The Froude–Ruskin Friendship: as represented through letters*. New York: Pageant Press.

Viljoen, Helen (ed.) (1971). *The Brantwood Diary of John Ruskin Together with Selected Related Letters and Sketches of the Persons Mentioned*. New Haven, CT and London: Yale University Press.

Wise, T.J. (ed.) (1897). *Letters from John Ruskin to T.J. Furnivall*. London: Ashley Library (privately printed).

Wise, T.J. (ed.) (1919). *Letters addressed to A.C. Swinburne, by J. Ruskin, W. Morris, E.B. Jones and D.G. Rossetti*. London: Richard Clay (privately printed).

Secondary works

Anthony, P.D. (1977). *The Ideology of Work*. London: Tavistock.

Anthony, P.D. (1983). *John Ruskin's Labour: A Study of Ruskin's Social Theory*. Cambridge: Cambridge University Press.

Arnold, Matthew (1960). *Culture and Anarchy* [1869]. Cambridge: Cambridge University Press.

Arnold, Matthew (1966). *Essays in Criticism* [1869 and 1888]. London: Dent.

Ball, Patricia (1971). *The Science of Aspects: The Changing Role of Fact in the Work of Coleridge, Ruskin and Hopkins*. London: Athlone Press.

Barnes, Janet (n.d. [1985]). *Ruskin in Sheffield: The Ruskin Gallery Guild of St George Collection*. Sheffield: Sheffield Arts Department.

Batchelor, John (1997). 'Ruskin and Shakespeare'. In J. Batchelor, T. Cain and C. Lamont (eds), *Shakespearean Continuities: Essays in Honour of E.A.J. Honigmann*. Basingstoke: Macmillan.

Bate, Jonathan (1991). *Romantic Ecology: Wordsworth and the Environmental Tradition*. London: Routledge.

Beer, John (1998). *Providence and Love: Studies in Wordsworth, Channing, Myers, George Eliot, and Ruskin*. Oxford: Clarendon Press.

Beerbohm, Max (1987). *Rossetti and his Circle*, ed. N. John Hall. New Haven, CT and London: Yale University Press.

Beetz, Kirk H. (1976). *John Ruskin: A Bibliography*, Metuchen, NJ: Scarecrow Press.

Bell, Quentin (1978). *Ruskin*. London: Hogarth Press.

Birch, Dinah (1988). *Ruskin's Myths*. Oxford: Clarendon Press.

Birch, Dinah (1990). *Ruskin on Turner*. London: Cassell.

Birch, Dinah (ed.) (1999). *Ruskin and the Dawn of the Modern*. Oxford: Oxford University Press.

Birkenhead, Sheila (1965). *Illustrious Friends: The Story of Joseph Severn and his Son Arthur*. London: Hamish Hamilton.

Blau, Eve (1982). *Ruskinian Gothic: The Architecture of Deane and Woodward, 1845–1861*. Princeton, NJ: Princeton University Press.

Bradley, J.L. (ed.) (1984). *Ruskin: The Critical Heritage*. London: Routledge and Kegan Paul.

Bradley, J.L. (1997). *A Ruskin Chronology*. Basingstoke: Macmillan.

Briggs, Asa (1979). *The Age of Improvement, 1783–1867*. London: Longman.

Brooks, Michael W. (1989). *John Ruskin and Victorian Architecture*. London: Thames and Hudson.

Browning, Robert. *Poetical Works. See* Jack and Ingelsfield (eds).

Bullen, J.B. (ed.) (1989). *The Sun is God: Painting, Literature and Mythology in the Nineteenth Century*. Oxford: Clarendon Press.

Bullen, J.B. (1994). *The Myth of the Renaissance in Nineteenth-Century Writing*. Oxford: Clarendon Press.

Bullen, J.B. (1998). *The Pre-Raphaelite Body: Fear and Desire in Painting, Poetry, and Criticism*. Oxford: Clarendon Press.

Burd, Van Akin (1979). *John Ruskin and Rose La Touche: Her Unpublished Diaries of 1861 and 1867*. Oxford: Clarendon Press.

Burd, Van Akin (1982). 'Ruskin, Lady Mount-Temple and the Spiritualists'. Guild of St George Ruskin lecture. London: Brentham Press.

Burne-Jones, Georgiana (1909). *Memorials of Edward Burne-Jones*, 2 vols. London: Macmillan.

Carlyle, Thomas (1880). *Chartism* [1840]. London: Chapman and Hall.

Carlyle, Thomas (1888). 'Shooting Niagara: and After?' [1867] in *Critical and Miscellaneous Essays*. London: Chapman and Hall.

Carlyle, Thomas (1897). *The History of Frederick the Great*, 8 vols [1858–65]. London: Chapman and Hall.

Carlyle, Thomas (1899). *Past and Present* [1843]. London: Chapman and Hall.

Carlyle, Thomas (1907). *Latter-Day Pamphlets*. London: Chapman and Hall.

Carlyle, Thomas (1966). *Heroes and Hero-Worship* [1841]. London: University of Nebraska Press.

Carlyle, Thomas (1987). *Sartor Resartus* [1838]. Oxford: Oxford University Press.

Carlyle, Thomas (1989). *The French Revolution* [1837]. Oxford: Oxford University Press.

Carlyle, Thomas (1997). *Reminiscences* [1881]. Oxford: Oxford University Press.

Cassels, William [1882]. *Wealth: Definitions by Ruskin and Mill*

Compared: A Paper read before the Ruskin Society of Glasgow, on 23 January 1882 by a member. Glasgow: Wilson and McCormick, 120 St Vincent Street.

Casteras, S.P. (ed.) (1993). *John Ruskin and the Victorian Eye*. Phoenix Art Museum: Harry N. Abrams.

Clegg, Jeanne (1981). *Ruskin and Venice*. London: Junction Books.

Clegg, Jeanne (1983). *John Ruskin: An Arts Council Exhibition, 1983*. London: Arts Council.

Clegg, Jeanne, and Tucker, Paul (1993). *Ruskin and Tuscany*. Sheffield: Ruskin Gallery.

Collingwood, W.G. (1893). *The Life of John Ruskin*, 2 vols. London: Methuen. Revised edn in 1 vol. 1905.

Collingwood, W.G. (1900). *The Art Teaching of John Ruskin*. London: Rivington.

Collingwood, W.G. (1903). *Ruskin Relics*. London: Isbister.

Conner, Patrick (1979). *Savage Ruskin*. Basingstoke: Macmillan.

Cook, E.T. (1890). *Studies in Ruskin: Some Aspects of the Work and Teaching of John Ruskin*. London: George Allen.

Cook, E.T. (1911). *The Life of John Ruskin*. London: George Allen.

Cook, E.T. (1912). *Homes and Haunts of John Ruskin*. London: George Allen.

Crawford, Alan (1985). *C.R. Ashbee: Architect, Designer & Romantic Socialist*. New Haven, CT and London: Yale University Press.

Culler, A. Dwight (1985). *The Victorian Mirror of History*. New Haven, CT and London: Yale University Press.

Cumming, Elizabeth and Kaplan, Wendy (1991). *The Arts and Crafts Movement*. London: Thames and Hudson.

Dante Alighieri (1814). *The Vision of Hell, Purgatory and Paradise* [i.e. *The Divine Comedy*], trans. H.F. Cary. London: Frederick Warne.

Dante Alighieri (1970). *The Divine Comedy*, 3 vols, trans. and ed. C.S. Singleton. Princeton, NJ: Princeton University Press.

Darley, Gillian (1990). *Octavia Hill: A Life*. London: Constable.

Dearden, James S. (1960). *Catalogue of the Pictures by John Ruskin and Other Artists at Brantwood Coniston*. Bembridge: Yellowsands Press.

Dearden, James S. (1967a). *Brantwood Books from John Ruskin's Library*. Bembridge: Yellowsands Press.

Dearden, James S. (1967b). *Catalogue of Drawings by John Ruskin at Ruskin Galleries, Bembridge*. Bembridge: Yellowsands Press.

Dearden, James S. (ed.) (1967c). *The Professor: Arthur Severn's*

Memoir of John Ruskin. London: Allen and Unwin.

Dearden, James S. (1994). *Ruskin, Bembridge and Brantwood: The Growth of the Whitehouse Collection*. Keele University, Staffs: Ryburn Publishing.

Digby, K.E. [Kenelm] (1822). *The Broadstone of Honour: Or, Rules for the Gentlemen of England*. London: F.C. and J. Rivington.

Digby, Kenelm Henry (1876–7). *The Broadstone of Honour: Or, The True Sense and Practice of Chivalry*, 5 vols (Vol. I, Vol. II, Vol. III, Vol. IV Part 1, Vol. IV Part 2). [A revised and expanded edn, following Digby's conversion to Catholicism in 1825.] London: Bernard Quaritch.

Doughty, Oswald (1949). *A Victorian Romantic: Dante Gabriel Rossetti*. London: Frederick Muller.

Downes, David Anthony (1984). *Ruskin's Landscapes of Beatitude*. New York: Peter Lang.

Emerson, Sheila (1993). *Ruskin: The Genesis of Invention*. Cambridge: Cambridge University Press.

Ensor, R.C.K. (1936). *England: 1870–1914*. Oxford: Clarendon Press.

Evans, Joan (1954). *John Ruskin*. London: Jonathan Cape.

Fain, J.T. (1956). *Ruskin and the Economists*. Nashville, TN: Vanderbilt University Press.

Farrar, Dean (1904). *Ruskin as Religious Teacher*. Bournville: St George Press, and London: George Allen.

Faxon, Alicia Craig (1994). *Dante Gabriel Rossetti*. London: Phaidon.

Fellows, Jay (1975). *The Failing Distance: The Autobiographical Impulse in John Ruskin*. Baltimore, MD and London: Johns Hopkins University Press.

Finley, C. Stephen (1992). *Nature's Covenant: Figures of Landscape in Ruskin*. University Park, PA: Pennsylvania State University Press.

Fleming, G.H. (1967). *Rossetti and the Pre-Raphaelite Brotherhood*. London: Rupert Hart-Davis.

Fleming, G.H. (1998). *John Everett Millais: A Biography*. London: Constable.

Garrigan, Kristine Ottesen (1973). *Ruskin on Architecture*. Madison, WI: University of Wisconsin Press.

Geddes, P[atrick] (1884). *John Ruskin: Economist*. (The Round Table series, III.) Edinburgh: William Brown, 26 Princes Street.

Gill, Stephen (1998). *Wordsworth and the Victorians*. Oxford: Clarendon Press.

Girouard, Mark (1981). *The Return to Camelot: Chivalry and the*

English Gentleman. New Haven, CT and London: Yale University Press.

Hamilton, James (1997). *Turner: A Life*. London: Hodder and Stoughton.

Hardman, Malcolm (1986). *Ruskin and Bradford: An Experiment in Victorian Cultural History*. Manchester: Manchester University Press.

Harrison, Frederic (1902). *John Ruskin*. London: Macmillan.

Haskell, Francis (1993). *History and its Image: Art and its Interpretation of the Past*. New Haven, CT and London: Yale University Press.

Heffer, Simon (1995). *Moral Desperado: A Life of Thomas Carlyle*. London: Weidenfeld and Nicolson.

Helsinger, Elizabeth K. (1982). *Ruskin and the Art of the Beholder*. Cambridge, MA: Harvard University Press.

Hewison, Robert (1976). *John Ruskin: The Argument of the Eye*. London: Thames and Hudson.

Hewison, Robert (1978). *Ruskin and Venice*. London: Thames and Hudson.

Hewison, Robert (ed.) (1981). *New Approaches to Ruskin: Thirteen Essays*. London: Routledge.

Hewison, Robert (1996). *Ruskin and Oxford: The Art of Education*. Oxford: Clarendon Press.

Hilton, Tim (1970). *The Pre-Raphaelites*. London: Thames and Hudson.

Hilton, Tim (1985). *John Ruskin: The Early Years*. New Haven, CT and London: Yale University Press.

Hobson, J.A. (1898). *John Ruskin: Social Reformer*. London: James Nisbet.

Hough, Graham (1947). *The Last Romantics*. London: Duckworth.

Hunt, John Dixon (1982). *The Wider Sea: A Life of John Ruskin*. London: Dent.

Hunt, John Dixon and Holland, Faith M. (eds) (1982). *The Ruskin Polygon*. Manchester: Manchester University Press.

Jack, Ian and Inglesfield, Robert (eds) (1995). *The Poetical Works of Robert Browning*, Vol. 5, *Men and Women*. Oxford: Clarendon Press.

James, William (1947). *The Order of Release: The Story of John Ruskin, Effie Gray and John Everett Millais*. London: John Murray.

Jenkyns, Richard (1980). *The Victorians and Ancient Greece*. Oxford: Blackwell.

Keck, Stephen L. (1991). 'John Ruskin's Understanding of History: A Comparison of *The Stones of Venice* and *St Mark's Rest*' (unpublished DPhil thesis, University of Oxford).

Kemp, Wolfgang (1990). *The Desire of My Eyes: The Life and Work of John Ruskin*, trans. Jan van Heurck. New York: Farrar, Strauss and Giroux.

Kitchin, G.W. (1904). *Ruskin in Oxford: and Other Studies*. London: John Murray.

Landow, George P. (1971). *The Aesthetic and Critical Theories of John Ruskin*. Princeton, NJ: Princeton University Press.

Landow, George P. (1985). *Ruskin* (Pastmasters series). Oxford: Oxford University Press.

Leon, Derrick (1949). *Ruskin: The Great Victorian*. London: Routledge and Kegan Paul.

Links, J.G. (1968). *The Ruskins in Normandy: A Tour in 1848 with Murray's Handbook*. London: John Murray.

Lutyens, Mary (1965). *Young Mrs Ruskin in Venice*. New York: Vanguard Press.

Lutyens, Mary (1967). *Millais and the Ruskins*. London: John Murray.

Lutyens, Mary (1972). *The Ruskins and the Grays*. London: John Murray.

MacCarthy, Fiona (1994). *William Morris: A Life for Our Time*. London: Faber.

MacDonald, Greville (1924). *George MacDonald and His Wife*. London: Allen and Unwin.

MacDonald, Greville (1932). *Reminiscences of a Specialist*. London: Allen and Unwin.

McLaughlin, Elizabeth T. (1974). *Ruskin and Gandhi*. London: Associated University Presses.

Mallock, W.H. (1878). *The New Republic: Or, Culture, Faith, and Philosophy in an English Country House*. London: Chatto and Windus.

Marwick, William, and Parkes, Kineton (eds) (1890). *Igdrasil: Journal of the Ruskin Reading Guild, 1890*, 2 vols. London: George Allen.

Maurice, F.D. (1968). *Learning and Working*. London: Oxford University Press.

Merrill, Linda (1992). *A Pot of Paint: Aesthetics on Trial in Whistler v. Ruskin*. Washington and London: Smithsonian Institution Press.

Mill, John Stuart (1969). *Autobiography* [1873]. Oxford: Oxford University Press.

Mill, John Stuart (1993). *Utilitarianism [1863], On Liberty, Considerations on Representative Government*, ed. Geraint Williams. London: Dent.

Morley, Catherine W. (1984). *John Ruskin: Late Work 1870–1890: The Museum and Guild of St George: An Educational Experiment*. New York and London: Garland Publishing.

Morris, William (1970). *News from Nowhere* [1891]. London: Routledge.

Morris, William (1979). *Political Writings of William Morris*, ed. A.L. Morton. London: Lawrence and Wishart.

Newsome, David (1997). *The Victorian World Picture*. London: John Murray.

Norwich, John Julius (1983). *A History of Venice*. Harmondsworth: Penguin Books.

Penny, Nicholas (1988). *Ruskin's Drawings*. Oxford: Phaidon.

The Pre-Raphaelites (1984). London: Tate Gallery.

Pugin, A. Welby (1898). *Contrasts* [1836]. Edinburgh: John Grant.

Reynolds, Sir Joshua (1992). *Discourses* [1797], ed. Pat Rogers. Harmondsworth: Penguin.

Rhodes, Robert and Janik, Dee Ivan (eds) (1982). *Studies in Ruskin: Essays in Honour of Van Akin Burd*. Athens, OH: Ohio University Press.

Ritchie, Anne Thackeray (1893). *Records of Tennyson, Ruskin and Browning*. London: Macmillan.

Rogers, Samuel (1830). *Italy: A Poem*. London: Cadell and Moxon.

Rooksby, Rikki (1998). *A.C. Swinburne: A Poet's Life*. Aldershot: Scolar Press.

Rosenberg, John D (1963). *The Darkening Glass: A Portrait of Ruskin's Genius*. London: Routledge.

Rossetti, William Michael (1899). *Ruskin: Rossetti: Pre-Raphaelitism*. London: George Allen.

Rossetti, William Michael (ed.) (1900). *PraeRaphaelite Diaries and Letters*. London: Hurst and Blackett.

Rossetti, William Michael (ed.) (1979). *The Germ: The Literary Magazine of the Pre-Raphaelites* [1850], with a preface by Andrew Rose. Oxford: Ashmolean Museum.

Rubinstein, W.D. (1998). *Britain's Century: A Political and Social History, 1815–1905*. London: Arnold.

Seaman, L.C.B. (1973). *Victorian England*. London: Methuen.

Tanner, Tony (1992). *Venice Desired*. Oxford: Blackwell.

Thomson, David (1950). *England in the Nineteenth Century.* Harmondsworth: Penguin.

Trevelyan, Raleigh (1978). *A Pre-Raphaelite Circle.* London: Chatto and Windus.

Unrau, John (1978). *Looking at Architecture with Ruskin.* London: Thames and Hudson.

Unrau, John (1984). *Ruskin and St Mark's.* London: Thames and Hudson.

Valcanover, Francesco (1981). *The Galleries of the Accademia.* Venice: Storti.

Viljoen, Helen Gill (1956). *Ruskin's Scottish Heritage: A Prelude.* Urbana, IL: University of Illinois Press.

Waldstein, Charles (1894). *The Work of John Ruskin: Its Influence upon Modern Thought and Life.* London: Methuen.

Wheeler, Michael (ed.) (1995). *Ruskin and Environment.* Manchester: Manchester University Press.

Wheeler, Michael (ed.) (1996). *Time and Tide: Ruskin and Science.* London: Pilkington Press.

Whistler, J.A.M. (1890). *The Gentle Art of Making Enemies.* London: Heinemann.

White, William (1890). *A Descriptive Catalogue of the Library and Print Room of the Ruskin Museum, Sheffield.* London: George Allen.

Whitehouse, J.H. (ed.) (1920). *Ruskin the Prophet.* London: Allen and Unwin.

Whitehouse, J.H. (ed.) (1934). *To the Memory of Ruskin.* Cambridge. Cambridge University Press.

Wilenski, R.H. (1933). *John Ruskin: An Introduction to Further Study of his Life and Work.* London: Faber.

Williams-Ellis, Amabel (1928). *The Tragedy of John Ruskin.* London: Jonathan Cape.

Willis, R. (1835). *Remarks on the Architecture of the Middle Ages: Especially of Italy.* Cambridge: Deighton.

Wilton, Andrew and Upstone, Robert (1997). *The Age of Rossetti, Burne-Jones and Watts: Symbolism in Britain 1860–1910.* London: Tate Gallery.

Woodward, E.L. (1938). *The Age of Reform, 1815–1870.* Oxford: Clarendon Press.

NOTES

CHAPTER I

1819–35

1 John Ruskin, *Praeterita*, in *The Works of John Ruskin* (Library Edition), ed. E.T. Cook and Alexander Wedderburn (39 vols; London: George Allen, 1903–12), XXXV, pp. 36–7. (The Cook and Wedderburn edition is hereafter referred to as *Works* with the volume number.)

2 Van Akin Burd (ed.), *The Ruskin Family Letters: The Correspondence of John James Ruskin, his Wife, and their Son, John, 1801–1843* (2 vols; Ithaca, NY and London: Cornell University Press, 1973). Subsequent references to all published work indicated by author or editor and date, thus: Burd, I, 1973.)

3 The male Ruskins of the three generations will be referred to as 'John Thomas' or 'John Thomas Ruskin' (John Ruskin's grandfather), 'John James' or 'John James Ruskin' (John Ruskin's father) and 'Ruskin', 'John Ruskin' or 'John' (the subject of this biography).

4 Helen Gill Viljoen, *Ruskin's Scottish Heritage: A Prelude* (Urbana, IL: University of Urbana Press, 1956), pp. 38–42 and family tree facing p. 40.

5 Viljoen is right to say that 'if Catherine had not had just cause for pride in her family, with its traditions of good education and good birth, the life of John James Ruskin might well have been eventually less rewarding, although more immediately less harassing because of his own inescapably two-class parentage in that Edinburgh of his youth'. Viljoen, 1956, p. 48.

6 Burd, I, 1973, pp. li–lii, 25–31.

7 Viljoen, 1956, p. 60.

8 *Works*, XXXV, p. 409.

9 Viljoen, 1956, pp. 73–5.

10 Burd, I, 1973, p. 3.

11 Viljoen, 1956, pp. 112–13.

12 Viljoen, 1956, pp. 114–15, 125–6.

13 Viljoen, 1956, pp. 231–2 n, gives the following chronology: first trip to London to work at Fyfe Druggist, when John James was still sixteen, early 1802 (before 10 May); return to Edinburgh for 'some months', late summer 1803; return to London to work with Amyand Cornwall, late 1804 (or early 1805) until late 1808 (or early 1809). He had news of his father's debts, and promised to pay them, in February 1808. He completed payment nine years later (before the end of 1817). Five years with Gordon Murphy Co., to whom he went when he was still '23' in the late 1808, until mid-August 1813. Convalescence in Perth from mid-August 1813 to early 1814. Joined Domecq in London for the sale of Haurie wine in late 1814. Founded the firm of Ruskin, Telford & Domecq in 1815.

14 Quoted in Viljoen, 1956, p. 115, from an account of his young manhood written by John James on 1 September 1848 to John Gray, father of Effie.

15 Sometimes referred to by Ruskin as 'Peter' Domecq; 'Pedro' Domecq for the purposes of this book.

16 Viljoen, 1956, p. 116.

17 Quoted in Viljoen, 1956, p. 132.

18 Burd, I, 1973, pp. 16–17, 18 n.

19 Here and throughout the book spelling variants or irregularities in quoted documents are left as in the original.

20 [] indicates a word inserted in the ms.

21 Burd, I, 1973, pp. 22–3.

22 Burd, I, 1973, pp. lii–liii.

23 Burd, I, 1973, p. 66.

24 Burd, I, 1973, pp. 74, 76.

25 Burd, I, 1973, pp. 76–7.

26 Burd, I, 1973, p. 84.

27 *Works*, XXXV, p. 19 and Burd, I, 1973, p. 85 n.

28 Burd, I, 1973, pp. 79, 80.

29 Burd, I, 1973, p. 86.

30 Margaret Ruskin to John James Ruskin, 26 March 1819, 23 June 1819 and 10 April 1820: Burd, I, 1973, pp. 93, 95, 98.

31 Burd, I, 1973, p. 104.

32 *Works*, XXXV, p. 90.

33 *Works*, XXXV, p. 19.

34 Burd, I, 1973, p. 109.

35 Burd, I, 1973, p. 108.

36 Burd, I, 1973, p. 116.

37 Burd, I, 1973, p. 138.

38 *Works*, XXXV, pp. 15–16. *Praeterita* has its own agenda. Ruskin felt that irreparable emotional damage had been done to him as a small child, and that this was to be laid at the door of his dead parents. There is no doubt about the damage, but it did not take quite the form that he describes. As one would expect, given the terminology available to an English intellectual in the 1880s, he had more insight into his social than into his sexual maladjustment.

39 *Works*, XXXV, pp. 19–20, 21.

40 Burd, I, 1973, p. 128.

41 *Works*, XXXV, pp. 24–5. *Praeterita* takes the form of a Romantic autobiography, like Wordsworth's *The Prelude*, and inverts it. Where *The Prelude*'s account of a child becoming a poet is triumphal, *Praeterita*'s account of a child becoming a misfit is exculpatory. Where Wordsworth was allowed full possession of his 'spots of time', Ruskin's 'rivers of Paradise' were, on the whole, forcibly withheld from him. Where for the infant Wordsworth the natural world became the warm and animate 'nurse and guardian', for Ruskin the natural world was at a distance, as were the human parents: 'visible powers of nature to me, no more loved than the sun and the moon'. In his early twenties Ruskin was to embrace Wordsworth as one of his two heroes (Turner being the other).

42 *Works*, XXXV, p. 44.

43 *Works*, XXXV, p. 61.

44 *Works*, XXXV, pp. 52, 54.

45 *Works*, XXXV, p. 47.

46 *Works*, XXXV, p. 410.

47 Burd, I, 1973, p. 165 n.

48 Burd, I, 1973, pp. 156–7.

49 *Works*, XXXV, p. 71.

50 Burd, I, 1973, p. 174 n.

51 John James's travels for the firm were extensive and exhausting. On 26 October 1829 and again on 6 November 1829 he sent John Ruskin jocular lists in which he names ninety-six different towns (in England, Scotland, Wales, Ireland and the Isle of Man) that he had visited or was planning to visit. The lists need not be taken literally, but his letters home are never addressed from the same town more than two nights in succession, and there is no doubt that he travelled far more than he or his family liked.

52 Burd, I, 1973, p. 150.

53 *Works*, II, p. 267.

54 *Works*, II, pp. 309, 286, 302, 303.

55 *Works*, II, pp. 297, 315.

56 *Works*, XXXV, pp. 75–8.

57 *Works*, XXXV, p. 76.

58 Burd, I, 1973, pp. 258, 261 n.

59 Samuel Rogers, *Italy: A Poem* (London: Cadell and Moxon, 1830), p. 47.

60 *Works*, XXXV, p. 79.

61 Burd, I, 1973, pp. 256–61, and *Works*, XXXV, p. 139.

62 *Works*, XXXV, pp. 88–9, 90.

63 *Works*, XXXV, pp. 92–3.

64 *Works*, I, pp. xxix–xxx, and *Works*, II, pp. 340–87; facsimile of the ms. showing Ehrenbreitsen faces p. 356.

65 *Works*, IX, pp. 7, 23 n. See Mark Girouard, *The Return to Camelot: Chivalry and the English Gentleman* (New Haven, CT and London: Yale University Press, 1981), p. 63, and Stephen L. Keck, 'John Ruskin's Understanding of History' (unpublished DPhil thesis, Oxford: 1991), pp. 77 ff. As Digby writes (in a consciously archaic style) in his introduction, the 'Broad Stone' of his title is itself a fortified position on the Rhine 'where coward or traitor never stood'. Digby's book is addressed specifically to 'gentlemen' (he is quite clear that 'churls' have no claim to 'honour'). His chosen young men will be taught 'as servants of a British Monarch, to emulate the virtue of their famous ancestors, and as Christian gentlemen, to whom Europe is a common country,

to follow the example of those worthies of Christendom, who were the patrons of the Church, the defenders of the poor, and the glory of their times'. His purpose is to take 'tomes of chivalry and ancient wisdom' – Malory's account of King Arthur and his knights, together with the lives of Charlemagne and Godefroy of Bouillon – as sources of 'ensamples and doctrines' for modern young English gentlemen. Kenelm Digby, *The Broad Stone of Honour: Or, Rules for the Gentlemen of England* (London: Rivington, 1823 [1822]), pp. xi–xiii.

66 *Works*, II, p. 345.
67 *Works*, II, p. 367.
68 *Works*, XXXV, p. 115.
69 *Works*, XXXV, p. 137.
70 *Works*, XXXV, p. 138.
71 Burd, I, 1973, pp. 311 and 314 n.
72 *Works*, XXXV, pp. 215–16.
73 Burd, I, 1973, pp. 329, 330 n.
74 *Works*, II, pp. xix, 395–448.
75 Burd, I, 1973, p. 300 n.
76 His comments on his father's coat of arms are given in *Works*, XXXV, pp. 389–91.
77 Burd, I, 1973, p. 261 n.
78 *Works*, I, pp. 357–98.
79 *Works*, XXXV, p. 83.
80 *Works*, XXXV, pp. 301–2.
81 Burd, I, 1973, pp. 330–1.
82 Burd, I, 1973, p. 348 n.
83 *Works*, XXXV, p. 178.
84 Burd, I, 1973, p. 350.
85 Burd, I, 1973, pp. 386–90.
86 *Works*, I, p. 373.
87 Burd, I, 1973, pp. 395–6.
88 Writing in the 1880s, Ruskin may here be reflecting a feature of mid-Victorian 'muscular Christianity' (expressed most characteristically in Kingsley's writings): the faith in cold baths and vigorous exercise as effective antidotes to the sex drive. By 1834 he could already have encountered such beliefs in Kenelm Digby's *The Broad Stone of Honour*, referred to above (first published 1822).
89 *Works*, XXXV, pp. 179, 180, 181, 182.
90 *Works*, XXXV, p. 180.
91 *Works*, I, pp. 287–304.
92 Thus weirdly anticipating Matthew Arnold's device, in his 'Marguerite'

poems, of using a Swiss setting and a false name to express his feelings about Mary Claude.

93 *Works*, II, pp. 449–69.
94 Shakespeare was perceived as belonging to the late Middle Ages, and we can see this adolescent attempt to recreate Shakespeare's world as of a piece with Ruskin's later desire to medievalise Victorian England in *The Stones of Venice* (and it relates to his championing of the Pre-Raphaelites in the 1850s).
95 Quoted in *Works*, III, p. 636.
96 *Works*, III, pp. 638–9.
97 *Works*, XXXV, p. 218.
98 *Works*, XXXV, p. 183.
99 *Works*, XXXV, p. 185.
100 *Works*, XXXV, p. 187.

CHAPTER 2

1836–42

1 Burd, II, 1973, p. 432. John Ruskin's diaries for 1836–40 have not survived, so the major sources of information about his day-to-day life during his early undergraduate years are *Praeterita* and the surviving correspondence.
2 Quoted in Burd, II, 1973, p. 430.
3 Burd, II, 1973, p. 427.
4 Burd, II, 1973, p. 428.
5 Burd, II, 1973, p. 437.
6 *Works*, XXXV, pp. 195–6.
7 G.W. Kitchin, *Ruskin in Oxford and Other Papers* (London: John Murray, 1904), p. 13.
8 Burd, II, 1973, p. 439.
9 Letter of 9 March 1837; Burd, II, 1973, p. 447.
10 Margaret Ruskin reports the visit from Liddell and Gaisford in her letter to John James of 15 February 1837. John Ruskin adds a postscript indicating that Strangeways, one of the young gentry, 'says he's coming to see some *very beautiful* sketches of mine whose fame has reached his ears, I suppose through Liddell – who was quite enthusiastic'. Burd, II, 1973, pp. 433, 434.
11 Quoted from H.L. Thompson's *Memoir of Henry George Liddell* (1899), in Burd, II, 1973, pp. 424–5 n.
12 Burd, II, 1973, pp. 450–1.
13 Burd, II, 1973, pp. 460, 462–3.

14 *Works*, XXXV, p. 199.
15 Ibid.
16 *Works*, XXXV, p. 188.
17 Burd, II, 1973, pp. 478–80.
18 *Works*, XXXV, pp. 197–8.
19 Burd, II, 1973, p. 481.
20 Letter of 30 November 1837; *Works*, XXXV, p. 630.
21 Quoted by Tim Hilton, *John Ruskin: The Early Years* (New Haven, CT and London: Yale University Press, 1985), p. 48.
22 Burd, II, 1973, p. 574 n.
23 Joan Evans and J.H. Whitehouse (eds), *The Diaries of John Ruskin* (3 vols; Oxford: Clarendon Press, 1956–9); hereafter Evans and Whitehouse, *Diaries*. I, p. 82, and *Works*, XXXV, p. 305.
24 Quoted by Derrick Leon, *Ruskin: The Great Victorian* (London: Routledge and Kegan Paul, 1949), p. 61.
25 *Works*, XXXV, pp. 274–5.
26 Evans and Whitehouse, *Diaries*, I, p. 123.
27 *Works*, I, p. 407.
28 *Works*, I, p. 412.
29 *Works*, I, pp. 420–1.
30 *Works*, I, pp. 432–3.
31 *Works*, I, p. 445.
32 Evans and Whitehouse, *Diaries*, I, p. 118.
33 Evans and Whitehouse, *Diaries*, I, p. 117.
34 Evans and Whitehouse, *Diaries*, I, p. 123.
35 Evans and Whitehouse, *Diaries*, I, p. 129.
36 Evans and Whitehouse, *Diaries*, I, pp. 139–40.
37 12 February 1841; *Works*, I, pp. 434–5.
38 16 May 1841; *Works*, I, pp. 452–3.
39 Evans and Whitehouse, *Diaries*, I, pp. 183, 185.
40 Evans and Whitehouse, *Diaries*, I, 189.
41 *Works*, I, p. 397.
42 Unpublished letter to Clayton, 1843, Ruskin Library, Lancaster, B VIII.

CHAPTER 3

1843–50

1 *Works*, XXXV, p. 311.
2 *Works*, III, p. 80.
3 *Works*, III, p. 83.
4 *Works*, III, p. 85.
5 *Works*, III, pp. 255–7.
6 Robert Hewison quotes an article about Harding which says that at the beginning of his career he did not know what direction his art should take, and 'in this state of mind, whilst sketching some trees near Greenwich, the thought at once occurred to him that the trees obeyed laws in their growth, and if he could ascertain these *laws*, and put *them* on his paper, he would get at the truth he so desired'. As Hewison points out, there is remarkable similarity between this story about Harding and Ruskin's passage about the road to Norwood. Robert Hewison, *John Ruskin: The Argument of the Eye* (London: Thames and Hudson, 1976), p. 42.
7 *Works*, XXXV, p. 310.
8 *Works*, XXXV, p. 314.
9 Robert Hewison says of this episode that 'it is imaginatively true. There *was* a change of attitude, and he did begin to see things differently.' Hewison, 1976, p. 42.
10 Quoted in *Works*, III, p. xxiv.
11 Hilton, 1985, pp. 74–5.
12 Augustus Welby Pugin, *Contrasts* [1836] (Edinburgh: John Grant, 1898). See also Hewison, 1976, pp. 128–9. Robert Hewison, writing explicitly about Ruskin's writing on architecture rather than about his whole method, remarks that 'Ruskin was disparaging of Pugin, and claimed that he had only glanced once at his book, but this very disparagement betrays the sympathy he felt for Pugin's view of the moral responsibilities of the architect'.
13 Cited in J.L. Bradley (ed.), *Ruskin: The Critical Heritage* (London: Routledge, 1984), p. 64.
14 Bradley, 1984, p. 65.
15 One of the most remarkable came a few years later, in 1847. Walt Whitman wrote in the *Brooklyn Eagle* praising Ruskin's 'intellectual chivalry, enthusiasm' and 'high-toned sincerity'. Bradley, 1984, p. 76.
16 Bradley, 1984, p. 5.
17 W.G. Collingwood, *The Life of John*

Ruskin, Vol. I (London: Methuen, 1893), pp. 109–10.
18 *Works*, VII, p. 9.
19 *Works*, III, p. 108.
20 *Works*, III, p. 116.
21 *Works*, III, p. 118.
22 *Works*, III, pp. 128–9.
23 *Works*, III, p. 130.
24 *Works*, III, p. 136.
25 *Works*, III, p. 140.
26 *Works*, III, p. 229.
27 *Works*, III, p. 254.
28 *Works*, III, pp. 571–2.
29 *Works*, III, p. 290.
30 *Works*, III, p. 383.
31 *Works*, III, p. 416.
32 *Works*, III, p. 109.
33 *Works*, III, p. 111.
34 *Works*, III, p. 123.
35 *Works*, III, pp. 163, 165, 166. 'They painted their foregrounds with laborious industry, covering them with details so as to render them deceptive to the ordinary eye, regardless of beauty or truth in the details themselves' (p. 166).
36 *Works*, III, pp. 168–9.
37 *Works*, III, p. 308.
38 Hilton, 1985, p. 73 and *Works*, III, pp. xxxvii–xxxix.
39 Hilton, 1985, pp. 100–2.
40 *Works*, IV, p. xxi.
41 J.L. Bradley, *A Ruskin Chronology* (Basingstoke: Macmillan, 1997), pp. 8–9.
42 Harold I. Shapiro (ed.), *Ruskin in Italy: Letters to his Parents, 1845* (Oxford: Clarendon Press, 1972), introduction, pp. xiii–xviii.
43 *Works*, IV, p. 264.
44 Shapiro, 1972, pp. 17–18.
45 Shapiro, 1972, p. 51.
46 Shapiro, 1972, pp. 54–5.
47 Shapiro, 1972, p. 57.
48 Shapiro, 1972, pp. 60–1.
49 Shapiro, 1972, p. 63.
50 Shapiro, 1972, pp. 78–9.
51 Shapiro, 1972, p. 92.
52 Shapiro, 1972, p. 119.
53 Shapiro, 1972, p. 130.
54 Shapiro, 1972, pp. 144–5.
55 Shapiro, 1972, pp. 198–9.
56 Shapiro, 1972, p. 209.
57 Shapiro, 1972, pp. 210, 11–12.
58 Shapiro, 1972, p. 219.
59 Shapiro, 1972, p. 229.
60 Evans and Whitehouse, *Diaries*, I, pp. 321–2.
61 *Works*, IV, p. 35.
62 *Works*, IV, p. 3.
63 *Works*, IV, pp. 343, 344–5.
64 *Works*, IV, p. 7.
65 *Works*, IV, p. 60.
66 *Works*, IV, p. 57.
67 *Works*, IV, pp. 77–8.
68 *Works*, IV, p. 72.
69 *Works*, IV, p. 79.
70 *Works*, IV, pp. 142–3.
71 Letter of 25 May 1846; *Works*, VIII, p. xxiii.
72 *Works*, VIII, p. xxxiv.
73 *Works*, VIII, p. xxvi.
74 *Works*, VIII, p. 95 n. See R. Willis, *Remarks on the Architecture of the Middle Ages: Especially of Italy* (Cambridge: 1835). In the early 1850s Ruskin later had friendly meetings and helpful conversations with Willis in the course of his work on *The Stones of Venice* (*Works*, VIII, p. xl).
75 *Works*, VIII, pp. xlv–xlvi.
76 *Works*, VIII, pp. xxxii–xxxiii.
77 *Works*, VIII, p. xxxvi.
78 *Works*, VIII, pp. xxxvii–xxxviii.
79 As Ruskin said of it years later in his lecture on 'Traffic', *Works*, XVIII, p. 443.
80 *Works*, VIII, p. 46.
81 *Works*, VIII, p. 102.
82 Letter of 20 August 1847; *Works*, VIII, p. xxvii.
83 *Works*, VIII, p. xxix.
84 *Works*, VIII, p. 68.
85 *Works*, VIII, p. 20.
86 *Works*, VIII, p. 25.
87 Thomas Carlyle, *Chartism* [1840] (London: Chapman and Hall, 1880), pp. 5–6.
88 Letter to W.H. Harrison, 6 June 1841; *Works*, XXXVI, p. 25.
89 G.A. Cate (ed.), *The Correspondence of Thomas Carlyle and John Ruskin* (Stanford, CA: Stanford University Press, 1982), p. 2.
90 *Works*, VIII, p. 157.
91 *Works*, VIII, pp. 159–60.
92 *Works*, VIII, p. 161.
93 *Works*, VIII, p. 164.
94 *Works*, VIII, p. 218.

95 *Works*, VIII, p. 225.

96 *Works*, VIII, p. 228.

97 *Works*, VIII, p. 257.

98 *Works*, VIII, pp. 258–9.

99 *Works*, VIII, pp. 263–4.

100 *Works*, VIII, p. 261.

101 *Works*, VIII, p. 264. That the 'yeoman' is better left uneducated is a central doctrine of E.M. Forster's great liberal novel *Howards End* (1910); yet in that same novel Forster imagines Ruskin's teaching to be useless to the working man, Leonard Bast, because Leonard's circumstances prevent him from leading the kind of life Ruskin advocates. There is a comic parallel between Ruskin on how to appreciate Venice and how Leonard's horrible flat could be described in a parody of Ruskin.

102 Mary Lutyens (ed.), *Young Mrs Ruskin in Venice* (New York: Vanguard Press, 1965), pp. 4–7.

103 *Works*, XXXV, pp. 421–2.

104 Letter of 2 September 1847; weirdly, in the 1880s John Ruskin was later to note on this letter that it was 'extremely important and beautiful' but 'not for autobiog' (i.e. *Praeterita*).

105 Quoted in part in Mary Lutyens, *The Ruskins and the Grays* (London: John Murray, 1972), pp. 49–50, and Lutyens, 1965, pp. 10–11, original in L 4 at the Ruskin Library, Lancaster University. In the letters printed by Mary Lutyens I have restored John James's characteristic use of '&' and his quirks of punctuation from the mss.

106 Lutyens, 1972, p. 54.

107 William James (ed.), *The Order of Release: The Story of John Ruskin, Effie Gray and John Everett Millais* (London: John Murray, 1948), pp. 49–50, 85.

108 James, 1948, pp. 146–7.

109 James, 1948, pp. 154–5.

110 James, 1948, p. 152.

111 Letter of 6 January 1850; Lutyens, 1965, p. 105.

112 Lutyens, 1965, pp. 111–12.

113 Lutyens, 1965, p. 130.

114 Lutyens, 1965, p. 121.

115 Lutyens, 1965, p. 137.

116 Letter of 27 October 1851; Lutyens, 1965, p. 204.

117 Lutyens, 1965, p. 90.

118 Lutyens, 1965, p. 225.

119 Lutyens, 1965, p. 149.

120 Lutyens, 1965, p. 154.

121 Written on 4 January 1852; Lutyens, 1965, p. 242.

122 J.L. Bradley (ed.), *Ruskins Letters from Venice 1851–1852* (New Haven, CT: Yale University Press, 1955), pp. 109–10.

123 Letter of 8 February 1852; Lutyens, 1965, p. 264.

124 Bradley, 1955, pp. 66–7, 168–72.

125 Bradley, 1955, p. 175.

126 Bradley, 1955, p. 37.

127 Bradley, 1955, p. 49.

128 Bradley, 1955, p. 124.

129 Bradley, 1955, p. 133.

130 Bradley, 1955, pp. 179–81.

131 Bradley, 1955, p. 185.

132 Bradley, 1955, pp. 191–2.

133 Lutyens, 1972, pp. 246–7.

134 Lutyens, 1972, p. 247.

135 Lutyens, 1972, p. 255.

136 Letter of 26 April 1852; Bradley, 1955, p. 261.

CHAPTER 4

1851–5

1 *Works*, X, pp. 82–3.

2 J.L. Bradley and Ian Ousby (eds), *The Correspondence of John Ruskin and Charles Eliot Norton* (Cambridge: Cambridge University Press, 1987), p. 34.

3 In his exemplary study *Ruskin and St Mark's* (London: Thames and Hudson, 1984) John Unrau has shown how Ruskin's famous description of the visitor's first view of St Mark's is the product not of impressionism but of massive and detailed sketching, measurement and annotation.

4 Quoted in *Works*, X, p. 1.

5 Charles Eastlake, *A History of the Gothic Revival* (1872), quoted in *Works*, X, pp. liii–liv. See also n. 6.

6 *Works*, IX, p. 423. See Michael W. Brooks, *John Ruskin and Victorian Architecture* (London: Thames and Hudson, 1989), pp. 42–9, and W.D. Rubinstein, *Britain's Century: A Political and Social History, 1815–1905* (London: Arnold, 1998), pp. 315–16.

7 *Works*, V, pp. 428–9.
8 Brooks, 1984, p. 49.
9 Verona, 2 June 1852, to his father; Bradley, 1955, p. 293.
10 *Works*, VIII, p. 218.
11 *Works*, VIII, p. 219.
12 *Works*, XI, p. 157.
13 *Works*, XI, pp. 157–8.
14 *Works*, XI, p. 162.
15 *Works*, XI, p. 187 and note.
16 *Works*, XI, p. 67.
17 *Works*, XI, p. 118.
18 *Works*, XII, p. 341.
19 *Works*, XII, pp. 342–3.
20 *Works*, XII, pp. 344–5.
21 *Works*, XII, p. 350.
22 *Works*, XII, p. 354.
23 *Works*, XII, p. 13.
24 *Works*, XII, pp. 24–5, 26, 51–2.
25 *Works*, XII, p. 78.
26 *Works*, XII, pp. 128–9.
27 *Works*, XII, p. 133.
28 James Hamilton, *Turner: A Life* (London: Hodder and Stoughton, 1997), p. 310.
29 *Works*, XII, p. 148.
30 *Works*, XII, p. 157.
31 *Works*, IX, p. 3.
32 *Works*, IX, p. 14.
33 *Works*, IX, pp. 9–10.
34 *Works*, IX, p. 17.
35 *Works*, IX, p. 38.
36 *Works*, IX, pp. 56–7.
37 *Works*, IX, p. 8.
38 *Works*, IX, pp. 44–5.
39 *Works*, IX, p. 47.
40 *Works*, IX, p. 71.
41 *Works*, X, p. 193.
42 Quoted *Works*, X, p. 460.
43 *Works*, X, pp. 182–3, 184.
44 *Works*, X, pp. 185, 188, 190.
45 *Works*, X, pp. 192–3.
46 *Works*, X, p. 194.
47 *Works*, X, p. 195.
48 *Works*, X, pp. 202, 203, 205, 206, 207.
49 *Works*, X, p. 214.
50 *Works*, X, pp. 236–8.
51 *Works*, XI, pp. 22–4.
52 *Works*, XI, pp. 5, 14.
53 *Works*, XI, pp. 15–16, 17.
54 *Works*, XI, pp. 133–4.
55 *Works*, XI, pp. 48, 49.
56 Bradley, 1955, p. 69, letter of 24 November 1851. The observation

about the floor of St Mark's was in a book by Hester Lynch Piozzi (first published in 1879).
57 Bradley, 1955, pp. 94–5.
58 Bradley, 1955, pp. 108–9, 106–7.
59 Bradley, 1955, pp. 231–2.
60 Letter of 30 December 1851; Bradley, 1955, pp. 111, 115.
61 Bradley, 1955, pp. 121, 120.
62 Letter of 16 January 1852; Bradley, 1955, pp. 134, 135, 136.
63 Bradley, 1955, pp. 141, 144–5.
64 Bradley, 1955, pp. 153, 155–6.
65 Bradley, 1955, p. 267.
66 Quoted from Hunt's 'The Pre-Raphaelite Brotherhood' by G.H. Fleming, *John Everett Millais* (London: Constable, 1998), p. 28.
67 Quoted in Fleming, 1998, p. 73.
68 *Works*, XVI, pp. 319–22.
69 *Works*, XVI, pp. 325–6, 327.
70 Quoted by Mary Lutyens, *Millais and the Ruskins* (London: John Murray, 1967), pp. 36–7.
71 Fleming, 1998, pp. 75–6.
72 Elizabeth Cumming and Wendy Caplan, *The Arts and Crafts Movement* (London: Thames and Hudson, 1991), pp. 11–15.
73 Lutyens, 1967, p. 97.
74 Lutyens, 1967, pp. 100–1.
75 Lutyens, 1967, pp. 120–1.
76 'James, 1948', p. 216.
77 Lutyens, 1967, p. 184.
78 See Hilton, 1985, pp. 147–8.
79 Lutyens, 1967, pp. 198–9.
80 Bradley, 1984, pp. 187–8, 193–4.
81 Quoted in Cate, ed., 1982, p. 15.
82 Virginia Surtees, *Reflections of a Friendship: John Ruskin's Letters to Pauline Trevelyan* (London: George Allen and Unwin, 1979), pp. 270–5.
83 Lutyens, 1967, p. 192.
84 Lutyens, 1967, p. 191.
85 Lutyens, 1967, p. 230.
86 Bod MS Acland d 72, fols. 54–5, quoted in part in Hilton, 1985, p. 223.
87 F.D. Maurice, *Learning and Working* (London: Oxford University Press, 1968), p. 53.
88 Maurice, 1968, p. 28.
89 W.E. Styler, ed., introduction to Maurice, 1968, pp. 2–7.
90 Leon, 1949, p. 226.

91 Oswald Doughty, *A Victorian Romantic: Dante Gabriel Rossetti* (London: Frederick Muller, 1949), p. 162.

92 Quoted by Doughty, 1949, p. 163–4.

93 Doughty, 1949, pp. 166–8.

94 William Michael Rossetti, *Ruskin: Rossetti: Pre-Raphaelitism* (London: George Allen, 1899), pp. 28–9.

95 Rossetti, 1899, pp. 70–5.

96 Rossetti, 1899, p. 65.

97 Letter of 10 July 1855; *Works*, XXXVI, pp. 216–17.

98 Bod MS Eng Lett 33, fol. 221.

CHAPTER 5

1856–64

1 From 'Ad Valorem', the fourth essay in *Unto this Last*; *Works*, XVII, pp. 104–5.

2 Ford Madox Brown, *Diary*, 7 August 1855; see W.M. Rossetti, *Ruskin: Rossetti: Pre-Raphaelitism* (London: George Allen, 1899), p. 41.

3 Quoted in Eve Blau, *Ruskinian Gothic: The Architecture of Deane and Woodward, 1845–1861* (Princeton, NJ: Princeton University Press, 1982, p. 50.

4 Letter of 12 December 1854; *Works*, XVI, p. xliii.

5 *Works*, XVI, pp. 211–12.

6 *Works*, XVI, p. xlv.

7 Blau, 1982, pp. 70–8.

8 Letter of 29 December 1857, to William Michael Rossetti; Rossetti, 1899, pp. 192–3.

9 Quoted from Bradley, 1997, p. 46.

10 From the letter of 16 May 1854, to Henry Acland; Surtees, 1979, p. 271.

11 *Works*, XII, p. 334.

12 David DeLaura, *Ruskin and the Brownings: Twenty-five Unpublished Letters* (Manchester: John Rylands Library, 1972), pp. 324–6.

13 Quoted in Ian Jack and Robert Inglesfield (eds), *The Poetical Works of Robert Browning*, Vol. 5, *Men and Women* (Oxford: Clarendon Press, 1995), pp. xxxiv–xxxv.

14 Letter of 12 November 1855, written from Denmark Hill, to Tennyson; *Works*, XXXVI, pp. 230–1.

15 Raleigh Trevelyan, *A Pre-Raphaelite Circle* (London: Chatto and Windus,
1978), p. 110.

16 *Works*, XXXVI, pp. 320–1.

17 *Works*, XXXVI, p. 141.

18 Letter of 21 April 1848, written from Chiswick on Good Friday, to Mary Russell Mitford; *Works*, XXXVI, p. 87.

19 *Works*, XXXVI, pp. 104–5.

20 David Newsome, *The Victorian World Picture* (London: John Murray, 1997), pp. 95–6.

21 Letter of 4 March 1855; *Works*, XXXVI, pp. 191, 197.

22 *Works*, XXXVI, p. 197 n.

23 *Works*, XXXVI, p. 215.

24 Letter of 27 November 1856; *Works*, XXXVI, p. 247.

25 *Works*, XXXVI, p. 239. I have retained, here and elsewhere, Cook and Wedderburn's practice of smoothing out Ruskin's punctuation and writing the ampersand as 'and'. The original (Bod MS Acland d 72) has a kind of rough playfulness that gets lost in the published text, but it seems sensible to keep the familiar form adopted by the editors.

26 *Works*, XII, pp. 556–7.

27 *Works*, XXXVI, p. 115.

28 Letter of 8 November 1853; *Works*, XXXVI, p. 153.

29 *Works*, III, p. 624, quoted with additional comments in *Works*, XII, p. 339.

30 *Works*, XII, p. 341.

31 *Works*, XII, p. 343.

32 *Works*, XII, p. 77.

33 *Works*, XII, pp. 97–8.

34 Hilton, 1985, pp. 103, 183, 199.

35 *Works*, VII, pp. xxii–xxiii.

36 Rossetti, 1899, pp. 141, 143.

37 Letter of 26 September 1865; Surtees, 1979, p. 113.

38 Letter of Thursday 17 June 1858; John Hayman (ed.), *John Ruskin: Letters from the Continent, 1858* (Toronto: University of Toronto Press, 1982), p. 49.

39 Hayman, 1982, p. 74.

40 Hayman, 1982, p. 75.

41 Hayman, 1982, p. 87.

42 Letter of 15 July 1858; ibid.

43 Hayman, 1982, p. 91.

44 Letter of 19 July 1858; Hayman, 1982, p. 92.

45 *Works*, VII, xl–xli.
46 Letter of 17 July 1858; Hayman, 1982, p. 89.
47 Letter of Wednesday 4 August 1858; Hayman, 1982, pp. 115–16.
48 Letter of 29 August 1858, from Turin; Hayman, 1982, p. 152.
49 Hayman, 1982, p. 182.
50 The letter is misdated 14 October by Cook and Wedderburn; see DeLaura, 1972, p. 338.
51 Surtees, 1979, p. 131. Some of the erotic figure drawings have in fact survived; examples are reproduced in Hamilton, 1997.
52 *Works*, XXXVI, pp. 291–2.
53 *Works*, XXXVI, p. 293. See also Bradley and Ousby, 1987, pp. 46–7.
54 Bradley and Ousby, 1987, pp. 49–50.
55 Letter of 31 July 1859; Bradley and Ousby, 1987, p. 51.
56 *Works*, V, p. 387; 'The Moral of Landscape', *Modern Painters*, III.
57 *Works*, V, p. 369.
58 *Works*, V, p. 365.
59 *Works*, V, p. 368.
60 *Works*, V, pp. 353, 387.
61 *Works*, VI, p. 3.
62 *Works*, VI, p. 75.
63 *Works*, VII, p. 264.
64 *Works*, VII, p. 270.
65 *Works*, VII, p. 441.
66 *Works*, XXXVI, pp. 460–1.
67 Letter of 28 February 1852, from Venice; Bradley, 1955, pp. 202–3.
68 Surtees, 1979, p. 188.
69 Burd, 1969, pp. 369–70.
70 Burd, 1969, p. 371.
71 Bradley, 1955, p. 293.
72 Letter of Sunday 4 January 1852, from Venice; Bradley, 1955, p. 123.
73 Letter to John James of 23 October 1862, from Mornex; quoted in *Works*, XVII, pp. lxiii–lxiv.
74 *Works*, XVII, p. xxviii.
75 *Works*, XVII, pp. xlix–l.
76 *Works*, XVII, p. 44.
77 *Works*, XVII, p. 45.
78 *Works*, XVII, p. 46.
79 *Works*, XVII, pp. 52–3.
80 *Works*, XVII, p. 56.
81 Dante Alighieri, *The Divine Comedy*, Vol. 3, *Paradiso*, ed. and trans.

Charles S. Singleton (Princeton, NJ: Princeton University Press, 1975), pp. 204–5.
82 *Works*, XVII, p. 62.
83 *Works*, XVII, pp. 83–4.
84 *Works*, XVII, p. 90.
85 *Works*, XVII, pp. 104–5.
86 William Wordsworth, *The Excursion*, Book IV, lines 763–6.
87 *Works*, XVII, p. 143.
88 *Works*, XVII, p. 111.
89 *Works*, XVII, pp. 143–4.
90 *Works*, XVII, pp. 108–9.
91 *Works*, XVII, pp. 109–10.
92 *Works*, XVII, pp. 106–7 and n.
93 Pierre-Joseph Proudhon wrote 'La propriété c'est le vol' in the first chapter of his famous book, *Qu'est-ce que la propriété?* (1840).
94 *Works*, XVII, pp. 132–3.
95 *Works*, XVII, p. 141.
96 *Works*, XVII, pp. 141–2.
97 *Works*, XVII, p. 169.
98 *Works*, XVII, pp. 176–7 and n.
99 *Works*, XVII, p. 181.
100 *Works*, XVII, p. 183.
101 *Works*, XVII, pp. 194, 199–200.
102 *Works*, XVII, p. 208.
103 *Works*, XVII, pp. 232–3.
104 Collingwood, 1893, II, pp. 3–4.
105 Collingwood, 1893, II, pp. 69–72.
106 Cook and Wedderburn remark that the logic of the three sets of writings is not obvious, though it can be broadly identified: attack the existing; establish the alternative; describe the latter's construction.
107 *Works*, XVII, pp. 469–70.
108 *Works*, XVII, p. 371.
109 *Works*, XVII, Ch. XX, esp. pp. 418–19.
110 *Works*, XVII, p. 415.
111 *Works*, XVII, p. 369.
112 *Works*, XVII, p. 376.
113 *Works*, XVII, p. 377.
114 *Works*, XVII, p. 380.
115 *Works*, XVII, p. 381.
116 *Works*, XVII, p. 392.
117 *Works*, XVII, p. 393.
118 *Works*, XVII, p. 411.
119 *Works*, XVII, p. 415.
120 *Works*, XVII, p. 424.
121 *Works*, XVII, pp. 430, 431–2.
122 *Works*, XVII, p. 437.
123 Leon, 1949, p. 334.

CHAPTER 6

1865–71

1 Opening of 'The Two Boyhoods', *Works*, VII, pp. 374–5.
2 *Works*, VII, p. 377.
3 *Works*, XXXVII, p. 471.
4 *Works*, XXXVII, pp. 483–4.
5 *Works*, XXXVII, pp. 493–4.
6 J.W. Claiborne, 'Two Secretaries: The Letters of John Ruskin to Charles Augustus Howell and the Rev. Richard St John Tyrwhitt' (PhD thesis, University of Texas at Austin, TX, 1969), p. 23.
7 Ruskin's letters of 24 February and 5 March 1866, to Howell; Claiborne, 1969, pp. 36–7.
8 Letters of 7 July and 10 August 1868, to Howell; Claiborne, 1969, pp. 126–8.
9 Claiborne, 1969, pp. 157–9.
10 Claiborne, 1969, pp. 26–7.
11 He wrote on 12 July 1862, from Milan, to Rossetti, suggesting this, but seems not to have followed it up; *Works*, XXXVI, pp. 411–12.
12 *Works*, XXXVI, p. xlviii.
13 Rikki Rooksby, *A.C. Swinburne: A Poet's Life*, (Aldershot: Scolar, 1997), pp. 56–60, 83–4.
14 Surtees, 1979, p. 249.
15 *Works*, XXXVI, p. xlix.
16 Probably December 1865; Surtees, 1979, p. 250.
17 *Works*, XVII, pp. 327 and n., 329.
18 *Works*, XVII, letters XVI and XVII, pp. 394–404.
19 *Works*, XVII, pp. 396–7.
20 *Works*, XVII, p. 402.
21 *Works*, XVII, p. 403.
22 *Works*, XVII, pp. 424–5.
23 *Works*, XVII, p. 397.
24 *Works*, XVII, p. 399.
25 Virginia Surtees (ed.), *Sublime and Instructive: Letters from John Ruskin to Louisa, Marchioness of Waterford, Anna Blunden and Ellen Heaton* (London: Michael Joseph, 1972), pp. 79–103.
26 Surtees, 1972, p. 99.
27 Letter of 26 June 1858, to John James Ruskin, quoted in Surtees, 1972, p. 100.
28 Van Akin Burd (ed.), *The Winnington Letters: John Ruskin's Correspondence with Margaret Alexis Bell and the Children at Winnington Hall* (London: Allen and Unwin, 1969), Introduction, pp. 22–55.
29 Ruskin, letter of Monday 14 March 1859, from Winnington Hall, to John James Ruskin; Burd, 1969, pp. 105–6.
30 Letter of 17 March 1859; Burd, 1969, pp. 109–10.
31 Burd, 1969, p. 32.
32 Burd, 1969, p. 329.
33 Georgiana Burne-Jones, *Memorials of Edward Burne-Jones*, I (London: Macmillan, 1909), p. 263.
34 Burd, 1969, pp. 639–47, 675.
35 *Works*, XXXV, p. 525.
36 Van Akin Burd (ed.), *John Ruskin and Rose La Touche: Her Unpublished Diaries of 1861 and 1867* (Oxford: Clarendon Press, 1979), p. 25.
37 Burd, 1979, p. 40.
38 Burd, 1979, p. 25.
39 *Works*, XXXV, p. 529.
40 *Works*, XXXV, pp. 530–1.
41 *Works*, XXXV, p. 58.
42 Letter of 25 February 1861, from Denmark Hill, to Norton; Bradley and Ousby, 1987, p. 61.
43 Letter of 2 June 1861, from Denmark Hill, to Norton; Bradley and Ousby, 1987, p. 64.
44 *Works*, XVIII, p. 55.
45 *Works*, XVIII, p. 61.
46 *Works*, XVIII, p. 85.
47 *Works*, XVIII, p. 103.
48 *Works*, XVIII, p. 110.
49 *Works*, XVIII, p. 128.
50 *Works*, XVIII, pp. 128–33.
51 *Works*, XVIII, pp. 150–1.
52 *Works*, XVIII, pp. 121–2.
53 *Works*, XXXVII, p. 477.
54 *Works*, XVIII, p. 202.
55 *Works*, XVIII, pp. 303–5.
56 *Works*, XVIII, pp. 405–6.
57 *Works*, XVIII, pp. 412–13, 415.
58 *Works*, XVIII, p. 440.
59 *Works*, XVIII, pp. 443–4.
60 *Works*, XVIII, p. 448.
61 *Works*, XVIII, pp. 453–5.
62 *Works*, XVIII, pp. 496–7.
63 *Works*, XVIII, pp. 500–1.
64 Written on his birthday, 8 February 1864; Burd, 1979, pp. 88–90.
65 Burd, 1979, pp. 94–6.

66 Burd, 1979, p. 97.

67 Letter of 15 May 1866, from Neuchâtel; Surtees, 1979, p. 280.

68 Trevelyan, 1978, p. 235.

69 Letter of 11 June 1866, to Rawdon Brown; *Works*, XXXVI, p. 509.

70 Letter of 10 May 1866, Carlyle to Ruskin; Cate, 1982, p. 117.

71 Burd, 1979, p. 96.

72 J. L. Bradley (ed.), *The Letters of John Ruskin to Lord and Lady Mount-Temple* (Columbus, OH; Ohio State University Press, 1964), p. 247.

73 Bradley, 1964, p. 155.

74 Bradley, 1964, p. 161.

75 Burd, 1979, p. 115.

76 Bradley, 1964, p. 167.

77 Bradley, 1964, p. 290.

78 Bradley, 1964, p. 310.

79 Bradley and Ousby, 1987, p. 115.

80 Collingwood, 1893, II, p. 139.

81 Letter of 11 September 1868; Bradley and Ousby, 1987, p. 115.

82 Letter of 26 April 1969; Bradley and Ousby, 1987, p. 133.

83 *Works*, XIX, pp. 328–9.

84 *Works*, XIX, pp. 388–9.

85 *Works*, XIX, p. 166.

86 *Works*, XIX, p. 395.

87 *Works*, XIX, p. 397.

88 *Works*, XIX, p. 309.

89 *Works*, XIX, pp. 95–6.

90 *Works*, XIX, pp. 60–1.

91 Bradley and Ousby, 1987, p. 144.

92 Bradley and Ousby, 1987, p. 142.

93 Bradley and Ousby, 1987, pp. 143, 149.

94 Bradley and Ousby, 1987, pp. 151–2, 153, 155, 156–7.

95 Bradley and Ousby, 1987, pp. 167, 168–9.

96 Bradley and Ousby, 1987, pp. 181, 183.

97 Letter of 8 January 1870, from Denmark Hill; Bradley, 1964, p. 247.

98 Bradley and Ousby, 1987, pp. 185, 186, 188.

99 Bradley and Ousby, 1987, pp. 189, 191–2.

100 *Works*, XVII, p. 31.

101 Letter of 19 June 1870; Bradley and Ousby, 1987, p. 194.

102 Letter of 8 July 1870, from Bellinzona; Bradley and Ousby, 1987, p. 197.

103 Letter of 29 July 1870; Bradley and

Ousby, 1987, p. 200.

104 Letter of 26 August 1870; Bradley and Ousby, 1987, p. 207.

105 Letter of 15 December 1870, from Florence; Bradley and Ousby, 1987, pp. 214–15.

106 Bradley and Ousby, 1987, p. 226.

107 Letter of 24 July 1871, from Matlock, Derbyshire, to Thomas Richmond; *Works*, XXXVII, pp. 33–4.

108 Letter of 1 November 1871; Bradley and Ousby, 1987, p. 240.

109 Ruskin to W.H. Harrison; *Works*, XXXVII, pp. 42–3.

110 *Works*, XXXVII, p. 44.

111 Bradley and Ousby, 1987, pp. 244, 245.

112 Bradley and Ousby, 1987, pp. 175, 178–9.

CHAPTER 7

1872–8

1 Letter of 8 November 1853, to his former tutor, the Rev. W.L. Brown; *Works*, XXXVI, p. 153.

2 Bradley and Ousby, 1987, p. 254.

3 Letter of 24 August 1848, from Lisieux; *Works*, XXXVI, p. 90.

4 *Works*, XXXVI, p. 155.

5 *Works*, XXXV, p. 43.

6 *Works*, XXXVI, pp. lxxxix–xci.

7 Letter of 5 June 1880; *Works*, XXXVI, p. 317.

8 Sheila Birkenhead, *Illustrious Friends: The Story of Joseph Severn and his Son Arthur* (London: Hamish Hamilton, 1965), pp. 154–69.

9 Bradley, 1964, p. 324.

10 Letter of 3 August 1872, from Denmark Hill, to Mrs Cowper-Temple; Bradley, 1964, p. 326.

11 Evans and Whitehouse, *Diaries*, II, p. 729.

12 Bradley, 1964, pp. 328–9.

13 Bradley, 1964, p. 330.

14 Bradley and Ousby, 1987, p. 195.

15 Collingwood, 1893, II, pp. 101–2, 103, 104.

16 Lecture on 'Outline', first in the course of 'Lectures on Landscape', given on 26 January 1871; *Works*, XXII, p. 17.

17 *Works*, XXII, pp. 46–7.

18 Lecture on 'The Relation of Wise Art to Wise Science', third in the course of

'Lectures on the Relation of Natural Science to Art', given on 15 February 1872; *Works*, XXII, p. 165.

19 Lecture on 'The Story of the Halcyon', from the same course (see previous note), given on 7 March 1872; *Works*, XXII, pp. 239–41.

20 *Works*, XXII, pp. 242–4, and Matthew Arnold, *Culture and Anarchy* (Cambridge: Cambridge University Press, 1960), p. 107.

21 *Works*, XXII, p. 244.

22 *Works*, XXII, pp. 469–70.

23 *Works*, XXII, pp. 472–3.

24 *Works*, XXII, p. 441.

25 *Works*, XXII, pp. 171, 482–4.

26 Letter of 23 May 1855; Cate (ed.), 1982, p. 66.

27 Cate, 1982, p. 67.

28 Letter of 5 March 1865; Cate, 1982, p. 74.

29 Cate, 1982, p. 76.

30 Letter of 29 October 1860; Cate, 1982, p. 89.

31 Letter of 4 April 1862; Cate, 1982, p. 100 n.

32 April 1863; Cate, 1982, p. 103.

33 Letter of 20 December 1865; Cate, 1982, p. 113.

34 Cate, 1982, pp. 131–40.

35 Cate, 1982, p. 165.

36 Cate, 1982, p. 177.

37 Essay on 'Model Prisons' (1 March 1850); Thomas Carlyle, *Latter-Day Pamphlets*, Vol. XXX of the Centenary edition of *The Works of Thomas Carlyle* (London: Chapman and Hall, 1907), p. 65.

38 *Works*, XVIII, pp. 500, 502–3.

39 *Works*, XVIII, p. 511.

40 *Works*, XVIII, pp. 512, 513.

41 Thomas Carlyle, *Past and Present*, Vol. X of the Centenary edition of *The Works of Thomas Carlyle* (London: Chapman and Hall, 1899), p. 197.

42 Letter of October 1873, from Oxford; Cate, 1982, p. 173.

43 Quoted in Cate, 1982, p. 173 n.

44 Cate, 1982, p. 189.

45 Cate, 1982, p. 185.

46 Cate, 1982, p. 187.

47 Cate, 1982, pp. 191, 196, 197.

48 Cate, 1982, pp. 197–201.

49 Cate, 1982, pp. 206, 207–8.

50 Cate, 1982, p. 212.

51 Letter of 6 November 1874, from Carlyle to his brother John, and letter of 17 November 1874; Cate, 1982, p. 37.

52 Frederic Harrison, *John Ruskin* (London: Macmillan, 1902), p. 185.

53 Cate, 1982, p. 159.

54 *Works*, XXVII, pp. 84, 86.

55 *Works*, XXVII, pp. 90, 91.

56 *Works*, XXVII, pp. 254–5.

57 *Works*, XXVIII, p. 14.

58 *Works*, XXVIII, pp. 15–19.

59 *Works*, XXVIII, pp. 20–3.

60 *Works*, XXVIII, pp. 70–2.

61 Letter 41, May 1874; *Works*, XXVIII, pp. 84–5.

62 Letter 42, June 1874, written in Italy (Assisi?); *Works*, XXVIII, pp. 92, 100–2.

63 Letter 43, July 1874; *Works*, XXVIII, p. 107.

64 *Works*, XXVIII, p. 113.

65 Letter 48, December 1874, *Works*, XXVIII, pp. 202–3, 206–7.

66 Letter 63, March 1876; *Works*, XXVIII, p. 538.

67 *Works*, XXVIII, p. 547.

68 Letter 64, 'The Three Sarcophagi', April 1876; *Works*, XXVIII, p. 565.

69 Letter 66, 'Miracle', June 1876; *Works*, XXVIII, pp. 612–13, 615.

70 *Works*, XXIX, p. xix.

71 Letter 75, March 1877, *Works*, XXIX, pp. 70–1.

72 *Works*, XXIX, p. 72.

73 *Works*, XXIX, pp. 136–7.

74 Letter from John Keats to John Taylor, 27 February 1818.

75 *Works*, XXIX, p. 138.

76 Letter 83, November 1877; *Works*, XXIX, p. 265.

77 *Works*, XXIX, pp. 148–9.

78 *Works*, XXIX, pp. 294–5.

79 Letter 86, February 1878; *Works*, XXIX, pp. 336, 341–2.

80 W.H. Mallock, *The New Republic: or Culture, Faith, and Philosophy in an English Country House* (London: Chatto and Windus, 1878), pp. 26–7.

81 Mallock, 1878, pp. 45–6.

82 Mallock, 1878, pp. 132–4.

83 All these diary entries are quoted from Evans and Whitehouse, *Diaries*, II, pp. 716–25.

84 *Works*, XXVIII, pp. 198–9.

85 Evans and Whitehouse, *Diaries*, II, p. 732.

86 Sheila Birkenhead gives a good account of the first impressions that the menage had on taking up residence; see Birkenhead, 1965, p. 223.

87 Bradley, 1964, pp. 337, 339–40.

88 Evans and Whitehouse, *Diaries*, II, pp. 729–31, 734.

89 Birkenhead, 1965, pp. 236–41.

90 Birkenhead, 1965, p. 242.

91 Letter of 6 December 1874; Birkenhead, 1965, pp. 243–5.

92 Letter of 15 December 1874; Burd, 1979, p. 130.

93 Letter of 28 December; Bradley and Ousby, 1987, p. 349.

94 Cate (ed.), 1982, p. 178.

95 Entries for 4, 6, 9 and 16 January 1875; Evans and Whitehouse, *Diaries*, III, pp. 834–5.

96 Letter of 28 May 1875; Burd, 1979, pp. 131–3.

97 Birkenhead, 1965, p. 248 and letter of 4 June 1875, from Oxford; Cate, 1982, p. 225.

98 Quoted in Van Akin Burd, 'Ruskin, Lady Mount-Temple and the Spiritualists', Guild of St George Ruskin lecture, 1982 (London: Brentham Press, 1982), p. 26.

99 Entries on 18, 19 and 20 December 1875; Evans and Whitehouse, *Diaries*, III, pp. 876–7.

100 These letters are quoted from Van Akin Burd, *Christmas Story: John Ruskin's Venetian Letters of 1876–1877* (Newark: University of Delaware Press, 1990), pp. 202–7.

101 Burd, 1990, pp. 229–30.

102 Burd, 1990, pp. 234–6.

103 Burd has [?] at this point.

104 Burd, 1990, pp. 236–7.

105 Letters of 14 December 1875, 13 January 1876, 18 January 1876, 1 February 1876 and 16 January 1877; Bradley and Ousby, 1987, p. 372–7, 389.

106 Bradley and Ousby, 1987, pp. 390–1.

107 Bradley and Ousby, 1987, p. 392.

108 Bradley and Ousby, 1987, p. 394.

109 For a detailed discussion of these points see John Batchelor, 'Ruskin and Shakespeare', in J. Batchelor, T. Cain and C. Lamont (eds), *Shakespearean Continuities: Essays in Honour of E.A.J. Honigmann* (Basingstoke: Macmillan, 1997), pp. 319–34.

110 Helen Gill Viljoen (ed.), *The Brantwood Diary of John Ruskin* (New Haven, CT: Yale University Press, 1971), pp. 92–3.

111 Beinecke Library, Yale, quoted in part in Leon, 1949, p. 510.

112 Viljoen, 1971, pp. 100–1.

113 Letter of 10 March 1878; Viljoen, 1971, pp. 65–6.

114 Viljoen, 1971, pp. 64–5.

115 Evans and Whitehouse, *Diaries*, III, p. 976.

CHAPTER 8

1879–88

1 Letter of 27 January 1886, from Brantwood, to Professor J.S. Blackie; *Works*, XXXVII, p. 550.

2 Letter of 3 March 1882, Ruskin to the Rev. J.P. Faunthorpe; *Works*, XXXVII, p. 388.

3 *Works*, XXXVII, p. 328.

4 *Works*, XXIX, pp. 157, 159, 160.

5 Susan Phelps Gordon, 'Heartsight Deep as Eyesight: Ruskin's Aspirations for Modern Art', in S.P. Casteras (ed.), *John Ruskin and the Victorian Eye* (Phoenix Art Museum: Harry N. Abrams, 1993), pp. 116–20.

6 *Works*, XXIX, pp.581–2.

7 Quoted from J.A.M. Whistler, *The Gentle Art of Making Enemies* (1890), p. 5, in Casteras, 1993, p. 118.

8 Burne-Jones and W.M. Rossetti quoted in Leon, 1949, pp. 524–5.

9 *Works*, XXIX, p. xxiv.

10 *Works*, XXIX, p. 584.

11 Leon, 1949, p. 526.

12 Quoted from Whistler, 1867, p. 30, in Casteras, 1993, p. 118.

13 Quoted from Whistler, 1867, in Leon, 1949, p. 527.

14 *Works*, XXIX, p. xxv.

15 Linda Merrill, quoting John Dixon Hunt, in *A Pot of Paint: Aesthetics on Trial in Whistler v. Ruskin* (Washington and London: Smithsonian Institution Press, 1992), p. 211.

16 Quoted in Merrill, 1992, p. 217.

17 *Works*, XXIX, p. 585.

18 *Works*, XX, p. 13.

19 'The Three Colours of Pre-Raphaelitism', *The Nineteenth Century* (November and December 1878); *Works*, XXXIV, p. 148.

20 *Works*, XXXIV, p. 172.

21 *Works*, XXXIV, pp. 173–4.

22 Letters of 4 November 1877, from Brantwood (Ruskin); 5 November (Octavia Hill); 7 November (Ruskin); 8 November (Octavia Hill); *Works*, XXIX, pp. 354–60. See also Gillian Darley, *Octavia Hill: A Life* (London: Constable, 1990), Chs 3, 5, 6 and 12.

23 *Works*, XXXIV, p. 286.

24 *Works*, XXXIV, pp. 278–9 n.

25 *Works*, XXXIV, pp. 265–8.

26 *Works*, XXXIV, pp. 270–2.

27 *Works*, XXXIV, pp. 342–3.

28 *Works*, XXXIV, pp. 349–50.

29 *Works*, XXXIV, pp. 37, 39. See also Evans and Whitehouse, *Diaries*, III, pp. 978–9 for the 13 August entry with minor variants.

30 Evans and Whitehouse, *Diaries*, III, p. 981.

31 Catherine W. Morley, *John Ruskin: Late Work 1870–1890: The Museum* (New York and London: Garland Publishing, 1984), Appendix, pp. 25–7.

32 Leon, 1949, pp. 433–5.

33 Morley, 1984, pp. 275–6.

34 Rosenbach Museum and Library, Philadelphia, John Ruskin to Henry and Emily Swan, 1855–76 (10 vols, all unpublished). Quoted from the 'Introduction' to the letters written by William S. Allen (executor and oldest son of the late George Allen, Ruskin's publisher). Hereafter, Rosenbach, Letters to Swan.

35 Rosenbach, Letters to Swan, no. 21.

36 Rosenbach, Letters to Swan, Allen's Introduction.

37 Letter received 15 January 1873; Rosenbach, Letters to Swan, no. 17.

38 Letter of 27 June 1877; Morley, 1984, p. 60.

39 Letter of 18 January 1876; Rosenbach, Letters to Swan, no. 30.

40 Letter of 10 December 1876 and letter received on 21 December 1876; Rosenbach, Letters to Swan, nos. 67 and 68.

41 Letter of 8 June 1878; Rosenbach, Letters to Swan, no. 133.

42 Rosenbach, Letters to Swan, no. 134.

43 Janet Barnes, *Ruskin in Sheffield: The Ruskin Gallery Guild of St George Collection* (Sheffield: Sheffield Arts Department, n.d. [1985]), pp. 23–4.

44 Morley, 1984, p. 59.

45 Rosenbach, Letters to Swan, no. 145 (15 February 1879) and Swan's reply (26 February 1879).

46 *Works*, XXIX, p. 83.

47 *Works*, XXIX, pp. 86–7.

48 *Works*, XXIX, pp. 89–92.

49 Entry for 13 July 1880; Evans and Whitehouse, *Diaries*, III, p. 981.

50 Evans and Whitehouse, *Diaries*, III, p. 991.

51 Entry for 31 July 1880; Viljoen, 1971, p. 247.

52 Letter of 27 May 1880, from Brantwood; *Works*, XXXVII, p. 315.

53 Entries of 24 and 25 May 1880, at Brantwood; Viljoen, 1971, pp. 238–9.

54 Letter of 24 March 1881; Bradley and Ousby, 1987, p. 443.

55 Letter of 26 April 1881; Bradley and Ousby, 1987, p. 444.

56 Evans and Whitehouse, *Diaries*, III, p. 1008.

57 Entries of 6 January, 8 January, 12 January, 13 January, 14 January, 16 January, 18 January, 19 January 1882, at Brantwood; Evans and Whitehouse, *Diaries*, III, pp. 1013–14.

58 Letter of 12 May 1878, from Brantwood; Viljoen, 1971, pp. 501–2.

59 Letter of 23 March 1881, from Brantwood; Viljoen, 1971, p. 502.

60 Letter of 2 August 1881, from Brantwood; Bradley, 1964, p. 379.

61 Bradley, 1964, p. 379 n.

62 Letter of 20 August 1881, from Brantwood; Viljoen, 1971, p. 484.

63 Letter of 5 March 1882, from Herne Hill; Viljoen, 1971, p. 502.

64 Letter of 5 April 1882, from Herne Hill; Viljoen, 1971, pp. 484–5.

65 Entry of 2 February 1883; Viljoen, 1971, pp. 296–7.

66 Letter of 21 February 1881; Viljoen, 1971, pp. 544–5.

67 Letter of 9 March 1881; Viljoen, 1971, pp. 546–8.

68 Viljoen, 1971, pp. 552–3.

69 Entry of 5 September 1882; Evans and Whitehouse, *Diaries*, III, p. 1021.

70 Entry of 19 September 1882, in Annecy; Evans and Whitehouse, *Diaries*, III, p. 1027.

71 Letter of 26 September 1882, from Turin; Quoted in Viljoen, 1971, p. 270.

72 Evans and Whitehouse, *Diaries*, III, pp. 1027–30.

73 Letter of 16 October 1882; Bradley and Ousby, 1987, p. 453.

74 *Works*, XXXII, pp. 53–4.

75 *Works*, XXXIII, pp. 186–7.

76 *Works*, XXXIII, p. 131.

77 *Works*, XXXIII, p. 230.

78 Letter of 3 October 1882; Bradley and Ousby, 1987, pp. 449–50.

79 Letter of 5 November 1882; Bradley and Ousby, 1987, pp. 454–5.

80 Letter of 15 March 1883, from Herne Hill (Ruskin to Norton), and letter of 3 April 1883, from Shady Hill, Cambridge, MA (Norton to Ruskin); Bradley and Ousby, 1987, pp. 461–2, 465.

81 Letter of 9 September 1885, from Brantwood; Bradley and Ousby, 1987, p. 486.

82 Letter of 20 October 1885; Bradley and Ousby, 1987, pp. 487–9.

83 Evans and Whitehouse, *Diaries*, III, pp. 1115–17.

84 Entry of 22 December 1885; Evans and Whitehouse, *Diaries*, III, p. 1117.

85 Letter of 6 July 1883; *Works*, XXXVII, p. 459.

86 Letters of 1 May, 20 July and 1 October 1884; *Works*, XXXVII, pp. 483, 489, 495.

87 *Works*, XXXIII, pp. liii–iv, 510.

88 Entries of 27 November, 8 December, 9 December and 19 December 1884; Evans and Whitehouse, *Diaries*, III, pp. 1088–9.

89 Entry of 17 March 1885; see Evans and Whitehouse, *Diaries*, III, pp. 1101, 1096, 1102.

90 *Works*, XVI, pp. 236–7.

91 *Works*, XXXIII, pp. lvi-vii.

92 Entry of 4 May 1886, referring to 2 and 3 May; Evans and Whitehouse, *Diaries*, III, pp. 1123, 1125–6.

93 Evans and Whitehouse, *Diaries*, III, p. 1132.

94 Kathleen Prynne and Rayner Unwin (eds), *The Gulf of Years: Letters from John Ruskin to Kathleen Olander*

(London: Allen and Unwin, 1953), p. 78.

95 Prynne and Unwin, 1953, pp. 80, 88.

96 Birkenhead, 1965, pp. 333–42.

CHAPTER 9

EPILOGUE

1 *Works*, XXIV, p. 277.

2 Letter 71, October 1876; *Works*, XXVIII, pp. 744–5.

3 *Works*, XXIV, pp. 170–2.

4 *Works*, XXIV, pp. 207–8.

5 *Works*, XXIV, p. 222.

6 *Works*, XXIV, p. 233.

7 Lecture from *Deucalion*, Ch. I; *Works*, XXVI, p. 112–13.

8 *Works*, V, p. 387. In *Modern Painters*, III, Ruskin had identified Turner as master of the 'science of aspects' (that is, of the *appearance* of nature), as contrasted with Bacon, master of the *laws* of nature.

9 Introduction to *Deucalion* (July 1876); *Works*, XXVI, pp. 95–7.

10 *Works*, XXV, pp. 231–2.

11 *Works*, XXV, p. 233.

12 *Works*, X, pp. 185–7.

13 Ruskin Library, Lancaster, L 41.

14 W. G. Collingwood, *The Life of John Ruskin* (revised in 1 volume; London: Methuen, 1905), pp. 397, 396.

15 *Works*, XI, p. 226.

16 *Works*, VI, p. 425.

17 Ibid.

18 It has been well said that the equation 'work equals virtue' was both a product of the rise of the Protestant ethic and also an instrument with which the bourgeois owner could justify the degradation in which his employees too often lived: 'Once work is dignified, it is a short and almost inevitable step to dignifying the worker, and when work is set up for enthusiastic comparison with idleness it is difficult to avoid admiration for the worker and contempt for the idle'; P.D. Anthony, *The Ideology of Work* (London: Tavistock Publications, 1977), p. 44. But the Protestant ethic in the high Victorian era did not carry all before it. There was a separate ideological strand which was partly a Tory, pre-industrial survival, partly a stirring of middle-

class conscience. As P.D. Anthony expresses it: 'The critics of industrialization were vociferous, disparate in their interests, and often Christian. Were these critics, men like Southey, Wordsworth, Kingsley and Ruskin, simply survivors from a vanishing age? [Their] tradition was strong in the nineteenth century and has continued into the twentieth century. It may be that the only unifying force which binds it is the moral outrage of good men' (1977, p. 63). The official high Victorian ideology comprised two linked priorities, '*laissez-faire*' and 'Self-help'. P.D. Anthony remarks that this ideology is the product of a 'bold' (and, he could have added, profoundly self-deluding) philosophical move which 'required self-interest to be seen as a moral principle. Almost every other moral system has emphasized concern for others; Victorian business ideology was distinguished in its promotion of self-regard to a moral duty' (Anthony, 1977, p. 67). See also P.D. Anthony, *John Ruskin's Labour: A Study of Ruskin's Social Theory* (Cambridge: Cambridge University Press, 1983).

ACKNOWLEDGEMENTS

The author wishes to express his gratitude to Penelope Hoare for her loving care and patience as editor, to Dinah Birch who kindly read and commented on some of the later chapters, to Felicity Bryan who has cherished this project since its inception, and for other forms of help to Tom Cain, Rebecca Finnerty, Ruth Hutchison, Tony Nuttall, Graham Ridley, Jon Stallworthy and Michael Wheeler. He would like to thank the British Academy and the Humanities Research Board for funding research visits to Italy and the United States and for the purchase of microfilms of a substantial part the Bodleian Library's Ruskin archive and for funded sabbatical leave during which he wrote a substantial part of the book, he would also like to thank the University of Newcastle for research support and funded sabbatical leave. He is grateful to the Ruskin Literary Trustees, The Guild of St. George, for permission to quote copyright material, and to the Bodleian Library, Oxford, The Rosenbach Museum and Library, Philadelphia, and The Ruskin Foundation, The Ruskin Library, University of Lancaster, for permission to quote from material in their collections, and he would like to thank the staff and curators of those institutions and of the following libraries: The Beinecke Museum and Library, Yale; The Berg Collection, New York Public Library; The British Library; Durham University library; The Firestone Library, Princeton; The National Library of Scotland; The Robinson Library, University of Newcastle; The John Rylands Library, Manchester. His debt to Henrietta Batchelor is immeasurable, and includes in particular his gratitude to her for sharing her expertise as a psychotherapist and for her steadfast support over the whole period of work on this book.

INDEX